2004

W9-ADS-808

Image Ethics in the Digital Age

Image Ethics

in the Digital Age

**Larry Gross
John Stuart Katz
Jay Ruby, Editors**

University of Minnesota Press
Minneapolis • London

Portions of chapter 6 originally appeared as "Trash, Class, and Cultural Hierarchy" in Laura Grindstaff, *The Money Shot: Trash, Class, and the Making of TV Talk Shows* (Chicago: University of Chicago Press, 2002); copyright 2002 by The University of Chicago; all rights reserved. Chapter 7 was originally published as "The Digital Threat to the Normative Role of Copyright Law," by Sheldon W. Halpern, in 62 *Ohio St. L.J.* 569 (2001); reprinted with permission of *Ohio State Law Journal*. Chapter 8 was originally published as "Fair Use and the Visual Arts, or Please Leave Some Room for Robin Hood," by Stephen E. Weil, in 62 *Ohio St. L.J.* 835 (2001); reprinted with permission of *Ohio State Law Journal*. Chapter 8 also appeared in Stephen E. Weil, *Making Museums Matter* (Washington, D.C.: Smithsonian Institution Press, 2002). Portions of chapter 9 were originally published in *The Image Factory: Consumer Culture, Photography, and the Visual Content Industry;* reprinted with permission of Berg Publishers; all rights reserved. An earlier version of chapter 13 originally appeared in *Indigenous Cultures in an Interconnected World,* edited by Claire Smith and Graeme Ward (St. Leonards, Australia: Allen and Unwin, 2000).

Published by the University of Minnesota Press
111 Third Avenue South, Suite 290
Minneapolis, MN 55401-2520
http://www.upress.umn.edu

Library of Congress Cataloging-in-Publication Data

Image ethics in the digital age / Larry Gross, John Stuart Katz, and Jay Ruby, editors.
p. cm.
Includes index.
ISBN 0-8166-3824-1 (HC : alk. paper) — ISBN 0-8166-3825-X (PB : alk. paper)
1. Photojournalism—Moral and ethical aspects. 2. Photography—Moral and ethical aspects. I. Gross, Larry P., 1942– II. Katz, John Stuart.
III. Ruby, Jay.
TR820 .I42 2003
174'.907049—dc21
2003009776

Printed in the United States of America on acid-free paper

The University of Minnesota is an equal-opportunity educator and employer.

12 11 10 09 08 07 06 05 04 03 10 9 8 7 6 5 4 3 2 1

Contents

Introduction

Image Ethics in the Digital Age

Larry Gross, John Stuart Katz, and Jay Ruby

Depending on where you came in, there are many ways in which you have experienced the dramatic changes in technology, in the practices of journalism, entertainment, and advertising, in the visual environment itself, that together contribute to labeling this the digital age. In the past quarter century, the world of mediated images has undergone transformations that have profound implications for the moral and ethical, as well as the legal and professional, dimensions of image-producing practices. Most notable is the emergence of widely accessible digital manipulation technologies, but the list also includes significant developments in the legal status of ownership rights over images and other forms of "intellectual property"; the worldwide, nearly instantaneous distribution of images via the Internet, unfiltered by editorial professionals; the erosion of privacy under the onslaught of media sensationalism and competition for "live" images of celebrities or private citizens caught up in "newsworthy" events; and the spread of police (and media) surveillance cameras, now common in the United Kingdom and popping up around the United States.

In 1988, when we published a collection of papers under the title *Image Ethics: The Moral Rights of Subjects in Photographs, Film, and Television,* the digital revolution was still in its infancy. Early warnings were being sounded, as in Howard Bossen's 1985 account of the "electronic-computer darkrooms" then just beginning to appear in "research departments of corporations, advertising agencies, government, and universities, in the Associated Press headquarters in New York, and in the *Deutsche Presse-Agentur* offices in Frankfurt" (27). At that time—so recent and yet so remote—Bossen noted that "the image quality [of the electronic still camera] is not nearly as good as a conventional camera image" (27), but also warned: "It may only be a matter of time before a visual equivalent of Richard Nixon's eighteen and one-half minute gap haunts the body politic. It may only be a matter of time before the electronic darkroom falls prey to an electronic equivalent of Janet Cooke, who invents pictures of such power and believability that even the Pulitzer committee is taken in" (31).

Occasions of Sin

The electronic darkroom that seemed somewhat distant in 1985 now comes packaged with digital cameras and scanners selling for a few hundred dollars. Today, nearly anyone can experience the ethical qualms brought on by what photo editor Hal Buell described to Bossen as the "occasion of sin" provided by digital technologies. For many people engaged with issues of photographic practice, the issue was first joined when the February 1982 cover of the *National Geographic* carried a photographic image in which two Egyptian pyramids had been nudged a fraction of an inch closer together. The decision by a photo editor to create a more picturesque composition by engaging in a hitherto off-limits manipulation set off a firestorm of criticism within the precincts of photojournalism, although it is doubtful the public was aware of, or concerned about, the transgression. A decade later, when *Time* magazine ran an image of O. J. Simpson with his skin darkened on its June 27, 1994, cover—a manipulation made obvious by *Newsweek*'s simultaneous use of the same LAPD photo without alteration—there was a firestorm of media criticism. Photographer Matt Mahurin, who produced the cover image for *Time,* later recounted, "By the next day, I had calls from ABC, NBC, Dateline, CNN" (quoted in Abrams 1995, 6). Similar, but smaller, furors were aroused when *Newsday* created an image of figure skaters Tanya Harding and Nancy Kerrigan together on the ice and when *Newsweek* bestowed digital orthodontia on septuplet mother Bobbi McCaughey for its December 1, 1997, cover.

Public concern over digital retouching, whether for artistic or editorial purposes, often exists in a parallel universe separated from the universe of photojournalists and editors, who have long known full well that all images are manipulated and thus have long engaged in and countenanced a variety of image-altering practices. While citizens of the Free World were amused during the Cold War by the crude brutality with which Soviet officials revised the photographic history of their revolution (see King

1997 for numerous illustrations), image manipulation has never been a Communist monopoly. U.S. examples range from the serious (as when a fake photo purporting to show then Senator Millard Tydings huddling with Communist leader Earl Browder contributed to Tydings's failure to be reelected in 1952) to the ludicrous (as when *TV Guide* donated Ann-Margret's body to Oprah Winfrey for a 1989 cover image). *Fortune* magazine's November 2001 cover photo of the "11 smartest corporate leaders" started out as the "12 smartest," but by the time the issue was ready, the twelfth had been digitally edited out. His name: Ken Lay. *Fortune* spokeswoman Terry McDevitt told Howard Kurtz (2002) of the *Washington Post* that the former Enron chief was part of a group photo shoot in August 2001, but by deadline time his company was sinking, and "we didn't feel like he fit the criteria anymore for being one of the smartest people we know." The emergence of digital technologies has merely raised the stakes and heightened professional and public concerns by vastly increasing options and lowering technical barriers. One result has been that professional associations and many media organizations have elaborated guidelines concerning digital retouching (see the chapters in this volume by Dona Schwartz and Marguerite Moritz).

When the temptations of digital manipulation overcome the norms of journalistic practice, there is predictable outrage. In some instances the offense seems trivial, as when ABC News in 1994 was caught posing Cokie Roberts in an overcoat in front of a photo of the Capitol, thus saving her the effort and discomfort of leaving a warm studio to travel across town and stand out in the cold in order to demonstrate her closeness to the events she was reporting. Much less innocent, however, was ABC News's staging of a scene with an actor passing a briefcase to another man and then manipulating the image so that the actor appeared to be diplomat Felix Bloch, then suspected of, but ultimately never charged with, espionage (Wise 1990).

Also disturbing, although in a very different dimension, was an element of the *CBS Evening News* broadcast on New Year's Eve in 1999. The news program that night was broadcast live from Times Square in New York City, and viewers might have been impressed by the large billboard in the background advertising CBS News. They would probably also have been impressed, although less favorably, had they known that the image of the billboard was digitally superimposed on the real objects behind Dan Rather: the NBC Astrovision and a Budweiser ad. In this instance, however, there were no official reprimands or public apologies. Quite the contrary: CBS *Early Show* producer Steve Friedman noted that the network had been using a new technique to place CBS News logos on sides of buildings, on the backs of horse-drawn carriages, and so forth, for several months. "We were looking for some way to brand the neighborhood with the CBS logo," Friedman told the *New York Times.* "It's a great way to do things without ruining the neighborhood. Every day we have a different way of using it, whether it's logos or outlines. And we haven't scratched the surface of its uses yet." He also noted, "It does not distort the content of the news," and the *Times* reported that Dan Rather "knew about the use of the virtual technol-

ogy during the broadcast and did not protest the practice" (Kuczynski 2000). CBS News is not alone in taking advantage of new digital techniques; many sports viewers, for example, see different corporate sponsor logos in the backgrounds of televised playing fields. In time, the particular logo that appears on a viewer's screen may be determined by the information the viewer's cable company has gathered about his or her demographic profile and marketing preferences.

Media Unbound

The rapid and often unimpeded intrusion of new digital technologies into the precincts of journalism has been made easier by transformations in the structure of media industries over the past two decades that rival those in information technology. A general trend in the media industries (and adjacent/overlapping territories, such as the Internet) is that of the weakening of boundaries that previously separated arenas, enterprises, institutions, professions, and so on. In some instances, the blurring of boundaries is a direct result of technological innovation (satellite transmission, the Web); in others, it is a result of corporate consolidation that unites previously distinct (even competitive) entities. The "fire wall" that traditionally has stood between news and advertising is eroding.[1] The influence of marketing/advertising considerations on editorial and feature content has increased in recent years. In part because of the corporate consolidation of media enterprises (and the bottom-line, stock-price orientation that generally accompanies these mergers), we can expect that market calculations will continue to influence journalistic practice more rather than less. Commercial influence can also be seen in entertainment media, in both the increasingly prevalent placement of products and brand logos within film and TV settings and the intrusion of sponsors' preferences in programming decisions. In August 2001, for example, CBS attracted unwelcome media attention when it deferred to the wishes of Procter & Gamble by pulling several episodes of *Family Law* from its rerun schedule after the major advertiser objected to such hot-button issues as gun ownership, the death penalty, abortion, and interfaith marriage (Carter 2001).

In the case of the news media, the weakening of boundaries can be seen in the growing coverage of national (even international) news by local outlets (often competing in news coverage with their network affiliates' "flagship" news programs). Made possible by the growth and reduced costs of transmission technologies (satellite and cable), this change is diminishing the local versus national distinction. In addition to the sheer number of "sources" and channels, there has also been a marked increase in the speed with which "stories" are disseminated through these various channels. The instantaneity of the transmission and diffusion of images and reports around the world has done much to eliminate the editorial function in journalism (see the chapters in this volume by Marguerite Moritz and David Perlmutter).

The boundaries between mainstream journalism and the "fringes" have been seriously weakened. The triumph of "entertainment" and, in particular, of "personality"-

fixated, gossip-oriented journalism has transformed the media landscape and shifted (if not, in some instances, erased) the boundary between the private and the public lives of almost anyone caught up in the media's net (see the chapter in this volume by Larry Gross). Key gatekeepers and opinion leaders still play important roles—especially in the later stages of a story's career—but they are often outpaced by the faster cycles of frenzied feeding now common in journalism, especially the rapidly expanding domain of cable-carried 24/7 news channels. Ever since the nation's seemingly insatiable feasting on O. J. coverage, it seems that we are never left waiting long for the next banquet. In between full-scale orgies such as Monica or Elián, the public's appetite is appeased with smaller offerings such as JonBenet Ramsey or Chandra Levy. And, of course, there is the seemingly inexhaustible pool of those willing to engage in private conflict on the public stages supplied by Jerry Springer and his competitors (see the chapter in this volume by Laura Grindstaff).

Caught in the Webcam

Digital technologies and the Internet have combined to satisfy our collective voyeuristic urges in formats less focused on crime or even family feuding. Although it is always artificial to fix a starting point for such things, MTV's 1992 launching of *The Real World*—which itself might be considered an offshoot of *An American Family*, PBS's early-1970s experiment in cinema verité—may qualify for the honor of having initiated the recent flood of "reality" programming. Putting a group of photogenic twentysomethings together in an overdecorated urban "dorm" for several months of self-exploration, angst, romance, and other late-adolescent preoccupations yielded a season's worth of edited-down "documentary" drama. The success of the series—the ratings have grown steadily over the years, and the producers now receive thousands of requests to audition—was a major impetus to the emergence of a new genre of television. One of the first of these was *Road Rules*, made for MTV by Jonathan Murray and Mary-Ellis Bunim, the creators of *The Real World*, which takes the format on the road, sending the participants around the country in a recreational vehicle, performing "missions" set by the producers. The next stages in the evolution of the genre occurred in Europe, where producers in Britain, the Netherlands, Germany, and Sweden initiated two new formats: the *Survivor* game, which plops a disparate cast of volunteers in some remote and picturesque spot, where they contend with deprivation, exotic foods (i.e., rats, insects), and summer camp games until all but the winner have been "voted off the island" by their peers; and *Big Brother*, which substitutes an indoor stripped-down dorm for the wilderness setting, while audiences witness the silly games and scheming intrigues that occupy the players as their numbers are whittled down to the final winner. In the case of *Big Brother*—much less successful in the United States than *Survivor*, although both formats have been smash hits in Europe—audiences unsatisfied with thrice-weekly edited programs can check out the action on the program's Webcams twenty-four hours a day.

The Webcam is among the more flexible instruments of the digital age, as it has permitted amateur as well as commercialized exhibitionism and growing amounts of official and semiofficial surveillance. Here, too, there is a candidate for trend initiator. In 1996, Dickinson College student Jennifer Ringley set a camera up on her dorm room computer and began placing photos of the room—showing whatever the camera caught—on a Web site, a new picture every three minutes, twenty-four hours a day, seven days a week, 365 days a year.[2] After a few years, Ringley graduated and moved to Washington, D.C., and her Web site (www.jennicam.org) became semicommercial, offering three-month memberships for fifteen dollars. Members have access to a new picture every minute (nonpaying guests get only one every fifteen minutes), as well as a complete archive of images since 1997, a chat room, and much, much more. Here is how Ringley explains JenniCam on the site:

> JenniCam is, to put it most simply, a sort of window into a virtual human zoo. My name is Jennifer Ringley, and I am not an actor or dancer or entertainer. I am a computer geek and recent entrant into the field of social service. I design, code, and administer this website and manage the company that keeps the site alive. I also do occasional freelance website design when I've got time. This is my website, and JenniCam is a part of it.
>
> The "JenniCam" is, in essence, a series of cameras located throughout the house I live in with my amour, Dex. These cameras that take images of this house all day long, every day.
>
> Simply, pictures of us, doing whatever we're doing. I don't sing or dance or do tricks (okay, sometimes I do, but not very well and solely for my own amusement, not yours). By the same token, JenniCam is virtually unedited and uncensored. Except for camera shy guests (whose wishes I humbly and happily respect, and hope you will too), and places the cameras can't reach, nothing is cut.
>
> Consider yourself warned: We are not always at home, sometimes you may see an empty house for hours or longer at a stretch. That's life. Or I may be working at my computer, watching television, or being intimate. You may see nothing but cats all day long.
>
> I keep JenniCam alive **not** because I want to be watched, but because I simply don't mind being watched. It is more than a bit fascinating to me as an experiment, even (especially?) after five years.
>
> So feel free to watch, or not, as you so desire. I am not here to be loved or hated, I am here simply to be me. If that's not enough, there's an entire web of other sites for you to visit. Find your happy place. There is enough love and happiness in the world for us all.

In the short period since JenniCam pioneered this electronic frontier, Webcams have proliferated into a worldwide phenomenon. Entering the term *Webcam* in the Google search engine elicits more than eight million hits, many of them leading to

sites such as WebCamWorld and WebCam Central, which are themselves directories of Webcams across the world. Leonard's Camworld advertises itself as a "Family Oriented Travel, Entertainment and Educational Site Featuring Current Outdoor Views of Cities Across The Globe," with links to more than seven thousand Webcams. There is another dimension to the Webcam industry that isn't likely to be featured on a family-oriented site. For that you might instead begin with www.boudoir.com, which at one point hosted JenniCam but now seems entirely devoted to hard-core pornographic image purveyors, helpfully arrayed in categories, from "Amateur Girls" to "Asian Peaches," "Back Door Boys," "Black Finger," through "Upskirt Teenies" and "XXX Asians." A box on the Web site alerts potentially vulnerable office workers: "DOES YOUR EMPLOYER KNOW YOU'RE SURFING? INTERNET ERASER WILL PROTECT YOUR PRIVACY!" Some of the sites available pose as JenniCam variants— and some might even be what they claim. "Voyeur Dorm features college-age women living together in a Tampa house rigged with cameras in every room. For a fee, subscribers are able to watch them eating, sleeping, showering, changing clothes and sunbathing—sometimes naked. Dude Dorm offers the same service featuring college-age men, and was meant to appeal to women and gay men" (Reuters, cited in "Dude Dorm" 2001). A Google search for Dude Dorm yields some twenty-three thousand hits, high among them the original: "This site is like *Real World* but with LIVE naked guys!" According to the *Tampa Bay Guardian,* "The dudes get free college tuition, free rent and a salary of about $500 a week. In exchange, cameras document their every move for subscribers who pay $34 a month" (Evans 2001). No one familiar with the history of communications technology would be surprised by the prevalence of pornography on the Internet; no one familiar with pornography would be surprised by the prevalence of images of "compliant" Asian beauties within that pornotopia (see the chapter in this volume by Darrell Hamamoto).

Video surveillance may often occur in less voluntary, as well as less commercial, circumstances. New technologies offer far more sophisticated options than those of such old-fashioned gimmicks as the Cambron Super Snooper, which promised, "Now you can photograph *everything* and *everybody you always wanted to shoot if you disguise your camera with the Super Snooper and shoot around the corner.*" Miniaturized cameras connected to video recorders or computers now permit parents to keep an eye on their children's nanny—the so-called nanny cam—or to catch a thieving housekeeper in the act. Such a camera permitted a Massachusetts father to film a teenage baby-sitter showering in his home's bathroom (Calvert 2000, 129). Undoubtedly, many other voyeurs who have never been caught have been aided by such cameras as well. Those reminded of Linda Tripp's tangle with the law in Maryland may be comforted to know that unlike the laws applying to audiotaping, there are few laws prohibiting surreptitious videotaping as long as the subjects are neither nude nor minors (for examples of cases in which local TV news crews have taken hidden cameras into public restrooms, see the chapter in this volume by Larry Gross).

Closed-circuit television cameras mounted in public places are common in the United Kingdom, and they are becoming fixtures in many U.S. locales. Although citizens have long been accustomed to being on-camera while doing business at banks and late-night convenience stores, they are less familiar with the more sophisticated surveillance technologies increasingly utilized by commercial establishments to keep tabs on customers and employees as well as thieves, and by official agencies to deter crime or catch offenders. In addition to hosting the popular Voyeur and Dude Dorms housing public-spirited university students, Tampa, Florida, is well on the way to becoming the national leader in the use of public surveillance. Many Americans first learned of the latest trend in law enforcement after the 2001 Super Bowl was played in Tampa. As the *St. Petersburg Times* reported: "Each and every face that entered Raymond James Stadium for the big game was captured by a video camera connected to a law enforcement control room inside the stadium. In milliseconds, each facial image was digitized and checked electronically against the computer files of known criminals, terrorists and con artists of the Tampa Police Department, the FBI and other state and local law enforcement agencies" (Trigaux 2001). According to a press release from Graphco, the "leading developer of technology and solutions for biometric authentication, secure access, and expert information-sharing systems" that supplied the system: "A law enforcement task force of local, state and federal agency personnel monitored the system. Once individuals were matched with photo files in the database, officers of the joint task force, circulating throughout the complex, could be dispatched immediately to make possible arrests, quickly and discreetly."

News accounts of the Super Bowl surveillance attracted media attention and editorial condemnation as an example of creeping Big Brotherism. Some noted that the system did not, in fact, lead to the capture of any criminals. Yet, as a recent report from RAND insists: "While facial recognition did not lead to any arrests at the Super Bowl, there is evidence that using such a system can help deter crime. In Newham, England, the crime rate fell after police installed 300 surveillance cameras and incorporated facial recognition technology. While it is possible that the criminals only shifted their efforts to other locales, crime in Newham at least was deterred" (Woodward 2001, 10). The RAND analysts conclude that "biometric facial recognition can provide significant benefits to society," adding that "we should not let the fear of potential but inchoate threats to privacy, such as super surveillance, deter us from using facial recognition where it can produce positive benefits" (14). The positive effects cited, it should surprise no one, are mainly the possible apprehension of terrorists and pedophiles: "Super Bowl XXX showcased its potential to help prevent terrorist acts.... Many parents would most likely feel safer knowing their children's elementary school had a facial recognition system to ensure that convicted child molesters were not granted access to school grounds" (12).

In the meantime, while we wait for local school systems to dedicate large portions of their budgets to such systems, we can see how they might work by following

the tale of Tampa. In June 2001, Tampa installed twenty-six color cameras that the city received from Visionics Corporation, augmenting the existing bank of ten black-and-white cameras mounted on lampposts and employing the company's Face-It software, which matches images of pedestrian faces with a database of the faces of wanted felons and sexual offenders. As of mid-August 2001, the police had not yet arrested anyone identified by the surveillance system, although they thought they had come close in one instance. When a story about the system included an image of a construction worker on his lunch break taken by one of the cameras, a woman in Tulsa saw the picture in *U.S. News & World Report* and called Tampa police. She said the man in the photo was her ex-husband and was wanted on felony child neglect charges. The man was then accosted at his work site by police officers carrying copies of the magazine open to the picture, captioned "You Can't Hide Those Lying Eyes in Tampa." It turned out the man had never been married, and he had never been to Oklahoma.

Borders bookstores ran into opposition when it was revealed that the company was planning to introduce a surveillance system called SmartFace in its eleven British stores. The system keeps a database of "unique digital face-maps" and checks customers' pictures against those of known shoplifters. Although Borders was somewhat defensive in response to criticism of the company's use of SmartFace—a spokesperson assured the public, "If the system infringes on anyone's human rights then Borders wouldn't be using it"—news accounts noted that the system was in use by the U.S. Immigration and Naturalization Service to check for illegal immigrants trying to cross the Mexican border, by the Israeli Army on the Gaza Strip, and at Iceland's Keflavik Airport to seek out known terrorists (Johnston 2001). In the aftermath of the terrorist attacks of September 11, 2001, in which hijacked commercial airlines were crashed into the World Trade Center towers and the Pentagon, the use of such systems has increased, and public resistance has diminished or even turned into demands for expanded surveillance.

Enclosure Laws in Cyberspace

Article 1 of the U.S. Constitution (Section 8, Clause 8) stipulates, "The Congress shall have power... To promote the progress of Science and useful Arts, by securing for limited Times to Authors and Inventors the exclusive right to their respective Writings and Discoveries." Thus copyright is a constitutional guarantee in the United States, but granting that does not resolve the complex issues of whose rights are thus assured, for what purposes, and in what manner. Although the history of copyright in Anglo-Saxon law can be traced to the sixteenth-century monopoly on the book trade granted to the Stationers Company by Queen Mary, its later forms owe more to the 1710 Statute of Anne, which is usually interpreted as intended to encourage and reward creativity by ensuring that creators would benefit from the fruits of their labor.[3] However, two other interests are readily brought to bear, making copyright a

multidimensional playing field. The constitutional clause clearly invokes the public interest in promoting science and the useful arts, and this interest requires that members of the public be invested with a *right of access* to the "Writings and Discoveries" of their fellow citizens. Finally, there are the proprietary rights of those who obtain control over "Writings and Discoveries" in order to distribute, sell, and license them—publishers, in their many forms. In other words, there is a three-way play of rights that often pits the interests of creators, proprietors, and the public against one another. In recent years, it has been the proprietors who have come out ahead in the arena of U.S. intellectual property legislation (see the chapter in this volume by Sheldon Halpern). In addition to the property protections secured by copyright law, corporations have also explored and expanded the possibilities offered by trademark protection (the ® is becoming as familiar as the ©) and increasingly ubiquitous forms of product branding.

The U.S. Constitution stipulates the securing of exclusive rights for "limited Times," and in the beginning, as in the Statute of Anne, this meant fourteen years, with the possibility of renewal for another fourteen years. Successive legislation has repeatedly extended the period of copyright. By the mid-1990s, new and recent works were covered for the life of the creator plus fifty years; presumably, the incentive to create requires confidence that one's grandchildren will be compensated. The Sonny Bono Copyright Act of 1998—the name might suggest something about the commercial interests being served by Congress—extended the period to life plus seventy years (taking into account the grandchildren's longer life expectancy?) and extended corporate copyright from seventy-five to ninety-five years. As many noted, the primary lobbyist for the extension was the Disney Corporation, fearful that Mickey Mouse would be captured by the public domain in 2004 (stick around and watch the congressional lobby in 2023). Disney, which paid no royalties for the use of Hans Christian Andersen's "Little Mermaid" or Scheherazade's "Aladdin," was joined in lobbying for the extension by the Gershwin estate, although it is difficult to see how an additional twenty years could inspire George Gershwin to further creative achievements. As law professor David Post has put it, "There is no conceivable public benefit from the additional twenty years," as retroactive extensions cannot possibly influence the original creator's incentive to produce works of science and the useful arts (quoted in Walker 2000). A group of Harvard University law professors unsuccessfully petitioned the U.S. District Court for the District of Columbia to strike down the copyright extension act as a violation of free speech. In the words of Lawrence Lessig, "Extending a dead author's copyright won't encourage him to write another book" (quoted in Lewis 2000).

The latest developments in copyright law have favored corporate interests in many more important ways than by extending the period of coverage. The emergence of digital technologies and the explosive expansion of the Internet have put information at the center of the world economy and made cyberspace an inescapable crossroads of contemporary economics, politics, and culture. Moreover, although cyber-

space was first sighted and celebrated by pioneers who believed they were settling an open and free frontier, it wasn't long before corporations and the U.S. government were working together to enclose its open spaces and erect toll booths along the information highway. In the words of legal scholar Jessica Litman (1999), "While the public's attention on Internet-related issues was absorbed with smut control, and the media debated the pros and cons of censorship and hard-core porn, big business persuaded politicians of both political parties to transfer much of the basic architecture of the Internet into business's hands, the better to promote the transformation of as much of the Net as possible into a giant American shopping mall" (213).

The vehicle for the latest transfer of copyright power—from both creators and users—to proprietors is the Digital Millennium Copyright Act of 1998, passed by Congress with the support of the Clinton administration (see the chapter in this volume by Sheldon Halpern). The DMCA is particularly focused on the new digital technologies, which make it possible to produce an infinite number of perfect copies from a digitized original and to disseminate such copies anywhere in the world with the click of a mouse. In other words, control over information has become vastly more difficult and the danger to property rights more acute. In the minds of the corporate property holders, every consumer is now a potential pirate. Much of the DMCA is meant to address, and prohibit, the use of technological means to circumvent encryption mechanisms designed to limit the use of copyright material. When a DVD or an electronic book is encrypted so that it cannot be copied, even by the buyer who wishes to have a backup or read the book on a second computer, it is now a crime to provide a means to disable that encryption. This point was dramatized when Russian programmer Dmitri Sklyarov was arrested at a computer convention in Las Vegas in July 2001 after he had given a presentation in which he described security flaws in the encryption software used to prevent the copying of electronic books (Harmon and Lee 2001).

Microsoft has a Web site devoted to the company's efforts to defeat decryption programs, explaining: "Microsoft has been at the forefront for many years in initiatives that foster respect for digital intellectual property. As eBooks inspire a new era in publishing, Microsoft is pleased to support the Association of American Publishers (AAP) in its unprecedented efforts to implement programs to proactively address the threat of eBook piracy." The company proceeds to outline its approach to combating copyright piracy—which, as suggested, seems to include any individual who wishes to make a copy of an electronic book that he or she has purchased. Microsoft concludes with a chilling echo of Big Brother: "Using technology developed by Microsoft to protect its own intellectual property on the Internet, the AAP has implemented an aggressive Internet surveillance program, which includes an automated, intelligent Internet search tool that searches for unauthorized distribution of eBook content 24 hours a day, seven days a week. The information and evidence gathered by this tool can form the foundation for subsequent civil and criminal enforcement" (Microsoft 2001).[4]

The approach embodied in the DMCA and other recent U.S. copyright law undermines one of the crucial protections of the public interest embodied in the copyright law: fair use (see the chapter in this volume by Stephen Weil). Before the Copyright Act of 1976, "fair use" was cited and accepted as an *excusable infringement* of copyright. However, the 1976 law goes further, providing that certain uses for purposes such as criticism, comment, news reporting, teaching, scholarship, or research might be "fair uses" and consequently *noninfringing*. The criteria for determining whether a use is fair are as follows: "(1) the purpose and character of the use, including whether such use is of a commercial nature or is for nonprofit educational purposes; (2) the nature of the copyrighted work; (3) the amount and substantiality of the portion used in relation to the copyrighted work as a whole; and (4) the effect of the use upon the potential market for or value of the copyrighted work" (Section 107).

The importance of fair use to scholarship, criticism, and teaching should be self-evident. Fair use has been successfully invoked by musical creators who draw on prior works, in some instances at least (for extensive examples and defenses of fair use in the arts, see the "Intellectual Property Issues" area of the Negativland Web site, at www.negativland.com/intprop.html). In particular, limited quotation for parody or criticism has been held to be legitimate, as in the Supreme Court's 1994 ruling in *Campbell v. Acuff-Rose Music, Inc.,* which upheld the right of the rap group 2 Live Crew to sample Roy Orbison's "Oh, Pretty Woman." But a broad interpretation of fair use is particularly important in the case of visual images, as Stephen Weil explains in chapter 8 of this volume, because in these instances the option of excerpting or quoting is often meaningless. The editors of a collection of critical essays titled *The Many Lives of the Batman* conclude their acknowledgments with a rueful note: "We regret the absence of illustrations, particularly since they would have, in many cases, helped to elucidate the argument. DC Comics refused to grant us the right to use images as they did not feel that this book was consistent with their vision of the Batman" (Pearson and Uricchio 1991, vi). Henry Jenkins, a contributor to the collection, has noted: "If you can't quote what you're talking about, then at a certain point it becomes impossible to talk about it all. You cut off certain ideas from being heard" (quoted in Walker 2000).

Despite the DMCA and even Microsoft's 24/7 intelligent search tool, digital technologies permit individuals to make use of existing works in creating new ones. Just as George Lucas was inspired by Kurosawa's *The Hidden Fortress* when he made the first *Star Wars* film, so, too, have legions of fans been inspired to parody, remake, and rework material in the *Star Wars* corpus for their own creative purposes. As programmable digital video becomes more widely available, increasing numbers of viewers will be able to create their own "fan cut" versions of their favorite films, editing out parts they don't like and reshuffling other portions as they wish. Just as Lucas "revised" *Star Wars* when it was reissued in 1997, so fans have produced versions of

The Phantom Menace that eliminate the unpopular Jar Jar Binks (Hoberman 2001). And they are hardly the first to invade this digital territory, coming as they do after *Zelig, Forrest Gump,* and the digital resurrection of Fred Astaire, John Wayne, James Cagney, and Humphrey Bogart, none of whom were asked or agreed to star in television commercials (although their estates presumably did agree, and accepted payment). The realm of nature and wildlife films has long been accustomed to more image manipulation than the creators of these films have publicly acknowledged, and now that the filmmakers are equipped with digital technologies, audiences who thrilled to the fictional dinosaurs of *Jurassic Park* can be educated, as it were, by *Walking with Dinosaurs* on the Discovery Channel (see the chapter in this volume by Derek Bousé).

One of the largest domains of privately owned images is nearly invisible to the public. The "stock photography" industry, which is dominated by Getty Images and Corbis (owned by Microsoft chairman William Gates), owns and licenses images for use by news outlets, publishers, and advertising companies (see the chapter in this volume by Paul Frosh). By many estimates, the major stock photography companies now control the majority of the world's great image collections, including the digital reproduction rights to the holdings of many major art museums (Flynn 2001). Scholars who are unaware of, and uninterested in, the backstage workings of ad agencies and the news media might have taken notice of the ongoing consolidation of image ownership when Corbis bought the Bettman archive in 1995, taking over the most significant collection of historical photographs in the world. The Bettman's twelve million images are in the process of being digitized, and the originals moved to an underground storage site in Pennsylvania. Photographers have reason to be concerned about the concentration of image ownership and distribution in few hands, as this development leads to the favoring of market-driven, commercially safe styles over riskier, innovative creativity. An industry executive whom Frosh quotes put it bluntly: "In the end, it's still probably your one cute kitten shot that sells, not the edgier stuff you shot to get the agencies to notice you. . . . At Index Stock 70 per cent of our sales are of traditional photography" (see chapter 9).

Commercial photography is not all about cliché images; ad agencies have also colonized the domains of art and news photography. The Italian clothing chain Benetton succeeded in attracting attention in the 1990s through the use of dramatic documentary photos on which the company's logo was superimposed, enlisting private suffering and tragedy in the service of Benetton's "edgy" image (see the chapter in this volume by Matthew Soar). Around the same time, Sebastião Salgado, whose fame rests on images of workers that teeter on the border between documentary and hyper-aestheticization, created a series of ads for Le Creuset cooking pots. According to an advertising trade journalist, Salgado shot "the grimy-faced Algerian and Italian immigrant workers in natural light. . . . The results were grainy, true-to-life and unpretentious" (quoted in Soar, chapter 12, this volume). The ads, on the other hand, might

well strike us as being pretentious as well as exploitative of the lives of these workers, who do not, after all, benefit from the sale of Le Creuset cookware.

Old Wine in New Bottles

In 1988, Brian Winston began a discussion of the "tradition of the victim" in documentary by quoting A. J. Liebling's remark that it is difficult for the cub reporter to remember that his (or her) great story is somebody else's disastrous fire (34). Conflicts between the intentions and interests of image makers and those of their subjects remain as ethically fraught as they were when we compiled our earlier *Image Ethics* collection. The issues are familiar, even when they appear in a new guise, and sometimes they appear in familiar forms.

Actor Dustin Hoffman sued *Los Angeles* magazine over a 1997 fashion spread in which an image of his head taken from *Tootsie* was digitally placed on a woman's body and captioned, "Dustin Hoffman isn't a drag in a butter-colored silk gown by Richard Tyler and Ralph Lauren heels." Hoffman accused the magazine of illegal commercial exploitation and of robbing him of his dignity, professionalism, and talent. The judge agreed and levied a $1.5 million fine (Kuczynski 1999), but a federal appeals court overturned the decision. "Viewed in context," Judge Robert Boochever wrote, "the article as a whole was a combination of fashion photography, humor and visual and verbal editorial comment on classic films and actors" (quoted in Egelko 2001).

The rich and famous, of course, are not the only ones who find their images used to suit other people's purposes. The November 1999 issue of *Latina* magazine illustrated an article titled "My Child Is Gay. ¿Qué Hago? [What do I do?]" with a photo of three young women smiling. The three women, two sisters and their cousin, sued the magazine for sixty million dollars, claiming that the photographer, Bruce Byers, "took pictures of those girls, and they had no idea that they would be used for commercial purposes" and that the magazine subjected the women to "ridicule, humiliation, social stigma, and social ostracization" (Associated Press 2000). As Clarence Arrington could tell these young women, their chances of prevailing in court are slim. When he found his picture on the front page of the *New York Times Magazine*—not having even been aware that he had been photographed—the courts were not sympathetic to his claim of damage (see Gross, Katz, and Ruby 1988, 11–12).

Still others who are even less able to assert their interests sometimes find themselves caught in the camera's eye and can only hope for the best. Following in the footsteps of Frederick Wiseman's *Titicut Follies* (1967), filmmakers Maryann DeLeo and Sarah Teale made a documentary for HBO's America Undercover series titled *Bellevue: Inside Out*. As *New York Times* critic Julie Salamon (2001) notes, the filmmakers selected cases that were interesting, casting both "normal looking" and "wild eyed" patients. One of the patients, a woman named Cheryl, screams at the camera, "People who are suffering mental illness are suffering from pain, and it's nothing to

laugh at. It isn't funny." At the same time, Cheryl's face, centered in close-up with eyeglasses askew, one lens held in place by tape, is likely to evoke laughter, however nervous and guilty. As with *Titicut Follies,* nearly four decades ago, we are left wondering what sort of informed consent these patients could have given, and whether their exposure serves a purpose worth sacrificing their privacy for (Anderson and Benson 1988).

The ubiquitous availability of video recording and editing equipment has enabled countless individuals to take up the mantle of filmmaker, and quite often their family members find themselves cast in leading roles. There is, in fact, an entire genre of family film—not to be confused with home movies—often the work of beginners who start by asking and telling about those closest to them. In such circumstances we might often wonder whose interests are being served and what sort of consent has been sought or received (see the chapter in this volume by John Stuart Katz).

On anyone's list of the most powerful images of the twentieth century is *Tomoko Is Bathed by Her Mother,* Eugene Smith's 1971 photo of a child with a congenital disease caused by mercury pollution in Minamata, Japan. Although Tomoko died in 1977 at the age of twenty-one, her parents were upset by the continued use of the photograph (and by the assumption that they had gained financially from its widespread reproduction). In 1998, Smith's widow, holder of the copyright on the photograph, acceded to the wishes of Tomoko's parents by forbidding any future use of the image.[5] Granting the wish of Tomoko's parents to let their child rest in peace, however, has an impact beyond exhibitions of the "One Hundred Greatest Photographs of the Twentieth Century." Those wishing to enlist Tomoko's image in the fight against industrial pollution believe that her life and her spirit would be better served through the use of the power of the photograph in continuing the struggle.[6]

At the opposite end of the spectrum from the mainstream commercial media that blanket the planet, seeking to fill every corner and every minute, can be found the growing presence of images and messages produced for and by communities primarily interested in speaking for and to themselves. Newer technologies have empowered these communities to declare independence from the colonizing powers of media practices that view them as objects rather than subjects. In recent decades, indigenous media movements have flourished in Australia, Canada, and the United States (see the chapters in this volume by Faye Ginsburg and Hart Cohen), and they are a ray of hope for those who believe in the liberating potential of technology.

In 1988, Larry Gross concluded his essay in *Image Ethics* on a note of pessimism, noting that "history offers too many precedents of new technologies which did not live up to their advance billing; which ended up being part of the problem rather than part of the solution.... there surely are opportunities in the new communications order for more equitable and morally justifiable structures and practices, but I am not sure we can get there from here. As Kafka once wrote in his notebooks, 'In

the fight between you and the world, bet on the world'" (201). It remains to be seen whether living in the digital age has improved our odds.

Acknowledgments

The preparation of this volume was made possible by the generosity of the Technology and Society Program of the Annenberg Public Policy Center of the University of Pennsylvania and its director, Kathleen Hall Jamieson. Research and bibliographic assistance was provided by Sasha Costanza-Chock, Denine DiBenedetto, Janice Essner, David Gudelunas, Marina Levina, and Joan Saltzman. The Image Ethics in the Digital Age Conference held at the Annenberg Public Policy Center in March 2000 was ably assisted by Deborah Porter, Debra Williams, and Rich Cardona and Kyle Cassidy of the Annenberg School computer staff. At the University of Minnesota Press, Jennifer Moore, Carrie Mullen, and Anna Pakarinen were especially helpful and encouraging.

Notes

1. A sales pitch for the public relations firm Media Relations, Inc., puts it bluntly: "The media is separated into two categories. One is content and the other is advertising. They're both for sale. Advertising you can purchase directly from the publication or through an ad agency, and the content space you purchase from PR firms" (press release, May 31, 2001).

2. Although Jennifer Ringley might be the first person to choose to live in the eye of the Webcam, the honor of being the first Webcam subject probably goes to a coffeepot in a Cambridge University computer lab. In 1991, lab workers pointed a video camera at the coffeepot so they could check on the availability of coffee without leaving their workstations; when a new camera was installed in 1993, it was linked to the newly created Internet, and soon people around the world were checking on the Cambridge coffeemaker. The rest is e-history. In August 2001, the laboratory moved to new facilities, and the coffeemaker was put up for auction on Ebay; within fifteen minutes the (nonfunctional) coffeemaker was bought for just under five thousand dollars by the computer branch of the German news weekly *Der Spiegel,* which plans to resurrect the coffeepot Webcam as a "true piece of Internet history" (Zeller 2001).

3. The key aspects of the Statute of Anne were these: First, the act granted rights to authors, not to publishers. Second, it did so for the utilitarian purpose of inducing learned men to write and publish books. Third, the act established a larger societal purpose for copyright, namely, to promote learning. Fourth, it granted rights only to authors of newly authored books. Thereafter, ancient books were in the public domain and could be printed by anyone. Fifth, it limited the duration of copyright to fourteen-year terms (renewable for another fourteen years if the author was living at the end of the first term), thus abolishing perpetual copyrights. Sixth, the statute conferred rights of a limited character (not to control all uses, but to control the printing and reprinting of protected works). Seventh, it imposed a responsibility on publishers to deposit copies of their works with designated libraries. Eighth, it provided a system for redressing grievances about overpriced books. (This account is drawn from Samuelson 1999.)

4. A company called Ranger offers a similar service to corporations concerned about leakage: "Using powerful, proprietary Intelligent Online Scanning (IOS) technology, the

Ranger solution goes to the heart of the problem by uncovering illegal distribution points on-line. With the information that Ranger accumulates, owners can take action against offenders and regain control of their products online. The Software and Entertainment (digital) industries and the Consumer Goods (non-digital) industries are two categories in which Ranger helps corporations do just that. . . . We never sleep. Our IOS software is constantly searching the Internet 24 hours a day, 7 days a week. Our intelligent scanning probes are customized to each client's needs and patrol the Internet searching for suspicious sites." See Ranger Online (2001).

5. "Regarding the Photograph, *Tomoko Is Bathed by Her Mother.*

"The photograph entitled *Tomoko Is Bathed by Her Mother* was taken in December 1971 by Eugene and Aileen Smith. At the time, Tomoko was a plaintiff in the First Minamata Disease Trial and was suing the Chisso company for damages. Her parents wanted society to know of the fate of their daughter and therefore agreed to the taking and publishing of the photograph.

"Since 1972, this photograph has been published in Life Magazine, a book of photographs entitled *Minamata* (1975 in English, 1980 in Japanese) and caused a sensation, becoming a symbol of the Minamata disease.

"The plaintiffs won their case in March of 1973 but sadly, Tomoko died in December 1977 at the tender age of 21. Despite this, however, the photograph continued to be used as a symbol of the Minamata disease in books and exhibitions, leaving a strong impression on a large number of people. I later heard that this resulted in a certain amount of conflict within the minds of her family, who wanted to see the end of the kind of pollution that caused the problem, while at the same time wished to let Tomoko rest in peace.

"Generally, the copyright of a photograph belongs to the person who took it, but the model also has rights and I feel that it is important to respect other people's rights and feelings. Therefore, I went to see the Uemura family on June 7, 1998 and promised that the photograph in question would no longer be used for publication or exhibition.

"For the above reasons, the photograph entitled *Tomoko Is Bathed by Her Mother* will not be used for any new publications. In addition I would be grateful if any museums etc. who already own or are displaying the work would take the above into consideration before showing the work in the future." Aileen Mioko Smith (copyright holder), October 30, 1998.

6. "Smith's photograph of Tomoko probably has done more to raise world consciousness about the effects of pollution than any other image and continues to play a vitally needed educational function. While I can understand the family's mixed feelings about its use, Tomoko could continue to save lives for generations to come if the photograph continues to be seen. While I have no way of knowing if her soul rests in peace, I would hope that she would rest more easily knowing that the discomfort she experienced in having her picture taken by a stranger had long-term beneficial effects for humanity and may help prevent others from suffering from debilitating, if not fatal, pollution-caused diseases. I urge the family to authorize its use in contextually appropriate publications and donate the income to the cause of environmental protection." Gary D. Saretzky, archivist, Monmouth County Archives, March 1, 2000.

References

Abrams, Janet. 1995. Little Photoshop of horrors: The ethics of manipulating journalistic imagery. *Print* 49 (November–December).

Anderson, Carolyn, and Thomas Benson. 1988. Direct Cinema and the myth of informed consent: The case of *Titicut Follies*. Pp. 58–90 in *Image ethics: The moral rights of subjects in*

photographs, film, and television, edited by Larry Gross, John Stuart Katz, and Jay Ruby. New York: Oxford University Press.

Associated Press. 2000. Three women sue "Latina" magazine for alleged misuse of their photos. January 11.

Bossen, Howard. 1985. Zone V: Photojournalism, ethics, and the electronic age. *Studies in Visual Communication* 11, no. 3:22–32.

Calvert, Clay. 2000. *Voyeur nation: Media, privacy, and peering in modern culture.* Boulder, Colo.: Westview.

Carter, Bill. 2001. CBS drops reruns as advertiser pulls commercials. *New York Times,* August 17.

Dude Dorm under attack in Tampa. 2001. *Broadcasting & Cable,* March 1. On-line at http://www.broadcastingcable.com.

Egelko, Bob. 2001. Actor Dustin Hoffman loses damages award on appeal. *San Francisco Chronicle,* July 7.

Evans, Ron. 2001. Dude Dorm gets new digs and a surprise visit. *Tampa Bay Guardian,* February 28.

Flynn, Laurie. 2001. Licensing famous art, digitally. *New York Times,* August 20.

Gross, Larry. 1988. The ethics of (mis)representation. Pp. 188–202 in *Image ethics: The moral rights of subjects in photographs, film, and television,* edited by Larry Gross, John Stuart Katz, and Jay Ruby. New York: Oxford University Press.

Gross, Larry, John Stuart Katz, and Jay Ruby, eds. 1988. *Image ethics: The moral rights of subjects in photographs, film, and television.* New York: Oxford University Press.

Harmon, Amy, and Jennifer Lee. 2001. Arrest raises stakes in battle over copyright. *New York Times,* July 23.

Hoberman, J. 2001. "A do-it-yourself 'Star Wars.'" *New York Times,* July 15.

Johnston, J. 2001. Big Borders bookshop is watching you. *Glasgow Sunday Herald,* August 26.

King, David. 1997. *The commissar vanishes: The falsification of photographs and art in Stalin's Russia.* New York: Metropolitan.

Kuczynski, Alex. 1999. Dustin Hoffman wins suit on photo alteration. *New York Times,* January 23.

———. 2000. On CBS News, some of what you see isn't there. *New York Times,* January 12.

Kurtz, Howard. 2002. The story that wouldn't live. *Washington Post,* February 25.

Lewis, Paul. 2000. The artist's friend turned enemy: A backlash against copyright. *New York Times,* January 8.

Litman, Jessica. 1999. Electronic commerce and free speech. *Ethics and Information Technology* 1:213–25.

Microsoft. 2001. Beyond encryption: Microsoft's commitment to secure distribution of digital intellectual property. On-line at http://web.archive.org/web/20011030233748/http://www.microsoft.com/ebooks/das/antipiracy.asp.

Pearson, Roberta, and William Uricchio. 1991. Acknowledgments. In *The many lives of the Batman,* edited by Roberta Pearson and William Uricchio. New York: Routledge.

Ranger Online. 2001. The solution. On-line at http://web.archive.org/web/20010608153643/www.ranger.inc.com/solution/solution_bot1.htm.

Salamon, Julie. 2001. Safe on the outside (or so you think). *New York Times,* May 4.

Samuelson, Pamela. 1999. Copyright and censorship: Past as prologue? Paper prepared for a conference on private censorship held at Yale Law School, April. On-line at http://www.negativland.com/past_as_prologue.html.

Trigaux, Robert. 2001. Cameras scanned fans for criminals. *St. Petersburg Times,* January 31.

Walker, Jesse. 2000. Copy catfight: How intellectual property laws stifle popular culture. *Reason,* March. On-line at http://reason.com/0003/fe.jw.copy.shtml.

Winston, Brian. 1988. The tradition of the victim in Griersonian documentary. Pp. 34–57 in *Image ethics: The moral rights of subjects in photographs, film, and television,* edited by Larry Gross, John Stuart Katz, and Jay Ruby. New York: Oxford University Press.

Wise, David. 1990. The Felix Bloch affair. *New York Times Magazine,* May 13, 42.

Woodward, John D., Jr. 2001. *Superbowl surveillance: Facing up to biometrics.* Santa Monica, Calif.: RAND.

Zeller, Tom. 2001. Seen my sock drawer lately? *New York Times Magazine,* August 19, 14.

The Internet: Big Pictures and Interactors

David D. Perlmutter

For affluent nations, communities, and peoples, ours is an era in which science fiction—what writer Thomas Disch (1999) calls the "dreams our stuff is made of"—has become a blueprint for cognitive, material, commercial, and social realities. This is so in the case of the Internet and its main platform, the World Wide Web. They seem about to fulfill the vision of H. G. Wells (1937/1996), who, in one of his last works, describes a ubiquitous electronic encyclopedia and medium, the "world brain" (see also Bove 1996), that stores everything ever written, recorded, or pictured. Wells also foresaw the Internet's most distinctive feature: it allows users to navigate, remix, explore, and redirect the content of communication. For that reason, although we know that audiences of previous media, from listeners to Homer to readers of *Das Kapital* to viewers of *Star Wars,* were and are not stereotypically passive receivers, the Internet age will generate a new descriptor signifying a technological and perhaps cognitive step beyond creator, producer, deliverer, listener, reader, and viewer: the *interactor.*

Although science fiction has accurately foreseen the creation of some of today's technological innovations and new social, cultural, and political conditions, the genre

has met with less success in predicting how new technologies will affect not only society and individuals but each other. This is especially true for the publicly commodified visual image that is not only part of the historical consciousness of all its viewers, but a contested terrain of political argumentation. By example, the late Isaac Asimov once noted that some science fiction writers had correctly foretold that one day we would have a worldwide visual medium something like television. At the same time, it was a science fiction commonplace that men would eventually travel on rocket ships to the moon. But no one, Asimov pointed out, had ever suggested that when men did land on the moon, half of the human species would be *watching* it happen on television. The visions of the future traveled on parallel lines; no one foresaw their convergence.

Asimov's observation, however, raises other issues about the technological revolutions in the creation and distribution of imagery: notably, he chose to make a point about his craft through a famous image, an icon of the modern age (Perlmutter 1998). The "astronaut on the lunar surface" photo and the subsequent "big blue" image of Earth became instant members of the pantheon of news and event photography. Such "big pictures" are thought to have achieved worldwide recognition across peoples, cultures, and generations, and even to have "changed the world" (e.g., Monk 1989). They include such mnemonic familiars as Robert Capa's *Dying Spanish Militiaman* (1936); Charles Moore's police dogs attacking black civil rights marchers in Birmingham, Alabama (1963); Bob Jackson's *Jack Ruby Shooting Lee Harvey Oswald* (1963); Eddie Adams's *Saigon Execution, Tet* (1968); John Paul Filo's *Girl Screaming over a Dead Body at Kent State* (1970); Huynh Cong Ut's *Naked Little Girl and Other Children Fleeing Napalm Strike* (1972); Charles Cole's picture of a man confronting a column of tanks near Tiananmen Square (1989); a still shot from a Pentagon Gulf War video of a missile's-eye view of an Iraqi building (1991); the images of the bodies of American servicemen dragged through the streets of Mogadishu (1993); "little Elián's" (2000) encounter with government agents; and, of course, most recently, the smoking towers of the World Trade Center and the sardonic visage of Osama bin Laden in videographic self-portraits.

It is also widely assumed that such icons can be powerful political tools, engaging people's attention, upsetting our emotions, changing our beliefs, and even affecting government policies and programs. This notion of visual determinism first arises in Plato's *Republic,* where the philosopher is so fearful of the effects on public opinion and political decision making of vivid visual images that he advocates banning most artists. Today, when depicting moments of human tragedy, suffering, or savagery, photojournalistic photography and video are assumed to be affective and effective bullets of opinion and behavioral change, that is, "icons of outrage." And indeed there is contemporary research evidence that news images, especially of novel, unusual, disturbing, or negative events and situations, are more memorable than other kinds of news and images (Graber 1990; Newhagen and Reeves 1992).

Yet discussion of famous images by all discourse elites, from presidents to historians, is rarely precise, and such icons have an ambiguous genesis and legacy. Why were the original images produced? Why did they achieve renown? What properties, real or imposed, do they share? Why, of all the thousands of human conflicts, have some been favored with icons to make them immortal? What exactly constitutes a "powerful impact"? How is such an impact operationalized? What rules of evidence should we provide for that impact being authenticated or measured? The Apollo moon landing shots, for example, were widely shown, continue to be so to this day, and constitute documentation of a singular moment in our technological history. Yet what are the effects and properties of that importance? What do the photos actually do aside from showing a news event? When the Apollo program wound down, there was almost no widespread public support, active corporate lobbying, or congressional consensus for continuing the manned exploration of the moon. The pictures had most certainly not changed the world in that way. We may add to Asimov's cautionary tale, then, the notions that the political influences of "big pictures" is not so easily predictable and that obviously an image can be visually and journalistically interesting, even striking, without having measurable political effects.

A more telling example from the journalistic and historical pantheon of visual culture—a true icon of outrage—was created in 1968, a year before the moon landing, when National Liberation Front (Viet Cong) and North Vietnamese forces launched surprise attacks all over South Vietnam, and in particular captured the ancient capital of Hue and parts of the U.S. embassy complex in Saigon. Whatever the military outcomes, most observers agreed that the Tet Offensive was a public relations disaster for American policy in Vietnam. A single image (taken on both still and motion picture film) emerged from the fighting to win widespread publication, commentary, and the Pulitzer Prize: that of a South Vietnamese police chief executing a Viet Cong suspect at close range (Perlmutter 1998, 1999b).

But what was said about the image is more revealing than the picture itself. Hundreds of journalists, politicians, and historians, of strongly different political sympathies, have characterized it as "the photo that lost the war." For example, William C. Westmoreland (1976), commander of U.S. forces in South Vietnam during Tet, wrote in his memoirs, "The [Saigon execution] photograph and the film shocked the world" (328). News anchor John Chancellor (1997) observed: "The [Saigon] execution was added to people's feeling that this is just horrible. This is just terrible. Why are we involved in a thing like this? People were just sickened by this, and I think this added to the feeling that the war was the wrong war at the wrong place." Robert F. Kennedy commented, "[It led] our best and oldest friends to ask, more in sorrow than in anger, what has happened to America?" (quoted in Katsiaficas 1992, 90). Cultural historian V. Godfrey Hodgson (1976) wrote that its "impact was arguably the turning point of the war, for it coincided with a dramatic shift in American public opinion, and may well have helped to cause it" (356–57). South Vietnamese Ambas-

sador to the United States Bui Diem (1987) lamented, "The immediate reaction to such scenes was a gut revulsion to the barbarity of the war which tended to supersede more rational, long-term considerations" (220).

They were all wrong—or, rather, there is no proof that they were right. There was and is no evidence of any public fury in reaction to the Saigon shooting image. Support for the war effort actually temporarily increased during Tet, and all survey evidence shows that Americans' growing disapproval of the war "as it was being fought" (i.e., not being won sooner) was related to the increasing American—not Vietnamese, ally or enemy—casualties and the dragging on of the conflict without resolution (Mueller 1971, 1973; Milstein 1974; Kernell 1978; Hammond 1988). More revealing, among the twenty million Americans who saw a film of the shooting on the *Huntley-Brinkley Report,* reaction was undetectable (Bailey and Lichty 1972). The effects of the image on "the American people," then, are a fata morgana, fading when subjected to closer view. These mundane, unromantic facts, however, have not arrested the myth; still, today, the image is reprinted with a caption or commentary asserting its "powerful" impact, with no evidence offered to support this quantitative claim save the writer's own feelings or the footnoted feelings of another writer. In short, a *first-person effect* seems to accompany icons of outrage, whereby discourse elites impose on the public their own reactions (or assumptions of the proper reactions) to mediated stimuli (Perlmutter 1998). Clearly, it is more useful to consider icons of outrage as tools of rhetoric than as independent, unguided missiles.

The future of the phenomenon of visual determinism, however, is uncertain. The World Wide Web has not yet itself produced an icon, or an icon of outrage (or even one that was then also passed on by other media), although many interesting, arresting images have been posted on the Web and have found greater or additional audiences through Internet transmission.[1] To understand visual news on the Web, we must understand how some of the qualities of news icons are transported into the medium. Accordingly, in this chapter I explore some basic questions concerning the news icon in the age of the Internet and interactive communication:

- Is the very dispersed and fractured nature of the Internet antithetical to producing a sole "big picture" recognizable by the "whole world"?
- Is the Internet simply a new distribution channel for fundamentally unchanged corporate-controlled and commercial-driven processes?
- Will the nature of news icons—their archival longevity, popularity, utility as tools of political discourse, and, most important, profitability and "effects" on policy makers and citizens—change when they are created for and distributed through new media?
- Will the concept of "picture" or film or video "clip" become obsolete? Will we need to think less in terms of images and icons and more in terms of portals or gateways to 5S (five-sense-stimulating) "multimedia arrays"?

- Do and will new technologies enrich the context of images in the news stream, making them more open to contention, debate, and pluralistic dialogue?

These questions and issues all fall within the genre of science fiction—speculation about the future based on current knowledge and practices. But more important is their ethical component. News, whether it is imprinted into our consciousness through an archaic early-evening network broadcast received on a black-and-white television or downloaded onto PDAs (portable digital assistants), is the stuff our reality is made of. Why and in what way news is gathered and packaged are the major determinants of how democracy works; conversely, any new technologies or standards of news production, distribution, and reception are affected by how people want to use them. Finally, what will be the normative expectations about the "proper" relationships among the news industries (if they exist at all), individuals and groups, image artisans, and the pictures themselves? Will the "world brain" allow all its participants to gestate an empowered class of "interactors"? To understand these issues, it is necessary to examine some of the qualities ascribed to photojournalistic icons and to consider science and sociological fictions of how the Internet may transform them.

Instantaneousness

To begin, modern news icons become famous soon after the events they purport to show. The rewards of prominence, frequency, and celebrity (and thus profit) are quickly rendered once images enter the news stream.[2] This has only recently been the case; it was not until the end of the twentieth century that advances in the new visual technology of photography allowed home audiences to view the actual, moving events rather than see them only in retrospect. Even news film of the "living-room battles" of Vietnam took about twenty-four hours to be processed from the battle front to the TV screen (Larson 1992; Mosettig and Griggs 1980). We reached the seemingly ultimate extension of a compression of transmission during the 1991 Coalition-Iraq War, when home-front audiences saw video "live from ground zero" (Arlen 1969; Arnett 1994; Wiemer 1992; Perlmutter 1999b). As the size of cameras and satellite dishes diminishes, a single reporter (or soldier) with a laptop, a cellular modem, and a digital camera can send live views of war or any other news in front of his or her camera lens—as did on-site reporters from Afghanistan—to a wired or unwired planetwide audience from any location under any conditions.

But the Internet affords a redefinition of the meaning of *instantaneous* toward that which is instantly impermanent, or fleeting—various archiving projects aside. In part of my work on a continuing survey, I have been tracking the changes on the *New York Times* Web site's home—or entrance—page (www.nyt.com). I have classified the changes into two types: change of lead story and change of photographs. The

latter of these usually occurs in conjunction with the former: the lead story changes about five times a day and the lead photograph about four times a day. Thus the Internet is less a place for the posting of printed material than it is a continually flowing wire service plugged into the home. "We have no publication date," comments Bernard Gwertzman (1999), editor of the *Times* Web site. "I can't tell you that this was Monday's edition, because we might have twelve different updates where we revise the main page and the stories that appeared on that day's paper."

Notably, when there are "big stories" that receive saturation coverage in other media, the turnover of images and articles devoted to those stories on the *Times* Web site decelerates. The analogy to CNN's persistent focus on big stories is obvious, with the main difference being that the Web site never loses its ability to offer choices other than the big story of the moment. An example is the twenty-four-hour period in July 1999 after John F. Kennedy Jr.'s plane was reported missing. Most television news networks devoted almost total coverage to the search, and to endless discussions and commentaries about the plane's passengers, the Kennedy family, and so on. CBS News's Dan Rather, for one, was on the air almost continuously for twelve hours.

An obvious ethical critique of this coverage, of course, is that it included absolutely no news beyond the fact that Kennedy's plane was missing. For twelve hours, all anyone could learn from watching news programming was that nothing new had happened or had been learned. A seeker of other news programming on television had no escape from this herd concentration; more channels did not provide more choices of news content. The *New York Times* Web site mirrored this front-page focus and in one sense was "slower" than television news. (The *Times* has only recently set up a "convergence" desk that seeks to facilitate the transfer of news that the paper's reporters are working on or have just filed.) At the time of the Kennedy story, the *Times* Web site was updated fifteen times within a day. New pictures—mostly of beaches, the Kennedy compound in Hyannis Port, and government spokespersons—appeared; no one icon emerged.

What the Web site did allow, with clicks and links, was diversion from the smothering uniformity of the television news coverage. As of this writing, for example, the *New York Times* Web site offers sections analogous to those of a newspaper, where one can look at updates on the war on terrorism, closing stock prices, hockey scores, and television program listings. In addition, since January 1, 2000, the Web site has offered links to more than three hundred other sites. The *Washington Post* Web site currently includes links to more than 250 other sites; the *Los Angeles Times* Web site, two hundred; CNN, more than four hundred. This is a crucial distinction: television news operates as if the whole world is watching when any one particular event gains the spotlight of the mainstream institutional cameras (Perlmutter 1999a). Newspapers, because of their sectionalization and their greater data space (all the words spoken in a broadcast of the *CBS Evening News* could fit into a page and a half of the *New York Times*), at least offer options. In this sense, the Web is much more like a

newspaper and, from an ethical perspective, allows, if not the contextualization of the big story, at least freedom from it. The big story certainly appears on a news Web site's entrance page, but hyperlinks can take us to other news and information. On television news programs and news stations, the only alternatives to the big story of the day usually take the form of preprogrammed fare unrelated to any current news story (e.g., the Golf Classics channel). The Web, then, presents us with a mixture of the instant icon—the big picture of the front page—and the option to divert our focus to what editors consider subsidiary or peripheral words and images about the events of the day.[3]

Finally, it is interesting to speculate about what will happen when all news on the Internet is updated frequently. The history of visual journalism suggests that what we mean by *frequently* will itself change, as shifts in content become more and more rapid. The interactor's contact with news will thus be even more fleeting, because the morning paper—an integrated text, available for later review—will no longer exist. Research has shown that people's ability to remember information they encounter in news is exceedingly tenuous, although they may retain some information in the form of general rather than specific "common knowledge" (Price and Zaller 1993; Wicks 1995). However, compared with viewers of televison news, higher retention rates have been found among those who read news stories on the Web and in print, perhaps as a result of greater purposive focusing on the computer screen and paper page (DeFleur et al. 1992). Even more interesting is the apparent existence of a translation phenomenon, in which people forget whether the sources of their memories about news were words or images—they may transpose the two (Grimes 1990).

If the Internet allows shared experiences—by people conversing about subjects viewed on Web sites in real time through instant messaging software, or post hoc via e-mail, or in old-fashioned personal conversation—this may profoundly affect the way people structure their memories of events and the relative importance they ascribe to those events (Pasupathi, Stallworth, and Murdoch 1998). Icons may endure because people continue to focus on what is big and new at the Web site entrance page, and the corporately enforced standards of news value conspire to agree on what ought to be big and new. Whatever ethic of the instant the Internet cultivates, then, may be decided not by empowered interactors, but traditional powerful corporate producers and distributors.

Prominence

Icons have high quantitative representation in news publications and newscasts, as well as in books on history, photojournalism, and visual cultural analysis. By one count, for example, the picture of the "man standing against the tanks" near Tiananmen Square during protests against the Chinese government in 1989 has appeared more than twelve thousand times in different print media publications. In contrast, the vast bulk of each day's news images (which themselves constitute a minute number

when compared with the number of pictures taken by visual journalists that are not selected for publication, broadcast, or wire service deployment) make brief or limited appearances and are rapidly retired. In addition, icons have another property imposed on them that is coincident with repetition: "big pictures" are typically front-page, lead-of-the-news items that eventually show up on the covers of historical or political works. This environmental context buttresses and reaffirms the icons' status as "important." People are more likely to pay attention to and recall items that are more prominently displayed in the news stream; discourse elites (politicians and commentators) are more likely to pick up on such images as being worthy of notice and rhetorical employment.

The Internet augments these iterations. Simply put, there are now more places for icons to appear: some four thousand newspapers, magazines, and electronic news organizations publish on-line editions as of this writing. To a large extent, what appears in a newspaper's or newsmagazine's on-line edition is a replication of what appears in its main print or electronic edition. The icon, on mainstream sites such as those belonging to *Time, Newsweek,* the *New York Times,* and so on, is, unsurprisingly, the most likely image to be repeated. There are also commensurate opportunities for prominence on the Web page that can be defined, as suggested earlier, as being featured on the home or entrance page to a news site. The dueling images in the Elián Gonzalez story of April 24–26, 2000, for example—one of black-clad government agents raiding the relatives' house to snatch the boy, and one of Elián playing with his father—appeared without variation across major broadcast, cable, print, and Web news sites. The Web did allow us to see the initial postraid scene in pictures.

This increase in "screens" on which to display news images (and not just icons) is but a taste of things to come. The expansion of the Internet and the increasing miniaturization of video screens will soon place visual images in contexts in which they do not now normally appear. Types of images that heretofore have been relegated to precise locations within the visual environment—such as billboards, movie screens, and television sets—will be embedded within all parts of home and life. A logical extension currently being marketed in Korea is the TV phone, which is able to exhibit visual images beamed in through either television receptors or wireless connections to the Internet. The embedding of Internet-friendly screens into household appliances, such as the surface of a refrigerator, or into kitchen countertops is projected as part of a master plan of a house seamlessly woven into the Web. Experiments are being conducted with disposable displays as well: the morning news may one day be broadcast on the sides of milk cartons. Video screens will necessarily become flatter, lighter, larger, and mountable on walls; they may even *be* the walls, as suggested in Ray Bradbury's *Fahrenheit 451.* In the house of the future, the news icon of the moment may stare back at the occupants from a hundred places, or perhaps, more frighteningly, it may *be* the house. New technologies will only enhance the omnipresence of the icons, whatever processes determine which images achieve icon status. This panoptic view of news, in which we are surrounded by images, will become the ethic of what

is news—although, again, it will be easy to confuse quantity and ubiquity with depth and context.

Celebrity

The public plays almost no expressive or even approving role in selecting "big pictures" of photojournalism (the exception being some contests to name "photo of the year"). Editors do not poll the public before displaying images of the day's news and selecting those worthy of more extensive coverage and comment. The Pulitzer Prize, too, is voted upon by journalistic elites. Photographers and journalists (through prize committees), editors (through selection), and political and editorial elites (through notation and commentary) impose greatness and thus fame on images. Historians and textbook companies, by reemploying or "quoting" such images for discussion or simply illustration, reaffirm that they are "great." Obviously, after repeatedly viewing and absorbing such observations, members of the public are likely to agree with this verdict, even if they may be less than susceptible to the pictures' affecting their beliefs or actions. Elites, thus, largely set the agenda of greatness and establish the criteria for which images are judged great.

Moreover, it is clear that celebrity involves a class distinction as well. Students of visual culture tend to have such images imprinted in their memories through repeated exposure and personal interest. The pantheon of images captured by photojournalists, including the "great" images that have won the Pulitzer, are the canon that they—the "iconeratti"—have absorbed. It is not clear how famous such images are among the general public, or, to be more exact, whether the celebrity of the images goes beyond superficial familiarity. Paul Messaris (1994) conducted experiments in which students were shown "famous" images and were asked to define their provenance and circumstances; he found that recognition among the test subjects rarely exceeded 50 percent.[4] I have noted comparable findings in similar experiments (Perlmutter 1998). And research on collective memory suggests that recollections of news events "tend to be a function of having experienced an event during adolescence or early adulthood" (Schuman, Belli, and Bischoping 1997, 56).[5] In my students' case, I found that they recognized and correctly identified in place and circumstance, if not exactly in time, images from the video of the *Challenger* space shuttle exploding, the Gulf War, and the O. J. Simpson white Bronco car chase—all events they had "experienced" through mass media. They almost totally failed to recognize icons of the Vietnam War, World War II, the civil rights movement, and the Depression and previous eras and events. Today's students will, no doubt, carry the images of September 11, 2001, into their old age. The icons of one generation or audience are the enigmas, or at best the shadows, of another generation or audience.[6]

It is also unclear to what extent the Internet increases the celebrity of an image or acts to make any particular image celebrated in a way that is different from the conventional process enacted through newspapers, magazines, television, and historical or retrospective works. A case in point is the Web site operated by the most significant

arbiter of which images are important, the Pulitzer Prize committee and organization (www.pulitzer.org). As of this writing, the site is a model of the least that can be done with images on the Web. Essentially, the photos are pasted like those on a high school bulletin board, with minimal captioning and contextual information. For instance, the 1998 Pulitzer winner for spot news photography was "Awarded to the Associated Press Photo Staff for its portfolio of images following the embassy bombings in Kenya and Tanzania that illustrates both the horror and the humanity triggered by the event." We are told the criteria for the awarding of this prize. The image appears as a 480-by-647-pixel JPEG file. Links are available to the general works for which the Associated Press staff was awarded the prize for their photo coverage of the bombing of the embassies, but there are no links to news stories about the events. The "History" link shows not a history of the bombing or the images or the context in which photographers and events came into contact, but the history of the Pulitzer. The "Resources" section simply lists procedures for entry submission and contact information for the Pulitzer committee, the Columbia Graduate School of Journalism, the Columbia Center for New Media, and the Columbia Journalism Review. Essentially, this is a minimalist slide show; it offers nothing that could not be available in print form in a Sunday magazine or an extended photo-essay. In sum, this site provides only two advantages over the presentation of these images in print form; as one photo editor described it to me in citing the advantages of his newspaper's Web site over the paper itself: "more pictures" and "all of them in color." This hardly constitutes a cognitive or cybernetic breakthrough for photojournalism.

Additionally, given that the icon is a political construct as much as a document of any event, the latent message of the Pulitzer site is celebrity itself. By not telling us anything about the images save that these are the famous ones—"look upon them, ye photographers"—the site implicitly asserts that the selection process by which an image becomes an award-winning icon is natural and not the result of marketing or corporate production forces. It is clear that the icon—or rather the status as icon of an image—is the message. What is important to the power holders within the photojournalistic community is that the system of producing "big pictures" not be challenged by questions of context, method, viewpoint, or ambiguity.

Furthermore, the pictures are treated like headlines—the hyperlinks are directly to the article and a dead end or to the picture itself. These are what might be called *shallow* hyperlinks, typical of poster-board journalism on the Web. They are, in fact, not real links, because they link only to themselves. Hyperlinks to numerous other sources, articles, images, publications—these can have higher degrees and numbers of links. A photo-essay, for example, may have *rich* links that lead to all sorts of further information, greater and wider contexts, and historical antecedents to the story. Rich links help the reader understand context; shallow links point only to the images or the article itself. It is a great wonder of photojournalism that most icons on the Web are still treated in this shallow fashion.

In considering this property of image icons—their imposed "fame"—we can ask a question the answer to which will determine the evolution or stasis of all other present-day properties of icons of outrage: Can the Internet develop independent of the ethic of corporate control? The answer to this query—if we have only current events from which to judge—is absolutely negative. If most sources of visual news and information are provided by advertiser-supported, corporate-controlled sources, then the inevitable result is not plurality and diversity of focus or context but homogenization. That there are four thousand or more news organizations with Web sites does not mean that there are four thousand visual versions of the news to choose among.

An unresearched question is how a rapid updating of news Web sites can affect this process. On the one hand, news organizations can now monitor by the minute what colleagues are covering. A regional paper, for example, can continually track the big stories on the MSNBC, CNN, and *New York Times* Web sites, whereas the nightly-news or morning-paper model of homogenization has different news production facilities. Perhaps the simplest proof that the methods of icon production are not being changed is that no icon has yet emerged from an obscure Web site, then been passed along to the people and finally achieved general renown; major news organizations and other usual suspects, whatever their media, still thrust greatness upon images in the traditional manner, with the conventional results. The false ethic, perpetuated by photojournalists and some photohistorians, that the "people" play a prominent role in the making of icons continues unchallenged; a newer ethic that either admits the corporate control of icons or allows greater pluralism about their creation and reception has yet to emerge.

Fame of Subjects and Importance of Events

Major news events often produce icons, not necessarily because of their aesthetic worth or striking composition, but because discourse elites assert that particular images define, sum up, or document important events. An example is the image of Itzhak Rabin shaking hands with Yassir Arafat at a White House ceremony to mark the signing of a peace treaty, which CBS News anchor Dan Rather, an indisputable member of the discourse elite corps, could confidently label "the picture of the decade so far" (Shales 1993; Guy 1993). Some images become icons simply because they portray people who are famous—typically in some moment of popular or propagandistic publicity or candor—such as Churchill making a "V for victory" hand gesture, Princess Diana shaking hands with AIDS patients, or Che Guevara striking a "visionary" pose. At the same time, many icons depict subjects who, before their encounters with visual journalists, were unknown: the Viet Cong suspect, the man against the tanks at Tiananmen, the Oklahoma City baby and fireman, the little girl (and vulture) of the Sudan, the migrant mother, "little Elián," and so on.

Rarely does such fame bring rewards. During the Tiananmen events, President

George Bush proclaimed, "I was so moved today by the bravery of that individual that stood alone in front of the tanks rolling down, rolling down the main avenue there. And I'll tell you, it was very moving. And all I can say to him, wherever he might be or to people around the world is we are and we must stand with him" (quoted in NBC News 1989). *Time* magazine crowned that anonymous man "person of the year" and even considered him for person of the century. Nevertheless, today his fate (and indeed his identity) is still unknown; he may be in hiding, shackled in a dungeon, or buried in a ditch.

One of the intriguing challenges to this property of icons is the changing nature of celebrity in the past century. On the one hand, it is clear that modern mass media, especially those involved in so-called news and information programming, are obsessed with defining, observing, and judging celebrities (Gamson 1992; Bonner et al. 1999). This in itself is not an innovation in human culture; the "mass" media of Assyria, Rome, and dynastic China were equally concerned with the personalities, doings, and utterances of kings, high priests, and magnates. What has changed are the qualifications for celebrity and the characteristics of celebrities in the less strictly controlled class and power hierarchies of the mass-mediated age. Archaeologists have long noted, in measuring political and social power, a roughly direct relationship between the space accorded to the living or working quarters of any individual and his or her rank in society; the palaces of kings have always covered much more real estate and required more masonry than the huts of peasants. In the mediated age, a similar rule holds for celluloid, videotape, and still images. Presidents and movie stars have thousands of pictures taken of them and draw the attention of herds of photographers, even when they are engaged in seemingly mundane activities. Most of us, in contrast, get only one shot at fifteen minutes on *Jerry Springer.*

But in another sense, the cultural space inhabited by celebrities and the qualifications for celebrity have become an admixture of conflicting social trends. Although it is not true that everyone in the twentieth century was famous for fifteen minutes, an immense number of people achieved notoriety and mediated cultural space far beyond what in previous ages might have seemed to merit the songs of troubadours, the erecting of statues, or the stares of the public in the marketplace. There is a Twilight Zone sort of egalitarianism within certain genres of celebrity mediation. For example, on VH1's *Behind the Music* series, the Vanilla Ice episode is the same length as the John Lennon portrait; on A&E's *Biography* series, Mamie Van Doren and Winston Churchill are accorded texts of equal tone and production values.

What happens when the Internet becomes our main mediation of a person's visualized celebrity and status? As of this writing, there are several thousand "cams" (cameras) registered through various "cam.com" Web sites. These sites vary in how well they are executed and maintained, and the cam subjects range widely. Reykjavik Weather Cam offers "views of ice in Iceland" (www.hugbun.is/~pjetur/pic/]), while on aspiringactress.com two enterprising young women in Hollywood promise that "mem-

bers have full unlimited accesses to all lifeCams, including Lisa's BedroomCAM, Karen's BedroomCAM, BathroomCAM, LivingroomCAM, and OverheadCam." Some cam sites charge fees to subscribers; others are free. In terms of surface area, their cultural space is equal to, if not generally greater than, say, the manifestations of the president of the United States on the *Washington Post* Web site. The personal cam sites can be said to be analogous to personal publicity newsletters, with audiences ranging from many thousands (as in the case of the popular JenniCam) to few (as in family Web sites) to one (as in Web sites that are found only by accidental or random clicking and seem designed for no audience except the sender).[7]

Only in the rarest of instances can any such self-portraits, even those on sites such as JenniCam or some of the very successful and highly profitable "amateur" porn cam sites, be associated with icons. Notably, cam dwellers have not, as of this writing, done anything—committed suicide on-screen, overthrown a government— that by any mainstream definition is especially newsworthy. Anyone, as well, could potentially become comfortable with and even enthusiastic about public displays of his or her private actions given sufficient stimulus and persistent and unintrusive exposure (Perlmutter 2000). More likely, people will become unwilling celebrities, icons against their will and intention (Wischmann 1987). The pervasiveness of surveillance as a tool for commercial and legal control is the sure constant of the future; we will all be "cammed" without our consent, if not in images, then in consumer profiles (Johnson 1994; Elmer 1997; Lyon 1998).

But the self-generated celebrity of mediated subjects cannot be dispensed with as a footnote or an irrelevant grotto of the World Wide Web. It is unclear to what extent interactors will judge present-day notions of celebrity to apply to subjects in Web sites and events to come. CGI (computer-guided or -generated imagery) technology, which is rapidly becoming familiar through movies such as *Star Wars: Episode I— The Phantom Menace* and others (George Lucas has actually stated that he looks forward to the day when he can make a film without actors, using only CGI figures) allows the creation of unreal celebrities. In other words, a person who never existed can be created and placed within visual contexts that are indistinguishable from images taken in the time and space of a president or a movie star and claimed to have corporeal reality. Even more intriguing, perhaps, is the idea that dead celebrities can be resurrected and inserted into digital texts with nearly seamless integrity. Recent television commercials in which Fred Astaire and John Wayne appear to be hawking products are but the preliminary sketches of a fantasy reality to come where the working life is not arrested by death; indeed, death may be, in the language of Hollywood, a "smart career move." Is the high concept here that the public will think that dead spokesmen can't lie?

The Internet's ethic of self-representation, then, if the Internet truly becomes the medium through which all mediations of time, space, event, and person travel between interactors, may very well fracture our present-day notions of what constitutes

fame and how visual images can represent the events that determine that fame. Meyerowitz (1985) wrote, before the advent of the Internet, of television's contortion of the "situational geography of everyday life," where the media make us "audiences to performances that happen in other places and give us access to audiences who are not physically present" (7). Television has allowed us all to be "there" at the same time, for example, at the moon landing and other globally watched events. Television, as well, permits a certain sharing of that space, at least visually and in sound, that can be then reprocessed the next day among people "at the watercooler." But in a 5S Internet world, where a computer can generate three-dimensional images as well as sound and even smell, taste, and, most intriguingly, touch (through sophisticated tactile gloves or other more indirect nerve-stimulation inputs), we can share an experience to the point where not only can we join with others in watching something happen, we can be the subject of that happening. Today's children, playing first-person video games, are obviously primed and practiced to accept a future reality world in which they need no longer be content to view celebrities doing celebrated things. Instead, we, by every measure that our brains can make, will be the celebrities ourselves; that is, we can be in the Saigon execution picture—the South Vietnamese colonel firing the gun or the "Viet Cong officer" receiving the bullet—or perhaps we can shake the hand of another nation's premier and then take out our Montblanc pen to sign the arms accord.

The Web world offers a complete redefinition of person and personal space, of we and they, of self and other, of emic and etic (e.g., Mitra 1997). It raises ethical considerations of what constitutes empathy in a perpetually connected world. In *I and Thou,* Martin Buber (1974) argues that the most essential human characteristic is the paradox of not only being self-aware—but occasionally being aware of the fact that other people are self-aware—that is, that other people may have states of opinion, feeling, and sensation that are sometimes similar to and sometimes different from our own. The integration of interactor into the news icon and all other news images on the Internet will potentially allow us to feel the states of others, including their pain and suffering, as never before: interactive, Internet empathy. The question, then, will be whether we will translate this technical (and thus vicarious) empathy into cognitive and behavioral empathy and act with greater understanding and sensitivity toward our fellow suffering creatures throughout the world. In making ourselves famous, will we become better humans, or, as the video game example tends to suggest, will the experience of merging with others become merely a tool of play and gratification, a visceral excitement that leaves us, for all of its sensory exhilaration, drained and desensitized to the plights of those with whom we are temporarily conjoined?

Profit

The copy for an ad for the Wingman tactile joystick, designed to be used with the first-person shoot-'em-up video game, reads: "Psychologists say it's good to feel something when you kill." Whatever new ethic of empathy emerges in the "i" or "d" or "e"

future, we can be certain that profit, not humanitarianism, even if that notion too is redefined, will be the major influence. Undoubtedly, news images are sources of profit for their owners—the institutions more than the individuals, especially for frequently and prominently displayed "big pictures." Profits continue after the news becomes history. Permission to use an Associated Press photograph in a book, for example, typically requires payment of a fee of two to three hundred dollars. CNN charges up to six hundred dollars for the use of one of its news clips. The profitability of the cash-cow icon is enhanced by another property of the Internet: simply put, there are many more places available for the posting of images. Declines in the numbers of magazines and newspapers published have been more than compensated for by increases in the numbers of news Web sites. And the photos that appear on-line are also for sale. The *New York Times* site notifies the reader, "Find out how to obtain reprints of *New York Times* photos by downloading the following information." We are close to a time when we will see a picture of tragedy coupled with a banner instructing us how to "buy this picture."

The Internet, however, challenges the traditional profit-making structures of photojournalism and the cash-cow aspects of the news icon in several ways. The most obvious danger to the integrity of the photographer's work is that the digitally posted image is now directly copyable. Even in the case of Web slide-show photo-essays, which purposely disable "save as" and "print" commands for most Web navigation software, a simple click of the right-hand mouse button allows the viewer to save an image into a JPEG or GIF file. The person copying the image at home then owns a duplicate of the original. In a sense, this is a fulfillment of Walter Benjamin's thesis about art in the age of mechanical reproduction: when an artwork is infinitely copyable, it loses any sense of uniqueness; at the same time, the original in the museum takes on a sense of secular sacredness.

Photographers, photo agencies, and news organizations understand that this technical revolution has the potential to undermine, if not legal copyrights over images, then the supposed nine-tenths of the law that favors actual possession. People have always been able to clip copies of news images from newspapers or magazines, and today they can videotape or digitally record the evening news, but the copying of pictures from news Web sites allows the interactor, barring legal action or notice, to redeploy the image instantly for his or her own use. For this reason, as one photo editor told me, "There are a lot of photographers out there who don't like their pictures to be on-line." Indeed, a news photographer I spoke with says that she discourages her photo agency from selling her pictures for use on Web sites because "they become everyone's property." The analogy to tacking up art not in a guarded museum but in the public square, where anyone can walk off with it, seems strained, but considering the value of the images, such fears are understandable.

Balancing this concern is the transience of Web postings, as discussed earlier. Photo agencies and photographers sell their images to news organizations for printed use and for Web posting, but for the latter an expiration date of the rights is built

into the contract. In the case of the *New York Times* Web site, one of the editors told me that the site had received a legal notice from the Associated Press indicating that rights for several photos on the site had expired (Gwertzman 1999). The Associated Press, like many other news and photo agencies, actually employs people whose job it is to check on the status of the agency's contracted images. It would be prohibitively expensive even for large organizations to keep posted images for which they must continue paying rights fees. The exceptions are images created within the news organization; for example, the *New York Times* owns the rights to photos taken by *Times* staff photographers in perpetuity.[8]

The result is that, although the technology of the Web allows the archiving of vast amounts of visual data—in the future, storage devices will increase in capacity, but, as is the case with software programs, digital imaging files will also probably grow in size and complexity—the economic and ideological model of corporate news discourages extensive archiving. In a sense, then, the profit potential of icons on the Web is extended beyond the dimensions of space—that is, the horizontal (more places to put the image) and the vertical (more postings of the same image)—but constricted in the dimension of time. The icon loses its permanence because it will eventually be deleted in all other news platforms except that of the original copyright holder, only to reappear, as it does now, in retrospective stories, follow-ups, and historical works. In other words, the future of the icon may, in terms of a production cycle, be very similar to what exists now, because the profits associated with its reproduction impose certain guidelines that channel its appearance. Continuing, too, may be the doublespeak associated with the profitability of news icons: journalists are loath to admit that they are selling or marketing products. The icon, however, despite being surrounded by discourse that appreciates its aesthetic, emotive, and political qualities, is at its core a thing of cash value.

Metonymy

Decisive moments are said to be decisive because they "capture" not only an instant but an era, an event, a people. "The photo said it all," proclaimed *USA Today* about the Rabin-Arafat handshake (Guy 1993). "Said it all" suggests that the most significant and useful function of icons (for news industries and discourse elites employing the image for rhetorical persuasion) is that of metonym. This function may be implicit, for, as Barthes (1977/1988) has commented, "metonymic logic is that of the unconscious" (140–41). Often, however, it is overt (e.g., "This is the situation in Beijing today..."). The assertion of metonymy is the unacknowledged, most important professional contribution of photojournalists, who are instructed in their training to capture a moment: their institutional clients and employers seek images that not only provide aesthetic or entertainment value but fulfill the "plug and play" function of the photograph on the news page or news video. The role of the photograph is to illustrate the story and entertain and interest the viewer; it serves as a background for what is be-

ing said or written and is rarely, except in the case of icons (and this is the way they become icons), a topic of independent interest or, even rarer still, of critical analysis.

News images, then, are treated as windows onto the world. The decisive metonym is the big lie of photojournalism—that a window, however faithfully rendered, of some small portion of reality explains all of that reality. Publics can doubt images or, more typically, ignore them, but the idea of alternative images as showing multipolar and multivocal realities is almost unknown within the canon of photojournalism. No photojournalist is trained to shoot "both sides of the story," and so the news photograph's literary equivalent is the anecdote, a tiny tale about one place at one time (Perlmutter 1992). Anecdotes can be used to enliven conversation and as examples for argumentation, but whether an anecdote can truly sum up a general condition, and should be left standing for the contemporary news-viewing public and the historical audience as the decisive moment, is always subject to debate (or should be).

A great, unheralded winnowing process, however, is threatening our ability to critique photojournalism's so-called decisive moments and monuments. Sol Worth (1981) made a distinction between the *cademe* (the image, most likely a negative created within the camera) and the *edeme* (the photograph as it appears in the publication). Visual history, and the study of visual culture, subsumes many areas of research and critical activities, but at least some of these involve the exploration of cademic reality—that is, what other pictures were taken contemporaneously by the same creators or others of the same scenes, ideas, people, and objects. It is always of interest, when one is studying visual production, to examine the photographs that elaborate the contexts of those that are lifted to the status of icon.

A simple example is the famous photograph of a dying Spanish militiaman taken by Robert Capa. Since the first published appearance of the image, there has been some controversy as to whether it depicts a natural moment, "caught" by the cameraman, or a staged enterprise. Capa's original roll of negatives has in fact been preserved, and recent inquiry suggests that the pictures taken before and after the famous image give no hint of subterfuge or intent to deceive. Photos taken with modern digital cameras are not subject to such investigation. Although digital photography is improving in quality of resolution, the maximum storage capacity of the cameras, the storage policies of ownership organizations, and the attitude toward the *concept of archiving* that digital imagery inculcates in its producers are essential issues. Whereas previously photographers might shoot many rolls of images and return the exposed film to their news organizations, which would develop the film and then select and edit the images they wished to use, all of the images would be preserved; that is, all of the negatives would be kept in the news organizations' archives. The economic model driving digital photography encourages deletion of this unused "background" material. Images that the photographer does not want to submit to his or her editor, or images not chosen for publication, can be deleted completely; no trace of their existence will remain in the archive or historical record.

The incentives to shoot less, erase more, and keep few are largely related to profit forces. I am currently conducting a survey of photojournalists who work for major newspapers and magazines. My preliminary results confirm anecdotally reported testimony from interviews with these photojournalists: those who use digital cameras shoot fewer stills. One reason for this is that the memory cartridges of even very advanced digital cameras, such as the high-end Nikon Ds, can store only a limited number of images. The higher the resolution of the images, the fewer can be stored to any one cartridge. The difference between shooting film and digital imagery is marked. As one news photographer put it to me: "I never used to think about running out of film. That was always the cheapest thing for me. You always shot much more than you could use. Now I'm always worried about running out of space on the tape [or disc]. I shoot less; I keep less." Another echoed: "Film is cheap; [computer] memory is not." Moreover: "Film was easy to catalog—you just file it on the shelf." Storing, cataloging, and databasing the same number of computer images as held in a sheet of negatives is labor-intensive—and thus expensive. In addition, compared with the unused film images destroyed under the old system, newspapers and magazines delete digital images that are taken but not printed at a much higher rate. Whatever the cause, then, image makers and corporate owners hold that digital images, unless they are profitable, are rightly expendable—their ephemeral nature is a new norm of visual ethics in the digital age.

There are stark consequences that may violate ethical notions of those concerned for the public interest in such an industrial proscription against preservation. That what appears in publication is almost all that remains of the visual record is a major violation of the social contract between image-producing organizations and scholars, the public, and future generations. If entertainment and news organizations have any social justification for their production, it includes the preservation of this cademic context. It may be the case that scholars of the future, looking back, will have nothing but icons to consider in understanding the visual production of our age. This winnowing, it is important to underscore, occurs before images are posted on the Internet; the archiving capabilities of Web sites cannot save images that have never been preserved. And most on-line newspaper archives do not allow users to access the photos that accompanied articles as they originally appeared in either paper or electronic editions.

Cademic context is also crucial for contemporary political argumentation. One of the promised benefits of the Internet originally touted by proponents of the medium is its multivocal nature. Indeed, to media egalitarians, the Internet must appear to be the last, best hope in the fight against the conglomerization and homogenization of news. Most American cities today are served by a single newspaper, and the content of major newsmagazines and broadcast and cable news programs is so topically, stylistically, and ideologically similar as to make them all seem mere variations on the same audiovisual theme. The Internet offers the opportunity for alternative voices

and visions to have equal public space to that of multibillion-dollar corporations. Copyright, and its aggressive legal preservation, to some extent undermines the ability for opposing visions to use edemes from mainstream news. But the erasure of cademes themselves means that critics of mainstream news must either create their own images or rely on simple lexical-verbal assertions about the questionable accuracy and fairness of those presented on corporately approved Web sites.

The situation is exacerbated by the Internet's premier distinctive feature as a medium. When a Web news site such as that operated by the *New York Times* is updated, images disappear. Many are stored in digital archives, although we may speculate about whether these archives are reliable because, first, they are largely inaccessible to the interested interactor or the critical theorist or historian, except by purchase, and second, there is no guarantee that picture file formats will not change; older images may one day be as unviewable as data on IBM punch cards or WordStar files on five-and-a-quarter-inch floppies are now. More important, unless one has printed the entire Web page as an integrated unit, it no longer exists at all. As the *Times*'s Bernard Gwertzman (1999) explained to me, "We save the individual pictures and stories but not the page." Unless that page has been systematically copied, downloaded, or printed, it may be lost forever as a text for analysis, clarification, inspection, comparison, or simply a refreshing of memory. That updating is also one of the great benefits of the Internet—a capability that most proponents of the medium cite as a positive tool for enhancing individuals' interaction with news—is a contradiction. The problem would be solved, however, if newspapers and magazines that operate Web sites took seriously the threat to visual history that their current practices represent and began archiving updated pages as well as individual items.

But such threats are not the last word on the metonym of new media images. Futuristic fiction fails when it does not take into account the interactions among commerce, society, culture, and technology. Many mainstream Web sites provide innovative, interesting, reasonably contextual arrays of images and words that would be almost impossible to re-create in printed or televised form. The *New York Times* Web site is just such an innovator in its transformation of the slide show into the multimedia array. As of this writing, one of the most interesting of these is a series of extended documents that subsumes and surrounds a photo-essay by Vanessa Vick, an independent photographer who spent several years in Rwanda documenting the aftermath of the ethnic genocide that occurred in 1994. Titled "Children of Rwanda's Genocide," it is divided into three thematic essays: "Families without Parents," "Surviving on the Streets," and "Orphans and Detainees." The text is extensive, with detailed word essays and longer captioning; more important, the presentation fully exploits the World Wide Web's linkage technology. It includes a RealPlayer audio clip that describes the issues, people, history, and context of the events. One can also hyperlink to nongovernmental aid organizations "providing assistance to the children of Rwanda."

Within each of the subessays, the captioning is much more extensive and includes links to almost every article the *New York Times* has published on the Rwanda story since 1994, when almost half a million people were killed and hundreds of thousands of children were left without any adult family members. The presentation even includes a map of Rwanda and a time line. It would be difficult for an individual to travel through this essay and not emerge better informed, if not moved. That almost all the information presented has been written, edited, and approved by employees of a mainstream news source, the *New York Times,* is of course the major obstacle to calling such an essay an example of the radical possibilities of democratic debate and multivocality and multipolarity theoretically possible on the Web. But "Children of Rwanda's Genocide" is an imaginative work despite its corporate gestation.

Conclusions

Students of visual culture have long complained that historians and others have relegated photographs to a purely illustrative role in their conceptualization and description of history (Perlmutter 1994; Schwartz 1991). On the other hand, digital media's fractured core structure has set up challenges to many existing notions of the integrity of visual forms, from media art to photojournalism (Broeckmann 1997). Within another generation, we may need to think differently about the still photograph and video than we do today. Rather than flat images to which the briefest commentary and context are added by terse captions or references within the body text of articles or narrations, pictures may become multimedia arrays that affect complex contexts of multiple realities and variable interpretations. One day, all images may contain within them embedded links that lead to further stories, images, and sounds. Visual objects within images may become links in themselves. Click on the face of a man standing by the side of a road watching earthquake victims being retrieved from the rubble and hear his interview in full; click on the rubble and read a story about builders accused of using beach sand in the concrete; another link provides background information on the journalists, their commentary about the image, why they were assigned to this story, their impressions about the shooting experience; and so on.

The World Wide Web has often been deemed less an organized system of information than a data shipwreck, but perhaps H. G. Wells's metaphor of a world brain is the most appropriate. The neural networks of the human mind are often maddeningly haphazard when it comes to what information is stored and seemingly deleted: we may not recall our first date with our spouse, but an episode of *Gilligan's Island* could be synaptically etched forever. Yet the Internet's unique ability to create linkages to multiple documents beside the image itself—including other images—allows us to glimpse the possibility of a future where there is some degree of liberation from the stranglehold of narrow conglomerate media, from contextless content. The Internet could possibly empower a viewer or receiver to become a wholly new entity

within the traditional models of mass communication transmission, the interactor, someone who contributes to the creation of meaning through exploration.[9] The power of audiences has long been recognized, but the Web allows audiences to explore and react, to interact, in ways that were either infeasible or not easily achieved in the past.[10]

It would be easy to get caught up in the thrill of such a prospect and fail to consider the immensely powerful forces of corporate profit and control that oppose such liberation. More extreme ideas about the Web held by the digerati—people who believe that, unlike most previous scientific revolutions, digital technology and the Internet will produce only positive benefits for democratic society—are difficult to sustain (Sudweeks and Ess 1998; Shaner 1998). This present essay is a rather selective survey, but there is no evidence that the Internet and digitization have yet changed the way the people who control the news think about images in the news; the ethical standard of pluralism, multivocality, and multipolarity is being propagated only indirectly. Mainstream news sources of existing print, broadcast, and cablecast organizations are attempting to maintain, and may well succeed in maintaining, their traditional (and profitable) gatekeeping role (Singer 1997)—that is, to program for an active audience of any kind (Eastman 1998).

Interactivity itself may be a chimera. Certainly, there has been no consensus on how we should define the term or the process (Durlak 1987; Frenette and Caron 1995; Ha and James 1998; Mayer 1998; see especially Massey and Levy 1999). The mechanics of the Web may allow us to be "interactors" rather than viewers or readers or receivers, but the content may be created and "pushed" at us in ways similar in style and results to those of traditional forms of media. We must not underestimate the ability of the powers that be to adapt their systems of propaganda, control, commodification, and commercial exploitation to and through any new technology. Governments, commercial power holders, and indeed all authorities will attempt various "containment strategies," ranging from the passive to the coercive (Taubman 1998). Simply clicking on hyperlinks is as little an experience of liberation as that of a mouse facing the corridors of a laboratory maze. Looking back at the early years of the Internet, future critical analysts may define interactivity as simply a clever marketing ploy.

Whatever the result, there is some possibility of a new ethic of more contextual photojournalism and more complex understanding of icons of current affairs. Independent scholars and photographers can, through this new medium, make an attempt to create voices, words, and pictures of subversion, protest, challenge, heterodoxy. In fact, the Web and many accessible tools of Web page creation make such guerrilla documents very simple. A multimedia portal, with links to stories, added context, audio, other pictures, and perhaps even the kinds of images least present on the news print page—images with viewpoints that are either directly or implicitly captioned as ideologically or politically different from those of the authoritative "published"

image—is achievable. Such a portal will allow the news picture to become more detailed, complex, and contextual more cheaply than news pages, and will offer possibilities of escape from the minimalist trap in which most news pictures find themselves. The real challenge is to make icons of such multimedia arrays—that is, to attract an audience aside from students of visual culture and affect general beliefs and policies. Simply putting something up on the Web and drawing an audience of parents, pals, and cognoscenti is not mass communication.

Above all, the ethic of those of us who care about news images and icons in the Internet age should be to suggest that, although we may always be thinking of new technologies to look at images, we should also be looking for new ways to think about images and the effects they do and do not have on world history and our daily lives.

Notes

1. An example is the photo of the missile streak associated with the 1996 crash of TWA Flight 800, which was widely distributed among conspiracy buffs on the Web.

2. An example is the Clinton-Lewinsky scandal.

3. This complexity suggests a challenge to the mainstream socializing effect of the news agenda and the icon itself: Will people be able to consent to one news agenda? That is, if stories change often, and people have interests that lead them through many parts of the maze of sites, will they, in interpersonal contacts, agree on what constituted the "big story" and "big picture" of the previous day? Or will everyone have his or her own news? "Push" technology and personalized news choices increase this complexity.

4. As a thirty-year-old master's student, I participated in one such study and scored very poorly.

5. This issue is especially important to any investigation of how well people recall mediated news of events (see Stauffer, Frost, and Rybolt 1983).

6. There is mixed evidence concerning whether texts (words or images) viewed on-line are less or more strongly imprinted on memory than those encountered and engaged through other media. In one study, subjects recalled less vividly and for a shorter time advertising that was integrated into a Web page compared with identical ads viewed on a print page (Sundar et al. 1998). It may be a matter of the aesthetics of what is being viewed: on the Web, animation of images seems to increase recall rates, at least for banner ads (Li and Bukovac 1999).

7. Web self-publicists can become local celebrities in the legal sense (see Bunker and Tobin 1998).

8. Even those images are replaced frequently, however, because they lose their news value over time.

9. Or an interactor might contribute through countercommentary. Programs now exist that allow people to place virtual Post-its on public Web sites; others owning the special program can read their notes, and the Web site operators cannot erase them.

10. Certainly, the interactivity that is possible through hypertext links and choices of texts in new Web sites reflects at least a shift of technical control from sender to receiver (Li 1998). Furthermore, the Web allows formerly marginalized groups to create considerable virtual, if not physically extensive, communities of shared interest and expression (Kibby 1999). News organizations may even find it to their benefit to cede Internet information consumers

at least partial autonomy in determining the types, extent, and directions of their interactions with news, what Khoo and Gopal (1996) call "prosumerism" (29; see also Dennis 1996).

References

Arlen, Michael J. 1969. *Living-room war.* New York: Viking.

Arnett, Peter. 1994. Live from *the battlefield.* New York: Simon & Schuster.

Bailey, George A., and Lawrence W. Lichty. 1972. Rough justice on a Saigon street: A gatekeeper study of NBC's Tet execution film. *Journalism Quarterly* 49:221–29.

Barthes, R. 1988. *Image-music-text.* Translated by Steven Heath. New York: Noonday. (Original work published 1977)

Bonner, Frances, Rebecca Farley, David Marshall, and Graham Turner. 1999. Celebrity and the media. *Australian Journal of Communication* 26, no. 1:55–70.

Bove, V. Michael, Jr. 1996. Beyond images. *Convergence* 2, no. 2:30–46.

Broeckmann, Andreas. 1997. Towards an aesthetics of heterogenesis. *Convergence* 3, no. 2:48–58.

Buber, Martin. 1974. *I and thou.* New York: Macmillan.

Bui Diem (with David Chanoff). 1987. *In the jaws of history.* Boston: Houghton Mifflin.

Bunker, Matthew D., and Charles D. Tobin. 1998. Pervasive public figure status and local or topical fame in light of evolving media audiences. *Journalism & Mass Communication Quarterly* 75, no. 1:112–26.

Chancellor, John. 1997. Remarks made in *Newsreels to Nightly News,* episode 4, Vietnam: The Camera at War. History Channel.

DeFleur, Melvin L., Lucinda Davenport, Mary Cronin, and Margaret DeFleur. 1992. Audience recall of news stories presented by newspaper, computer, television and radio. *Journalism Quarterly* 69, no. 4:1010–22.

Dennis, Everette E. 1996. Values and value-added for the new electronic journalism: Public debate and the democratic dialogue. *Media Asia* 23, no. 2:107–10.

Disch, Thomas M. 1999. *The dreams our stuff is made of: How science fiction conquered the world.* New York: Simon & Schuster.

Durlak, Jerome T. 1987. A typology for interactive media. Pp. 743–57 in *Communication yearbook* 10, edited by Margaret L. McLaughlin. Newbury Park, Calif.: Sage.

Eastman, Susan Tyler. 1998. Programming theory under stress: The active industry and the active audience. Pp. 323–77 in *Communication yearbook* 21, edited by Michael E. Roloff. Thousand Oaks, Calif.: Sage.

Elmer, Greg. 1997. Spaces of surveillance: Indexicality and solicitation on the Internet. *Critical Studies in Mass Communication* 14, no. 2:182–91.

Frenette, Micheline, and Andre H. Caron. 1995. Children and interactive television: Research and design issues. *Convergence* 1, no. 1:33–60.

Gamson, Joshua. 1992. The assembly line of greatness: Celebrity in twentieth century America. *Critical Studies in Mass Communication* 9, no. 1:1–24.

Graber, Doris A. 1990. Seeing is remembering: How visuals contribute to learning from television news. *Journal of Communication* 40, no. 3:134–55.

Grimes, Tom. 1990. Encoding TV news messages into memory. *Journalism & Mass Communication Quarterly* 67, no. 4:757–66.

Guy, P. 1993. Handshake photo worth 1,000 words. *USA Today,* September 15, 8B.

Gwertzman, Bernard. 1999. Telephone interview by author. December 10.

Ha, Louisa, and Lincoln E. James. 1998. Interactivity reexamined: A baseline analysis of early business Web sites. *Journal of Broadcasting & Electronic Media* 42, no. 4:457–74.

Hammond, William M. 1988. *Public affairs: The military and the media,* 1962–1968. Washington, D.C.: U.S. Army, Center of Military History.

Hodgson, V. Godfrey. 1976. *America in our time.* Garden City, N.Y.: Doubleday.

Johnson, J. T. 1994. The private I, you, they. *Journal of Mass Media Ethics* 9. no. 4:223–28.

Katsiaficas, George, ed. 1992. *Vietnam documents: American and Vietnamese views of the war.* Armonk, N.Y.: M. E. Sharpe.

Kernell, S. 1978. Explaining presidential popularity. *American Political Science Review* 72:506–22.

Khoo, Derrik, and Ramesh Gopal. 1996. Implications of the Internet on print and electronic media. *Journal of Development Communication* 7, no. 1:21–33.

Kibby, Marjorie D. 1999. The didj and the Web: Networks of articulation and appropriation. *Convergence* 5, no. 1:59–75.

Larson, James F. 1992. *Television's window on the world: International affairs coverage on the U.S. networks.* Norwood, N.J.: Ablex.

Li, Hairong, and Janice L. Bukovac. 1999. Cognitive impact of banner ad characteristics: An experimental study. *Journalism & Mass Communication Quarterly* 76, no. 2:341–53.

Li, Xigen. 1998. Web page design and graphic use of three U.S. newspapers. *Journalism & Mass Communication Quarterly* 75, no. 2:353–65.

Lyon, David. 1998. The World Wide Web of surveillance: The Internet and off-world powerflows. *Information Communication and Society* 1, no. 1:91–105.

Massey, Brian L., and Mark R. Levy. 1999. Interactivity, online journalism, and English-language Web newspapers in Asia. *Journalism & Mass Communication Quarterly* 76, no. 1:138–51.

Mayer, Paul A. 1998. Computer-mediated interactivity: A social semiotic perspective. *Convergence* 4, no. 3:40–48.

Messaris, P. 1994. *Visual literacy: Image, mind, and reality.* Boulder, Colo.: Westview.

Meyerowitz, J. 1985. *No sense of place.* New York: Oxford University Press.

Milstein, J. S. 1974. *Dynamics of the Vietnam War: A quantitative analysis and predictive computer simulation.* Columbus: Ohio State University Press.

Mitra, Ananda. 1997. Diasporic Web sites: Ingroup and outgroup discourse. *Critical Studies in Mass Communication* 14, no. 2:158–81.

Monk, Lorraine. 1989. *Photographs that changed the world: Photographs as witness, photographs as evidence.* New York: Doubleday.

Mosettig, Michael, and Henry Griggs Jr. 1980. TV at the front. *Foreign Policy* 38:67–79.

Mueller, John E. 1971. Trends in popular support for the wars in Korea and Vietnam. *American Political Science Review* 65:358–75.

———. 1973. *War, presidents, and public opinion.* New York: John Wiley.

NBC News. 1989. *China in crisis.* Special report, aired June 5.

Newhagen, John E., and Byron Reeves. 1992. The evening's bad news: Effects of compelling negative television news images on memory. *Journal of Communication* 42, no. 2:25–41.

Pasupathi, Monisha, Lisa M. Stallworth, and Kyle Murdoch. 1998. How what we tell becomes what we know: Listener effects on speakers' long-term memory for events. *Discourse Processes* 26, no. 1:1–25.

Perlmutter, David D. 1992. The vision of war in high school social science textbooks. *Communication* 13:143–60.

———. 1994. Visual historical methods: Problems, prospects, applications. *Historical Methods* 27, no. 4:167–84.

———. 1998. *Photojournalism and foreign policy: Framing icons of outrage in international crises.* Westport, Conn.: Greenwood.

———. 1999a. Journalistic norms and forms of crossnational imagery: How American news-magazines photographed Tiananmen. Pp. 123–42 in *International news monitoring,* edited by Kaarle Nordenstreng and Michael Griffin. Boston: Hampton.

———. 1999b. *Visions of war: Picturing warfare from the Stone Age to the cyberage.* New York: St. Martin's.

———. 2000. *Policing the media: Street cops and public perceptions of law enforcement.* Thousand Oaks, Calif.: Sage.

Price, Vincent, and John Zaller. 1993. Who gets the news? Alternative measures of news reception and their implications for research. *Public Opinion Quarterly* 57, no. 2:133–64.

Schuman, Howard, Robert F. Belli, and Katherine Bischoping. 1997. The generational basis of historical knowledge. Pp. 47–77 in *Collective memory of political events: Social psychological perspectives,* edited by James W. Pennebaker, Dario Paez, and Bernard Rimé. Mahwah, N.J.: Lawrence Erlbaum.

Schwartz, Dona. 1991. Photojournalism and the historians. *American Journalism* 8, no. 1:62–66.

Shales, Tom. 1993. Peace in their time. *Washington Post,* September 14, B1.

Shaner, Scott. 1998. Relational flow and the World Wide Web: Conceptualizing the future of Web content. *Electronic Journal of Communication* 8, no. 2.

Singer, Jane B. 1997. Still guarding the gate? The newspaper journalist's role in an on-line world. *Convergence* 3, no. 1:72–89.

Stauffer, J., R. Frost, and W. Rybolt. 1983. The attention factor in recalling network television news. *Journal of Communication* 33, no. 1:29–37.

Sudweeks, Fay, and Charles Ess. 1998. Culturally mediated computing: Editorial preface. *Electronic Journal of Communication* 8, nos. 3–4.

Sundar, S. Shyam, Sunatra Narayan, Rafael Obregon, and Charu Uppal. 1998. Does Web advertising work? Memory for print vs. online media. *Journalism & Mass Communication Quarterly* 75, no. 4:822–35.

Taubman, Geoffry. 1998. A not-so World Wide Web: The Internet, China, and the challenges to nondemocratic rule. *Political Communication* 15, no. 2:255–72.

Wells, H. G. 1996. *The world brain.* London: Adamantine. (Original work published 1937)

Westmoreland, William C. 1976. *A soldier reports.* Garden City, N.Y.: Doubleday.

Wicks, Robert H. 1995. Remembering the news: Effects of medium and message discrepancy on news recall over time. *Journalism & Mass Communication Quarterly* 72, no. 3:666–81.

Wiemer, R. 1992. *Live from ground zero.* New York: Doubleday.

Wischmann, Lesley. 1987. Dying on the front page: Kent State and the Pulitzer. *Journal of Mass Media Ethics* 2 (spring/summer):67–74.

Worth, Sol. 1981. *Studying visual communication.* Edited by Larry Gross. Philadelphia: University of Pennsylvania Press.

2

Professional Oversight:
Policing the Credibility of Photojournalism

Dona Schwartz

Photography's integration into journalism during the late nineteenth century offered a number of advantages to news producers. Earlier in the century, publishers had discovered the utility of adding illustrations to written reports. The inclusion of pictures in the press increased circulation, broadening the appeal and the reach of existing publications. According to historian Simon Michael Bessie (1938):

> Most successful of the technical advances [of the nineteenth century] was the increased use of illustrations and photographs. Pulitzer used this attraction to the limit and it was to the *World's* unprecedented exploitation of pictures that the *Journalist* attributed its unparalleled circulation. By September of 1886 the *World* was selling 250,000 copies daily, "the largest circulation ever attained by any American newspaper" up to that time. (45–46)

Publishers deployed the evidentiary status attributed to the image as part of the larger attempt to assert the nonpartisan, objective view offered by the fourth estate, thereby positioning newspapers as consumable objects that transcended specific

political, social, or cultural affiliations (Schwartz 1999). When hand-drawn illustrations of newsworthy events proved awkward, because of both the lag time necessary to reproduce them in the press and the noticeable liberties taken by sketch artists in their representations, photography was embraced as technology's solution to these irksome problems. Photographic technology improved in the period from the late nineteenth century to the early twentieth, and with the introduction of the halftone process, which made possible the reproduction of photographs in the press, publishers came to value photographs as rapidly produced (and reproduced), reliable records of current events.

Although it may be difficult to challenge the advantage of the greater efficiency photography introduced into the news production process, claims regarding the medium's unimpeachable honesty do warrant scrutiny. Alert readers noticed sketch artists' practice of reusing stock picture elements to save time. The questionable tactics employed by some draftsmen yielded a critical, suspicious climate for the reception of all news illustrations. Sketch artists' lapses provided a wedge that enterprising photographers used to make entry into the news business. As Roger Fenton claimed when he compared drawings depicting events of the Crimean War with the photographs he had produced,

> Goodall's sketches seem to astonish everyone from their total want of likeness to the reality, and it is not surprising that it should be so, since you will see from the (photographic) prints sent herewith, that the scenes we have here are not bits of artistic effect which can be effectually rendered by a rough sketch, but wide stretches of open country covered with an infinity of detail. (Quoted in Gernsheim and Gernsheim 1954, 21)

Although Fenton emphasized the degree of detail, and therefore the greater fidelity, offered by photography, the more emphatic view shared by many observers stemmed from their view of the technological nature of the medium. Nineteenth-century writers called photographs "sun pictures," and William Henry Fox Talbot entitled his early volume of photographs *The Pencil of Nature,* as if to suggest that photographs, as opposed to drawings, emerge from the confluence of naturally occurring optical, chemical, and mechanical processes. Contemporary writers spoke not of picture makers, but of camera "operators," implying that camera users merely facilitated an image-making process that the camera itself performed.

Because machines make photographs, logic suggested, photography is free of the bias resulting from human intervention, bias that compromises the truth-value of other, nonmechanical pictorial media. This prevalently held view of photography was clearly articulated by such writers as Lady Elizabeth Eastlake, who described photography in the *London Quarterly Review* in 1857 as follows: "She is the sworn witness of everything presented to her view. What are her unerring records in the service of mechanics, engineering, geology, and natural history, but facts of the most

sterling and stubborn kind?" (quoted in Newhall 1982, 85). In 1910, George Bernard Shaw echoed Lady Eastlake's views of the medium in remarks published in *Camera Work:*

> True, the camera will not build up a monumental fiction as Michael Angelo did, or coil it cunningly into a decorative one, as Burne-Jones did. But it will draw it as it is, in the clearest purity or the softest mystery, as no draughtsman can or ever could. And by the seriousness of its veracity it will make the slightest lubricity intolerable. . . . Photography is so truthful—its subjects so obviously realities and not idle fancies—that dignity is imposed on it as effectually as it is on a church congregation. (Quoted in Taft 1938, 319)

Despite evidence confounding its claim to truth, photography's evidentiary status held sway. Even though 1920s newspaper readers viewed the press cynically, giving rise to the commonplace "You can't believe all you read in the newspapers," Bessie (1938) suggests that photographs maintained their credibility and readers were more apt to trust what they saw (in news photographs) than what they read: "To a generation which had yet to learn that the camera can be the author of as many lies as truths, seeing was still believing and a newspaper picture taken (allegedly) on the spot was accepted as proof of a story's accuracy" (69). Even the abundant use of photo fabrications such as the "composographs" that had appeared in tabloid newspapers since the early twentieth century did not dislodge photojournalism's credibility, and the privileged status of news photographs has endured intact until recently.

Just as the move from hand-drawn illustrations to photographs altered routine habits and assumptions regarding news images, new technologies ushered in during the 1980s have produced fundamental change in the newspaper industry. The introduction of digital imaging, like the introduction of photography, offered efficiencies that streamlined the process of producing images for the printed page and, with the rise of the Internet, for news sites available on the World Wide Web. Technological change seems to produce punditry as a by-product, and William J. Mitchell makes the following claim in reference to digital imaging in his 1992 book *The Reconfigured Eye:* "From the moment of its sesquicentennial in 1989 photography was dead—or more precisely, radically and permanently displaced—as was painting 150 years before" (20).

Across the nation and around the world, photojournalists, editors, and scholars have sounded the alarm in response to digital technology's invasion of the newsroom. The news photograph, unchallenged purveyor of visual truth, seemed to face possible extinction, along with the profession of photojournalism. Those who expressed their concerns made clear that digital imaging's greater efficiency came at a price: its facility also made possible seamless alterations that compromised the public's faith in photographic truth. Discussion groups and symposia addressed the impending disaster, generating strategies to shore up credibility and assure the future of news photography.

A variety of schemes emerged: written rules, guidelines for discussion, unwritten codes of conduct, and labeling protocols, all predicated on the view that digital imaging profoundly alters the nature and practice of photojournalism.

Another historical parallel aligns the introduction of digital imaging technology in the twentieth century with the introduction of photography in the nineteenth. Widespread commonsense beliefs regarding the nature of each mode of image production have shaped emergent codes of professional practice and policy decisions, beliefs regarding each technology that are both naive and powerful. Camera *users* make photographs, not cameras, and so too are digital images made by users of the technology and not immaculately conceived. Here is the difficulty: photographs are viewed as mechanically produced and therefore neutral (a good attribute), whereas digital images, like sketch artists' renderings of reality, are considered handcrafted (a bad attribute).[1] What is widely viewed as the "recent" reintroduction of the human hand has triggered photography's decline as a trusted vehicle of truth.[2]

The photographer's "hand" has never been absent from the image-making process. Decisions regarding the equipment and supplies used—cameras, lenses, film stocks, developers, photo papers—shape the nature of the images produced. Darkroom procedures such as cropping, burning, and dodging provide emphasis and focus viewers' attention. Photographers employ their knowledge of the medium when they choose among the array of alternatives available—the way different lenses depict space, the selective focus that controlling depth of field offers, the rendition of light and shadow resulting from the use of natural or artificial light. The photographer decides where to stand (kneel or climb), how to address the subject, how to frame it, and when to release the shutter. The photographers hired by newspapers must demonstrate through painstakingly compiled portfolios the craft skills they bring to the task of photo reporting. Yet despite the photojournalist's role as the intermediary between camera and reality, and progenitor of the resultant representation, publishers and readers have agreed to accept news photographs as neutral records of actions and events.

Digital imaging has shaken the public's faith in photography. Perhaps because the performance of these skillful activities no longer takes place in the sequestered confines of the darkroom, or perhaps due to the introduction of digital imaging technology into the consumer market (and therefore the domestic sphere), contemporary viewers have fixated on the digital image's potential for manipulation. Professionals acknowledge that photographers and production personnel have always possessed the ability to perform the kinds of manipulations now made on the computer. A 1939 textbook titled *Pictorial Journalism* matter-of-factly describes the process of retouching news photos to improve their appearance in preparation for reproduction:

> Retouching is done on the glossy print with water-soluble black or white paint or with mixtures of the two to give the various gray shades. The paint is applied with an ordinary camel's-hair paintbrush or with an airbrush....

> Since clarity of outline is his first concern, the retoucher examines the print to see
> if the figures, forms, or faces stand away from the background distinctly. He may
> sharpen up the outline of a house or a tree, or, in the case of an interior, of a table or
> desk or chair. He may deepen the profile of a face. (Vitray, Mills, and Ellard 1939, 147)

These alterations enhance the reproduction quality of the photograph and may seem
justifiable, even innocent, when viewed through the lens of the technological limita-
tions of the era. However, the text's authors allow retouchers additional leeway to
make decisions regarding photographic content, as this passage makes clear:

> Washing over the whole background with white or black paint so as to obliterate it
> completely is a good plan with *some* pictures, particularly those where the back-
> ground is unimportant to the story the picture has to tell yet is so full of detail that
> it distracts the eye from the faces or the figures in the foreground. . . . Keep in mind
> that the purpose of washing out the background is to obliterate confusing detail:
> furniture and ornaments, foliage on a tree, background figures. (149–50)

The authors go on to provide instructions on how to disguise the retouching that has
been done so that it will be invisible to the viewer. They also outline other, more ob-
vious and intrusive retouching strategies, but their discussions of retouching are al-
ways accompanied by the caveat that the retoucher's task is simply to enable the
photographer to tell the story better. These manipulative practices, among others,
were routinely and uncontroversially employed in the production of news photography.

Even the issue of photo fakery receives gentle treatment in this influential text:

> The charge that news photos are "faked" is occasionally heard and now and then is
> justified—*rarely*, in our time. The truth is that real photography has driven the
> fakes out of the field so completely that current examples would be difficult to find.
> Also, few of the critics would recognize a fake were they to see one, and if it oc-
> curred in a reputable newspaper—as now and then one does—they would probably
> not even sniff at it. (391)

Most interesting of the three types of fakes enumerated is the much-scorned "com-
posograph." As the authors describe its occasional use, their tone suggests that such
lapses are understandable, even if they are not laudable:

> The third type of fake, the real "composograph," may still occasionally be found in
> newspapers, but only by those whose eyes are sharp. It is a photo built up out of sev-
> eral photos, but it differs from the photomontage in that it seeks to conceal the tell-
> tale evidence that it is not a single shot. It may show Hitler and Mussolini clasping
> hands, or famous athletes or royal personages in conclave, or the flight of an air-
> plane over some familiar skyline. When the event is one which has great popular in-
> terest and no pictures are obtainable, editors sometimes seek to represent the news
> by this little trick of cutting out and pasting down to get a scene close to the actual

one. Usually nothing is said in the cutline to indicate that such a picture is a composograph, and the reader of the very conservative newspaper might be greatly shocked if he knew it was. Yet the purpose is not so much to fool him as to give him what he has come to desire: the news in pictorial form.

To be sure, the inventor of these composographs needs to watch himself against slips. Airplanes (in newspapers) have been seen to fly over mountain tops with their propellers visible. On the other hand, queens and duchesses have been beheaded and their heads set nimbly onto bodies more fashionably or seasonally garbed than they—and no complaint has ever yet been made. Famed personages have given each other a hearty handclasp with hands which never belonged to themselves, and no hard feelings have resulted. Ladies have been made a present of a better set of legs, gentlemen have had their straw hats chopped off and replaced with fedoras. If such a composograph *misrepresents the news* it is a dangerous weapon. Such abuses, however, would be impossible to point to and probably do not exist. (393–94)

This text offers a very loose set of guidelines for professionals and implies ethical norms. Actual practice may well have exceeded the limits suggested by the authors.

Advances in technology have made many image manipulations easier, quicker, and less noticeable than earlier methods, and with the introduction of digital cameras, the evidence provided by unique original negatives is obliterated. But, as I have argued and the preceding passages attest, manipulation (sometimes excessive, sometimes subtle) is and has always been an inherent part of the process of making photographic images, whether or not we assign them the task of truthfully representing reality. The act of symbolizing, even with the use of a mechanical device capable of producing iconic representations, is a socioculturally defined communicative event. If technology previously masked the craft processes fundamental to photographic image making, rendering photographs apparent "mirror reflections of reality," why has the recent introduction of digital imaging technology had the inverse effect and initiated a process of exposing the medium?

These changes in attitude reveal the importance of the underlying belief system that informs both the production and the consumption of photographic images. By adhering to professional conventions, word reporters construct written accounts that many readers consider neutral. Readers are encouraged to assume that reporters who conform to professional norms produce stories devoid of bias. Reporters acknowledge their responsibility to justify readers' faith in their integrity. A social contract binds together news producers and those who consume their products. Similar assumptions guide the production and reception of news photographs. But these assumptions, once strengthened by beliefs regarding the nature of photography, have been eroded by the introduction of digital imaging and beliefs regarding the technology's capacity for facilitating deceit. As Vitray, Mills, and Ellard (1939) suggest, institutional repute and credibility provide the necessary foundation for readers' trust. "Conserva-

tive" and "reputable" newspapers sustain public faith, despite what may be viewed as occasional or unintentional lapses. Contemporary photojournalists similarly acknowledge an implicit contract with the public. When he was serving as president of the National Press Photographers Association, John Long (1989) expressed this view regarding the impact of digital imaging:

> The only hope lies in you and me. We must be honest in all our professional dealings. We ourselves, the photojournalists, must be trusted because the images themselves will no longer be proof positive. Reporters have a long and honored tradition of honesty. It is a tenet of their profession, it is their Hippocratic oath. We need to develop the same internal standards, the same deep beliefs in the rightness of what we are doing. Our future depends on us and no one else. (14)

In order to demonstrate their abiding commitment to honesty, photojournalists, news editors, and news publishers have begun to institute professional codes, standards governing the use of digital imaging technology. Building upon the assumption that cameras tell the truth, the rules by which photojournalists have been asked to abide rein in the use of digital imaging so that new technology parallels old: only photographic processes used in the predigital "wet" darkroom can be used by news organization personnel. Digital imaging codes have been established in such a way as to exploit earlier naive attitudes toward photography; in effect, they attempt to preserve the status quo. The logic supporting new imaging policies proceeds from the assumption that technology is neutral but human users may introduce bias, either unwittingly or willfully. Therefore, photographers and photo technicians who prepare images for publication are expected to limit their own intervention in the image production process, keeping photographic output as close to its "raw" state as possible. Proving their serious intent, newspapers have enacted photo guidelines that are *more* stringent than the informal rules that governed earlier wet-darkroom procedures. Remarks made by Sherman Gessert (1991), director of photography at the *Milwaukee Sentinel,* illustrate this retrograde dynamic:

> Recently, at a Wisconsin News Photographer's convention, I witnessed a local photojournalist's contest entries being chastised for overburning, a definite change from past judgings. Is this shift the result of the inevitable electronic age? Because of electronics, were we preparing ourselves for a return to realism? As one who has been known to "cheat just a bit" in the past, I'll admit, I've seen the light, witnessed the disaster electronics could bring if left unchecked, and am ready to return to the days of purism!
>
> Steichen, Stieglitz, Adams and the rest of you old timers, wake up, here we come! (16–17)

Gessert's conversion experience encouraged him to draw a parallel between the exigencies of contemporary photojournalism and the art tradition of so-called "straight

photography," a peculiar stance, given the cited photographers' grounding in the art world and the manipulative processes they employed to give their photographs a heightened realism.

A review of the digital manipulation policies guiding professional practice at major U.S. newspapers helps to illuminate the nature of the ethical code in force. Policies endorsed by the National Press Photographers Association (NPPA) and the Associated Press provide a template for individual news organizations, large and small. The large-circulation newspapers examined in the following discussion are the *New York Times, Los Angeles Times, Washington Post, Chicago Tribune, Chicago Sun-Times, Philadelphia Inquirer, New York Daily News, Detroit News and Free Press, Dallas Morning News, Houston Chronicle, Boston Sunday Globe, USA Today,* and *Newsday.* My interviews with photo editors at these publications have elicited a common perspective. A brief memo addressed to all *USA Today* staff photo editors from the paper's managing editor for graphics and photography, Richard Curtis, dated January 26, 1989, succinctly expresses the paper's position and represents the prevailing norm:

> WE DO NOT ALTER ANY PHOTOGRAPH, ELECTRONICALLY OR OTHERWISE, TO CHANGE THE CONTENT, AND WE SHOULD BE VERY CAREFUL ABOUT COLOR CORRECTING OR ANY OTHER POTENTIAL ALTERATION.

Formal and informal policies at the major metropolitan dailies and small weeklies I have examined all echo Curtis's stance.

The NPPA magazine *News Photographer* has published numerous reports on ethical debates regarding digital imaging, the majority of which appeared from 1989 through 1992. By keeping abreast of the dilemmas outlined and responses generated, photojournalists have been able to access formal regulations and informal provisos, accounts of controversies and their repercussions. Exchanges among photographers on the NPPA's electronic discussion list suggest that these reports inform and influence the daily routines of photojournalists. The publication of policy statements by major news organizations receives particular note. The October 1990 issue of *News Photographer* included a story summarizing deliberations over a "Statement of Principle" by the Executive Committee of the NPPA alongside a reprint of the Associated Press policy. The AP policy appeared with the text of an address given by executive photo editor Vincent Alabiso, adding a sense of gravity and personal commitment. The policy reads as follows:

> Electronic imaging raises new questions about what is ethical in the process of editing photographs. The questions may be new but the answers all come from old values.
>
> Simply put, The Associated Press does not alter photographs. Our pictures must always tell the truth.
>
> The electronic darkroom is a highly sophisticated photo editing tool. It takes us out of a chemical darkroom where subtle techniques such as burning and dodging

have long been accepted as journalistically sound. Today these terms are replaced by "image manipulation" and "enhancement." In a time when such broad terms could be misconstrued we need to set limits and restate some basic tenets.

The content of a photograph will NEVER be changed or manipulated in any way.

Only the established norms of standard photo printing methods such as burning, dodging, black-and-white toning and cropping are acceptable. Retouching is limited to removal of normal scratches and dust spots.

Serious consideration must always be given in correcting color to ensure honest reproduction of the original. Cases of abnormal color or tonality will be clearly stated in the caption. Color adjustment should always be minimal.

In any instance where a question arises about such issues, consult a senior editor immediately. The integrity of the AP's photo report is our highest priority. Nothing takes precedence over its credibility.

Similarly, the NPPA drafted its "Statement of Principle" in November 1990; the NPPA Board of Directors revised and adopted the statement at the organization's national convention in July 1991. *News Photographer* published the document in its March 1992 issue:

As journalists we believe the guiding principle of our profession is accuracy; therefore, we believe it is wrong to alter the content of a photograph in any way that deceives the public.

As photojournalists, we have the responsibility to document society and to preserve its images as a matter of historical record. It is clear that the emerging electronic technologies provide new challenges to the integrity of photographic images. This technology enables the manipulation of the content of an image in such a way that the change is virtually undetectable. In light of this, we, the National Press Photographers Association, reaffirm the basis of our ethics: Accurate representation is the benchmark of our profession.

We believe photojournalistic guidelines for fair and accurate reporting should be the criteria for judging what may be done electronically to a photograph. Altering the editorial content of a photograph, in any degree, is a breach of the ethical standards recognized by the NPPA.

Rather than compose their own policy statements, some newspapers default to the NPPA's position. *Detroit News and Free Press* photography director Steve Fecht explained that the paper has no written policy, but uses the NPPA's guidelines. The *New York Times, Chicago Tribune, Chicago Sun-Times, New York Daily News, Detroit News and Free Press, Houston Chronicle, Boston Sunday Globe, USA Today,* and *Newsday* also have no formal written policies. Peter Southwick, photography director at the *Boston Globe,* offered an explanation for his paper's lack of a formal written policy: "We have a policy not to have written policies." This is an approach intended to

shield the newspaper from legal action. Southwick went on to aver that the *Globe* does have a policy, nevertheless. The photo editors at all of the newspapers I examined gave the same emphatic response when asked about their stance on photo manipulation: "*We don't do it!*"

Many editors suggest that prohibitions against manipulating news photographs are informally *understood* by newspaper staffers, although tensions surface in their commentary. One photography director implied that designers, not photojournalists, are the culprits responsible for undermining photographs' integrity, saying, "All designers are scumbags." Another editor similarly pointed a finger at his paper's designers. New at his post, he asserted that he had discovered "too much fiddling around here." He explained: "Photo illustrators keep asking for permission to put someone's head on another body. I don't even want readers to know we have the technology to do it." The editor had sent a memo to members of his staff indicating his position on the practice. In the meantime, he said, one of his first tasks would be to write a stylebook that would make his edict clear (the resulting stylebook appears in the appendix to this chapter).

Editors often distinguish between the goals of journalists and the goals of "production people." They imply that photojournalists understand the ramifications of overt digital manipulation and the impact that knowledge of manipulation in *any* part of the newspaper might have on readers' assessments of the credibility of news photographs. Journalists emphasize news values, and *photo*journalists similarly abide by codes of the industry. Journalists often question designers' allegiances, implying that they are likely to succumb to their artistic impulses. Designers may be motivated to "fiddle around" by artistic considerations, but David Einsel, photography director at the *Houston Chronicle*, suggests that photographers themselves may also want to improve their pictures electronically. He insists that the division of labor at his newspaper helps photographers resist this temptation. At the *Houston Chronicle*, photographers do not scan their own photographs; rather, a small pool of "imaging techs" takes on that responsibility. When the same six or eight people do all the scanning, Einsel says, the process is easier to control, the rules are easier to enforce, and consistent quality is assured. This arrangement "frees photographers to shoot" and do the job for which they were actually hired.

Credibility is the key issue addressed by photo editors in both written and unwritten policies: news photographs should never mislead or deceive readers who trust newspapers to tell the truth. The *Washington Post* guidelines articulate this view unambiguously:

1. Photography has come to be trusted as a virtual record of an event. We must never betray that trust. It is our policy never to alter the content of news photographs. Normal adjustment to contrast and gray scale for better reproduction is permitted. This means that nothing is added or subtracted from the image such as a hand or tree limb in an inopportune position.

2. Photographic silhouettes, mortises, angled images, type surprinted on photographs. Silhouettes should be used sparingly—generally reserved for feature material. Mortises and photographs tipped at an angle should be avoided at all cost. In rare instances headlines and captions may be set into photographs. When in doubt about use, consult AME Photo or Art departments or their assistant editors. If further discussion is needed Len [Leonard Downie Jr., executive editor] or Bob [Robert Kaiser, managing editor] can be involved.

3. The use of photographs in whole or in part to achieve satire, humor or visual pun and the use of photographic collage is acceptable with reservations. The use of photos in collage artwork is permitted for illustrative purposes only. This must be limited to stories where the art can be impressionistic or interpretive. This does not include news stories and such use must be pre-approved by the AME Photo or Art departments or their assistant editors. Again, Len or Bob may need to be involved.

4. Digital photographic alteration. The use of technology to create new kinds of imagery is acceptable only where such use is clearly a work of fictional imagery. If a caption is necessary to explain that the content is not real then we should not use the image.

5. The decision to alter. When the idea to alter a photo arises, take a reality check. Is this really a good idea? Will readers be confused? Do others get the point of this irony or visual pun? A rule of thumb ought to be: kick the idea up to the next editing level.

Washington Post policy regarding altering photographs: Photographs are trusted by our readers to be an accurate recording of an event. Alteration of photographs in any way so as to mislead, confuse or otherwise misrepresent the accuracy of those events is strictly prohibited. Traditional darkroom techniques such as adjustment of contrast and gray scale are permitted. New technologies that enable the manipulation of photographic images have blurred the line between fact and fiction. It is The *Post's* policy to allow the use of these technologies only in a way that clearly makes their use evident and in no way misrepresents real events or depicts photographic collage or illustration as real events.

Photo editors express concern regarding the use of digital manipulation even for illustrative purposes. This may be where tension arises between photojournalists and designers, coworkers whose attitudes toward digital imaging technology may not coincide. News workers worry that once readers encounter manipulated photographs in one section of the paper, they will assume that manipulated photographs could be used in *any* section of the paper. Newspapers have used two strategies to avoid confusion. First, they have discussed and elaborated codes for labeling photographs as nonnews or feature illustrations. They have employed such terms as *photo-illustration* and *composite* to distinguish overtly manipulated images from news images, which

may be only minimally altered to achieve optimal color balance, good contrast, and maximal sharpness. Some editors have proposed the use of labels like *photo-reportage, photo-portrait,* and *photo opportunity* to facilitate more clear-cut distinctions among types of news images. Despite attempts to guard against misrepresentation, there have been celebrated cases in which publications have appropriately labeled manipulated images as photo-illustrations, but readers failed to find or be impressed by the appended information. *Time* magazine properly labeled the digitally altered mug shot of O. J. Simpson that appeared on its cover in 1994, but readers needed to examine the contents page to find the label. Similarly, only careful readers noted the label "photo-illustration" when *Newsday*'s cover showed figure skaters Tonya Harding and Nancy Kerrigan together on the ice the day *before* their Olympic competition.

The second strategy is more extreme. Some newspapers employ the policy that if a photographic image cannot perform its illustrative function without being manipulated, the alterations should be so overt, so implausible, that readers cannot conceivably mistake the illustration for a news image. Pictures such as these must not appear in news sections and should be used only to accompany feature stories. The attitudes that most photo editors express suggest that they prefer overt manipulation be used sparingly, if at all. But designers' needs must also be accommodated by newspapers' picture-use policies, and this prevents the strictest prohibitions. The following section of the *Los Angeles Times* photo policy clearly addresses the issue:

Graphics and Photo Illustrations:

Using photographs in graphics or as part of photo illustrations is permissible when these techniques work best to illustrate or explain a particular story. Generally, photo "cutouts" should not be used in news sections of the paper. To ensure consistency, all photo illustrations must be approved by a managing editor. An illustration should be created in such a way that it is obvious to readers that the image has been altered and does not represent a real situation. Even so, all graphics and photo illustrations must be properly credited with specific information about where the various elements came from and how the image was altered.

For illustrations that combine photos and graphics, for example, the credit might read: "Illustration: JOHN DOE/Los Angeles Times; Photo: MARY SMITH/Los Angeles Times." In cases where photographs have been altered as part of an illustration, a credit line or the caption should state, for example, "computer altered photo," or "composite photo." Generally, the more information we provide to readers about how we create these illustrations, the less chance there will be of misleading readers.

If local standards do not appear to ensure the enactment or enforcement of appropriate, consistent professional norms, concerned photojournalists have conceived of informal methods of nudging errant colleagues into line from afar. Many photojournalists consider it important for news photographers to maintain a "united front" with regard to professional ethics, reasoning that even local ethical breaches jeopar-

dize the profession at large. During the early 1990s, the NPPA held an annual Electronic Photojournalism Workshop to introduce photographers and editors to new digital imaging technologies and techniques as well as the attendant issues they raise. John Long, former NPPA president and editor of *News Photographer* magazine, co-founded the workshop and, in conjunction with colleague Mitch Koppelman, conceived the "Jackelope Award." Long (2000) recalls:

> It was created at the Electronic Photojournalism Workshop about 1990 or 91. I was one of the co-founders of the EPW, and ethics was my specialty. Still is. Mitch and I were having lunch when he told me about this idea of giving an award for the most digitally manipulated photo of the year. We wanted to point out the error of people's ways but we wanted to do it in a gentle way. (Seeing how things have progressed, maybe we should have attacked with venom instead of humor. Things have not changed as much as we wanted them to.) The first recipient was *Texas Monthly* for a cover they did of Governor Ann Richards riding a motorcycle. The only part of the photo that was Ann Richards was her head. We had a plaque made up, and we presented it at the final night's dinner of the EPW, in absentia, and then we sent it to *Texas Monthly.* They did not get too upset. They didn't care.
>
> We found it a useful concept to threaten people with the award. People would write and say, "Hey, I found you a Jackelope winner." The message was immediate. That has been its most lasting value. The EPW has ended and the people who ran it have moved on to other things and no one has picked up the gauntlet to keep the Jackelope alive but the word still has impact. All the efforts NPPA has made in keeping the concept of ethics alive in the digital age have had some impact. Newspapers are sensitive to the issue and most have adopted an ethical approach to photography. In the long run, however, I am afraid the forces of manipulation will win. It is just too prevalent and too easy to do.

Despite the emergence of both formal and informal strategies designed to curb digital manipulation that violates generally acknowledged ethical standards, breaches continue to occur, as Long's ruminations suggest. In addition to *Newsday's* Tonya Harding/Nancy Kerrigan gaffe, both *Time* and *Newsweek* have visibly manipulated news images appearing on their covers and generated controversy. Vehement criticism erupted over *Time* magazine's darkened mug shot of O. J. Simpson featured on the cover in 1994. Despite the firestorm that illustration generated, in 1997 *Newsweek* demonstrated similarly dubious judgment when in a cover photo it filled the gap between the front teeth of Bobbi McCaughey, an Iowa woman who had given birth to septuplets. (Ironically, in each case the other magazine ran an unretouched version of the same image on its cover, drawing attention to the rival publication's manipulation.) In November 1996, *Life* magazine ran an apology for having digitally altered a photograph in the August issue: "An altered version of the above photo appeared in our August issue. The red-sleeved arm behind the matador was electronically removed. Such electronic manipulation of news photographs is against our policy, and

Life regrets the lapse." In October 1996, *Ladies' Home Journal* removed tattoos and tailored the dress worn by Cher on the magazine's cover. And in May 1997, the *New York Post* removed the name of the *New York Daily News* from name tags worn by participants in a national spelling bee that was sponsored by the *Post's* rival.

One might defend photojournalism by arguing that gaffes make good news copy, while the day-to-day success of written policies and informal understandings of ethical norms goes unchronicled, despite its greater significance. Even after the Harding/Kerrigan fiasco, editors such as *Newsday's* photo director, Jim Dooley, aver that the newspaper's approach to digital imaging is successful. No written policy exists at *Newsday,* but Dooley insists, "We don't manipulate" (add or subtract elements of) news photos. Pointing to the keystone of *Newsday's* success, Dooley emphasizes that *journalists,* not "production people," input images into the paper's computer system, echoing the view that journalists understand principles inherent to news value, whereas production people may foreground craft values that could jeopardize the journalistic integrity of the news photograph. Similarly, David Einsel, photo director at the *Houston Chronicle,* asserts the success of the *Chronicle's* manipulation policy. He attributes the lack of any "goof ups" to the division of labor among photo personnel and the existence of a chain of command that can negotiate ambiguities. According to Einsel, only what the photographer captured should appear in a news photograph: "If you miss it, you miss it. Just because you have the tools doesn't mean you can cheat."

Even though photo editors at the nation's major dailies say their policies are working, rank-and-file photographers seem less certain. Questions abound on the NPPA electronic discussion list, examining issues such as whether eliminating redeye caused by the use of a flash constitutes a violation of ethical norms. The following excerpts from postings to the discussion list illustrate ambiguities and confusion that photojournalists confront. One photojournalist wrote:

> Because of a couple issues that came up recently of photo manipulation at my place of work, I've been sort of walking the line on whether some of the manipulation we have been doing is truly okay. It deals with retouching the eyes on night sports assignments.... Occasionally I'll get a subject with his retinas burning bright white like I stuck a couple white flares in his eye sockets.
>
> To date, we've pretty much accepted this manipulation as okay because we could have done it in the old darkroom with a little touch-up with spot toner. However I'm starting to wonder if we are going too far. What are all of your opinions on this? Do you see this tiny bit of manipulation as okay or dreadfully wrong?

The photographer's query elicited several thoughtful responses. One photographer considered digital red-eye reduction permissible because there is "NO reasonable way to 'get rid' of red-eye . . . in that situation . . . photographically, at the time of taking the picture." After lauding the writer for his concern about the ramifications of such ethical quandaries, another photojournalist offered a rationale his colleague might adopt to negotiate situations that seem ambiguous:

The way I look at it is that if what you are manipulating is something that was mechanically, artificially produced or added by your equipment (like a reflection from your flash), don't worry about "fixing" it. Otherwise, it's off limits.

This suggestion provoked the following forceful disagreement:

"Manipulate ONLY that which is introduced by the photographic process itself"? Could we then sharpen out of focus backgrounds in pictures shot with a 300 [telephoto lens]? Colorize black and white images? (The black and white is, after all, purely a product of the photographic process.) Do some heavy, heavy digital alteration of an image shot with a 16mm lens, to make the image more closely resemble what the eye would "see"?

I don't mean to be facetious, but it seems to me that the photographic process is hardly a good standard by which to measure ethical issues. I have yet to discover a perfect set of ethical guidelines that will cover every situation, but the phrase "the intent to deceive" frequently crops up in the guidelines I think come closest.

As this author suggests, ethical guidelines offer a starting point, but they by no means cover all circumstances. Photojournalists face shifting criteria and rationales introduced by both superiors and colleagues and must either scrupulously adhere to a rigid set of procedures or engage in ethical decision making on the fly. Neither guarantees success.

Most photographers agree, albeit somewhat reluctantly, that cosmetic changes that do not affect the meaning of the image are nevertheless inappropriate. They invoke a "slippery slope" metaphor to explain that opening the door to minor manipulation can result in a flood of unacceptable interventions. A photographer posted this question to the list:

I get this great shot of a gentleman crying at the [Vietnam War Memorial] wall, his fist clenched to his chest, yet right on the end of his nose is this little tiny drop of snot. I mean tiny, maybe it's just because I took the photo I noticed it, but it bugs the crap out of me. Now, as you probably have guessed, my question is on whether to clone out the tiny bit of snot on his nose, to save his dignity and not gross anyone out in the process, or leave it in. I mean it's tiny, but noticeable and the background's dark and fuzzy, so it stands out.

He received the following response:

Ken, you're asking us if it's okay to alter reality just a tiny, tiny little-itty-bitty bit for the sake of the subject and to maintain the dignity of the photograph. I guess you should GO FOR IT. Just don't forget to explain in the caption. It can be like:
"Joe Blow grieves at the Vietnam War Memorial replica Wednesday May 1, 1997 at Someplace Square. The Memorial will be on display and open to the public through May 14. A tiny bit of snot on his nose was electronically removed to save

his dignity and not gross anyone out in the process. It's tiny but is noticeable in the dark and fuzzy background, so it should not be part of this image."

If you explain this in the caption, then you're not pulling the wool over the readers' eyes and the picture maintains its dignity. Interesting question: What if Ken were to give the guy a print for his wall? Since the photograph would no longer be part of a newspaper that stakes its reputation on giving the public honest reporting, does it matter if it is snot-less, and thus not exactly a real moment as was seen? I've often thought about that digital manipulations (erasing people, retouching, etc.) by commercial (non-profesional) photo services is okay because pictures in an album don't carry the name and reputation of the newspaper behind them. The public expects the newspaper's photos to be honest and truthful—that nothing (or no one) was taken out of or added in the photo. People expect more of us and we should do everything to maintain that trust.

This author raises multiple key points while responding to the specific problem his colleague described. He alludes to some of the strategies editors have employed when captioning photographs that have been digitally retouched, and his parody suggests some of the difficulties they face as they hedge the fact that they have published an altered image. His proposed caption and sarcasm strongly suggest the perceived impropriety of such maneuvers. He also raises the issue of news organizations' credibility, relying on commonsense notions regarding the expectations of readers and the social contract between newspapers and the public implicit in those assumptions. Unfortunately, acknowledging these issues does not make the determination of appropriate professional practices any easier. Rather than use photographs that require cosmetic touch-ups, photographers and editors often choose not to run them at all. David Einsel, director of photography at the *Houston Chronicle,* shot a project in Mexico, and one of his photographs showed a farmer whose fly was fastened with safety pins because the zipper had broken. The appearance of the safety pins offended an editor, who thought it might also upset readers. Rather than digitally zip up the farmer's pants and run the photo, Einsel eliminated it from the story, preserving his own and the newspaper's integrity. The decision not to publish such photographs keeps journalists off the "slippery slope" and allows editors and publishers to avow their publications' reputations and resultant credibility.

The routine retouching procedures that Vitray, Mills, and Ellard (1939) recommended in their journalism textbook, such as "washing out" a background's "confusing detail," can no longer be justified, as the following discussion list query and response attest.

I've noticed a disturbing photo retouching technique that is being used with greater frequency. The technique mutes the background to highlight a foreground figure. I'd like to know what other photojournalists think about this....

Do you feel that photojournalists always have to be on watch to make sure that photos are not used in this manner? Do you feel that such photo manipulation has

gone too far? Do you think people without photo backgrounds have excessive say on how photos can be used? Maybe you have no problem with this technique.

The writer provided URLs for the photographs he found troubling and encouraged his colleagues to see for themselves. A respondent to this list of questions offered this restrained rebuke:

> The photo looks like someone got a little excited with Photoshop and decided to find as many uses as possible for funky picture manipulations. It doesn't cross as many ethical boundaries as it violates rules of good design. It doesn't mislead the reader, but it certainly might cause the paper to lose a little credibility. It makes it harder to take the paper seriously.

The respondent concludes by pointing a finger at designers who, the writer implies, may elevate aesthetic concerns above journalistic standards:

> Sooner or later, everyone has a picture stylized by a designer. There is a place for it, though I would argue that those places are limited. This isn't one of them.

Even routine practices such as converting color photographs to gray scale now receive scrutiny and create confusion:

> I had shipped someone some shots on disk for a project I had been working on and found that I liked some of the images better when I dropped them from colour into grey-scale. I think this is a legitimate and fully ethical "manipulation" of an image, just the same as taking the negative and printing it on black and white paper, which I do at times for proofs. The response I got was that this was digital manipulation and is unethical.
>
> When I think unethical I tend to think of the 1994 NY metro-daily cover of Harding and Kerrigan skating on the same rink without any note of digital manipulation. I am against altering news photos, and am fairly sure that making some of the shots B&W when shot on colour negative film is well within the bounds of ethical news photography.

Photojournalists at major metropolitan dailies regularly shoot color film, and newspapers routinely print color images appearing on inside pages in black and white. Nevertheless, the photographer quoted above is only "fairly sure" that the practice is ethical. The range of competing views espoused and their often contradictory nature confound many practitioners.

Other previously noncontroversial "tools of the trade" employed by photographers in the act of shooting are now suspect. Question:

> If I put a gradient filter in front of the lens to enrich a sunset, is that wrong? I think not, because it creates a nice image that portrays a sunset as most people remember it. Creating the same effect electronically is just a different means to the same end.

Answer:

> My rule of thumb has always been that of intent. If a particular manipulation (pre-exposure, chemical or digital) helps to make the printed scene look more like it did to a human observer, then it's OK. Sunsets are a particularly good example because the tonal scale exceeds the ability of the process to capture it. A properly used gradation filter only helps to keep the film from recording the scene inaccurately.

The definitive-sounding answer offered here charts a course back to the inconclusive debates cited earlier regarding the utility of using "what the eye sees" as a practical standard.

This final example suggests the level of uncertainty many photojournalists confront on the job:

> Friends,
>
> I have been asked by my coworkers to pose the following question:
>
> "Is a photograph using motion blur inappropriate in photojournalism?"
>
> . . . Last week, one of our staff photojournalists turned in a feature photo of a child participating in a hula-hoop competition. He used a slow shutter speed and existing light to capture the movement. He had no idea what kind of firestorm he was about to ignite.
>
> After the picture ran on the cover the Bureau Chief of our group notified our Photo Chief along with all the managing editors in her office that "If you get a photo like the one on today's (paper) DO NOT USE IT. Our job as a newspaper is to present clear, in-focus photos."
>
> All of us, including the M.E. that chose to run the picture were appalled, not because this picture was a masterpiece, but because we felt that motion blur was an acceptable technique and also we felt that blanket policies are unfair.
>
> Today in our monthly staff meeting, our Photo Chief read a letter from that same Bureau Chief meant to be a follow-up. In it she reiterated her opinion that "news photos should be in focus and not distorted to achieve an artistic effect. We do not allow reporters to distort facts when they write a story: therefore we should not allow a photojournalist to distort the fact she or he is presenting in a photograph."

Some of the photographers posting responses suggested that motion blur is a *more* accurate depiction of a spinning hula hoop than would be a freeze-frame. Others suggested that because photography inherently manipulates the reality in front of the lens, either choice is acceptable, depending on the photographer's judgment. Still others focused on the fact that a photograph of a child spinning a hula hoop would be classified as a feature shot, and therefore no ethical boundaries had been violated because it was not presented as news. The response of the student photo editor at a university newspaper sums up the prevailing view expressed on the list:

As people have pointed out, slow shutter speeds do not *distort* reality, they simply show it as it is over that slow speed, just like 1/500 shows reality as it is for that instant. Now playing around in Photoshop to make fake motion blurs (which I've done for a computer graphics class but *never* for my paper), *that* would be a distortion.

The exchanges among photojournalists on the NPPA discussion list demonstrate the ethical uncertainties photojournalists confront on a day-to-day basis. The confusion engendered by digital darkroom processing has extended its reach to shake photographers' faith in their use of commonplace shooting practices as well. Even long-standing, formerly noncontroversial photographic techniques, such as motion blur and the use of filters, receive close scrutiny from bureau chiefs, editors, and hapless photojournalists. Unfortunately, the terms of the debate are as murky today as they have been during the past decade. One might argue that contemporary photojournalists work on an ethical "fault line" characterized by shifting conceptions and eroding certainties. The ethical norms that emerge from these discussions among photojournalists suggest a range of ethical stances rather than a uniform approach, despite attempts at standardization by the NPPA and Associated Press. From these exchanges it is possible to extrapolate three distinct strategies, based on the various belief systems in play, that could be recommended and implemented.

1. *Publish only photographs that depict the subject as the "camera sees it."* The complications endemic to this approach could be resolved in part through the simplification of photographers' tool kits. That is, if the proclivity of photographers to make independent decisions regarding the use of the technology intervenes and shapes the resulting representations, all photojournalists could be issued standard equipment that streamlines the available array of choices. Recognizing the different technical requirements associated with different situations, news organizations might assemble specific equipment ensembles and film stocks for photographers' use in shooting sports, outdoor settings, indoor settings, and so on. The limitations imposed by the different tool kits would define the way the "camera sees" in different photographic situations and limit the degree to which a photographer could impose his or her own aesthetic. The important choices remaining to photographers would be subject framing and the moment at which the exposure is made. More rigid aesthetic codes could be formulated to standardize these decisions and the resultant images.

2. *Publish only photographs that depict the subject as someone present at the scene would have seen it.* The definitional problems posed by this strategy present greater difficulties, but allow photojournalists more latitude to translate the scenes they encounter into representations. Photographers would need to assess, for instance, the tonal range the average viewer would see when witnessing a sunset, as the query quoted above regarding filters suggests. This raises questions about the nature of perception,

however, and such variables as attention and motivation, as well as physiological characteristics of human vision, would require examination. In order to employ such an approach effectively, photojournalists, their editors, and publishers would need to study vision and perception and negotiate a set of guidelines and procedures to which all could adhere without confusion.

3. *Authorize photographers to make decisions regarding image production consistent with the prevailing norms governing journalistic representations across communicative modes.* This option builds on the "social contract" between news organizations and publics and relies on news organizations and individual news workers to establish and maintain reputations for accuracy and credibility. It suggests the need for written rules governing professional practice, rules that could be either publication specific or proffered by a professional organization such as the NPPA. News organizations might choose to publish the guidelines by which their employees produce stories regularly, making clear to readers the principles by which they abide. They might also acknowledge that news reports, whether written, spoken, or photographed (still or moving), *represent* rather than *duplicate* events and explicitly articulate the guidelines that govern the process by which they produce the *representations of events* they publish. They might go so far as to publish stories about the process of making news and offer case studies of ethical decisions made by photographers and their editors that illustrate the principles they routinely employ.

Contemporary photojournalists walk a tightrope, balancing ethical constraints and guidelines that come in a variety of shapes and sizes. They encounter threats of termination for violations of newly emergent norms that vary from place to place, resisting logic and consistency. Frustration oozes from their postings to the NPPA list as they stand their ground or reach for a colleague's hand to pull them from the quagmire:

> If only we were using technically perfect devices with film capable of rendering every hue and shade as our eyes see them. . . .
>
> Unfortunately, the tools we have are not perfect, film is more contrasty than real life and sometimes the shadows are so deep we have to throw a little light in to create the image that communicates what we saw to the reader.
>
> If it was only about "reporting what we see" there wouldn't be much point to our jobs, a trained monkey could replace us. What we want to do is to go beyond the limitations of our equipment, if that means adjusting the contrast range between the subject and background (darkening the sky) then so be it. I'd even go so far as to say we ARE in the business of creating art or at the very least a craft, to say otherwise ignores the technical skills we apply.
>
> Digital manipulation of news photos is obviously unacceptable, so there is little point in discussing it.

Or, as another frustrated and confused photographer wrote:

> When it comes to ethics in the digital medium, I feel that we have more to what we are ethically allowed than just scanning in the image straight off the negative.
>
> Let's face it . . . the camera doesn't see things as the human eye would. Personally, I have to agree with the standpoint that should a person use a program like Photoshop to restore the image to what was seen visually by those present, then it is alright.
>
> If a person is to alter that image from what was seen or the camera saw . . . it is manipulation and no longer a true representation of the moment and can no longer be classified as a simple photograph.

During the early 1990s, when the issue of digital imaging ethics first exploded, Lou Hodges offered his colleagues sage advice. Unfortunately Hodges's suggestions have not been heeded, despite the fact that they appeared in a booklet on photojournalism ethics widely distributed by the NPPA. Hodges (1991) took on the "myth of objectivity" and offered a productive take on the technology invading the profession:

> So the digitizing debate affords us an opportunity to dislodge the myth of objectivity by remembering our unavoidable subjectivity. The list of important subjective elements in news photography, as in all of journalism, is long. . . .
>
> What does all this mean, then, for news photographers' ethics in the digital age?
>
> It means, first, that because of our new power to deceive through digital manipulation we must increase caution in our professional watchdog role to weed out the charlatans.
>
> It means, second, that we must become all the more creative in using new technology to improve our pictures, to present reality all the more clearly, compellingly and accurately.
>
> What's new is that it is time for our concern and debate about digitizing to move to a higher plane: It is time now to debate ways of using new tools to do our time-honored job all the better. (8)

The time of which Hodges speaks is long overdue. But the myth of objectivity may still be too firmly embedded in the contemporary ideology of journalism for editors, publishers, and media CEOs watching the bottom line to confront adequately the ethical challenges posed in the digital era. Objectivity has offered publishers a valuable selling point, allowing news publications to maintain an image of transcendent neutrality and hence proffer their content as "one size fits all." In an era of shrinking readership and market segmentation, objectivity may be too comfortable a mantle to shed.

The history of the illustrated press suggests an unsatisfactory trajectory that contemporary practice might well parallel. When the work of sketch artists was found wanting in accuracy and verisimilitude, and when the repeated use of stock elements became evident to readers, publishers turned to a technological fix to rescue the

veracity of pictorial journalism: the unimpeachable photograph. Photography now confronts similar challenges, but no immediate technological antidote has appeared. Rather than recycle the same assertions about the inherent truthfulness of one medium or another, and lacking an heir apparent to the photograph, practitioners will need to rethink the nature of the process of news making and, in particular, the ontology of news pictures. A new trope is emerging in the news industry and in journalism schools that offers the potential for reformulation and provides some hope that we might, as Hodges urges, move discussion to a "higher plane."

Recent technological innovations have propelled a convergence of media, and new approaches to news making are being thrust upon journalists, requiring them to rethink and retool. Terms emerging within the profession, such as *visual journalism* (which brings photojournalism, broadcasting, and graphic design together under a common rubric), suggest that change is well under way. Journalists and educators alike have begun talking straightforwardly about news as a narrative genre: the work journalists do is increasingly referred to as "storytelling." Perhaps invoking storytelling will begin to dislodge naive assumptions about photography's inherent objectivity and lead to more productive debates about appropriate photojournalistic norms and practices. The metaphor might even encourage identifying story*tellers* and, therefore, the makers of photographs who create the stories they invoke. My own reading of recent news photographs suggests that influential papers such as the *New York Times* have begun pushing conventional aesthetic boundaries, forsaking the established "look" of news photography and foregrounding photojournalists' individual aesthetic styles. Whether or not this is the visible manifestation of an enduring move toward "visual storytelling" is unclear. Nor is it obvious that a retreat from objectivity is under way. It is clear that introducing digital technology into the field of photojournalism has produced upheaval, frustration, and uncertainty and has irrevocably changed professional practice. As digital imaging technologies stabilize and a "new media" aesthetic intrinsic to the characteristics of convergent media begins to emerge, new ethical standards are likely to crystallize, rendering the current confusion a vivid, unpleasant memory. As knowledge of the capacity to manipulate photographic representations invades the realm of common sense (undermining prior notions about photography's inherent unquestionable veracity), photojournalists and their multimedia descendants will do well to build their reputations for credibility not on the devices they use but on the methods they use to *tell their stories*.

Appendix

SUN-TIMES DESIGN
First in a series of memos about the evolution of our design, editing, packaging and presentation
Issue One – Nov. 3, 1999
Interim design guidelines

The Sun-Times redesign will aim to maximize Clarity, Consistency, and Creativity. More on that later. As we rapidly accelerate prototyping and move into next year, please take the following into account when working on all pages for the paper, whether live editions, advance sections or prototypes. The following guidelines will be in effect through the launch of the redesign in late winter or early spring, and may be revised or expanded at any point. Ultimately, all such guidelines will find a home in the paper's new stylebook. Any questions, suggestions, comments or concerns, talk with Ron Reason [assistant managing editor for design and photography].

"Art heads." For the most part, discouraged. Will appear on pages like Weekend Plus cover, Showcase, Travel, and Real Life cover, but use sparingly on daily pages. Any questions, ask Jim Wambold [director of art and pagination] or Ron Reason.

Silhouettes (cut-outs), faded edges, and mortises of photos. Silhouettes should be used with restraint, on pages where some real flair and the impact of an outlined image will draw the reader in. If you have questions about whether a silhouette is appropriate, ask Jim Wambold or Ron Reason. Only cut out photos that are sharp and which have dark, defined edges; do not cut out staff documentary photos; studio illustrations intended to be cut out should be shot on a white background.

The edges of photos should not be faded, unless the image is of an "old-time" nature that might actually have been faded over time. Example: photos used in 20th Century series. Use a standard 1 pt. Black rule around all photos.

Avoid mortises—overlapping one photo on top of another.

Headline type on photos. Restrict to Weekend Plus cover, Showcase and Travel, with conversation in advance. Never put any kind of type over a critical area of an image—always look for "appropriate space," i.e. solid tone portion of the background. Avoid using small type like captions or quotes inside photos.

Captions/credits. Place all captions underneath the photo; captions are flush left, credits are flush right, immediately under right corner of photo. Do not reverse captions into photos. Avoid "ganging up" captions for photo packages ("above, center, below, left," etc.).

Photo collages and illustration. Collages are discouraged; use sparingly. Currently they are too often used as a crutch when the "real art" fell through. Over time, we're working toward emphasizing excellent photojournalism, graphics and illustration that are direct and impactful; that doesn't mean collage will never be used as a storytelling device, but plan on this being the exception.

Never create or ask for a photo "illustration" that has even the slightest possibility of misleading the reader that it is an actual image—i.e. swapping

heads onto other people's bodies, or overlapping images in such a way that it appears that various people appeared in the photo as it was originally shot. Keep in mind that the reader does not understand computer photo composition in the way that we do, and takes all images on face value.

Toning photos. Newsroom design, editing and art staff should not tone photographic images, whether taken by staff or handout. All toning or adjustments for technical reasons will be done by the photo staff or production staff downstairs. Editors will be accountable for selecting and approving quality images in their original state; after being sent through the system, production staff will be accountable for making adjustments for optimum reproduction. This focus is critical as we aim for the best system to produce the best printing on our new presses.

Illustrations. We are working on ways to get more illustrations into the paper. The use of illustration should be considered, where appropriate, during prototyping. If you have an idea for an illustration, please talk to the art staff or Ron and we'll consider our options.

Notes

1. Even though mechanical devices are employed to produce digital images, the activities of image makers have become more visible since photo technicians have moved out of the darkroom and into the newsroom. Manipulations formerly obscured from scrutiny are now performed in full view of others on the computer screen. Even consumers can easily manipulate digital images on their home computers, performing operations once undertaken only by professionals or amateur devotees. Competitively priced digital cameras, image-processing software packages, and color printers are transforming photofinishing, and photo manipulation, into a domestic activity.

2. News writers once confronted a range of ethical issues that were different from those faced by their photojournalist colleagues. Whereas writers might be suspected of fabricating subjects or misquoting sources, photographers were virtually immune to such charges, even though conventional darkroom practices do make analogues of these ethical breaches possible. Only people devoid of personal or political interests and commitments and malicious or self-serving intentions can be assumed to produce objective reports. Codes and conventions governing reporters' practices evolved to ensure objectivity and enlist public trust; less explicit rules governed the work of photojournalists. Because mechanical devices "produce" photographic reports, images could evade suspicion. Now that digital imaging technology has foregrounded previously obscured production practices, new ethical questions have come to the fore, bringing the issues confronting word and picture reporters closer together. The hot-button issue that contemporary photojournalists confront is their credibility, supplanting questions regarding their conduct, intrusiveness, perseverance, or invasiveness. Perceptions of photography as predominantly mechanical served as an ethical prophylactic, shielding the medium from well-warranted critique.

References

Bessie, Simon Michael. 1938. *Jazz journalism: The story of the tabloid newspapers.* New York: E. P. Dutton.

Gernsheim, Helmut, and Alison Gernsheim. 1954. *Roger Fenton, photographer of the Crimean War.* London: Secker & Warburg.

Gessert, Sherman. 1991. The protocol story at the *Milwaukee Sentinel.* In *NPPA Photojournalism Ethics: Protocol,* presented at the annual convention of the National Press Photographers Association, Washington, D.C., July.

Hodges, Lou. 1991. The moral imperative for photojournalists. In *NPPA Photojournalism Ethics: Protocol,* presented at the annual convention of the National Press Photographers Association, Washington, D.C., July.

Long, John. 1989. Fakes, frauds and phonies. *News Photographer* 44, no. 11:13–14.

———. 2000. Personal communication, January 21.

Mitchell, William J. 1992. *The reconfigured eye: Visual truth in the post-photographic era.* Cambridge: MIT Press.

Newhall, Beaumont. 1982. *The history of photography:* 1839 *to the present.* New York: Museum of Modern Art.

Schwartz, Dona. 1999. Pictorial journalism: Photographs as facts. In *Pictures in the public sphere: Studies in photography, history and the press,* edited by Bonnie Brennen and Hanno Hardt. Champaign: University of Illinois Press.

Taft, Robert. 1938. *Photography and the American scene: A social history,* 1839–1889. New York: Dover.

Vitray, Laura, John Mills Jr., and Roscoe Ellard. 1939. *Pictorial journalism.* New York: McGraw-Hill.

News Norms and Emotions:
Pictures of Pain and Metaphors of Distress

Jessica M. Fishman

"The power of the news photograph is such that it brings difficult judgments for all of us," testifies longtime editor Harold Evans (1978, ii). The "power" attributed to certain images, as Evans notes, plays a key role in the filtering and framing of photojournalism. In this chapter, I focus on the rhetoric of U.S. news workers as they describe the symbolic power of photographs displaying the postmortem subject. As they and others attest, when death is publicly recorded in the pages of a newspaper, much is believed to be at stake.

Voices of outrage from readers and social commentators exhibit some of what is at stake. In an article titled "Dying on the Front Page," which appeared in the *Journal of Mass Media Ethics* in 1987, a concerned citizen expresses outrage at the distribution of death photographs such as the famous and widely circulated image from the 1970 Kent State student shootings in which a young woman kneels screaming beside a fatally shot young man. Arguing that death photographs are "exploitative," the author suggests that choices to publish photos of death spring from an unethical, profit-driven motive aimed at selling more editions of the news. The piece concludes, "There is simply no need and no excuse [to depict death]. After all, would you sell tickets to a

funeral?" (Wischmann 1987, 73). According to this claim, there is value in telling the story, but showing it should be condemned. Pictures, the author argues, violate society's sense of propriety in a way that words depicting the same subject cannot. This opinion, as we shall see, is widely shared.

According to many academics, critics, and even media insiders, photojournalism is dangerously fixated on death. According to Johanna Neuman, *USA Today* foreign editor and author, photojournalism has long endured an indecent fixation on death. This fixation, she attests, can be traced to the Civil War's battle of Antietam, one of photography's earliest combat missions. In her book *Lights, Camera, War* (1996), Neuman critiques the relationship between tragedy and pictorial exposure. She states that Antietam was "the first battle whose dead were photographed as they lay... as bloated, gouged, twisted grotesque figures in painful demise" (quoted in Hickey 1996, 56). The news media's overindulgence in sensational gore, she contends, has continued ever since.

Journalist Neil Hickey (1996) echoes Neuman's views as he testifies that such images "traditionally have attracted both print and electronic journalists like kids to a ballpark." He adds that the media are still insatiably attracted to "the prospect of mayhem, bombings, gun battles, mortar attacks, and civil strife" (54). Journalist Joe Holley (1996) asks fellow members of his trade if it is possible for those responsible for news coverage "to resist the allure of mayhem" (27). This question, crafted rhetorically, reveals Holley's conviction that they cannot.

Media scholar John Taylor (1991) argues that "editors demand impact or shock-value" (1) from photojournalism because "photographs of the dead carry... the heat of 'news'" (5). "Death [in the news] becomes a commodity," argues Taylor, "to stir the blood of the living, who for a few pence can contemplate the proof of others' mortality" (5). Photojournalists are said to serve a market that thrives on getting "'impactful' pictures fast and cheap" (Jobey 1996, 42). In the same vein, the authors of a trade account bemoan, "It is evident that [many photographs are] only used to gratify public demand for sensation and to make money for the publisher" (Vitray, Mills, and Ellard 1939/1973, 396). Such voices accuse news organizations of making death an indecent spectacle by routinely pandering to base interests. The censure, it should be stressed, clearly rests on the assumption that ghoulish images proliferate in news media.

However, as I discovered in conducting a systematic analysis of the past twenty years of American newspaper coverage, news photographs rarely reveal corpses (Fishman 2001). This holds true for both elite and popular papers.[1] The trend has carried into the digital age as well; on-line newspaper photojournalism continues to hide the postmortem subject. In both on-line and print contexts, headlines, story copy, and even photo captions repeatedly focus on fatal events, yet very few photographs reveal the corresponding body of evidence. Even though few photographs of this kind are published, many are professionally produced. For instance, news wire services make

photos of corpses available, often on a daily basis, to subscribers, who typically reject them.[2] The photo editors of newspapers tend to select photographs for publication that hide rather than transcribe the body.

In this chapter I examine a set of norms and ethics frequently articulated by print and on-line news workers when they were asked to consider the role of corpse photos in the press. Their accounts are drawn from a larger project in which I conducted semistructured interviews with twenty-one newspaper professionals—eight photojournalists, eleven photo editors, and two ombudsmen—employed by seven of the largest U.S. newspapers. On average, the interviews lasted approximately one and a half hours. All respondents gave me permission to tape-record the interviews. In addition to the formal interviews, twenty of the news professionals allowed me to shadow them for a day as they worked at their desks with images, conducted business over the phone, and convened meetings. The time I spent with them resulted in still more fruitful discussion about news norms and practices.[3] In the interviews, I took the role of the friendly skeptic. I informed the respondents that I was not interested in morally condemning the publication of death images by the press. All of them asked that I not publish their identities, so that they could be forthcoming about their work without fear of future repercussions, as media ethics is a hotly contested terrain. I use pseudonyms below.

Framing the Image

When news of death makes it to the headlines, accompanying photographs may place the corpse in the far distance, so as to render it essentially unrecognizable, or they may disguise the presence of the corpse by depicting the covered body. Other photos may displace the corpse by focusing instead on some related vision, such as the deceased when alive, damage to inanimate objects, or survivors. As photojournalistic practices repeatedly conceal and displace the corpse, death lies somewhere outside the camera's frame. Instead, it is the story, its headline, and even photo captions that duly report on the loss of life.

Marc Wilson, a staff photographer, offered an example of how, in many cases, publishing photos of the body bag serves as a means of displacing the corpse from photo coverage: "We've gone on stories where there has been a gang shooting where they have driven down the street and shot literally everyone who was walking down the sidewalk. There will be five or seven dead bodies lying in the middle of the sidewalk, cars have driven over them—it's been like a war zone." Wilson continued, "We'll stay there and cover it but . . . [we'll] wait until the coroners start bagging the bodies up." He added, "You know what will get published and it's [the photos of] the body bags, not the actual bodies." Other news workers shared similar stories about their efforts to hide the body. As a matter of routine, photo editor Paul Howe stressed, "you imply with the picture what is happening; you let the reader assume that this is what is happening without actually showing them what is happening."

In addition to concealing the corpse, staff photographers frame the corpse in the image's far distance—at a distance far enough to disguise the presence of death. For instance, when interviewing one photographer, I asked if police sometimes prevent photographers from getting close-up, tight shots. He replied, "Sometimes the police get to the scene first, they rope it off with yellow tape, keeping the press back. But we do have lenses powerful enough to shoot [the corpse] close in that we don't use." In other words, photographers refrain from using their equipment to zoom in for that revealing picture.

These practices of concealment and camouflage are exceptional in an industry where the success of a photojournalist often depends on his or her ability to capture a clear, intimate view of the subject. As the old industry saw goes, "If your pictures aren't good enough, you're not close enough." Photojournalists rely heavily on tele-photo lenses to get close-up shots when circumstances prevent them from standing close to their subjects. As a veteran photojournalist put it, "If you're forced to step back on a newspaper assignment, you just switch to a longer focal-length lens," generally referred to as a zoom or close-up lens, because it gives the effect of "zooming in" and positioning the subject within the immediate proximity of the viewer (Hagaman 1996, 30). In *The Associated Press Photojournalism Stylebook,* which is subtitled *The News Photographer's Bible,* Horton (1990) discusses the importance of "impact" and the need to eliminate competing compositional elements so that "the reader's eye won't be confused with the clutter" (41). He declares, "We've got to get in tight . . . to have a dominant foreground" (62–63). To underscore his point, he adds: "There is an easy way for photographers to improve the impact of pictures. It's the choice of the lens they use" (41).

Given these imperatives, the general tendency of photojournalists to remove or obscure the dead from the image highlights the strength of particular proscriptions shaping death's representation. As a result of such proscriptions, photojournalism frequently neglects its long-standing role as the "eyewitness" that lends sight to a remote public, allowing it to "bear witness." In this sense, photojournalists covering death take exemption from the standard practices of their profession, temporarily undoing their training to make the corpse essentially unreadable. In fact, photojournalists who fail to disguise or displace the dead in their coverage may jeopardize their success or even lose their careers. A photojournalist covering the death of Bill Cosby's son Ennis, for instance, was fired "for doing a tight shot of Ennis Cosby's dead body" (Brill 1999, 103).

Dangerous Spectacles

Photographs of death seem morbidly vulgar, unhealthy, or even pathological to many twentieth-century Americans (Ruby 1995, 1, 7, 52), and news workers are no exception. Reflecting this deep cultural anxiety, news workers describe the spectacle of the corpse, as mediated through the photographic image, as a sensitive encounter. Their

explanations commonly pivot around shared metaphorical discourses. In addition, the discussions reveal how the visual codes they employ structure news content while reflecting cultural beliefs about the symbolic power of the corpse.

When asked about the role corpse photojournalism plays in print and on-line news outlets, the news workers I interviewed consistently attested to a related set of norms, beliefs, and ethical mandates. Using metaphors of psychological and physical injury, they framed this image type as nonnewsworthy because of its presumably dangerous effects on viewers. They conceived of the corpse photo as a communicative ambush, wherein high-impact, injurious messages are instantaneously thrust upon a defenseless viewer. Specifically, they attributed to corpse photographs the power to assault an array of senses—not only the visual, but also the auditory and tactile. They described the corpse image as capable of inducing suffering through these various channels of perception.

Using these terms, the news workers explained how corpse photos should be recognized as pictures that induce shock and pain. They used well-defined rhetoric about sources of such sensation to import the structure of meaning from a familiar domain of understanding to an uncertain one in need of definition. As Lakoff and Johnson assert in the classic *Metaphors We Live By* (1980), metaphors work by mapping the unknown in the language of the known. In addition, metaphors collapse the original domain of experience with the one they organize, creating a new reality or interpretive structure that is tacitly understood and repeatedly invoked. In this case, the experience of viewing a corpse photograph is collapsed with the experience of being exposed to uncomfortable auditory or tactile stimuli. In the news workers' accounts of why corpse photojournalism is unprincipled, these metaphoric entailments informed the pathways of interpretation.

For example, photo editor Sam Cardwell made an analogy between exposure to death photos and the shock of being suddenly subject to an extremely loud sound that "blasts away" the unsuspecting. He described the experience of turning on a radio unfortunately preset to a painfully high level of volume and then suggested that photos can also have a variable amount of "volume." Because of widespread familiarity with the concept of decibel levels, his analogy is compelling. We understand that decibel levels calibrate a range of vibrations spanning from the inaudible to the shrill or the thundering sonic boom. Photojournalistic codes, Cardwell argued, should be used to moderate the level of "impact" the corpse has on those who are exposed to a picture of it. According to the entailments of the auditory metaphors used, the corpse needs to be silenced or muted. In turn, to do otherwise and give "voice" to the corpse is to engage in a tacitly depraved practice.

Cardwell began his discussion of industry "volume" preferences while viewing a selection of funeral images from the Columbine High School shootings in Littleton, Colorado. Each depicted scenes from the funeral of eighteen-year-old Isaiah Shoels, who was slain weeks before he was to graduate. Working with photos taken from the

Associated Press and Reuters wire services, Cardwell narrowed his choices down to nine photographs, one of which would be published in the next day's paper. "The series of pictures show how you can pick the level of volume," he instructed. He then described each photograph, explaining how he could allocate a volume level (ranging from one to ten, where ten is the loudest) to each image to indicate the level of impact it inflicted. He shared his thoughts regarding each of the photographs, starting with the ones he declared to have the "highest volume." As he did so, it became clear that the varying prominence and visibility of the corpse corresponded with the level of volume he assigned to each photograph.

Cardwell characterized the first photograph (Figure 3.1) as having the "most volume." Indeed, he assigned it a ten, the highest level of volume, and designated it the least likely candidate for publication in his paper. As Cardwell pointed out, the image reveals a relatively tight shot of a corpse in an open casket. This is a fairly simple and uncomplicated composition that directs the viewer's attention to death itself (and the painful social consequences demonstrated by the griever). In Cardwell's opinion, this unobstructed and intimate view of the corpse created a hazardous image and made publication ethically unscrupulous.

Cardwell then turned to consider a second image that he considered inappropriate because it framed the corpse in the same tightly cropped manner as in the first photo. He considered this image to be almost as "loud" as the first, assigning it a volume level of nine. It was thus ranked as having the second-highest level of volume—still far too high for him to consider it an appropriate choice for publication. As he explained, it had slightly less impact than the prior image because the pictorial elements were more complicated, and these additional elements helped divert some attention away from the corpse. To be specific, in the photo a classmate of the deceased stood emotionless beside the body while prominently holding a large white flower. As the editor reasoned, "The white flower is a nice touch" because it "breaks up" the focus on the body. The flower softened the impact of the corpse that was considered too poignant in Figure 3.1.

Next, he turned to discuss an image he rated as possessing a level of volume of seven. As Cardwell explained, he assigned this image (Figure 3.2) a somewhat lower level of volume because in it the body is placed at a further distance than is the case in the earlier images. The distanced corpse keeps the picture a little more "quiet" and less harmful to its viewers. Although he cited the distance between the body and the viewer as the key factor in determining the level of volume, Cardwell also noted that, unlike the mourner in Figure 3.1, the mourner in this photo shows no signs of grief. The presence of an emotionless bystander in an image, he added, further reduces the impact.

Proceeding toward the photographs with lower levels of volume, Cardwell described the next photograph (Figure 3.3) as having an approximate six, a high but not extremely high level of volume. As Cardwell noted, this image places the dead body

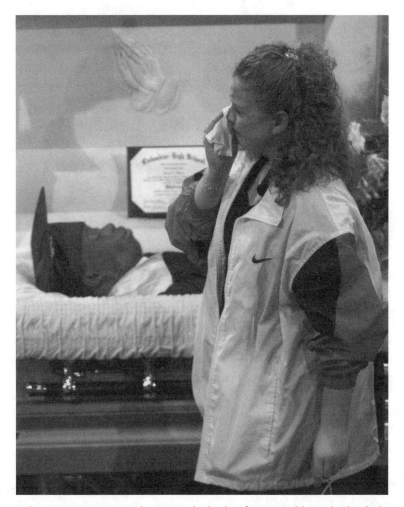

Figure 3.1. "A mourner weeps as she passes the body of 18-year-old Isaiah Shoels dressed in his graduation cap and gown at his funeral April 29. Shoels was due to graduate from Columbine High School but was killed in the shootings there last week." Original caption from Reuters. Photograph by Rick Wilking/Reuters.

"somewhat in the distance" and thus diminishes the volume. In addition, he explained that the living people shown in this image offer a competing point of focus that draws most attention away from the corpse. Most important, Cardwell stressed, is that the casket, along with the camera angle, obscures most of the corpse's face. This degree of concealment significantly reduces the volume emitted by this image.

Indeed, to reveal the dead body is to amplify the acoustic effect of the image. Concealment of the corpse, however, does not always solve the "problem." In fact, Cardwell also decided not to publish the image shown in Figure 3.4, even though in that photo the corpse is hidden. Although this photo does not denotatively reveal the corpse, it does place connotative emphasis on its presence. Cardwell characterized

Figure 3.2. "A mourner views the body of 18-year-old Isaiah Shoels." Original caption from Reuters. Photograph by Rick Wilking/Reuters.

this image as emitting a level of volume of six. He explained, "The volume here is medium-high because they're looking at the corpse." The depicted mourners and casket, along with the caption, inform us that a corpse is "right there and it's very palpable." Although the corpse is not visible, the tight focus takes the viewer close to the body. The resulting potent sense of the corpse's proximity, Cardwell explained, means that the picture is still a relatively noisy one.

As he evaluated a photograph depicting the parents of the deceased crying as they sit among the large crowd attending the funeral service (Figure 3.5), he attributed to it a "medium level of volume at about five." The level of volume is further reduced in this case because the corpse is not only visually displaced but connotatively distanced from the viewer. Cardwell still judged this image inappropriate for publication, but his reasons were unrelated to the presence or prominence of the corpse. On aesthetic grounds, he claimed, "it captures an awkward moment and the face in the background and the chair [in the foreground] is distracting, so it's less good than some of the other [photographs]." When an image includes a corpse, "distracting" elements help qualify it for publication. In contrast, according to this photo editor, when the camera focuses on living subjects, distracting elements detract from the value of the image.

Yet another photograph from the wire services depicts the parents seen in Figure 3.5 standing with an unidentified woman. The three appear visibly saddened as they stand close together, their arms and hands linked. Cardwell assigned this image, tightly cropped to show only the mourners, a level of volume of "about four or five." He described this image as having "a medium-high volume because again you see some grieving." Most important, however, "you don't see the deceased, which de-

Figure 3.3. "Vonda (C) and Michael Shoels (R) close the cover on the casket of their son." Original caption from Reuters. Photograph by Rick Wilking/Reuters.

Figure 3.4. "Michael Shoels, right, and Vonda Shoels, the parents of Columbine High School student Isaiah Shoels, view their son's casket." Original caption from Associated Press. Photograph by Michael S. Green/AP.

Figure 3.5. "Vonda and Michael Shoels weep after a video tribute to their son, 18-year-old Isaiah Shoels, at his funeral." Original caption from Reuters. Photograph by Rick Wilking/Reuters.

creases the hazardous volume" and, in turn, makes it a "more appropriate image for publication." The photo editor ultimately rejected this image for publication, explaining that although the mourners' intimate stances were "a nice touch, I don't like the fact that [one depicted] woman is unidentified."

One of the photos Cardwell found to be of lowest volume, at a level of about three or four, focuses on Colorado governor Bill Owens as he speaks at the funeral (Figure 3.6). "This has a low volume" explained Cardwell, "because the main focus of the image is on a living person, and not the victim noted in the caption." Although the casket is visible, a viewer cannot assess its contents; the corpse remains hidden away. In addition, as Cardwell noted, "the casket is fairly well camouflaged by an arrangement of flowers and low lighting." It recedes into the darker bottom half of the image, while the speaker stands in a well-lit section of the stage. The casket may "hint at the presence of death," but, as rendered in this image, its visual unobtrusiveness effectively muffles a "morbid" message.

According to Cardwell, the final picture he discussed qualified for publication because in it the corpse is effectively displaced (Figure 3.7). For this reason, he rated the image at a "low" level of volume, "around three." As he stressed, the "many things captured" in the photo made it preferable to those that focus on the corpse. In other words, contrary to most photojournalism aesthetics and the judgment he leveled against the image shown in Figure 3.5, Cardwell interpreted the competing composition in the photo he selected to be a positive attribute rather than a flaw. "Again," he noted, "it's turning down the knob on what sort of emotion the picture is going to

Figure 3.6. "Colorado Governor Bill Owens speaks at the funeral of 18-year-old Isaiah Shoels." Original caption from Reuters. Photograph by Jeff Mitchell/Reuters.

evoke, and how strongly." He also happened to be under the impression that this image does not depict a corpse. When I pointed out that the photo does (although it is made barely visible by its placement), he responded, "I didn't notice it. And, anyway, when it is reduced in size for news print you would never know [that it is there]." Essentially, Cardwell chose this photo for publication because it succeeds in concealing the corpse while still offering a visually indirect and subtle reference to the boy's death. The perspective provided by the image renders the corpse inaudible or effectively imperceptible. As Cardwell summarized, "This image has the least amount

Figure 3.7. "A capacity crowd of over 4,000 attend the funeral for 18-year-old Isaiah Shoels." Original caption from Reuters. Photograph by Rick Wilking/Reuters.

of volume" and is thus the only image suitable for publication. When Cardwell presented this image to the paper's other editors at one of the paper's daily meetings, he announced, "I should point out that while it is hard to notice, the body is in the photograph." Still, the other editors agreed it was appropriate for publication because the body is, in practical terms, visually eradicated.

Reflecting on the series of funeral photos he had organized according to level of volume, Cardwell noted that the body is first visible, then obscured, then enclosed by a casket, and then rendered unrecognizable in the distance. As Cardwell formulated, the progressive distance by which "we further remove ourselves from the dead body" reduces the auditory stimulus of the photo. In other words, he postulated an inversely correlated relationship between the level of noise communicated through a photo item and its newsworthy status.

Ordinarily, however, when we think of news norms, we think news content ought to be high in "volume" or impact. The more impact the better, insist textbooks such as *Opportunities in Photography* (Johnson and Schmidt 1979) and reference books such as *The Associated Press Photojournalism Stylebook* (Horton 1990). Important news events, it is believed, ought to be loudly and clearly communicated to the world. But when death becomes a news event, Cardwell suggests, photographs communicating about it should do so "quietly," so as not to be potently and painfully received.

News workers also describe the pain that corpse photos inflict by using metaphors of physical power. They describe the corpse image as one that employs direct force and "stops you dead in your tracks," "stuns," and "takes your breath away," as would a violent punch. As with the previous discussion of auditory assaults, this

rhetoric of brute force again frames the explicit death photograph as a violent agent. A number of the photo editors I interviewed demonstrated the violent force of these images for me by actually punching a fist into an open palm. For example, photo editor Stuart Singer directed my attention to the power with which his tightly closed fist slammed against his other hand to convey dramatically the destructive force of the corpse photo. He explained:

> s.s.: I chose not to approve [the wire corpse photo] because I thought it was too much. There is that line. [He pauses and punches his fist into his palm.]
>
> j.f.: What is the risk of doing too much?
>
> s.s.: We didn't need to go that extra step. [He pauses and again punches his fist into his palm.] We had the body bag [photo] and that was the level of impact we wanted to have. The picture of the body bag was a very high impact picture and that was as strong as we needed to go.

While pumping his fist in a punching motion, Singer told me that the corpse image would have delivered too much brute, physical "impact." Similarly, when photo editor Greg Levy faced a tough decision regarding Associated Press photos, he used the same language to explain the visceral effect death photography can have on the viewer. In contention were three photographs of the aftermath of a terrorist attack in Pakistan that left a number of Americans dead in a bullet-ridden car. These images provided a spectrum of death imagery in which two photos rendered the corpse up close and in detail and the third placed it at a distance with much of the body obscured. In a personal letter relaying the decision-making process, one of the paper's photo editors explained that they decided not to run the two clear depictions of death because they were "gratuitous" and "too gruesome." They decided to publish "a much more reasonable" alternative that "would not be hitting the readers over the head with a 2 × 4 (showing a very close-up shot of dead people)." The editor explained that with the selected image "there is a dead person visible in the car [but] it's much less prominent than the dead people pictured in the other photos." Like the other editor who spoke of intimate renderings of the corpse as a punch, this editor related the destructive power to a "2 by 4" plank of wood wielded against viewers. In both cases, the news workers imported metaphors of physical violence to illustrate their concern over publishing the corpse images.

News workers also attributed to corpse depictions the ability to "violently thrust the viewer" into an imagined "reality." "You are just there" even if "you don't want to go there," explained photographer Steve Watson. Stories about death "don't force you to visualize anything," but photographs of the corpse don't provide the viewer a choice: "Your sight is forced." Elaborating, he added: "When you read the headline you might not have a hurtful image in your mind. When you open the paper up and there is a dead person there, you haven't had a chance to decide if you don't want to

go there. You are just there." The photographic corpse does not allow readers the chance to decide if they wish to seek out imaginative proximity to the body. According to such testimony, the troubling vision uses brute force to thrust the viewer immediately into an unfavorable physical place inhabited by the corpse. Metaphors of violence now invoke the fear that viewers' senses of place and space will be fundamentally altered as they are transported, against their will, into sharing physical presence with the corpse.

Several of the news workers I interviewed shared this fear. For instance, Susan Zinter asserted that the corpse photo pushes viewers to the kind of deeply disturbing place where "you say, 'Oh my God, I don't want to be here.'" Similarly, photographer Dierdre Branley described the horror of a photo of a dead California county sheriff: "You can tell me that he was there, you can describe the scene, but I do not want to go there with him. In the photo you are *there with him*. You are there with the photographer looking down and you *don't* want to see it." The photograph of the corpse terrorizes by placing you "there with" the dead sheriff. Ideally, then, photographs of death make the body invisible or ethereal. Photographs that conceal or displace the corpse from view transform the violent bodily spectacle into an acorporeal representation that is, by contrast, controlled, tamed, and stripped of its aggressive power.

Conclusion

As I have discussed, the metaphors of brute force and auditory stimuli both describe the viewer's loss of control when encountering the corpse photo. Many news workers I interviewed, in turn, emphasized the importance of limiting death's measurable impact so that it is only vaguely heard or felt. Indeed, they argued that the death photograph must be carefully restricted and controlled because it has the power to affect the viewer in damaging and painful ways. As described, the potentially harmful force of corpse photography is of paramount concern among newspaper editors. Ombudsman Nancy Zelizer claimed that photographs of the body "stun like nothing else," as they "attack" and "torment," leaving the newspaper reader "helpless."

Repeatedly, these news workers summarily defined the publication of corpse photos as constituting various sorts of "torture." Such images purportedly attack viewers, who have not the time, space, or means to escape their ascribed cruelty. For example, photographer and editor Michael Tulman explained that photographs of corpses rarely accompany stories of death because "I don't think our job is to *torture* people."

Once defined as an instrument of "torture," the corpse photograph is ethically condemned for inducing traumatic pain and crippling individual agency by denying the reader choice and an opportunity to escape the pain. Indeed, the denial of a choice to avoid pain is quite the definition of victimization. And when the corpse photo is framed in these terms, it becomes the responsibility of the photographer or editor to protect the public from such images. As my respondents attest, images of

death can be shocking, impertinently and painfully so. In turn, these news workers reveal the origins of an editorial force to hide death.

As we have seen, the news workers interviewed transformed the conventional, authoritative power of the news photograph (as valuable visual "evidence" or "proof") into a largely transgressive power in the case of the corpse photo. As they struggled to frame what is "wrong" about distributing photos of the dead, they invoked metaphors of distress. Defining the photographic transgression, they asserted that the images hazardously assail viewers' auditory and tactile receptors. For the news workers, the corpse photo so powerfully provokes anxiety that discourses about injury and impairment become unavoidable. As we have seen, the rhetorics of emotion are deeply embedded in larger moral discourses that they dramatize (Illouz 1997; Lutz 1988; Rosaldo 1988).

Fear of the magical and dangerous image, it should be noted, is not a new phenomenon. Indeed, the problem is as old as the image itself (Mitchell 1994). For instance, anthropologists who have studied "primitive" societies have told us about fears that recording a person's image with a camera can steal a soul. In the postindustrial West, photographs are still often understood to transform us magically in unfortunate ways.

As demonstrated above, rhetoric about the dangerous image continues to thrive. Still today, "magical thinking pervades *our* treatment of pictures—although we may 'know' that the pictures we study are only flat, two-dimensional objects marked with colours and shapes" (Evans and Hall 1999, 17). In turn, I have followed Tagg's (1988) exhortation to consider the practices and institutions through which the photograph can "incite a phantasy, take on meaning, and exercise an effect" (4). The purported danger of the corpse photograph is, indeed, a cultural fantasy deserving interrogation.

In examining how news workers employ metaphors of distress, I have examined a set of conceptual frameworks used to classify these images as injurious and thus ethically suspect. News workers use these metaphors of distress to frame the problematic images in terms of a cognitive and cultural model with understandings that are shared and have motivational force. They direct ethical mandates and a guide for action. These metaphors, like all shared and durable metaphors, can "create . . . social realities" (Lakoff and Johnson 1980, 10). As Lakoff and Johnson discuss, metaphors inform the conceptual systems that frame the world we encounter and shape our understanding of it. Particular metaphors and the frames they support become shared and enduring because they strike "a responsive chord" that "rings true with extant beliefs, myths, and folktales" (Snow and Benford 1992, 141).

As media professionals, critics, and members of the general public have attested, pictures of the dead constitute largely dangerous spectacles that can injure onlookers, emotionally and physically. This is the "responsive chord" that reverberates with and shapes our understanding of which representations of death should be published. As I have discussed in this chapter, news workers, like others, may thus deny the corpse

photo legitimacy as a mode of public communication. Images that conceal or displace the corpse are therefore often preferred, because they connotatively communicate death through the body's absence rather than through its painful presence.

Notes

1. Contrary to conventional wisdom, I found that print and on-line versions of popular papers such as the *New York Post* actually publish fewer corpse photographs than do elite papers such as the *New York Times*. As a noteworthy aside pertinent to ethical considerations, I found that, although the reasons for this are multiple, a large part of the discrepancy can be attributed to prestige papers' willingness to document non-American corpses. That is, a high proportion of the corpse photos found in the prestige or elite press depict the "other," the foreigner, whereas the popular press is reluctant to showcase either "our" or "their" dead. Broadcast news programs on U.S. television also display foreign corpses much more frequently than they do the domestic dead. These are issues that I address at length in a forthcoming book tentatively titled *Death and Devastation: News Images of Tragedy.* In addition, see Fishman and Marvin (in press) for a discussion of prestige photojournalism as a practice with nationally stratifying visual codes that morally distinguish in-groups and out-groups. See also Fishman (2001) for qualitative and quantitative analyses of photojournalism in the prestige and popular presses and Taylor (1991, 1998) for a qualitative study of the British press that reaches both similar and different conclusions.

2. Wire editors claim it is their professional responsibility to document death even though newspaper editors rarely choose these images for publication. In addition to their stated reluctance to "manage the news," there is no economic incentive for wire services such as the Associated Press to stop providing gory images, given that newspapers do not pay by the photo. Rather, each member of a wire service's professional cooperative pays a yearly fee that is based primarily on the newspaper's circulation.

3. All of the subjects were extremely generous with their time and help, and I am grateful for their patience and willingness to evaluate the photojournalistic decision-making process diligently.

References

Brill, Steven. 1999. Curiosity vs. privacy. *Brill's Content,* October, 98–109, 127.

Evans, Harold. 1978. *Pictures on a page.* Belmont, Calif.: Wadsworth.

Evans, Jessica, and Stuart Hall. 1999. What is visual culture? Pp. 1–20 in *Visual culture: The reader,* edited by Jessica Cardwell and Stuart Hall. London: Sage.

Fishman, Jessica M. 2001. Documenting death: Photojournalism and spectacles of the morbid in the elite and tabloid press. Ph.D. diss., University of Pennsylvania.

Fishman, Jessica M., and Carolyn Marvin. In press. Violence in newspaper photographs as cues to group identity. *Journal of Communication.*

Hagaman, Dianne. 1996. *How I learned not to be a photojournalist.* Lexington: University Press of Kentucky.

Hickey, Neil. 1996. Over there. *Columbia Journalism Review,* November/December, 53–56.

Holley, Joe. 1996. Should the coverage fit the crime? *Columbia Journalism Review,* May/June, 27–32.

Horton, Brian. 1990. *The Associated Press photojournalism stylebook: The news photographer's bible.* Reading, Mass.: Addison-Wesley.

Illouz, Eva. 1997. *Consuming the romantic utopia: Love and the cultural contradictions of capitalism.* Berkeley: University of California Press.

Jobey, Liz. 1996. In the age of celebrity journalism. *New Statesman* 126, no. 4336:42–43.

Johnson, Bervin, and Fred Schmidt. 1979. *Opportunities in photography.* Skokie, Ill.: National Textbook.

Lakoff, George, and Mark Johnson. 1980. *Metaphors we live by.* Chicago: University of Chicago Press.

Lutz, Catherine A. 1988. Emotion, thought, and estrangement: Western discourses on feeling. Pp. 53–80 in *Unnatural emotions: Everyday sentiments on a Micronesian atoll and their challenge to Western theory,* edited by Catherine A. Lutz. Chicago: University of Chicago Press.

Mitchell, W. J. T. 1994. The pictorial turn. In *Picture theory: Essays on verbal and visual representations.* Chicago: University of Chicago Press.

Neuman, Johanna. 1996. *Lights, camera, war: Is media technology driving international politics?* New York: St. Martin's.

Rosaldo, Michelle Z. 1988. Toward an anthropology of self and feeling. Pp. 137–57 in *Culture theory: Essays on mind, self, and emotion,* edited by Richard A. Shweder and Robert A. LeVine. Cambridge: Cambridge University Press.

Ruby, Jay. 1985. *Secure the shadow: Death and photography in America.* Cambridge: MIT Press.

Snow, David A., and Robert D. Benford. 1992. Master frames and cycles of protest. Pp. 133–55 in *Frontiers in social movement theory,* edited by Aldon D. Morris and Carol McClurg Mueller. New Haven, Conn.: Yale University Press.

Tagg, John. 1988. *The burden of representation: Essays on photographies and histories.* Amherst: University of Massachusetts Press.

Taylor, John. 1991. *War photography: Realism in the British press.* New York: Routledge.

———. 1998. *Body horror: Photojournalism, catastrophe and war.* Manchester, Engl.: Manchester University Press.

Vitray, Laura, John Mills Jr., and Roscoe Ellard. 1973. *Pictorial journalism.* New York: Arno. (Original work published 1939)

Wischmann, Lesley. 1987. Dying on the front page: Kent State and the Pulitzer Prize. *Journal of Mass Media Ethics* 2, no. 2:67–74.

4

Instant Transmission:
Covering Columbine's Victims and Villains

Marguerite J. Moritz

On April 20, 1999, two students at Columbine High School in Littleton, Colorado, armed themselves, entered the school building, and killed twelve of their classmates and a teacher before taking their own lives. More than twenty others were wounded, and Columbine became the site of the worst school shooting incident in the nation. Because the event took several hours to play out, television crews and still photographers captured much of the action as it unfolded. A story of enormous proportions, Columbine generated thousands of images. In the first week after the shootings, ninety-six hours of national and local television news programming were devoted to the story. In the first year, Columbine was the subject of more than a thousand newspaper accounts in the Denver area alone (Gaeddert 2000).

The visual dimensions of the Columbine story are wide-ranging and instructive on a number of counts. The typical news images were dramatic and highly personal and involved underage victims. Many were broadcast live, distributed worldwide, and re-played countless times; eventually they became available on the Web. In addition,

surveillance cameras captured images of the gunmen and their victims inside the school, and the killers themselves recorded their plans on videotape, the last taping session taking place only hours before their rampage. Because of their widespread distribution (CNN and MSNBC began continuous coverage from the scene forty minutes after the first shots were fired) and disturbing content, the images of Columbine became the subject of intense debate among media professionals, school officials, community members, and victims of the crime.

Well before the first anniversary of the event, there was open hostility in the Columbine community toward the media. At various times, reporters and photographers were pelted with iceballs and verbally attacked. Some had their cars egged; in one case, a car was almost overturned. Editors began to caution news staff members not to risk their health and safety when assigned to stories in Littleton. And, in what may be a unique development, school officials held a "media summit" several weeks before the first anniversary of the story in an effort to shape the coverage of that day. Among their many demands: no repetition of images from the day of the shootings, no pictures of students with their hands in the air, of helicopters overhead, of yellow police tape, of wounded students. Dozens of journalists attended the summit, and the officials' demands were met with a surprising degree of compliance.

In the case study presented in this chapter, I examine the professional codes and practices of today's journalists, whose work has been dramatically altered by developments in the environment of digital news gathering and by the demands of 24/7 news coverage on the Internet as well as on cable television. The discussion is based primarily on interviews that I conducted with reporters, photographers, videographers, videotape editors, producers, and newspaper and photo editors from local and national news organizations in the year following the Columbine killings. In addition, school administrators and media professionals participated together in several round-table discussions, and these "Columbine détente" sessions became part of the data for this chapter.

Although many different viewpoints emerge, there is consensus on at least a few points: first, the ability to capture and distribute images is greatly enhanced by technologies that are increasingly available to professionals and nonprofessionals alike; second, the images in question have enormous emotional impact and can work as psychological triggering mechanisms weeks or months after an event; and third, precisely because of this, news audiences and news subjects are making increasing demands for media accountability and restraint in the use of such images, a position that media professionals in general understand and, in some cases, actually respect.

Day One: Live TV Coverage

The first images of the events at Columbine High School came from local television stations in Denver, which were alerted to the story early and moved on it quickly. The Denver television market is highly competitive, with three network affiliates

and the independent KWGN-TV all having significant news operations in the city. Because visual material often comes from video of spot news stories—fires, car chases, crimes, accidents, traffic stories—the stations have a number of routines in place to monitor police and fire activity. Assignment editors' desks are typically no more than a few feet from scanners that carry voice traffic of local law enforcement activities, and this is how most of the Denver newsrooms got their first hints that a story was breaking at Columbine.

At KUSA-TV, the NBC affiliate, assignment editor Scott McDonald picked up police scanner traffic about "a kid at a school with a gun" and alerted the newsroom shortly after 11:21 A.M.—when the first shots were fired (Dennis 2000). Almost immediately, phones started to ring as drivers and residents in the vicinity of Columbine called KUSA asking for information. Quickly it became clear that police cars, fire trucks, and ambulances were racing to the scene and that something was going on at the school. News director Patti Dennis began to deploy reporters and camera crews to suburban Littleton. Anchors Kyle Dyer and Gary Shapiro, who were preparing for the regularly scheduled noon newscast, rushed into the studio in case the decision was made to break into programming with a bulletin. By 11:30 A.M., Dyer and Shapiro were on the air with a map of Littleton and a "phoner" from a woman who had a line of sight to the school and was describing what she was seeing to the anchors. After that brief cut-in, KUSA-TV returned to local programming.

For more than two decades, microwave and satellite technologies have enabled television stations to carry live pictures from almost any location quickly, but not instantly. Reporters and crews need to travel to the scene, set up their cameras, and beam in their signals. In the case of Columbine High School, crews needed fifteen to twenty minutes of travel time alone. What enabled local Denver stations to get the Columbine story on the air so quickly and to gather enough information to keep the story going was conventional telephone and, more important, cell phone technology. CNN (1999) would later label Columbine "the first interactive siege on such a scale" precisely because so many students inside the school had cell phones from which they called Denver television stations to give eyewitness accounts of the crime "as it was executed."

In the case of KUSA, a second cut-in to regular programming followed quickly, this one with the public information officer of the Jefferson County Sheriff's Office, Steve Davis, who called in to the station on his cell phone while he was en route to the high school. Anchor Shapiro (2000) recalled the drama of that report, with Davis roaring down the highway, sounds of sirens all around him: "We asked him what was going on and he said that shots were fired and SWAT teams were responding. That was the first indication that this might be a huge story." The Davis cell phone call gave news managers the official confirmation they needed to stay with the story. Now the anchors were on the air with continuous coverage, all commercials canceled. Before noon, with the gunmen still terrorizing students inside the school, MSNBC

picked up the signal from its Denver affiliate and went live with the story. CNN also picked up the KUSA signal and rebroadcast it live to CNN audiences around the nation and eventually around the world. Contractual and technical connections make these kinds of decisions relatively common and simple for the networks, according to CNN's vice president of news planning, David Bernknopf (2000):

> We have affiliate relations with hundreds of stations. Denver is a market where we have multiple affiliates, not just one per city like NBC would have. When a story breaks, we can bring it up on a satellite or on fiber-optic lines and see what's happening. In this case, as soon as we saw what they were broadcasting, we took the signal live.

Now everything that KUSA did was being delivered to a national audience. But for news director Patti Dennis (2000), the primary concern was the local audience, particularly the parents of Columbine students:

> Being a parent, I put myself in that role. And I live in that community so it was very personal for me. I thought those parents need information and they need it fast. As much as we could give them. That was the most important thing in those first hours, helping 1,800 parents find 1,800 kids.

Much of KUSA's early information came from telephone callers, who typically provide the fastest, most direct descriptions from the scenes of breaking news situations. Calls came into the assignment desk in the main newsroom, where they were screened and selectively forwarded to the control room, the nerve center of the broadcast. Executive producer Dave Kaplar was in the control room almost from the start, helping the show's producer sort through the information that was coming in by phone. "The desk would call and say I have the hospital or I have the police," Kaplar (2000) recalled. The producers decided whom to put on the air and in what order, relaying their decisions through the earpieces worn by the anchors. "There's new information coming in all the time," recalled anchor Gary Shapiro (2000). "As the viewer is learning about what's going on with the story, we're learning what's going on with the story."

Among the many callers to the station were Columbine students, some of whom were already back in their homes after running from the school at the first indication of serious trouble. Other students, however, were trapped inside the school and were using their cell phones to call parents, police, and news stations, providing the first eyewitness accounts from inside the school. "It was," according to CNN (1999), "the first time television had featured an account from someone inside a school that was currently under siege."

One of the callers to KUSA, identified on the air by his first name only, reported that he was hiding inside a locked classroom as shots were being fired in the hallway outside. Videotape obtained from KUSA reveals the following exchange, which was broadcast live:

SHAPIRO: We want to go on the phone right now to James who is a student. James, we understand you are inside the school.

JAMES: Yes, I am.

SHAPIRO: And you're in a secure area, I imagine.

JAMES: Yeah, I'm in the classroom behind locked doors.

Kaplar had spoken with "James" several times before making the decision to put him on the air. He later explained:

> What he was saying seemed to be true because while he was saying he was hearing gunshots, our crews in the field were still hearing gunshots. He sounded very legitimate and he sounded scared. I think he was watching the coverage on TV and he just sort of repeated what he was hearing. (Kaplar 2000)

"James" was on the air three different times before KUSA reversed its decision to broadcast calls from students who were inside the school. Anchors who had earlier accepted these calls now started telling students to call police, not the newsroom. The next day, Kaplar tried to trace "James" through the information he had been given. He found that "there was no one registered at Columbine High School or at any Jeffco [Jefferson County] school by that name. That's when we kind of realized that we'd been gotten" (Kaplar 2000).

Because CNN was still carrying the KUSA signal, Bernknopf (2000) said, it was "gotten" as well by the hoax calls.

> There's always a risk when you take the local affiliate. You are in essence turning your editorial process over to them. You are entrusting your editorial judgment to them. In the case of the hoax calls, we have standards that we don't put anyone on the air until we call them back so we can be sure they are who they say they are and they are where they say they are. In this case, a hoax got on and we look just as bad as the local station. . . . People all over the world are seeing it.

According to Bernknopf, most hoax callers are merely trying to "get a laugh." Some are part of a network of Howard Stern listeners who lure in news anchors with dramatic details and then deliver a punch line invoking the name of their radio hero. Bernknopf observed, "These calls generally don't lead to anything bad, but they do make you look stupid." More than a mere embarrassment, broadcasting the hoax calls from "James" as well as the legitimate cell phone calls from students inside the school was a violation of ethics policies formulated by the Radio-Television News Directors Association for covering hostage situations. As long-standing members of RTNDA, the news managers at KUSA were in violation of policies they presumably endorse. The RTNDA policy statement, titled "Ethics: Covering Hostage Taking Crises, Police Raids, Prison Uprisings, Terrorist Actions" (1999), states the following:

In covering an ongoing crisis situation, journalists are advised to always assume that the hostage taker, gunman or terrorist has access to the reporting.... Seriously weigh the benefits to the public of what information might be given out versus what potential harm that information might cause. This is especially important in live reporting of an ongoing situation.

As KUSA general manager Roger Ogden (2000) noted in an interview, breaking stories put television news people under tremendous time pressures: "Your deadlines are every minute and you don't have the luxury of reflection. In the heat of the moment, mistakes are made." In the aftermath of the Columbine coverage, KUSA put in place more stringent requirements to verify the authenticity of live telephone calls, according to all of the news managers at the station (Ogden 2000; Dennis 2000; Kaplar 2000).

Images from the Scene

As a hostage drama, Columbine was unusual in that it took so long to unfold. In contrast to the news media response to the story, the Jefferson County Sheriff's Office was extremely cautious in its reaction. Most of the school's students had run from the building minutes after the first gunfire, but others were locked in classrooms, afraid to move. Sheriff's office SWAT teams waited outside the building for orders to enter. More than two hours elapsed between the first wave of gunfire and the SWAT teams' initiation of a systematic, room-by-room search of the building.

As a result, dozens of local television reporters and crews were showing viewers the story in progress, as it was actually playing out. Much like their viewers, television anchors, reporters, and news producers were unaware of what might happen next before their live cameras. What the cameras captured were stunning and dramatic images, many of them in close-up: students streaming from the school, their hands over their heads; paramedics rushing the wounded into ambulances; intensely emotional reunions of parents and children, siblings, and friends. There were live images from the high school; from the makeshift triage area on the lawns of nearby homes; from local hospitals, where the dead and wounded were being rushed; and from nearby Leewood Elementary School, where Columbine students were being reunited with their parents.

Reporter Kathy Walsh of KCNC-TV, Denver's CBS affiliate, was so overwhelmed by what she saw at the triage site that she broke down on the air. When Walsh arrived with her crew, close to a dozen wounded students were lying on the lawns of suburban houses, waiting for ambulances and paramedics. A hospice nurse who had been in a nearby home visiting a patient ran out to offer her help. *Denver Post* medical writer Ann Schrader (2000) later recalled that the nurse was "using her stethoscope as a tourniquet. People were tearing off their T-shirts and giving them to her and she was using them to stanch the blood. It was very, very raw stuff."

Walsh, a veteran reporter with more than two decades of television experience,

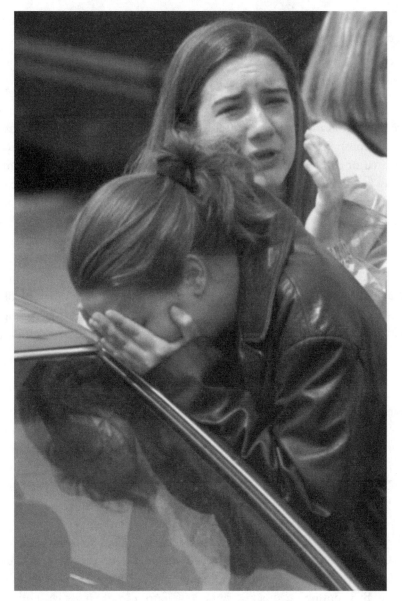

Figure 4.1. Still and video photographers had both the access and the technology to capture dramatic and personal photos that were then transmitted all over the world. Photograph by David Handschuh.

was preparing for her live shot as ambulances, medical personnel, and parents began rushing to the scene. Most of the wounded students had just been evacuated when Walsh's live report from the scene began.

WALSH: There were four or five students there and another two or three over there. One went up in a helicopter. The emotion was incredible. [She turns away from the

camera, breaking down in tears, and then turns back.] It's hard for a parent [her voice breaking] to see the parents.

ANCHOR: Kathy, take a moment for yourself. We're going to give Kathy Walsh a break from a very trying situation out there.

In addition to being broadcast live, the most dramatic and emotional images gathered by video cameras were also replayed heavily. Because TV stations are set up to simultaneously record all video feeds from the field, this material is then available to be edited or to be re-played instantly (the familiar instant replay of sports). At least three factors led to the intensive use of video replay on the first day of coverage. First, the audience for the story was building throughout the day: anchors had to assume well into the evening that many of their viewers were tuning in for the first time and therefore would want to see the images that had been gathered throughout the day. Second, stations opted to stay with Columbine to the exclusion of other news stories. As a result, repetition of video became a useful way to fill in those gaps where producers are waiting for new developments in the story. And finally, television is at its core a visual medium. Producers quickly learn to cover talking heads with videotaped images that often only generally refer to what the speaker is actually saying.

Helicopters, Long Lenses, and Steady Cams

In addition to their ground crews, Denver television stations and newspapers deployed helicopters to get aerial views of the scene at Columbine. Because of the development of internal stabilizing mechanisms and improved lens technology, television cameras—so-called steady cams—can now deliver clear, close-up shots from hundreds of feet away. As CNN's Bernknopf (2000) has observed, these technologies have contributed to one of the most significant changes in live television coverage in recent years. In the past, shots from choppers yielded wide, shaky pictures. As a result, they were used only briefly, usually to deliver overall establishing shots of news scenes. Close-ups were left to ground crews, who are often kept at a distance by police lines. Today, the technology is such that an aerial shot delivers a clear, stable view of a scene. By zooming in, an aerial camera operator can often get close-up shots in which facial features are easily identifiable.

The use of aerial shots had become a topic of public discussion and newsroom debate long before Columbine. A number of stations that had used choppers to show live pictures of police shootouts, highway chases, and public suicides had been widely criticized, but none so heavily as CNN in its coverage of the Ennis Cosby murder. The twenty-seven-year-old son of entertainer Bill Cosby was shot and killed in January 1997 as he stopped to change a tire on a Los Angeles freeway. He had been shot in the early morning hours, and KTLA-TV dispatched a helicopter and crew to get pictures of the scene as soon as the sun came up. The station did not broadcast

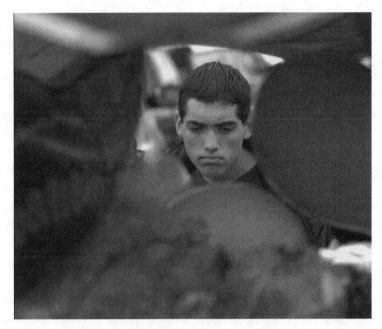

Figure 4.2. Today's powerful cameras can reveal facial features even in pictures taken from hundreds of feet away. Photograph by David Handschuh.

the images, but did provide CNN with the unedited videotape. Later that day, when CNN had confirmation that the victim was indeed Ennis Cosby, the cable network aired the video, which showed Cosby's Mercedes-Benz, its emergency lights still blinking. The camera then zoomed in for a close-up of the victim in a pool of blood. According to an Associated Press (1997) report:

> After CNN showed the scene at 2:02 p.m. EST, there was an "immediate, negative reaction" from CNN staff in the Atlanta newsroom and hundreds of calls of protest from the public.... CNN anchorwoman Bobbie Battista came on the air from a commercial break at 2:28 and said: "There was some tape that aired that showed a close up of Ennis Cosby, and it was inappropriate to air that. We apologize for that and to his family as well."

Because the CNN video carried the credit "Courtesy of KTLA," the Los Angeles station also received numerous complaints. That evening, the Reverend Jesse Jackson appeared on CNN's *Larry King Live* on behalf of the Cosby family. Jackson said the Cosbys were upset by the "grotesque" images of their son that CNN aired. Three days later, CNN News president Tom Johnson again publicly apologized for the images, saying a "serious mistake" was made and that if "any network is going to stay away from tabloid journalism . . . it must be and it will be CNN." Johnson said that CNN has policies against showing close-ups of bodies or graphic violence. (Earlier in the week, a CNN spokesperson had said the network had no precise rules for airing

such footage but rather makes judgments on a case-by-case basis.) Johnson announced that the producer who ordered that the Cosby footage be put on the air had been suspended (Bickley, 1997).

Despite this history, news organizations, including CNN, used graphic close-ups from cameras in helicopters in both live coverage and videotaped replays in the Columbine situation. One of the most vivid and detailed sequences began when Patrick Ireland, a student, suddenly appeared behind a shattered second-story window in the school building. He had been shot three times, and his right arm and leg were immobile. A live KMGH-TV (the ABC affiliate) camera shooting from a helicopter first captured Ireland as he flung his upper body over the jagged glass on the window ledge. As he inched himself out the window, KMGH cut back to coanchors in the studio. One anchor said, "I don't know if we can go back to that picture or not." The director immediately returned to the live picture. The camera zoomed in tight as Ireland dropped from the window. His blood-soaked foot smashed through the glass of a first-story window as he fell into the outstretched arms of police officers. Anchor Bertha Lynne, whose microphone was live, was heard gasping, and the shot again went back to the studio. Lynne, stunned, looked into the camera and shook her head in utter disbelief.

A still photo of another student, a picture that appeared on the front pages of newspapers around the country the next morning, was also an image captured by an aerial camera. The shot was taken by *Rocky Mountain News* photographer Rodolfo Gonzales, one of about a dozen *News* photographers on the scene, all of whom were later honored for their work with a Pulitzer Prize.

Gonzales had been assigned to shoot an indoor adventure/playground that day, and he was carrying a 400 mm lens. As the story broke, his pager went off and he read the message, "SHOOTING AT COLUMBINE HIGH SCHOOL. Plz call ASAP!" Thirty-five minutes later, Gonzales was in one of a half dozen news helicopters that were hovering over Columbine High School.

> As we joined other aircraft we kept pretty high as we circled the school in fear of drawing weapons fire or aggravating the scenario below....
>
> ...It took me a few seconds with the wind and camera shake from the helicopter before I spotted a group of kids huddled and hiding behind a car with a police officer's weapon drawn and pointing towards the school's entrance. As I tried to focus on the kids behind the car I saw a shape lying on the sidewalk. (Quoted in "Covering the War" 1999)

At first, he thought it was a student, but as the pilot repeatedly circled, Gonzalez began to think he was looking at "a bunch of book bags.... deep down, I was really hoping, no, praying it was anything else but a victim" (quoted in "Covering the War" 1999).

Gonzales's film was first reviewed by *News* photo editor Janet Reeves. When the bare negative was viewed on a light table, the image was so small that Reeves could

not see clearly what was in it. But when the image was brought up on a computer and enlarged, it revealed the body of a student lying lifeless on the sidewalk outside the school. Under normal circumstances, the *News* would not run an image of a dead body, Reeves (2000) said. She showed the picture to editor John Temple, who realized the image was disturbing but powerful. And even though it was shot from a helicopter, the facial features of the boy on the sidewalk were identifiable, a fact that added to the difficulty of running the photo. As Temple (2000) explained in an interview: "I knew as a parent myself that if that boy were my son I would know that it was him lying there. And I did not know if the parents would know that their son was dead or alive."

According to Reeves, a lengthy debate ensued as to whether to run the image: "So many things you hide from the public because they can't handle it, it's too graphic or it will upset the family, which was the number one concern by everyone." Reeves sided with Temple, who ultimately gave the order to run the picture in the *News* and to put it out on the wires.

> We needed to show people. We could not soften what had happened to the point where people didn't realize how terrifying the event was. We did not put it on page one, which some papers did around the country. We had a color spread for photos on pages 12 and 13. If you had already made it to 12 and 13, you knew what you were looking at and you needed to see the most, the best, images and that's where we ran it. (Temple 2000)

Reeves recalled that the editorial team left the building at 2:00 A.M. At 7:00 A.M., the parents of slain Columbine student Daniel Rohrbough contacted John Temple. "They had had no confirmation that their son was dead until they saw that photo. It wasn't bloody, but they saw his green shirt and they knew" (Reeves 2000). Said Temple (2000), "I think that says more about the police than it does about the newspaper." Indeed, Rohrbough's body remained on the sidewalk until his father went to the police and demanded that someone remove it. Gonzales has said that he has been haunted by the photos he took that day and deeply disturbed that his photography confirmed for these parents "their son's fate after what I can only imagine was an eternal night of not knowing" (quoted in "Covering the War" 1999).

As wrenching as the newspaper photo was, the most serious criticism of aerial shots was directed at live TV cameras from local Denver stations that repeatedly revealed the positions of SWAT teams, another direct violation of the RTNDA (1999) guidelines, which state, "Avoid describing with words or showing with still photography and video any information that could divulge the tactics or positions of SWAT team members." CNN is especially conscious of this directive because the network is so frequently the first place viewers, including hostage takers, turn for information during breaking stories. News managers acknowledge that revealing these kinds of details can "cost people their lives." In fact, in the aftermath of the Columbine coverage,

CNN reexamined its policies about carrying local signals and directed all producers to "cut out of a broadcast if we see police movement being covered," regardless of the magnitude of the story (Bernknopf 2000).

Live Shots, the Networks, and Teen Sources

The emergence of CNN in the 1980s and the success of cable television news across the United States permanently altered the news cycle and ultimately increased the competition for news audiences. Viewers no longer needed or were willing to wait for the 6:00 P.M. news to get details on a major story. In response, the broadcast networks began to interrupt their regular programming to cover major breaking stories. Heading these efforts, either from studios in New York or from the scenes themselves were their most potent news celebrities. As the coverage of Columbine clearly illustrates, these responses are now commonplace.

As dawn broke on April 21, 1999, helicopters were once again covering the airspace over Columbine. The media presence, already substantial on the first day, grew even larger, with representatives of national and international media arriving by the hundreds. As Denver reporters quickly found out, this would change the reporting dynamic for everyone involved. Reporter Carla Crowder was assigned to be outside the school at nearby Clement Park at 5:00 in the morning:

> This is when we thought the bodies of the victims would be coming out. This shows the naïveté of what we thought here at the *Rocky Mountain News*. My editor said I want you to be with some of the parents who didn't know what had happened to their children, whose children had not come home, and just stand there outside the school as these bodies are being carried out. Well, I get to the school and a huge area, hundreds of yards around the school, was completely cordoned off, and there were limos carrying Katie Couric and all the morning-show people, all the national media was there. It was complete chaos. It was a madhouse and it was 5:00 in the morning. (Crowder 2000)

Correspondent Vince Gonzales was sent to Littleton by CBS, whose contingent of fifty made it the smallest of the network teams. His reports were carried at various times during the day, but never on the evening news, because "they flew in the heavyweights, the people who have experience with events of this magnitude" (Gonzales 2000). According to Gonzales, CBS, NBC, and ABC all originated their national broadcasts from the scene for both professional and competitive reasons: "Anytime there is an event that's of national importance you're going to see Brokaw, Rather, and Jennings show up. Dan feels he can serve the public best by being there. Also, there's the competition. If everyone else is there, you have to be there."

The sheer number of reporters trying to get timely information from a relatively small group of sources immediately complicated matters. For the journalists, it meant an intensity of competition that typically worked to the advantage of the national

news organizations, especially the television networks. As veteran newspaperman Mike Patty (1999) said in an interview: "Journalism has now crossed the line with entertainment. In a TV era, a reporter with a pad and pencil is not so attractive. It's much easier to say no to me than to Barbara Walters." Crowder (2000) recalled: "You had hundreds of reporters relying on sixteen-year-olds. And then *Dateline* was sending them huge bouquets of flowers and promising college scholarships if these kids would talk."

Today we are clearly in the era of instant news. In every blockbuster story, most interviews—indeed, most of the television production process—are seen live and unedited, by millions of viewers. During a breaking story, the process of taping interviews, getting pictures, and researching background information and then selectively editing this material for a produced piece during the evening newscast is a thing of the past. According to ABC's Tom Foreman: "Reporting is now done on the air. You just get in front of the camera and tell what you know. That's your guiding light through a lot of ugly circumstances." NBC's Roger O'Neil (2000) has noted that Columbine proved to be a particularly difficult story to report in a live environment:

> You're dealing with adolescents and their emotions are in your face. To what degree do you interview them, take their pictures, and then broadcast them? They are almost saying anything. You have to balance what to use, what to hold, what to verify. And yet you are obligated to report what you hear as soon as you can, but you are taking the risk of reporting things that are not true. The trenchcoat mafia is a perfect example.... It was one of a number of things that proved to be wrong. The worst came from the sheriff who said there were twenty-five dead and everybody reported it. How could you not? It came from the sheriff.

It is standard practice at both morning and prime-time network news shows to secure interviews on an exclusive basis. For example, *Good Morning America* field producer Bill Cunningham (2000) will "typically ask for *GMA* first, and hopefully exclusively. We ask because we are competitive. We want to be first. It enhances our appeal. We want to be first and best." At Columbine, the push for exclusive interviews, exclusive details about the injured and the dead, was coupled with an aggressive effort to secure new and dramatic images to carry the story forward. "They really wanted to get images inside the school, and it wasn't just the tabloids," according to the Jefferson County schools' public information officer Rick Kaufman (1999). "A student was approached and offered ten thousand dollars to carry a camera inside the building because we had put the clamps on the media."

At the same time teen sources seemed to be everywhere, official sources were backing away from interviews. According to CBS's Vince Gonzales (2000), when the network reporters arrived, "a lot of doors closed because the local officials don't want to give Brokaw the wrong information." Beth DeFalco (2000), a student intern for the *Denver Post* during the events at Columbine, saw another problem: reporters attempt-

ing to make sense of a youth culture they did not fully understand. "They had so many people who were thirty and forty and trying to do these trend pieces about what kids are doing on the Internet and what a horrible game Doom was and half of my friends were playing it on the weekend."

At its height, 750 news organizations and 5,000 journalists and support staff were present in Littleton, including media from Japan, Britain, Germany, Italy, and Mexico. School officials were averaging a thousand phone calls a day from representatives of media around the world. In the Columbine community, journalists were everywhere, and the media coverage continued unabated. *Rocky Mountain News* reporter Karen Abbott (2000) later recalled, "We all looked like swarming insects trying to feast on this tragedy." In Littleton, resentment started to build. As CNN's Rusty Dornan (2000) has explained: "There is ambivalence. They want to talk to you, but then they turn around and claim they have been exploited by the media."

No Moment Too Private?

Thirteen funerals and a host of public memorials with thousands of people in attendance provided the kind of emotionally compelling visuals that carried the next phase of the story. But because the print medium uses images next to text, whereas television uses images with text, the visual contents of the two kinds of news products were strikingly different.

Words and pictures of parents, children, students, public officials, and clergy provided powerful material for television news. Many of these events were covered live, but video of them was also replayed, often in slow motion and set to music. Television news also used a technique in which the visual track from one video is edited to the audio track of another. KCNC-TV, for example, aired a five-minute montage called "Columbine Memorial," compiled by video journalist Bill Masure. The video chronicles the tragedy from its beginning through the community memorials, using images of students on stretchers, SWAT teams, ambulances, reunions of parents and children, flowers at the impromptu memorial wall—in short, the most dramatic visuals, all replayed in slow motion. The audio track is derived from interviews with students who were witnesses to the worst of the carnage and statements made by police, medical personnel, and local pastors, all set to the strains of violins. The overall impact is highly compelling and evocative.

Analog (linear) video editing to add slow motion, dissolves, and music tracks has been possible for a long time, but it is generally a complex and time-consuming matter. Today's digital editing systems, now in wide use in newsrooms, make the editing of videos to add such effects relatively easy and quick, which is essential when news workers are under intense deadline pressure. Indeed, the television coverage included slow-motion video on the very first day of the Columbine story, and reports continued to employ this effect frequently, particularly in the accounts of survivors and of victims' families, where the content was especially emotional. The television

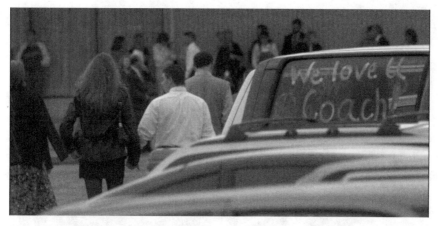

Figure 4.3. After extensive coverage of the shooting, the news media began to cover thirteen funerals. Editors at many news organizations said they agonized over the selection of images. Photograph by David Handschuh.

coverage also used filters and graphic effects such as posterization and solarization, although less frequently than slow motion. Posterization gives an image flatter colors, recreating the feel of an art print; solarization enhances color contrasts and intensifies light. Like slow motion, both effects remove a sense of realism from the image. For example, CNN used these two effects in a report titled "Generation Y," which discussed the alienation of youth culture. Through digital editing, images can also be brought into sharper focus, to reveal greater detail, or they can be obscured (in what has been called electronic censoring), so that, for example, facial features can no longer be detected. At television stations, all of the visual material gathered on a story is compiled into a readily available archive of imagery called a *file tape*. During the first two weeks of Columbine coverage, the television stations used their file tapes repeatedly.

Whereas television news outlets routinely replay video, combining file footage with each day's new material, newspapers typically demand new images each day. At the *Rocky Mountain News,* the process of selecting images to run each day with reporting on the Columbine story was both delicate and deliberate, according to editor John Temple (2000): "We had a huge table where every day the people involved, the DOP and the editors, would sit. . . . We'd have all the images, more than one hundred pictures. We wanted to avoid repetitious images because they are numbing. It was a careful selection." The case related below illustrates the selection process.

The *News* decided to devote a page of photos to each Columbine victim. Photo editor Janet Reeves (2000) explained in an interview, "On the day they were buried we tried to give each of them a page, a memory of who they were." During the funeral for Kelly Fleming, a *News* photographer was allowed in the church. "He was discreetly in the corner and he had a number of very strong images, but one ripped

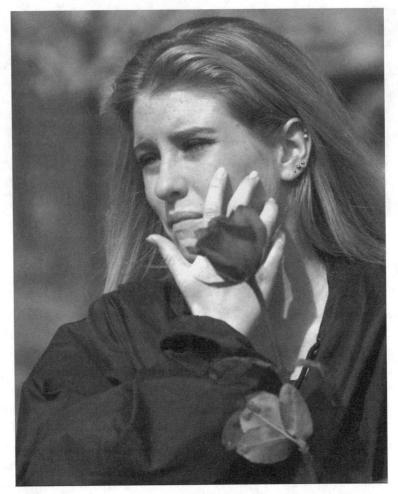

Figure 4.4. Initially, students seemed eager to tell their stories, but as weeks and months passed, many said they wanted the media to leave them alone. Photograph by David Handschuh.

your heart out. It was a picture of Kelly's sister, who looked very much like her, and as the casket was being closed, her parents were holding her up and you could almost hear the cry that came from her. It was a tremendous image."

As Reeves and another editor were debating whether to use the image, Temple came in and saw them both in tears. They asked him for an opinion: Was the image too personal? "Judging from the looks of you two," Temple told them, "I'd say yes." They opted not to run the picture, Reeves recalled. "If the family wanted to save this page as a memorial, was that the image they would want to look at the next morning and for the rest of their lives?" Reeves chose a photo taken from behind the parents and their surviving daughter as they walked out of the church behind the casket. In the end, some moments were deemed too private for public consumption.

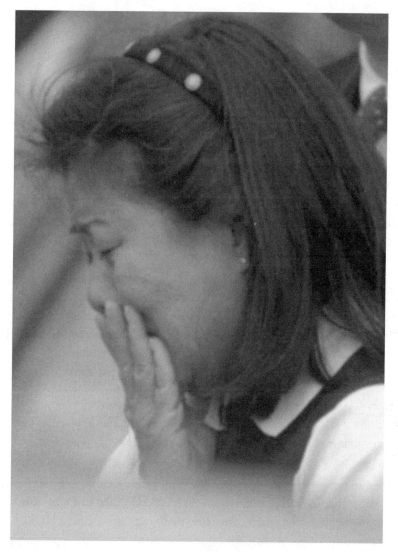

Figure 4.5. Critics said news reporters and photographers were invasive and deprived the community of any sense of privacy. Photograph by David Handschuh.

Newspaper coverage was also relentless. Many of the television network crews packed up and moved on after the second week. Those that remained left on May 3, when devastating tornadoes claimed forty-four lives in Oklahoma. After that, local television "backed off very quickly," according to Rick Kaufman (2000). "They had seen through ratings that they had saturated the story." Indeed, when Columbine students arrived at nearby Chatfield High School, where they were to finish out the semester, Denver television stations agreed to pool coverage as a way of keeping the media presence in check. KUSA-TV went even further, opting not to show any video of the event at all. Said news director Patti Dennis (2000): "We made the decision

based on feedback from the field. Going into Chatfield was stressful enough. If nothing happened, then that wasn't really news. We mentioned it in the news, but we decided that there was not a lot of benefit to viewers to us being there, but there was a lot of benefit to leaving [the students] alone."

Meantime, the *Denver Post* and the *News,* locked in an intense circulation war, "kept the story alive," according to Kaufman (1999). "We wanted to move on, but each story would take us back to April 20th. We were made to relive that horrible day over and over and over again." Writing in *Brill's Content,* Jessica Seigel (1999) agreed, saying, "As preachy advice and aftermath reporting continued unabated, the media wore out its welcome—perhaps an inevitable ending in an era when people's emotions are commodities for round the clock news" (85). Local reporters themselves began to question the intensity of their coverage. The *Post's* Trish Callahan (2000) recalled, "Because of the newspaper war and competition even with national papers, we wrote about every little development to the point where people just got weary." For weeks after the event, Denver's daily newspapers continued to generate daily front-page headlines on various aspects of the events at Columbine, including pieces on gun control, youth violence, and youth alienation—all legitimate, significant debates that emerged following the school shootings. Nonetheless, the overall impact in the community of seeing so many headlines was often negative. According to Carla Crowder (2000), a reporter at the *News,* when the national press went home, the local papers pursued "in-depth follow up stories, reinterviewing kids, knocking on doors. That's when the resentment really came across."

Surveillance Cameras, Home Movies, and a Training Tape

Added to the news coverage was a disturbing array of videotaped images that came from other sources: the school, the gunmen, and the local fire department. All of these illustrate the increasing prevalence of the use of video cameras in both public and private settings. Today, many amateur photographers are familiar with creating and manipulating video, adding sound tracks, employing close-ups, and generally emulating Hollywood production techniques. And journalists are increasingly likely to seek out the images created by such amateurs as a way of extending their own reportage. When made public, each of the additional tapes connected to the Columbine shootings became the subject of news stories, thus aggravating the already tense relationship between the news media and the community.

The school's videotapes came from four surveillance cameras that were permanently installed in the cafeteria. The Jefferson County Sheriff's Department had released the tapes to a variety of law enforcement agencies for use in training sessions, one of which was held in October 1999 at an emergency workers seminar in New Mexico. A television reporter from KRQE-TV (the CBS affiliate in Albuquerque) was in attendance and videotaped the footage as it was presented at the seminar on a large projection screen. That evening, KRQE aired the Columbine surveillance video.

The station also made the tape available to CBS in New York, which aired it on the *CBS Evening News* (Associated Press 1999).

There is no sound on the tape, but the visuals—edited down to moments of intense activity—are disturbing. Students are seen eating their lunches in the cafeteria when a bomb explodes. Some then take cover under tables, while others run out of the room. Minutes later, three men, who have been identified as maintenance workers, run through the cafeteria and apparently warn students about the ongoing attack in the school. Still later, the gunmen, Dylan Klebold and Eric Harris, enter the lunchroom. Harris, in a white T-shirt, carries a rifle; Klebold, in a black T-shirt and backward baseball cap, carries a semiautomatic weapon. At one point on the tape, Harris is seen resting the barrel of his rifle on a railing and pointing it into the lunchroom.

When the video aired on the CBS national news, parents and school officials expressed outrage and asked Denver television stations not to air the footage. KUSA-TV general manager Roger Ogden (2000) later said his station agreed to honor the request because "we did not think it advanced the story." But the Denver stations also knew (at one point KUSA was getting three to five hundred e-mails a day on the topic) that their local audience was growing increasingly critical of the media's treatment of the Columbine story and of the sensational visuals that emerged from that coverage. In other local markets, however, some stations did air the tape.

In June 2000, the school's surveillance tapes were released to the public, the result of a court order in favor of ten Columbine families who had sought the material under the Colorado open records law. At the same time, the judge ordered released the tapes of calls to 911 on the day of the shootings. The surveillance tapes, the 911 dispatches, and Jefferson County's official report were all made available for purchase on the Web. A $60 fee covers the cost of a two–CD-ROM set of the report, the 911 calls, photos of the scene, and two videotapes containing the unedited surveillance footage.

More detailed images of Klebold and Harris emerged through a series of videotapes they made of themselves. These were made public through a cover story in *Time* magazine. The tapes had been confiscated in a search of the gunmen's homes and held as evidence by the Sheriff's Department. In December 1999, the department agreed to show the tapes to *Time* reporters, who then wrote an extensive report describing in detail the "five secret videos [Klebold and Harris] recorded before the massacre, [where] the killers reveal their hatreds and their lust for fame" (Gibbs and Roche 1999). In the cover story, the reporters called the tapes "almost unbearable to watch" because of the cool dispatch with which the gunmen look into the lens of their home video camera and describe their dream of killing "250 of you." When the story hit the newsstands just days before Christmas, there was again community outrage in Denver, and yet another lawsuit was brought (as yet unresolved) to prevent the videos from becoming available to the public.

Another tape, this one shot by a Littleton firefighter "on his own time using his own equipment," was made public in April 2000, a week after the first anniversary of

the Columbine shootings. The footage was taken the day after the shootings, as Little-ton law enforcement personnel went through the school, room by room. The video, which was made for training purposes, does not show bodies, but it does reveal pools of blood on the carpet and desks, shattered windows, demolished computers, and numbered cards marking the places where bodies had been found. It also includes ae-rial footage taken by news cameras of murdered students lying outside the school and of wounded students being evacuated. In what many consider a bizarre twist, the en-tire tape is set to music—an unauthorized sound track of songs by recording artists Sarah McLachlan and Cheryl Wheeler. The tape had been used at eighty-two train-ing seminars in the United States and Canada before it became the subject of news coverage. Again the community expressed shock and indignation. Said the Associ-ated Press: "To the horror of Columbine victims' families, authorities released video-tapes that offer the public the first glimpse of the high school's library" a day after ten students were gunned down there (Banda 2000).

This time, the Sheriff's Office did not wait for a court challenge; it simply made the three-hour tape available to the public for $25. Shortly after, attorneys for McLach-lan and Wheeler pointed out that the video's producers had never been granted per-mission to use their clients' songs. They demanded and got the audio track removed. Today, excerpts from the tape are also available on the Internet (for example, at www.thedailycamera.com/shooting/27achs.html).

The Media Summit

Hostility toward the media in Littleton reached a boiling point in February 2000, when two Columbine students were shot and killed at a neighborhood Subway sand-wich shop. Because of the Columbine connection, the national press returned to the community, this time to the jeers of students and adults who no longer wanted their neighborhood to be in the spotlight. The situation was so tense that some reporters feared for their safety. Editors told staff members to avoid provoking people, even if that meant leaving the scene of the story. Against this backdrop, news organizations began planning their coverage of the first anniversary of the high school shootings. At the *Denver Post,* several reporters insisted that the paper's approach should be subdued. One reporter thought the paper should not cover the anniversary at all. The *News* staff offered similar perspectives. "Maybe some people are really clamoring for this, but everyone I've talked to, everyone, you say Columbine and their eyes glaze over. They feel it's all repetitive and there is nothing new or insightful to say" (Crowder 2000).

As news organizations struggled with this new dilemma, Littleton's school district was developing its own plan for April 20, 2000. One month before the anniversary, district officials took the unusual, perhaps unprecedented, step of calling on repre-sentatives of local and national news media to attend a "summit" to discuss some ground rules. Scores of local and national journalists showed up. Also on hand were

students, administrators, counselors, psychologists, and victims' families. Their key point: any retelling of the Columbine story and replaying of its images by the media would be emotionally devastating to the community. School administrator Sally Blanchard (2000) urged journalists to "choose your words and images wisely so people are not retraumatized. Seeing those images is gut-wrenching for parents, especially for parents whose kids were injured. The more you see them, that's what you then start to see in your mind's eye." The students expressed a "strong request" that the media have only limited access to the school and to their planned memorial services. Psychologists at the summit cited research that has demonstrated that TV images can act as triggers, bringing people back to moments of trauma. They advised the media to avoid replaying shots of running students, wounded students, ambulances, SWAT teams, and yellow police tape as well as the sounds of helicopters overhead.

Sue Petrone, mother of slain student Daniel Rohrbough, asked the media to refrain from using any footage from the first day's coverage of the shootings while covering the anniversary. She said she was speaking for all of the families who lost children in also requesting that the media not show any images "of the two individuals who shattered our lives." In an interview conducted in early April 2000, reporter Trish Callahan said that in a year of covering Columbine she had become very aware of the antipathy toward Klebold and Harris: "Parents call them 'the gunmen.' There's a sense that everyone knows the names Eric Harris and Dylan Klebold but they don't know the names of the students who were killed."

Representatives of the local television stations at the summit said that they had already removed most of the problematic images from circulation and would not reinstate them on the anniversary. The network journalists were not as easily persuaded. In an interview conducted on the anniversary of the shootings, NBC Denver bureau chief Roger O'Neil (2000) said: "We are cognizant of their feelings. Certainly, pictures of students walking by a dead body will not be used." The network, however, would not honor the community's request that it avoid using any images from April 20, 1999. *Good Morning America*'s Bill Cunningham (2000) said that ABC could not agree to the request: "I don't know how to tell the story one year later without the images. It would be impossible." CNN's Rusty Dornan (2000) said the situation was problematic for journalistic reasons: "They have set quite a precedent in a way. Instructing us on what we are going to do. But would you not air the Zapruder film?"

CNN management issued a memo prior to the anniversary coverage instructing executive producers to refrain from showing close-ups of dead bodies and to hold back the most disturbing video. "We listened and we discussed it a lot," said CNN vice president David Bernknopf (2000). "As for the names, I understand why that bothers people who lost children. But how can you tell the story without telling the names? It doesn't make sense to me. If you made the decision that you are going to do the anniversary story, you have to mention the people who caused the heartache."

"Ultimately," he said, "a news organization cannot turn over news decisions to the people they are covering."

Conclusion

When CNN launched a twenty-four-hour news network in 1980, it created a revolution in the consumption patterns of news. The addition of MSNBC, CNBC, and Fox News Channel to the cable choices, and the emergence of the Internet, further solidified audiences' expectations that major news stories are covered live. In the last decade of the twentieth century, major stories—starting with the Gulf War and ending with the Columbine shootings—resulted in distinct ratings spikes. And although breaking stories also mean unprecedented numbers of hits on news Web sites, television still dominates the news landscape, and television is a visual medium. As the Columbine case demonstrates, the news-gathering process changes dramatically in the case of live coverage. The usual routine of accumulating and verifying information no longer takes place behind the scenes. Instead, viewers see the news process unfold before them. As CNN's Bernknopf (2000) has observed: "The first interviews are getting on right away. The time to check things out has shrunk to nothing."

In this setting, both accuracy and control are sacrificed for speed of delivery. Television news programs air interviews without first verifying their content; they air images without prior screening. On television, news is delivered before journalists have the opportunity for reflection or filtering, a practice whose drawbacks again became painfully obvious during the 2000 presidential election coverage. At least with respect to major breaking stories, we have indeed witnessed the transformation of the nature of news presentation. It began with the arrival of cable television news, and it has only accelerated with the increasing availability of the Internet, cell phones, digital cameras, communication satellites, and fiber-optic cables. As communication technologies become even more ubiquitous and more user-friendly, viewers can expect that not only cell phone calls but amateur video images will continue to become part of the public record, and Web broadcasts promise to make them harder to screen or limit.

The Columbine case also illustrates another fact of contemporary journalistic practice: the definition of a major story is often determined by audience appeal as much as by news value. The coverage of the murder of JonBenet Ramsey is the most obvious example of this fact. As with the JonBenet story, television provided saturation coverage of Columbine for days and weeks after the initial tragedy. As a blockbuster story, it meant a huge media presence in Littleton that included the nation's most prominent journalists. The continual repetition of images on television, the steady stream of newspaper headlines—in short, the intense media focus—eventually created a backlash in the community. But in this instance, the news subjects made their complaints known through a public relations initiative that at the very least added to a widespread dialogue in newsrooms around the country about the appropriateness of the very standards that journalists so typically apply.

References

Abbott, Karen. 2000. Interview by author. Offices of the *Rocky Mountain News,* Denver, April 19.

Associated Press. 1997. CNN apologizes for airing graphic video of Cosby son. January 17.

———. 1999. Television stations broadcast Columbine school tape. October 13.

Banda, P. Solomon. 2000. Authorities release Columbine footage. Associated Press, April 27.

Bernknopf, David. 2000. Interview by author. University of Colorado at Boulder, October 19.

Bickley, Claire. 1997. CNN suspends producer over Cosby case. *Toronto Sun,* January 21.

Blanchard, Sally. 2000. Interview by author. Offices of the Jefferson County (Colo.) School District, March 24.

Callahan, Trish. 2000. Interview by author. Offices of the *Denver Post,* April 4.

CNN. 1999. Cell phones bring new angle to Colorado shootings. April 21. On-line at www.cnn.com/us/9904/21/school.shooting.media/.

Covering the war at home: The Colorado tragedy: The shooting. 1999. May. On-line at http://www.digitaljournalist.org/issue9905/shooting01.htm.

Crowder, Carla. 2000. Interview by author. Offices of the *Rocky Mountain News,* Denver, April 19.

Cunningham, Bill. 2000. Interview by author. Denver, March 23.

DeFalco, Beth. 2000. Interview by author. University of Colorado at Boulder, February 16.

Dennis, Patti. 2000. Interview by author. Offices of KUSA-TV, Denver, March 21.

Dornan, Rusty. 2000. Interview by author. Denver, April 20.

Foreman, Tom. 2000. Interview by author. Denver, April 20.

Gaeddert, Elizabeth. 2000. Database of Columbine newspaper articles.

Gibbs, Nancy, and Timothy Roche. 1999. The Columbine tapes. *Time,* December 20.

Gonzales, Vince. 2000. Interview by author. University of Colorado at Boulder, September 22.

Kaplar, Dave. 2000. Interview by author. Offices of KUSA-TV, Denver, March 21.

Kaufman, Rick. 2000. Interview by author. Offices of the Jefferson County (Colo.) School District, March 24.

Ogden, Roger. 2000. Interview by author. Offices of KUSA-TV, Denver, March 1.

O'Neil, Roger. 2000. Interview by author. Denver, April 20.

Patty, Mike. 1999. Interview by author. Denver, October 10.

Radio-Television News Directors Association. 1999. Ethics: Covering hostage taking crises, police raids, prison uprisings, terrorist actions. July. On-line at http://www.rtnda.org/ethics/crisis.shtml.

Reeves, Janet. 2000. Interview by author. Offices of the *Denver Rocky Mountain News,* April 19.

Schrader, Ann. 2000. Interview by author. Offices of the *Denver Post,* March 1.

Seigel, Jessica. 1999. Hugging the spotlight. *Brill's Content,* July/August, 80–85.

Shapiro, Gary. 2000. Interview by author. Offices of KUSA-TV, Denver, March 21.

Temple, John. 2000. Interview by author. Offices of the *Denver Rocky Mountain News,* April 19.

Privacy and Spectacle: The Reversible Panopticon and Media-Saturated Society

Larry Gross

We're Soaking in It

We are a society saturated by one of the most powerful attractions known to our species: entertainment. All human societies have created, shared, and consumed with pleasure the symbolic products we can collectively call *culture* or *the arts* (without entering into the issues of class bias often implied by the use of these terms to cover only a portion of their legitimate territory). The very processes through which all human societies create and maintain themselves are those of storytelling in a variety of symbolic modes: verbal, visual, and musical. The powerful forces that are contained within and unleashed through stories, songs, dances, and objects were created by and used in the interests of group members (which is not to claim that all group members had the same interests). What we call *religion* can label many of the institutional contexts in which members of societies (in groups or individually) consumed the symbolic products of their cultures. These were the shared rituals that cultivated their common worldview, explained the way things were, and thus underwrote their moral codes.

In an environment where "luxuries" and "necessities" were created out of the same pool of available labor, and where stable roles and institutions governed the allocation of time, effort, and pleasures (where the new is inherently suspect and the traditional inherently valued), the distribution of cultural pleasures was largely determined by the collectivity's own creative resources and the dictates of its symbolic codes. Industrialization and, in particular, the nineteenth-century invention of mass production and marketing brought about a fundamental change that societies were not prepared to resist.

The history of human societies in the past few centuries gives ample evidence of the destructive attractiveness of substances for which cultural defenses have not evolved. It is precisely in this sense that Western cultures—and, later on, peoples around the world—proved to have little resistance to the flood of industrially produced entertainment that resulted from the image and sound technologies developed in the late nineteenth and the twentieth centuries.

For the vast majority of humanity's history, the stories that humans heard and watched and sang along with were stories being told by members of their own immediate communities, with whom they shared the basic conditions of life, or by people mingling in town markets and traveling along limited trade routes. The industrial era changed the very means of cultural production to such a degree that people around the globe now find themselves surrounded by the products of corporate entities with which they have nothing whatever in common and whose motives, as mass marketers, are not likely to include their autonomy or well-being.

The revolution that began with the invention of the printing press and accelerated with the advent of industrialized mass production also gave rise to the competition for consumer attention that has placed advertising at the center of the global economy. In the age of commercialized media and the industrial production of cultural forms, we are constantly confronted with the temptations of entertainment because somewhere, someone wants to sell us something. The new technologies of the Internet have greatly increased advertisers' ability to divide us into demographic market niches, the better to tailor the messages that will attract our attention and deliver our consumer dollars to their corporate sponsors.

Marshall McLuhan's familiar claim that we live in a "global village" was both insightful and deceptive: he accurately pointed to the homogenization and sharing of common messages that mass media have brought about, but he falsely equated the sharing of received messages with the mutual interaction and regulation that are characteristic of authentic community. In stark contrast to the lives of people in preindustrial societies, in which the culture consumed is almost entirely dependent on what members can produce, we in the industrialized world now are faced with endless competing choices, twenty-four hours a day, on multiple channels of sound and image. Some numbers:

- In 1909, 27 million phonograph records were produced in the United States; in 1983, 578 million were made. In 1996, the music recording industry sold just over a billion albums, and ten- to thirty-four-year olds accounted for about 65 percent of these purchases (Gitlin 1990, 38).
- From the 1930s through 1950, a radio was played for more than 4 hours each day in the average household. After a post-TV falloff, radio listening was back to 3.25 hours by 1981. In 1997, there were more than 12,000 radio stations in the United States (most, however, owned by a small number of major media corporations) (Gitlin 1990, 38).
- Average weekly movie attendance in the United States in the mid-1930s was 2.57 films per household. In the late 1990s, about 420 movies appeared on the screens of more than 25,000 theaters, and Americans bought about 1.3 billion movie tickets per year; nearly half of these were sold to twelve- to twenty-nine-year-olds, who represent about 30 percent of the population (Gitlin 1990, 38).
- Daily television viewing per household has risen steadily, from 4.5 hours in 1950, when only few had TVs, to more than 7 hours since the early 1980s, by which time nearly every household had at least one. By 1986, 57 percent of U.S. households had two or more television sets; in 1999, 64 percent of American teenagers had TV sets in their bedrooms (Gitlin 1990, 38; Roberts et al. 1999, 9, table 1).
- Of course, when we watch TV we are watching more than programs: the average TV viewer sees more than 38,000 ads every year (Dr. Tom Robinson, cited in *Broadcast News,* June 14, 2001).
- Finally, the Internet's virtual global village, in which words, images, and sound can be instantly accessed by millions of people around the world, is well on its way toward commercialization.

Remember: this endless cornucopia is not there because anyone asked for particular images, songs, or stories, but because someone, somewhere, has a commercial motive. Profit-focused entities want to tempt us to buy their products or attract our attention so that they can sell us as audience members to someone else with something to sell.

Star Images: The Rhetoric of Authenticity

Celebrity was not invented by the modern mass media—in earlier times, of course, fame and notoriety attached to such disparate figures as Lord Byron, Jenny Lind, Oscar Wilde, and Sarah Bernhardt—but the emergence of the motion picture industry (and, later, radio and TV) brought about the creation of a star system that has become woven into the fabric of contemporary society. The rapid expansion of movies in the early decades of the twentieth century fueled an unexpected explosion of

public fascination with individual performers. In 1910, the trade paper *Nickelodeon* took note of the newly visible public interest: "The development of the art has produced actors in the silent drama second to none on the legitimate stage, and they richly deserve the public recognition which is even now awaiting them" (quoted in Staiger 1991, 10).

In 1911, *Motion Picture Story* queried its readers about what kinds of film stories they preferred, but the ballots the magazine received focused instead on their favorite stars, "and the fact that audiences distinguished films by stars became unavoidable" (Root 1989, 181). By the mid-teens, the elements of the "stardom industry"—studio publicity departments, fan magazines, and entertainment gossip writers—were falling into place as an integral part of the rapidly expanding motion picture industry. One of the defining characteristics of the star system was present right at the start: "The private lives of the stars emerged as a new site of knowledge and truth. . . . It is around this time that the star becomes the subject of a narrative that is quite separate from his/her work in any particular film" (deCordova 1991, 26–27). As *Photoplay* posed the question in 1916: "Is your *reel* hero ever a *real* hero?" (quoted in deCordova 1991, 27).

It did not take long for the industry to learn that there was enormous benefit to be reaped from the cultivation of stars—before, during, and after the run of a single film—through public appearances, pinups and other publicity photos, and studio press releases, as well as interviews, biographies, and press coverage of the stars' "private" lives. Stars took on an existence for their fans that preceded and extended beyond their roles, as they came to "articulate what it is to be a human being in contemporary society; that is, they express the particular notion we hold of the person, of the 'individual'" (Dyer 1986, 8). But the star image was always a dual one, as the audience was invited to consume both the fictional roles played on the screen and the supposedly real, although often equally fictional, persona of the star as an individual. The public's seemingly endless fascination with the real characters and lives of the stars feeds a burgeoning "rhetoric of authenticity" that builds on the assumption that "what is behind or below the surface is, unquestionably and virtually by definition, the truth" (Dyer 1991, 136).

The rhetoric of authenticity that permeates the discourse of celebrity reflects the conviction that sexuality is the dimension of human experience closest to the truth of character and motivation. As Foucault (1976) has observed, "Sex gradually became an object of great suspicion; the general and disquieting meaning that pervades our conduct and our existence, in spite of ourselves; . . . we demand that sex speak the truth, . . . and we demand that it tell us our truth" (69). In an age increasingly imbued with Freudian convictions about the importance of unconscious forces lurking out of sight, the truth about personality is to be discovered beneath the surface, behind the facade, and sexual secrets are assumed to be the most revealing.

As the twentieth century progressed, the backstage narratives once available primarily in movie and fan magazines metastasized until they became the mainstay of

TV talk shows (daytime, prime time, and late night), star biographies and "nonbooks," supermarket tabloids and respectable personality magazines (Time-Life's *People* magazine is the most successful new magazine of the past twenty-five years), and proliferating Internet Web sites.

Show business celebrities quickly learned the rules of the game, cooperating with the studios and the media in the construction of public facades and the covering up of potentially embarrassing glimpses of hidden backstage realities. The gossip columnists and magazines were both antagonists and collaborators with the industry in the game of showing and telling the public about the stars. Although they vigorously sought "what a story!" scoops about the stars' private lives, in the long run the gossip media knew that their success was inextricably bound with that of the stars they were "exposing." Thus they routinely broadcast lies fed them by studio publicists, as long as the stories conformed to the romantic narratives avidly sought by the public. Among the most important services provided by the gossip columnists was "inning"—promoting false heterosexual images of lesbian and gay celebrities.

Rock Hudson (formerly Roy Fitzgerald) was hastily married off to his agent's secretary in 1955 after *Confidential* magazine threatened to expose him as homosexual.[1] Similar pressures and motives were widely rumored to lie behind many of Hollywood's most prominent and apparently romantic couplings, prompting movie star Nelson Eddy to joke to Noel Coward that "marriage is the tax on stardom" (quoted in Hadleigh 1991, 72). Nowadays, stars are not necessarily required to get married or engage in other charades. What they *are* required to do, of course, is steadfastly present themselves as heterosexual.

Despite, or perhaps because of, the stereotypical assumption that show business is a haven for homosexuals, there has never been a major Hollywood star of screen or television who has voluntarily come out.[2] This is not exactly a matter of personal choice. The entire industry operates on the principle that the American public is suffused with prejudices that must be catered to. In earlier decades the same logic required Jewish actors to submerge and hide their ethnicity. Although today there may be less pressure on Jewish actors to change their names (or their noses), lesbian and gay performers are still expected to stay quietly in the closet.

From Gossip to Outing

Despite the explosion of lesbian and gay visibility since the late 1960s, the near-total absence of openly gay celebrities ensures the continuing importance of gossip in the crafting of gay subcultural identity. Insider gay gossip has always focused heavily on the exchange of names of famous people who are secretly gay, just as Jews have told each other with pride about rich and famous people who are, but are not generally known to be, Jewish.

The denial and erasure of lesbian women and gay men from the formal curricula of our schools and from the informal but even more influential curriculum of our

mass media leads to the understandable desire among gays and lesbians to discover and celebrate the contributions of lesbian and gay figures. Just as African American activists and educators have brought attention to the often obscured achievements of people of color, and just as feminist art historians have uncovered the accomplishments of women artists whose work had been misattributed to men, so too have lesbian and gay scholars assembled lists of famous people who were (or are) homosexual. Such lists present scholars, journalists, and activists with important issues of evidence and ethics: What constitutes proof of someone's sexual identity, especially when evidence is likely to have been suppressed or destroyed, and what considerations should influence the decision to reveal a person's previously hidden homosexuality? Are historians the outers of the past, or are outers the historians of the present?

It is lists like these that outing proponents refer to when they talk about role models to help gay people as well as the rest of society counter the stigmatizing images fostered by invisibility and stereotypes. This is a *celebratory* form of outing, good for building internal morale, and easily translated into a public tactic, as when marchers in annual June gay pride parades carry signs with the pictures and names of famous lesbian and gay "ancestors."[3] The more political form of outing that focuses on exposing hypocrites who actively work against gay interests while hiding their own homosexuality has also been a commonplace of gay gossip, and its move into the public arena is the least controversial aspect of outing. But the most radical aspect of outing is the argument that all homosexuals are members of a community, whether they admit it or not, to which they owe a measure of accountability and allegiance (Gross 1993). Even gay activists who would not subscribe to such a radical statement are caught in the web of rhetoric spun around the concepts "that gay men and women were an oppressed minority and that, like other minorities, they possessed a culture of their own" (D'Emilio 1983, 248). If gay people constitute a *minority* in this sense, then the rhetoric of allegiance and accountability is not as farfetched as it sounds to many who respond to outing as an unwarranted invasion of privacy.

Conventional notions of a community include the expectations that members protect one another and that the group may on occasion sacrifice some members to protect or further the group's interests. Outing would appear to be an example of such a sacrifice. In traditional political liberalism, community members will, it is assumed, offer themselves voluntarily for possible sacrifice, but there are cases, such as the military draft, where the community compels members to sacrifice themselves. The question, therefore, is whether the present embattled conditions—AIDS, antigay violence, virulent political attacks—override the "longstanding tradition that required sodomites to keep each other's secrets"? (Goldstein 1990, 33).

However, even without focusing on the present crises of AIDS and right-wing antigay campaigns, as the achievements of the lesbian and gay movement steadily expand the possibilities for being openly gay in many places and occupations, there is a corresponding increase in resentment and hostility toward those who choose to re-

main closeted while reaping the benefits of expanded psychological and social breathing space created through others' efforts. This resentment is not directed indiscriminately. The advocates of outing are not blaming the truly vulnerable for remaining in the closet, even though militants who have themselves taken the risks and suffered the costs of being out might wish everyone would follow their lead. Lesbian writer Victoria Brownworth (1990) turns the ethical question around:

> Every gay man and lesbian woman who "passes" (and tries to) oppresses me further and reaps the benefits of my activism while hiding the strength of our numbers from the people to whom those numbers would make a difference.... Is it ethical to stay in the closet, pass for straight, assume the mantle of heterosexual privilege and enjoy its benefits while those who are openly gay suffer the oppression of their minority status? (48)

Some might object that the closeted celebrities who have been the targets of outing are not harming anyone and are not obviously taking advantage of other gay people merely because they are living "private" lives. We may be amused by the disingenuousness of the claim of privacy when it is made by showbiz celebrities who "share" their lives with millions of television viewers along with Jay Leno, Oprah, and any other talk-show host who will have them, or invite *People* magazine into their home. But beyond the shallowness of the argument that celebrities deserve to have their privacy protected—when they're not parading their "private" lives before the media—there is the fact that stars not only take advantage of the presumption of heterosexuality but actually promulgate the assumption of the ubiquity and normality of heterosexuality. In other words, their very public pseudoreal lives, endlessly circulated by the gossip media, are cultivating the images and undergirding the ideology that oppresses gay people. No one is obliged to make a fabulous living as a movie, television, or recording star, and those who do take on this burden can be held accountable for the images they promote.

Quite aside from the question of the ideological consequences of their public personaes, closeted celebrities and public officials are disingenuous in another way when they claim that their private lives are unrelated to the larger lesbian and gay community. They benefit in important ways from the accomplishments of the lesbian and gay movement, even if they lack a sense of political engagement or responsibility.

The successful gay, lesbian, and bisexual figures who live in well-appointed closets are able to enjoy much fuller gay lives than could their counterparts in past generations. Although the upper classes have always been able to indulge in private tastes behind the high walls of their preserves, today's rich and famous have the option to partake of private pleasures in the semipublic precincts of the gay world. Such people can be condemned as tourists who exploit the freedoms provided by others' efforts and risks while refusing to use the power provided by their positions and visibility for the good of the community, and even occasionally using that power in ways that

directly hurt gay people. The response of openly gay people in many instances, understandably, is resentment and, sometimes, outing.

Whose Right to Privacy?

The emergence of outing as political tactic in the early 1990s evoked heated debates over the ethics of activists and journalists who seemed willing to override the "right to privacy" generally enjoyed by closeted celebrities.[4] Unlike the gossip columnists who had long colluded in protecting celebrity closets, outing presented a dilemma to mainstream journalists because it tries to hold them to their most fundamental principles: telling the truth and not knowingly telling lies. In the case of closeted lesbian and gay public figures, the press is faced with a challenge, and it responds by applying various criteria to determine whether the "private truth" is newsworthy. Reporters who assume the public has a right to know about the personal lives of public figures drew—and still, for the most part, draw—the line at the privacy of lesbian and gay people.

Most accounts of outing published in the early 1990s noted that disclosing someone's homosexuality was not currently a respectable journalistic practice, although the motives given for this discretion varied depending on who was writing. Editorial writers in the mainstream press climbed to moral high ground from which they made statements such as "Sex is a private matter unless it affects the performance of public duties or has adverse effects on the lives of others" ("Gays and Privacy" 1990). From another perspective, Randy Shilts, the openly gay national correspondent for the *Chronicle,* wrote on the *New York Times* op-ed page in 1990: "The refusal of newspapers to reveal a person's homosexuality has less to do with ethical considerations of privacy than with an editor's homophobia. In my experience, many editors really believe that being gay is so distasteful that talk of it should be avoided unless absolutely necessary."

The concept of a right to privacy arose out of nineteenth-century Victorian morality, which created an ideology of distinct public and private spheres and confined women to the private, domestic sphere. As this ideology was articulated by one of its foremost proponents, the influential critic John Ruskin, confinement to the home not only protects women, it enables women to maintain a safe refuge for men: "This is the true nature of the home—it is the place of Peace" (quoted in Wolff 1988, 120).

By the late nineteenth century, however, the growth of mass media and recently invented new communications technologies threatened to invade the "place of Peace" and disrupt the tranquility of the domestic sphere. As Marvin (1988) notes, "With the advent of the telephone and other new media came relatively sudden and unanticipated possibilities of mixing heterogeneous social worlds—a useful opportunity for some, a dreadful intrusion for others" (107). In 1890, the popular press in Boston wrote about the parties and dances of elite society in ways that seemed dreadfully intrusive, at least to Mrs. Samuel D. Warren. Mrs. Warren's outrage "prompted her hus-

band, a professor of law at Harvard University, to join a colleague, Louis D. Brandeis, in devising 'the right of the individual to be left alone.' A Warren-Brandeis law journal article on the right to privacy became the fountainhead of later law and social policy in the United States" (Smith 1980, 3). Warren and Brandeis (1890) singled out the new technologies and the media they served:

> Recent inventions and business methods call attention to the next step which must be taken for the protection of the person, and for securing to the individual . . . the right "to be let alone." Instantaneous photographs and newspaper enterprise have invaded the sacred precincts of private and domestic life; and numerous mechanical devices threaten to make good the prediction that "what is whispered in the closet shall be proclaimed from the house-tops." (195)

In the period following World War II, the defense of the private realm became the primary focus of liberal efforts to reconcile the "interests of society" and the rights of the individual. The "right to privacy," first expressed in an effort to protect the sanctity of the Victorian domestic sphere, would now be invoked as a defense against the enforcement of Victorian morality.

In the arena of sexuality the ground was broken by the publication of the Kinsey report on sexual behavior in the human male in 1948 and its companion volume on sexual behavior in females in 1953 (in both cases, the "human species" the researchers studied consisted exclusively of white Americans), which lifted a curtain to reveal much more active and varied sexual lives than Americans were supposed to enjoy (notable among the scandalous findings was the high proportion of males who had engaged in same-sex sexual encounters). Taken together with the success of the psychiatric profession in supplanting the previously dominant religious and legal perspectives on sexuality (Weeks 1981), the Kinsey reports set the stage for a reevaluation of public morality and individual rights.

In 1954, following a sensational trial in England concerning homosexual offenses in which "there was no evidence of 'corruption'; no suggestion that the acts were anything but consensual and in private" (Weeks 1981, 241), the British government established the Wolfenden Committee on Homosexual Offences and Prostitution. The committee's report, issued in 1957, was a landmark in the postwar evolution of a new standard for policing sexual behavior. Although generally seen as a victory for liberalism and individual freedom, the *Wolfenden Report* must also be seen as a strategic retrenchment rather than an abdication of the desire to control the expression of sexuality.

The key to the *Wolfenden Report* is in the distinction between public and private. The purpose of criminal law, the report's authors argued, is to preserve *public* order and decency, not to enforce *private* morality: "There must be a realm of private morality and immorality which is in brief and crude terms not the law's business. . . . It is not in our view the function of the law to intervene in the private lives of citi-

zens or to seek to enforce any particular patterns of behaviour" (Wolfenden Committee 1964, 23–24). But there is an important corollary to the report's hands-off stance toward private morality; as Weeks (1981) observes, "The logic of the distinction between private and public behaviour was that the legal penalties for *public* displays of sexuality could be strengthened at the same time as private behaviour was decriminalized" (243). The report's recommendations regarding homosexuality, therefore, focused on a single point: where homosexual acts were taking place. Such acts between consenting adults *in private* should no longer be treated as criminal offenses. But, the committee emphasized, "it is important that the limited modification of the law which we propose should not be interpreted as an indication that the law can be indifferent to other forms of homosexual behaviour, or as a general license to adult homosexuals to behave as they please" (87).

Advocates of the new law urged discretion on those who stood to benefit from it, asking them, in the words of Lord Arran, "to show their thanks by comporting themselves quietly and with dignity" (quoted in Weeks 1981, 243). For the purpose of the new law, *public* was defined as meaning not only a public toilet but anywhere where a third person was likely to be present.[5] In the first few years after decriminalization of private homosexual acts, the numbers of prosecutions actually increased, as the police sought to increase "the 'privatization' and moral 'segregation' of homosexuals" (Weeks 1981, 275). However, on the whole, the *Wolfenden Report* did much to promote the "right to privacy" as the rallying cry of liberal reformers as Western culture moved into the "permissive" 1960s.

In the landmark case of *Griswold v. Connecticut* in 1965, the U.S. Supreme Court first recognized a constitutional right to privacy. The Court voided the state of Connecticut's prohibition against the sale or use of contraceptives, because the law could be enforced only if the police were allowed to "search the sacred precincts of marital bedrooms for telltale signs."

The right to privacy extended to married couples and, in later decisions, to unmarried persons wishing to use contraceptives, unmarried women wishing to terminate pregnancies, and people wishing to watch dirty movies in the privacy of their homes (Smith 1980, 269). But, it is important to note, the Court in *Griswold* stressed that the right to privacy "in no way interferes with a State's proper regulation of sexual promiscuity or misconduct." It was soon made clear that the Supreme Court was not about to interfere with any state's desire to regulate *some* expressions of sexuality: in 1976 it upheld a Virginia decision punishing sodomy between consenting male adults, and later in the same year it left standing another Virginia decision that punished a married couple for engaging in oral-genital sex.

In 1986, in the infamous *Bowers v. Hardwick* decision, the U.S. Supreme Court stripped the right to privacy argument of its last vestige of credibility as a defense of gay sexuality. Diverging from the logic of sexual liberty implicit in *Griswold* and many subsequent decisions, and showing what Justice Blackmun in his dissent termed

an "almost obsessive focus on homosexual activity," the Court asserted that the right to privacy does not extend to homosexual acts, even when committed by consenting adults in private. Simply put, "The Constitution does not confer a fundamental right upon homosexuals to engage in sodomy.... Any claim that... any kind of private sexual conduct between consenting adults is constitutionally insulated from state proscription is unsupportable."

The Reversible Panopticon

The U.S. Supreme Court may have revealed the tenuousness of the right to privacy as a protection for gay people, but it wasn't long before the media did the same for heterosexual politicians. In 1987 the rules of the game long played by politicians and the media changed when the *Miami Herald* staked out presidential candidate Gary Hart's townhouse to verify that Donna Rice spent the night there. Despite criticism from editorialists and negative reactions to these tactics expressed in opinion polls, a line had been crossed, and it wasn't long before a photograph of Rice sitting on Hart's knee jumped from a supermarket tabloid to the mainstream press. Hart's presidential hopes ended abruptly, and so did the tacit restraint that had previously protected politicians' privacy.

By 1992, when Gennifer Flowers sold her story of an affair with Bill Clinton to the supermarket *Star,* the pattern was familiar: the media felt free to report on the allegations and the rumors. Although the respectable media were still hesitant to break such stories, they all, it seemed, wanted to be the first to be second. Clinton saved his campaign by agreeing to a risky interview on 60 *Minutes,* during which Hillary Clinton referred to a "zone of privacy," but this clearly no longer restrained the media from asking, or politicians from being expected to tell. The public seemed ambivalent. A poll conducted for *Time* magazine by Yankelovich Clancy Schulman at the time showed only 25 percent agreeing with the statement that American voters should "be informed about the private lives of presidential candidates—including extramarital affairs" and 82 percent feeling that "the press pays too much attention to a candidate's personal life." Yet, if politicians are devoted to poll numbers, television ratings and newsstand sales told a different story, one that editors and publishers were most attentive to.

The spectacle of the media simultaneously engaging in a feeding frenzy and flagellating themselves over their inability to resist has become all too familiar. A solid year of O. J. Simpson coverage seemed to set a new record for media obsession, but that now seems almost quaint in comparison with Hurricane Monica. If the Kinsey reports opened America's eyes in the 1950s to the realities of sexual lives—in contrast to the official pieties—the Starr report may have played a similar role in the late 1990s. But, where Kinsey was scrupulously nonjudgmental in his elicitation and recounting of sexual details, Starr was sanctimonious and sniggering. Starr attempted to convict Clinton not only of perjury but, at least in the court of public opinion, of

sexual crimes and misdemeanors. More than fifty years after the publication of *Sexual Behavior in the Human Male,* however, the shock of revelation had worn off, and the public, although clearly fascinated with the sordid details, did not grab pitchforks and mob the White House.

Clinton may have avoided removal from office because the sexual revolution has led to increased tolerance for behavior once deemed unacceptable, if not illegal. On the other hand, this same sexual revolution was largely brought about by the distribution of sexual images and information via the media, and the eroding of public inhibitions has contributed to the breaching of the "zone of privacy" Hillary Clinton hoped to maintain.

In his proposal for an ideal penitentiary, which he called the Panopticon, Jeremy Bentham envisaged a structure that would permit a single supervisor to subject a multitude of prisoners to continuous surveillance. As Foucault (1977) has famously characterized the Panopticon, which he proposes as a model for the organization of power relations in modern societies, citizens are subjected to a state of permanent visibility that ensures the automatic functioning of power. Yet it might also be argued, as John Thompson (1995) suggests, that the modern mass media have created a rather different version of the Panopticon, one that turns the surveilling eye on the powerful:

> Whereas the Panopticon renders many people visible to a few and enables power to be exercised over the many by subjecting them to a state of permanent visibility, the development of communication media provides a means by which many people can gather information about a few and, at the same time, a few can appear before many; thanks to the media, it is primarily those who exercise power, rather than those over whom power is exercised, who are subjected to a certain kind of visibility. (134)

While politicians whose sexual histories have become media fodder decry the collapse of privacy, it is difficult to sympathize with those who have assiduously worked to deny others the protections they now wish to maintain for themselves. As Katha Pollitt (1998) puts it:

> Year after year, bipartisan swarms of politicians and preachers parade their wives, dogs and children as proof of their sexual rectitude and use this image to lend gravitas to their attacks on the intimate behavior of ordinary citizens: teenagers who are sexually active, divorced people, homosexuals, single mothers, women on welfare, women who have abortions—the majority of Americans, actually.

Yet the image of the Panopticon's eye focused on the corridors of power should not delude anyone into thinking that the machinery of public surveillance has been dismantled. The media's appetite for sensational stories—often in the form of "infotainment"—and the escalating competition for audience share in an increasingly

crowded media market have undermined the privacy rights of private citizens as well as public figures. The TV show *Cops,* which sends camera crews out with police officers, routinely broadcasts the faces and names of people being arrested—*Miranda* rights do not protect them from public exposure. In 1997, Kansas City, Missouri, began "John TV," in which the names, faces, birth dates, and hometowns of women arrested for prostitution and men arrested for soliciting prostitutes are broadcast on the municipal cable channel.[6]

Tearoom TV

For gay men the media do not require an arrest as a pretext for panoptical exposure. Unearthing a tactic that was used by police before being curtailed in the 1960s, local TV stations in 1998 began sneaking cameras into public toilets in the hope of catching men engaged in sex.[7]

A Seattle TV station did a story about a Web site (cruisingforsex.com) that lists places across the country where men meet for sex and followed up by sending a reporter into a local men's room with a hidden camera. The Seattle story was quickly imitated by the San Diego ABC affiliate, in time for the February sweeps period, and the ploy was quickly picked up by other ABC affiliates. The standard practice in these stories is to scramble the image electronically to obscure the faces of the men depicted, but in at least one instance, the San Antonio station screwed up and clearly broadcast the faces of two men. Also, as *Detroit Free Press* reporter John Smyntek (1998) has noted, it is not known what happens to the original tapes; station executives might assume that all hidden-camera footage is erased after the broadcast, but, in fact, station personnel may keep copies. The *San Diego Union-Tribune* printed an article about the local story by Preston Turegano (1998), who pointed out that the station appeared to violate California state law, which forbids such hidden filming in bathrooms, but also noted that "there will be no action taken against Channel 10 unless someone who was taped comes forward and complains to police that their privacy was invaded, said a spokeswoman for the City Attorney." The article also revealed that portions of the San Diego television report were taken verbatim from the earlier story broadcast by the Seattle station.[8]

By the time the May sweeps were looming, the story gimmick had been "written up in the *Rundown,* a weekly eight-page trade paper and tip sheet for TV stations" (Rozansky 1998), and spread across the country as local news directors exchanged ideas for audience-attracting stories. "If a station in a market finds a story that does really well, that story will make the rounds in every market," the news director for two stations in Florida told a reporter (Rozansky 1998). By November 1998, local TV stations in more than forty cities ran such stories, heavily hyped—usually during sweeps periods. As the new general manager of New York's Fox TV station admitted, he was under orders to improve ratings: "I'm here to stem the downturning tide," and toilet-tryst TV might do the trick (Goldstein 1998). TV station WSOC in Charlotte,

North Carolina, offered its videotapes to the local vice squad, which subsequently arrested eleven men.[9]

Gay leaders responding to the TV tabloid sensationalism were often eager to condemn public sex while decrying the media's tactics. Karen Boothe, president of the National Lesbian and Gay Journalists Association, was quoted in an NLGJA (1998) press release as stating: "NLGJA in no way condones illegal sexual activity in public places, but nor do we condone exploitive coverage that panders to sexual curiosity as a way of pumping up ratings." Mark Segal, publisher of the *Philadelphia Gay News* said that he was "opposed to heterosexuals or gay men or anybody having public sex," but that the local TV story was a "scare story," not an investigation of public sex (quoted in Weiner 1998). At the same time, other gay leaders pointed out the double standard under which public sex between men and women, in parked cars or on beaches, is seen as romantic and even amusing, whereas public (although much less visible) sex between men is seen as horrible and perverted.[10]

Although the stations that air such stories typically focus on the threat to children who might stumble on men engaged in sex, none have turned up evidence of this happening. The New York Fox station ran ads for several days that were typical of those used by stations across the country: "Sexual deviants are roaming our local stores and malls, places that you shop, with your children.... Could you or your child be an innocent victim of cruising for sex?" (Goldstein 1998). In fact, as has been known at least since 1970, when sociologist Laud Humphreys's study *Tearoom Trade* was published, "outsiders" rarely stumble onto such scenes, as the activities typically cease when a newcomer enters the space and only resume when that person either leaves or indicates an interest in watching or participating. Vice cops succeed in apprehending men engaging in "public sex" in rest rooms only by giving clear signals that they are interested themselves—whether in watching or participating—and then arresting men who respond positively to their signals, as singer George Michael learned in a Los Angeles park rest room in April 1998.[11] The reporters who fearlessly caught men in the act in shopping mall rest rooms must have also "played by the rules" in order not to have caused their targets to cease their activities.

When the Philadelphia NBC affiliate, WCAU-TV, was preparing to air its version of this kind of story during the November 1998 sweeps, local activists sought to persuade the station that its "Hidden Camera Investigation" was exposing a nonexistent problem: "None of the places where the footage was shot said they had even a single complaint about children encountering sexual activity in their bathrooms" (Weiner 1998). In my own discussions with the station news director and the reporter who prepared the story, when they trotted out the "What if a child walked in and saw these men?" mantra, I explained that such activities cease when an outsider enters—and certainly if a child enters—and would only resume if the newcomer indicated interest. The reporter protested, "Well, they didn't stop when I was there," to which I replied, "You were showing interest!" The reporter, a good-looking young

man, was wearing a pair of eyeglasses with a camera built into the nosepiece, which meant that in order to capture the shocking behavior on video he had to be looking directly and steadily at the men who were engaging in whatever it was; such looking certainly passes for interest and encouragement under the familiar "rules of the game" for tearoom sex. One might well describe the reporter's actions as video entrapment. The local media establishment felt differently, apparently, as the series won a mid-Atlantic Emmy Award for "Outstanding Service News."

Society of the Spectacle

Today, in the early years of the twenty-first century, we have become accustomed to sights that would have surprised and revelations that would have shocked earlier generations. In 1952, Richard Nixon made media history with his bathetic, but effective, "Checkers speech," which was given, after all, in a fairly traditional manner. In 1968, presidential candidate Richard Nixon appeared on *Rowan & Martin's Laugh-In*, rather awkwardly intoning, "Sock it to *me?*" presumably in an effort to ingratiate himself with younger voters. But none of this prepared us for the political theater of Watergate, with the revelations (some still unfolding) of taped White House conversations and the spectacle of a presidency unraveling on television. Still, all of this seems tame by the standards of recent years, whether we think of candidate Bill Clinton answering questions about his preferences in underwear from an MTV audience or the endlessly repeated image of Bill embracing "that woman" with whom he "did not have sexual relations," even after we all knew about the Oval Office blow jobs and the cigar.

The very concept of gossip seems threatened, as Gail Collins (1998) has noted, based as it is on the idea of hidden behavior, at a time when every public figure's closet door seems to have burst open. In 1998, the congressional Republicans contending with revelations of sexual indiscretions, youthful or otherwise, included Robert Barr, Daniel Burton, Helen Chenoweth, Newt Gingrich, Henry Hyde, and Robert Livingston. The public absorbed all of these dirty secrets without seeming to turn against the miscreants; all of the "exposed" members of Congress were reelected (although Robert Livingston resigned just before he was to be elected speaker of the House) and, of course, the impeachment of President Bill Clinton failed to remove him from office.

On talk show after talk show, the Washington punditocracy bemoaned the "death of outrage"—the title of William Bennett's book-length complaint—diagnosing a state of moral laxity that has pervaded American society. We are, according to conservative jurist (and failed Supreme Court nominee) Robert Bork, slouching toward Gomorrah. The American people are criticized for distinguishing between the personal and the political while at the same time maintaining an ambivalent fascination with the private (especially the sexual) lives of public figures. An argument can be made that the moral license granted to politicians at the end of the decade

was first extended to show business celebrities who pioneered the art of personal "revelation" in the form of gossip magazine and talk-show interviews, mingling news and entertainment, fact and fiction, confession and fabrication, long before political consultants mastered the art of spin.

At the same time that the media's panoptic gaze is turned on the lives of the rich and famous, it does not spare the privacy of those, neither rich nor famous, who fall into the category of "newsworthy" according to the increasingly sensation-oriented standards of news media competing with tabloids and the Internet. But unlike celebrities and politicians, who after all reap material rewards and ego gratification, private citizens caught in the media's eye have little to gain and much to lose from their (usually) brief moments in the spotlight. The public's "right to know"—especially during sweeps periods—has come to be uncomfortably akin to the worst of small-town gossip, augmented by the technological possibilities of surveillance beyond the dreams of neighbors peeping from behind their curtains.

In our media-drenched culture, we know all, or so it seems, and it all becomes part of the infotainment spectacle the media endlessly offer as a lure for our (commercially valuable) attention. We can, of course, always turn it off, give it up, stop paying attention. But, some of us, all of the time, and all of us, some of the time, keep on watching. If we are a media-addicted society—and our drug of choice is entertainment (whether in the respectable guise of "news" or more honestly portrayed)—then we should not be surprised at our willingness to sacrifice privacy to the intrusions of media we have collectively empowered.

Notes

1. Universal Studios squelched *Confidential*'s threatened expose of Hudson by "trading" the magazine a story about another Universal contract actor, Rory Calhoun, who had served jail time for stealing cars in his youth. The Calhoun story was less damaging than a gay scandal about (the more valuable property) Rock Hudson would have been, and it gave Calhoun, and *Confidential,* the opportunity to focus on his rehabilitation by the prison chaplain. The trade also gave *Confidential* leverage in future dealings with the studio, and a sort of hold over Hudson as well (Desjardins 2001).

2. Ellen DeGeneres, whose coming out as a person and as a character on her eponymous TV show garnered unprecedented public and media attention in the spring of 1997, comes close to being an exception, but she doesn't quite qualify as a major star (equivalent, say, to Martina Navratilova in sports, or k. d. lang in popular music), and her show was canceled the next season.

3. The lack of lesbian and gay role models has been cited as a contributory factor to the alarming statistic that "up to 30 percent of completed adolescent suicides annually" may be accounted for by gay teens (Gibson 1989, 110). *Village Voice* columnist Michael Musto (1991), defending outing, has pointed to letters he has received "from formerly suicidal lesbian teens who now feel empowered" by the knowledge that an outed celebrity is also gay.

4. By the end of the decade, however, these arguments were loosing their force. In 1991, conservative gay writer Andrew Sullivan denounced outing, having discerned a "gleam in the eye of the outer" that he diagnosed as "not the excess of youth or the passion of the radical. It

is the gleam of the authoritarian." In late 1999, Sullivan wrote a column for the *New York Times Magazine* that seemed to endorse outing and certainly engaged in it. Sullivan avoided mention of his own earlier position, but did note the changes wrought by the previous decade: "There comes a point, surely, at which the diminishing public stigmatization of homosexuality makes this kind of coyness not so much understandably defensive as simply feeble: insulting to homosexuals, who know better, and condescending to heterosexuals, who deserve better."

5. As philosopher Richard Mohr (1996) points out, "There is nothing magical here about the number of participants in a sexual encounter being two and nothing magical about enclosing walls rather than park shrubbery being the site of the private act. . . . The traditional and sometimes legally enforced belief that two participants at most constitute a private sexual encounter—that three or more people automatically make sex a public act—is a displaced vestige of the view that sex is only for reproduction."

6. Print media, which occasionally decry the sensationalism of tabloid TV, are nonetheless often willing to print the names and addresses of men arrested in "sting operations" by vice cops who stake out public parks and rest rooms. In January 1998, the *Arkansas Democrat-Gazette* listed the names and addresses of twenty-four men arrested in a "3-day park sting" (in contrast to the paper's discretion in not revealing the names of the men arrested in an earlier heterosexual prostitution sting), and one of the men subsequently committed suicide. His suicide note said, "My name and everything is in the paper this morning." The *Columbus Dispatch* followed suit in November 1999, reporting, "Dozens Charged with Indecency in City Park" and listing the names, ages, and addresses of forty-three men. The article singled out several clergymen, teachers, and a school board member, who promptly resigned his position (Mayhood 1999). Sometimes the sting operations bite their instigators, as when an Elkhart, Indiana, vice cop arrested the president of the City Park Board, "the man who helped lead a task force charged with cleaning up lewd acts at Elliot Park," when he "behaved in an indecent manner with an undercover male police officer" (Tyler 1999).

7. In one of the most publicized instances of police surveillance, LBJ aide Walter Jenkins, a middle-aged Catholic with six children, was arrested in October 1964 in a YMCA rest room a few blocks from the White House. The White House and the FBI attributed Jenkins's behavior to "fatigue, alcohol, physical illness and lack of food." Jenkins quickly resigned, and when presidential candidate Barry Goldwater refused to make a campaign issue out of the story, the scandal quickly subsided (Collins 1998, 183–85).

8. California Penal Code Section 647(k) makes the following conduct a misdemeanor: "Anyone who looks through a hole or opening, into, or otherwise views, by means of any instrumentality, including, but not limited to, a periscope, telescope, binoculars, camera, or camcorder, the interior of a bathroom, changing room, fitting room, dressing room, or tanning booth, or the interior of any other area in which the occupant has a reasonable expectation of privacy, with the intent to invade the privacy of a person or persons inside." A violation of 647(k) is punishable by a fine of one thousand dollars and/or six months in jail.

9. The police do not necessarily depend on TV news crews to do their work. Police in Oakland County, Michigan, installed a camera in an Oakland University men's bathroom after "officers verified there were unusually high numbers of people going in and out of the bathroom during the summer, when enrollment is at its lowest," and subsequently arrested two men, whose names were then printed in the local paper (Murray 1999). And then there are the entrepreneurs: in July 1999, the Associated Press reported that "athletes at eight universities say they were secretly videotaped in locker rooms and the tapes were sold through Internet sites advertising 'hot young dudes.'" Other Internet sites offer videos purportedly shot in women's rest rooms and health club locker rooms.

10. An article in the *UCLA Daily Bruin* pointed out the hypocrisy inherent in the differential response to heterosexual and homosexual "public sex," noting that an episode of the ABC sitcom *Dharma and Greg* broadcast the same day as a news report about gay public sex featured the two lead characters "pondering where they would like to have sex in public." The article also recalled a *Daily Bruin* interview with graduating seniors in which one cited as his fondest memory having sex with his girlfriend in the library (Siegel 1998).

11. News reports made it fairly clear that Michaels had been masturbating in front of a vice cop, who must have been giving encouraging signals. Following his arrest, Michaels quickly made an appearance on CNN in which he came out as a gay man, surprising no one who had paid any attention to the singer's career, but successfully defusing the arrest scandal.

References

Brownworth, Victoria. 1990. Campus queer query. *OutWeek*, May 16, 48–49.

Collins, Gail. 1998. *Scorpion tongues: The irresistible history of gossip in American politics.* New York: Harcourt Brace.

deCordova, Richard. 1991. The emergence of the star system in America. Pp. 17–29 in *Stardom: Industry of desire,* edited by Christine Gledhill. London: Routledge.

D'Emilio, John. 1983. *Sexual politics, sexual communities.* Chicago: University of Chicago Press.

Desjardins, Mary. 2001. Systematizing scandal: *Confidential* magazine, stardom, and the state of California, in *Headline Hollywood: A century of film scandal,* edited by Adrienne L. McLean and David A. Cook. New Brunswick, N.J.: Rutgers University Press.

Dyer, Richard. 1986. *Heavenly bodies: Film stars and society.* New York: St. Martin's.

———. 1991. *A star is born* and the construction of authenticity. Pp. 132–40 in *Stardom: Industry of desire,* edited by Christine Gledhill. London: Routledge.

Foucault, Michel. 1976. *The history of sexuality,* vol. 1, *An introduction.* New York: Vintage.

———. 1977. *Discipline and punish: The birth of the prison.* Harmondsworth: Penguin.

Gays and privacy. 1990. *San Francisco Chronicle,* March 13.

Gibson, Paul. 1989. Gay male and lesbian youth suicide. Pp. 110–42 in *Report of the Secretary's Task Force on Youth Suicide,* vol. 3. Washington, D.C.: U.S. Department of Health and Human Services.

Gitlin, Todd. 1990. On drugs and mass media in America's consumer society. Pp. 31–52 in *Youth and drugs: Society's mixed messages,* edited by Hank Resnik. Rockville, Md.: U.S. Department of Health and Human Services.

Goldstein, Richard. 1990. The art of outing: When is it right to name gay names? *Village Voice,* May 1, 33–37.

———. 1998. Camera in the [can]. *Village Voice,* May 12.

Gross, Larry. 1993. *Contested closets: The politics and ethics of outing.* Minneapolis: University of Minnesota Press.

Hadleigh, Boze. 1991. *The vinyl closet: Gays in the music world.* San Diego: Los Hombres.

Humphreys, Laud. 1970. *Tearoom trade: Impersonal sex in public places.* Chicago: Aldine.

Marvin, Carolyn. 1988. *When old technologies were new.* New York: Oxford University Press.

Mayhood, Kevin. 1999. Dozens charged with indecency in city park. *Columbus Dispatch,* November 6.

Mohr, Richard. 1996. Parks, privacy, and the police. Internet distributed column, January 5. On-line at http://www.qrd.org/qrd/media/print/richard.mohr/1996/parks.privacy.and.the.police-01.96.

Murray, Diana. 1999. 2 men accused of sexual activity in OU bathroom. *Oakland Press* (Rochester, Mich.), October 6.

Musto, Michael. 1991. Reply [to several letters]. *Village Voice,* April 23, 5.

National Lesbian and Gay Journalists Association. 1998. NLGJA deplores unprecedented "bathroom journalism" by TV news. Press release, May 11. On-line at http://www. nlgja.org/news/newsrel.html.

Pollitt, Katha. 1998. Great big baskets of dirty linen. *The Nation,* October 19, 8.

Roberts, Donald F., Ulla G. Foehr. Victoria J. Rideout, and Mollyann Brodie. 1999. *Kids and media @ the new millennium.* Menlo Park, Calif.: Henry J. Kaiser Family Foundation.

Root, Cathy. 1989. Star system. Pp. 180–83 in *International encyclopedia of communications,* vol. 4, edited by Eric Barnouw. New York: Oxford University Press.

Rozansky, Michael. 1998. "Shocking" exposes that make the rounds. *Philadelphia Inquirer,* November 16, C5.

Shiltz, Randy. 1990. Is "outing" gays ethical? *New York Times,* April 12, A19.

Siegel, Marc. 1998. Sex in public not lewd—just a mood. *UCLA Daily Bruin,* available on-line at http://gaytoday.badpuppy.com/viewpoint.html, November 17.

Smith, Robert Ellis. 1980. *Privacy: How to protect what's left of it.* New York: Anchor.

Smyntek, John. 1998. Secret rest room taping raises privacy concerns. *Detroit Free Press,* May 28.

Staiger, Janet. 1991. Seeing stars. Pp. 3–16 in *Stardom: Industry of desire,* edited by Christine Gledhill. London: Routledge.

Sullivan, Andrew. 1991. Sleeping with the authoritarians. *Ottawa Citizen,* September 15, B3.

———. 1999. Not a straight story: When it comes to public figures disclosing their sexuality, the new rule is kinda ask, sorta tell. *New York Times Magazine,* December 12, 64.

Thompson, John. 1995. *The media and modernity: A social theory of the media.* Stanford, Calif.: Stanford University Press.

Turegano, Preston. 1998. Timing and legality of sex report questionable. *San Diego Union-Tribune,* March 2, E-1.

Tyler, David. 1999. Park board chief quits after plea to indecency. *Chicago Tribune,* November 21.

Warren, Samuel, and Louis Brandeis. 1890. The right to privacy. *Harvard Law Review* 4, no. 5.

Weeks, Jeffrey. 1981. *Sex, politics and society.* London: Longman.

Weiner, Jennifer. 1998. Protest at ch. 10 ends in 9 arrests. *Philadelphia Inquirer,* November 13, B8.

Wolfenden Committee on Homosexual Offences and Prostitution. 1964. *The Wolfenden report.* New York: Lancer.

Wolff, Janet. 1988. "The culture of separate spheres." In *The culture of capital: Art, power and the 19th century middle class,* edited by Janet Wolff and John Seed. Manchester: Manchester University Press.

Daytime Talk Shows:
Ethics and Ordinary People on Television

Laura Grindstaff

"If an individual consents, by virtue of what appear to be acts of free choice, to be degraded, exploited, or oppressed, does that act of consent end the moral problem that his or her situation seems to constitute?" David Gerber (1996, 38) poses this question in relation to the participation of human exhibits in nineteenth-century freak shows, and, as he notes, at various points in history it has been asked of proletarianized industrial workers, indentured servants, prostitutes, and Victorian-era women. I aim to pose the same question in relation to another group often compared to sideshow freaks and presumed to be similarly degraded and exploited: so-called ordinary guests on daytime television talk shows.

Daytime talk shows have proved to be one of the most controversial television genres of our times. They are considered virtually synonymous with bad taste, and the willingness of guests to shout, laugh, sob, and bicker about their personal affairs in public is said to epitomize the degradation of American culture. Critics of daytime talk are concerned not only about the topics that guests discuss and the performances they give, but about the orchestration of these performances behind the scenes—the

115

tactics that producers employ to elicit the desired level of emotional expressiveness from guests. In this chapter, I examine the how and why of those tactics, the ways in which guests can be said to be manipulated and deceived, the degree to which "manipulation" is inseparable from mass mediation, and the challenges of thinking about "choice" and "consent" on talk shows given the differences that typically exist between producers and guests in terms of class, education, and media experience. Subtending this discussion is the larger question of whether it is in fact degrading or exploitative to discuss aspects of one's private life in public, as many critics assume. By what right do scholars and critics sit in judgment of the guest who bickers with her in-laws, admits to cheating on her spouse, or discloses the details of her acrimonious divorce? Is it possible to separate a concern with ethics from middle-class notions of appropriate conduct or good taste?

I explore these questions having spent more than a year as an ethnographer "behind the scenes" at two nationally televised daytime talk shows, which I call *Diana* and *Randy* (both pseudonyms).[1] As a broad, generic category, the talk show has been around since the earliest days of television, and before that, radio. The specific format of today's daytime talk show—with host, panel of guests, and live studio audience—dates back to the late 1960s, with the debut of *The Phil Donahue Show.* For almost two decades, *Donahue* was the only show of its kind. By the late 1980s, however, it had been joined by *Sally Jessy Raphael, Oprah,* and *Geraldo,* and by the mid-1990s—the peak of the talk-show boom—there were nearly two dozen different shows on the air. Geared primarily toward women and focused on a wide range of topics, from gay parenting and domestic violence to love triangles, weight loss, and family feuds, talk shows put the backstage of life on display. They make public issues of personal experience, and in the process they make stars and experts of ordinary people—despite the fact that most shows also include professional experts and even the occasional celebrity. (*Ordinary* in this context thus refers to the structural position occupied by guests who are not experts or celebrities as conventionally defined; it does not necessarily mean average, typical, or representative of the population. Indeed, talk-show guests, like the subjects of news accounts, are often chosen for their unique qualities rather than for their typicalness. The more bizarre, horrific, or heart-wrenching a person's story, the more attractive a guest he or she makes.) Generally speaking, the ordinariness of ordinary guests lies in both what they talk about (the details of their personal lives, especially their romantic or familial relationships) and how they talk about it (with a maximum of emotional and physical expressiveness). These qualities clearly distinguish the performances of ordinary guests from those of "real" experts and celebrities, who are invariably positioned as more distant, restrained, and dignified participants.

These qualities also clearly distinguish daytime talk shows as "low" rather than "high" culture, as belonging to the tabloid rather than the respectable media. Never a particularly esteemed form of television, daytime talk shows came under sustained

attack in the mid-1990s as their numbers grew and the resulting competition for ratings prompted a shift to more sensational or tabloid fare. Topics became more "personal" ("moms who steal their daughters' mates" "teens who dress like tramps"), and guests—always predominantly female but now increasingly young, black, queer, and, especially, working-class—were encouraged to abandon politeness and restraint for more raucous, carnivalesque performances. It was in the service of creating such performances and in producing what elsewhere I have called "the money shot" of the talk-show text that producers began to orchestrate scenarios involving conflict and surprise confrontation among guests.[2] In March 1995, at the height of this trend, an incident known as "the *Jenny Jones* murder" occurred, in which one talk-show guest shot and killed a fellow panelist several days after taping an episode of *Jenny Jones,* ostensibly because of information revealed during the taping.[3]

Criticism of the genre did not begin or end with this incident, but it served to focus existing complaints and concerns and create a fresh wave of condemnation. Thereafter, and despite the diversity of programming within the genre, talk shows were described in the establishment media as trashy, sleazy, and pornographic. Producers were branded "pimps" and "pushers," and guests were routinely characterized as "trailer trash," "freaks of the week," or "nuts and sluts." In the words of television critic Howard Kurtz (1996), "by parading the sickest, the weirdest, the most painfully afflicted before an audience of millions, these shows bombard us with sleaze to the point of numbness" (63). Even politicians joined the fray, staging several "talk summits" to debate the ethics of talk-show production and to urge the American people to "just say no" to TV trash. As a result of this negative publicity, many hosts and executive producers vowed to "tone down" their shows. Oprah Winfrey dropped conflict-based topics entirely and began a regime of moral and spiritual uplift, and Geraldo Rivera created a "Bill of Rights and Responsibilities" to help encourage more ethical production practices.[4] In contrast, Jerry Springer bucked the trend, rejecting all pretense of rational discussion (along with, not coincidentally, the participation of experts) in the service of orchestrating ever more volatile behavior among guests. Consequently, "talk" on *Springer* consists mostly of body language, and the show stands as an object lesson in the breach of taken-for-granted norms about acceptable public conduct. Not insignificantly, it has also become the most popular show on the air, eclipsing even *Oprah* in the ratings.

Generally speaking, and as the brief summary above might suggest, there are two intertwined concerns about daytime talk shows: (1) the potential manipulation of guests by producers in the service of orchestrating dramatic money shots, and (2) the more generalized exploitation assumed to inhere in the act of airing one's dirty laundry on television. Although the former was emphasized in the immediate aftermath of the *Jenny Jones* murder, the latter is a more diffuse and long-standing critique that grew in direct proportion to the increasing level of sensationalism. It reflects the fact that a genre once aimed largely at middle-class white women and devoted to producing a

soft-core version of the money shot grew more hard-core, and consequently began targeting guests who were poor or working-class. Barbara Ehrenreich (1995) is correct when she observes that you won't find investment bankers bickering on *Ricki Lake*, or see Montel Williams recommending therapy to sobbing professors. But whether this is "class exploitation pure and simple," as she concludes, is a rather more open question. In the sections that follow I examine the issue of ethics and daytime talk shows in terms of both sets of concerns. Talk shows provide a unique space for discussing matters of manipulation, exploitation, choice, and consent in an entertainment context, a context itself embedded in a larger cultural landscape characterized by social inequality.

Producing Ordinary People

Elsewhere, I have described how the work of producers on daytime talk shows has much in common with other forms of media production, must notably news gathering and the production of late-night celebrity talk (Grindstaff 1997, 2002). Like journalists, producers work under the pressure of deadlines, they have "beat" territories (topic areas) that they cover on a regular basis, and, once assigned a show, they rely on routine channels to secure participants. For serious, social-issue topics they find guests mostly through other media sources or through "experts" affiliated with established groups and organizations; for more tabloid or purely personal topics they tend to rely internally on "plugs"—brief advertisements that air at the end of every show soliciting volunteers. ("Does someone you know live a lifestyle you hate? Do you want to confront them on the air? Call 1–800-GO-RICKI.") The performative requirements of the genre mean that producers choose subject matter that is controversial and guests who are "visual." Like the producers of celebrity-based talk (see Tuchman 1974) or those of "serious" political debates among experts, producers of daytime talk must generate "lively interaction" among participants. In all cases, this is partly a function of the topic itself, partly a function of the strategic juxtaposition of panelists, and partly a function of backstage preparation and coaching.

At the same time, the fact that daytime talk shows feature ordinary people rather than professional experts or celebrities means that producers of daytime talk face challenges that producers of other forms of talk TV do not. Indeed, talk shows are trashy in reputation and difficult to produce for some of the same reasons: because ordinary people are by definition not media-savvy professionals, and because their ordinariness is associated with emotional expressiveness rather than emotional restraint. The two qualities are related to each other, and their combination makes the performances of ordinary guests less predictable and hence more difficult to routinize on a daily basis. On top of this, many guests are experiencing personal problems or crises. They may be battling cancer, AIDS, or multiple personality disorder; they may be homeless or the victims of crimes; they may be feuding with their in-laws, cheating on their spouses, or going through acrimonious divorces. This helps to

maximize the probability of emotional expressiveness, but at the same time it exacerbates the unpredictability of their behavior, because the very things that make people willing and desirable guests also make their lives difficult and their participation problematic—from a production as well as an ethical standpoint. As a *Diana* producer said to me about producing a show on Munchausen syndrome (a condition in which people deliberately harm themselves or loved ones because of a need for sympathy and attention):

> That show was touch and go from the beginning, it was just the most exhausting ordeal—because these people are mentally ill. They're pathological. And yet you still have to try to understand them, relate to them, talk to them, in order to get them to come on and say whatever it is you want them to say.

Complicating matters still further is the emphasis on surprise and confrontation—a strategy that, like targeting people in crisis, simultaneously helps ensure a dramatic money shot and makes its production more difficult. At *Randy,* for example, producers deliberately minimize their pretaping contact with an unsuspecting guest in order to avoid giving away too much information and ruining the surprise, but this lack of contact then means they often have a poor sense of the guest as a performer. In the words of one producer there: "With surprise shows, you can't really prepare the person properly—'cause they don't even know why they're here. You just have to say, 'Whatever happens, you've got to be emotional.'"

Such shows still "work" most of the time because there is conflict already built into the topic. In fact, getting guests to deliver dramatic performances is often not the biggest challenge for the producers of confrontational shows—after all, if two people hate each other and you fan their mutual enmity and then put them together on the same stage in a context that actively encourages emotional expressiveness, the outcome is really not all that uncertain. Rather, the challenge is persuading guests to appear in the first place and then keeping them committed to participating. According to another *Randy* producer:

> You get a lot of people who say, "I'm definitely coming." So you do their hotel and limousine reservations, and you spend a lot of time talking to them, getting them to condense their story. And then the day the plane's leaving they say, "I changed my mind, I'm not coming." That happens all the time.

This situation, in combination with the frantic pace of production, means that when putting together confrontational shows, producers aim to book certain guests at the last possible moment, so they have little time to reconsider or press for more information. In an effort to compensate for last-minute cancellations, producers also tend to overbook their shows, going after six, eight, even ten panelists when there is realistically only time for two or three. More significant is the fact that, because of this reluctance or hesitation on the part of guests, successful producers become skilled

salespeople, with finely honed methods of persuasion. They learn how to push the right buttons, and they work hard to develop personal relationships with guests to allay their fears or misgivings.

Depending on the topic and what they sense will motivate particular individuals, producers may appeal to potential guests' self-interest ("Coming on the show may be your last chance to reconcile with your sister"), altruism ("If sharing your story can help protect even one child, your daughter will not have died in vain"), sense of justice ("After what your boyfriend did to you, he deserves whatever he's got coming to him"), or personal vanity (We can make you look like a million bucks"). They may arrange for day care, offer money in the form of "lost wages" or per diem stipends, or stress the excitement and glamour of being on TV, in some cases playing upon a guest's acting or modeling aspirations. Producers often emphasize the cathartic or therapeutic aspects of disclosure, pointing out that "talking about it will help" or that a public forum is safer than a private one. Because they work in pairs, producers may occasionally play a version of "good cop/bad cop" with guests, where the "good" cop agrees to certain favors or conditions in order to secure their participation and then blames the other "bad" one if the favors fail to materialize or the conditions are not met. If a guest has initially agreed and then changed his or her mind, producers may stress the obligations of the informal contract, wheedle, cajole, threaten, or claim their jobs are at stake ("If you don't show up, I'll lose my job"). Industry insiders do not think of these practices as deceptive or manipulative necessarily, but as essential, even obligatory, job skills. Not surprisingly, in conflict situations the easiest guest to book is the person who initially phoned in to the show—the "confrontee" or the one wanting to reveal a secret—and the most difficult guest to book is the one to be confronted or surprised. Almost without exception, producers need the help of the former to secure the participation of the latter; if such help is not forthcoming, producers will drop the show.

Once guests have been booked, they must be prepared for the taping itself. If they are not coming on the show to be surprised, they will already have completed one or more lengthy preinterviews with the producers. These interviews function not only as information-gathering sessions but as mini-auditions. Producers claim that they know within the first minutes of conversation whether someone will make a "good" guest—that is, whether she is energetic, articulate, opinionated, and forthcoming with intimate details. If she is, there are follow-up conversations to iron out the details of the story, get information about other potential participants, and make arrangements for the limousine, flight, and hotel. On the day of the taping, guests arrive, nervous and expectant. They are ushered into dressing rooms or greenrooms, and then they are made-up and wired for sound. Depending on the topic, different groups of guests may be carefully segregated prior to taping; this both ensures that any conflict occurs onstage rather than offstage and allows producers to give the appearance of supporting both sides of a story. Producers also spend considerable time

prepping guests to ensure that they won't fall apart onstage. "Falling apart" typically means getting nervous and clamming up or wandering, digressing, or going off on tangents when they speak; it also means failing to emote in the appropriate way. Here producers are concerned about both content (helping guests tell their story succinctly, following the conventional pyramid structure used by journalists) and style (encouraging the right kind of performativity from guests). They all use some variation on the same routine:

> Tell it straight from the heart, don't hold back on those emotions because this is your big chance to show millions of people you really care about this issue. If you're going to laugh, laugh big. If you're going to cry, cry big. If you get mad, show us HOW mad! This is YOUR show, so take charge! If you have something to say, jump right in there, don't wait for the host to call on you and don't let the other guests push you around.

In keeping with the pornography metaphor and the premium placed on eliciting the money shot, I call this sort of backstage coaching "fluffing," because the primary goal is to get guests "hot and bothered" enough to go out there and "show wood" (see Grindstaff 1997, 2002).

Most of the time, guests are able to do just that. In fact, producers probably have a far greater success rate than actual fluffers (see Faludi 1995). By choosing controversial or volatile topics to begin with, by recruiting guests who are both familiar with the genre and willing (for whatever reasons) to discuss these topics on television, and by giving them the license to express—and exaggerate—their emotions, producers create the conditions for a successful performance onstage.

Round Pegs in Square Holes: Manipulation and Deception

The association of ordinariness with emotional expressiveness and the things producers do to ensure its display—such as targeting guests experiencing problems or crises and encouraging conflict and confrontation between guests—raise important ethical issues, as do the strategies producers employ to recruit guests, keep them onboard, and elicit from them the "right" sort of performances. Critics are right, for example, when they suggest that producers have an instrumental stance toward guests and their problems, that as much as hosts or producers might stress educational, informational, or therapeutic goals, talk shows are making entertainment out of ordinary people's lives, "using" their transgressions and hardships to garner ratings. There's a well-known saying among industry insiders that summarizes well the attitude of producers toward guests once the show is over and the guests have delivered the goods: "Bring 'em in by limo, send 'em home by cab." After the taping, producers are not concerned about establishing rapport with guests, accommodating their requests, or coaxing them to the brink of emotional readiness; rather, they are concerned with bringing guests down to earth and getting them out the door.

One set of objections has to do with the perceived manipulation and deception of guests by producers. Manipulation occurs at both individual and structural levels, and although some forms are relatively easy to identify and condemn, others are not. A certain amount of deception is inherent in talk-show production, given that part of what producers do is convince people to tell their stories on television and then package those stories in such a way as to enhance their dramatic, unusual, or spectacular effect. Every phase of the process involves the transformation of a lived reality into a mediated one; as a producer once said to me, "Asking a producer to describe manipulation is like asking a fish to describe the aquarium."

Of course, some forms of manipulation are more transparent and troubling than others. Certainly it is unethical for producers to lie to guests: to tell guests that a show is about *X* when it is about *Y*, to make promises they have no intention of keeping, or to lure guests onto a show under false pretenses and then ambush them with unpleasant surprises. Such practices are condemned in the "Bill of Rights and Responsibilities" mentioned earlier and have given rise to several well-publicized lawsuits over the years (see Heaton and Wilson 1995). After the *Jenny Jones* murder, many shows adopted official policies expressly forbidding deception, and even playing "good cop/bad cop" with guests is grounds for dismissal of producers on many shows. Producers, not surprisingly, deny ever lying to guests. In fact, many insist that honesty is not only good ethics but good producing as well, because it ensures greater cooperation and more reliable information in the long run. The older producers I came across believed that the more producers tell guests, the more committed the guests become. In the words of one ten-year veteran:

> On any show I've ever worked on I always let everybody know what's coming down the line. I say, "Your sister's going to be here, she's going to call you a slut, now, I'm telling you this is going to happen, I don't want you to be fooled or surprised"—you almost get people even more willing to participate because you are being candid and giving them so much consideration.

Yet producers can avoid outright deception and still not be completely forthright with guests, largely because in any given scenario there are multiple participants who receive varying kinds of information. Producers commonly withhold the full details of a given situation from certain guests, choose their words carefully to frame a topic in a particular light, emphasize different aspects of a topic when speaking to different sides in a dispute, or emphasize only the positive benefits of participating. Thus producers can fail to give guests adequate information regarding their participation and that of other panelists, even though, strictly speaking, they may not be lying. Shows involving surprises are often the most problematic, because fully informing a guest about the surprise would clearly spoil it, and because producers can never predict with 100 percent accuracy how a guest will react and thus how the show will unfold. For this reason, and to cover the show legally, *Randy* was one of a number of shows

to institute the use of a supplementary consent form expressly for surprise-based topics. The form warns the guest that the news he or she is about to receive could be positive or negative, that it could come from anyone the guest knows, and that signing the form means the guest agrees to hear the news, whatever its content or source.

In my own experience behind the scenes, I found that guests rarely complained about outright lying or deception of the sort that might prompt a lawsuit (indeed, I should say here that a slight majority of ordinary guests I worked with or interviewed had no complaints at all). Nevertheless, some did report feeling misled or betrayed in way or another. Nancy, for example, went on *Diana* to talk about her experience of domestic violence and was unprepared for—and upset by—the sudden appearance of another guest whose job it was to argue the "other side" of the issue. It was not this other woman's point of view that was the main problem (although that, too, was problematic), it was the fact that Nancy had not been forewarned of her participation. Likewise Vernon, a guest on a *Diana* show about bigamy, was nonplussed to find himself sharing the stage with a man who had married fifty women; Vernon himself had only five wives, and his association with a more serious offender dashed his hopes of generating positive publicity for his case (he had a trial pending at the time of the taping). Another *Diana* guest went on the show primarily to publicize her book about near-death experiences, yet when the show aired she found that all mention of the book had been edited out. An *Oprah* guest who appeared on a show titled "Casanova Conmen" wanted more than anything else to name the two men who swindled her so members of the public could help the police apprehend them; that was her chief motivation for going on the show. Moments before the taping, however, she was told by producers that legal reasons precluded the disclosure of their names. Jordan, a young *Jerry Springer* guest who appeared on a show titled "My Daughter's a Teen Prostitute," claimed that producers promised to help her get off the streets and make a fresh start in life but then failed to make good on the promise.

More often, however, what guests find surprising or disturbing is the nature of the forum itself, the ways in which the stories they tell producers on the phone become something different on stage, or the inability of the genre to meet their goals and expectations. Like all forms of media (and as the work of producers behind the scenes attests), talk shows do not simply hold a mirror up to society, reflecting the world back to itself. Yet guests without any media experience may go on a show expecting a "faithful" reproduction of their stories; they are then ill prepared for the subtle (and not-so-subtle) "heightening of reality" that occurs to make for more sensational television. A former producer for *Geraldo* made this point in an interview. "It's built into the process," he said, referring to manipulation. He went on:

> The executive producer comes up with a title for the show, and then producers have to go forth and make that title real. So you're putting these round pegs into square holes. And the story is almost there, but to make it really happen, the

manipulation has to take place. And so guests are often like, "Yeah, that was the story, but not exactly."

This describes well the sentiment of guests from a wide range of shows. Ramón, for example, accompanied his fifteen-year-old legal ward, Cheri, on a *Sally Jessy Raphael* show about mother-daughter conflicts. He knew who would be on the panel, he knew the title of the show ("Daughters Who Dress Too Sexy"), and he was even aware that Cheri's mother had been in close and consistent contact with producers from early on. Nevertheless, he was unprepared for the way the conflict itself played out on stage to so clearly privilege her version of events—information was selective, certain details were exaggerated, and all participants were not given equal chances to speak. The same thing happened to Anitra, a single mom who responded to a *Jenny Jones* plug about family feuds. She went on the show hoping to achieve closure on a long-standing conflict with her two sisters over custody of her daughter; she even helped recruit the other parties involved. Yet when the lights came on and the cameras rolled, she found she had lost control of the story. Other guests reported milder versions of the same phenomenon. Katherine, a *Ricki Lake* guest, told me that her most vivid memory of the taping was having the host rephrase on the air something Katherine had said in the preinterview, but making it sound more inflammatory than she had intended. "It wasn't an outright twisting," she said, "but I didn't mean it the way she made it sound." Likewise, a *Diana* guest was upset because the host announced at some point during the show that the guest had been attacked by her boyfriend with a bottle, when in fact he had only *threatened* to attack her:

> All I told them was that he had raised up a bottle and said, "If you try and leave, I'll bust you in the head." He never hit me with the bottle. And then they also put there on the screen that he had threatened me with a knife—well, I never actually talked about that on the show, so why include it?

Taken to an extreme, of course, the pressure to create sensational television can lead to more serious distortions and deception of another sort: the outright fabrication of stories by guests, sometimes with, but often without, producers' knowledge and complicity.[5]

Guests also resent the ways talk shows decontextualize issues and events, focusing on only the most dramatic or sensational elements of a story. As the *Diana* guest just quoted above said later in our interview, "That's what I kept telling the producer at the beginning, it's kind of hard to take an incident like this and tell it in two minutes. It's too complicated." A lack of context was also the chief problem for Fran, the *Oprah* guest who had been conned. She and her husband had lost twenty thousand dollars and the deed to their house in a marketing scam; she wanted to publicize her experience so that others might be saved a similar fate and to increase the chances that the two con men would get caught. But the only aspect of Fran's long and com-

plicated narrative to receive any attention at all was the most negative and (for her) the most shameful: the fact that she had slept with one of the con men in order to get the deed to her house back. As she told me:

> Yes, I did sleep with the man to get the house back. But that was only a minute portion of the entire story. I was a single mom when I met my husband and I worked seven and a half years at two jobs to get this house. So I mean, there was a story behind the story in the fact that I couldn't let my house go. But none of that came out.

None of that came out because the other guests invited on the show were (in Fran's words) "more glamorous-looking people" with more sensational stories of injustice, and in the end most of the airtime was devoted to them.

Indeed, if there was a single most common complaint among the guests I interviewed, especially those with an agenda of advocacy or education, it was that the genre is too much show and too little talk, that guests have too little time to tell their stories as they feel they ought to be told. Guests understand that they have to speak concisely, that they have to deliver their narratives in a particular order and in a particular way. Nevertheless, they are frequently shocked at how little of what they prepared to say prior to taping actually gets said during the show. This observation was confirmed by a ten-year veteran of the industry, who insisted that the pressure to "cut to the chase" is by far the most pervasive kind of manipulation on talk shows:

> Eighty percent of the manipulation that goes on is the manipulation to cut to the chase. We only have forty-two minutes and some change to get to the point. What we want [guests] to do is cut the exposition and get to that sound bite, in much the same way politicians do, get to the sound bite so we can have a dramatic and entertaining show.

This mandate, in combination with the number of voices competing to be heard and the fact that "the point" left standing after all the exposition is gone invariably relates to the most sensational aspect of a guest's story, means that guests can come away from a taping feeling frustrated, upset, or used.

Interestingly, guests on *Diana* were somewhat more likely to complain about manipulation than were guests on *Randy*, despite the fact that *Randy* was by far the "trashier" show. This is partly because *Diana* guests were recruited through established groups and organizations as well as plugs, whereas *Randy* guests were recruited almost exclusively through on-air plugs. *Randy* guests were thus typically talk-show viewers as well and tended to be familiar with the codes of the genre, whereas many *Diana* guests did not watch talk shows on a regular basis, if at all. More significantly, guests on shows like *Diana* and *Oprah* tended to have higher expectations for what the genre was all about and what they could accomplish by participating. Many "ordinary" *Diana* guests in fact had expectations much like those of expert guests, who, in my sample of interviewees, were among the most dissatisfied guests of all. To the

degree that talk shows are more about talking bodies than talking heads, they are clearly not well suited to the goals of experts. Thus Helen, an ordinary guest on a *Diana* show about date rape, described the taping as "really disappointing" and "a big circus": "There were so many people participating that there was just, like, a bunch of weird statements being made, and there wasn't any time for response or clarification." When I asked her if she felt the producers had intentionally misled her about what to expect, she said no, not really, but then noted that there was manipulation involved nonetheless:

> I'm not a producer, but it seems to me you don't have to have any high-tech education to know that six people on the panel and another three in the audience is a bit too much for, you know, a forty-minute show on such a serious topic.... I just— like I said, I just felt the situation [itself] was manipulated.

The Problem of Informed Consent

All of this complicates any discussion of "choice" and "consent" on the part of guests. *Informed consent* typically means consent that is knowledgeable, exercised in a situation of voluntary choice, and made by individuals who are competent or able to choose freely. As Thorne (1980) observes, these dimensions of consent are but starting points, for in any given context it may be unclear just how much information needs to be imparted for consent to be knowledgeable, or how to know when a choice is sufficiently voluntary or competent. Moreover, as Gerber (1996) points out, unintended or undesired consequences may follow from any given course of action, so one should not assume that just because a person chooses one course, he or she consents to everything that follows from that choice.

What does it mean, then, to be truly informed as guest on a daytime talk show? How can a guest anticipate the full implications of his or her participation? Just how much information does a person need in order to make a meaningful choice about participating? What if differences in age, culture, education, and media experience hamper producers' ability to provide adequate information to guests? Legalistic notions of informed consent—originally formulated in the context of protecting medical patients from abuses—are not entirely appropriate in the talk-show context because they fail to account for the dynamic and personal nature of producer-guest relations. Guests may sign consent forms, but that does not mean they are truly informed. Indeed, the kind of written consent that producers obtain routinely from guests backstage is about lawsuits, not ethical conduct; this procedure actually enables deception, because when guests sign such forms they release the show from any responsibility for what happens, good or bad, during the taping.

Such questions help illustrate the dilemma of thinking about informed consent in a media context. The *Jenny Jones* murder was an indirect warning signal to the industry about the acceptable limits of deception in the service of obtaining a dramatic

money shot; clearly, guests are not able to choose freely or make informed decisions about participating when they have been lied to, misinformed, or misled. But the failure to inform guests adequately is not always or necessarily deliberate, because talk shows are predicated on spontaneity and live-audience participation, and hence may involve unanticipated events, and because the problem of last-minute cancellations means that producers themselves may not know until just prior to taping the exact composition of the panel or the final details of the show. Even when they do know these things, the pace of production means they do not have time to review the script carefully with each and every guest—in fact, producers are trained *not* to "over-rehearse" guests because this compromises the freshness, realness, and spontaneity on which the genre depends. Moreover, for producers and guests alike there is a fine line between being informed and being uninformed, between honesty and deception, between exaggeration and outright distortion. Producers who encourage guests to exaggerate their emotions or prioritize the more sensational aspects of their stories do so not in the name of deception but in the name of producing "good" television; this *requires* manipulation at some level, because ordinary people might be "playing themselves," but they are playing themselves on national television before a live studio audience and millions of viewers amid all the trappings of conventional theatrical performance. For their part, some guests exaggerate their emotions or embellish—even fabricate—their stories with little or no encouragement from producers, because they, too, know what constitutes "good" television within the parameters of the genre.

This is not to suggest that all forms of manipulation are equal or equally deceptive, or that deception has to be deliberate or a matter of individual intention to be considered unethical. Nor does it have to be experienced the same way by everyone. As we have seen, whether guests feel manipulated or deceived can have less to do with what actually happens to them onstage, objectively speaking, than it has to do with a goodness of fit between expectation and outcome. Guests who want to champion a cause or educate the public can be more upset by their participation than those who are confronted, made fun of, humiliated, or ridiculed. Thus whereas Helen was annoyed with how producers at *Diana* handled her show about date rape, Jack—who went on *Randy* to be confronted by his mother for sexually molesting his young brother—had no complaints about his experience, despite the fact that he was given very little information about the taping in advance, he knew he would be positioned as the bad guy, and in the end he did not accomplish his stated goals (he wanted reconciliation with his family, and he was also hoping that *Randy* would offer to pay for a private therapist). An avid *Randy* viewer, he did not feel manipulated because he knew that the producers had a different set of goals ("to produce ratings to keep the show on the air") and that they were "just doing their job." Whatever his motivations, realized or not, there was a certain fit between Jack's expectations of the show and what actually transpired. This raises the question, then, as to how much guests can reasonably be expected to know (or find out) about a particular show before they

get involved, especially if they are not also viewers. A related issue has to do with the fact that when guests on shows like *Randy* do feel manipulated because they have been unexpectedly humiliated or ridiculed, producers are not the only ones responsible. Producers could never orchestrate a surprise confrontation without the complicity of the guest who wants to do the confronting. Because they typically have close, preexisting personal relationships with the confrontees, such guests—whom producers sometimes call "ringleaders"—are both more persuasive than producers in securing the confrontees' participation and, in some ways, more responsible (from a moral if not a legal standpoint) for what happens to the people onstage.[6]

Another consideration here is that guests can be given a great deal of information about their particular shows and still feel "used" or misled because producers and guests occupy very different structural positions in the talk-show world. Whereas producers orient toward their shows above all as *work,* with one show being much like any other, guests, unless they are aspiring actors faking their stories, do not experience their participation this way. For them, appearing on national television is an exciting, usually once-in-a-lifetime event; they have particular reasons for participating, and they naturally invest their own performances with a special meaning and significance. The relation of any individual guest to the production process is thus strategic and opportunistic rather than routine, even though the place of ordinary people in the genre more generally is not. By contrast, the work of producers is highly routinized, despite, or perhaps because of, its emotional content. Given the frenetic pace of production, it has to be. Like the staff of a hospital emergency room or individuals who work in public health and welfare occupations, producers are so overtaxed on a daily basis they have little choice but to orient toward other people's tragedies and transgressions in a businesslike way—that is, "objectively," as mere objects or elements of the production process.[7] Thus one producer can speak approvingly of a guest as "an easy cry," or of a father and son breaking down on stage as an "amazing interview," and another considers the sight of an incest survivor raging out of control at her mother in front of millions of viewers to be "one of the best television moments you'll ever see." Guests, on the other hand, do not often speak of their performances in these terms.

Of course, none of this addresses the larger issue of whether it is ethical to make entertainment out of people's crises and conflicts in the first place—I will get to that momentarily. But it does remind us how important structural factors are in this context. Indeed, guests can be "fully informed" in all the obvious ways and still feel deceived or manipulated because mass mediation is, by definition, manipulative. Although being talk-show viewers goes a long way toward educating guests about the *results* of mediation, inexperienced guests have few resources to help them understand the *process* of mediation itself until they go through it for themselves. Being ambushed, confronted, humiliated, and ridiculed in public—these are not generally pleasant experiences for guests, nor are they ethical for producers to orchestrate. Yet they are not

the things to which guests most consistently object. The things guests find most frustrating and manipulative are not nearly so dramatic. They are not even unique to the genre. They are common to the production of mass-media discourse more generally, especially the production of that form of media with which talk shows are often contrasted: news. Talk-show guests are disgruntled or dissatisfied with the ways in which their experiences are appropriated and transformed for mass consumption. They get angry at hosts and producers for twisting their words, taking things out of context, framing issues or events in particular ways, making their stories into something they are not. These are certainly legitimate concerns, but experts who appear on the evening news or in the mainstream press complain of the very same things.

Scholars have long documented the ways in which the news media privilege individual solutions to complex social problems, decontextualize issues and events, require people to speak in sound bites, create conflict and drama by juxtaposing opposing viewpoints, and emphasize deviance, conflict, and violence over normal consensual relations—all things for which talk shows are criticized. All mass-media organizations seek to maximize profits, and most media professionals, not just talk-show producers, believe that dramatic personal narratives can influence audiences in ways that abstract generalizations cannot. It is for this reason that "good" stories—whether in the realm of news, sports, current affairs, soap operas, or sitcoms—are organized around moments of dramatic revelation and emotional expressiveness. Thus virtually all media texts, especially televisual ones, deliver their own particular versions of the money shot.[8] But the most significant feature that talk shows share with other media is the tendency to deny ordinary (nonexpert, noncelebrity) people routine access unless they engage in exceptional behavior. Talk shows are by no means alone in this regard. The media are strongly elite centered, which means that ordinary people by definition exist largely outside the official channels and established routines of news making and the entertainment industry. Because ordinary people are not naturally newsworthy for *who they are* (as is the case with celebrities and other elites), their access to media depends more on *what they do*, and notions of unusualness, disruptiveness, and deviance play a crucial role in determining this access (see Hall et al. 1978; Gans 1979; Langer 1998).

At some level, then, informing guests adequately about what participation in daytime talk shows entails means informing them about the manipulative practices of mass-media production more generally, given that talk shows merely throw into high relief the manipulative practices of other media forms, especially the news. News coverage of daytime talk shows—focused almost exclusively on murder, deception, and fraud—is itself good evidence of this common ground. Talk shows are especially maligned, however, because their strategies of manipulation are particularly visible, because they sometimes take manipulation to unacceptable levels, and, most important, because of the kind of ordinary people they target and the nature of the performances these ordinary people are encouraged to give. Having already addressed

the matter of manipulation at length, I turn briefly now to the latter two issues. In essence, they speak to the question of exploitation with which this chapter began.

Class Dismissed? Talk Shows and Class Exploitation

"If an individual consents, by virtue of what appear to be acts of free choice, to be degraded, exploited, or oppressed, does that act of consent end the moral problem that his or her situation seems to constitute?" (Gerber 1996, 38). Assuming, as critics do, that going on a daytime talk show is degrading and exploitative, this question posed in relation to talk shows is essentially asking whether it is ethical to put ordinary people, with all their problems, crises, and conflicts, on TV.

Gerber (1996) is concerned with freak shows and I am concerned with talk shows, but the two have much in common. Indeed, a number of scholars have looked to freak shows as an important historic precedent in the lineage of daytime talk (see Dennett 1996; Gamson 1998; Lowney 1999), particularly as the genre bifurcated into "classy" and "trashy" subcategories. Whereas shows on the "classy" end of the continuum embrace a public-sphere model of talk as rational discourse, those on the "trashy" end draw more heavily on a tabloid tradition of spectacle and display. Like talk shows today, freak shows made money by exhibiting "real" people who, whether "naturally" or through artful orchestration and design, challenged the boundary separating normality from deviance. As with talk shows, this exhibition was never a straightforward presentation of their "difference"; rather, "difference" was carefully constructed and narrativized to enhance its spectacular or exotic effect. Like talk shows, freak shows were said to cater to the lowest common denominator, capitalize on people's base voyeuristic instincts, and exploit the less fortunate for profit. Thus when media critics compare talk shows to freak shows, they rarely mean to flatter. In the words of columnist Walter Goodman (1995), "[Talk shows] are freak shows, with exhibition of dysfunction in many forms, run by shameless hucksters who are never more disgusting than when they are pretending to sympathize with the poor creatures they are displaying to a studio audience" (B2; see also Andersen 1993; Schiff 1995).[9] Talk shows, at least those of the "trashy" variety, are said to be "the most obvious modern form of the freak show," the chief difference being the substitution of psychological for physical freakishness (Dennett 1996, 320).

It is certainly true that talk shows target people experiencing particular problems or crises—that is why guests respond to plugs in the first place and why producers find their stories compelling. As in the culture at large, "realness" or "ordinariness" on talk shows signifies misfortune or disadvantage more commonly than it signifies prosperity or privilege. Producers are not interested in couples who are happily married, sisters-in-law who get along, or divorcing parents who negotiate amicable custody arrangements. Rather, they are interested in guests like Winona, who was persuaded to appear on *Randy* by her two adult daughters. A chain-smoker and recovering alcoholic, Winona had been estranged from her daughters for several years, ever since

they accused her of child abuse, and felt strongly that she had never received a fair hearing in the case. The opportunity to tell her side of the story was one of her motivations for participating. She also hoped the show would lead to a reconciliation of sorts—despite the fact that she had not had any positive contact with either daughter in years, despite the fact that she had recently reported the older one to the police (ironically, alleging that the daughter was abusing her own children), and despite the fact that Winona was under a court order not to see the younger daughter at all. Not surprisingly, the daughters had a very different agenda in mind for the show, and their version of events held sway. So enthusiastic and venomous was their joint denunciation of Winona onstage that the producers decided to drop the other stories in the lineup and devote the entire hour to the three women alone. Needless to say, Winona did not have a very positive experience.

Was it ethical for the producers to put Winona onstage? Does it matter that she was a consenting adult, a regular *Randy* viewer, that her daughters were complicit with the producers in orchestrating her humiliation? Although talk-show producers often emphasize the socially redeeming aspects of the job—reuniting long-lost loves, giving someone the chance to make a plea or right a wrong, sending a drug-addicted teenager to rehab at the expense of the show—helping people is not always the outcome, and producers do question the ethical implications of putting ordinary people, with all their problems and conflicts, on television. As one *Diana* producer said to me about reuniting adopted children with their birth mothers:

> I was basically playing psychiatrist, you know, saying, "This will be a really good thing for you, to be reunited with your child." And you know what? I didn't know if it's a good thing. But it was Sunday and I had a show to tape on Tuesday and major things were not in place. The show turned out really good and the guests were pleased with it and everything, but it was hellish because I felt like, "What am I doing here?" These are major dilemmas in people's lives that I'm playing with. You know, these are not minor problems.[10]

Randy producers were even more likely than *Diana* producers to confront ethical questions about the legitimacy of their work, because they generally did not have the luxury of believing, as *Diana* producers sometimes did, that they were helping guests resolve personal crises or educating the public about important issues. Many acknowledged that there is often a fine line between exploitation and ethical conduct, but noted that as long as they do not lie to a guest, as long as the guest knows the range of possibilities when a surprise or confrontation is involved, as long as the guest signs that consent form, they cannot be held responsible if a guest becomes angry or upset. Others pointed out that because guests are typically viewers responding to plugs, they know what the show is like and are not easily duped or victimized. In the words of one *Randy* producer, "People watch our show and they know it's about conflict and yet they still come on." A former *Geraldo* producer told me much

the same thing. *Geraldo* is a certain kind of talk show with certain kinds of guests, he said, and people are either going to come on or they're not. "Tricking a *Geraldo* guest into doing the show is like tricking someone into swimming. If they've ever seen water before, they know they're going to get wet."

Are these merely convenient excuses to justify exploitation? The particular context matters, of course. People who are depressed or suffering from psychiatric disorders are probably not in the best position to make decisions about whether or not to appear on national television. The same goes for those "normal" guests whose experiences of loss, betrayal, victimization, or abuse are acute, recent, or overwhelming. For producers (or, worse yet, their friends or family members) to capitalize on their vulnerability seems clearly unethical and exploitative. (Many producers actually avoid such guests, not for ethical reasons but because they cannot be trusted to yield "good" performances.) But what about guests who are more or less mentally stable, or whose conflicts and problems are not fresh or raw but ongoing and long-standing? What about guests who, in the absence of being duped or deceived by producers, *choose* to air their dirty laundry on television? What about guests who are simply poor or working-class? Are they, too, atypically vulnerable such that we can speak of their participation on talk shows as unethical or exploitative? What if guests themselves don't see it that way? What are the acceptable limits of vulnerability? Gerber (1996) asks by what right we sit in judgment of the choices of such people as the "fat lady" who displays herself for profit, but the same question obviously applies to guests on "trashy" daytime talk shows. In both cases, and as Gerber points out, one runs the risk of condescension.

Gerber (1996) suggests that one makes a "free choice" not only when one is uncoerced, or when one has the physical and mental capacity to make choices, evaluate options, and carry out the course of action the options suggest, but also when one has a significant range of meaningful alternatives. In the case of freak shows, people with physical anomalies have historically faced ostracism and stigmatization, which have effectively limited their options for work and social interaction. Thus "only by understanding the oppression, exploitation, and degradation experienced by the sort of people who become freaks can we understand the choices that led some, including those who claim to have valued and profited from their role, to appear to consent to be exhibited" (47). This larger context of oppression leads Gerber to conclude that consent on the part of human freaks can never be construed as freely chosen, and thus does *not* solve the moral problems raised by their exhibition. Ehrenreich (1995) and other critics have a similar perspective on talk-show guests. According to Ehrenreich, talk shows are largely about poverty and the distortions it visits upon the human spirit. Watch for a few hours, she suggests, and you'll see people who have never seen the light of external judgment, who have never before been listened to, and who are not taken seriously even if they are heard. "[Guests] are so needy—of social support, of education, of material resources and self-esteem—that they mistake being the center of attention for being actually loved and respected."

Without doubt, many talk-show guests, especially those on the "trashier" shows, are not exactly well endowed with material or cultural capital. The genre's overall shift to more tabloid fare and the increased competition for ratings not only encouraged heightened levels of manipulation and deception (on the part of both producers and guests), it increased the participation of "just folks" who were ordinary in ways consistent with the kind of emotional expressiveness producers had a mandate to produce. In other words, it attracted largely working-class folks with modest incomes and educations, people who often lead very difficult lives, and people who, for whatever various reasons, are willing to bare it all on national television. The case of Sonny and her daughter Jordan is illustrative. They appeared on a *Jerry Springer* show about teen prostitution, along with several other family members. At the time of our interview, Jordan was twenty years old, had a baby daughter, was pregnant with a second child, and had been working intermittently as a prostitute since the age of thirteen. She was living with her sixty-something-year-old boyfriend, allegedly a pimp, who "befriended" her when she was sixteen and provided her with expensive cars, clothes, and whatever else she wanted, including (so family members claimed) drugs and clients. It was Jordan who first called producers in response to a plug. Initially the show was supposed to feature a confrontation between the elderly boyfriend and Sonny, the mom. Sonny was to accuse him of being a pedophile and pimp, and tell him to "get the hell out of my daughter's life" or risk arrest for solicitation. But the boyfriend got cold feet and disappeared from his hotel room the morning of the taping. So producers quickly reframed the confrontation, substituting Jordan's uncle Casey (Sonny's stepbrother) for the other man. Bisexual, addicted to crack, and allegedly HIV-positive, the stepbrother was himself well-known to the police for "working the streets." He had told producers in his preinterview that his very first girlfriend—a prostitute eventually murdered by a serial killer—actually helped Jordan secure her first trick and that he, too, introduced his niece to "trustworthy" clients on occasion in order to save her a fate like the girlfriend's. He claimed that Sonny secured Jordan tricks for the same reason. So the conflict was between Sonny and the stepbrother, Casey, each accusing the other of prostituting Jordan. During the taping itself, Casey was physically attacked by two family members and suffered a broken rib. Nevertheless, a month or so later he and Sonny returned to Chicago together to tape another show on love triangles.

Ehrenreich's assertion that talk shows take lives distorted by poverty and hold them up as entertaining exhibits rings painfully true here. And yet the show itself represents but the tip of the iceberg when it comes to the problems some guests face. Now thirty-seven and on permanent disability because of multiple sclerosis, Sonny never knew her biological father and was raised by her mother (who is alcoholic) and stepfather. A white woman, Sonny says she was raped at the age of seventeen by a black man and conceived Jordan as a result, but because she refused to give the child up for adoption, her family accused her of being a "nigger lover" and disowned her. Stepbrother Casey was the only one who stood by her. Sonny then entered a bad

marriage with an abusive white husband whose sister was also a prostitute, killed by the same serial killer who murdered Casey's girlfriend. Sonny is currently separated from her husband and lives with her mother. Before going on disability, she worked as a housekeeper in a large hotel. She says she did her best raising Jordan, but has never been able to control the girl. As she put it, "Sometimes you have choices of where you live, and how your kids are raised, and what they're raised around. I had no choice because this family is into drugs, and prostitution, and everything else—that's what Jordan's had to get around."

Ordinary People and Media Discourse

How, then, should we think about the "choice" of ordinary people to go on daytime talk shows, especially those on the "trashy" end of the continuum? On the one hand, and as Gerber (1996) notes, even individuals who have everything going for them often make poor choices, and guests on *Jerry Springer* could hardly be said to have everything going for them. Nor does a person need to experience exploitation consciously in order for exploitation to exist. Whether one considers talk shows exploitative might depend not only on the attitudes or motivations of guests, but on the attitudes of audience members as well (do audiences understand the show as a performance to be appreciated, or as a display to be mocked or ridiculed?). On the other hand, talk-show guests, unlike sideshow freaks, do not depend on their performances for their livelihood, and if a guest wants to participate and has not been deceived or coerced by producers, what right does anyone else have to insist she is being exploited, regardless of what audiences think? How paternalistic are we willing to be?

Ultimately, I think we can best address the issue of exploitation, like the issue of manipulation, by distinguishing the individual from the structural level of analysis. At the individual level, for example, we can ask why people go on talk shows, what happens to them there, and how they feel about the experience. People clearly have different reasons for participating and different ways of understanding their participation. They may have wrongs to right, causes to promote, or scores to settle. They may want free trips to New York or Los Angeles, or they may simply want to be on TV. They may be aspiring actors seeking on-air exposure; they may be young folks faking their stories "just for kicks." As individuals, some guests walk away from talk shows feeling exploited or used, some do not. In fact, some—Anitra, Winona, and Sonny among them—turn around and go on a second show! We may question their judgment or even their powers of rational thought, but people's willingness to air their dirty laundry on television is not merely a matter of individual predilection or desire. The fact that people are willing to broker their conflicts or crises in exchange for the experience of being a guest—regardless of what happens to them in that role—also tells us something about the power of national media exposure for people who are rarely granted it and who lack a significant range of "meaningful alternatives" for achieving it. Here we tread on structural rather than individual ground.

Media coverage or exposure is a powerful form of validation in our culture, for ordinary people no less than celebrities, experts, politicians, and activists of various sorts (see Molotch 1979; Gitlin 1980). Yet, as Gitlin and other media scholars have documented, people become news worthy only by submitting to the rules of news making, by conforming to journalistic notions of what constitutes a good story, a dramatic event, or a compelling performance. This submission is required of all media participants, not just ordinary people on daytime talk shows (how many experts on *Nightline* actually *prefer* debating international politics in thirty-second sound bites?). To paraphrase Gamson (1996), when you seize the microphone in a media culture, you achieve a complicated sort of power, because the voice that emerges is never only yours: if you speak, you must be prepared to be used. But not all ways of being used are equal. Generally speaking, the more invisible you are within mainstream media—by virtue of your politics, physical attractiveness, educational status, age, gender, race, class, and sexuality—the higher the price of admission is likely to be. Although the talk of guests on *Nightline* is as mediated as the talk of guests on *Jerry Springer,* the rules and codes of mediation in the two cases are clearly not the same.

When a category of people without a lot of power and resources suddenly gains visibility in popular discourse after having been largely ignored, the resulting portrait is rarely, at least initially, multifaceted, nuanced, or complex. Any person from a marginalized constituency knows this to be true. Kano (1997) documents how when women were first admitted to the Kabuki theater in Japan, they had to enact ultra-stereotypical versions of femininity in order to convey the notion of femaleness, which, up until that point, had been the purview of male actors. Ironically, when "real" women took over, their biological status was not enough; they had to (and do still to this day) play exaggerated, male-defined versions of themselves. Minstrel shows provide another clear example in relation to racialized representations of African Americans. One of the earliest points of entry of black culture into U.S. popular entertainment, minstrel performances (which initially featured whites imitiating blacks) were hardly an "accurate" representation of blackness. Even when African American actors became part of the minstrel tradition, their status as "racial other" was not other enough, for they too had to perform in blackface (see Lott 1993; Lhamon 1998). Likewise for the working classes on "trashy" daytime talk shows: when "real" nonexpert, noncelebrity people play the role of ordinary guest, their actual ordinariness cannot be presented as such but must be re-presented as a stereotypical facsimile of lower-class life. In the world of daytime talk shows, "excessive" emotional and bodily displays operate implicitly as markers of class difference, not because they come "naturally" to guests necessarily (if they did, producers wouldn't spend so much time preparing guests for their roles) but because they are consistent with existing cultural stereotypes and thus are actively constituted as such through the backstage activities of the production process. Only by conforming to these markers do ordinary people

have routine access to national television in the first place. It is in this sense, I think, that we can best talk about talk shows as exploitative.

At the same time, the attitude that condemns the behavior of guests as trashy and debased warrants closer scrutiny. Talk shows undoubtedly got "trashier" as they got more "personal" and emotionally excessive. But why should emotional excess, or disclosing personal intimacies, be considered trashy? Ehrenreich notwithstanding, the denigration of daytime talk shows in the establishment media and elsewhere appears to be motivated less by a concern with class exploitation per se than with enforcing what Bourdieu (1984) calls "the aesthetic disposition"—the separation of culture from nature such that the nature against which culture is constructed is whatever is deemed popular, low, vulgar, course, common, generic, "easy," and so on. Bourdieu argues that culture is used to distinguish among social classes, but the political dimensions of this function are naturalized as matters of aesthetics or taste—tastes are thus practical affirmation of seemingly inevitable (because seemingly natural) cultural difference.

The body is the most indisputable materialization of class taste, as well as its most explicit battleground. Culturally "legitimate" bodies reflect the bourgeois aesthetic that privileges restraint, control, distance, and discipline over excess, impulse, and sensuality, and certain bodies—those that defy social norms of "proper" size, dress, manner, speech, and so on—are by definition in violation of that aesthetic. What is at stake in the struggle for distinction, as Bourdieu so aptly demonstrates, is the ability to establish a perceived distance from, and mastery over, the body and its material existence. The association of the lower classes with the body is therefore grounded in historical-material reality, an embodied manifestation of real class difference, and the ideological means by which difference-as-hierarchy is justified. Middle-class disgust with daytime talk helps to reproduce the hierarchy when it confuses the characterization of talk shows as overly emotional and excessive with a negative moral valuation of those characteristics. This valuation targets not only the talk and behavior of guests, but their reasons for participating. Guests have various reasons for getting involved, and they are not all considered equally legitimate. The more their reasons privilege the body over the mind—that is, the more they have to do with "mere exposure," with simply wanting to be on TV rather than championing a cause or educating the public—the "trashier" they are considered to be.

The taste-class nexus is in turn connected to the separation of public from private space. Like the aesthetic disposition, "the private"—a product of history, culture, ideology—is defined "naturally" in moral terms. The private is constructed as sacred, inviolable, and exclusive. It is the space of bodily processes, intimate functions, sexuality, the backstage preparation of self. So when private matters—especially those branded shameful, dirty, or polluting—spill out into public discourse, it is perceived as a moral breech. The immorality lies not so much in the specific contents of private life as in the violation of the public/private boundary itself, the intrusion of the con-

tents of one sphere into the space of the other.[11] Like the aesthetic dimensions of taste, the moral dimensions of privacy work to naturalize social and material privilege. In the United States, privacy and access to privacy (including, especially, access to private goods and services) are connected explicitly to wealth. Ehrenreich (1995) recognizes this when she writes, "It is easy enough for those who can afford spacious homes and private therapy to sneer at their financial inferiors and label their pathetic moments of stardom vulgar." If she had a talk show, she says, it would feature a different cast of characters and category of crimes: "CEOs who rake in millions while their employees get downsized," or "Senators who voted for welfare and Medicaid cuts." This is a great idea, but she would find that booking guests would be a challenge, given that the ability to keep one's "private" affairs off-limits to public scrutiny is part of what constitutes the very privilege—the eliteness—of elites to begin with.

So what can we conclude here? As long as middle-class norms of acceptable bodily conduct and legitimate public discourse hold sway, as long as the working classes (and other "others") are disproportionately associated with the violation of these norms, and as long as talk shows capitalize on the sorts of problems and hardships that the working classes are more likely to experience or for which they are more likely to seek public redress, it makes sense to speak of talk shows as exploitative to some degree, even when guests "choose" freely and willingly to participate. *Consent* and *free choice* are relative, not absolute, terms, and their meaning inheres not only in individuals but also in the social contexts in which individuals are embedded; if the context is characterized by structural inequality, then the choices of those at the bottom will never be as "free" as the choices of those at the top. Mass mediation further complicates this context, for the media do not reflect reality "out there" but (re)constitute it through the norms and practices of the production process. More often than not, this process works to perpetuate rather than challenge preexisting inequalities and oppressive social arrangements. Nevertheless, it is important that we not scapegoat talk shows for employing the manipulative practices common to all media forms, or use—dare I say "exploit"—the media more generally as a way of *not* talking about our society's most pressing social and economic problems. Although talk shows might take advantage of people in distress and are surely exploitative in this sense, they do not create out of whole cloth the conditions of hardship under which many guests live.

It is also important that we recognize that in the case of daytime talk shows, concerns about ethics or exploitation are not easily disentangled from middle-class notions of appropriate conduct and good taste. To be sure, talk shows reproduce deeply held stereotypes by positioning the working classes as closer to nature and more obviously (that is, negatively) embodied than social and cultural elites. But the critical condemnation of guests' "trashy" behavior is not any less classifying than the initial stereotypical association of this behavior with ordinary people. I find it telling that critics object to guests' airing their dirty laundry in public when it is entirely possible

to frame the "problem" of talk shows in quite different terms. For example, what about the propensity of talk shows to psychologize complex social issues and to suggest that, whatever the hardship, the solution is therapy? Personally, and also as a matter of ethics, I am far less disturbed by watching screaming in-laws duke it out on *Jerry Springer* than I am by listening to an "expert" on *Oprah* assure guests that the reason they are broke and can't make ends meet is not because some people's wealth depends on other people's poverty, but because they are not "in touch with their inner spirit" or have not tried hard enough "to invite money into their lives." Talk about exploitation![12]

Notes

1. I worked behind the scenes as both an intern and a researcher. The two shows I targeted represent opposite ends of the genre's continuum: *Diana* is a "classy" show focused primarily on romantic and familial relations as well as "light" current affairs; *Randy*, by contrast, is a "trashy" show devoted almost exclusively to interpersonal conflict. To date, both are still on the air. My duties as an intern included transcribing calls to the toll-free phone line for viewer comments and responses to on-air plugs soliciting guests, booking the studio audience, opening fan mail, assisting production staff on the set with guests, answering the phones in the control booth during taping, running errands for producers, contacting former guests about the upcoming airdates for their shows, and occasionally preinterviewing potential guests. During my last few weeks at *Diana* one of the producers was unexpectedly called out of town, and I stepped in to help her partner put together the final two shows of the season. This meant researching the topics, finding and interviewing guests, learning how to write and edit the script, and attending daily production meetings. In my last days at *Randy* I was fortunate to have comparable access to producer-guest interactions (that is, above and beyond that of a typical intern) when one of the associate producers allowed me to shadow him during the production of several shows. In addition to taking extensive field notes, I conducted more than eighty formal interviews with producers and guests (at *Diana* and *Randy* as well at as other shows around the country) and attended more than a dozen live tapings of different shows in Los Angeles, New York, and Chicago.

2. *The money shot* is a term I borrow from film pornography, and it refers to the outpouring or display of emotion expressed in visible, bodily terms. It is the moment during the show when tears well up in a woman's eyes and her voice catches in sadness and pain as she describes having lost her child to a preventable disease; when a man tells his girlfriend that he's been sleeping with another woman, and her jaw drops in rage and disbelief; when members of the studio audience lose their composure as they listen to a victim recount the lurid details of a crime. Like the orgasmic money shot of film pornography (also known as the "cum shot"), the money shot of talk shows marks a precise moment of letting go, of losing control, of surrender to the body and its emotions. It is human behavior in its "raw" rather than "cooked" form, or, to draw on phrase used by John Fiske (1989) in another context, it is the breakdown of culture into nature. These moments have become the hallmark of the genre and are central to its status as "reality" television as well as its negative reputation. According to producers, the more emotional and volatile the guests and audience members, the more "real" (and the more "ordinary") they are (see Grindstaff 1997).

3. More specifically, during the taping of an episode devoted to "secret crushes," a gay man, Scott Amedure, confessed to having a crush on Jonathan Schmitz, another male guest

on the show that day. Schmitz, who is heterosexual, had been expecting a female admirer. Three days later, he shot and killed Amedure, claiming to have been unbearably humiliated by the surprise confession. Schmitz was convicted of second-degree murder in 1996, and in a later civil trial Warner Bros.—which owns the *Jenny Jones* show—was found negligent and fined twenty-five million dollars. The latter decision has been appealed.

4. Geraldo's "Bill of Rights and Responsibilities" guaranteed, among other things, that guests would always be fully informed about the nature of their participation, that producers would accentuate the positive aspects of topics rather than dwell on the negative and bizarre, that onstage violence would no longer be tolerated, and that counselors, therapists, and trained professionals would play a more prominent role vis-à-vis ordinary guests.

5. Given that "real" stories told by "ordinary" people are the bedrock of the genre, this sort of deception—if made public—is a sore point for industry insiders. Over and over, I witnessed producers at both *Diana* and *Randy* deliberately reject people whose stories could not be verified or who appeared overly eager to get on TV (a producer on *The Maury Povich Show* called such guests "talk-show sluts"). At the same time, the structural demands of the workplace militate against authenticity, and I also saw guests at both shows take producers for a ride. Although producers desire to book real people with real problems—people who are not slick or practiced, who express genuine emotion, who are not media savvy, and have never been on talk shows before—these are the guests who, in many ways, pose the greatest challenges for producers, because the very qualities that make them "real" make them more difficult to manage in routine ways. The pressure of deadlines, the nature of the topics, and the performances required of guests actually push producers toward people who *are* media savvy, have prior talk-show experience, and may even be aspiring actors faking their stories. It is thus not surprising that the problem of fake guests worsened over time as the genre grew more raucous and sensational. First, the fact that "trashy" shows with sensational topics rely primarily on plugs to recruit guests rather than on contacts with established groups and organizations renders such shows more vulnerable to fraud because prospective guests have direct access to producers and are not dependent on referrals from experts or official sources. To complicate matters further, the more bizarre or freakish the topic, the more difficult it is to find real people to talk about it and the more pressure producers are under to look the other way when confronted with suspicious (i.e., potentially fraudulent) situations.

6. A number of the guests I interviewed were either ringleaders or had been recruited to participate by one. Nineteen-year-old Jordan, for example, responded to a *Springer* plug about teen prostitution and then convinced her mother, her uncle, her sixty-something-year-old "boyfriend" (allegedly her pimp), and several other family members to accompany her on the show. The stated purposes of the show were to stage a confrontation between the mother and the boyfriend and to encourage Jordan to get off the streets. Ramón, twenty-eight, and his legal ward, Cheri, fifteen, were initially contacted not by a producer but Cheri's mother, April, who had responded to a *Sally Jessy* plug about mother-daughter conflicts. Pam and Len were recruited to *Randy* by their own children, who called the *Randy* show wanting to confront their mother (Pam) about her lifestyle and to persuade her to pursue counseling. They had seen children do a similar thing on *The Montel Williams Show.*

7. I am drawing here on Arlie Hochschild's insights on "emotional labor" as developed in her early book *The Managed Heart* (1983). According to Hochschild, emotional labor is "alienated labor" when the individual's feelings are externalized, separated from the self, and treated as objects to be managed and manipulated.

8. Journalists, for example, recognize certain key phrases or quotes as "ringers," and reporters for supermarket tabloids actually use the expression "good-money quote" (Bird 1992).

"Serious" political talk shows often entail shouting, finger-pointing, and other displays of less-than-civil discourse that could be said to parallel the emotional outbursts of ordinary people on daytime talk. Likewise, when celebrities appear on television newsmagazines, the "best" interviews are considered to be those in which they reveal personal information and express visible emotion. Desire for the money shot was the driving force behind Allen Funt's long-running *Candid Camera,* which deliberately placed ordinary people in extraordinary situations in order to provoke them into losing their cool. It is also what prompts television reporters to interview people immediately after they have experienced terrible shocks or tragedies—a form of ambushing if there ever was one.

9. Andersen's (1993) comparison of talk shows with freak shows is especially snide: after describing the freak show as a place where "scores of anonymous wretches abused themselves grotesquely for the amusement and amazement of paying customers," he points to daytime talk as its "straightline, mainstream descendent, a virtual round-the-clock pageant of geeks inviting the contempt of viewers without even the old quiz-show promises of kitchen ranges or living-room furniture."

10. On rare occasions, producers find themselves persuading guests *not* to participate when shows bring up strong conflicts with their own sense of personal ethics. Several producers related incidents where they felt that an individual's appearance, although in the best interests of the show (in terms of ratings and profitability), was not in the best interests of the would-be guest, despite the fact that the person him- or herself was willing to participate. These are the exceptions rather than the rule, however.

11. Perhaps this is one reason television more generally—a technology that brings the outside world into people's homes and thus blurs the boundaries between public and private at a fundamental level (see Meyrowitz 1985)—so often raises the ire of cultural critics.

12. Lowney (1999, 91–93) makes a similar point in her book on talk shows. We both are referring to episodes of *Oprah* featuring financial consultant Suze Orman. Orman argues that how wealthy you are all depends on how you think about money.

References

Andersen, Kurt. 1993. Oprah and JoJo the Dog-Faced Boy. *Time,* October 11, 94.

Bird, Elizabeth. 1992. *For enquiring minds: A cultural study of supermarket tabloids.* Knoxville: University of Tennessee Press.

Bourdieu, Pierre. 1984. *Distinction: A social critique of the judgment of taste.* Cambridge: Harvard University Press.

Dennett, Andrea Stulman. 1996. The dime museum freak show reconfigured as talk-show. Pp. 315–26 in *Freakery: Cultural spectacles of the extraordinary body,* edited by Rosemarie Garland Thomson. New York: New York University Press.

Ehrenreich, Barbara. 1995. In defense of talk shows. *Time,* December 4, 92.

Faludi, Susan. 1995. The money shot. *New Yorker,* October 30, 64–87.

Fiske, John. 1989. *Understanding popular culture.* Winchester, Mass.: Unwin Hyman.

Gamson, Joshua. 1996. Do ask, do tell. *Utne Reader,* January/February, 79–83.

———. 1998. *Freaks talk back: Tabloid talk shows and sexual nonconformity.* Chicago: University of Chicago Press.

Gans, Herbert. 1979. *Deciding what's news.* New York: Pantheon.

Gerber, David. 1996. The "careers" of people exhibited in freak shows: The problem of volition and valorization. Pp. 38–55 in *Freakery: Cultural spectacles of the extraordinary body,* edited by Rosemarie Garland Thomson. New York: New York University Press.

Gitlin, Todd. 1980. *The whole world is watching: Mass media in the making and unmaking of the New Left.* Berkeley: University of California Press.

Goodman, Walter. 1995. Daytime TV talk: The issue of class. *New York Times,* November 11, B1–B2.

Grindstaff, Laura. 1997. Producing trash, class, and the money shot: A behind the scenes account of daytime TV talk shows. Pp. 165–202 in *Media scandals,* edited by James Lull and Stephen Hinerman. New York: Columbia University Press.

———. 2002. *The money shot: Trash, class, and the making of TV talk shows.* Chicago: University of Chicago Press.

Hall, Stuart, Chas Critcher, Tony Jefferson, John Clark, and Brian Roberts. 1978. *Policing the crisis: Mugging, the state, and law and order.* London: Macmillan.

Heaton, Jeanne Albronda, and Nona Leigh Wilson. 1995. *Tuning in trouble: Talk TV's destructive impact on mental health.* San Francisco: Jossey-Bass.

Hochschild, Arlie Russell. 1983. *The managed heart: Commercialization of human feeling.* Berkeley: University of California Press.

Kano, Ayako. 1997. Oscar Wilde's *Salome* in Japan: The body beneath the kimono and the emergence of the actress. Unpublished paper, University of Pennsylvania, Department of Asian and Middle-Eastern Studies.

Kurtz, Howard. 1996. *Hot air: All talk, all the time.* New York: Times Books.

Langer, John. 1998. *Tabloid television.* New York: Routledge.

Lhamon, William, Jr. 1998. *Raising Cain: Blackface performance from Jim Crow to hip hop.* Cambridge: Harvard University Press.

Lott, Eric. 1993. *Love and theft: Blackface minstrelsy and the American working class.* New York: Oxford University Press.

Lowney, Kathleen. 1999. *Baring our souls: TV talk shows and the religion of recovery.* New York: Aldine de Gruyter.

Meyrowitz, Joshua. 1985. *No sense of place: The impact of electronic media on social behavior.* New York: Oxford University Press.

Molotch, Harvey. 1979. Media and movements. Pp. 71–93 in *The dynamics of social movements,* edited by Mayer Zald and John McCarthy. Cambridge, Mass.: Winthrop.

Schiff, Steven. 1995. Geek shows. *New Yorker,* November 6, 9–10.

Thorne, Barrie. 1980. "You still takin' notes?": Fieldwork and problems of informed consent. *Social Problems* 27, no. 3:284–97.

Tuchman, Gaye. 1974. Assembling a network talk-show. Pp. 119–35 in *The TV establishment: Programming for power and profit,* edited by Gaye Tuchman. Englewood Cliffs, N.J.: Prentice Hall.

Copyright Law and the Challenge of Digital Technology

Sheldon W. Halpern

The revolution in information technology is changing access to information in fundamental ways. Increasing amounts of information are available in digital form. Networks interconnect computers around the globe, and the World Wide Web provides a framework for access to a vast array of information, from favorite family recipes and newspaper articles to scholarly treatises and music, all available at the click of a mouse. Yet the same technologies that provide vastly enhanced access also raise difficult fundamental issues concerning intellectual property, because the technology that makes access so easy also greatly aids copying—both legal and illegal. As a result, many of the intellectual property rules and practices that evolved in the world of physical artifacts do not work well in the digital environment.[1]

Pirate Stories

A recent newspaper story was devoted to the activities of CD "pirates"—individuals who copy commercial compact discs containing copyrighted music onto blank CDs and then sell the copies on street corners to passersby, many of whom are regular

customers.[2] The sellers, by copying the CDs and distributing the copies, clearly infringe the rights of the copyright owners of the music contained in the CDs (the composers, authors, and publishers of the works) and the copyright owners of the sound recordings embodied in the CDs (the producers of the recordings). There is no mystery or subtlety here, or close question of law: the Copyright Act is unequivocal in vesting in these respective copyright owners the exclusive right to make such copies and to distribute them.[3] Moreover, although there may well be some public confusion with respect to the legality of noncommercial copying,[4] there is no reason to believe that similar confusion exists with respect to blatantly commercial copying and distribution. Both the sellers and the buyers know that they are dealing in unlawfully created commodities. Nevertheless, when a customer was asked why he regularly patronizes one of these street-corner vendors, he replied: "Everybody buys from [him]. The quality is very good. He's reputable and he's honest."[5]

According to another story in the *New York Times,* "about a million otherwise law-abiding adult citizens are demonstrating no compunction about using the service [of Napster, an Internet service linking computers to exchange copyrighted music among unrelated individuals] to get free what they would have to pay for in a record store."[6] As one potential investor in the service put it, "If I believe the new model [of music distribution] is a better way for artists to operate, that is a moral justification for feeling good about investing in Napster... even though technically what they're doing is facilitating illegal behavior."[7] One user of the service framed the moral issue succinctly: "But how illegal is it, really?... Is it illegal if you go three miles over the speed limit?... So yeah, you're breaking the law, but how big a law is it?"[8]

These simple interchanges demonstrate a sharp dissonance between the law as perceived by the public and the moral impact of the law on conduct.[9] Of course, such dissonance, to one degree or another, has long been part of society and societal response to specific laws.[10] Concomitantly, complex legislation such as the law of copyright can easily give rise to a fair amount of misunderstanding. For example, notwithstanding the fact that the Copyright Act in general does not exculpate "private" copying, "widespread (and incorrect) belief prevails in society that private use copying is always or almost always lawful."[11] So, too, people generally are surprised to learn that singing "Happy Birthday to You" in a public restaurant is an infringing act. But the dissonance that goes beyond such misunderstanding is quite different, in that it revolves around an active disregard for the law. Such disregard has always existed to some extent, as individuals, with a wink and a nod, make copies of rented videotapes or of borrowed computer software. The problem, however, has potentiated with the growth of digital technology. Although the CD started to replace vinyl records about fifteen years ago, it is only quite recently that the technology for making virtually perfect copies of CDs became widely available at an affordable price. The general availability of expert-level tools for manipulating digital images similarly is a recent phenomenon. Digital video, digital sound, and digital imaging provide

the wherewithal both for extraordinary creativity with respect to the creation of works of the mind and for incredibly easy reproduction, manipulation, and distribution of such works. Adding the Internet to the mix as a digital distribution tool providing virtually instantaneous access to millions of users serves to make the problem one of huge universal dimensions. As the authors of the newly released National Research Council report titled *The Digital Dilemma* observe:

> The information infrastructure—by which we mean information in digital form, computer networks, and the World Wide Web—has arrived accompanied by contradictory powers and promises.... It is at once a remarkably powerful medium for publishing and distributing information, and the world's largest reproduction facility.
>
> Information in digital form has radically changed the economics and ease of reproduction. Reproduction costs are much lower for both rights holders (content owners) and infringers alike. Digital copies are also perfect replicas, each a seed for further perfect copies. One consequence is an erosion of what were once the natural barriers to infringement, such as the expense of reproduction and the decreasing quality of successive generations of copies in analog media.... Computer networks have radically changed the economics of distribution. With transmission speeds approaching a billion characters per second, networks enable sending information products worldwide, cheaply and almost instantaneously. As a consequence, it is easier and less expensive both for a rights holder to distribute a work and for individuals or pirates to make and distribute unauthorized copies.
>
> Today, some actions that can be taken casually by the average citizen—downloading files, forwarding information found on the Web—can at times be blatant violations of intellectual property laws.[12]

In the past, it took some effort to make infringing copies of copyrighted works or to create unauthorized derivative works. It took even greater effort, and expense, to distribute such copies or works widely. The effort required, and particularly the time involved, created a framework in which the individual might pause to consider the implications of his or her conduct and balance moral imperative and expediency. The proliferation of home computers, with the capability of easily copying material, created a breach in this framework. Now, as we have moved to a "digital" paradigm and a World Wide Web of vast interconnectivity, the framework is largely gone: "The information infrastructure makes private infringement of [intellectual property] rights vastly easier to carry out and correspondingly more difficult to detect and prevent. As a result, individual standards of moral and ethical conduct, and individual perceptions of right and wrong, become more important."[13]

Individual determinations of moral and ethical conduct require a moral and ethical context. The problem for intellectual property law in general, and the law of copyright in particular, is the lack of such an underlying clear context. The nature of

American copyright law makes it difficult, if not impossible, for individuals to find or to construct an unambiguous moral compass.

The Inherent Contradictions of a Law Founded on Compromise

Our copyright law arises out of a grand compromise intended to reconcile the need to encourage the creative process by protecting the interests of authors and the public need for access to the product of the creative process. The compromise begins with the U.S. Constitution. Congressional power to act with respect to copyright (and patent) is derived directly from Article I of the Constitution: "The Congress shall have Power... To promote the progress of Science and useful Arts, by securing for limited Times to Authors and Inventors the exclusive right to their respective Writings and Discoveries."[14]

Thus the power is granted to create the copyright monopoly, but "for limited Times" and for a limited purpose—promotion of "the progress of Science and useful Arts." The compromise continued with congressional implementation of the power by specific enumeration of the bundle of rights held by a copyright owner,[15] an enumeration that, by its very nature, both grants an array of specific rights and, by implication, excludes other rights:

> Copyright law strikes a precarious balance. To encourage authors to create and disseminate original expression, it accords them a bundle of proprietary rights in their works. But to promote public education and creative exchange, it invites audiences and subsequent authors to use existing works in every conceivable one that falls outside the province of the copyright owner's exclusive rights. Copyright law's perennial dilemma is to determine where exclusive rights should end and unrestrained public access should begin.[16]

Compromise and balance pervade the Copyright Act; it reflects a legislative history characterized by a continuing balancing of strongly represented interests.[17] For example, section 109 of the act codifies the "first sale" doctrine,[18] an exception to the copyright owner's exclusive right publicly to distribute a work,[19] giving the lawful owner of a copy of a copyrighted work the unlimited right to transfer or otherwise dispose of that copy without the consent of the copyright owner. Under this provision, lawful copies of copyrighted books, videotapes of copyrighted motion pictures, and similar works may be sold, transferred, or rented. However, responding to the concerns of the record industry and of publishers of computer software, Congress amended that section to make the first sale doctrine inapplicable to the commercial rental of records or computer software.[20] Similarly, as a general matter, copyright protection does not extend to utilitarian works and industrial design.[21] This doctrine served to preclude protection for architectural works (as opposed to architectural drawings and plans), but Congress, responding both to the need to conform to the Bern Convention and to sharp criticism of the existing state of the law, passed the

Architectural Works Copyright Protection Act of 1990, which protects architectural works, separating them from the general exclusion of utilitarian works.[22]

Although the process of continuing congressional compromise has been criticized as being too responsive to the needs of specific and influential interest groups,[23] it is also responsive to the continuing need to reexamine the law as conditions change. For good or ill, this legislative give-and-take plays an important and continuing role in the development of the law; it serves as a flexible tool and a tool for giving the law flexibility. This rather pragmatic flexibility in the details of copyright law, however, also makes it difficult to find moral imperatives in those details. The law, in essence, says not "Thou shalt not copy," but "Thou shalt not copy certain works, under certain circumstances, which may change from time to time."

Congress, the Copyright Act, and Technology

Although congressional tinkering is a long-standing practice, the fundamental copyright law was largely unchanged for a period of almost seventy years until the major revision culminating in the Copyright Act of 1976.[24] In that revision, Congress attempted to create a comprehensive structure flexible enough to accommodate technological change and cover virtually any kind of creative activity. Explicit recognition of the need to deal with emerging technology was found only in contemporaneous congressional creation of the National Commission on New Technological Uses of Copyrighted Works, whose task was to determine what, if any, special legislation was needed to deal with computer software.[25] Ultimately, the commission's deliberations resulted in minimal recommendations, which Congress adopted: the inclusion in the act of a definition of a computer program[26] (the effect of which was to qualify a computer program, if sufficiently original, for protection as a "literary work")[27] and special provisions relating to permissible copying.[28] Apart from these minor adjustments, it was assumed that the act could cope with any technological changes or any new technologies that may be developed in the future.

The unintended consequences that arise from the process of compromising conflicting interests and the assumption that the existing law can accommodate technological change are glaringly apparent in the congressional response to industry concerns over the development of digital audio technology. Althogh the music industry had long railed against private audiotaping of phonograph records,[29] that concern was alleviated somewhat by the rapid displacement of phonograph records by CDs; an analog audiotape of a digital CD could not approach the sound quality of the original.[30] However, the development of digital audiotape recorders, with the ability to make virtually perfect copies with no degradation from generation to generation, produced a reaction verging on panic that resulted in congressional passage of the Audio Home Recording Act of 1992.[31] The provisions of this act, essentially directed at wholesale recording of copyrighted musical works, seek to prevent sequential copying—the making of digital copies of digital copies of a digitally recorded

work—and impose royalty obligations on sales of recording equipment and tape. On the assumption that these provisions would alleviate any serious problems, the act expressly immunizes from liability noncommercial digital or analog copying of musical recordings.[32]

In any event, whether because of or in spite of the Home Recording Act, there has not developed an appreciable consumer market for digital audiotaping in the United States. The widespread digital copying through the use of the equipment described by that act and foreseen by the record industry did not occur. Rather, completely different problems, arising out of an unanticipated technology, have produced results far more serious for the music industry. Focusing on digital tape technology, neither Congress nor the music industry was prepared for the distribution of music through the Internet. Although the "uploading" of copyrighted music to an Internet Web site is an infringing "distribution,"[33] considerable controversy existed over whether the immunities in the Home Recording Act extended to "downloading" by a consumer or the copying of that downloaded material from a computer hard drive onto a CD or other device. Although there had been judicial language supporting the exemption,[34] it has most recently been held that "the Audio Home Recording Act does not cover the downloading of MP3 files to computer hard drives."[35]

To rub salt into the wound created by these unintended consequences, it has been held that an MP3 recorder or similar device designed to record from an individual's computer is not the kind of equipment subject to the limitations and royalty provisions of that act.[36] The immunities—the product of an attempt to deal comprehensively with one perceived technological threat—together with the fact that it is now easy and inexpensive to make perfect copies of CDs, have now produced the exact phenomenon that Congress had thought it had avoided, the proliferation of perfect sequential copies of copyrighted music without the payment of royalties.[37] Neither Congress nor the interested parties contemplated a "revolutionary new method of music distribution made possible by digital recording and the Internet; . . . the brave new world of Internet music distribution."[38]

Playing Catch-Up: Escalating Technology Wars

One of the exacerbating problems related to the dissonance between legal proscription and normative conduct is the use of technology to alter the ground rules. Rather than rely simply on finding and prosecuting claims of copyright infringement, the copyright owner attempts to find a way physically to prevent copying of the work, only to be confronted with further advances in technology designed to defeat the protection scheme. This seemingly endless game of catch-up, as encryptors and decoders leapfrog one another, takes place usually in a context in which there is a large class of consumer-infringers (as well as consumers who are not infringers) who either do not consider the copying involved to be an infringing act or do not believe that the law ought to inhibit or punish their conduct. The matter is further complicated

by the fact that copyright owners of consumer-directed products generally do not choose to use the cumbersome machinery of litigation against individual consumers, but prefer to concentrate on those who provide the wherewithal for the consumers to make their copies.

For example, in the early days of consumer software development, it was quite common to sell copy-protected software—software containing code that prevented the user from making a usable copy of the software. The schemes were created to prevent piracy, the unlawful copying of the software. Copy protection through such encryption was overkill in that it also served to prevent lawful copying; nevertheless, it served as a reasonably useful prophylactic. However, in short order software was developed to unlock or otherwise evade the copy-protection schemes. The creation of such software was not itself an act of copyright infringement; liability, if any, in connection with the sale of that software could take the form only of a claim for contributory infringement. The fact that the evasive software could be used for substantial *noninfringing* purposes, such as the making of a *lawful* archival copy by the lawful owner of the original copy of the software,[39] served to defeat any contributory infringement claim.[40]

Similarly, in order to prevent unlawful copying, producers of videotaped motion pictures and, more recently, DVDs encode their tapes and DVDs to prevent making of usable copies. In the case of videotape, this fortress almost immediately became vulnerable; for a relatively low price, one could buy a "black box" that, when connected between playback and recording VCRs, would produce a clean copy of the copyrighted motion picture. Again, although the individual making the copy would be liable for infringement if pursued, the manufacturer and distributor of the "black box" could be liable only if the standards for contributory infringement were met; manufacturing and/or distributing the device to defeat the copy-protection system was not itself actionable outside of the parameters of contributory infringement.

Digital technology has significantly enhanced the ability of copyright owners of digital material to encrypt the material. Where the material is distributed digitally and available through digital networks, such encryption can not only effectively prevent copying in the traditional sense, it can serve to limit access to the material itself, even for otherwise lawful purposes. Obviously, the same digital technology used to encrypt may also be used to decrypt, to decode and evade the encryption scheme. One would expect, once again, to find technological leapfrogging between the encryptors and the decoders.

Congress, however, has altered the balance with its passage, in late 1998, of the Digital Millennium Copyright Act (DMCA).[41] Among other provisions, that act, in bringing U.S. copyright law into harmony with copyright law in the European Union, specifically makes it actionable to "circumvent a technological measure that effectively controls access to a [copyright protected] work," or to "traffic in any technology, product, service, device, component, or part thereof" that circumvents technology that

effectively controls access to a copyrighted work or otherwise protects any rights of a copyright owner.[42]

The DMCA was the product of intense negotiations and compromise among various interested groups. That compromise can be seen in a number of specific exemptions for certain kinds of "circumvention" activities. Other activities are proscribed even if access and/or copying would otherwise be permissible but for the act of circumvention. The act, both in its proscriptions and in its exemptions, responds specifically to a variety of parochial concerns. However, in that specificity may lie the source of considerable difficulty in the future as technology changes. Indeed, in its specific response, both to the needs of copyright owners to use encryption technology and to concerns about the further use of decryption technology, the DMCA may well serve to widen the gap between widespread conduct and legal precepts and thereby may further attenuate the normative role of copyright law.[43]

The Peculiar Problem of Visual Works

Generally

By the very nature of the legislative process, technology will always be ahead of the law, and it is a difficult task to craft a law, or for the courts to interpret the law, fully to accommodate technological change. Consider some of the problems created by technological change in the application of traditional copyright doctrine to visual works.

To be constitutionally protected under the Copyright Act, a work must be the "writing" of an "author." Beginning with the 1884 U.S. Supreme Court opinion in *Burrow-Giles Lithographic Company v. Sarony,* holding that a photographer may be an "author" whose photograph is a "writing," there has been a consistent expansive interpretation of these terms.[44] With the Supreme Court's defining statement that "an author...is '[one] to whom anything owes its origin,'"[45] it has readily been accepted that visual artists, sculptors, composers, photographers, and other expressive creators using tools other than the written word are "authors," whose works, if appropriately fixed, are "writings" in the sense constitutionally required for protection.[46]

For copyright protection to attach to a fixed "writing" it must be an "original work of authorship."[47] The Supreme Court has made it clear that "originality remains the *sine qua non* of copyright," a constitutional prerequisite to copyrightability.[48] "Originality" is a complex construct, embodying both the concept of independent origin and a minimal level of creativity, a modest amount of intellectual labor: "Original...means only that the work was independently created by the author (as opposed to copied from other works), and that it possesses at least some minimal degree of creativity."[49] However, "the requisite level of creativity is extremely low; even a slight amount will suffice."[50] In short, "the least pretentious picture" can meet the originality standard.[51]

Photography has been the source of doctrinal development and implementation of the constitutional constructs of "writing," "author," and "originality." The recent

application of sophisticated digital technology to photography (and other visual techniques) has created concern and confusion as to the applicability and limits of what had been established doctrine. *Sarony* was decided in the early days of photography, and the Court's opinion was informed by the state of an art that then involved a high degree of skill (and effort) and creative decision making. "The particular portrait at issue in that case was sufficiently original—by virtue of its pose, arrangement of accessories in the photograph, and lighting and the expression the photographer evoked— to be subject to copyright."[52] The *Sarony* Court expressly left open the doctrinal question whether "the ordinary production of a photograph" invariably satisfies the originality requirement, but the passage of time, along with the enormous advances in photographic technology, essentially replaced analytic dissection of a particular photograph with a categorical rule: all but the most mechanical photographs contain sufficient originality and creativity to be eligible for copyright protection.[53]

The development of this doctrine antedated the nearly universal phenomenon of auto-focus, auto-exposure, auto-wind photography. The result is the identical treatment, for purposes of copyrightability, of the carefully framed and created photograph and the impulse-driven, tossed-off point-and-shoot image. Each is considered an "original work of authorship" entitled to full copyright protection. Can this doctrinal democracy be justified as we move to fully digital image creation, which, to a large extent, produces greater transparency between photographer and subject—even greater than that provided by auto-focus, auto-exposure, auto-wind, point-and-shoot photography?

The decision to grant the copyright monopoly indiscriminately in these circumstances may require reconsideration of the long-standing doctrine of "nondiscrimination." That doctrine recognizes the limits of judicial capability; the court is not the appropriate place to make aesthetic distinctions or judgments. As the Supreme Court observed in *Bleistein v. Donaldson Lithographing Co.,* "It would be a dangerous undertaking for persons trained only to the law to constitute themselves final judge of the worth of pictorial illustrations, outside of the narrowest and most obvious limits."[54] The aesthetic merit or societal worth of a work is irrelevant to a determination of copyrightability. Simply stated, *any* "original work of authorship" that is fixed in a tangible medium expression will receive copyright protection. With two cases, straddling the end of the nineteenth century, the Court set out the basis for an expansive and evenhanded approach to copyrightability—an approach that, theoretically at least, is devoid of value judgment and predicates the grant of the copyright monopoly on the most minimal standards compatible with the constitutional mandate.

Certainly, the capability problem—the difficulty of making sound aesthetic judgment—has, if anything, been intensified by the enormously increased output of visual imagery. Nevertheless, with the enhanced potential for image creation, manipulation, and dissemination provided by digital technology, it may be necessary to rethink the evenhanded nondiscriminatory and nonjudgmental approach to the vesting of exclusive rights. The digital tools available today may be used equally for the

virtually mindless arranging and rearranging of pixels and for the truly creative production of visual images; the "creative" process may require little or no real effort. Although the Supreme Court has made it clear that copyright is to be based upon some minimal degree of intellectual creativity rather than effort, expense, or workmanlike skill,[55] the social cost of treating the resulting digital creations equally may well exceed the cost of making informed aesthetic distinctions.

Creativity in Derivative Works

The Copyright Act vests exclusively in the copyright owner the right to create derivative works.[56] At the same time, the act recognizes that a derivative work may itself be copyrightable independent of the work upon which it is based.[57] A "derivative work" is defined as "a work based upon one or more pre-existing works."[58] Because "art reproduction" is specifically included in the act's definition of a derivative work,[59] it follows both that reproduction of a copyrighted artwork without consent of the copyright owner is an act of infringement and that such reproduction may itself be a copyrighted work to the extent of "the material contributed by the author" of the reproduction. The use of digital technology to reproduce or to transform visual works has resulted in the need to rethink the conventional doctrine concerning both what is an infringing derivative work and what kind of "contribution" will be sufficient to give the creator of the reproduction or transformation a copyright interest in the resulting work.

Infringement by Creation of Derivative Works

Vesting in the copyright owner of a work the exclusive right to create derivative works appears to be a necessary corollary of the copyright monopoly. The transformation of Shaw's *Pygmalion* from the stage to the screen, and the subsequent further transformation of the play into the stage musical *My Fair Lady* and then the motion picture version of that musical, involved the serial creation of derivative works, each building on the others preceding it and each requiring consent of the copyright owners of the preceding works.

However, the derivative right may also be an invitation to confusion in the creative process. Artistic, creative works are often the products of various influences, direct and indirect, blatant and subtle. The exclusive right to prepare a derivative work does not serve as an omnibus shield against any and all misappropriation; it protects against the taking, through one or another form of transformation, of the creative expression contained in the underlying work, as in, for example, the transformation of a novel into a motion picture. To be an infringing derivative work, "the infringing work must incorporate a portion of the copyrighted work in some form."[60] The latter work must incorporate, to some extent, *expressive* material from the underlying work.

Although it is clear that copyright protects only the original *expression* of an idea and not the idea itself,[61] the determination of what, in any given work, is "expres-

sion" and what is "idea" is an extraordinarily subtle and complex task, in which the standards and criteria exist only at the highest analytic level. If copyright protection were limited only to the *literal* expression in a work, the task of determining infringement would be relatively simple. The law, however, developed in a much more expansive direction, making it clear that the copyright in a work extends beyond literal expression to the sufficiently developed nonliteral, structural aspects of the work.[62] "Two works need not be identical in order to be deemed 'substantially similar' for purposes of copyright infringement. . . . Both literal and nonliteral similarity may warrant a finding of copyright infringement."[63] Where a taking involves the nonliteral elements of a work, the line between evocation or use of ideas and copying of protected expression is by no means clear. In the case of works of visual art, where one literally builds upon the work of another, it may often be a difficult task to determine where "homage" ends and unlawful taking begins.

This problem, of course, is not new, and arguments have been raised against the application of derivative-works liability to transformative visual art.[64] However, the widespread and relatively inexpensive availability of digital image manipulation tools adds a new and more complex dimension to that old problem. For example, one may now easily create a digital copy of a work (by scanning, downloading from the Internet, or any of a large variety of techniques) and then, with image editing tools, transform that image so radically that the final product on its face bears virtually no resemblance to the source work. The initial copying would be an infringing act if done without consent.[65] Would the digital transformation be an infringing derivative work, even if the original copying were done with consent? Given the wide availability of digital images with respect to which copyright owners have granted permission for consumer, personal copying and use, the problem of digital transformation that essentially consumes and transfigures the underlying work in the creation of the derivative work is by no means academic.

The final product may certainly be artistic, aesthetically pleasing, and the result of creative use of the available tools well beyond the simple appropriation of another's work. The analytic models that have been developed in the law of copyright with respect to derivative works generally do not contemplate the kind of transformation now made possible through digital techniques, a consumptive transformation by which the expressive elements of the underlying work are largely unrecognizable. Nevertheless, the fact that the new work in fact physically incorporates expressive elements of the old would appear to be sufficient to make it an infringing derivative work.[66] That may be a sound result in terms of policy, but if so, it should not be the product of the mindless application of doctrine developed in a different technological milieu. Rather, we need serious discussion of the impacts of this transformative technology on our generally understood ideas of "copying." Certainly, a work that borrows only the general ideas or general structural themes of an earlier work to evoke the original would not be considered an infringing derivative work. It is at least arguable that a work that, while incorporating an earlier work's expressive

elements, so transforms them that they cannot readily be found in the new work is similarly an evocative work but not an infringing "derivative work."[67]

Of course, this example also has implications for the doctrine of fair use. The general matter of fair use is outside the scope of this discussion; however, it may well be that expanded fair use constructs can be applied to works that are the products of digital manipulation to produce workable results. For example, the Ninth Circuit has held:

> [Although] disassembly [of computer software] is wholesale copying that falls squarely within the category of acts that are prohibited by the statute . . . where disassembly is the only way to gain access to the ideas and functional elements embodied in a copyrighted computer program and where there is a legitimate reason for seeking such access, disassembly is a fair use of the copyrighted work, as a matter of law.[68]

In language particularly relevant to the larger issue of the relationship between technological exigencies and copyright doctrine, the court observed: "We are not unaware of the fact that to those used to considering copyright issues in more traditional contexts, our result may seem incongruous at first blush."[69]

> From the infancy of copyright protection, [the fair use doctrine] has been thought necessary to fulfill copyright's very purpose, "[t]o promote the Progress of Science and useful Arts." . . . "[I]n truth, in literature, in science and in art, there are, and can be, few, if any, things which in an abstract sense, are strictly new and original throughout. Every book in literature, science and art, borrows, and must necessarily borrow, and use much which was well known and used before."[70]

As Benjamin Kaplan observed more than thirty years ago:

> If man has any "natural" rights, not the least must be a right to imitate his fellows, and thus to reap where he has not sown. Education, after all, proceeds from a kind of mimicry, and "progress," if it is not entirely an illusion, depends on generous indulgence of copying.[71]

The Supreme Court has made it clear that the concept of "transformative" use lies at the heart of fair use analysis; that the greater the degree of creative transformation of an underlying work, the more appropriate is the application of the defense of fair use:

> The goal of copyright, to promote science and the arts, is generally furthered by the creation of transformative works. Such works thus lie at the heart of the fair use doctrine's guarantee of breathing space within the confines of copyright, . . . and the more transformative the new work, the less will be the significance of other factors, like commercialism, that may weigh against a finding of fair use.[72]

Certainly, this language does not arise in the context of the wholesale appropriation of the entirety of a copyrighted work, and it would strain the fair use doctrine to immunize one who engages in such appropriation simply by reframing the work of another or transforming it into another medium.[73] However, the fair use doctrine does need to accommodate the creative transformative possibilities that digital technology affords. Such accommodations can perhaps provide a greater degree of synchrony between behavior and the law.

To that end, it is perhaps necessary to shift the focus of "copying" analysis from the process by which a transformative work is created to the end product itself. Although such a shift may be actuated by the fact that a great many people have both lawful access to large libraries of works of visual art in digital format and highly sophisticated tools for manipulating those images, there is a more compelling reason for reconsideration. The law of copyright, if it is to have normative force, must also recognize and foster the creative potential arising from that technology. This is essential if the law is indeed to serve the broad purpose behind the constitutional copyright grant.

> The primary objective of copyright is not to reward the labor of authors, but "to promote the Progress of Science and useful Arts." . . . To this end, copyright assures authors the right to their original expression, but encourages others to build freely upon the ideas and information conveyed by a work.[74]

The Digital Dilemma suggests, more broadly,

> exploring whether or not the notion of copying is an appropriate foundation for copyright law, and whether a new foundation can be constructed for copyright, based on the goal set forth in the Constitution . . . and a tactic by which it is achieved, namely, providing incentive to authors and publishers. In this framework, the question would not be whether a copy had been made, but whether a use of a work was consistent with the goal and tactic.[75]

It is in this context that the complex doctrine of fair use may best be used both to shelter the creative transformative work that may use, but not exploit, an underlying work and to protect the creators of copyrighted material from unfair, exploitative appropriation.

Originality in Derivative Works: Digital Reproductions

As noted above, a derivative work that is itself noninfringing is copyrightable to the extent of "the material contributed by the author" of the work.[76] So, too, the Copyright Act expressly contemplates that a reproduction of a work of art may qualify as an independently copyrightable derivative work, again, to the extent of the material contributed by the creator of the reproduction.[77] That contribution, as with any of the material for which copyright protection is sought, must meet the minimal standard

of originality (i.e., independent in origin and having some minimal "creativity"). The courts have struggled with the question of what quantum of originality is necessary for a derivative work to be protected. The matter is far from trivial:

> The requirement of originality is significant chiefly in connection with derivative works, where if interpreted too liberally it would paradoxically inhibit rather than promote the creation of such works by giving the first creator a considerable power to interfere with the creation of subsequent derivative works from the same underlying work.[78]

Consequently, more is required of derivative works than is required of other works to meet the low originality threshold.[79]

The "originality" question is fairly easily resolved with respect to certain kinds of derivative works. For example, one may easily distinguish the original creative components that go into creating a musical version of a play from the original expression contained in the play itself and thus find the derivative work (the musical) copyrightable to the extent of that added creative material. The matter becomes far more complicated when one attempts to determine whether a reproduction of a visual work contains sufficient added originality to be a copyrightable derivative work. These complications are seen in a series of opinions by the U.S. Court of Appeals for the Second Circuit, the court generally considered to be the premier copyright tribunal in the United States. In 1951, in *Alfred Bell & Co. Ltd. v. Catalda Fine Arts, Inc.,* the court held that mezzotint reproductions of public domain oil paintings were copyrightable derivative works, so that one who copied these reproductions without consent was held to be an infringer.[80] The standard for copyrightability of the reproduction was that there be a "distinguishable variation" from the original. Referring to the differences, the court observed:

> Even if their substantial departures from the paintings were inadvertent, the copyrights would be valid. The copyist's bad eyesight or defective musculature or a shock caused by clap of thunder, may yield sufficiently distinguishable variations. Having hit upon such a variation unintentionally, the "author" may adopt it as his and copyright it.[81]

Subsequently, the federal district court, relying upon this precedent, held that a highly accurate small-scale reproduction of Rodin's *Hand of God* was a copyrightable derivative work.[82]

Later cases, both in the Second Circuit and elsewhere, however, have made it clear that for a reproduction to be considered a copyrightable derivative work there must be substantial difference or more than a "trivial variation" between it and the underlying work.[83] In the leading case of *L. Batlin & Son, Inc. v. Snyder,* a sharply divided Second Circuit observed:

We follow the school of cases... supporting the proposition that to support copyright there must be at least some substantial variation, not merely a trivial variation such as might occur in the translation to a different medium.

Nor can the requirement of originality be satisfied simply by the demonstration of "physical skill" or "special training." A considerably *higher* degree of skill is required, true artistic skill, to make the reproduction copyrightable.

The court went on to state:

Absent a genuine difference between the underlying work of art and the copy of it for which protection is sought, the public interest in promoting progress in the arts—indeed, the constitutional demand... could hardly be served. To extend copyrightability to minuscule variations would simply put a weapon for harassment in the hands of mischievous copiers intent on appropriating and monopolizing public domain work.[84]

The court attempted to distinguish its earlier and more expansive holding in *Alfred Bell*.[85] However, later opinions[86]—and the Supreme Court's strong rejection, in *Feist,* of effort alone, or "sweat of the brow," as a substitute for originality[87]—have effectively isolated, if not overruled, that earlier approach to copyrightability of derivative works.

The matter was most recently and dramatically dealt with in *Bridgeman Art Library, Ltd. v. Corel Corporation*.[88] Bridgeman claimed to have acquired the exclusive rights in photographic transparencies, and digital transformations thereof, of well-known works of art located in museums around the world; presumably, these rights were acquired from the museums and/or the photographers who created the transparencies, and the Copyright Office had issued to Bridgeman a certificate of registration for the reproductions as derivative works.[89] Bridgeman alleged that Corel had infringed Bridgeman's copyright in 120 reproductions by distributing digital copies thereof without consent.[90] The federal district court held that (1) the fact that the Copyright Act expressly refers to "art reproduction" as an example of a derivative work does not obviate the need for meeting the "originality" test as a prerequisite to copyrightability, and (2) these high-quality photographic reproductions of public domain paintings, as virtually exact, "slavish" copies of the underlying works, do not possess the minimal originality to qualify as copyrightable derivative works.[91]

In this case, plaintiff by its own admission has labored to create "slavish copies" of public domain works of art. While it may be assumed that this required both skill and effort, there was no spark of originality—indeed, the point of the exercise was to reproduce the underlying works with absolute fidelity. Copyright is not available in these circumstances.[92]

As discussed above, and as the *Bridgeman* court acknowledged, "there is little doubt that many photographs, probably the overwhelming majority, reflect at least

the modest amount of originality required for copyright protection."[93] The *Bridgeman* case represents the collision between the efficient categorical doctrine holding essentially all photographs copyrightable irrespective of their subject matter or the circumstances of their creation and the originality requirement as applied to derivative works. It has heretofore generally been understood that the physical and technological limitations in reproducing a work of art are such that one may approximate, but not actually duplicate, the original. These limitations inevitably leave room for the "substantial variation" justifying including "art reproduction" in the category of derivative works. In a context in which duplication, as opposed to approximation, was a technologically difficult task, it was not necessary for the Copyright Act, in providing examples of derivative works, to encase the phrase "art reproduction" in a limitative cocoon.

With a technology that facilitates both very close duplication and the worldwide dissemination of duplicated images, the conflict presented by the *Bridgeman* opinion can have quite serious repercussions. Is the "substantial variation" test workable in the context of relatively inexpensive high-fidelity digital reproduction of public domain works of art? Certainly, the categorical protection of a photograph whose only function is to duplicate a public domain work represents a possible threat to the public domain. Nevertheless, there is also a social cost to putting at risk one who uses leading-edge technology accurately to duplicate and to disseminate to a broad public important works otherwise accessible only to very few. The issues, and conflicting needs, are subtler, and have more ramifications for society, than would appear from simple doctrinal analysis.

Does One Size Fit All?

Much of the preceding discussion could be reframed in terms of the tensions created by the attempt to apply, to significantly diverse works, a unitary legal construct whose precepts are purportedly universally applicable. That is, we have a single Copyright Act that purports to apply equally across media, technological, and other boundaries, to any and all "original works of authorship fixed in a tangible medium of expression."[94] The nondiscrimination doctrine, discussed above, is a corollary of that unitary construct. The universal, as opposed to a particularistic, approach to copyright binds together, under one set of standards, works of fiction and fact, poetry and prose, art and architecture, drama and dance, sculpture and software; commonality is found only at the fundamental level of original authorship and fixation.

This framework does not accommodate a society in which differing codes of conduct might apply to different kinds of works. In our daily lives, as well as in our commercial lives, we do not really treat books the same way we treat computer software, even though both are "literary works" for purposes of the Copyright Act,[95] nor do we treat the seemingly ephemeral digital reproductions of musical or artistic works that may appear on our computer screens the same way we treat their more tangible

embodiments. Although the courts purportedly refrain, we continually make aesthetic judgments and apply quite different standards in the ways we treat works of fine art, television commercials, and photographs. These different standards undoubtedly affect our sense of what is appropriate behavior in dealing with the different products of the creative process. Someone who would, at the very least, feel pangs of guilt about taking paragraphs of material from another's work might feel much less constrained about "sampling" parts of a musical work. Should our law take these differences into account? Perhaps it would be more appropriate to ask whether our legal system is *capable* of taking these differences into account without sacrificing predictability and a modicum of efficiency.

Certainly, the law as it exists is not nearly as unitary as it purports to be. For example, as noted above, "architectural works" are protected notwithstanding the general principle against protection of utilitarian works, but the protection is not quite as extensive as that afforded to other works.[96] So, too, the rights of the owner of the copyright in a sound recording are far more limited than those of the copyright owner of the music contained in the recording.[97] In fact, the Copyright Act is liberally salted with special exceptions for particular kinds of works of authorship. Different classes of work may well merit different treatment, with perhaps differing scopes of protection and differing definitions of infringing activity. Such particularistic treatment may be most appropriate in the application of the judge-made concept of fair use, recognizing that more latitude is required for certain kinds of works than for others. Indeed, the U.S. Supreme Court has recognized that "some works are closer to the core of intended copyright protection than others, with the consequence that fair use is more difficult to establish when the former works are copied."[98]

Moreover, there may be other avenues of intervention to enhance the normative function of the law. Areas to explore here might include the peculiar matter of personal/private use of copyrighted material, the use of compulsory licenses, and the role of mass licensing organizations.

Personal/Private Use

There is a general misconception that there really is not anything wrong, legally or morally, with copying for purely personal (as opposed to commercial) use.[99] As *The Digital Dilemma* notes: "This viewpoint is difficult to support on either legal or ethical grounds. It is important to find ways to convince the public to consider thoughtfully the legality, ethics, and economic implications of their acts of private copying."[100]

> Individuals find themselves capable of reproducing vast amounts of information, in private, using commonplace, privately owned equipment. A single individual can now do in private what once would have required substantial commercial equipment and perhaps criminal intent. One important consequence is that copyright law is becoming more concerned with regulating private behavior of individuals.

Traditionally, copyright has concerned public actions with public consequences, such as public performance, public display, and dissemination of copies (an inherently public act), and has focused on actions of organizations or individuals (like pirates) whose actions have large-scale public consequences. But with computer and communication equipment becoming commonplace in the home, the potential impact of the private behavior of individuals has grown, and so correspondingly has interest in regulating that behavior.[101]

The Copyright Act does not provide broad exemption for private, noncommercial copying, although it does contain a number of very specific exemptions related to private taking of copyrighted material.[102] Particularly in the cultural context of digital copying, manipulation, and wholesale distribution, it is too easy to look at "private" copying as "harmless," if not permissible;[103] "the view is too prevalent that private use copying is virtually always fair use and . . . is often invoked to mask activities that, in the plain light of day cannot be justified."[104] In fact, in many cases the impact of such copying is a market displacement, as the recipient of the copy receives free something that would otherwise be subject to payment of royalties to the copyright owner.[105]

Nevertheless, it is worth exploring whether private use copying has differing impacts on different kinds of works and whether, irrespective of case-by-case fair use analysis, the "bundle of rights" (the components of the copyright for certain types of works) might exclude the purely private taking.[106] Of course, there is the danger of overspecification in defining certain works of authorship differently from others, but as we gain more experience with digital technology it may become easier to define and determine those kinds of works for which a more flexible copyright structure could harmonize the realities of the marketplace with the legitimate needs of the copyright owners.

Compulsory Licensing

One of the significant mediating devices of the Copyright Act is the compulsory license. The compulsory license device, where it applies, is the product of a congressional determination that the principal value of a certain use is economic and that the copyright owner should be satisfied with a fixed compensation for that use. Essentially, with a compulsory license the copyright owner, for a fee, involuntarily relinquishes the right to determine who may exercise certain of the owner's exclusive rights. In exchange for appropriate payment, the copyright owner is precluded from enforcing the right to exclude and is deemed to have granted a license to the user.[107]

Prior to passage of the 1976 act, there was only one significant compulsory license, that "for making and distributing phonorecords."[108] The 1976 act significantly expanded the use of compulsory licenses, an expansion that continued with the 1998 Digital Millennium Copyright Act.[109] The newer compulsory licenses contemplate

industrywide negotiation leading to the development of appropriate license rates, rather than rates fixed by Congress.

A widely publicized compulsory license scheme would appear to be particularly appropriate for digital images created for general public distribution by owners of digital libraries.[110] Moreover, such a compulsory license arrangement could also cover the right to manipulate images and create derivative works in the same medium. With the certainty of cost and certainty of legality created by the compulsory license mechanism, there is a reasonable possibility that a significant reduction in "piracy" would accompany the setting of reasonable and affordable license rates. Ideally, such an approach would also foster creativity and the development of better digital imaging techniques, much the way the original compulsory license for phonograph recording was the foundation for the growth of a vibrant recording industry.[111]

Cooperative Rights Licensing Organizations

Along with the growth of the compulsory licensing device has been an increase in interest in cooperative licensing organizations. The paradigm was set by the major music performance rights organizations, the American Society of Composers, Authors, and Publishers (ASCAP) and Broadcast Music, Inc. (BMI). These organizations work to enforce the exclusive right of the copyright owner of a musical work publicly to perform that work.[112] Quite apart from the difficulty of any copyright owner tracking live performances of copyrighted works, the vast proliferation of broadcast recorded music makes individual enforcement of performance rights a virtual impossibility. Moreover, there is certainly no general societal consensus as to the desirability of the copyright owner's performance right. Indeed, the right is almost counterintuitive, as one in lawful possession of, for example, a music CD would feel entitled to play that CD publicly, notwithstanding a law that makes such act infringing.

Nevertheless, collective action, through blanket licenses issued and enforced by ASCAP and BMI, has proven quite successful in generating significant revenues to copyright owners without hindering the virtually uninterrupted stream of publicly performed music. In this instance, vigorous enforcement, coupled with blanket licenses at affordable fees providing certainty and predictability to the licensees, have proved sufficient to overcome strong public antipathy toward and resistance to the right being enforced. Similar collective action, in the form of the Copyright Clearance Center, has been effective in limiting unauthorized copying of material from journals while encouraging limited copying and use of the material for research and similar purposes.[113]

This model of collective action, with broadly based licenses and reasonable rates, may well be appropriate for the licensing of rights to widely distributed digital images. It is perhaps a bit early to identify the appropriate stakeholders, but with further development of widely available digital technology that problem should be easily resolved. This approach, of course, changes neither societal perception of right and wrong nor

the normative position of applicable copyright law. Rather, it seeks to make compliance easier and more affordable than it currently is by means of a model that encourages broad public dissemination of creative works.

Malum in Se, Malum Prohibitum, and Compromise

I began this essay with an attempt to find and define the normative role of copyright law in the face of the pressures of advanced digital technology, pressures such that the law, even when understood, is often ignored. The task is complicated by the fact that there is widely divergent thinking as to the proper role of copyright in society. As one scholar notes:

> Hostility to copyright has a long and honorable history. . . .
>
> . . . one need climb no fences to make copies of intellectual products. The restraints are obviously artificial, making the state's hand visible in a way a physical barrier does not. One knows that one is doing something wrong when one tries to sneak into a neighbor's house or pick the lock of another's automobile; it may not seem so obviously wrong to tape a musical recording or duplicate a computer program that is already in hand. In addition, an act of copying seems to harm no one. There is no perceptible loss, no shattered lock or broken fencepost, no blood, not even a psychological sensation of trespass. As a result of all these factors, ordinary citizens may perceive a copyright owner's intangible interest as imposing an "extra" restriction, limiting their liberty in a way that ordinary property does not.
>
> [There] seems to be the perception, whether spoken or unspoken, that intellectual property is somehow a "sport," the statutory exception to the common law pattern, imposing unique restraints on liberty.[114]

There is a significant corpus of legal scholarship devoted to the pursuit of justification—or lack of justification—for copyright itself.[115] This work makes serious and important contributions to our understanding of the foundations of the American copyright system. Discussions of the purpose and function of copyright law may guide and inform constructive action. On the other hand, there is little to be learned from polemical debate over whether copyright is a "good" or "bad" institution. Unfortunately, in recent years there has been much gross oversimplification, in which copyright proprietors are demonized and users (authorized or unauthorized) of copyrighted material sanctified. Those who make such arguments do so generally in the interest of unstated premises bearing little relation to the reality of copyright and to the fact that the copyright construct is, after more than two hundred years, a fundamental part of the American legal system. That reality, born of both principle and compromise, defies such simplification. Meaningful discussion of accommodation of this complex law to technological exigencies and human behavior must be approached with an open mind, seriously, but without solemnity or stultifying preconceptions.

As we seek a normative approach to copyright, we must be aware of the pressures

of globalization and the need for harmonization. It is no longer possible for American law to operate in isolation or to disregard the intellectual property laws of the rest of the world, and it is therefore no longer sensible to make grand moral pronouncements as to the idiosyncrasies of American law.

American culture, particularly academic culture, has a strong strain of antipathy to copyright ownership—or at least to the rights attendant to such ownership; European culture, at least as embodied in the activities of the European Union, is far more protective of both the economic and the personal rights of copyright owners. Thus, whereas in American law there has been long-standing dispute and struggle over the place of industrial design, the European Union has long provided such design sui generis protection. Similarly, while the U.S. Congress and a variety of special interest groups continue to debate the matter, the European Union has issued and implemented a directive creating special protection for databases. So, too, the intricately complex fair use doctrine is largely a uniquely American judicial creation.

In general, the European and American approaches to intellectual property and related matters are the products of strikingly different cultural and societal forces. That is not to say that members of the general public in the European Union operate with greater moral constraints with respect to copyright than do Americans. There are, indeed, comparatively few universally accepted moral precepts related to copyright. Perhaps in this area pragmatism and politics must trump principle.

Certainly, to the extent that copyright law is unnecessarily complex, vigorous commitment to public education as to what is and what is not permissible under the law would be helpful. In *The Digital Dilemma,* the National Research Council's Committee on Intellectual Property Rights and the Emerging Information Infrastructure offers the following conclusion and recommendation:

> *Conclusion:* A better understanding of the basic principles of copyright law would lead to greater respect for this law and greater willingness to abide by it, as well as produce a more informed public better able to engage in discussions about intellectual property and public policy.

> *Recommendation:* An educational program should be undertaken that emphasizes the benefits that copyright law provides to all parties. Such a copyright education program needs to be planned and executed with care.[116]

Education, however valuable, can do little with respect to conscious disregard of or disrespect for the law, particularly the disregard that is fostered by a technology that makes infringing activity so easy and painless as to leave no mark on the conscience. Much of the conduct that we would call infringing, both in the past and in the context of digital technology, most people would consider "wrong," *malum in se;* other conduct that the law would consider infringing would be shrugged off by many, perhaps with a wink, as merely *malum prohibitum,* "Yeah, you're breaking the

law, but how big a law is it?"[117] In between is what might perhaps be called a moral swamp, an area of uncertainty. It is in that context that the much-maligned access, circumvention, and copying restrictions of the DMCA may serve a useful purpose. The danger, of course, as discussed above, is that of both overspecification—and the risk of legal constraints being overtaken and made irrelevant by further technological change—and overprotection, with concomitant limitation upon otherwise perfectly lawful and harmless activity and diminution of the public domain as a source of further creativity.

Ultimately, any normative role for copyright law must be as complex and contradictory as the law itself. The advances in digital technology of recent years have significantly upset what was always a precarious balance, and it is likely that further refinements to that technology will give rise to even more serious disruption. There is no simple set of "ought" and "ought not" to match the legal precepts of "shall" and "shall not." I have suggested a few areas of intervention that might serve to narrow, if not bridge, the gap between legal precepts and behavior. To some extent, there need to be areas that are *malum prohibitum* while not *malum in se* in order to foster those creative activities consistent with the overall constitutional purpose of copyright law; to some extent there needs to be greater flexibility in the law to foster those creative activities that would otherwise be hampered by the threat of infringement claims. This rather messy, complicated, and compromise-laden schema mirrors our rather messy, complicated, and compromise-laden world, and perhaps that is as it should be.

Notes

1. National Research Council, Committee on Intellectual Property Rights and the Emerging Information Infrastructure, *The Digital Dilemma: Intellectual Property in the Information Age* at ix (National Academies Press, 2000). The executive summary of *The Digital Dilemma* is reprinted in 62 Ohio St. L.J. 951 (2001).

2. Brian E. Zittel, "The Pirates of Pop Music Fill Streets with $5 CD's," *New York Times*, September 9, 1999, E1. "Music 'pirates' use digital recording technology to make and to distribute near perfect copies of commercially prepared recordings for which they have not licensed the copyrights"; *Recording Industry Association of America v. Diamond Multimedia Systems Inc.*, 180 F.3d 1072, 1073 (9th Cir. 1999).

3. 17 U.S.C. § 106 (1994 & Supp. IV 1998).

4. See the subsection below headed "Personal/Private Use."

5. Quoted in Zittel, note 2.

6. Amy Harmon, "Potent Software Escalates Music Industry's Jitters," *New York Times*, March 7, 2000, A1.

7. Quoted in ibid.

8. Quoted in ibid.

9. As a member of the music industry observed: "'There's an incredible disconnect out there between what is normal behavior in the physical world versus the online world.... There are people who think nothing of downloading entire CD collections on Napster who wouldn't dream of shoplifting from Tower Records.'" Quoted in ibid.

10. The American experience with Prohibition is the most glaring example.

11. National Research Council, note 1, at 214.

12. Ibid. at 2–4.

13. Ibid. at 21. See Neil Weinstock Netanel, *Copyright and a Democratic Civil Society*, 106 Yale L.J. 283, 285 (1996): "Digital technology threatens to upend copyright's already uneasy accommodation of public access with private ownership. Once a creative work is freely available online, anyone can, with a few clicks of a mouse, make perfect digital copies and limitless digital variations, and can electronically distribute them to the ends of the earth."

14. U.S. Const., Art I, § 8, Cl. 8.

15. 17 U.S.C. § 106 (1994 & Supp. IV 1998).

16. Netanel, note 13, at 285.

17. See generally Jessica D. Litman, *Copyright, Compromise, and Legislative History*, 72 Cornell L. Rev. 857 (1987).

18. 17 U.S.C. § 109 (1994 & Supp. IV 1998).

19. § 106(3).

20. Record Rental Amendment of 1984, Pub. L. No. 98–450, 98 Stat. 1727 (1984) (codified as amended at 17 U.S.C. § 109[b] [1994 & Supp. IV 1998]).

21. See generally Sheldon W. Halpern, Craig Allen Nard, and Kenneth L. Port, *Fundamentals of United States Intellectual Property Law: Copyright, Patent, and Trademark* § 2.4.4 (Kluwer Law International, 1999).

22. Architectural Works Copyright Protection Act, Pub. L. No. 101–650, 104 Stat. 5133 (1990) (codified as amended at 17 U.S.C. § 102[8] [1994]) (adding "architectural works" to the enumeration of "works of authorship").

23. See, for example, Jessica D. Litman, *Copyright Legislation and Technological Change*, 68 Or. L. Rev. 275 (1989).

24. Act of October 19, 1976, Pub. L. No. 94–553, 90 Stat. 2541 (1976) (codified as amended in scattered sections of 17 U.S.C.).

25. National Commission on New Technological Uses of Copyrighted Works, Pub. L. No. 93–573, 88 Stat. 1873 (1974).

26. 17 U.S.C. § 101 (Supp. IV 1998) (defining the computer program as "a set of statements or instructions to be used directly or indirectly in a computer in order to bring about a certain result").

27. See, for example, *Apple Computer, Inc. v. Franklin Computer Corp.*, 714 F.2d 1240, 1249 (3d Cir. 1983) (holding that "a computer program . . . is a 'literary work'").

28. 17 U.S.C. § 117 (Supp. IV 1998) (providing a limited exception to the exclusive right of copyright owners to control the copying of computer programs).

29. This concern was the basis for the amendments to the "first sale" provisions relating to rental of records, discussed in note 19 above and accompanying text.

30. *Diamond Multimedia*, 180 F.3d at 1073: "For example, when an analog cassette copy of . . . a compact disc is itself copied by analog technology, the resulting 'second-generation' copy of the original will most likely suffer from the hiss and lack of clarity characteristic of older recordings."

31. 17 U.S.C. §§ 1001–1010 (1994 & Supp. IV 1998).

32. § 1008.

33. See *A & M Records, Inc. v. Napster*, 239 F.3d 1004, 1014 (9th Cir. 2001).

34. See *Diamond Multimedia*, 180 F.3d at 1079: "As the Senate Report explains 'The purpose of [the act] is to ensure the right of consumers to make analog or digital audio recordings of copyrighted music for their *private, noncommercial use*.' . . . The Act does so through its home taping exemption, *see* 17 U.S.C. § 1008, which 'protects all noncommercial

copying by consumers of digital and analog musical recordings,' H.R. Rep. 102–873(I), at *59."

35. *Napster,* 239 F.3d at 1024.

36. *Diamond Multimedia,* 180 F.3d at 1079: "The Act seems designed to allow files to be 'laundered' by passage through a computer."

37. In *Diamond Multimedia,* 180 F.3d at 1074, the court stated: "These technological advances have occurred, at least in part, to the traditional music industry's disadvantage. By most accounts, the predominant use of MP3 [digital compression technology used on the Internet] is the trafficking in illicit audio recordings. . . . Various pirate websites offer free downloads of copyrighted material, and a single pirate site on the Internet may contain thousands of pirated audio computer files."

38. Ibid.

39. 17 U.S.C. § 117 (Supp. IV 1998).

40. See, for example, *Vault Corp. v. Quaid Software, Ltd.,* 847 F.2d 255 (5th Cir. 1988).

41. Pub. L. No. 105–304, 112 Stat. 2860 (1998) (codified as amended in scattered sections of 17 U.S.C. [Supp. IV 1998]).

42. § 1201(a)(1)(A); § 1201(a)(2), (b)(1). See generally Halpern et al., note 21, § 11.2.

43. See National Research Council, note 1, at 221–23.

44. *Burrow-Giles Lithographic Company v. Sarony,* 111 U.S. 53 (1884) (involving a photograph of Oscar Wilde).

45. Ibid. at 57–58.

46. See, for example, 17 U.S.C. § 102(a) (1994): "Works of authorship include the following categories: (1) literary works; (2) musical works, including any accompanying words; (3) dramatic works, including any accompanying music; (4) pantomimes and choreographic works; (5) pictorial, graphic, and sculptural works; (6) motion pictures and other audiovisual works; (7) sound recordings; and (8) architectural works."

47. Ibid.

48. *Feist Publications, Inc. v. Rural Telephone Service Co., Inc.,* 499 U.S. 340, 348 (1991).

49. Ibid. at 345. "The requirement of originality actually subsumes two separate conditions, i.e., the work must possess an independent origin and a minimal amount of creativity"; *Baltimore Orioles v. Major League Baseball Players,* 805 F.2d 663, 668 (7th Cir. 1986). "A work is original if it is the independent creation of its author. A work is creative if it embodies some modest amount of intellectual labor"; ibid. at 668 n. 6.

50. *Feist,* 499 U.S. at 345. In *Atari Games v. Oman,* 979 F.2d 242, 247 (D.C. Cir. 1992), the court reversed denial of registration of a simple geometric "paddle" video game. Judge (now Justice) Ruth Bader Ginsburg emphasized how minimal the creativity standard is: "We are mindful . . . of the teaching of *Feist* that 'The vast majority of works make the [copyright] grade quite easily' "; ibid.

51. *Bleistein v. Donaldson Lithographing Co.,* 188 U.S. 239, 250 (1903); compare *Mazer v. Stein,* 347 U.S. 201, 214 (1954): "Individual perception of the beautiful is too varied a power to permit a narrow or rigid concept of art."

52. *The Bridgeman Art Library, Ltd. v. Corel Corp.,* 36 F. Supp. 2d 191, 195 (S.D.N.Y. 1999). See also *Time, Inc. v. Bernard Geis Assoc.,* 293 F. Supp. 130 (S.D.N.Y. 1968) (finding originality in the photographer's decision as to the camera angle, lighting, the choice of film, exposure speeds, focus, and variety of other factors that go into producing the finished product); *Rogers v. Koons,* 960 F.2d 301, 307 (2d Cir. 1992) ("Elements of originality . . . may include posing the subjects, lighting, angle, selection of film and camera, evoking the desired expression, and almost any other variant involved"); *Leibovitz v. Paramount Pictures Corp.,* 137 F.3d 109, 116 (2d Cir. 1998) (quoting *Rogers,* 960 F.2d at 307).

53. See *Bridgeman*, 36 F. Supp. 2d at 196 (holding that there is broad scope for copyright in photographs because "a very modest expression of personality will constitute sufficient originality"; footnote omitted).

54. *Bleistein*, 188 U.S. at 251.

55. See generally *Feist*, 499 U.S. at 340.

56. 17 U.S.C. § 106(2) (1994).

57. § 103: "(a) The subject matter of copyright... includes... derivative works.... (b) The copyright in a... derivative work extends only to the material contributed by the author of such work, as distinguished from the pre-existing material employed in the work, and does not imply any exclusive right in the pre-existing material."

58. § 101: "A 'derivative work' is a work based upon one or more pre-existing works, such as a translation, musical arrangement, dramatization, fictionalization, motion picture version, sound recording, art reproduction, abridgement, condensation, or any other form in which the work may be recast, transformed, or adapted. A work consisting of editorial revisions, annotations, elaborations, or other modifications which, as a whole, represented an original work of authorship, is a 'derivative work.'"

59. Ibid.

60. H.R. Rep. No. 94–1476, at 62 (1976); S. Rep. No. 94–473, at 58 (1975). See also *Lewis Galoob Toys, Inc. v. Nintendo of America, Inc.*, 964 F.2d 965 (9th Cir. 1992) (holding that the manufacturer of Game Genie, which allowed players to alter features of Nintendo's copyrighted games, was not a derivative work).

61. 17 U.S.C. § 102 (1994). See generally Halpern et al., note 21, § 2.3.3.

62. This fundamental proposition was initially set out by Judge Learned Hand in two early opinions that have set the analytic basis for determination of infringement: *Nichols v. Universal Pictures Corp.*, 45 F.2d 119 (2d Cir. 1930); *Sheldon v. Metro-Goldwyn Pictures Corp.*, 81 F.2d 49 (2d Cir. 1936).

63. *Bateman v. Mnemonics, Inc.*, 79 F.3d 1532, n. 25 (11th Cir. 1996). See also *Twin Peaks Productions, Inc. v. Publications International Ltd.*, 996 F.2d 1366, 1372 (2d Cir. 1993): "Substantial similarity can take the form of 'fragmented literal similarity' or 'comprehensive nonliteral similarity'" (citation omitted).

64. For an extreme statement of the position, see Louise Harmon, *Law, Art, and the Killing Jar*, 79 Iowa L. Rev. 367 (1994).

65. Even the "intermediate" copying of the original in the creation of a work that does not ultimately contain the copyrighted material can be infringing. See, for example, *Sega Enterprises Ltd. v. Accolade, Inc.*, 977 F.2d 1510, 1518–19 (9th Cir. 1992).

66. See, for example, *Lewis Galoob Toys*, 964 F.2d at 967: "A derivative work must incorporate a protected work in some concrete or permanent 'form.'... The examples of derivative works provided by the [Copyright] Act all physically incorporate the underlying work or works. The Act's legislative history similarly indicates that 'the infringing work must incorporate a portion of the copyrighted work in some form'" (citations omitted).

67. It has been suggested that a new work cannot be considered an infringing derivative work if it is not "substantially similar" to the underlying work. See, for example, *Litchfield v. Spielberg*, 736 F.2d 1352, 1356 (9th Cir. 1984). However, in general, the "substantial similarity" test is used to determine infringement in the absence of direct proof of copying; access and substantial similarity together provide circumstantial evidence of copying. Where, as in the hypothetical situation posited here, the copying and physical incorporation are conceded, the relevance of a substantial similarity inquiry is questionable.

68. *Sega*, 977 F.3d. at 1525, 1518, 1527–28. *Sega* was followed in *Sony Computer Entertainment, Inc. v. Connectix Corp.*, 203 F.3d 596 (9th Cir. 2000). *Sega* was expressly adopted in

Bateman, 79 F.3d at 1540 n. 18: "We find the Sega opinion persuasive in view of the principal purpose of copyright—the advancement of science and the arts." See *Atari Games Corp. v. Nintendo of America Inc.,* 975 F.2d 832, 843 (Fed. Cir. 1992): "Reverse engineering object code to discern the unprotectable ideas in a computer program is a fair use."

69. *Sega,* 977 F.2d at 1527.

70. *Campbell v. Acuff-Rose Music, Inc.,* 510 U.S. 569, 575 (1994) (second alteration in original; footnote omitted) (quoting U.S. Const., Art. I, § 8, Cl. 8; *Emerson v. Davies,* 8 F. Cas. 615, 619 [C.C.D. Mass. 1845] [Story, J.]).

71. Benjamin Kaplan, *An Unhurried View of Copyright* 2 (Columbia University Press, 1967).

72. *Campbell,* 510 U.S. at 579.

73. *Rogers,* 960 F.2d at 310.

74. *Feist,* 499 U.S. at 349–50 (quoting from Justice Brennan's dissenting opinion in *Harper & Row Publishers, Inc. v. Nation Enterprises,* 471 U.S. 539 [1985]).

75. National Research Council, note 1, at 232.

76. The derivative work may be noninfringing because it was created with the consent of the copyright owner of the underlying work, because the underlying work is in the public domain, or because the derivative work is considered a fair use of the underlying material.

77. 17 U.S.C. § 101 (Supp. IV 1998).

78. *Gracen v. Bradford Exch.,* 698 F.2d 300, 305 (7th Cir. 1983) (holding that artist's rendering of Dorothy from *The Wizard of Oz* was not an original derivative work copyrightable under the Copyright Act).

79. See, for example, *Entertainment Research Group, Inc. v. Genesis Creative Group, Inc.,* 122 F.3d 1211, 1218–19 (9th Cir. 1997): "The copyright protection afforded to derivative works is more limited than it is for original works of authorship."

80. *Alfred Bell & Co. Ltd. v. Catalda Fine Arts, Inc.,* 191 F.2d 99, 104–5 (2d Cir. 1951).

81. Ibid. at 105.

82. *Alva Studios, Inc. v. Winninger,* 177 F. Supp. 265, 267 (S.D.N.Y. 1959): "Great skill and originality is called for when one seeks to produce a scale reduction of a great work with exactitude."

83. *Gracen,* 698 F.2d at 305; *Durham Industries, Inc. v. Tomy Corp.,* 630 F.2d 905, 909 (2d Cir. 1980) (holding that plastic reproductions of Disney figures were not copyrightable); *L. Batlin & Son, Inc. v. Snyder,* 536 F.2d 486, 490 (2d Cir. 1976) (holding copyright of mechanical toy banks invalid for lack of any substantial variation from the original); *Hearn v. Meyer,* 664 F. Supp. 832, 835 (S.D.N.Y. 1987) (holding that reproductions of illustrations by an author were not original, and thus not copyrightable).

84. *L. Batlin & Son,* 536 F.2d at 486, 491, 492.

85. *Alfred Bell & Co. v. Catalda Fine Arts, Inc.,* 191 F.2d 99 (2d Cir. 1951).

86. In the Second Circuit, see *Durham Industries,* 630 F.2d 905; *Bridgeman Art Library, Ltd. v. Corel Corp.,* 36 F. Supp. 2d 191 (S.D.N.Y. 1999) *(Bridgeman II);* and *Hearn v. Meyer,* 664 F. Supp. 832. See also *Gracen,* 698 F.2d 300.

87. See *Feist,* 499 U.S. at 352–60.

88. *Bridgeman II,* 36 F. Supp. 2d at 191.

89. *Bridgeman Art Library, Ltd. v. Corel Corp.,* 25 F. Supp. 2d 421, 423–24 (S.D.N.Y. 1998) *(Bridgeman I).*

90. Ibid. at 424.

91. *Bridgeman II,* 36 F. Supp. 2d at 197. In its earlier opinion, *Bridgeman I,* 25 F. Supp. 2d at 421, the court had reached the same conclusion applying the law of the United King-

dom. Ibid. at 426. On reconsideration, in *Bridgeman II,* 36 F. Supp. 2d at 195, the court determined that the law of the United States as to "originality" governed.

92. *Bridgeman II,* 36 F. Supp. at 197.

93. Ibid. at 196.

94. 17 U.S.C. § 102(a) (1994).

95. See § 101.

96. See, for example, § 120(a): "The copyright in an architectural work that has been constructed does not include the right to prevent the making, distributing, or public display of pictures, paintings, photographs, or other pictorial representations of the work, if the building in which the work is embodied is located in or ordinarily visible from a public place."

97. § 114.

98. *Campbell,* 510 U.S. at 586.

99. See National Research Council, note 1, at 214, and the text accompanying note 11.

100. Ibid.

101. Ibid. at 46.

102. See, for example, the text accompanying note 32, above.

103. National Research Council, note 1, at 124: "Misconceptions [about private copying] concern print, graphics, or other visual content. Some of these are that if the purveyor of the illegal copies is not charging for them or otherwise making a profit, the copying is not an infringement; that anything posted on the Web or on a Usenet newsgroup must be in the public domain by virtue of its presence there; that the First Amendment and fair use doctrine allow copying of virtually any content so long as it is for personal use in a home, rather than redistribution to others; that anything received via email can be freely copied and that if the uploading, posting, downloading, or copying does not, in the view of the end-user, hurt anybody or is just good free advertising, then it is permissible."

104. Ibid. at 135–36.

105. See generally ibid., chapter 4, "Individual Behavior, Private Use and Fair Use, and the System for Copyright."

106. The very definition of the rights attaching to a given work of authorship may be limited, just as the distribution, performance, and display rights are limited to "public" activities. 17 U.S.C. § 106(3), (4), & (5) (1994 & Supp. IV 1998).

107. See generally Halpern et al., note 21, § 6.1.2.

108. 17 U.S.C. § 115 (1994).

109. Pub. L. No. 105–304, 112 Stat. 2860 (1998) (codified as amended at scattered sections of 17 U.S.C. [Supp. IV 1998]).

110. The economic trade-off between payment of a set fee and relinquishment of the right to exclude would not seem to be applicable to the case of the individual creator of a visual work not designed for mass distribution.

111. See Halpern et al., note 21, § 6.1.2.6.

112. 17 U.S.C. § 106(4) (1994). ASCAP, the first and still largest of the performing rights societies, is essentially a licensing, collection, and distribution body. Its members—composers, authors, and publishers of copyrighted musical works—assign to the society the nonexclusive right to license the small performance rights (the nondramatic musical performance rights) to their works collectively. With the licenses from the individual members, the society then negotiates blanket licenses with broadcast stations, restaurants, bars, health clubs, and any other entities desiring to perform any of the works. In exchange for payment of an annual fee, a licensee then may exercise the nondramatic musical rights attaching to any and

all of the society's works. The organization then distributes the accumulated license fees, after expenses, to the members more or less on the basis of the frequency of performance of their works, as determined by statistical samples. See generally Bernard Korman and I. Fred Koenigsberg, *Performing Rights in Music and Performing Rights Societies,* 33 J. Copyright Soc. U.S.A. 332 (1986).

113. See generally *American Geophysical Union v. Texaco, Inc.,* 802 F. Supp. 1 (S.D.N.Y. 1992), *aff'd,* 60 F.3d 913 (2d Cir. 1994).

114. Wendy J. Gordon, *An Inquiry into the Merits of Copyright: The Challenges of Consistency, Consent, and Encouragement Theory,* 41 Stan. L. Rev. 1343, 1344, 1346–47 (1989).

115. For particularly comprehensive, thoughtful, and provocative discussions, see ibid. and Netanel, note 14.

116. National Research Council, note 1, at 217.

117. See note 8 and accompanying text.

8

Fair Use and the Visual Arts:
Please Leave Some Room for Robin Hood

Stephen E. Weil

My argument in this chapter rests on two foundations. One is the conception of fair use that federal judge Pierre N. Leval has so eloquently articulated over recent years—that is, that fair use is not an *exception* to copyright's overall objective but, rather, wholly *consistent* with that objective.[1] If copyright's initial purpose was, as Leval has argued, to be an incentive that would stimulate progress in the arts for the intellectual enrichment of the public, then what is basically required in order to determine whether any particular use is or is not a fair one is a two-pronged inquiry. First, is the use consistent with copyright's underlying purpose of stimulating further productive thought and public instruction?[2] Second, if so, does it then do so without unduly dampening copyright's incentive for creativity?

The other foundation upon which my argument in this chapter rests is the proposition that the realms of the verbal and the visual are so fundamentally different that the rules developed to govern fair use in one realm—language-based rules developed primarily in the context of the printed word—are not necessarily the most productive rules by which to govern fair use in the other. I will argue here that the objective

of copyright could better be achieved if the visual arts had a distinct and separate fair use regime of their own. In considering the outlines of such a regime, regard must be given not only to the ways in which the visual arts, taken as a whole, differ from their creative counterparts in other realms and most especially from the domain of the printed word, but also to the ways in which the various genres within the visual arts differ from one another. I consider four such differences below.

Appropriation

In contrast to its relatively infrequent use in literature, appropriation has played and continues to play an important role in many of the most significant visual art movements of the past century. On a recent visit to the Hirshhorn Museum and Sculpture Garden, I was struck by how many objects there were on view in which one artist made reference to the work of another.[3] In the museum's then-ongoing special exhibition, *Regarding Beauty*, the first six works of art that a visitor encountered—works by artists as diverse as Jannis Kounellis, Michelangelo Pistoletto, Yasumasa Morimura, and Cindy Sherman—all incorporated, in part or in whole, other works of art: casts of antique sculpture, a series of portraits from the Renaissance, and, in one instance, Manet's great painting *Olympia* in its entirety.[4]

On another floor, Nam June Paik's *Video Flag*—its seventy thirteen-inch monitors arranged in the familiar format of the American flag—was pulsing out a barrage of microsecond-long snippets culled from television newscasts, documentaries, commercials, and films. Elsewhere were Larry Rivers's witty reprises of Cezanne's *Card-players* and David's standing portrait of Napoleon together with Gerhard Richter's sumptuous repainting of Titian's *Annunciation* and Andy Warhol's own idiosyncratic version of the Mona Lisa. Outside the museum, in shimmering stainless steel, stood Jeff Koons's six-foot-high *Kiepenkerl*, a work cast directly from a twentieth-century replica of a nineteenth-century bronze sculpture depicting a local tenant farmer that once stood in a square in Münster, Germany.

All this is more than coincidence. As the California-based experimental music and art collective Negativland has said:

> Artists have always perceived the environment around them as both inspiration to act and as raw material to mold and remold. However, this particular century has presented us with a new kind of . . . human environment. We are now all immersed in an ever-growing media environment—an environment as real and just as affecting as the natural one from which it sprang.[5]

In tandem with the emergence of this "ever-growing media environment" has been the emergence, not surprisingly, of a new legal environment as well. The environment by which artists had once been surrounded was a freely usable one of landscapes, seascapes, and townscapes, of cottages and cows. This new environment—the one that artists today are seeking to mold and remold—consists of an ever-greater

measure of media and other human creations in which intellectual property rights generally subsist. A contemporary artist who today seeks to portray aspects of everyday life must, in the course of doing so, almost inescapably bump up against somebody else's copyrighted material.

Beyond this change in subject matter, the repertory of techniques available to contemporary artists has also expanded. One important early-twentieth-century development was the emergence of collage, a technique that frequently depends on the use of previously printed materials. A corollary technique—common to virtually all of the photography-based arts—is montage, which, again, may rely heavily on pre-existing films, photographs, or video.[6] Artists who would avoid complications by limiting their appropriations to material in the public domain find that the public domain itself has shrunk and continues to shrink. The American artist Cindy Sherman, for example, is not yet fifty years old. If the artists of some future generation should choose to build upon her art in the same manner that she herself has chosen to build upon the work of still earlier artists, it could well be another one hundred years or more before her work is safely in the public domain and those artists of the future are clearly at liberty to do so.

If our society is to continue to be enriched by the vigorous production and distribution of original works of visual art, then visual artists need a license to forage widely—far more widely than conventionally interpreted copyright law might permit—in gathering the raw materials out of which to compose their work. In *Campbell v. Acuff-Rose Music,* the U.S. Supreme Court unanimously ruled that the rap group 2 Live Crew's 1989 version of Roy Orbison's 1964 hit song "Oh, Pretty Woman" could be characterized as a parody and that, accordingly—under a judicially crafted exception to the copyright law—it did not constitute an infringement of the original.[7] Although the 2 Live Crew case might be read as a promising step in the right direction, it should be viewed with great caution. In the end, 2 Live Crew's in-your-face rap music proved so outrageous that the Supreme Court could not escape its parodic element.[8]

That the deadpan and often elusive ironies of postmodernist visual art are also parodies may not be quite so clear. *Rogers v. Koons,* a case in which the court never really *got* what the artist intended, certainly seems a case in point.[9] Even had the *Koons* case been decided otherwise, it would still have left visual artists with a remarkably narrow fair use opening through which to wiggle. Parody is by no means the only mode by which one work of art may refer to another in order to achieve a desired artistic effect.

The American literary critic R. P. Blackmur once observed that poetry has the capacity to add to our "stock of available reality."[10] Works of visual art share that same capacity. When the copyright law is used—as it was in *Koons*—not merely to award damages but actually to suppress a work of art, then its effect is to diminish the stock of reality available to all of those who might one day have come into contact

with that work. Or worse, as Louise Harmon points out in an article that raises questions about the *Koons* decision, the loss to the public in such an instance may go far beyond just that one particular work of art. "Other artworks," she writes, "may never reach maturation; some may never be conceived. There is much to mourn in Jeff Koons's defeat. Little unseen deaths inside you, inside me."[11]

In terms of the public's enrichment, the benefits to be expected from permitting visual artists to work at their imaginative fullest would seem to outweigh by far any resulting disincentives to creativity. Visual artists, above all, need a fair use rule that is both flexible enough and spacious enough to permit them a considerable degree of appropriation. To the extent that they might abuse such a privilege, remedies less drastic than to deprive the public of their work might better be established elsewhere than under the copyright law.

Reproduction

For the visual arts to achieve their maximum vigor, artists require not only the freedom to work at their imaginative fullest but also the support provided by an "art world" of collectors, curators, critics, and others. Such an art world cannot function properly, however, without the relatively unimpeded circulation within it of images of contemporary art in forms such as slides, transparencies, and printed illustrations. Of the several sensory dominions we inhabit, that of the visual is arguably the most complex—both in the richness of the elements by which it is composed and in the simultaneity with which those elements may be apprehended. At any given moment, an individual's visual field can encompass hundreds or even thousands of these elements, each of a distinctive color, contour, and texture. In terms of color alone, the appearance of any single element may change from moment to moment, depending on the distance from which it is seen, the light by which it is illuminated, and the proximity it has to one or more other elements. If Eskimos truly do have thirty words for snow, that number pales by comparison to the vocabulary that would be required—perhaps a million words or more—to name all the distinct colors among which the human eye can purportedly differentiate. The computer does even better. A twenty-four-bit monitor has the capacity to produce more than sixteen million different colors.

Regard must be given here to those differences alluded to earlier between the realms of the verbal and the visual. That words can be adequately defined by other words is what makes a dictionary possible. By the same token, most verbal compositions—novels, plays, even narrative poems—can be effectively summarized or even paraphrased. A reviewer, for example, might write a perfectly intelligible review of a new novel or play without ever actually quoting a single line of text.

In general, however, images cannot be defined adequately at all, either by words or by other images. Likewise, works of visual art—because they partake of the simultaneity and infinite complexity of the visual realm—cannot be adequately summa-

rized or paraphrased. Neither can they be accurately described. Imagine trying to provide an adequate verbal account of Botticelli's *Primavera* or Rembrandt's *Night Watch*.[12] Unlike the situation of the literary critic, it would be virtually impossible for an art reviewer to write an intelligible review of a new painting without providing the reader with some pictorial notion of what the painting itself looks like. Not even quotations can help. A work of visual art, unlike a literary work, is incapable of yielding up a quotable extract—some small detail that might give a better sense of the whole. If works of contemporary visual art are to be discussed, analyzed, debated, compared, championed, criticized, or demonized, or otherwise to serve as the center of any serious discourse, then images of those works—images of them in full, not just details—must be available to circulate among those who participate in that discourse and who ultimately provide a support system for the creators of those works.

Just as it might be sound copyright policy to provide contemporary visual artists with greater latitude than other creative practitioners as to what they may incorporate into their own work, it may also be sound policy to limit the ability of such artists to use copyright to impede the free circulation of images of that work within the cultural and commercial marketplaces. It is also important that artists (or, as may be more frequently the case in actual practice, the surviving spouses or other heirs of artists) not be able to use copyright in wholly arbitrary ways as a means to stifle and/or control the views expressed by others with respect to their work. To put too great an emphasis on the exclusionary aspects of copyright is to undermine its fundamental public service objective.

Section 107 of the Copyright Act provides that the factors to be considered in any particular case in determining whether certain uses for purposes such as criticism, comment, news reporting, teaching, scholarship, and research might be "fair uses" and consequently noninfringing shall include the following:

> (1) the purpose and character of the use, including whether such use is of a commercial nature or is for nonprofit educational purposes; (2) the nature of the copyrighted work; (3) the amount and substantiality of the portion used in relation to the copyrighted work as a whole; and (4) the effect of the use upon the potential market for or value of the copyrighted work.[13]

Arguably, then, in determining the fairness or unfairness of producing and distributing photographic and/or printed copies of a work of art for educational purposes or for comment and criticism, one should give little or no weight to the third of section 107's four fair use factors—the amount and substantiality of the portion used in relation to the copyrighted work as a whole.[14] Because visual images cannot be summarized, paraphrased, described, or even quoted from, it follows that uses intended for the purposes of education, criticism, and comment must—if they are to engender the meaningful discourse essential to the ongoing well-being of the visual arts—necessarily include some greater "amount and substantiality" of the copyrighted original

than might be the case for some other kind of a use or in some other area of creativity. Instead, added weight must go to factor 1—the purpose and character of such a use.[15]

Thus approached, a use that is truly aimed at encouraging a broader and/or more discriminating appreciation of a work of visual art should, absent some fatal problem under factor 4, per se qualify as a fair use. Factor 3, then, might regain some greater weight only when the purpose of the use does not pertain to education, criticism, or comment.

Business Models

The extent to which strong copyright protection is warranted for a work of visual art may depend upon the business model by which it is distributed to the public and the medium in which it was originally created. Works of visual art are distributed to the public through a broader variety of business models than are the products of other creative domains. Consider the spectrum along which these might be arrayed.

At one extreme is the model employed by Thomas Kinkade, the California painter of sentimental landscapes and rain-glittering city scenes whom the *New York Times* described in 1999 as this country's most commercially successful artist.[16] Kinkade reportedly does not sell his original paintings at all. What he sells instead are prints made from the original. Distributed by a captive network of more than two hundred galleries (the "Signature Galleries"), these prints are offered in a dazzling variety of formats: "Studio Proofs," "Gallery Proofs," "Renaissance Editions," versions touched up with a little paint by studio assistants, and versions touched up with quite a bit more paint by the artist himself. Prices can range from $35 for a small framed gift card to $10,000 or more for a large hand-touched paper print mounted on canvas. Although some editions are limited, the limits can run up to several thousand for each size of each image. For fiscal 1999, Kinkade's publisher—the New York Stock Exchange–listed Media Arts Group, Inc.—reported net revenues of $126 million. Assuming that half the retail sales proceeds were retained by the galleries, that would suggest that the volume of Kinkade sales to the public was then in the vicinity of $250 million annually.

At the Kinkade end of the spectrum, then, what we have is the work of art as the source of a valuable image. At the other end of the spectrum—in total contrast—is the work of art as a precious object. The most familiar example of a work of art of this latter type is the hand-painted canvas that an artist has personally created in a single copy—a copy that he or she hopes to sell for a price that will generally constitute the entire income ever to be realized from its production. As a specific example, consider a work by the contemporary British figurative painter Lucian Freud, who has reportedly sold several of his most recent paintings for prices upward of $2 million each.

Let us now suppose, first, that each of these artists still retains copyright to his work and, second, that an art museum—the Philadelphia Museum of Art, for ex-

ample—without the authorization of either artist, produces and offers for sale in its on-site gift shop a set of full-color postcards of paintings by both these artists, Kinkade and Freud. Assuming that the museum can successfully argue that its distribution and sale of postcards is at bottom educational, thereby meeting the threshold test of section 107, and assuming that the third section 107 fair use factor is not to be given any weight, how confidently can we proceed to apply the fourth fair use factor—the one that addresses the effect of this use on the market?

In the case of Kinkade, the fourth factor makes an excellent fit. Kinkade's business model is essentially that of a book publisher who, without ever attempting to sell the underlying manuscript itself, simultaneously offers deluxe clothbound and paperbound editions of the text. Under those circumstances, the unauthorized Kinkade postcards might compete directly with the small framed gift cards that Kinkade's galleries themselves offer for $35. An attempt to defend such a use as fair under section 107 might very well founder over this fourth factor, potentially having an effect on the market for or value of the copyrighted work. To permit the manufacture and distribution of such postcards could only, in Judge Leval's analysis, diminish the artist's incentive for creativity without providing the public with any substantial benefit beyond that which it already enjoys.

The case of the Freudian postcards is different. Freud's business model—a very traditional model for painters—is to sell his original paintings and to suppress whatever urge he may otherwise feel to traffic in printed copies of these. The fourth factor of section 107 scarcely fits his situation at all. Assuming in the first place that the paintings depicted on the postcards were for sale—they might not be; they might be in the hands of museums that never dispose of works of art from their collections—it would still be ludicrous to contend that these postcards might adversely affect the artist's market because a potential purchaser of one of his paintings would not likely be tempted to acquire a postcard as a substitute.

Alternatively, although such an unauthorized postcard might be competitive with an *authorized* small-scale printed version of the painting—in which case its manufacture and distribution might be palpably unfair—what if no such authorized small-scale version is to be anticipated? The 2 Live Crew case, discussed earlier, suggests that an unauthorized derivative work may constitute a fair use when there is little likelihood of a similar version ever appearing with the copyright owner's authorization.[17] If these postcards and other small-scale printed versions are unauthorized derivative works, then it might be arguable, again in Levallian terms, that the museum's production and distribution of these Freudian postcards is enriching to the public without diminishing the artist's incentive for continued creativity in any substantial way.[18]

Between these Kinkadian and Freudian extremes are a host of other business models, each with its own following among visual artists. In every instance, to what extent and how the section 107 factors can be applied to even so seemingly simple a

copy as a picture postcard will depend on very specific facts and circumstances. And picture postcards, in turn, are only the tip of the complexity. Offered within every museum shop, beyond those postcards, are a host of other art-derived products, some of such hefty and indisputable educational value as scholarly catalogs and some of such tangential or even dubious educational value as coffee cups and T-shirts. Notwithstanding the fantasies of those who hope that copyright law might be smoothed out to an easy, uniform application, each of these many uses might still require a separate determination, on the basis of all of its particular facts and circumstances, of whether or not it is a fair one.

Further complicating the application of the fourth fair use factor in section 107 is that the range of materials and techniques employed to create both original works of visual art and copies of those works is also far broader than that to be found in other creative domains. Notwithstanding the variety of forms they may take, literary works are invariably embodied in language. Determining whether, and to what degree, any particular text may be a copy of some other—even when the language of the original has been changed through translation—may be little more, at least conceptually, than a case of comparing apples with apples. Within the visual arts, however, comparisons can rapidly escalate to the level of apples and oranges.

Until late in the nineteenth century, the visual fine arts largely consisted of painting in a variety of media and on a variety of surfaces, sculpture (both cast metal and carved wood or stone), printmaking, and drawing. In the years since, however, that list has expanded to include collage; constructed sculpture; sculpture cast or otherwise fabricated in glass, plastic, and ceramic; conceptual art; fabric art; earth art; and, perhaps most important, the whole and still-expanding range of photography-based fine art forms, including still photography, motion pictures, video art, and, now just emerging, Internet art. Also expanded has been the range of materials and techniques by which these original works of fine art may be copied, sometimes in their original media, sometimes in other media altogether.

Returning to our hypothetical on-site museum store—the one that specializes in unauthorized copies—the least perplexing cases for fair use purposes might be those in which an original work of art was copied so exactly in terms of both its medium and its appearance as to be virtually indistinguishable from the original. That might be the case, for example, with a minimalist sculpture by Donald Judd or Carl Andre, a black-and-white photograph by Robert Mapplethorpe, or a work of digitalized video art by Bruce Nauman. In those instances, the fourth fair use factor of section 107 again appears to make an easy fit. Setting aside their lack of appeal to that perhaps handful of collectors with the means to pay a premium price for a real Judd, Andre, Mapplethorpe, or Nauman original, the production and distribution of these copies might readily be enjoined on competitive grounds, that is, that—to use another Levallian term—they are wholly duplicative rather than in any sense transformative.[19] Here the balance tips toward protection. For the public, no gain. For the artists, some pain.

Not so obvious, however, might be the outcome when the copy is in a different medium: a small black-and-white photograph of a monumental and brilliantly colored kinetic sculpture, for instance, or a videotape of the works hung in a painting exhibition. Consider the case of the sculpture. Even if the assertion that the photograph of the sculpture is fundamentally educational in purpose fails to eliminate the third fair use factor from consideration, it would by no means be clear how the "amount and substantiality" of the portion used in the photograph would weigh in relation to the monumental sculpture as a whole. As for the fourth fair use factor, its application to the museum-made photograph might, in turn, depend on whether the sculptor herself is seeking to exploit a market in such a derivative. At a policy level, this photographic copy—more transformative, less duplicative—might be understood as providing the public with a benefit beyond that furnished by the original without unduly penalizing the copyright owner in the course of doing so. Thus understood, such a use might, on balance, qualify as a fair one.

Again, as in the case of the different business models, generalities may be misleading. The determination of whether any particular unauthorized copy does or does not qualify as a fair use requires a careful examination of all the facts and circumstances surrounding both the original and that copy.

Copies and Quotations

Particularly applicable to works of visual art is Susan Sontag's dictum that "art is not only about something; it is something."[20] It is here that the situation of the visual arts diverges most radically from that of the literary ones. With the possible exception of lyric poetry, literary works are primarily *about* something. This is not so for works of visual art. They are about, but they also *are*.

That distinction has not always been recognized. In the second of his *Bridgeman Art Library* opinions, for example, Judge Lewis A. Kaplan observed that photographic "transparencies stand in the same relation to the original works of art as a photocopy stands to a page of typescript."[21] Notwithstanding whatever accuracy that analogy might have had in the particularly narrow context in which he invoked it— the question before Judge Kaplan concerned the degree of originality involved in making photographs of paintings—beyond that context the analogy he offered is wholly misleading. A transparency or other photograph of a work of art most emphatically does *not* bear the same relation to such work as does a photocopy to a page of typescript. The photocopy is literally a reproduction. It includes virtually everything of importance about the typescript except perhaps the watermark, weight, weave, and finish of the paper on which it was originally typed. In terms of the information it conveys about the text, however, it can readily be considered complete.

By contrast, the transparency of the painting is anything but complete. A confection of celluloid and colored dyes, it may capture the painting's informational content—in essence, what it is about—but in no way does it reflect what the painting is: that it is a tangible object with a physical scale and presence, a canvas support

or other surface encrusted and/or stained with a distinctively applied coat of paint in a range of pigment-based colors that in the depth of their hues and their subtle interplay far exceed anything that a camera might possibly record. That the various paper products commonly generated from such transparencies—catalog and book illustrations, postcards, posters, and various size prints suitable for framing—are so frequently referred to as "reproductions" seems unfortunately imprecise and misleading. If Judge Kaplan's photocopy is truly what counts as a reproduction of the typescript from which it was made, then the only thing that ought comparably to count as a reproduction of a six-foot-square, heavily impastoed abstract expressionist canvas would be another six-foot-square canvas—a full-scale and just as heavily impastoed copy of the original. The transparency and its progeny are not reproductions. A more accurate term for them might be *photoreductions*.

Here again, the third of section 107's fair use factors comes into play. The degree to which these photoreductions omit substantial parts of what a painting "is" may arguably have implications for the application of this third factor. In dealing with such a photoreduction, what is the "portion used" that is to be compared in "amount and substantiality" with the copyrighted work as a whole? For example, in the case of one of our Freudian postcards, might we not appropriately think of such a postcard as little more than a thin, pale reflection of the larger and more imposing original? Might we not even analogize such a postcard to the quotation of a brief passage excerpted from a longer text?

Such an interpretation would, of course, provide a further degree of fair use protection to many of the photoreduction-based images in which museum shops traditionally deal. As a possible improvement on Judge Kaplan's photocopier analogy, consider this: a photograph has the same relation to an original painting as the literal translation of a palindrome might have to the palindrome itself. "*Madame, je suis Adam*" may certainly catch the literal sense of "Madam, I'm Adam." With equal certainty, however, what it has lost in translation is everything that made the original a palindrome, and also that which made it interesting in the first place.

Conclusion

Fair use has so integral a connection to the maintenance of a robust visual creativity in our society that we can ill afford even to limit its application, no less to lose it completely. Of the several threats it faces, two seem particularly noteworthy. The first threat is any effort to simplify its application—to formulate a one-size-fits-all rule that might be incorporated into software and provide prompt, clear, and reliable answers as to which proposed uses are and are not fair ones. For better or worse, fair use in the visual realm—with its extreme reliance on particular facts and circumstances— may never be a neat and tidy affair. The other threat, perhaps equally dangerous, might be the restriction of access to copyrighted materials in cyberspace. That could be particularly damaging in the case of artists.

Fair use is quintessentially a "don't ask" practice. First comes the use, and the discussion of whether or not it was a fair use follows, if and when the original copyright owner objects. A use authorized in advance is only an authorized use, not a fair one. When the authors of a 1995 report for the U.S. Patent and Trademark Office speculated in an ominous footnote that fair use might be an "anachronism with no role to play" in the age of electronic commerce, what they presumably meant was that fair use is a potential stumbling block.[22] Fair use is far too fact specific to make an easy fit with a seamlessly functioning, self-regulating, and encryption-guarded system in which all of the aspects of a copyright negotiation—the scope and terms of a proposed use, the fee to be paid, and perhaps even the payment itself—might be wholly integrated into one smooth process.

Whatever the advantages of such a system in commercial convenience, the potential threat to creative freedom could be considerable. If visual artists are to enrich our society by "molding and remolding" the environment in which we live, they require unfettered access to all of the aspects of that environment—including however much thereof may happen to consist of materials copyrighted by others—so that they can do their work and so that we may have its ultimate benefit. In its way, fair use is the "Robin Hood" provision of copyright. Within limits, it permits the artist— not infrequently envisioned as a sort of rogue—to poach on the content-rich so long as excessive harm is not done and so long as something with a value beyond that of the original is thereby made available to everybody else. Even now as the lush and enchanted forest of cyberspace springs up all about us, room—some place for play, some proper clearing in the woods—still needs to be left for Robin Hood.

Notes

1. Judge Leval was first appointed to the District Court for the Southern District of New York in 1977 and subsequently elevated to the U.S. Court of Appeals for the Second Circuit in 1993. See generally Pierre N. Leval, *Toward a Fair Use Standard,* 103 Harv. L. Rev. 1105 (1990).

2. Judge Leval refers to uses that meet this first test (i.e., uses that introduce additional creative elements rather than simply duplicate the original copyrighted material) as "transformative" uses. He has set forth his views on fair use, which have proven highly influential, in an extensive series of opinions, speeches, and law review articles.

3. The Hirshhorn Museum and Sculpture Garden is the Smithsonian Institution's museum of modern and contemporary art. Located on the National Mall in Washington, D.C., between Seventh and Ninth Streets, Southwest, it first opened to the public in October 1974.

4. *Regarding Beauty: A View of the Twentieth Century* was a group exhibition organized by the Hirshhorn Museum and Sculpture Garden and shown in Washington from October 7, 1999, through January 17, 2000. It was subsequently shown at the Haus der Kunst in Munich from February 11 through April 30, 2000.

5. Negativland, *Fair Use,* on-line at http://www.negativland.com/fairuse.html (last visited January 11, 2003).

6. A montage is "the combining of pictorial elements from different sources in a single composition." *Webster's College Dictionary* 878 (1991).

7. *Campbell v. Acuff-Rose Music,* 510 U.S. 569 (1994).

8. Ibid. at 578–85. Further details concerning this case, together with samples from the two musical versions, can be found at the Copyright Web site, *Finally, Fair Use,* at http://www.benedict.com/audio/crew/crew.asp (last visited January 12, 2003).

9. *Rogers v. Koons,* 960 F.2d 301 (2d Cir. 1992). The work of art at issue was a sculpture titled *String of Puppies* that the well-known New York artist Jeff Koons had based directly (and without authority) on an image by the relatively lesser-known California photographer Art Rogers. Rogers sued for copyright infringement. Koons's defense was that his sculpture was essentially satiric or parodic in nature and, accordingly, was immune from any charge of infringement as a form of fair use. In rejecting that claim and finding for Rogers, the court noted that parody can function as such only when the work subject to parody is already familiar to the audience for the parodic version and found that such was not the case in this situation. Ibid. at 310.

10. James D. Bloom, *The Stock of Available Reality: R. P. Blackmur and John Berryman* (Bucknell University Press, 1984).

11. See Louise Harmon, *Law, Art, and the Killing Jar,* 79 Iowa L. Rev. 367, 412 (1994).

12. Sandro Botticelli (1445–1510), *Primavera* (c. 1477–78), Uffizi Gallery, Florence; Rembrandt van Rijn (1606–69), *The Militia Company of Captain Frans Banning Cocq ("Night Watch")* (1642), Rijksmuseum, Amsterdam.

13. 17 U.S.C. § 107 (1994).

14. § 107(3).

15. § 107(1).

16. Tessa DeCarlo, "Landscapes by the Carload: Art or Kitsch?" *New York Times,* November 7, 1999, 51 (describing Kinkade's working methods, marketing strategy, philosophy, and audience).

17. *Campbell,* 510 U.S. 569.

18. In other words, it is arguable that such a use might tend to be of benefit to the public without unduly discouraging the artist from further production. See note 1, above, and accompanying text (discussing the two-pronged test proposed by Judge Leval).

19. See note 2, above (discussing Leval's concept of "transformative").

20. Susan Sontag, "On Style," in *Against Interpretation* 39 (Farrar, Straus & Giroux, 1969).

21. *Bridgeman Art Library, Ltd. v Corel Corp.,* 36 F. Supp. 2d 191, 198 (S.D.N.Y. 1999). The principal question in *Bridgeman* was whether meticulously prepared color transparencies of two-dimensional works of art that were themselves in the public domain contained a sufficient degree of originality to entitle such transparencies to independent copyright protection. The court held that they did not.

22. U.S. Patent and Trademark Office, U.S. Information Infrastructure Task Force, *Intellectual Property and the National Information Infrastructure: The Report of the Working Group on Intellectual Property Rights,* 73 n. 227 (U.S. Patent and Trademark Office, 1995).

Digital Technology and Stock Photography:
And God Created Photoshop

Paul Frosh

On average, an image is downloaded from the www.tonystone.com website every 12 seconds of every day.

Getty Images PLC press release, July 27, 1999[1]

In the latter half of 1999 and the first half of 2000, Getty Images PLC, a multinational corporation specializing in "visual content," bought two of its three largest rivals in deals worth $183 million and $220 million. These acquisitions were the most dramatic developments in the consolidation of what has traditionally been known as the "stock photography industry": a global business that supplies ready-made photographic images for use in advertising and marketing. This industry produces, according to some estimates, the majority of still images that appear in promotional commercial messages, as well as a growing proportion of those employed in product packaging, multimedia production, and Web site design. It also possesses a distinctly disturbing structural and ideological advantage, for its centrality to the trajectory of contemporary visual culture is founded, at least in part, on its invisibility to us, its products' ultimate viewers.[2]

In this chapter, I attempt to lift the veil on stock photography through a discussion of the impact of digital technologies. Yet to undertake such a task is to risk immediate obsolescence. As I write, a range of converging technologies, as well as the technical, cultural, and commercial discourses and practices that frame them, are transforming the stock business in radical and unanticipated ways. Accompanying this rapid, fundamental change is the sense that "stock photography," as an internally coherent phenomenon with a unified structure, purpose, and identity, no longer exists. It seems to have been engulfed by something new: a global, technology-driven "visual content industry," dominated by transnational conglomerates, that is erasing the discursive and institutional boundaries that separate advertising, documentary, historical, and fine art photographs as well as those that separate moments of production, distribution, and consumption. Thus the impact of digital technology on stock photography might be described first and foremost by the word *extinction*.

That said, the present juncture can also be narrated as stock photography's ultimate triumph, its evolution into another, "higher" stage, consummated by the very forces held responsible for its sudden demise. In this interpretation, the stock industry's commercial, aesthetic, and archival logics find their perfect incarnation in the potential of an ensemble of digital technologies: fast, effective, and increasingly unconstrained image manipulation; maximally efficient data storage and management; unlimited duplication from digitized originals with no loss of quality; and almost instantaneous on-line delivery worldwide. And this immaculate self-transcendence is made manifest, by the global visual content industry, in a far broader range of products and markets than ever before.

In this version of events, one must resist conceiving of technology in terms of its "impact," as though technology were a hurtling meteor and stock photography a fragile and unheeding planet. Rather more prosaically, technology "emerges from complex processes of design and development that themselves are embedded in the activities of institutions and individuals constrained and enabled by society and history" (Silverstone 1999, 20). Any technology takes its form within preexisting and often dynamic systems of power, practice, knowledge, and representation, and can be as much affected and shaped by these systems as it may be transformative of them. Stock photography, conceived as a cultural industry and as a mode of visual representation, is such a system. Moreover, the upheaval it is both promoting and undergoing is not the result of technology alone; rather, it is connected to at least two additional agents of change, cultural and structural-financial. Finally, to complicate matters even more, the transformations themselves are intricately tied to significant counterpressures—continuity with the past and resistance to change—that further muddy any simple picture of a technologically determined breach with a prior regime.

By insisting on the articulation of digital technologies within existing discourses, and their complex interaction with older systems and practices, I am in sympathy with the arguments of theorists and critics such as Kevin Robins (1996), Sarah Kember

(1995, 1996), Martin Lister (1995), and Don Slater (1995a), who have provided a valuable alternative to the occasionally sophisticated but often millenarian mainstream discourse (academic and journalistic) on digital and "virtual" technologies. In its dominant celebratory mode, this discourse ascribes utopian possibilities to the mere use of new visual technologies; in its dystopian antithesis, it laments their emergence as inevitably signaling the end of authenticity, certainty, and innocence.[3] In contrast, the writers I have mentioned broadly subscribe to the belief that the question of technology is primarily a social, cultural, and political one, and they examine the ways in which technology can act as a conservative as well as a transformative force—and as an agent of subordination as well as subversion—in specific historical and cultural circumstances.

In this chapter, I hope to explore some of these complex interactions between the stock industry and digital technologies as well as their ethical and ideological implications. To do this I will first briefly describe the core practices and discourses of the predigital stock photography business that emerged in the 1970s and 1980s. I will then connect these to the central cultural, commercial, and technological dynamics of the digitized visual content industry, focusing on the expectations and anxieties underlying professional discourses and practices and their relevance to broader questions of value, power, and ethics in contemporary visual culture.

The Golden Age of (Stock) Photography

The stock photography industry assumed its definitive contemporary form in the mid-1970s. Led by two U.S. agencies, the Image Bank and Comstock (founded in 1974 and 1975, respectively), it shifted from a largely "editorial" orientation based on the supply of images for magazine and newspaper articles to an industry that almost exclusively served the needs of consumer advertising and corporate marketing (Miller 1999, 128). Its main commercial premise was that in a decade of economic recession, fiscal retrenchment, and tight advertising budgets, advertisers and their agencies would find it more cost-effective to "rent" ready-made images from archives than to commission photographers for specific assignments in the hope of producing the images they sought ("Pioneers" 1994, 4). Clients would acquire the reproduction rights—not the copyrights—to images in return for fees fixed, often after negotiation, according to type of usage (print advertisement, product packaging, corporate brochure, and so on), time period, and extent of exclusivity.

In the most common scenario, the stock agency did not own the copyrights to the images it promoted. It simply acquired the license to sell the reproduction rights in return for giving the photographers set percentages of any sales revenue—usually 50 percent for domestic sales and less for international sales, although after the agency made various deductions for marketing, licensing, administrative, and distribution costs, the actual figure was sometimes closer to 36 percent (ASMP 1999a). The images for which the agency had acquired reproduction rights would then be stored in

the agency archive, filed according to denoted subject matter and cross-referenced for associative "conceptual" meanings. The agency would market a selection of the images to prospective clients through printed catalogs, and clients would receive any purchased images in the form of prints or slides. The possibility of making multiple sales of the same image to different clients over months or years was fundamental to the whole enterprise's success: it would ensure a profit after the combined costs of production, administration, storage, marketing, and distribution, while guaranteeing that any particular purchase price—ranging from a few hundred U.S. dollars for use of an image in a small brochure to several thousand dollars for use of images in national advertising campaigns (Comstock 1999)—could undercut the fees and expenses of traditional commissioned assignments.

This system is called "rights-protected," "managed rights," or even "traditional licensing" stock photography, and it has proved mutually beneficial to agencies, photographers, and clients. It relieves agencies of production expenses, and they gain access to vast reservoirs of content that they can sell over long periods. Photographers pay for image production but bear very little of the burden of marketing and distribution, and they receive regular income from multiple sales without forgoing copyright. Clients benefit by being able to acquire, extremely quickly and relatively cheaply, the images of their choice while evading the organizational and financial quagmires of assignment photo shoots and the danger of disappointing results ("The Best Sellers" 1994, 13). Indeed, the system has worked so well that the market tripled from 1980 to the early 1990s ("Pioneers" 1994, 5), massively increasing turnover and profits. No less significantly, it has recruited a diversity of creative and photographic talents; established advertising and marketing as its central legitimating discourse; formalized an industrial, legal, and professional infrastructure; systematized an ensemble of aesthetic and technical predilections; and created a definitive, easily recognizable, and eminently reproducible product—the "generic" stock image of consumer well-being (happy couples on sun-drenched beaches) or corporate achievement (well-groomed businessmen shaking hands).[4]

The system, of course, did not emerge overnight, nor was it created ex nihilo. Photographic archives have been in existence almost as long as photography itself, and critics have written of photography's special investment in an archival logic at work in modern Western culture, a point to which I shall return later. More specifically, however, the production of preprepared images to be sold for use in advertising can be traced to far earlier formations. Michael Hiley's (1983) analysis of the dawn of advertising photography in late-nineteenth-century England suggests that something similar to the stock system (even though Hiley does not use the term) produced a thriving market in commercial images before commissioned assignments became the norm. Early advertising photographers were adept at producing "telling scenes," stereotyped narrative images that "might prove useful to advertisers" (Hiley 1983, 108, 135) and could be speedily supplied. J. Abbott Miller (1999, 128), in turn, traces

Figure 9.1. "Generic" stock photographs and image categories from the Comstock Web site.

the historical evolution of companies producing and selling stereoscopic images in the nineteenth century, first into news and documentary photo agencies and later into advertising-oriented stock agencies. He gives credit for the establishment of the advertising-oriented stock system to large stereoscope companies as early as the first two decades of the twentieth century, with the "industry's" first catalog being published by the stereoscope firm of Underwood and Underwood in 1920. Finally, Helen Wilkinson (1997) makes it clear that stock photographic practices were well established in 1930s Britain, with agencies such as Photographic Advertising Ltd. geared primarily to the manufacturing and marketing of generic advertising images.

What was different about the stock industry that emerged in the mid-1970s was the high degree of systemic interdependence and integration between moments and agents of production, promotion, and circulation and the dominance of the legitimating discourse of global corporate marketing ("Pioneers" 1994; Heron 1996; Miller 1999). This discourse was formulated in three interconnected strategies that transformed already existing patterns of activity and established the nascent industry's core practices and values.

The first and most important strategy was the *institutional priority* given to the production of advertising and marketing images, to advertising and marketing clients, and to the techniques of professional marketing and promotion (exemplified by the adoption of corporate logos and the use of image catalogs as marketing tools),[5] such

that the term *stock photograph* became a virtual synonym for advertising imagery and stock agencies began to define themselves as image-producing adjuncts to the advertising industry and, at the same time, as "brands" to be positioned and marketed in their own right. The second strategy involved *high-quality production values,* especially technical excellence and photographic talent. It included the simultaneous creation of a new market for stock images (professional cultural intermediaries in marketing and advertising), a pool of high-quality stock images that could compete in this market with assignment photographs, and a cohort of elite photographers to produce these images. In particular, it required the definition of an authoritative visual aesthetic, based on the preferred subjects and iconography of contemporary advertising imagery, that would determine for photographers the precise "look" of stock images. This strategy was to become the source of a central tension between two imperatives within stock photography: the need, on the one hand, to produce images sufficiently generic, polysemic, and anonymous to facilitate multiple reuse in diverse promotional contexts and for different products and the necessity, on the other hand, to promote images of a singular quality and apparent originality—the marketable works of prominent individual photographers—that would be able to compete with the context specificity and artistic pretensions of assignment photographs. As I will show later in this chapter, this tension between the generic and the singular, the anonymous and the attributable, has reappeared in the digitized "visual content industry."

The third strategy manifested itself in the *global orientation* of leading agencies, which set up international operations on the basis of mutually exclusive contracts with local licensees and through wholly owned overseas offices, rather than through one-to-one agreements to be represented by independent foreign agencies in their home markets (the traditional, and still very common, basis for international sales). This not only imparted a unified corporate identity and purpose for an agency across national and cultural boundaries that might echo and parallel the identificatory strategies of the agency's largest clients, it was also a way of demonstrating an agency's importance in the culture of global corporate capitalism, where, among other things, power is displayed through geographic extension.

Although not all stock agencies in the 1970s and 1980s conformed to every element of the system I have described, it became stock photography's governing paradigm, in part because it both gave rise to and was exemplified by a small number of multinational "superagencies," based in the United States and Europe, that came to dominate the industry: the Image Bank and Tony Stone Images, today both owned by Getty Images PLC (Getty acquired the Image Bank and its associated businesses in September 1999 from Eastman Kodak); Visual Communications Group (owner of FPG International, Telegraph Colour Library, and others), which was owned by United News and Media PLC until its acquisition by Getty in February 2000; and, much more recently, Corbis Corporation, privately financed by Microsoft CEO Bill

Gates. Today these superagencies compete alongside a much larger number of smaller and medium-sized agencies, around twenty-five hundred worldwide, in a business that supplies a significant proportion of the images used in U.S. and European advertising, marketing, and graphic design ("Stock Photography" 1998) and whose global sales turnover is currently estimated at around one to two billion dollars a year.[6] It is these superagencies that are responding most vigorously and intensively to the potential of digital technologies and that are driving stock photography's reincarnation as the visual content industry.

Moments in the Life of the Digital Stock Image

The best way to approach the dynamic interactions of cultural, commercial, and technological forces in the visual content industry is through the specific applications of digital technologies at two key moments in the life of the image: production and distribution.[7]

Production

It is still not usual practice for advertising or stock photographers to take pictures using digital equipment; according to the 1999 APA (Advertising Photographers of America) National Photographer's Survey, photographers shot only 1.8 percent of jobs in digital format during 1998.[8] This reluctance to embrace digital equipment is partly the result of a widespread feeling among professional stock photographers that digital cameras do not yet provide the level of accuracy or resolution achieved by their conventional analog ancestors. Accompanying this technical justification, however, is the attachment to nondigital equipment and processes resulting from routine daily familiarity and years of financial and emotional investment, plus the lingering affection of some for the "alchemy" of the old chemical technology and the "artisanal skills" associated with it (Brian Seed, at Photo Expo East '98, October 30, 1998).[9]

Hence the primary use of digital technologies occurs after the photograph has been taken and converted into digital form. In this phase, software programs such as Adobe Photoshop are employed to "retouch" or "enhance" the image, and it is the apparent threat that such "manipulation" poses to the credibility of the photograph (and the credulity of the spectator) that has made it one of the most common preoccupations of philosophical and theoretical writing on digital imaging technologies:

> As still photography leaves its optical-chemical past and enters the optical-electronic-computer future, new possibilities and challenges emerge for the news media. Long held notions of what constitutes credibility of source, credibility of information, and philosophical concepts of truth are rapidly becoming outmoded. (Bossen 1985, 27)

I will not dwell on the assumptions about the nondigital photograph underlying such preoccupations, assumptions about the photograph's "analogical perfection" in relation to the real (Barthes 1977, 17), the claim that it does not "translate" real

appearances through a code but "quotes" them directly (Berger and Mohr 1982, 96), the sense that photographs "really are experience captured" (Sontag 1977, 3). Nor will I rehearse the arguments of those who celebrate the effect of digital technologies as a liberation from the prison house of this (mythically objective) referentiality (see Mitchell 1992; Tomas 1996) or, conversely, of those who mourn it as the withering of photography's essence, the defining necessity—"the fatality," as Barthes (1984, 6) calls it—of the photograph's indexical relationship to its referent and its status as a form of evidence (for example, see Ritchin 1990), although I will return later to a possible ethical consequence of this "loss." Suffice it to say that both rejoicers and lamenters are marking a type of ontological fracture, a crisis in the very being of photography:

> The substance of an image, the matter of its identity, is no longer to do with paper or particles of silver or pictorial appearance or place of origin; it instead comprises a pliable sequence of digital codes and electrical impulses. It is their configuration that will decide an image's look and significance, even the possibility of its continued existence. (Batchen 1998, 22)[10]

Several commentators have already noted a key difficulty with this sense of a decisive break with a predigital mode of photographic signification, given that photographic "truth" has been widely questioned for several decades at the very least (Bossen 1985; Kember 1996). This suggests that the departure from a previous formation may be less connected to ontology and technology than to differences in the material and discursive contexts in which photography and image manipulation occur. It also highlights the inadequacy of designating "photography," whether analog or digital, in the *singular,* as a unity that spans, accommodates, and integrates photojournalism, fine art photography, domestic photography, advertising photography, and other practices (see Lister 1995, 14). What photojournalists perceive as causing an ontological and ethical crisis, for example, commercial and advertising photographers may see in an entirely different light.

Nevertheless, the shift in the "identity" of the photographic image caused by digital "enhancement" technologies *has* affected the discourse of stock photographers. Rather than an ethical or ontological crisis, it appears as an epistemological and practical transformation, a change in what it is possible to *know about* and *do to* a photographic image. We can call this transformation the "disenchantment" of photography. By this I mean that digital technology removes photography from the sphere of alchemy and magic by allowing for the image's conversion into numerical sequences, for the decomposition and sampling of its continuous textures and forms, and for their controlled reconfiguration. This is perhaps a strange claim to make, given photography's historical and discursive connection to positivism and science, and its primacy, therefore, "within the most thoroughgoing appropriation of the world as pure object, and thus within a project of total disenchantment" (Slater 1995b, 223). How, if photography is itself an agent of disenchantment (of the visible world), can it be amenable to disenchantment by digital technology?

The answer lies in a paradox of modernity described by Don Slater (1995b), in which the visibility so central to scientific validation and technical demonstration also inspires awe: nineteenth-century scientific demonstrations, for example, did not simply furnish visible experimental "evidence" but possessed "highly dramatic and spectacular qualities" that worked against their own disenchanting grain to reenchant the world through visual spectacle (223). Hence scientific technologies make nature wonderful and, in their mastery of nature's laws, become wonders in their own right. These technologies are for Slater a form of "natural magic," because "the power of science and technique at the height of their rationality appear to us (who do not understand them) as a new form of magic" (227). Photography, understood as a revelation of optical and chemical laws that allows nature to represent itself, and also as a performance of the technical ability to command nature and replicate its appearance on demand, seems clearly "magical" in this sense. Moreover, the magic of photography is inseparable from its indexicality (or, in Slater's phrase, its "ontological realism"; 222), which seems to make the image uniquely cosubstantial with its referent, an emanation or shadow of the real.[11]

As I have said, new digital technologies, by dematerializing and reconfiguring the photograph before our eyes, by allowing for our absolute mastery over its every particle, disenchant photography just as photography disenchanted the visible world. In the process, as Kevin Robins (1996) contends, they extend the project of rational control to the very core of the image-making process, promising both to empower their users and to distance them from what they see. But at the same time, the new technologies themselves appear to be magical, staging themselves as wondrous spectacles of replication and simulation.

Hence stock photographers and agencies are almost completely unperturbed by ethical considerations that might arise from *their own* use of digital image manipulation technologies (as we shall see, they are less sanguine about the uses others might make of them), and they are almost overwhelmingly overawed and enchanted by the power of these technologies. Patrick Donahue, former director of photography at Tony Stone Images, has nicely encapsulated this combination of mastery and miracle. He has noted that in the late 1990s, 80–90 percent of the photographs his agency promoted were digitally manipulated: "Adobe didn't create Photoshop. God did" (Photo Expo East '98, October 31, 1998). Most stock photographers have responded to digital imaging technologies with similar enthusiasm. For example: "With the advent of digital, if we choose, we now have more control, in every way, than we ever did before" (John Lund, digital photographer, quoted in Feliciano 1998, 22).[12] Heron (1996) notes:

> Retouching is a major use of digital imaging for stock. . . . It's easy to remove a blemish that makes stock less saleable. . . . Another common use of digital retouching is to add background to enhance the shape of a photo. . . . But the most exciting aspect of imaging is the ability to create new, unimagined photos. Merge several

photos, distort them, alter color, change perspective. Make a real-looking scene more perfect than you could shoot it. Or create an impossible universe from your imagination. (176)

Digital manipulation is welcomed as an empowering and providential extension of the photographer's rhetorical craft, a craft that includes the miraculous perfection of the real through its fabrication. It has become an integral part of all image production in the stock business. And a concomitant of this unambiguous passion for image manipulation is the utter irrelevance of evidentiary truth-value or "ontological realism" to the work of stock photographers, the purposes of their images, or the perceived expectations of their ultimate viewers. Like advertising images in general, and due partly to the framing of advertising photography within a prior tradition of advertising illustration (Wilkinson 1997, 27), stock photography is not concerned with the unmediated and ideally objective reproduction of the material world in a neutral photographic "document." Rather, the purpose of the stock photograph is to convey a "concept" (Heron 1996, 26), a metaphorical or narrative structure only selectively and tangentially representative of social experience (Williamson 1978; Leiss, Kline, and Jhally 1997) that when associated with a product will work rhetorically to sell it. Thus the only questions asked about an instance of digital image manipulation— say, the addition of a patch of sky to a landscape photograph because its target audience (Americans, in this case) "tend to like to see the horizon" (Tracy Richards, director of photography, Panoramic Images, at Photo Expo East '98, October 30, 1998)—concern its compositional feasibility and, above all, its rhetorical efficacy; indexical fidelity to an external reality is beside the point. And stock photographers and their clients in design firms and advertising agencies assume that consumers, long accustomed to the formal conventions and promotional goals of advertising images, do not expect such fidelity from their photographs.

However, the legitimacy of image manipulation is not only conferred upon photographers themselves. Traditional, rights-protected stock photographs are sold primarily to professional cultural intermediaries—art directors and art buyers, picture editors, graphic designers—in advertising agencies, design studios, and marketing departments for use in promotional material. Such usage involves the *recontextualization* of the image, its combination with other graphic and textual elements (including other photographs), at which point the photograph can be substantially altered (on the manipulation of stock images transformed into backgrounds for other images, see, for example, "Distant Vistas" 1998, 13–14).

For some, digital technologies make possible recontextualizations that are so radical, so disfiguring to the initial image, that they pose a new type of threat:

Interactive multimedia technology enables users to manipulate data, alter images, turn still paintings into animated sequences, and combine music and art in idiosyncratic ways. While this may be exciting and innovative to the user, in the eyes of the

creator such manipulation may compromise the value of the original artwork. (Akiyama 1998)[13]

However, although such transformative power is new in degree, it is not new in principle: Helen Wilkinson's (1997) research on the U.K. stock agency Photographic Advertising in the 1930s shows that almost all the agency's images were altered by clients, even to the extent of their being made to look like drawings (26). Thus stock photography has always had to deal with a potentially far more explosive issue than the simple theft of images: the "completeness" or "unity" of the photographs it promotes and, given their availability for alteration by legitimate, fee-paying customers, the definition of their "value." The industry has typically contained possible clashes over the unity of images by permitting clients to make specifically sanctioned types of alterations. The transfer of artistic and cultural authority—the power to pronounce a work open or closed, complete or incomplete, more than or equal to the sum of its parts, and to change it and reproduce it in multiple, unanticipated contexts—is regulated through a precise legal and financial mechanism: the negotiation of reproduction rights and fees that lies at the heart of the traditional stock licensing system. On their own, therefore, digital image manipulation technologies have not radically challenged this system: they have been incorporated into a framework that already, from its inception, was designed to profit from the short-term resolution of what we can call the "existential angst" of the photographic image, although the increase in the range of alterations that these technologies make available to powerful clients and willing agencies has caused some disquiet among photographers. The real trouble begins, however, when the power of digital manipulation bolts through the open door of digital distribution.

Distribution

The two main technologies that make digital image distribution systems possible are CD-ROMs and on-line (usually Web site) delivery.[14] Just as digital production has not yet become the dominant technology for taking photographs, so digital delivery systems still account for only a minority of images distributed, although this is changing fast: in some companies, such as Getty Images, on-line or "e-commerce" sales account for a majority of overall sales (61 percent in the last quarter of 2001, 48 percent in the third quarter of the same year) (Getty Images PLC 2002).[15] Of the two technologies, on-line distribution is probably the more radical, because it erases time as a factor in delivery. It fulfills a similar function to that once performed by the telegraph in relation to news reporting, severing "content" (the image) from its fixed attachment to a material "vehicle" (the photographic print or slide) and allowing for its instantaneous transmission across the world at massively reduced cost, independent of postal or courier schedules and charges.

But perhaps the most significant transformation engendered by both CD-ROM and on-line delivery technologies is the prospect of inexpensive, faultless duplication

from a digitized original, providing the stock industry with a low-cost solution to two of its biggest technical and financial challenges: the expense of analog duplication and the constant struggle to keep costs down by ensuring that clients return the slides or prints of the images licensed to them (loss of these usually incurs a hefty fine, and in the case of lost or damaged original slides, fines are currently approaching fifteen hundred dollars per image; Index Stock 2000). The efficient distribution of perfect duplicates has revolutionized stock photography by making the delivery of images to a *mass market* (rather than a restricted professional one of art directors, graphic designers, and so on) a practical, cost-effective possibility, as well as a major source of anxiety. Karen A. Akiyama (1998) describes this as the "paradox of mass distribution," whereby "artists fear that their works will be distributed without adequate protection or compensation to millions of online consumers with the click of a mouse. Yet, the very possibility of such fast and far-reaching distribution is exactly what makes digital communications so appealing in the first place."

It was this potential for broadening the market that led to the rise of a new "royalty-free" (RF) sector operating alongside stock photography in the 1990s. Royalty-free images are sold on a single-fee, multiple-use, mass-distribution principle, which means that, in contrast to rights-protected stock photography, purchase of the image includes purchase of a very broad, nonexclusive license to use the image as, when, and however often the purchaser sees fit.[16] Generally sold on CD-ROM for anything between one hundred and five hundred dollars for several hundred (and sometimes several thousand) photographs, royalty-free images are also available individually via the Internet.[17]

The initial response of established stock agencies to the emergence of royalty-free was anything but positive, even though at first the two systems did not officially compete for the same markets: RF was aimed at small business users and general consumers who could not afford the prices of rights-protected stock. Nevertheless, RF producers were frequently condemned as pirates flooding the market with "low-end" (i.e., low-quality and low-cost) content that threatened both traditional stock and assignment photography (the same argument was made against stock by assignment photographers in the 1970s and 1980s) ("Future Stock" 1997, 66). RF producers countered that these claims were commercial self-interest dressed up as high moral and aesthetic principle. Competition between these image producers soon intensified, however, as royalty-free images began to enjoy increasing popularity among graphic designers and corporate marketing departments: in 1997, royalty-free accounted for 46 percent of image usage in "creative" (i.e., professional advertising, marketing, and design) markets, as opposed to rights-protected stock, which had dropped from 38 percent in 1996 to 24 percent ("Stock Photography" 1998). Of respondents to a U.S. graphic design trade journal's survey, 63 percent reported that they used royalty-free images (87 percent said they used stock agencies; Kaye 1998, 78). This has led to growing product differentiation and market segmentation within the royalty-free

sector, with industry giants such as PhotoDisc focusing on the "high-end" creative professional market and encroaching on rights-protected stock's traditional clientele.

In the past few years the relationship between traditional stock and RF has shifted from hostility to accommodation and collaboration. RF is now applauded for pioneering new, nonprofessional, markets as well as for driving up the prices of traditional stock—because (so goes the claim) rights-protected stock can guarantee the quality and exclusivity for which top clients will willingly pay more ("Future Stock" 1997, 64–66; Klein 1998). This accommodation to RF has been sealed with the acquisition of RF companies by or the establishment of RF divisions within the big stock agencies: Getty Images PLC, now the largest "visual content" agency, was formed through a merger between the owners of leading traditional stock agency Tony Stone Images and RF pioneer PhotoDisc (Getty Images PLC 1997); Corbis bought RF producer Digital Stock in February 1998 (Walker 1997, 22; "Corbis Buys Digital Stock" 1998); the Image Bank (prior to its acquisition by Getty) bought Artville in November 1998 ("Photos for Sale" 1998; "TIB Enters R-F Business" 1998); and Visual Communications Group (also prior to its purchase by Getty) opened an RF division at FPG International in late 1999 (FPG International 1999) and at around the same time acquired Definitive Stock, an on-line provider of royalty-free imagery.

This convergence of royalty-free and rights-protected systems has been marked by attempts to redraw the boundaries between them. The danger of competition between RF and stock agencies owned by the same conglomerates, and the need for superagencies to offer product diversity, has led to the alignment of distribution and licensing systems with particular instrumental advantages, namely, the potential exclusivity of expensive rights-protected stock as opposed to the low price and ease of use of RF. However, specific *aesthetic* characteristics have also been attributed to the two systems. The most prominent claim, frequently made by the senior management and marketing departments of the superagencies themselves, is that much of the "low-end," "generic," and clichéd content produced by traditional stock agencies has moved over to RF, with traditional agencies emphasizing "quality," "creativity," "uniqueness," and "individual vision" in the images they promote ("Stock Photography" 1993, 108; Kaye 1998, 81–82).

The extent to which traditional stock has indeed undergone a "quality" revolution in the past decade is subject to some dispute (see "Best Sellers" 1999, 36–37, as well as the brief discussion below), as are the causes of such a transformation, which are lodged as much in cultural and structural-financial trends toward market differentiation and less homogeneous advertising design as they are in technological forces. But the claim intersects with questions of digital manipulation and recontextualization in very illuminating ways, because it amounts to a discursive strategy for containing anxieties about the unity of stock images.

Comstock (which opened its RF division in June 1997), for example, is among the claim's most vocal proponents. Not only does Comstock's CEO, Henry Scanlon,

distinguish between "the hardy few" "visionary" photographers creating quality work for stock and the mass of "technicians" manufacturing derivative RF images ("Future Stock" 1997, 64), but the company's promotional material, in particular its Web site, draws a distinction between Comstock's rights-protected and royalty-free "brands," adding an explicitly aesthetic dimension that other agencies tend to leave unstated.[18] In an on-line article titled "'Rights-Protected' vs. 'Royalty-Free'—Which Is for You? An Insider's Essential Guide to Making the Right Choice," Comstock (1998) gives the following advice to its clients:

> Rights Protected stock photos are intended to be used intact, shot to communicate a powerful message. Sure, good stock photos are always composed to give you flexibility for type, cropping and re-sizing. But, in general, they represent a "complete" composition with all elements of that composition designed to support a central theme or idea—a "story." (12)

Characterized at the level of form by compositional unity and at the level of meaning or effect by narrative potency and communicative clarity, the distinction of these images, Comstock asserts, is further bulwarked by their pedigree and the status of their source: they "represent the best creative work of some of the world's foremost professional photographers working at the top of their form" (12). All three dimensions— form, meaning, origin—can be subsumed in the term *integrity:* the image is valued for its integrity as the perfectly composed and powerfully communicative work of an exceptional individual. Conversely,

> a great royalty-free image is an image you look at and can't wait to change. You want to get it into your computer and begin to work with it. You want to take a part of it and flip it or manipulate it or put it with another picture and another and begin to create a unique, personal composition. Arguably, good royalty-free imagery is a direct result of the way computerized graphic design has vastly expanded—in essence *liberated*—graphic design from traditional structures. The increasing reservoir of royalty-free imagery is making this kind of multi-image composition (where, indeed, the image is often used not so much for its "story-telling," but, simply, for its graphic substance), both possible—and affordable. (13)

This manifesto for cultural differentiation that valorizes, on the one hand, elitist image conservation and, on the other, massive and radical image manipulation represents probably the most sophisticated and explicit strategy for the incorporation and containment of digital technology's challenge to image integrity. The dichotomous conceptions of value it formalizes, "integrity" and "graphic substance," specify precisely which photographs acquire purpose as the authorized and unchangeable works of sanctified artists and which are the raw visual material—a color here, a texture there—gathered up by merely competent technicians.[19] Of course, the "graphic substance" of many a uniquely powerful stock photograph, not to mention of a

royalty-free image, may itself originate, at least in part, in graphic substances provided by other digital images, themselves the products of prior acts of recontextualization.

The "liberation" of graphic substance from the (always fragile) unity of the photographic image is actually the radical extension—or possibly implosion—of a central dynamic in predigital stock photography (if not all photography): the reduction, abstraction, and ordering of the multifarious objects of the social and natural world into exchangeable sights in a vast "anthology of images" (Sontag 1977, 3). This "archival principle" of photographic signification, in which photography is both the tool and the object of a categorizing imperative that seeks to systematize and control the social and natural world, coupled with what we can call its "expansionist" mode of development—its relentless but selective representation of the world to more of the people within it—is a key theme in much photography theory and history (see, to name only a few, Sekula 1981, 1989; Krauss 1982; McQuire 1998). It is a theme often opposed to the indexical uniqueness of every photograph's relationship to its referent, working toward a homogeneity of similar signs rather than a diversity of singular representations.

Stock photographs, operating within the distinctive ideological framework of advertising imagery, participate in this selective abstraction and classification of reality. In the form of generic images, stock photographs are conceived, planned, and manufactured both *in order to be classified,* according to the specific archival matrices conventionally employed by stock agencies (under such categories as "people," "lifestyle," "business," and "science"), and *in order to classify,* according to the wider forms of social categorization by which advertising discourse creates its meanings. Thus the liberation of the graphic substance of the royalty-free image takes the archival principle one crucial step further: *into* the very material constitution of the photograph. Rather than treating images as the basic units of the archival system, to be stored, retrieved, and valued intact, it sees each image itself as a repository of exchangeable components, as a further "anthology of images"; it creates a new foundational unit for the digital archive—the "info-pixel" (Foster 1996). To borrow Heidegger's (1993) term (without necessarily endorsing the premises of his whole analysis of modern technology), the photograph loses its object status and becomes a "standing-reserve," valued solely as an arrangement of constituent elements for the purpose of a further deployment in a potentially endless succession of recontextualizations: "Everywhere everything is ordered to stand by, to be immediately on hand, indeed to stand there just so that it may be on call for a further ordering" (320). This drive to excavate the very graphic substance of the photograph manifests not only an archival logic but also a commercial one. It makes possible a significant expansion in the range of chargeable exchanges immanent to each image: a photograph may be multiply resold for use intact, and once it loses its integrity as a traditionally licensed image (say, for reasons of fashion), it can be recycled as a royalty-free image to be mined for its retrievable parts.[20]

Yet the centrality of the info-pixel as the archival unit of the digital visual data-base necessitates the vigorous reanimation of (never dormant) artistic discourses and commercial practices on behalf of image integrity, for the insistence on the integrity of the rights-protected stock image is also continuous with the commercial and aesthetic logic of predigital stock. Like the dynamic of the standing-reserve to which it is opposed, it picks up on the tension mentioned earlier between generic recyclability and the need for stock images to compete with the singular, personally attributable images of top assignment photographers. That is why mainstream superagencies continue to promote their mass of generic content with the selected work of "brand" photographers who have reputations outside the stock business (see, for example, the stress on "world-renowned photographers" in Getty Images PLC 1999h). In fact, the renewed emphasis on formal singularity and the centrality of the individual photographer has itself taken the shape of a stock agency: Photonica. Founded in Tokyo in 1987, Photonica began its international expansion with the opening of an office in New York in 1990. According to Miller (1999), the agency represents the stock industry's "avant-garde" wing: "The imagery is highly specific rather than generic, and the style foregrounds the signature style of individual photographers" (129).[21] Promoting abstract forms, highly specific content, unusual cropping and camera angles, and nonconventional use of focus and color, and above all emphasizing the individual "signature" styles of selected photographers (Photonica's Web site, at www.photonica.com, is organized around the work of individual photographers rather than by "subject" or "concept"), it has created a market for photographs that are definitely opposed to the aesthetic of the generic image. Photonica's success has led to the increasing production of "Photonica-like" images by the large mainstream agencies (Miller 1999, 129; BAPLA 1998–99, 105).

In one sense, Photonica represents an oppositional tendency at the heart of stock photography. Its values, also found in much of the self-help literature and many of the "how-to" guides produced by and for stock photographers (see, for example, Heron 1996), counter the dominance of corporate marketing formula through a discourse of photographic creativity that privileges personal artistic autonomy and authenticity. And, according to the industry's conventional wisdom, Photonica's photographs should make "unsuccessful stock images," because they "do not have a clear metaphorical application . . . they are more complex and challenging" (David Arky, photographer, Photo Expo East '98, October 30, 1998).[22] Interpreted more cynically, however, Photonica's strategy is simply exemplary brand positioning: working out what the stock industry lacks and represses, and then creating a stock agency to supply it—unconventional, elusive, mystifying, individual, and always "artistic" images, available on demand. Such a strategy is particularly effective when one considers that the clients of stock agencies are sophisticated cultural specialists (art directors, graphic designers) with high levels of cultural capital and erudition with regard to both high and popular cultural forms (Bourdieu 1986, 357–60; Nixon 1997, 209–17; Mort 1996,

91–113) and who possess their own powerful "creative" and "artistic" agendas and discourses. Specifically, Photonica's "artistic" pretensions serve their aspirations to cultural legitimacy while its oppositional stance toward mainstream stock photography matches their cultivated rhetoric of subversion and difference (Lash 1990).

The emphasis on image integrity and artistic vision, and its opposition to graphic substance and merely technical competence, also serves an important function within the system of labor relations that characterizes the visual content industry. It suggests the emergence of a two-tier hierarchy among photographers: a small group of relatively well-treated "stars" who can be marketed, along with their photographs, to high-fee-paying cultural intermediaries in advertising and graphic design and a far larger number of anonymous photographers serving the RF sector and their broader, low-fee-paying markets. As I mentioned earlier, photographers working as freelancers in traditional stock contractually receive around 50 percent of the income from non-digital domestic sales of their images. In contrast, RF photographers are entitled to about 10 percent of sales revenue: the actual amounts received allow them to make a living, according to industry management, because of the sheer volume of sales in a mass market. These percentages are set and precariously maintained within a context of increasing professional uncertainty regarding future industry trends that will directly affect livelihoods, and especially against a background of strained relations between photographers and many agencies, particularly the powerful corporate giants of the visual content industry.

Anxious for the rights of "average" photographers (Scanlon's "technicians"), the American Society of Media Photographers (ASMP), which represents most U.S. stock photographers, involved itself in a very public conflict with the Picture Agency Council of America (PACA), the U.S. stock industry's principal trade association, over PACA's alleged encouragement of business practices and contractual agreements that are unfair to photographers (ASMP 1999b).[23] Confirming some of the ASMP's worst fears, the largest superagencies have begun to challenge the 50 percent figure for traditional stock, using the question of technology strategically in order to reallocate revenue. Arguing that photographers benefit from the new markets opened up by digital technologies while the agencies bear the financial burden of capital investment in those same technologies, Getty's Tony Stone Images reduced commissions for domestic digital sales from 50 percent to 40 percent in September 1998 (Walker 1998).[24] This reduction is even more severe than it first appears, because it refers to the commissions actually specified in photographers' contracts. According to the ASMP, agencies can deduct as much as 23 percent of sales revenue to cover marketing and other costs, leaving the photographer with relatively little (ASMP 1999a). Hence, through their position as the gateway to new markets and also as a major corporate expense, digital technologies have become sources of friction as well as tactical weapons in the power relations between photographers and agencies, affecting the industry and its products not only as a direct result of their particular capacities regarding the

photographic image, but also through the financial and organizational structures to which they are tied. It is to these that I now turn.

Visual Content: Industry and Empire

Why has the "visual content industry" been so named, and what are its central ethos and governing dynamic? We can begin to answer these questions by focusing on the superagencies that lead the industry. Among these, Corbis is probably the best known outside the industry, doubtless because of its association with Microsoft's Bill Gates. In addition to its stock photography and royalty-free brands, Corbis owns the reproduction rights to the Bettmann archive, which includes the United Press International (UPI) photo library and extensive material from Reuters and Agence France Press, as well as the digital reproduction rights to much of the world's fine art (Corbis 1998; see also Batchen 1998).

However, it is Getty Images PLC that probably provides the best example of how marketing-led industry consolidation interacts with digital technologies. Prior to September 1999, Getty Images had employed an aggressive acquisition and technological development strategy to become the largest of the superagencies. It owned one of the biggest stock photography agencies (Tony Stone Images); one of the leading "high-end" royalty-free brands (PhotoDisc); EyeWire (royalty-free audio and graphics for designers); Energy Film Library (stock film footage); Art.com, which sells art ("Monet, van Gogh, Picasso, Herb Ritts and Robert Mapplethorpe") and "art-related products" on the Internet;[25] leading agencies specializing in sports (Allsport), news and reportage (Liason), and celebrity photography (Online USA); and the Hulton Deutsch Collection—bought in 1996 and subsequently renamed the Hulton Getty Picture Collection—which comprises fifteen million images from the major British newspaper and press archives of the nineteenth and twentieth centuries (Getty Images PLC 1999a). Getty's principal aims are to digitize as much of its content and as many of its transactions as possible (emphasizing especially on-line promotion and sales, or e-commerce), to target existing markets with specific "brands" while allowing for the profitable integration of content from diverse archives and agencies, and to open up new (especially Internet-based) markets, frequently through joint ventures (e.g., Getty Images PLC 1999c, 1999e). Digitization provides the opportunity for multiple promotion of the same content to several ostensibly distinct markets; in particular, the vast reserves of the Hulton Getty Picture Collection can be mobilized to serve traditional editorial sectors, nostalgic marketing and advertising campaigns, and on-line art consumers (see, for example, Getty Images PLC 1999d).

In September 1999, Getty stunned the industry by announcing that it was acquiring the Image Bank, one of its most venerable competitors, for $183 million, adding huge global contemporary stock photography and stock footage agencies, a leading royalty-free company, a fine art photography agency, a film footage archive, and the largest North American historical archive of still images to its already im-

mense resources (Getty Images PLC 1999f). Responses in the industry were mixed, with some emphasizing the extent of Getty's debt as a result of the acquisition and the agency's pressing need to please shareholders by showing immediate profits, further increasing the downward pressure on photographers' percentages of sales. Others praised Getty's scope and vision: "This creates a monster with global reach," commented David Moffly, former president of stock agency FPG International. "It creates huge synergies and economies of scale" (quoted in "Getty to Buy" 1999). Digital technologies, and predictions regarding their most lucrative future developments, are crucial to Getty's strategy: "The Image Bank's footage business is particularly strong because that agency has invested heavily in film storage, retrieval and distribution technology. And footage is expected to become a major growth area in the stock business as Internet bandwidth improves" ("Getty to Buy" 1999).

This was, however, only the beginning, for in February 2000 Getty announced that it was acquiring its largest competitor, Visual Communications Group (VCG), for $220 million. This act of consolidation, if not of industry domination, exemplified the way in which such developments in the stock industry were only a part of broader consolidating tendencies across media firms. The announcement of VCG's sale coincided with the (unsuccessful) attempt by its owner, United News and Media PLC, to merge with Carlton Communications—momentarily threatening to form one of the largest media conglomerates in the United Kingdom—and reflected a new focus on "core" mass-media businesses (especially television). VCG had been performing poorly in recent years, largely as a consequence, according to industry observers, of underinvestment in new digital and Web-based technologies ("United News and Media" 2000; Getty Images PLC 2000), but the acquisition turned Getty into a behemoth, providing it with an additional four major U.S. and European stock agencies—FPG International (United States), Telegraph Colour Library (United Kingdom), Bavaria Bildagentur (Germany), and Pix (France)—several specialty image collections (fine art, celebrity images, space, natural history), and a royalty-free company. Ironically, in the light of this sudden and overpowering incorporation of two of the four superagencies by a third, the hope of resistance to prospective domination by Getty was now lodged in Corbis, itself no mean consolidator. As Richard Steedman, president of the Stock Market (a large commercial U.S. stock agency), explained upon its acquisition by Corbis in May 2000, "It's nice to have that support [of Corbis] to fight against the Getty organization" (quoted in "Corbis to Acquire" 2000).

In this context, the introduction of the phrase *visual content industry,* for which Getty is chiefly responsible, can be seen to express three of the industry's main structural tendencies. First, although it makes extensive use of digital visual technologies, it is to be distinguished from those sectors that specialize in the production of such technologies. In other words, it is a *culture industry* and ultimately defines its own identity and tasks in cultural and commercial terms: the creation and circulation of valuable and relevant symbolic goods. The visual content industry is not therefore

chiefly concerned with technological "hardware," except instrumentally, as a means to the production and sale of images and as a catalyst for increased demand. As Getty Images CEO Jonathan Klein (1998) explains, in the future, "demand for visual content of all kinds will increase, for two reasons: we are all becoming more visually literate; technology is creating distribution mechanisms that demand more images— which in turn are making people more visually literate." Klein's second point—regarding the demand for still images created by new technologies—is amply illustrated in the case of multimedia products: "A typical 'electronic book' could use 1,000 stills along with video and sound clips. Video games need still image backgrounds, educational software uses still examples of situations or locations, and training products use stills for both" (Index Stock 2000).

Klein's analysis also indicates another tendency behind the notion of "visual content": the dismantling of the technical boundaries that separated previously distinct media (photography, painting and drawing, film, video) and their convergence and mutual convertibility. This radical ingathering of "all kinds of visual content" is of course intimately related to the militant universality of digital code, which transforms the Babel of incommensurate symbolic forms into a miraculous and basic equivalence (Binkley 1993; Lister 1997, 254–55). But such an ingathering is not merely a technical feat—it is also, and perhaps primarily, an institutional and discursive transformation. This is because of a radical disjunction between the moments of image production and later moments of distribution and reproduction, brought about by what can be described as the "corporatization" of almost all photographic archives. In the past, it was relatively safe to assume that the photographers and news agencies that produced news and documentary images maintained ownership and control over their reproduction, and that there was a direct organizational and professional connection between production and distribution. This link was in fact based on a separation, both discursive and institutional, between historical and photojournalistic photographers and archives, fine art photographers and archives, and those working in advertising and marketing. The distinction ensured a certain continuity of communicative milieu between production and subsequent reproduction—a photojournalistic image may have been reproduced in a history book, for example, but very rarely in an advertisement—that guaranteed the validity and constancy of contextual assumptions upon which the interpretation of photographs conventionally depended.

It comes as no surprise that these boundaries have disintegrated—or, rather, that the domains of historical and photojournalistic photography, and also of fine art photography, have been enfolded within the tender embrace of the master discourses of marketing and advertising under the aegis of the visual content industry. Admittedly, the connection between the production and the distribution of photographs has been increasingly tenuous since the emergence of photography as a media profession, but these latest trends, with the acquisition of historical archives and exclusive reproduction rights by transnational corporations that specialize in "visual content," signifies the absolute decontextualization and abstraction of images. Thus not

only are the distinctions between media erased, so are the differences in the values and purposes associated with different types of photographs. The visual content industry converts the complex material and symbolic specificity of images into an abstract universal, *content,* severing each image from the context of its initial production, circulation, and consumption and reinscribing it within the overarching system of commercial exchange. Such a reinscription parallels, on the discursive and institutional plane, the abstraction and equivalence of forms achieved by digitization on the technical plane. And it makes it almost impossible for viewers to trace the relations of power back through to the initial context of production, to determine who is exercising the authority to represent the world in this particular way.

The third tendency of the visual content industry is the concomitant of the second: the centrifugal, "imperialistic" trajectory of this centripetal ingathering of content. It draws increasing quantities of visual material into its orbit, with the aim of dispersing that material to more and more consumers across the world, to larger and more lucrative markets. Klein's (1998) projection starkly reveals the multiple roles of digital technologies in this dynamic: delivery tool, source of demand for images, and socializing agent of viewers.

Questions of Power

It is impossible to predict all of the potential implications of these structural, financial, and technological interactions. However, a number of interlinked dynamics seem to be emerging. I will first consider these dynamics as they relate to questions of social and cultural power, before concluding with an attempt to outline their ethical dimensions.

Centralization of Distribution

Silverstone (1999) has observed that "there is a detectable tendency for the new media to create a society with an excluded middle, in which . . . the mediating centre, the mid-sized firm and indeed the nation state are being squeezed out of contention by the forces of the large and the small, the global and the local" (26). Validating Silverstone's claim, medium-sized stock agencies are finding it hard to compete with the delivery systems, manageable costs (thanks to economies of scale), and marketing power of the superagencies, on the one hand, and the prices of royalty-free companies and specialist capacities of niche agencies on the other. As Superstock president Gary Elsner recently admitted, "Any midsized company in this industry is in a pickle now because of competition from royalty-free providers and mega-agencies" ("Superstock Cuts Prices" 2000). Niches can include not just subjects such as "golf" or "medical," but also "group" niches, such as women's agencies and lesbian and gay stock libraries. However, some also doubt the ability of even specialist agencies to distribute their images to a large market without the aid of the superagencies, especially because of the high costs of digitization (scanning, storage and data management, keywording, Web site creation and maintenance, security, and so on); Getty Images invested

thirteen million dollars in digitization in 1998 out of a total capital expenditure of almost twenty-eight million dollars (Walker 1998, 23). This in turn threatens to restrict the choices realistically available to clients as well as to photographers looking for representation.

Decreasing Power of Photographers vis-à-vis Agency Management

The financial and marketing clout of the superagencies makes photographers extremely dependent on these agencies for exposure and sales. The new "democracy" of the Web does not appear to benefit photographers here, unless, again, they cater to specialist niches.[26] They can set up their own Web sites in competition with the big agencies, but without large marketing budgets and campaigns, most potential customers won't know that they exist. This seems to be true of many industries on the Web: "without promotion, you're just a lemonade stand on the highway," says the head of one media conglomerate (quoted in Herman and McChesney 1997, 124). A search of the Web using keywords such as *stock photography* calls up thousands of Web pages, so marketing becomes the key to attracting customers. As Jonathan Klein (1998) puts it, "The web is chaotic—therefore it is a natural place for aggregators." This means that although photographers are officially encouraged to be "creative" and pursue their "unique vision," they may have to conform more and more to a few house styles, including, ironically, one that promotes a "Photonica" look.

Globalization

The global reach and instantaneous distribution offered by on-line delivery systems threatens to alter the power relations between corporate headquarters (based in the United States or Europe) and representatives in non-Western cultures who distribute on their behalf. It means that—at least in theory—stock agencies can retain a global clientele without the expense of maintaining local offices or franchisees across several continents. Indeed, one of the chief fears of many local franchisees is that in an age of on-line sales, Web sites, and instantaneous transactions, they are an expensive irrelevance to global corporate strategy. Although to date no local offices have been closed as a result, and most industry insiders argue that there is no substitute for the culture-specific promotional and "policing" tasks (tracking unauthorized uses) such offices undertake, on-line digital delivery increases concerns about the relationship between globalization and the dominance of Western cultural perspectives and commercial interests.[27] And, with the possible exception of landscapes, digital "enhancement" technologies may even aid the fabrication of "non-Western" photographic images at (or near) corporate headquarters, should this prove cost-effective.

Limitations of Image Diversity

As I mentioned earlier, stock's generally acknowledged rededication to "quality" is due at least as much to cultural and commercial forces as to technological factors. In line with general corporate and cultural trends toward market differentiation and more

complex and reflexive "hypersignificant" advertising imagery (Goldman and Papson 1994), the large stock agencies have diversified somewhat from the generic stereotypes of the 1970s and 1980s both to more abstract "fine art" and conceptual images and to images that address ethnic minorities and other previously underrepresented groups.[28] Interestingly, digital technologies have the potential to augment and advance this limited diversification of content. The flexibility, accessibility, and relative efficiency of digital delivery means that it has become easier and cheaper to distribute a diversity of images to a far greater range of users than previously. However, although, as Miller (1999) notes, "such attempts *have* broadened the repertoire of stock imagery" (128), they occur within a context where most of the photographers and management are still white heterosexual males who are frequently blind to the cultural distinctions and interpretations that their audiences take for granted (Robyn Selman, head of acquisitions for Direct Stock, Photo Expo East '98, October 30, 1998).[29] Moreover, given the overall framework of advertising practices, almost all stock photographs need to address the tastes and enthusiasms of the relatively small percentage of the population with large amounts of disposable income. The upshot of this is that, although images that use unconventional focus, cropping, and lighting are now far more common than previously, the bulk of stock imagery has not changed very much at all.[30] This was a recurring theme in a PDN survey of stock professionals who were asked to comment on "the look of stock in the new millennium" (Lehan 1999):

> In terms of content, what was good in 1900, good in 1930, good in 1999, is still going to be good in the year 2000, 2010, 2020. Relationships between people do not change. (Jon Feingersh, stock photographer)

> Best-selling images are those that very quickly convey a message. It's safe to say that the same concepts are always going to be popular: love, family, strength, success. . . . Unfortunately, there are a finite amount of options. (Paul Henning, consultant)

> It's fun to take chances, and I am getting great response from my newer stuff. But I think a smart photographer would still do some of the old tried-and-true shots. There's still a big market for straight and almost corny shots. Those are still my bread and butter. (Michael Keller, photographer)

> Very straightforward photography is still selling very well. Photo editors at agencies love exciting new photography, art directors love to do layouts with exciting new photography, but nothing makes people more conservative than actually opening your pocketbook, and it's the client who is spending the big money on an ad campaign. . . . In the end, it's still probably your one cute kitten shot that sells, not the edgier stuff you shot to get the agencies to notice you. . . . At Index Stock 70 per cent of our sales are of traditional photography. (Allen Russell, executive director of photography, Index Stock, and president of PACA)

So, largely irrespective of the digital transformation, the forces for image uniformity (the relations of structural and financial dependence among photographers,

agencies, and clients, and the discursive and institutional priority of marketing and advertising) are as powerful today as they were in stock photography's "analog" period. Digital technologies have shattered the ceiling on the number of images the industry can produce and deliver, and have met cultural and aesthetic shifts with a limited diversification in the content and, more especially, the style of stock photographs. The increase in the quantity of images means that inevitably—and thankfully— some are new. But it also means much, much more of the same.

Questions of Ethics

What might be the ethical consequences of these dynamics? I would briefly suggest these interconnected themes.

Exclusionary Representational Power

Like any archival system, including predigital stock photography, the visual content industry operates on an exclusionary basis. Its repertoire of images is selected and ordered in accordance with the classificatory regimes employed by advertising and marketing discourse to specify meanings and target audiences (most fundamentally, class, gender, sexuality, ethnicity, and age) and with these industries' almost pathological inability to comprehend social experience outside of or across sharply delineated normative categories (see Turow 1997). Such classificatory regimes function both *honorifically* and *repressively* (Sekula 1989, 347): they define their "inside," their archival integrity, in opposition to a constitutive "outside" of possible materializations and identifications that are foreclosed or denied.[31] Judith Butler (1993), borrowing from Julia Kristeva, describes these alternatives as "abject," culturally unthinkable and inexpressible: the abject designates "those 'unlivable' and 'uninhabitable' zones of social life which are nevertheless densely populated by those who do not enjoy the status of the subject, but whose living under the sign of the 'unlivable' is required to circumscribe the domain of the subject" (3). The abject zones of mainstream stock photography have shifted very little over time; in general, they are homosexuality (which did, however, emerge as a sanitized half-subject in the late 1990s; the images depict— admittedly chaste—physical proximity as a sign of intimacy and affection, but almost never show kissing),[32] the crossing of racial boundaries in sexual encounters, and the depiction of working-class subjects.

The ethical question raised here is clearly connected to representational power: the inability of certain groups to control representations of themselves, or even to be represented at all. Such a concern is raised by any archival system, so what makes the visual content industry different? Indeed, the concentration of extensive and diverse archival material within a handful of transnational conglomerates, combined with their global reach and the universality of digital code, suggests that the age-old dream of a universal library, a uniquely nonexclusionary archive, is about to become a reality. However, this invocation of digital technology and the powers it seemingly be-

stows is at the heart of the problem, for the fabled technical universality of digital systems actually disguises the functioning of power in an industry structured and driven by commodity exchange, an industry that selects and orders images in terms of their salability. The word *content,* so neutral and inclusive, is a key indicator of this concealment of exclusionary representational power through the magic of the binary code. And it is the claim of universality that is truly mystificatory here, for the visual content industry *is* universal, but mainly in the sense that money is—and money is one of the most potent excluders of all.

Loss of Autonomy

Even as the visual content industry is fissured by—and profits from—discourses of artistic vision and creativity, its dynamics of power strongly suggest that it threatens the autonomy of individual photographers. To say that this is an ethical issue, one concerning the constitution of individuals as creative, reflexive subjects in relationships of mutual responsibility with others, is not to pretend that "autonomy" is a universal, transhistorical possibility or that it has only recently come under threat. It is, however, to second Hal Foster's (1996) argument: "For many of us autonomy is a bad word, a ruse in aesthetic discourse, a deception in ego psychology, and so on. We forget that autonomy is a diacritical term like any other, defined in relation to its opposite, that is, subjection" (117).

Representational Mastery and Experiential Depletion

The visual content industry does, in several respects, empower viewers.[33] It makes a vast number of images available to average income earners and gives users technical and legal opportunities to alter those images and use them in works of personal creative expression. Such a form of empowerment, and particularly its unambiguous celebration, does come with a price however, and that price is a depletion of our ability to experience otherness through representation and to feel responsible to the represented. Predigital photographic technology entails a "referential excess" (Baker 1996), the indexical tendency of the photograph to reproduce aspects of the rendered reality irrespective of the photographer's intention or the viewer's expectations. It makes encounters with the radically unknown and unanticipated at least possible (as in Barthes's [1984] *punctum*), if not probable, and in encouraging a sense of the (ontological) reality of the depicted, it engages, at least minimally, with questions of responsibility toward them. Even when the photograph, like most stock images, is thoroughly staged or altered during and after development, these repressions of referentiality require hard, skilled work, a kind of laborious paying of dues as the price for gaining representational mastery.[34]

In contrast, the visual content industry is premised on the absolute eradication of photographic referentiality and on the provision of representational mastery to all—viewers no less than photographers. The bottom line of this mastery is that the

image is an extension of the ego, its tailor-made world: the other evaporates, along with any sense of duty toward it, into so many alterable info-pixels that stand at the service of the photographer and the viewer. And because the visual content industry appears to gather in all the images of the world, the ego becomes coextensive with the total phantasmagoria of the digital archive: otherness is no longer a radically unknown ontological reality, but something easily fabricated and speedily acquired in a global system of infinite image transformability. Such a dynamic makes the accidental encounter with the other, the shock of the unmasterable, *otherness as an experience of the self's limitation,* a structural and discursive improbability: it threatens to give photographers and viewers alike a sense of power without responsibility.

Institutional Invisibility

The visual content industry, like the predigital stock photography business, is largely hidden from the public that consumes its images: most people have never heard of it or the companies that dominate it. The industry is concealed from its viewers by its clients, the cultural intermediaries in advertising agencies, marketing departments, graphic design studios, and elsewhere who directly employ the images in their material while making little overt reference to their source.[35] And it is cloaked by the corporate acquisition of historical and artistic archives and the collapse of discursive and institutional boundaries between types of photographs, a collapse that destroys the continuity between production and consumption and the interpretive assumptions that such continuity traditionally underpinned. Together these factors make it almost impossible, as I have already said, for viewers to follow the traces of power back through the images to the context of their manufacture and to glimpse exactly who is exercising the authority to create these representations of the world. The key ethical concern is, once again, power without responsibility, only this time it is not just the power of producers and consumers to manipulate images on a computer, but veiled, hegemonic power over a vast empire of image creation. And it is a central irony of this concealment that the invisibility of the visual content industry lies behind its perpetual production of the visible—its trajectories and limitations—as though its very products shielded it from view. All this takes place in a globalizing and digitized culture of consumption that is ever more dependent on the images it makes.

In Conclusion

At present, the trends that I have discussed in this chapter are in their nascent stage, although the pace of change could lead to their rapid maturation. Together they paint a complex, obscure, but nevertheless unsettling picture: the fusion of miraculously transformative technologies, the collapse of discursive and institutional barriers between image types, the colonization of new markets and the containment of the process of image diversification, the use of technology as a weapon in the struggle to subordinate photographers, all carried out within the globalizing and commodify-

ing logic that drove the predigital stock industry itself. This development is not without its moments and dynamics of resistance and empowerment—the increased diversity of images, previously unrepresented groups coming into visibility, "viewers" enabled by digital technologies to take part in (and to take apart) the image-producing process—moments that the visual content industry seeks to neutralize or exploit. But perhaps most troubling of all is the point I discuss last in the section on ethics above: the concentration of power through which digital visual technologies themselves are being directed and shaped in the very instance of being deployed and the invisibility of the institutions that possess this power to most of the consumers of their products. If there is a single, unifying purpose to the whirlwind tour of the visual content industry that constitutes this chapter, it is to begin to shed some light on those institutions.

Appendix: Trade Publications

BAPLA Directory: Listing of members of the British Association of Picture Libraries and Agencies, the stock industry's trade association in the United Kingdom.

Communication Arts: Prestigious U.S. professional design and photography magazine.

Creative Review: Monthly U.K. commercial design magazine.

Graphic Design USA: Small monthly professional graphic design journal.

Light Box: The quarterly magazine of BAPLA, the British stock industry's trade association.

PDN (Photo District News): Leading monthly U.S. commercial photography trade journal; an extensive on-line version is available at http://www.pdnonline.com.

Photo Source News: Small professional stock photography trade journal and on-line news service.

Zoom: Bimonthly international professional photography magazine.

Notes

1. Unless otherwise stated, all Getty Images press releases can be found at www.gettyimages.com.

2. It has also been neglected by most media and cultural analysts, including many who specialize in photography. There is no significant published research on stock photography, with the exception of two short articles: Helen Wilkinson's (1997) study of stock photography in 1930s Britain and J. Abbott Miller's (1999) incisive but all too brief contemporary analysis.

3. William Mitchell (1992) exemplifies the sophisticated end of the utopian spectrum, arguing, for instance, that digital technologies are ideal critical devices for deconstructing the assumptions behind photographic objectivity. Among his chief problems, outlined by Robins (1996) and Lister (1997), is that his characterization of predigital photography is based on a very selective view of the medium that assumes it is defined primarily by the values of documentary realism. This problem is echoed in my claim below that stock photography, and advertising photography in general, involves rhetorical and performative practices that have always been at some remove from the discourse of photographic objectivity.

4. The term *generic image* is widely used in the industry. Examples of such images can be found on any of the main stock agency Web sites, including www.comstock.com, www.corbis.com, and www.gettyimages.com. To see "High-end" images, visit www.gettyimages.com, www.tonystone.com, or www.photonica.com.

5. The Image Bank claims to have introduced the image catalog as a marketing tool in 1982 ("Pioneers" 1994, 5), and Henry Scanlon counterclaims that Comstock pioneered its use ("Future Stock" 1997, 62).

6. Broadly endorsed within the industry during the late 1990s, the figure of $1 billion for total global sales was frequently mentioned during the trade conference Photo Expo East '98, although no one could point to a definitive source (Index Stock [1999] puts the value of the "visual content industry" at $2.5 billion in 2000, without spelling out how that figure was calculated). Brian Seed (1999), publisher of *Stock Photo Report* (probably the most thorough, although not necessarily the most popular, industry monitor), has confirmed this figure as an acceptable although "very rough, repeat very rough" estimate. In his keynote address at Photo Expo East '98, Jonathan Klein (1998), CEO of Getty Images PLC, bemoaned the secrecy of his competitors with regard to the publication of accurate financial figures.

7. For reasons of space I will not be able to address in any depth other such "moments," especially promotion and storage (including, for example, the particularly thorny and costly problems associated with "keywording," an issue that has revived debate—instrumental rather than critical—on the relationship between images and words).

8. The results of this survey, which are by no means conclusive, are available on the APA Web site at www.apanational.org. The findings are based on 164 returned surveys, representing roughly 25 percent of APA members. Additionally, not all APA members shoot stock images (according to the survey results, 9 percent of members' average income comes from stock usage fees, as opposed to 81 percent from assignments), and there are plenty of U.S.-based stock photographers who are not APA members. However, in the absence of more concrete and comprehensive data, the results of this survey do offer some useful indications about professional trends in U.S. advertising photography as a whole.

9. Photo Expo East '98, held in New York City in October 1998, was the East Coast version of the most important annual U.S. professional photography conference and exhibition. Unless otherwise stated, quotations from conference participants are from sessions that I attended as part of my fieldwork. Thanks are due to the Smart Family Foundation Communication Institute at the Hebrew University of Jerusalem for their support.

10. In all fairness to Batchen, he himself is not a member of either group. He does not argue that digital technologies are causing a fundamental alteration in photography's identity; rather, he stresses that the representation/reality dichotomy is a central problem and anxiety at work in photography from (and before) its inception (see Batchen 1998, 22–24; 1997).

11. These magical qualities of photography have been central to some of the foremost meditations on the medium; see Benjamin (1931/1980), Bazin (1967/1980), Sontag (1977), and Barthes (1984). The connection of Benjamin to the question of enchantment is especially interesting, because it suggests that in some sense the photograph itself may be "auratic." I am grateful to Yosefa Loshitsky for making this point.

12. John Lund, however, was at the center of a dispute that shows just how much control photographers actually have, providing an illuminating example of the trauma caused by digital image manipulation technologies to traditional conceptions of authorship and image integrity. One of Lund's photographs was licensed for use to Fat Cat Digital, a digital retouching company run by two photographers. The company, according to Lund's agent, Richard Steedman at the Stock Market, then "tampered with the image. It's been digitally altered in a sloppy or haphazard way. How a couple of professional photographers would allow this to happen to someone's work is so indecent, so unfeeling. . . . You can't take an artist's work and denigrate it" (PDNewswire 2000).

13. The article from which this quotation is taken was unfortunately removed from the Corbis Web site in late 1999, and I have been unable to find an alternative source for it. Karen

Akiyama does not appear on the current list of senior Corbis employees (her title at the time the Web site carried this article was manager of business and legal affairs).

14. These are also the two pillars of the digital promotion of images. However, most stock agencies and clients still rely heavily on conventional printed catalogs (Kaye 1998, 79–80). I would speculate that this has something to do with the different purposes for which habitual modes of seeing are deployed, as well as the specific advantages (portability, breadth of access) still retained by print. One technologically orientated designer I spoke to, for example, emphasized that he uses the promotional CD-ROMs issued by agencies when he knows exactly what kind of image he is looking for, but still prefers to flick through the printed catalog in order to get a general overview of what is available (Peeri 1998).

15. E-commerce does not include digital delivery on CD, so the figure for Getty's digital distribution is actually higher. To explain the large growth in e-commerce sales in the last two quarters of 2001, Getty points to its launch of a new Web site in October of that year.

16. However, "royalty-free" isn't necessarily royalty-free: almost all royalty-free producers place restrictions on the rights of users. In particular, the fine print of RF "terms and conditions" clauses usually prohibits "items for resale," which means that although the images can be used to *promote* products, they cannot always be incorporated into products (including other images) that are then sold, because this effectively involves the *resale* of the images (see Comstock 1998; "Will It Survive?" 1998).

17. Variations in price are determined primarily by the number of images on a disc and by their resolution, measured in pixels per inch and file size (number of megabytes). High-resolution image collections are usually aimed at professional designers rather than at the broad consumer market. Similarly, the prices of individual RF images bought from Web sites also increase with resolution and file size: low-resolution images are often available free to registered Web site users for employment in mock-ups or "comps" (comprehensive renderings) to be used in presentations to clients.

18. The cultural distinction is detectable in the names given to the brands: Comstock's rights-protected division was initially called Comstock Classic, and its royalty-free division was for a time named Comstock Klips, the use of the letter *K* being not a little reminiscent (perhaps deliberately so) of other brand names in related fields—Kall Kwick copying, for instance.

19. Comstock, unlike most of the other large agencies, can perhaps afford to be so forthright in its characterization of the majority of photographers, its own included, as mere "technicians." Rather than promoting images supplied by copyright-holding freelancers (who frequently need to be cultivated and humored, despite their overall dependence), it relies on photographs shot by in-house staff photographers who are paid wages. Comstock owns the copyrights to these images.

20. There is, however, a growing countertrend to the treatment of royalty-free images as infinitely malleable "raw material." In May 2001, Getty Images PLC was forced to apologize for a PhotoDisc advertisement that ran in the German magazine *Visuell*. The ad showed a (royalty-free) photograph of two women posing at a wedding on which the women's bodies, most notably their breasts, seemed to have been outlined in marker-pen in an act of adolescent male puerility. The ad copy declared, "Do whatever you want to our images. Pay once, use forever, for whatever." After outraged complaints by the photographer, other photographers, and the model agency representing the depicted women, Getty pulled the ad and assured the critics that "we respect the imagery our artists create, their copyrights in those images, and the rights of the models who appear in them." In this instance, however, the photographer had signed over copyright to Getty (see Editorial Photographers UK 2001).

21. Many industry observers would argue that from the very late 1990s onward, Tony Stone Images has also pioneered innovative imagery and pursued new directions in catalog design.

22. David Arky was not discussing Photonica when he made these remarks. He was participating in a panel discussion on how to create best-selling stock photographs.

23. Just to indicate the general drift of photographer-agency relations: the ASMP's 1999 survey of stock photographers shows that although 61 percent of photographers reported no change over the past five years in their share of sales, 25 percent reported a decrease (14 percent reported an increase). Furthermore, 25 percent reported an increase in deductions from payments to photographers that were made to cover agency costs, with less than 1 percent reporting a decrease (74 percent reported no change). See ASMP (1999a).

24. The *PDN* article cited here includes an interview with Getty CEO Jonathan Klein on the question of photographers' income. Klein's remarks received a scathing response from the executive director of the ASMP (see ASMP 1998).

25. Art.com is Getty's gateway to the vast "global consumer art market," which is estimated to be worth nine billion dollars, making it a much bigger fish than the traditional stock photography market. See Getty Images PLC (1999b).

26. There are, however, photographers who have successfully used the Web and argue that the fact that they cater to specialist niches is incidental to their success. See "Selling Stock Direct" (2000).

27. This is, of course, an extremely tricky question, and most of the literature on globalization stresses its dialectical relationship with forces of localization, or at least that globalization is "the condition whereby localising strategies become systematically connected to global concerns" (Poppi 1997, 285; see also, among others, Appadurai 1990; Friedman 1990; Morley and Robins 1995; Tomlinson 1999). Globalization of distribution systems need not necessarily mean centralization of image production in the United States and Western Europe, although the two have tended to coincide. Israel, for example, has three "general" stock agencies: the Image Bank, Visual Communications (which represents primarily large foreign agencies), and ASAP (a homegrown library that focuses specifically on "Israeli" imagery but also represents some U.S. and European agencies). Overall, the preponderance of stock photographs available, not to mention royalty-free images distributed on CD-ROM, are American or Western European in origin.

28. Lesbian and gay consumers make up one such group; see Corbis (1999).

29. According to the 1999 APA National Photographers Survey, only 14.5 percent of advertising photographers are women, representing a decline in the proportion of women in the profession since the last survey, in 1992. No figures were available concerning photographers' ethnicities.

30. Many of the images available from Photonica and Tony Stone are exceptions, as noted earlier.

31. I am grateful to Sarah Kember for reminding me of Sekula's point and its ethical dimension.

32. A few specialist agencies have produced images of lesbian and gay subjects, such as the U.K. agency Gaze (see its Web site at www.gaze.co.uk).

33. The point I make in this subsection is heavily indebted to the work of Kevin Robins (1996).

34. The price of representational mastery over staged photographs is in part a monetary one: models used are required to sign "model release forms," which state that they have been remunerated for the use of their "images" in the initial work contracts and have no claim on

the photographs' subsequent earnings. Similar contracts are employed with the owners of properties that appear in stock images. Most agencies will not accept images provided by photographers unless all individuals who appear in the images have signed model release forms.

35. The largest of the transnational superagencies, Getty Images, is by far the most publicly transparent. As a public limited company, it is subject to strict reporting and auditing requirements, and its activities as a consolidator have generated a great deal of attention within the industry (particularly the trade press) in comparison with its competitors. Of course, this is no guarantee that anyone outside the industry or its clients has heard of it.

References

Akiyama, K. A. 1998. Rights and responsibilities in the digital age. On-line at http://www.corbis.com.

American Society of Media Photographers (ASMP). 1998. ASMP executive director's letter to PDN on TSI and erosion of photographers' revenues. Press release, December 3. On-line at http://www.asmp.org.

———. 1999a. ASMP's stock survey results—May 1999. Press release, May. On-line at http://www.asmp.org.

———. 1999b. An open letter to PACA. Press release, April 29. On-line at http://www.asmp.org.

Appadurai, A. 1990. Disjuncture and difference in the global cultural economy. Pp. 295–310 in *Global culture: Nationalism, globalization and modernity,* edited by Mike Featherstone. London: Sage.

Baker, G. 1996. Photography between narrativity and stasis: August Sander, degeneration and decay of the portrait. *October* 76:73–113.

Barthes, R. 1977. The photographic message. Pp. 15–31 in *Image-Music-Text.* London: Fontana.

———. 1984. *Camera lucida: Reflections on photography.* London: Fontana.

Batchen, G. 1997. *Burning with desire: The conception of photography.* Cambridge: MIT Press.

———. 1998. Photogenics. *History of Photography* 22, no. 1:18–26.

Bazin, A. 1980. The ontology of the photographic image. Pp. 237–44 in *Classic essays on photography,* edited by Alan Trachtenberg. New Haven, Conn.: Leete's Island. (Original work published 1967)

Benjamin, W. 1980. A short history of photography. Pp. 199–216 in *Classic essays on photography,* edited by Alan Trachtenberg. New Haven, Conn.: Leete's Island. (Original work published 1931)

Berger, J., and J. Mohr. 1982. *Another way of telling.* New York: Pantheon.

The best sellers. 1994. *Zoom,* special issue: The Image Bank 20th anniversary. Best sellers. 1999. *Creative Review,* August.

Binkley, T. 1993. Refiguring culture. Pp. 92–121 in *Future visions: Introduction and development of new screen technologies,* edited by Phillip Hayward and Tania Wollen. London: British Film Institute.

Bossen, H. 1985. Zone V: Photojournalism, ethics and the electronic age. *Studies in Visual Communication* 11, no. 3:22–32.

Bourdieu, P. 1986. *Distinction: A social critique of the judgement of taste.* London: Routledge.

British Association of Picture Libraries and Agencies (BAPLA). 1998–99. *BAPLA directory.* London: BAPLA.

Butler, J. 1993. *Bodies that matter: On the discursive limits of "sex."* London: Routledge.

Comstock. 1998. "Rights-protected" vs. "royalty-free"—which is for you? An insider's essential guide to making the right choice. On-line at http://www.comstock.com.

———. 1999. Demystifying "rights protected" stock photo pricing. On-line at http://www.comstock.com.

Corbis. 1998. Company overview. September. On-line at http://www.corbis.com.

Corbis. 1999. Corbis images appeal to burgeoning gay and lesbian market: Newest royalty-free CD first to offer gay and lesbian lifestyle images. Press release, September 20. On-line at http://www.corbis.com.

Corbis buys digital stock. 1998. *Photo Source News,* March. On-line at http://www.photo-source.com.

Corbis to acquire the Stock Market. 2000. *PDN,* May. On-line at http://www.pdn-pix.com.

Distant vistas, still lifes. 1998. *Light Box,* October.

Editorial Photographers UK. 2001. Getty Images apologise for unacceptable advert. May 12. On-line at http://www.epuk.org/news/2001/05/12gettysorry.html.

Feliciano, K. 1998. Being there: Reflections on the digital revolution. Pp. 22–24 in *Photo Expo East '98 showguide.* New York: PDN.

Foster, H. 1996. The archive without museums. *October* 77:97–119.

FPG International. 1999. Visual Communications Group (VCG) launches interactive website for its FPG stock photography brand—includes new royalty-free line. November. On-line at http://www.fpg.com.

Friedman, J. 1990. Being in the world: Globalization and localization. Pp. 311–28 in *Global culture: Nationalism, globalization and modernity,* edited by Mike Featherstone. London: Sage.

Future stock: Comstock goes clip, Henry Scanlon explains why. 1997. *PDN,* September, 60–69.

Getty Images PLC. 1997. Press release, September 16.

———. 1999a. Company overview. November. On-line at http://www.gettyimages.com.

———. 1999b. Getty Images acquires leading online consumer art brand, Art.com: Acquisition marks leading visual content provider's expansion into online consumer marketplace. Press Release, May 5.

———. 1999c. Gettty Images' Art.com partners with key women's Web sites. Press release, June 3.

———. 1999d. Getty Images broadens access to Hulton Getty Collection through Art.com. Press release, May 25.

———. 1999e. Getty Images' PhotoDisk inks deal with Amazon.com. Press release, April 27.

———. 1999f. Getty Images to acquire the Image Bank: Acquistion to bring new opportunities for online distribution and brand leverage. Press release, September 21.

———. 1999g. Getty Images' Tony Stone Images announces success of first online catalog preview. Press release, July 27.

———. 1999h. Launch of new Tony Stone Images catalogue. Press release, July 18.

———. 2000. Getty Images acquires Visual Communcations Group. Press release, February 28.

———. 2002. Getty Images reports financial results for the fourth quarter and 2001. Press release, February 6.

Getty to buy the Image Bank. 1999. *PDN,* October. On-line at http://www.pdnonline.com.

Goldman, R., and S. Papson. 1994. Advertising in the age of hypersignification. *Theory, Culture & Society* 11:23–53.

Heidegger, M. 1993. The question concerning technology. Pp. 308–41 in *Basic writings,* edited by D. Farrell King. London: Routledge.

Herman, E., and R. McChesney. 1997. *The global media: The new missionaries of corporate capitalism.* London: Cassell.

Heron, M. 1996. *How to shoot stock photos that sell.* New York: Allworth.

Hiley, M. 1983. *Seeing through photographs.* London: Gordon Fraser.

Index Stock. 1999. Corporate history. On-line at http://www.indexstock.com/press/history.htm.

———. 2000. Licensing still images: Basic information for multimedia producers. June 4. On-line at http://www.indexstock.com/publications.htm.

Kaye, G. 1998. Stock photography rushes to meet millennium. *Graphic Design USA,* August, 78–84.

Kember, S. 1995. Medicine's new vision. In *The photographic image in digital culture,* edited by M. Lister. London: Routledge.

———. 1996. "The Shadow of the Object": Photography and Realism. *Textual Practice* 10, no. 1:145–63.

Klein, J. 1998. Content in the 21st century. Keynote address delivered at Photo Expo East '98, October 31.

Krauss, R. 1982. Photography's discursive spaces: Landscape/view. *Art Journal* 42, no. 4:311–19.

Lash, S. 1990. *The sociolgy of modernism.* London: Routledge.

Lehan, J. 1999. Future stock: The look of stock in the new millennium. Pp. 18–28 in *Photo Expo East '99 showguide.* New York: PDN.

Leiss, W., S. Kline, and S. Jhally. 1997. *Social communication in advertising: Persons, products and images of well-being.* London: Routledge.

Lister, M., ed. 1995. *The photographic image in digital culture.* London: Routledge.

———. 1997. Photography in the age of electronic imaging. In *Photography: A critical introduction,* edited by Liz Wells. London: Routledge.

McQuire, S. 1998. *Visions of modernity.* London: Sage.

Miller, J. A. 1999. Pictures for rent. Pp. 121–32 in *Design writing research: Writing on graphic design,* edited by E. Lupton and J. A. Miller. London: Phaidon.

Mitchell, W. 1992. *The reconfigured eye: Visual truth in the post-photographic era.* Cambridge: MIT Press.

Morley, D., and K. Robins. 1995. *Spaces of identity: Global media, electronic landscapes and cultural boundaries.* London: Routledge.

Mort, F. 1996. *Cultures of consumption: Masculinities and social space in late twentieth-century Britain.* London: Routledge.

Nixon, S. 1997. Circulating culture. In *Production of culture/cultures of production,* edited by P. du Gay. London: Sage/Open University Press.

PDNewswire. 2000. *PDN,* December.

Peeri, I. 1998. Interview by author. Peeri Communications. Tel Aviv, December 10.

Photos for sale. 1998. *Photo Source News,* December. On-line at http://www.photosource.com.

Pioneers who transformed an industry. 1994. *Zoom,* special issue: The Image Bank 20th anniversary.

Poppi, C. 1997. Wider horizons with larger details: Subjectivity, ethnicity and globalization. In *The limits of globalization: Cases and arguments,* edited by Alan Scott. London: Routledge.

Ritchin, F. 1990. *In our own image: The coming revolution in photography.* New York: Aperture.

Robins, K. 1996. *Into the image: Culture and politics in the field of vision.* London: Routledge.

Seed, B. 1999. Personal communication, January 30.

Sekula, A. 1981. The traffic in photographs. *Art Journal* 41, no. 1:15–25.

———. 1989. The body and the archive. Pp. 342–88 in *The contest of meaning: Critical histories of photography,* edited by R. Bolton. Cambridge: MIT Press.

Selling stock direct on the Web: Three case studies. 2000. *PDN*, January. On-line at http://www.pdn-pix.com.

Silverstone, R. 1999. *Why study the media?* London: Sage.

Slater, D. 1995a. Domestic photography and digital culture. In *The photographic image in digital culture*, edited by M. Lister. London: Routledge.

———. 1995b. Photography and modern vision: The spectacle of "natural magic." Pp. 218–37 in *Visual culture*, edited by Chris Jenks. London: Routledge.

Sontag, S. 1977. *On photography.* New York: Doubleday.

Stock photography. 1993. *Communication Arts,* January/February.

Stock photography. 1998. *Communication Arts,* August, 209.

Superstock cuts prices. 2000. *PDN*, March. On-line at http://www.pdn-pix.com.

TIB enters R-F business. 1998. *PDN*, December. On-line at http://www.pdnonline.com.

Tomas, D. 1996. From the photograph to postphotographic practices: Toward a postoptical ecology of the eye. Pp. 145–53 in *Electronic culture: Technology and visual representation*, edited by T. Druckery. New York: Aperture.

Tomlinson, J. 1999. *Globalization and culture.* Chicago: University of Chicago Press.

Turow, J. 1997. *Breaking up America: Advertisers and the new media world.* Chicago: University of Chicago Press.

United News and Media to unload VCG. 2000. *PDN*, February. On-line at http://www.pdn-pix.com.

Walker, D. 1997. Corbis looks at royalty-free business. *PDN*, September, 22–24.

———. 1998. New TSI contracts pose tough terms. *PDN*, October, 23–25.

Wilkinson, H. 1997. "The new heraldry": Stock photography, visual literacy, and advertising in 1930s Britain. *Journal of Design History* 10, no. 1:23–38.

Will it survive? Commercial stock photography. 1998. *Photo Source News,* January. On-line at http://www.photosource.com.

Williamson, J. 1978. *Decoding advertisements: Ideology and meaning in advertising.* London: Marion Boyars.

10

Computer-Generated Images: Wildlife and Natural History Films

Derek Bousé

"We have art," Nietzsche once reflected, "that we may not perish from Truth." It is one of the ironies of modern communication that similar sentiments should now be heard coming from those in the business of making wildlife and natural history films, a genre long thought to be (when thought about at all) virtually free of art. The indifference of critics and the trust of audiences have both stemmed from the fact that wildlife films have been seen as uncomplicated depictions of scientific facts and simple truths about the natural world, with little if any creative intervention—Truth, in other words, in no danger of perishing from art.

That wildlife films were devoted to scientific fact and devoid of creativity had never really been the case, of course, but it had been a profitable enough illusion. In the waning years of the twentieth century, however, wildlife and natural history films underwent a worldwide boom in production, distribution, and viewership that made it impossible for them to remain any longer in their quiet, comfortable niche. As capital poured in from mainstream production and broadcast sources, the wildlife

genre was inevitably pulled in their direction, not in that of science. The television mainstream, however, was a sink-or-swim environment; staying afloat and surviving not only meant swimming alongside sitcoms, melodramas, and action-adventure programs, but competing with them for audiences, ratings, prime-time slots, and financing. This meant, of course, competing on *their* terms. As a result, wildlife films began to shed their image as dry, scientific documentaries and to claim a place instead among the other colorful spectacles and dramatic adventures that attracted broad audiences and, in turn, sponsors and investors.[1] As the wildlife film industry grew larger and wealthier, it began congratulating itself at festivals and awards ceremonies that looked suspiciously like those of Hollywood. Creativity, not science, got the loudest applause and took home the awards.

There were also more opportunities to move into new digital technologies, each of which came with its own expressive and creative possibilities. Even before century's end, wildlife and natural history films were already headed toward full digitization, from shooting to postproduction to transmission. Opportunities for creative intervention were plainly evident at each stage along the way.[2] It was not long before digital visual effects and computer-generated images (CGI) of the sort seen in Hollywood fantasies began finding their way into wildlife and natural history films, even among those made by producers with reputations for commitment to scientific truth.[3] It all happened so quickly that there seemed no time (or perhaps no willingness) for filmmakers to discuss and reflect on the ethical implications of digitally manipulating the images upon which many in the viewing public relied for most of what they knew (or believed) about wildlife and the natural world.

The Law of the Tool

It really should not have been surprising (although it was) when some wildlife filmmakers and still photographers began to speak openly about having used digital technologies to enhance or manipulate some of their images, and even to create new ones.[4] Inevitably, "how-to" books even began appearing to help nonprofessionals join in the fun (see, e.g., Fitzharris 1998). In one sense this openness was admirable, perhaps even "ethical," but it also seemed as if the nature image makers were demanding recognition for creative and artistic contributions in an area where many believed there were not and/or should not be any.[5] Films about nature and wildlife, even more than still photographs, were still largely perceived in the contexts of science inscription and environmentalism rather than of art or entertainment, and so were seen by many as being even less tolerant of manipulation.[6]

Yet this may have been a bit unrealistic, given that most wildlife films were made by for-profit production companies for distribution to entertainment channels catering to popular tastes. Could any such product compete for ratings in the boisterous and crowded TV marketplace and still be a voice for nature preservation or an effective tool for science education? Could it still be *art?* Should it be? And what or whose ethical principles should it uphold? Scientists and environmentalists had their own

answers to such questions and frequently attended wildlife film festivals to lobby on behalf of their concerns. Not surprisingly, they were often seen as interlopers seeking to enforce constraints on creativity, if not to drag down ratings and depress sales. "We are in the entertainment business," the producers and distributors protested, "and must sell to the global market."

Still, there was something to the scientists' and conservationists' arguments that wildlife films are in a special category of images and that they carry a heavier burden than most other forms of art or entertainment to be accurate and truthful. In an age when so many people received most of their information about nature from television, there were legitimate concerns about nature television's influence on public attitudes, especially given that audiences, in their roles as consumers and voters, might make decisions that could affect the fates of species and habitats. There was already some question as to whether or not nature television was really increasing viewers' concerns about wildlife and the natural world, let alone motivating them to do something about those concerns.[7] Could the ratings-driven emphasis on scenes of predation, conflict, and danger in wildlife films lead to trepidation, fear, and loathing (at least toward some species) among viewers? "How we treat others," film critic Richard Dyer (1993) has argued, "is based on how we see them" (1). Thus, if an animal were widely portrayed (and therefore seen) as a treacherous, dangerous killer, would there be popular support for its protection if it faced extinction? It also seems possible, however, that an increasing volume of nature content might only banalize the subject and lead audiences instead to boredom and indifference toward nature—which could have its own negative consequences.

The arrival of digital technologies for image manipulation raised more concerns about the way nature and wildlife were represented—and perhaps treated as a result.[8] The ability to cut and paste a few more animals into the frame, or to remove unwanted roads or cars, or even to adjust the colors of the vegetation could significantly misrepresent such things as population densities, human presence and impact, and general habitat conditions, respectively. Even the movements of animals could be digitally altered to suit almost any whim, with the result that their essential patterns of behavior could, conceivably, be misrepresented without detection. All were subject to the "law of the tool"—that is, the technologies were simply too available, making manipulation too easy for some to resist doing it.

Moreover, in an increasingly competitive marketplace, it could even be difficult to justify not doing it. Film and television were already becoming so saturated with digital imagery that some began to fear conventional natural history films would fail to hold their audiences, let alone attract new ones. A bit of CGI, the thinking went, might not only liven up the genre, but give rise to new formats and perhaps, therefore, offer a "way forward" through the changing marketplace.

There were also more practical problems that digital technologies might soon be able to solve. Sending a crew on another shoot in a distant location, with no guarantee of getting usable shots of the species or behavior sought, could be expensive.[9]

A week or two of subcontracted computer work manipulating existing footage might prove cheaper and more reliable—and the more attractive option, therefore, to those controlling a film's finances. It had become clear not only that the genre's aesthetics were being driven by economics, but that image manipulation itself could even be redefined as sound business practice.

Film and photographic images have always been manipulated, of course, and this has always been problematic.[10] In wildlife film, creative editing has long been used, for example, to intensify (if not to fabricate) climactic scenes of predators chasing and catching prey. Because these events are extremely difficult to film in the wild, it has been tacitly held that if a good "two-shot" can be obtained, in which both animals can be seen in the frame together, the other shots needed for a complete sequence could be forgivably "back-filmed" later with other animals. The two-shot served as the guarantor of authenticity and truth, the hard-won "proof" that the event (or at least part of it) had actually occurred. Digital technology, however, made even the two-shot no longer reliable as evidence of anything having really happened. Just as two separate still images could be easily combined through the use of any number of consumer-grade softwares, so moving image softwares made it possible even for amateurs to create seamless, full-motion two-shots from wholly separate elements—that is, from images of animals that had never actually encountered one another.

Yet manipulating exisiting images was only part of the story. The true potential of CGI, as its name implied, lay in *generating* new images altogether. By the late 1990s, the power was already there for filmmakers to create dramatic chase-and-kill scenes independent of the camera, of the actual experience of witnessing real behavior, real events, or even, ultimately, real animals. Extinct species could even be reanimated. Indeed, even dinosaurs could now appear in conventional wildlife films, and in 1999 they did (more on that later). Whether all wildlife filmmakers and photographers sensed it at first or not, the heavy anchor in *profilmic* truth, which had often seemed to weigh them down as artists, had been cut loose.[11] Convincing, lifelike images of wild animals, even if extinct, could at last (or very soon) be made to suit any story line, no matter how imaginative. In theory, the power was there to provide convincing visual "evidence" for virtually any speculation, presumption, or superstition about life in the wild—and there were plenty of these to go around.[12]

This all began happening at a time when some felt that the demands of the media marketplace had already cut wildlife and nature depiction loose from its moorings in reality. Most working in the industry, however, seemed to welcome the freedom. "We are artists," they proclaimed, "and do not wish to perish from truth."

True, yet Not Always Real

Perhaps it was the fact that so many viewers associated wildlife films with truth that made the manipulations of wildlife filmmakers so worrisome when brought to light.

Figure 10.1. A young Wyoming moose confronts a Montana coyote—in the tundra of the Russian far east. It has long been possible to fabricate a "two-shot" in still photography, but the difficulty of doing so in motion pictures made shots such as this guarantors of authenticity—until the arrival of digital image manipulation.

At the end of their first century, however, wildlife films had something of a checkered past when it came to manipulation. Some filmmakers had been motivated by the mimetic desire to reproduce nature faithfully, some by more creative impulses, and still others by less savory urges to exploit for profit. Somewhere between the good intentions of those in the first group and the cynicism of those in the third, a certain amount of manipulation—whether of images, situations, or the animals themselves—had always been quietly tolerated. Often it was just easier and cheaper, but sometimes it was even legitimate and justifiable. Better to get some shots in the zoo and to construct some scenes through editing than to subject the animals to the harassment, or the camera team to the dangers, needed to get some kinds of events on film (the birth of polar bear cubs, for example).

Still, until recently, there were virtually no rules, regulations, or restrictions governing what wildlife filmmakers could do, or how far they could go in manipulating images of nature, the trust of the public, and the animals themselves. Moral and ethical responsibilities of the sort automatically assumed by filmmakers working with human subjects did not apply, and many animals appearing on film were, in fact, mistreated or killed for the sake of sensational "money shots." If left alive, they could not retract, contradict, or cry foul in the newspapers as, for example, Pat Loud had when her family was destroyed in the debacle of *An American Family* (1973).[13]

Wildlife films' frequent use of "disposable subjects" has, in fact, been a key difference separating them from the humanist ethos and often explicit humanitarian purposes of the documentary genre. A well-known early illustration is Selig's *Hunting Big Game in Africa* (also known as *Roosevelt in Africa;* 1909), which purports to depict Theodore Roosevelt shooting a lion. Roosevelt was played by an actor, but the disposable subject and his death for the camera (or was it for *art?*) were unabashedly real.[14] A decade later, the team of Martin and Osa Johnson began goading distressed animals into charging, then shooting them at close range in order to film dramatic scenes of heroic "self-defense."[15] Frank Buck, in the series of phony "capture" films *Bring 'em Back Alive* (1932), *Wild Cargo* (1934), and *Fang and Claw* (1935), specialized in provoking savage fights between animals who would normally have avoided each other in the wild. When put into small enclosures together, they usually reacted to their shared confinement by attacking each other ferociously—while Buck's cameras lovingly captured it all on film. His footage of these desperate struggles between terrified animals are now difficult to watch, but they were popular as bread-and-circuses spectacles for Depression America. Would that such practices were all a thing of the past.

Even the films in Disney's seemingly benign "True Life Adventures" series (1948–60) involved a good deal of abuse of animals, not to mention abuse of audiences' faith and trust. Among the most notorious examples is a sequence in *White Wilderness* (1958) for which lemmings were rounded up and herded over a cliff. The animals may have been "sacrificed," but the legend of lemming "mass suicide" was preserved (and *proved!*).[16] Wildlife filmmakers cringe today when this oft-cited example is brought up. Although they emphatically disown the "True Life" films, there is nevertheless a tacit agreement among them that virtually anything can be reconstructed, staged, faked, or created—so long as it depicts what cameraman Stephen Mills (1997) describes as "a scientifically observable fact" or, as David Attenborough has put it, is "faithful to the biological truth" (quoted in Langley 1985, 60). Marty Stouffer has described it as being "true . . . yet not always real" (quoted in Sink 1996; see also Attenborough 1961, 99–100; Parsons 1971, 19–21). In any case, the long history in wildlife films of "factual re-creations" left the door ajar, if not wide open, to digital manipulation, where the facts could often be re-created much more easily than in the field or editing room. Indeed, those hard-to-get images could even be *created* virtually from scratch. "Factual *creations*" seemed inevitable. Dinosaurs would someday walk again.

Meanwhile, what would continue to evade questioning, as it always had, was the sort of manipulation of reality involved when Hollywood-style narrative and formal conventions were used to portray natural events and behavior. This is implied in the statements quoted above, but is perhaps best articulated by BBC Natural History Unit producer Christopher Parsons in an early how-to book called *Making Wildlife Movies* (1971): "Unless the film is of an academic nature and made primarily for a scientific audience, the film-maker's only obligation to his audience is to ensure that his

film is true to life, within the accepted conventions of film-making" (14). By the end of the twentieth century, however, the "accepted conventions" of filmmaking had come to include an entire array of digital tools and effects, of which even the least intrusive—color correction, contrast enhancement, motion stabilizing, and so on—called into further question the already vague meaning of phrases such as *true to life.*

Thou Shalt Not

Even well before this time, filmmakers' ethical responsibilities had become a frequent subject of debate within the industry. Although discussion almost always centered on the moral obligation not to mistreat or endanger animal subjects, it could sometimes turn to the more vexing matter of responsibilities to audiences and of how much truth they had a right to expect in a largely creative (and highly competitive) medium.

Then, in the mid-1980s, the wildlife film industry was rocked when a CBC documentary titled *Cruel Camera* (1984) exposed a number of cases of mistreatment of animals by leading wildlife filmmakers and television producers, and suggested (accurately) that some such practices were still widespread.[17] Although aimed at exposing outright cruelty, *Cruel Camera* also suggested that staging, manipulation, and general fakery were just as widespread, and that wildlife films were neither as true to nature as they appeared nor perhaps as true to science as they implied. The evidence suggested not only that audiences had for some time been systematically deceived, but that their sympathies had been manipulated, their trust abused, and their faith betrayed. Critics soon began calling attention to the artifice and stagecraft in wildlife films (see James 1985; Tweedie 1985; Corry 1986a; Montgomery 1988), and reviewers, even when praising individual programs, began acknowledging that they did, in fact, involve some fabrication (see Webster 1986; Corry 1986b, 1987; Charle 1988). Some pointed to the issue of attempting to make art at the expense of truth (see, e.g., Brower 1998; Coward 1997; James 1985; McPhee and Kowalski 1997; Saile 1996). Others began to reflect with new sobriety on the limitations of the whole wildlife and natural history film enterprise (see Attenborough 1987; Steinhart 1988; Northshield 1989).

In the mid-1990s, the issue of cruelty to animals again forced wildlife films and filmmakers under the harsh lights and revealed that the industry's blemishes still had not cleared up. In early 1996 a pair of *Denver Post* reporters uncovered evidence suggesting that Marty Stouffer had engaged in questionable treatment of animals during production of his PBS series *Wild America* (Carrier 1996a, 1996b; McPhee 1996; McPhee and Carrier 1996a, 1996b, 1996c, 1996d). Again, the issue quickly turned from cruelty to staging, faking, and deception.[18] It began to appear that behind the mask of innocence was a Janus-faced industry. Another wave of critical indignation began to swell in the print media. Starting with other writers at the *Denver Post* (McGuire 1996; Obmsascik 1996; Saile 1996), it soon washed across North America (Foster 1996; Husar 1996; Sink 1996; Tayman 1996) and was still rippling on both

sides of the Atlantic more than a year later (Coward 1997; McLaughlin 1997; Owen 1997; "Wildlife Film-Makers" 1998).

Observers had raised a number of important questions. If the events unfolding on the screen had not happened in the way they were shown, was it possible that some of them had not really happened at all? The widespread acceptance of continuity editing and scene construction (in the style of Hollywood's "classical decoupage") assured that, however disillusioning, the answer to this one was *yes*. The follow-up question, however, was more difficult: *How much* manipulation, staging, faking, and deception had there been? Had only the tip of the iceberg been exposed? Other questions promised further disillusionment: Was the purpose of wildlife films to inform and educate, or merely to distract, to amuse, and to sell audiences to advertisers? If the latter, how great could their commitment to truth really be? Should viewers expect factual reports of reality from them, or marvel at the way they constructed convincing impressions of reality, as in mainstream cinema? The most heated questions came, however, not from the viewing public, but from journalists apparently uneasy with the prospect of another genre of nonfiction media, a second cousin to their own profession, being exposed as mere *art*—or at least as impure truth.

The wildlife film industry began to respond, although it was not easy; moral duty had to be fulfilled, but sales could not be put at risk. "Ethics" panel discussions soon became rituals at wildlife film festivals and symposia, but in a small, somewhat fraternal industry, no one was dragged over the coals. Over the years the most stubborn gadfly and prolific commentator on the subject was BBC Natural History Unit producer-cum-lecturer Jeffery Boswall, who summarized the problems in two simple "commandments" for wildlife filmmakers to follow:

 I. THOU SHALT NOT HARM THE ANIMALS.
 II. THOU SHALT NOT DECEIVE THE AUDIENCE.

To these he later added a third:

 III. THOU SHALT (BE WILLING TO) INCLUDE DISCLAIMERS.[19]

As a response in part to Boswall's prodding, and in part to concerns expressed by viewers, journalists, and attendants at "ethics" panels, in the 1990s the BBC Natural History Unit formulated a set of ethical "guidelines for the filming and handling of animals." The guidelines were subsequently adapted and promoted more vigorously by Swedish producer Bo Landin of Scandinature Films, with the intention of instituting an industrywide seal of approval, called "Wild Care," to certify that filmmakers had followed approved, safe procedures. Unlike Boswall's "commandments," however, the BBC and Landin documents sidestepped the matter of responsibilities to audiences.[20] Guidelines or "commandments" in this area might well have drawn attention to some of the issues related to digital image manipulation that were just around the corner, but would undoubtedly have opened a Pandora's box of ques-

tions, arguments, and criticisms aimed at virtually all of the creative formal devices in the wildlife filmmaker's repertoire: studio-made sound effects (not to mention dramatic music), slow motion, blue-screen effects, and continuity editing among unrelated shots in which differences are concealed by way of digital color balancing. In other words, it was probably impossible to draw a line between image "manipulations" and the other types of artifice already inherent in the formal structures of wildlife films and in the institutional practices that governed their making. The door had to be left open.

A Little Gingering Up

It is not fair to say that wildlife and natural history film is a genre dominated by artifice, but it is true that it has developed in such a way that filmmakers in the genre find it difficult to exclude the manipulations that have come about in the digital age. Having followed the path of mainstream, "classical" cinema rather than that of documentary, wildlife filmmakers have courted the values of creativity and entertainment rather than those of strict adherence to reality. The ideal of the camera as an instrument of science inscription (as in Muybridge's "locomotion studies" or Marey's dream of "animated zoology"; see Winston 1993) gave way in the earliest years to overdramatized safari films and action-adventure narratives, later to fanciful "true-life adventures," and, by the end the twentieth century, to animal "docu-soaps." Wildlife filmmakers spoke openly about going "beyond observational films" and of attempting instead "to create an experience . . . an illusion" by way of cinematic artifice.[21]

From the earliest years, many of those who deliberately set out to take natural history films down the road of strict scientific revelation soon found themselves pulled instead along the path of creative entertainment. This had happened, for example, to Raymond Ditmars, curator of reptiles at the New York Zoological Park (the Bronx Zoo), who set out in 1910 to make a "systematic, educational series of zoological films." It was not long, however, before his energies turned to setting up and staging dramatic conflicts, and he ended up, as he put it, a "movie director" (Ditmars 1931, 118).

In Britain, the team that made the "Secrets of Nature" film series at Gaumont British Instructional Films also found that *actuality* had to be dramatized if audiences were to watch, and they soon began emphasizing creativity and entertainment values in their films. Although the "Secrets" were hailed as "outstanding educational films," producer Mary Field confessed that this did not "prevent their main object from being entertainment" (Field and Smith 1939, 21). With the arrival of sound, the team even produced a pair of musical chestnuts (and early examples of editorial image manipulation), titled *Daily Dozen at the Zoo* and *Playtime at the Zoo* (both 1930), intended "to reproduce the Walt Disney technique with real animals instead of cartoons" (Field and Smith 1939, 231).[22]

That same year, animal behavior was again editorially manipulated and set to music, this time by no less a figure than Cherry Kearton, today the patron saint of

British wildlife and natural history film. The result was *Dassan* (1930), a hybrid film that is part animal behavior study, part comical satire. Kearton's attempt to breathe life and creativity into the wildlife film genre remains noteworthy, even if his methods were unsound. Ironically, three years later, in 1933, he appended an author's note to one of his books in which he expressed concern over image manipulation in "the world of the cinematograph,"

> where double exposure and many other devices are used to show animals in unnatural situations and to give the effect of their behaving as, in fact, they never behave. The people who try to give us "sensations" both in films and in books appear to imagine that "art" is needed in that respect to supply the defects of Nature; that the wild life of animals is sadly in need of a little "gingering up." (Kearton 1933, 110)

Substitute "digital imaging" or "CGI" for "double exposure," and this passage is remarkably applicable to today's issues of image manipulation and truth. It also suggests that over the decades little has really changed.

Looking back, it is difficult to understand how some could have missed wildlife and natural history film's turn toward creative expression. John Grierson (1979) shortsightedly dismissed the "Secrets of Nature" series as mere "lecture films" that "do not dramatize," but only describe (36).[23] Paul Rotha (1952) classified "nature films" in general as among the "plain descriptive pictures of everyday life," a creatively bankrupt category that included "travel pictures . . . educationals, and newsreels" (105). Succeeding generations of film critics and historians have likewise failed (or refused) to see in wildlife and natural history films any "creative treatment of actuality" (Grierson 1979) or "creative dramatisation of actuality" (Rotha 1952). It is now clear, however, that these elements were never missing from wildlife and natural history films. Indeed, such films may have been suffering an overabundance of creative interventions even before the arrival of digital manipulation.

Yet with images drawn from nature, wildlife and natural history film's claim, whether explicit or implicit, to represent "the real" has tended to exceed even that of documentary.[24] Both, however, have been subject to an "aesthetic of content" such that until recently they were largely exempted from formal or aesthetic debate.[25] What mattered was what was there on the screen, not how it was put there. This was less true of documentary, especially in the post-Grierson years of Direct Cinema, when the deliberate avoidance of Hollywood's style and slickness, in favor of a rougher and even faintly "amateurish" look, became a visible guarantor of authenticity (this has been called the "Zapruder quotient").[26] This, however, was precisely what wildlife filmmakers, already seen by many as perennial amateurs, sought to avoid. Although the rise of Direct Cinema came about at almost precisely the same time as the ascendance of wildlife films on television (starting in the early 1960s), the total lack of critical attention to wildlife films' formal style allowed creative interventions to proceed unchecked. The aesthetic of content succeeded in obscuring, or in diverting attention

from, even the obvious interventions of editing, scene construction, and camera placement, not to mention the imposition of fabricated stories (stories are still, in fact, seen by many in the industry as part of the profilmic content—that is, as something existing materially in nature). Their mode of representing nature thus unquestioned, wildlife and natural history films, along with several varieties of wildlife and nature still photography, became home to some of the most effectively *naturalized* images anywhere in modern media.[27]

Enter the Mouse

The stage was thus perfectly set for the entrance of digital image manipulation, but let's pause long enough to summarize events so far: to begin with, it should be clear that wildlife films have never been the simple windows onto the natural world that both their fans and their critics have thought. Their commitment to entertaining has from the start exceeded their commitment to strict truth telling. In this, wildlife films have followed the path of Hollywood-style fictions and cinematic "illusions" rather than that of documentary or science reporting. Yet with content that seemed ineffably linked to "the real" (it's *nature,* after all!), these films tended to distract attention from their form and from the ways in which they molded and manipulated reality into dramatic scenes and sequences. So when digital image manipulation and CGI technologies took the stage, there were few boos and hisses of the sort there would have been in the documentary arena.

Initially, it seemed the role of the new technologies would be merely functional—image stabilization, color balancing, and other technical "corrections." Digital color correction was already widely used in print journalism.[28] In wildlife films, it simply allowed shots filmed on different days under different lighting conditions to be more easily combined into scenes that appeared to depict continuous events—a scene of a cheetah in pursuit of a springbok, for example, could be made up of footage from several different chases.[29] This is how scene construction works, after all, but now the rough edges could be more effectively concealed. It could be justified, moreover, by an appeal to professionalism. After all, why should wildlife filmmakers, working under difficult natural conditions but competing for the same audiences as mainstream television programs filmed under carefully controlled conditions, be handicapped by circumstances that might make their product appear amateurish?

Then there were the more *cosmetic* uses. Telephone wires or tourist vans in view? They could be taken out easily enough. This could be justified in part by an appeal to tradition and in part by an appeal to art. Tradition favored "blue-chip" films—that is, lavishly produced, stylistically conservative productions of the sort that attract sponsors and have a track record of success with viewers, and that were long regarded therefore as fairly safe investments. What has largely been responsible for their success with audiences has been their romantic depiction of nature as a spectacular, *unpeopled* wilderness with magnificent, unspoiled scenery and animals who live and behave just

as they have for eons.[30] "There has to be a sense of timelessness," producer Dione Gilmour has noted (quoted in "Doing What Comes Naturally" 1996, 35). Cameraman Stephen Mills (1997) has described blue-chip films in somewhat more jaded terms, calling them "period-piece fantasies of the natural world" (6). Making nature appear timeless, however, could also entail avoiding (or removing) visual references that might date the film itself and thus threaten future rerun sales. Digital image technologies had clear cosmetic applications here and promised to solve a number of problems for filmmakers shooting from roadsides and tourist viewpoints, as many actually do. All traces of humans could now be easily and quickly erased.

The presence of people, especially *white* people (let alone tourists), has long been thought to spoil the cherished romantic image of nature as a timeless realm untouched and uncorrupted by civilization. Digital technologies now allow human figures to be removed or inserted as desired (see the example provided in Brand et al. 1985, 42), but the history of nature depiction, especially American landscape art, suggests a formula: keeping people out can produce romantic images of "a primal, untouched Eden, existing in a realm of 'mythic time'" (Novak 1980, 189).[31] Putting them in can remove an image from the "fine arts" to the realm of documentary, social commentary, or science depiction (Jussim and Lindquist-Cock 1985, 31). Ansel Adams, as is well-known, left the people out of his images but was criticized for doing so during the Depression, when some felt that addressing social issues should take precedence over attempts to create "mere" art (i.e., with no overt political message) and that Adams had therefore misused his medium (see Cahn and Ketchum 1981, 133; Solnit 1989, 43).[32] The same debates are regularly heard at wildlife and natural history film gatherings today, but the industry's orientation is clear: "We are in the entertainment business!" the producers bellow. "We are artists!" the filmmakers chime. As the harmony fades, one can hear the echo of endless opportunity for creative manipulation.

From the image of pristine, unpeopled, *artistic* nature, it was but a digital half step in the early years of the twenty-first century to that of *sanitized* nature. Too much blood in a climactic kill scene? It could be toned down or covered over. Sex organs too visible during the copulation scene? They could be concealed for the American version. These issues, in fact, became increasingly important with the impending arrival of large-screen high-definition television, where even small amounts of blood or genitalia could occupy quite a bit of screen space, and do so with graphic clarity. Decisions to undertake such sanitizing measures were typically determined by economic and marketing concerns, but the arguments sounded much like some of those heard in the news industry: altering or concealing "an accident of sunlight and angle . . . didn't change anything of importance about the content" (Harris 1991, 166). Given the predominant aesthetic of content, which diverted attention from formal manipulation, some could see no reason not to make such changes and looked forward to a day when nature on the screen would be "designed and composed," as one producer put it. Others were less sanguine about portraying nature as a place where

there were no "accidents" of light and shadow or occurrences of uncontrolled (read: "unscripted") behavior. Would the image of nature stripped of contingency be an image of *nature* at all?

The power to mislead could also be found in advanced applications of the *cut-and-paste* function already familiar to anyone using the simplest of word-processing software. Not as many wildebeests in the Serengeti as the camera team had hoped? No problem. A few hundred could be copied ("cloned") and pasted into the empty spaces almost as easily as with still images. On-screen, anyway, the Serengeti would forever remain as teeming with life as we had always imagined it. The image of huge aggregations of animals need never be affected by actual fluctuations or declines in populations. Species extinction could thus be *virtually* banished.

What about that background? Clouds or vegetation too sparse, or too pale? More could be borrowed from elsewhere as needed, then color adjusted for full aesthetic or dramatic effect. But it could get worse. Lion's mane not bushy enough? Claws or teeth not long enough? It soon became apparent that the technology gave image makers new power to define "enough" not just in cosmetic terms, but in ways that could significantly affect the scientific accuracy of their supposedly "documentary" reports on the conditions of wildlife populations and habitats.

Wildlife still photographer Art Wolfe had already come under fire for exactly this when he digitally cloned additional animals into some of the photographs in his book *Migrations* (1994). The effect, arguably, was to misrepresent not only the population densities of some species, but also the dynamics of the very thing the book purported to depict—at least if its title was to be taken seriously. In his introduction, Wolfe sought to justify his decision to manipulate the images with an appeal to art: "Since this is an art book, not a treatise on natural history, I find the use of digitalization perfectly acceptable" (v).[33] It may not have been a "treatise" on natural history, but it had all the trappings of a "documentary" photo-essay on the subject and was likely to be taken as such. Could Wolfe's rhetorical justification, effectively buried, as it was, amid pages of written text few were likely to read carefully, really serve as a valid disclaimer exculpating him from the charge of "nature faking"?[34]

The argument from art, however, could at the same time be heard coming from wildlife filmmakers, who had also increasingly come to use the film or television screen less as a window on the natural world than as a canvas on which to paint dramatic, expressive images of it. The fact that this canvas was getting bigger and more visually powerful with the arrival of HDTV and large-format cinemas helped the filmmakers lay an even greater claim to the legitimating mantle of art. Indeed, it seemed to increase the likelihood that their images would in future be guided by the demands of art rather than by those of factual reportage and documentary on the one hand or science and ecological concerns on the other.

The Wolfe incident was a clear harbinger of things to come in the motion picture end of nature imagery. Digital technologies had found wildlife filmmakers as receptive

a group of clients as still photographers had been. At a cost of only a few scruples, they too would be equipped with the most powerful and versatile artist's palette ever in their possession, free at last to mold and shape images of nature in virtually any way they saw fit and in ways that could be well nigh impossible to detect. Thus: more creative treatment of actuality plus greater possibilities for its concealment.

It was not surprising that as these new waves of technological change swept through the industry, there was talk, as elsewhere, about the industry's undergoing a "revolution." Of all the new digital capabilities, however, some saw HDTV, not CGI, as the real revolutionary force and sought to be in its vanguard (see, e.g., Clark 1997). Yet the rhetoric of the HD advocates sounded suspiciously counterrevolutionary. First, the resplendent clarity promised by large home-cinema screens demanded that filmmakers shoot in formats that were well beyond the financial reach of independents and small players, and would surely have the effect of excluding them from competition. Second, the return to large screens, albeit in the home, promised to reinforce the dominance of the old cinematic form and style rather than to foster continued exploration of new *televisual* styles, which were also the province of those with modest budgets and consumer-grade equipment.[35] It was not surprising, therefore, that there was talk among the powerful of returning to a more "cinematic approach . . . abandoning forever the clichés of the tired, old media" (Clark 1998, 18)— meaning conventional television, with its tolerance of inexpensive productions. Thus, however "new" it was, HD seemed aimed at consolidating the power of the old regime, not ushering in the new.[36]

More important in this context, however, is that the digital HD video cameras arriving on the scene at the end of the 1990s were already capable of registering *five* times the visual information in a single frame as super-16 mm film, then the industry's preferred origination format.[37] With many more pixels available, HD had the potential for image manipulation at an unprecedented level of detail, assuring that the next generation of CGI artists could manipulate images in ways that would be impossible to detect. Yet if "nature and HDTV were a marriage made-in-heaven" (Clark 1998, 18), as one producer suggested, it began to appear that Mother Nature might end up the abused spouse in this relationship, able only to lie quietly and submit (in the BBC's case, perhaps closing her eyes and thinking of England). In any case, it was becoming all too clear that in plans for the future, nature programming would not be *nature led*.

Natural History, Dinosaurs, and Techno-maximalism

By the end of the twentieth century, then, the wildlife film industry had begun to absorb nearly all available digital innovations with little disruption to business as usual— except for a greater emphasis on postproduction. This, one critic lamented, meant that films might no longer be made on a set or location, and that photography and sound recording would produce only a "semiproduct,"

a raw material which is then exposed to extensive image and sound processing in the digital suite; lighting, mood, colors, framing, sound-qualities and actors' lines being changed at will, even faces and backgrounds. . . . Post-production is no longer limited to a sub-ordinate, correcting and trimming role in relation to the shooting phase of production. It has taken over a lot of the basic, creative decisions from the shooting. (Svanberg 1997, 5)[38]

At a 1999 symposium in Munich, producer/writer/narrator Barry Paine echoed this concern over the eclipse in natural history programs of location production by computerized postproduction. "Graphic artists working with computers," he argued, "have escaped from the title sequences, and are now telling the stories." The problem, he suggested, was not just that a good deal more creative invention was seeping into natural history films, but that scientific accuracy was draining out. Television science documentaries, in particular, he noted, were becoming increasingly "producer led rather than scientist led."

As an example (here is where the dinosaurs come in), Paine pointed to the six-part BBC series *Walking with Dinosaurs* (1999), a "high-concept" production combining the conventions of blue-chip wildlife and natural history filmmaking with digitally produced dinosaurs of the sort seen in *Jurassic Park* (1993), *The Lost World* (1997), and, soon after, in the Disney fantasy *Dinosaur* (2000).[39] Unlike traditional documentaries on the subject, *Walking with Dinosaurs,* as well as its sequel *Walking with Beasts* (2001), eschewed interviews with paleontologists and the usual scenes of bones being found at dig sites and then reassembled into skeletons.[40] Instead of talking heads and close-up examinations of fossil fragments (typical of the expository conventions associated with television science documentary),[41] these films gave viewers the opportunity to see (or perhaps "witness") dinosaurs and other prehistoric creatures of all shapes and sizes as they fed, fought, migrated, reproduced, and died, all in full, lifelike motion and vivid detail. There was also some use of animatronic figures and life-size puppet constructions, but these sometimes appeared a bit clumsy in relation to the carefully composed digital figures.

Promotions for the DVD release of *Walking with Dinosaurs* suggested that vicarious experience, more than scientific information, was not only the program's chief selling point but its raison d'être. The appeal to consumers invoked the program's Hollywood cousins, boasting its "state-of-the-art digital effects and animatronics" and its "living, breathing images [?] that put you in the scene of a virtual *lost world.*"[42]

Here was perhaps the greatest example ever of Mills's (1997) description, quoted earlier, of blue-chip wildlife films as "period-piece fantasies of the natural world" (6), for although it depicted a time period almost inconceivably far back in the past, the storytelling model employed in *Walking with Dinosaurs* differed barely at all from that of countless blue-chip wildlife films depicting the still-living creatures of the Serengeti, the Masai Mara, the Galápagos, the rain forests of South America, and

elsewhere. With its extensive use of real locations as backgrounds (as opposed to being shot entirely in cyberspace), *Walking with Dinosaurs* amply fulfilled the conventional blue-chip requirements of spectacular scenic panoramas populated by charismatic (if extinct) megafauna—and, of course, no people.

Despite the oft-expressed hope at wildlife film festivals that digital technologies would offer "new ways of telling the stories," it seemed from *Walking with Dinosaurs* that they were compelling a retreat to the most staid, conventional forms of blue-chip storytelling. Some sequences even followed the "classic" narrative model of wildlife film by creating sympathetic individual dinosaur characters, following them as they embarked on perilous journeys, and using their experiences to dramatize the plight of the species or, more dubiously, to personify behavior patterns assumed to be typical of their species.[43] It was easy to become emotionally involved in these struggles, which were written and directed like those appearing in traditional blue-chip wildlife films. The Mesozoic melodrama of an aging ornithocheirus to find a place among the younger, stronger males from which he could make one last, sad attempt to attract a female was particularly poignant. Indeed, these computer-generated characters could be extraordinarily lifelike and convincing. Still, it seemed at times that, rather than identifying emotionally, one might be tempted to see the series as a kind of ironic (if expensive) parody of the wildlife genre.[44]

In either case, *Walking with Dinosaurs* heralded the arrival of what some had seen coming for years, and that now seems an inevitable part of the future of wildlife and natural history filmmaking: the elimination, at least in part, of the need to go out and *film,* and therefore to have to deal any longer with nature and wild animals on their own terms. Although the desire to go out on location and film wild animals remains unquenchable for many filmmakers, the *need* to do so, technically speaking, has all but disappeared. There are already vast reserves of stock and unused footage to fuel the creative energies of digital image makers for some time, and enough computing power to assure that the fabrications would be undetectable.

Still, it was unlikely that anyone was actually fooled into believing that real dinosaurs and extinct beasts had been caught on film. The problem with these films, therefore, was not "deception" in the usual sense, but that much of what was presented as *science fact,* especially in depictions of behavior, was largely theoretical. The animated, computer-generated images depicted intricate patterns of social behavior, including preening and courtship display, mating, and feeding, as well as bodily postures, locomotion, and skin coloration and textures that were often little more than hypothetical, or that rested largely on analogies to creatures living today. The results could not even be said to be "factual re-creations" based on "a scientifically observable fact" (Mills) or on "the biological truth" (Attenborough), because many of the truths about dinosaurs are simply not known. The producers of *Walking with Dinosaurs* rightly acknowledged the program's speculative aspects in interviews posted at the BBC Web site.[45] One of them nevertheless remarked that the success of

the series lay in "capturing the behaviour" of different dinosaurs who, although animated, were "just acting naturally."[46] Clearly, however, the behavior had not merely been "captured," and the animals were not just "acting naturally." All had been designed and created by "graphic artists" (to use Paine's term) based on selective interpretations of fossil data. If such distinctions were to become blurred for audiences as well, what might be the implications, in the future, for the fate of real, living creatures depicted in the inevitable spate of similar productions in which behavior is manipulated to fit dramatic convention? Or was Dyer's assertion that "how we treat others is based on how we see them" no longer relevant? Such questions were and still are beyond the ken of most of those working in natural history television production.

Walking with Dinosaurs and its sequels helped blur the differences not only between capturing and creating, but also between fact and the assertion of fact, as well as between evidence and interpretation. The combination of visual "evidence" with authoritative sounding voice-over narration, in which facts were asserted rather than established, left little room for doubt or questioning. Each acted to reinforce the other and to eliminate all trace of speculation or hypothesis, with the result that the film's speculative propositions about dinosaur life and behavior were internally validated. Indeed, the entire presentation became a kind of closed loop of self-validation. Unhampered by any nagging profilmic reality, or by the refusal of nature and wild animals to follow their scripted parts, the writers enjoyed the kind of digitally produced freedom never experienced by those working in straightforward wildlife films. The behavior of their creatures could be made to conform to virtually anything called for in the script. Yet the script had clearly been written not from behavioral observation, but from interpretation of fossil records, selected from among many different and often conflicting accounts. Paine might have been reassured, therefore, that the program was still to some degree *writer led.*[47]

Some have suggested that when digitally generated creatures are used in a factual setting to illustrate speculative or theoretical material, they should be made to appear on screen either in unrealistic colors (purple, red, yellow) or in some other clearly artificial manner that sets them apart from straightforward natural history content. It is thought that this would signal to audiences that what they are seeing represents *one view of how it might have been,* rather than that *this is how it was.* Boswall had raised a similar argument some years earlier regarding devices that would signal the use of slow motion. Up to a certain point, he argued, many viewers are unable to recognize slow motion, and until that "threshold of self-evidence" is reached—that is, unless or until the images become obviously artificial—slow motion should be accompanied by slowed-down "mush" sound, if not by explicit on-screen disclaimers.[48] The problem with slow motion, according to Boswall (1986), is that "the slower an animal moves, the larger it appears," and this makes the filmmaker's decision not just an aesthetic choice, but an ethical one. Why? Because, strictly speaking, to lead viewers to make a false inference, even if only about an animal's size, is to *mis*lead them, and to mislead

viewers is a violation of their trust, and of the filmmaker's ethical responsibility to them.[49] On a more practical level, it could be argued that to lead viewers to draw false inferences about animal size and locomotion could mislead them as well about those animals' behavior, physiology, strength, and power, and perhaps, therefore, about their abilities to withstand the pressures of human harassment or encroachment on their habitat. With wildlife film viewership in the scores of millions globally, the consequences of such distortions for real, not-yet-extinct wild animals could be considerable.

Walking with Dinosaurs also raised with new immediacy the issue of how wildlife numbers and population densities are represented. Being able to see thousands of dinosaurs moving about and interacting seemed in some way almost to soften the impact of their extinction. That is, they may be gone, but we could still see them, still marvel at their strength and speed, their hunting prowess, their defensive abilities. Nevermind that much of it was speculation; it made for a good natural history entertainment. There was reason to suspect, however, that "salvage zoology" of the digital kind could soon be the fate of other species hovering on the edge of extinction. Even before *Walking with Dinosaurs,* the wildlife genre was overpopulated by animals (typically charismatic megafauna) whose numbers were often, in reality, relatively low. Over the course of a few years a viewer might have been able to see more of some animals on television—pandas, tigers, or gorillas, for example—than actually existed in the wild. Could the appearance of plenty have the effect of blunting concern among viewers over actual declining numbers? It was not as much of an open question as it seemed. There was already good evidence that when human populations (especially demographic categories such as racial, ethnic, and sexual minorities) were systematically over- or underrepresented on television, the distortions would show up with some predictability in the perceptions and attitudes of viewers.[50]

Walking with Dinosaurs cast a bright light on the new and subtle ways in which natural history television might, despite good intentions, proffer distortions and create misperceptions of the realities of nature among viewers. In their roles as consumers and voters, those same viewers might well decide the fates of wildlife and habitats they had seen only on television—or *thought* they had seen.

The Epistemological Blow

Clearly, the ethical responsibilities of wildlife and natural history filmmakers rest on the assumption that they have an implicit agreement with their audience to deliver the truth, even if not the whole truth and nothing but the truth. It is an agreement, however, that has never been ratified. As a result, Boswall's petition for labeling slow motion likewise received few signatories; slow motion seems now to have passed into the realm of formal manipulations that have been in practice for so long that they have become accepted in the industry without question—and perhaps seen by many viewers without awareness.[51]

This should have stood as a warning in the still-burgeoning area of digital image manipulation, but many wildlife filmmakers and photographers had already become fairly sanguine about its use. At a 1997 gathering in Jackson Hole, Wyoming, they agreed that "digital enhancement—darkening of sky, say, and other things that have been done in the past by printing techniques in the darkroom—need not be labeled."[52] From this it was clear that the photographic darkroom represented for some an area of traditional, and therefore acceptable, manipulation—validated and exempted from ethical scrutiny by the fact that it had been done for so long. Old-fashioned darkroom "dodging and burning" had thus become so routine that to photographers it no longer seemed to be manipulation at all. There is little reason to believe that in another generation the same will not be true of digital manipulations that go well beyond what could be done in the darkroom.

When admitting to using computers to "enhance" photographs—lightening a shadow here, darkening a brightly lit figure there—nature photographers Art Wolfe and Franz Lanting justified the practice by arguing that these were extensions of traditional, and therefore *accepted,* darkroom practices. They claimed to draw the line, however, at digitally "altering or manipulating" images (Lanting, quoted in McPhee and Kowalski 1997) or creating "digital illustrations" (Wolfe, quoted in Brower 1998). Where were the lines, however, that separated enhancement from illustration, alteration, and manipulation?[53] In which category was it to remove a telephone pole, a road, or a bit of unsightly blood or entrails? Or perhaps to close the gap a bit between a cheetah and its fleeing prey? How long would it be before changes such as these would be accepted without question, just as editing conventions were in film, simply because they had been in practice long enough to become "traditional"? On this slippery slope there were no clear answers. Fortunately for all involved, the questions did not get asked.

It is fairly clear, nevertheless, that the status of nature films and photographs as reliable science inscription, factual reportage, or documentary evidence is in question. Their future is uncertain, but prognostications regarding the effects of digital image manipulation in general have been grim. It has been said to signal the end of "photography as evidence of anything" (Brand, Kelly, and Kinney 1985), the end of "the entire era of film and documentation" (Plagens 1989, 57), to "destroy the photographic image as evidence of anything except the process of digitalization" (Winston 1995, 259), and to be implicated in an "epistemological shift [that] has created a real legitimation crisis for the documentary" (Winston 1993, 55). Although I have argued elsewhere that the documentary label should not be applied to wildlife films (Bousé 1998, 2000), the concerns over digital manipulation are largely the same in both the documentary and wildlife film genres. So too are questions of audiences' reception and expectations, and of each genre's increasingly strained truth claims and "legitimations." Consider, for example, the following reflection on the state of documentary, in which I have replaced each mention of that genre with a reference to wildlife film:

Public reception of the [wildlife film] still turns on an unproblematised acceptance of cinematic mimesis. [Wildlife filmmakers] have, for years, obfuscated basic issues so that they could, at one and the same time, claim journalistic/scientific and (contradictory) artistic privileges. When they have paid attention, scholars, by and large, have avoided questions of definition. As a result, the [wildlife film], unclear as to its legitimations and confused as to its *raison d'être,* is thus not in a good position to counter current threats. (Adapted from Winston 1995, 6)

Arguably, the most significant "current threats" now facing wildlife and natural history film stem from the practice of digital image manipulation, even if kept to a minimum. When anything can be creatively faked, it becomes difficult for anything to be trusted or believed. Some wildlife filmmakers and photographers are justifiably worried that the credibility with audiences of even their hard-won *true* images is now seriously threatened. Nature photographer Galen Rowell has expressed concern that instead of wondering how a photographer got the shot, viewers will instead ask, "How did he fake it?" (quoted in Brower 1998). In an industry that has specialized in images that are amazing but true, those images must continue to be true in order to be amazing—unless we are content to be amazed by the skill and creativity of the image maker rather than by nature itself.[54] For this we don't even need nature or wildlife; more images of dinosaurs, space aliens, and dead film icons will do. Even before the end of the twentieth century, Fred Astaire danced again, and T-rex walked the earth once more.[55]

Now, in the twenty-first century, we may, as Brian Winston (1993) has suggested, simply have to "roll with the epistemological blow." That is, in wildlife and natural history film, as in documentary, we may have to consider abandoning once and for all "the claim to evidence, excising scientific legitimations and returning to an unambiguous . . . privileging of art over science" (56). In that case, the producers, filmmakers, and photographers eager for artistic rather than scientific legitimation, and to whom artistic acclaim means more than public trust, may have been right all along: they are in the business of making art and entertainment—full stop. With CGI and other digital image manipulations, however, they are in less danger of perishing from truth than ever before.

Notes

1. Elsewhere I have made the case more thoroughly than here that wildlife films have never actually been "documentaries" as such. The genre has, almost from its beginnings, been oriented toward entertainment, and, even before the coming of sound, it began to adopt the formal conventions of mainstream, narrative entertainments rather than of documentary (see Bousé 1998, 2000).

2. By the late 1990s, digital technologies had penetrated every corner of the wildlife film and television industry. Digital nonlinear editing (involving transfer of film to digital data) had already replaced flatbed film editing. Although digital video differed aesthetically

from film in significant ways, it nevertheless posed a serious challenge to film as the industry's preferred origination format. New satellite and cable television channels, which gave producers freedom to explore new program formats, were increasingly transmitting digitally. CD-ROMs and DVDs for the retail market, along with emerging Web-based video on demand, heralded new forms of nonlinear packaging of content. High-definition television (HDTV), with its ultrasensitive cameras and large viewing screens, also promised significant realignment of wildlife film aesthetics (see Bousé 2000, 185–93). The exceptions were large-format IMAX-style films, which had proven a highly successful (if limited) market for wildlife content and involved technical processes that were still film based. By 2000, however, there was already talk of developing digital large formats.

3. Even the redoubtable David Attenborough was persuaded, while shooting an episode of *The Life of Birds* (1998), to stand staring at nothing for nearly a minute to allow enough time for an extinct moa to be digitally reanimated and added to the frame space in front of him in postproduction. In the final version, he can be seen stepping back and appearing to watch as the giant bird materializes and begins to move. Although this sequence is presented in a fanciful, cartoonish fashion involving no deception, it is clear nevertheless that the BBC's highly regarded Attenborough "megaseries" franchise was not above employing digital image technologies in creative ways. The door, in other words, had been flung open.

4. Scholars and journalists had been voicing concerns for more than a decade. Celebrated cases involving a *National Geographic* cover as well as front-page photos in the *Orange County Register* and *St. Louis Post-Dispatch* confirmed their fears that digital image manipulation would spill into documentary, journalism, and other nonfiction modes. See Bossen (1985); Brand, Kelly, and Kinney (1985); Harris (1991); Kramer (1989); Martin (1991); and Zelle and Sutton (1991).

5. Fitzharris (1998) is clear in his desire that nature photographers be recognized as artists. "Digital imaging," he argues, has at last allowed them "into the ranks of the painter and sculptor" (14). This, however, may illustrate an "aesthetic fallacy" of assuming that the only issues involved are aesthetic ones. Likewise, the notion that creativity has *no* place in documentary or natural history may be a case of a "sociological fallacy" (see Cheatwood and Stasz 1979).

6. On *documentary* film as scientific inscription, see Winston (1993). On the early development of natural history film as science inscription, see Donaldson (1912) and Bousé (2000). On wildlife and natural history film as environmentalist propaganda or environmental education, see Fortner and Lyons (1985) and the reflections of Northshield (1989) and DiSilvestro (1990).

7. Interestingly, an exhaustive study by the World Wildlife Fund (1999) found significant declines in wildlife populations and habitats between the early 1960s and late 1990s—the same years that mark the period of wildlife films' ascendancy on television.

8. Throughout this chapter, I refer to digital *image manipulation* rather than *imaging*, in part because of my dislike of the use of *image* as a verb or gerund, but also to emphasize that what is at stake here is, in fact, manipulation—not just of images, but ultimately of public perceptions that could have serious consequences for the natural world. Yet to speak of manipulation, as Edwin Martin (1991) has pointed out, implies that there is some "photographic natural state" that has been "tampered with or falsified" (157). Clearly, in photography there is no such zero point of absolute truth, so Martin suggests that *manipulation* be understood as referring to departures not from Truth, but from "accepted, expected standards" (158). The problem, of course, is that these standards continue to change.

238 — Derek Bousé

9. For example: a friend of mine spent a week trying to get aerial footage of wild wolves in Latvia for a leading British production company. The travel expenses, including the costs of hotel rooms, fees, and the rental of a Russian helicopter and its crew, added up to about ten thousand pounds (fifteen thousand U.S. dollars). This was considered modest, but in the end only one minute of film was exposed, and of course not all of it was usable.

10. See Brower's (1998) recollections of manipulations by some of the "old boys" of nature photography, including Eliot Porter and Ansel Adams.

11. Fitzharris (1998) describes this as "stripping photography of its techno-mechanical straightjacket" (14).

12. For a discussion of scientific misconceptions in wildlife and natural history films, see my *Wildlife Films* (Bousé 2000, esp. chap. 5).

13. *An American Family* was an experiment in television documentary in which the Loud family of Santa Barbara, California, was filmed daily, then edited down to one-hour weekly broadcasts on PBS. Pat Loud, the wife, was at first pleased with the results, but later changed her mind and denounced the program and the filmmakers in her 1974 book *Pat Loud: A Woman's Story*.

14. The staging of this shooting is described in "Scientific Nature Faking" (1909).

15. An elephant in *Trailing African Wild Animals* (1923) and a lion in *Simba* (1928) are but two of the Johnsons' victims. Osa Johnson recalls more such killings in her memoir, *Four Years in Paradise* (1944). So too does George Eastman, of Kodak fame, who joined the Johnsons in the jolly-good "sport" of goading and provoking animals for the purpose of filming their deaths. Eastman (1927) later wrote that the film footage of a rhino killed in this way was one of his proudest trophies—the perverse voyeurism of which calls to mind the scenario of Michael Powell's film *Peeping Tom* (1960). Imperato and Imperato (1992) also discuss the goading/shooting/filming ritual.

16. This incident is recounted by Canadian cameraman Bill Carrik in the 1984 documentary exposé film *Cruel Camera* (see note 17, below).

17. The film originally aired on the CBC program *The Fifth Estate*. Its first half deals with the mistreatment of animals in mainstream Hollywood films, and its second half addresses mistreatment in wildlife films. With its uncompromising revelations, the film stepped on enough toes to be withdrawn from distribution; it is now virtually impossible to find.

18. *Wild America*'s PBS affiliation seemed to link the allegations of wrongdoing to the idea that PBS member donations, made in good faith, might in some way have been abused or misspent. There was little substance in this, of course, but coupled with the even more unlikely notion that tax dollars allotted to the Corporation for Public Broadcasting were in some way implicated, the whole matter quickly took on an air of scandal and led to the cancellation of the program after fourteen years on the air.

19. For statements of the first two "commandments," see Boswall (1962, 1968, 1974, 1982, 1986, 1989, 1997). The third, which was added later (Boswall, 1998), gave rise to its own share of discussion. Disclaimers, however, may be little more than legalistic ways of avoiding responsibility, rather than assuming it. Unless labels such as "simulation" or "re-creation" are superimposed over the behavior in question *while it is on screen,* it is unlikely that audiences will internalize disclaimers, especially those run in the usual spot amid end credits, let alone connect them to the specific images in a film that actually involved staging or faking.

20. The entire "Wild Care" document is available on-line at the Scandinature Films Web site, www.scandinature.se.

21. BBC producer John Downer used these phrases during a panel discussion at Wildscreen '96.

22. Significantly, these films, along with Kearton's *Dassan,* set animals to music long before the musical set pieces in Disney's "True Life Adventures," most famously in the scorpion square-dance scene in 1953's *The Living Desert.*

23. It has been suggested that Grierson's attempt to dismiss the work of the "Secrets" team may have been motivated by competition between his group and theirs (see Low 1979, 105).

24. On documentary's "ontological claim to the real," see Winston (1993).

25. The argument here is borrowed from Bill Nichols (1981), who holds that documentaries are seen as being governed by "an aesthetic of content" and that this has largely exempted them from formal scrutiny (171–72). Wildlife films are not documentaries, but the argument applies every bit as much.

26. The "Zapruder quotient" is, of course, named after Abraham Zapruder's famous 8 mm film of President Kennedy being shot (see Chanan 1998). Although strenuously avoided in blue-chip wildlife and natural history film, Zapruderesque roughness has become a key element in several television programs of the sort epitomized by wildlife "docu-soaps" such as *Animal Rescues, Animal ER,* and *Wildlife Emergency,* all of which have openly courted a sense of handheld immediacy that is clearly, if not deliberately, the antithesis of blue-chip-style filmmaking.

27. Brian Winston's (1993) statement that "documentary more than any other filmic form 'produces nature as a guarantee of truth'" (55; the last part borrowed from Stuart Hall) might thus be amended to read, "*Wildlife and natural history film* more than any other filmic form produces nature as a guarantee of truth."

28. It is revealing now to review accounts of how readily, if not unquestioningly, some digital manipulations were accepted by the editors and publishers of major newspapers and newsweeklies. See Brand, Kelly, and Kinney (1985); Harris (1991); Kelly (1991); Kramer (1989); and Rosenberg (1989).

29. A common practice in wildlife filmmaking is "back-filming." When a spectacular event is by chance or design caught on film but is not enough by itself to make a complete scene, whatever other shots are needed to make it such (close-ups, different angles, and so on) may be filmed later, frequently set up (with tame animals) to correspond visually to the event already filmed.

30. Freud (1971) once observed that "in fantasy, man can continue to enjoy a freedom from the grip of the external world." He found an exact parallel in our enjoyment of "reservations and nature parks" that do not betray the presence of humans and that "maintain the old condition of things . . . reclaimed from the encroaches of the reality-principle" (381).

31. Novak (1980) made this statement in reference to nineteenth-century American landscape paintings, but it is remarkably applicable to wildlife films made around the world in the late twentieth and early twenty-first centuries.

32. See also note 5, above, on the "sociological fallacy" of assuming that documentary images should eschew creativity.

33. The full text of Wolfe's (1994) blanket statement on the artistic aims of *Migrations* reads: "Art, as well as conservation, is the goal of this book. Over the years, as I reviewed the material, I often had to pass over photographs because in a picture of masses of animals invariably one would be wandering in the wrong direction, thereby disrupting the pattern I was trying to achieve. Today the ability to digitally alter this disruption is at hand. For the first time in *Migrations,* I have embraced this technology, taking the art of the camera to its limits. Since this is an art book, not a treatise on natural history, I find the use of digitalization perfectly acceptable, and in a small percentage of the photographs I have enhanced the patterns

of animals much as a painter would do on a canvas" (v). Kenneth Brower's (1998) critique of this practice in the *Atlantic* is a must read.

34. The allusion here is to a heated controversy that took place early in the twentieth century, when nature writer John Burroughs (1903) and President Theodore Roosevelt (1907) publicly accused several then-prominent writers of popular animal stories, including Jack London, of being "nature fakers" who had systematically misrepresented animal behavior and deceived their reading public. For scholarly assessments of "nature faking," see Lutts (1990) and Schmitt (1989).

35. During the 1990s, a number of new television formats emerged when the rapid expansion of cable and satellite outlets created a surge in demand for low-cost wildlife and natural history content (see Bousé 2000).

36. It seemed that if there were to be a real revolution, it would have to come from the legions of newcomers wielding mini-DV cameras and computer editing softwares. Although they lacked funds and organization, their mini-DV images could be converted to Digi-Beta, an industry standard, and few could spot the difference.

37. This figure comes from veteran underwater cameraman Al Giddings (quoted in Mrozek 1998, 28).

38. Of course, films have never been "made" exclusively during shooting. Witness Ralph Rosenblum's account of his experiences editing *Annie Hall*. Apparently, even the redoubtable Woody Allen was capable of delivering a "semiproduct," void and without form, which was then "made" in postproduction (see Rosenblum and Karen 1979).

39. At the BBC's *Walking with Dinosaurs* Web site (www.bbc.co.uk/dinosaurs), the series was described this way: "This isn't some dry lecture from paleontologists, nor is it a movie-style action-drama. Incredibly, it's a complete recreation of the dinosaur era, *filmed like the natural history documentaries for which the BBC is renowned*" (emphasis added). Indeed, the style and conventions of traditional BBC natural history films is aped to an astonishing degree in *Walking with Dinosaurs* as well as in its sequels. In an interview at the BBC Web site, producer Mike Milne compared *Walking with Dinosaurs* to its more expensive Hollywood counterparts: "All of the animators working on *Walking with Dinosaurs* look up to the animation in *Jurassic Park* and *The Lost World* as being second to none . . . [but we] think that in the realism of the skin textures and muscle movement we pushed the envelope further." Significantly, the series was animated not on high-end expensive equipment, but on "standard, off-the-shelf computers" using Softimage 3.7 (www.bbc.co.uk/dinosaurs/faq.shtml).

40. When the series aired in the United States on the Discovery Channel, however, some talking-head interviews were inserted—presumably in response to the controversy stirred by the original run in Britain.

41. On television science documentary, see Gardner and Young (1981), Silverstone (1984), Hornig (1990), and Wilson (1992, 117–56).

42. These descriptions are from a blurb on the *Walking with Dinosaurs* DVD jacket (BBC/Fox).

43. Elsewhere I have described in detail the "classic model" of wildlife films and the problems inherent in imposing conventions of narrative and character on images of wild animals (see Bousé 1995, 2000). The use, however, of *virtual* actors, or "vactors," such as those in *Walking with Dinosaurs,* in place of real wild animals now gives wildlife and natural history filmmakers the sort of freedom enjoyed in the past only by makers of animated films.

44. Character-centered narrative episodes such as this bear comparison to Disney's (only somewhat more fanciful) *Dinosaur,* which emerged just a few months later. Consider this promotional blurb from the Disney Web site in the spring of 2000: "Walt Disney Pictures'

epic new feature *Dinosaur* seamlessly blends digitally enhanced live-action photography, special-effects wizardry, and computer-generated characters to bring the prehistoric past to life. Set 65 million years ago during the late Cretaceous Period, *Dinosaur* immerses moviegoers in a photorealistic prehistoric world of wonders as it follows the dramatic, action-filled journey of a three-ton iguanodon named Aladar. Separated from his own species as a hatchling and raised on an island paradise by a clan of lemurs, Aladar's life is plunged into chaos when a devastating meteor shower forces him to join a group of migrating dinosaurs desperately searching for a safe nesting ground. With water and food in short supply and vicious carnotaurs posing an ever-present threat, Aladar challenges the traditional ways of the herd and attempts to show how adaptability can be the best path toward survival" (disney.go.com/disneypictures/dinosaur/html/index.html). The *orphan* theme so clearly in evidence in *Dinosaur* has long been a key narrative convention of wildlife films, further suggesting their close relationship to mainstream narrative entertainments (see Bousé 2000).

45. *Walking with Dinosaurs* producer Tim Haines remarked in an interview posted at the BBC Web site: "There are scenes that really are very good science and there are those which are more speculative, like mating. How on earth will we ever know how they mated? We're not always showing people stuff that we know is right, we're showing people *our best guess*." He added, "There is much that science does not know for sure and our approach to this was to make *informed speculations* about how animals behaved" (emphasis added). Fellow producer Mike Milne confessed that the filmmakers had to some extent generalized from creatures living today: "We took a day out at a safari park and watched an elephant walk round to see how her weight moved as she went from foot to foot. We also filmed her and watched that again and again to help us understand how large animals move" (www.bbc.co.uk/dinosaurs/faq.shtml). This use of "comparative anatomy" is common among paleontologists seeking clues about dinosaur locomotion, behavior, and so on. More often than not, however, it involves an alarming degree of reasoning by analogy—indeed, often more than by homology. This is clearly the case, for example, when the social hierarchy of some dinosaur species is compared to that of wolves, based on little more than evidence of facial scars found on fossil remains.

46. Producer Mike Milne, from an interview posted at the BBC Web site in 1999–2000 (www.bbc.co.uk/dinosaurs/faq.shtml).

47. In this vein, Konrad Lorenz (1963) once argued that when portraying animal behavior, a writer is "under no greater obligation to keep within the bounds of exact truth than is the painter or the sculptor in shaping an animal's likeness. But all three artists must regard it as their sacred duty to be properly instructed regarding those particulars in which they deviate from the actual facts. They must indeed be even better informed on those details than on others which they render in a manner true to nature. There is no greater sin against the spirit of true art, no more contemptible dilettantism than to use artistic license as a specious cover for ignorance of fact."

48. A similar conclusion was reached at a 1991 Poynter Institute for Media Studies conference on photojournalism ethics. The attendees agreed that "manipulation of photo art (feature pages only) needs to be so apparent to an unsophisticated viewer that no written explanation is necessary" (Kelly 1991, 16).

49. Compare Martin (1991): "A photograph manipulated without any warning or sign to the viewers might create false expectations, thus deceiving them" (159).

50. Ultimately, television's ability to "cultivate" misperceptions is seen as stemming from its power, as an entire "message system," to reinforce subtle distortions repeatedly and systematically. See, for example, Gerbner et al. (1994).

51. If the fears and concerns over digital manipulation expressed by scholars and critics in the mid-1980s now sound faintly naive or unduly alarmist, it may be a token of the extent to which we have simply become accustomed to such techniques. See Bossen (1985); Brand, Kelly, and Kinney (1985); Harris (1991); Kramer (1989); Martin (1991); Zelle and Sutton (1991).

52. Covering the same event, the *Denver Post* reported that the assembled photographers agreed that "techniques similar to those used in darkrooms . . . are acceptable" (McPhee and Kowalski 1997, B7). Some years earlier, the *San Francisco Examiner* officially adopted a similar position: that it would permit only the sorts of digital changes to photographs that had traditionally been done in the darkroom (Kelly 1991, 16).

53. Similarly unclear lines exist in photojournalism, where "photo-illustrations" are considered conceptual images, and therefore open to manipulation, whereas "documentary photographs" are not (see Kelly 1991, 17).

54. I am borrowing a phrase here from Brand, Kelly, and Kinney's (1985) response to a notorious manipulated cover of *National Geographic:* "In a magazine that makes its livelihood printing photographs which are amazing but true, the photos have to be perceived as infallibly true in order to be amazing" (45). The unfortunate inclusion of the words "perceived as" leaves the door open, however, to *very good* deceptions.

55. In the mid-1990s, Astaire could be seen in a television commercial dancing with a vacuum cleaner in a digitally reworked sequence from *A Royal Wedding* (1950) that originally involved a hat rack.

References

Attenborough, David. 1961. Honesty and dishonesty in documentary film making. *Photographic Journal* 101, no. 4:97–102, 130.

———. 1987. How unnatural is TV natural history? *Listener,* May 7, 12.

Bossen, Howard. 1985. Zone V: Photojournalism, ethics, and the electronic age. *Studies in Visual Communication* 11, no. 3:22–32.

Boswall, Jeffery. 1962. Filming wild nature: Fair means or foul? *Scientific Film* 3:110–13.

———. 1968. Right or wrong? An attempt to propound a rational ethic for natural history film-makers. *SFTA Journal* 32/33:53–59.

———. 1974. New responsibilities in wildlife filmmaking. *BKSTS Journal* 56, no. 2:28–32, 42.

———. 1982. The ethics of wildlife filmmaking: A discussion. *BKSTS Journal* 64, no. 1:12–13, 25.

———. 1986. The ethics and aesthetics of slow motion in wildlife films. *Image Technology* 68, no. 11:560–61.

———. 1989. Animal stars: The use of animals in film and television. In *The status of animals: Ethics, education, and welfare,* edited by David Patterson and Mary Palmer. Cambridge, Mass.: CAB International.

———. 1997. The moral pivots of wildlife filmmaking. *EBU Diffusion* (summer):9–12.

———. 1998. Wildlife film ethics: Time for screen disclaimers? *Image Technology* 80, no. 9:10–11.

Bousé, Derek. 1995. True life fantasies: Storytelling traditions in animated features and wildlife films. *Animation Journal* 3, no. 2:19–39.

———. 1998. Are wildlife films really nature documentaries? *Critical Studies in Mass Communication* 15, no. 2:116–40.

———. 2000. *Wildlife films.* Philadelphia: University of Pennsylvania Press.

Brand, Stewart, Kevin Kelly, and Jay Kinney. 1985. Digital retouching: The end of photography as evidence of anything. *Whole Earth Review,* July, 42–49.

Brower, Kenneth. 1998. Photography in the age of falsification. *Atlantic Monthly*, May, 92–111. Available on-line at http://www.theatlantic.com/issues/98may/photo.htm.

Burroughs, John. 1903. Real and sham natural history. *Atlantic Monthly*, March, 298–309.

Cahn, Robert, and Robert G. Ketchum. 1981. *American photographers and the national parks.* New York: Viking.

Carrier, Jim. 1996a. Activists demand end to staging of scenes in wildlife programs. *Denver Post*, February 15, 23A.

———. 1996b. Stouffer sought Klondike, Snow. *Denver Post*, February 6, 1A, 12A.

Chanan, Michael. 1998. On documentary: The Zapruder quotient. *filmwaves* 4 (spring):23–24.

Charle, Suzanne. 1988. Hunting wildlife with a movie camera. *New York Times*, March 13, 31, 39.

Cheatwood, Derral, and Clarice Stasz. 1979. Visual sociology. Pp. 261–70 in *Images of information: Still photographs in the social sciences*, edited by John Wagner. Beverly Hills, Calif.: Sage.

Clark, Barry. 1997. Viva la révolution! *EBU Diffusion* (summer):37–41.

———. 1998. New media for the new millennium. *Image Technology* 80, no. 9:18–19.

Corry, John. 1986a. *Cruel Camera*, about animal abuse. *New York Times*, March 24, C18.

———. 1986b. Where the driver ants and the drill baboon dwell. *New York Times*, April 27, H27.

———. 1987. Best of WILD AMERICA: "The Babies." *New York Times*, March 17, C18.

Coward, Ros. 1997. Wild shots. *Guardian Weekend*, December 6, 34–43.

DiSilvestro, Roger. 1990. *Fight for survival: A companion to the Audubon television specials.* New York: John Wiley.

Ditmars, Raymond L. 1931. *Strange animals I have known.* New York: Blue Ribbon.

Doing what comes naturally.... 1996. *incamera* (spring):34–35.

Donaldson, Leonard. 1912. *The cinematograph and natural science.* London: Ganes.

Dyer, Richard. 1993. *The matter of images: Essays on representations.* London: Routledge.

Eastman, George. 1927. A safari in Africa. *Natural History* 27, no. 2:533–38.

Field, Mary, and Percy Smith. 1939. *Secrets of nature.* London: Scientific Book Club.

Fitzharris, Tim. 1998. *Virtual wilderness: The nature photographer's guide to computer imaging.* New York: Amphoto.

Fortner, Roseanne W., and Anne E. Lyons. 1985. Effects of a Cousteau television special on viewer knowledge and attitudes. *Journal of Environmental Education* 16, no. 3:12–20.

Foster, David. 1996. Unnatural practices. *Broadcast*, October 11, 26.

Freud, Sigmund. 1971. Twenty-third lecture: The paths of symptom formation. In *A general introduction to psychoanalysis*, translated by Joan Riviere. New York: Pocket Books.

Gardner, Carl, and Robert Young. 1981. Science on TV: A critique. Pp. 171–93 in *Popular film and television*, edited by Tony Bennett, Susan Boyd-Bowman, Colin Mercer, and Janet Woollacott. London: British Film Institute.

Gerbner, George, Larry Gross, Michael Morgan, and Nancy Signorielli. 1994. Growing up with television: The cultivation perspective. Pp. 17–42 in *Media effects: advances in theory and research*, edited by Jennings Bryant and Dolf Zillman. Hillsdale, N.J.: Lawrence Earlbaum.

Grierson, John. 1979. *Grierson on documentary*, rev. ed., edited by Forsyth Hardy. Boston: Faber & Faber.

Harris, Christopher. 1991. Digitilization and manipulation of news photographs. *Journal of Mass Media Ethics* 6, no. 3:164–74.

Hornig, Susanna. 1990. Television's NOVA and the construction of scientific truth. *Critical Studies in Mass Communication* 7, no. 1:11–23.

Husar, J. 1996. Sage advice for those with "staged" fright: That's entertainment. *Chicago Tribune*, February 14, 4.

Imperato, Pascal James, and Eleanor M. Imperato. 1992. *The married adventure: The wandering lives of Martin and Osa Johnson.* New Brunswick, N.J.: Rutgers University Press.

James, Jamie. 1985. Art and artifice in wildlife films. *Discover,* September, 91–97.

Johnson, Osa. 1944. *Four years in paradise.* Garden City, N.Y.: Halcyon House.

Jussim, Estelle, and Elizabeth Lindquist-Cock. 1985. *Landscape as photograph.* New Haven, Conn.: Yale University Press.

Kearton, Cherry. 1933. *The animals came to drink.* New York: Robert M. McBride.

Kelly, Tony. 1991. Manipulating reality. *Editor & Publisher,* June 8, 16–17.

Kramer, Staci. 1989. The case of the missing Coke can: Electronically altered photo creates a stir. *Editor & Publisher,* April 29, 18–19.

Langley, Andrew. 1985. *The making of the living planet.* Boston: Little, Brown.

Lorenz, Konrad. 1963. *On aggression,* translated by Marjorie Kerr Wilson. New York: Bantam.

Low, Rachel. 1979. *Documentary and educational films of the 1930s.* London: George Allen & Unwin.

Lutts, Ralph H. 1990. *The nature fakers: Wildlife, science, and sentiment.* Golden, Colo.: Fulcrum.

Martin, Edwin. 1991. On photographic manipulation. *Journal of Mass Media Ethics* 6, no. 3:156–63.

McGuire, Jerry L. 1996. Shoot to thrill. *Denver Post,* January 21, 12A–13A.

McLaughlin, Kerry. 1997. Marty Stouffer: White hunter, black heart [interview]. *Bunnyhop* 7:27–31.

McPhee, Mike. 1996. Ch. 12 drops Wild America. *Denver Post,* February 14, 1A, 13A.

McPhee, Mike, and Jim Carrier. 1996a. Fate of wildlife show in doubt. *Denver Post,* February 10, 1A, 16A.

———. 1996b. Filmmaker would use disclaimer. *Denver Post,* February 20, 1A, 9A.

———. 1996c. Unnatural selection? *Denver Post,* February 11, 1A, 22A–23A.

———. 1996d. Wildlife photos called staged. *Denver Post,* February 9, 1A, 22A.

McPhee, Mike, and Robert Kowalski. 1997. Ethics pushed for wildlife photos. *Denver Post,* September 28, B1, B7.

Mills, Stephen. 1997. Pocket tigers: The sad unseen reality behind the wildlife film. *Times Literary Supplement,* February 21, 6.

Montgomery, M. R. 1988. TV's nature lessons. *Boston Globe,* October 31, 17.

Mrozek, Carl. 1998. Nature in high def: Perils and payoffs. *RealScreen* 1, no. 12:26–30.

Nichols, Bill. 1981. *Ideology and the image.* Bloomington: Indiana University Press.

Northshield, Robert. 1989. All those critters look cute, but.... *New York Times,* February 12, 31H.

Novak, Barbara. 1980. *Nature and culture: American landscape painting,* 1825–1875. New York: Oxford University Press.

Obmsascik, M. 1996. There really is a wild part to "Wild America." *Denver Post,* February 17, B1.

Owen, Jonathan. 1997. Filming: How far do you go? *BBC Wildlife* 15, no. 7:32–34.

Parsons, Christopher. 1971. *Making wildlife movies: A beginner's guide.* Harrisburg, Pa.: Stackpole.

Plagens, Peter. 1989. Into the fun house. *Newsweek,* August 21, 52–57.

Roosevelt, Theodore. 1907. Nature fakers. *Everybody's Magazine,* September, 427–30.

Rosenberg, Jim. 1989. Computers, photographs, and ethics. *Editor & Publisher,* March 25, 40–44, 54.

Rosenblum, Ralph, and Robert Karen. 1979. *When the shooting stops...the cutting begins.* New York: Da Capo.

Rotha, Paul. 1952. *Documentary film.* London: Faber & Faber.

Saile, Bob. 1996. Seeing may not be believing. *Denver Post,* February 20, D8.

Schmitt, Peter J. 1989. *Back to nature: The arcadian myth in urban America.* Baltimore: Johns Hopkins University Press.

Scientific nature faking: The Roosevelt African expedition as it was staged and photographed. (1909). *Collier's,* July 3, 13.

Silverstone, Roger. 1984. Narrative strategies in television science—a case study. *Media, Culture & Society* 6, no. 4:377–410.

Sink, Mindy. 1996. The call of the wildlife show. *New York Times,* April 15, C7(N), D9(L), col 1.

Solnit, Rebecca. 1989. Uncommon perceptions. *Sierra* 74, no. 4:43–50.

Steinhart, Peter. 1988. Electronic intimacies. *Audubon* 90, no. 6:10–13.

Svanberg, Lasse. 1997. Filmmaking in the digital age (or Bill Gates meets the Lumiére brothers). Paper delivered at the Wildlife Europe Film Festival, Sundsvall, Sweden, December 5.

Tayman, J. 1996. Marty Stouffer's apocryphal America. *Outside,* June, 26.

Tweedie, Tony. 1985. Secrets of the not-so-wild life: Attenborough defends use of captive animals. *Sunday Independent,* March 24.

Webster, Bayard. 1986. On the trail of cougars, crocodiles, and gooney birds. *New York Times,* May 11, sec. 2, 33–34.

Wildlife film-makers admit to using captive animals as stars. 1998. *Sunday Times,* August 9, 1–2.

Wilson, Alexander. 1992. *The culture of nature.* Cambridge, Mass.: Blackwell.

Winston, Brian. 1993. The documentary film as scientific inscription. Pp. 37–57 in *Theorizing documentary,* edited by Michael Renov. New York: Routledge.

———. (1995). *Claiming the real: The Griersonian documentary and its legitimations.* London: BFI.

Wolfe, Art. 1994. *Migrations* (text by Barbara Sleeper). Hillsboro, Oreg.: Beyond Words.

World Wildlife Fund. 1999. Living planet report. On-line at http://panda.org/news_facts/publications/general/index.cfm.

Zelle, Ann, and Ronald Sutton. 1991. Image manipulation: The Zelig phenomenon. *Journal of Visual Literacy* 11, no. 1:10–37.

White and Wong:
Race, Porn, and the World Wide Web

Darrell Y. Hamamoto

The Mouse That Roared

Like previous communications technologies, such as radio, television, and cable TV, the rapid growth of the World Wide Web over the past decade has brought with it grand claims of new possibilities, ranging from the satisfaction of base commercial needs to the more elevated pursuit of further democratizing society by transforming the institutions that undergird it.[1] This vision of unbounded, free-flowing democratic communication is clouded by the inability of quality Webzines such as *Slate* (slate.com) and *Salon* (salon.com) to break even (let alone turn a profit) while highly lucrative porn sites proliferate by leaps and bounds. According to Michael E. Kinsley, the former cohost of CNN's *Crossfire* who abandoned telejournalism to establish *Slate* in 1996, "No one has found quite the right business model or gotten one to work except for those marketing sex or greed, and even greed has not really done it" (quoted in Colker 2002).[2] Although certain activist political organizations have found the World Wide Web to be a useful tool in advancing their respective agendas,[3] these noble attempts at furthering democratic communication are dwarfed by the sheer number of Web sites that convey all manner of unsavory expression.

In the exploratory essay that follows, I delve into the more distasteful areas of activity that predominate on the World Wide Web. Rather than remain in the realm of philosophical speculation on morals and ethics in the abstract, I adopt here a strategy of total immersion in the base-level empirical realities of racism, pornography, and exploitation of new intellectual labor within the postindustrial capitalist world system. My assumption is that detailed attention to the specifics of the actually existing Web world will yield accurate and practical insights into a relatively novel technology whose implications and future prospects are only dimly understood at present.

I begin with a discussion of racist expression on the Internet by tracing the race-baiting tactics of hacker folk hero Kevin Mitnick and his pursuer Tsutomu Shimomura, while explaining the historical origins of anti-Asian racism in specific. This leads to an extended survey of Asiaphilic porn sites and their relationship to White supremacist attitudes and behavior used to sustain U.S. empire domestically and overseas. I then devote a major section of the chapter to a close reading of the Asiaphobic Flash animation series *Mr. Wong* and the claim of hip postmodern irony that its creators use to evade accusations of racism. In the final section, I argue for absolute adherence to First Amendment protections against government and private censorship, no matter how morally repugnant or ethically offensive a given example of free expression might be. At bottom, the present discussion of ethical and moral imperatives of the digital age is informed by the threat of already existing "new media" technologies that promise to undermine further the institutions, culture, and politics that are the foundation of a democratic society.

Cyber-racism

Despite the Panglossian effusions of gurus and hucksters (it is often difficult to tell them apart) who have played up the communitarian and democratic possibilities of the digital age, the World Wide Web has become an unbounded marketplace for the retrograde ideas, values, and sentiments that characterized U.S. society prior to the spread of the Internet beyond its military and university developers into the corporate-consumerist civilian world.[4] Although access to information and organizations committed to egalitarian and democratic principles has never been easier, thanks to the new digital technologies, the growth of the Internet has exposed the profound degree to which U.S. society and culture remain mired in a history of racism. Sites promoting White supremacy in all its variations and guises are rife on the Web.[5] Neo-Nazi groups, White separatists, racial nationalists, and the Christian identity movement are obvious examples of the basal hatred that a significant number of Americans have for those who do not fit the Aryan profile.[6]

The racist shape of things to come in the cyberworld was prefigured by the antics of one Kevin Mitnick, a second-rate recreational hacker who made the fatal error of issuing a personal challenge to a brilliant thirty-year-old master of computational science and computer security named Tsutomu Shimomura. From an early age, Shimo-

mura had been tutored by and studied formally with the top minds in his field. It was none other than his mentor, Richard Feynman of the California Institute of Technology, who suggested that Shimomura pursue a line of inquiry that explored the convergence of physics and computer science. It was while Shimomura was working as a senior fellow from 1988 to 1995 at the federally funded San Diego Supercomputer Center (SDSC) that he became the select target of Mitnick.

Mitnick had amused himself for many years by breaching the computer security systems of such companies as Sun Microsystems and Motorola, where he helped himself to software worth hundreds of millions of dollars. He was apprehended in 1995 and later served a term in federal prison after being convicted on seven counts of computer crime and fraud (Miller 2000). Shimomura had a direct hand in tracking down Mitnick after the self-styled "electronic joy rider" began hacking Shimomura's computer. What distinguished Mitnick's attack on Shimomura from his previous crimes was Mitnick's antagonist race baiting of his cyber-foe. In addition to calling Shimomura "japboy" in electronic messages, Mitnick left racist voice mail for his enemy in fake "Japanese" accents. "Damn you," Mitnick said. "I know sendmail technique. Don't you know who I am? Me and my friends, we'll kill you. . . . Hey boss, my Kung Fu is really good" (quoted in Goodell 1996, 233–34).

Shimomura's father is a world-renowned scientist with a research specialty in the bioluminescence of sea creatures. His mother was a pharmacologist before she left the field to raise her family (Shimomura 1996, 79–80). The Shimomura family is but one example of the large-scale immigration to the United States of Asian scientists and engineers who have helped transform the U.S. postindustrial economy in recent decades through their expertise in government-funded basic research. Like their nineteenth-century predecessors from southern China who helped construct the railway transportation infrastructure, many in the contemporary Asian American population toil as what I call "intellectual coolie labor."[7] That is, the advanced technical skills immigrants bring to the imperial core society are vital to the dynamism of postindustrial capitalism, yet once in the Unied States they run headfirst into the history of anti-Asian racism. Needed but not wanted, Asian Americans in contemporary U.S. society occupy an ambiguous and hence tenuous position. Throughout cyberspace, Web sites that alternately display both hatred and lust for Yellow people reveal this contradiction.

Oriental Love Dolls

Less obvious is the covert racism that lurks within seemingly benign Euro-American expressions of fondness and attraction to people of color, specifically Asians and Asian Americans. This is known as "Asiaphilia." On a manifest level, Asiaphilia is evident in the popular culture encompassing such mass-marketed phenomena as Hong Kong action-oriented movies, *anime* (Japanese animation), consumer electronics (e.g., Sony PlayStation 2), automobiles, and cuisine. At the level of social psychology,

perhaps the most salient example of Asiaphilia is the explosion of sexually explicit images that help slake the thirst for hypereroticized Yellow women. The Web site JapanBitch (japanbitch.com), for example, boasts fifty thousand hard-core photos: "Over 100 live Japanese sex shows, little cute Japanese girls masturbating live online, lesbian geisha girls eating pussy," and "15,000 of the hardest Japanese XXX movies" on the Internet.

The expansion and intensification of sexual desire among legions of White men for Asian women is particularly ironic given that for much of U.S. history, social intercourse between Whites and "Orientals" was controlled and dictated by both common cultural practice and the law. Moral crusades waged against the reputed licentiousness of Chinese immigrant women, for example, resulted in their exclusion as a group (Cheng 1984; Chan 1991). California and other states devised antimiscegenation laws to help ensure racial purity and thus maintain the system of White supremacy. Overseas, beginning with the military occupation of the Philippines in the aftermath of the Spanish American War, Asian women have served the needs of the U.S. military as servants, prostitutes, and brides in Japan, South Korea, South Vietnam, and Thailand.

On the island of Okinawa alone, the U.S. military currently maintains thirty-nine bases that claim about 20 percent of the island's prime farmland. Apart from the disruptions caused by constant military exercises, rampant environmental pollution, and the brothelization of the local economy, U.S. servicemen routinely terrorize the civilian population by committing serious crimes against them, ranging from sexual assault to murder. U.S. Navy and Marine bases in Japan have the highest numbers of courts-martial for sexual assault of all U.S. installations around the world. In addition, at present the U.S. government has abandoned approximately ten thousand Okinawan children sired by American G.I.s to the support of this most militarized of Japanese prefectures (Johnson 2001, 34–64).

"Me Love You Long Time"

Elsewhere, I have theorized the interplay between sexuality and political power that lies at the root of the White male fetishization of the Yellow female-object (Hamamoto 2000). Without revisiting the particulars of that theoretical piece, I offer the observation that the heightened contemporary racialized desire for the Yellow female-object can be understood historically as the conjoining of U.S. imperialism (with its supporting militarized culture) and the development of the World Wide Web. As the spawn of Internet technology—itself fathered by the U.S. military and its university contractors—the Web has facilitated the coming together of postmodern neoimperial culture, the demographic changes wrought by the rapidly growing Asian American population, and the attendant intensification of Asiaphilic desire among White males. The World Wide Web, with its infinite capacity to satisfy the sexual cravings of those linked to the Internet (the majority of whom are both White and male), has

surpassed print and video media in delivering Yellow women into the lap of the erotic imagination.

In recent years there has been a boomlet in skin magazines published in the United States that cater to the Asiaphile. *Asian Women, Oriental Dolls, Asian Beauties, Jade 18,* and *Oriental Women* are representative of the specialty. Selling for $5.99 to $7.99 but typically lower in quality than comparably priced products, these publications do not compete directly with established giants such as *Playboy, Penthouse,* and *Hustler*—mass-circulation magazines that rarely feature Asian women anyway. In a nod to mounting reader interest in Yellow flesh, *Hustler* publisher Larry Flynt has begun a new bimonthly publication appropriately called *Hustler's Asian Fever. Playboy,* perhaps noting the Yellowing of magazines competing for rack space, recently produced a special edition unimaginatively titled *Playboy's Asian Beauties* (Cohen 2000).

The main attraction of stroke mags such as those mentioned above are photo spreads that feature both Asian and Asian American models. The mise-en-scène does not often include men, which leaves an exclusive fantasy space for the reader/viewer. Where male models appear at all, without fail the pictorials feature White men. Photos originating in Asia, however, are refreshingly staffed by Yellow men. The first-person narratives that usually accompany the pictures provide the reader entrée to the personality, wants, and physical desires of each woman. The voyeuristic fourth-wall convention practiced in mainstream cinema often is violated by the subject's looking straight into the camera-gaze of the reader/viewer—an optic nerve mainlining of images delivered straight to the pleasure zones of the brain.

Reviews of current video and DVD releases are a key editorial component in many such publications. These serve the dual function of evaluating recent releases for purchase and rental while offering bonus shots of hard-core action that feature well-known talent such as Kira Kenner, Tricia Yen, Kitty Yung, and Kobe Tai along with up-and-comers like Amy Akamatasu. But also included are reviews of videos made primarily for the Asian market. Although this offers American readers rare exposure to erotica featuring Yellow women and Yellow men together, the evaluations, not surprisingly, are laden with racist condescension and disapproval disguised as aesthetic judgment. Those who "simply love seeing Asian people fuck on film" should check out *Slanted Slits,* suggests one reviewer. But if one is looking for hard-core action, one should "avoid this like bad sushi" (Kiss 2001).

Imperial Sex Factory

Short stories, comic strips, sex technique advice columns, supposedly authentic first-person accounts, travel guides, and letters to the editor complement the visual content of Asian-specialty pornzines. It is through such textual material that the relationships among Asiaphilic sexual desire, U.S. militarism, and neocolonial domination become clear. "Retire in the Orient!" (2001) announces an article that serves up the fantasy of cheap and plentiful sex with exotic young Asian women in the Philippines,

Cambodia, and Thailand. Along with a descriptive narrative interview with an expert in the Asian sex industry, the article rates each country according to "living conditions," "friendliness and availability of women," "nightlife," and "average cost of sex." It is no coincidence that the three underdeveloped countries surveyed are also legatees of U.S. military interventionism and imperial power. In the case of Cambodia, the sorry "living conditions" of the present owe directly to the Vietnam War and the human holocaust that resulted from U.S. support of the Pol Pot regime (Blum 2000, 87–90). The sex industries in both the Philippines and Thailand are also linked to the U.S. military presence throughout the entire region (Matsui 1989).

The editorial content of *Oriental Dolls* is consistent in its articulation of White colonial desire. The private eye Richard Dreggs in the comic strip "Private Dick" is little more than a nonaccidental sex tourist pursued by hordes of hypersexual Yellow women for his American super-sized Big Mac. "Cold Stiffs, Hot Pussy," a short story by a writer who claims to be a Vietnam War veteran, is accompanied by an illustration of a G.I. posing nonchalantly in profile. An enormous phallus thrusts heavenward from his fatigues as a nude Vietnamese woman marvels at this visible evidence of U.S. military prowess and superiority. But the veteran's story ends on an oddly poignant note as he conveys a sense of loss decades later:

> Makes you wonder if things were different, if that fucking war had not disrupted so many lives. But then, if it were not for the war, that fantastic evening with Thao in the rear of a refrigerator trailer, half a world away, could have never happened. Thirty years later, now that my family is grown and my wife and I hardly acknowledge each other's existence anymore, I think of Thao and that night. (Reems 1996, 67)

Curiously, not only is Asian American adult actress Mimi Miyagi listed as publisher of *Oriental Dolls,* her editorial hand is evident throughout its pages. If in truth Miyagi is more than a figurehead for the magazine, then she occupies a unique position within a financially robust industry (Schlosser 1997). In this, she bears comparison to her contemporary Asia Carrera, who also has managed to parlay a more limited career as an on-camera performer into full ownership of her talent-driven business enterprise.

Porn in the U.S.A.

Just as the numbers of Asian-themed hard-core magazines have multiplied recently, Yellow video erotica has come to command an increasing share of the larger market. Much of it is U.S. domestic product that features Asian American women coupling with White men, a combination that literally embodies a power relationship in which the master group holds dominion over Yellow people. But so strong is the demand for Yellow sex images that videos originating in Asia are beginning to challenge "Made in U.S.A." supremacy. The crucial difference between foreign and domestic goods is that whereas the latter routinely script Asian American women with White men, Asian-made porn depicts activity among fellow Yellows without the looming presence of

White Man. Imported Asian video porn is one of the few opportunities that Asian Americans have to view Yellow-on-Yellow intimacy in *any* medium, with the exception of Asian American independent films of recent vintage (see Hamamoto and Liu 2000).

To avoid having White viewers feeling unmanned by their exclusion from the action, one U.S. firm that imports Asian porno footage has resurrected the classic "Oriental" male reminiscent of the Mr. Yunioshi character played by the Scottish American actor Mickey Rooney (born Joe Yule Jr.) in *Breakfast at Tiffany's* (1961), directed by White man Blake Edwards. Bucktoothed, wearing thick horn-rimmed glasses, and speaking with a fake "Japanese" accent, "Ahso Hashimoto" serves as guide to the mysteries of Oriental sex in a porn series bearing his name. Paired with a White interlocutor who pretends to be an eager initiate into ancient and inscrutable Oriental sex practices, Hashimoto—a White actor in Yellowface—offers "insider" explanations and running commentary on the action as it unfolds. Titles in the Ahso Hashimoto series include the cleverly punned *Pokémanko* (conflating the TV and game fad Pokémon with the vulgar term *omanko,* which is roughly equivalent to "pussy" in English), *Sashimi Pink,* and *Kamikaze Kunts.*

Jacked-In Cyberotica

Completing the circuit of Yellow erotica while taking it to another level altogether are the Asiacentric sites that have proliferated on the World Wide Web in recent years. The sheer number of Asian porn sites, however, dwarfs the entire catalog of print media and video combined. A Google search using the keywords "asian women porno" turned up almost sixty-five thousand Web sites as of December 2000. We can safely infer that legions of relatively young, White, middle-class men are the primary audience for these on-line porno services, because that also happens to be the demographic profile of most Internet users. Typical of such Web sites, Golden Orient (goldenorient.com) advertises thousands of high-quality uncensored hard-core photos, streamed video, and "Live Sex & Chat" for sale. The site's home page notes that Golden Orient has been on-line since 1994; it has survived close to ten years in a competitive Internet business environment. Golden Orient must certainly command a customer base large enough to sustain profitability against competing sites that number in the tens of thousands.

The See Asians Web site (seeasians.com) offers a larger array of features than Golden Orient, including "Japanese Hentai" (pervert), "Asian High School," "Asian Anime," and the more traditionally Orientalist "Geisha House Live." The Asian Exxxtasy site (asianexxxtasy.com) promotes itself as "a site dedicated to beautiful Asian women" and includes games, "erotic stories," and a personals section as part of the subscription package. Like their print counterparts, Asian porn Web sites rely on clichéd Orientalist approaches in touting the charms of Yellow women. The copy on the Asian Pleasures site (porno-asian.com)—yet another site that claims to be

"number one"—falls back on the pseudo-Sinitic "chopsticks"-style lettering that is supposed to connote the "Oriental" characteristics of Chinese ideograms. Pidgin English catchphrases like "Me so horny" (rap group 2 Live Crew sampled these now-immortal words from *Full Metal Jacket,* a 1987 Stanley Kubrick film that bitterly spoofs American involvement in the Vietnam War) and "Sucky sucky" are used to beckon potential visitors to the different sites.

The Asian Thumbs Web site (asianthumbs.org) claims for itself the distinction of being the "*original* asian thumbnail gallery post." This mother of all Asian erotica home pages features an extensive archive of downloadable JPEG images that are offered free as an inducement for potential customers to visit and hopefully subscribe to full-service sites. The JPEGS are grouped first according to date (from 1998 to present) and then brief descriptions of overall themes and subjects are attached, preceded by numerical tallies of the thumbnail photos available. For example, December 2 lists such enticements as "20 Asian nuns sins of the flesh," "16 Japanese lesbo teen orgy," "20 Schoolgirls baring panties," "16 Thai couple sex," and "25 Cock sucking urabon slut." December 1 offers such sneak previews as "15 Chinese spread on the couch," "20 Shaved Asian spreaders," and "14 Porn slut cummed on." In addition to the generic teasers are those promoting specific personalities, including "12 Asia Carrera by her pickup truck," "20 Korean babe Jung So-Young," "20 Miho Nomoto scans," and many more.

Of the names mentioned above, Asia Carrera is perhaps the most widely recognized Yellow lust-object on the World Wide Web. Unlike other porno personalities, Carrera prides herself on being in complete control of her Web site, from conception through design and execution. A child prodigy on piano who once performed at Carnegie Hall, Carrera later attended Rutgers University as a sociology major on full scholarship. She is justifiably proud of being self-taught in hypertext markup language (HTML) and related specialized computer skills necessary to the development and maintenance of an excellent Web site appropriately named Asia Carrera's Butt-kicking Homepage! (asiacarrera.com). Her site recorded 16,467,512 hits between July 19, 1996, and January 1, 2001.

The site is chock-full of professionally rendered scanned photos and candid shots of Carrera on her travels and behind the scenes on the sets of the various films that have featured the acknowledged international superstar. But what keeps visitors returning to the site is the "Asia's Bulletins!" journal that Carrera updates religiously. Her words reveal the larger-than-life porn star to be all too human as she reflects on life with all its petty aggravations and mundane problems. Her oft-stated goal is to achieve financial independence through investments made from earnings in the adult film industry. Given her earning power, business savvy, and hard-won autonomy, it seems possible that Carrera might become the first porn performer—male or female of any ethnicity—to achieve this distinction. The successful business model Carrera has established is one that Asian Americans in general might well adopt in an effort to reclaim a sexuality that has been doubly alienated—at the level of individual psy-

chology and at the level of economic exploitation. X-rated Internet content is worth an estimated one billion dollars in annual sales, according to Forester Research Inc. (Blankstein 2000, C3). Asian Americans have a golden opportunity to grab a chunk of this rapidly expanding market with an eye on amassing the wealth required to buy political access and power within the American plutocratic system of governance.

Sorry, Wong Number

Asiaphilia as "racist love" is seen in all its over-the-top postmodern irony in an Internet animated series called *Mr. Wong,* which appears on the Icebox Web site (icebox. com).[8] Prior to the advent of its animated installments, the Icebox organization produced an incredibly stupid promotional featurette featuring a "Chinese" cook named Mr. Wong (mrwongskitchen.com). This crudely rendered caricature of a human being makes one better appreciate the relative skill of late-nineteenth-century American political cartoonists, who routinely depicted immigrant Chinamen as threats to the White Christian nation. Through much of 1999, postings to Asian American Internet newsgroups and Listservs expressed outrage at this latest of racist characterizations. Emboldened perhaps by the success of *South Park* (created by the dumb and dumber duo of Matt Stone and Trey Parker), with its arch anti–politically correct humor geared to the mentality of the average high school student, Icebox invested in quality animation, writing, and voice acting. This strategy caught the attention of the television industry. In 2000, *Mr. Wong* was even "reportedly being shopped around to movie studios as a potential feature property" (Frutkin 2000, 40).

As of December 2000, fourteen episodes of *Mr. Wong* were available on-line at icebox.com. The character Mr. Wong is an eighty-five-year-old manservant to a wealthy "round-eyed bitch" named Miss Pam. She inherited the peevish and resentful Chinaman, who is prone to frightening displays of temper. In the catchy "Mr. Wong Theme Song," Davy Jones (formerly of the Monkees) sings this summary of their mistress-servant relationship: "He came with the estate / Is it love or is it hate?" When not abusing him outright, Miss Pam condescends to Mr. Wong in the worst way while professing racist love for the crusty old Yellow man. "Oh you fuck face," says Miss Pam when she is reunited with Mr. Wong after he has been arrested, "I love you." (Her lackey had been jailed for desecrating the holy shrine of Elvis Presley by pissing on Elvis's grave while shouting blasphemous statements about the incestuously close relationship the King enjoyed with Mama Gladys.)

Although she treats Mr. Wong like a court eunuch, Miss Pam betrays lust for a handsome South Asian physician named Dr. Ronjon Mietra, who treats her personal Hop Sing for malaria in one episode. In contrast to Mr. Wong, Dr. Mietra has a physically commanding presence, speaks with no "Asian" accent, and is thoroughly masculinized. So strong is her sexual attraction to the man of medicine that Miss Pam conspires to keep Mr. Wong in his sickbed so that Dr. Mietra can move in with her until the ailing family retainer fully recovers from "yellow fever." Miss Pam entices Dr. Mietra into her lair by bragging that she has "no gag reflex to speak of."

A well-worn strategy for feminizing, emasculating, and thereby disempowering men of color is to cast them as homosexuals. Sure enough, the last few episodes of *Mr. Wong* are built on the flimsy premise of Miss Pam's mistaken assumption that Mr. Wong is having a homosexual affair with an entrepreneurially minded inventor named Gary Peterson. Even though Mr. Wong taunts his boss by stroking his feather duster/cock in front of her, she thinks that the "old Chink's gone homo." Mr. Wong and his business partner, however, are able to use Miss Pam's misperception as a ruse to keep her out of their joint venture. A recipe card for "Mr. Wong's Famous New Zealand Man-Pate Jizz Fritters" is shown while episode 9 is loading. Again, it imputes to Mr. Wong veiled homosexual desire for the current reigning symbol of White male masculinity:

> As you know, I, Mr. Wong, am a heterosexual Chinese American and fucking proud of it! But I guess if I had to go gay I would choose international cinema superstar, Russell Crowe. He was so sexy in that movie *Gladiator*. I bet he would be very understanding with a first timer like myself.

In the final episode, "Stand Up for Wong," Mr. Wong performs at a comedy club despite being heckled mercilessly by a racist in the audience. To demonstrate that the series has been all in good fun among ultrahip postmodern ironists who pretend to transcend racism by recirculating racist meanings, the producers of Mr. Wong have him recite a treacly speech at the end: "I may be of Chinese extraction," says the Chinaman, "but I'm an American." The racist heckler improbably turns out to be Mr. Wong's father. He has come to join Miss Pam and others in giving his abased son a surprise birthday party.

Predictably, there have been angry responses to the racist overtones of *Mr. Wong*. The National Asian Pacific American Legal Consortium and the Asian American Internet portal aOnline (aonline.com) have taken the lead in calling on Icebox CEO and cofounder Steve Stanford to drop the series (Clemetson 2000). A poll taken by aOnline found strong disapproval of *Mr. Wong*: 77 percent of respondents said that they were offended by the series, and 46 percent of those who were offended wanted the series ended. Stanford has cited (Canadian) Lorne Michaels's *Saturday Night Live* franchise and the humor of radio personality Howard Stern to legitimate the brand of comedy he has promoted with *Mr. Wong* (Black 2000). At the Digital Coast 2000 conference, held in September 2000, Guy Aoki of the Media Action Network for Asian Americans confronted Icebox president Gary Levine over the issue. Levine defended his product by arguing that there are no "sacred cows" in comedy (Bartlett 2000).

Fear of a Yellow Planet

The producers of *Mr. Wong* hope to blunt accusations of anti-Asian racism by taking care to mock White people as well. Working-class Whites from the South are belittled as ignorant and racist, an Orthodox Jew does a star turn as a stand-up comedian,

Bing Crosby is characterized as a child abuser (Der Bingle was reputed to be a harsh disciplinarian with the four sons from his first marriage, to Dixie Lee), Mr. Wong literally pisses on the memory of Elvis Presley, and Miss Pam herself is a slutty, privileged bitch. The seeming balance and symmetry between the disparaging treatment of Mr. Wong and the denigration of White people is more apparent than real, however. This rhetorical tactic takes license with post–politically correct humor by scrupulously offending every possible ethnic, racial, nationality, and religious group. In this way, post-PC White humorists can have it both ways: they can tap into the undercurrent of racism, homophobia, and xenophobia while disengenuously claiming to be free of malicious intent. In a globalized corporate film and television media system wherein White Canadian nationals far outnumber Asian Americans born and raised in the United States, it comes as no suprise that one of the two creators of *Mr. Wong*, Kyle McCulloch, hails from across the inadequately patroled northern U.S. border. The overrepresentation of White Canadians in comparison to U.S. citizens of color such as Asian Americans exposes the way in which racial privilege trumps nationality. McCulloch's creative partner is Pam Brady, a female writer for *South Park* who shares his White racial privilege.

Vicious and demeaning, controlling images of Mexican Americans, African Americans, and Native Americans are no longer acceptable in the mass media, but Asians and Asian Americans have been fixed in the sights of genteel racists who have targeted Yellow people as a threat to U.S. society. In response to allegations of questionable campaign donations made by wealthy Asians and Asian Americans to certain Democratic candidates running for political office, the conservative *National Review* Asianized Vice President Al Gore, President Bill Clinton, and First Lady Hillary Clinton on the cover of its March 24, 1997, issue. Gore is shown wearing the simple garb of a Buddhist monk while holding an alms cup spewing paper money, an allusion to the hundred thousand dollars in illegal campaign donations he netted at a 1996 reelection luncheon held at the Hsi Lai Temple in Hacienda Heights, California (Jackson 2001).[9] Sporting a queue, wispy Fu Manchu, and de rigueur conical hat, an obsequious-looking Bill Clinton carries a tray of tea, presumably to serve the Chinese agents of influence who supposedly helped orchestrate his rise to power (Lowry 1997). As a knock against her collectivist arrogance in initiating health care reform early in her husband's first term as president, a bucktoothed Hillary Clinton is depicted standing proudly in a People's Liberation Army uniform—complete with Chairman Mao cap—cradling the Little Red Book as she prepares to lead America down Hayek's "road to serfdom (see Figure 11.1)"

The *Mr. Wong* phenomenon coincides with growing government suspicion over the potential fifth-column presence of Asian American scientists and engineers who have come to occupy a vital role in the development of cutting-edge "new economy" technologies in the civilian sector (see Ong, Bonacich, and Cheng 1991). Many, such as physicist Wen Ho Lee, have enjoyed careers in service to the military-industrial

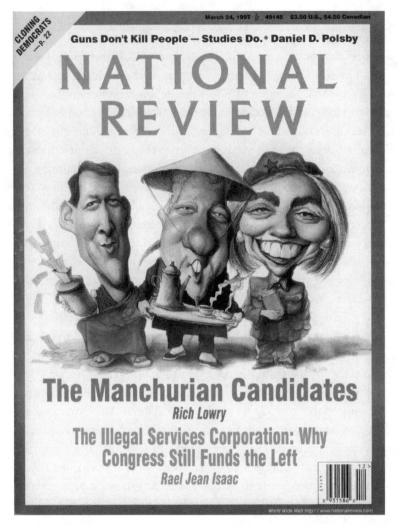

Figure 11.1. Al, Bill, and Hillary as Chinese agents of influence. Cover of *National Review,* March 24, 1997. Copyright 1997 by National Review, Inc., 215 Lexington Avenue, New York, NY 10016. Reprinted by permission.

complex, whose charge is to ensure that the balance of terror remains in favor of the United States. Despite being a naturalized U.S. citizen, in December 1999 the Taiwan-born Lee, a scientist at Los Alamos National Laboratory, was indicted on fifty-nine counts of violating the Federal Atomic Energy Act and the Federal Espionage Act. He subsequently spent nine months in jail awaiting trial before being released after pleading guilty to a single felony charge of mishandling classified information.[10] Although they avoid the ethical and moral questions raised by Lee's contributing to the design of the U.S. nuclear arsenal while he was working in the X Division at Los Alamos, many Asian American advocacy and civil rights organizations believe that

the current political climate is dangerously reminiscent of the one that led to the mass internment of Japanese Americans during World War II (Iritani 2000).

The generation of young people who have come to be known as "dot commies" cannot help but observe that the highly competitive, wildcatting world of new technology companies is overpopulated by hordes of Asian American engineers who have immigrated to the United States over the past few decades to help fill the skilled labor needs of both established corporations and start-ups vying to develop and monopolize the "next new thing." Jim Clark, the visionary, swashbuckling captain of the computer industry who founded Silicon Graphics and then Netscape, understands the value of Asian American engineers in the creation of an empire that has brought him untold wealth. South Asian American engineers in particular are his most important source of intellectual capital. "The Indian outcasts of Silicon Valley," as he describes them. "My Indian hordes" (quoted in Lewis 2001, 104).

Just as nineteenth-century railroad magnate Leland Stanford was fond of the Chinese American immigrant workers who made him wealthy, Clark once pragmatically observed to his South Asian American right-hand man, "We got to get some more Indians around here" (quoted in Lewis 2001, 56). The predominance of Asian American intellectual labor in the computer industry has given rise to barely concealed resentment among White competitors, who nonetheless still control managerial and executive positions. To ensure that the marginal advantage of White identity remains intact, Internet entertainment fare like *Mr. Wong* serves to remind Yellow people of their subordination within a racially stratified social system even if they do happen to be high-income-earning scientists and engineers with equity in start-up companies.

Calley-Reeves Syndrome

Wars of imperial conquest in Asia and the thoroughly militarized society that has come into being over the past century in the United States have made indelible impressions on popular culture and collective memory. From the staged battles of U.S. troops subduing Filipino resistance fighters in Edison silent films to "economic war" movies featuring Michael Douglas, Asia has been positioned as the number one threat to American empire, notwithstanding the more recent strategic shift to Latin America, the Balkans, and the Middle East.[11] In tandem with American cinema during the 1950s and much of the 1960s, Cold War television brought fear of the Chinese and North Korean "red menace" into American living rooms day and night (MacDonald 1985). As West, Levine, and Hiltz (1998) note, for the better part of the twentieth century, in both military and economic conflict, the "experiences and the memories of war defined the relationship between the United States and Japan, Korea, China, and Vietnam from the 1940s through the 1970s" (4).

Through military service, generations of young American men have been exposed directly to the Asian societies they have been born and bred to revile. Beginning with

the almost century-long military presence in the Philippines, generations of American servicemen have been weaned on Asian women working in the extensive sex industry that catered to their U.S. dollar–backed physical needs. The U.S. occupation of Japan (which continues to this very day), the heavy presence of troops in South Korea, and the fabled Thai sex service complex (a legacy of the Vietnam War) continue to fuel desire for Yellow flesh. Many G.I.s, far away from home for the first time and sexually immature, have experienced the contradiction of simultaneously hating and loving the enemy. Out of this imperial history arises a social psychology that Robert Jay Lifton (1992) calls the "gook syndrome." According to this esteemed psychiatrist, who has written extensively on the psychology of atrocity, the gook syndrome has "deep roots in American society," particularly "in our popular culture" (204).

The commodification of Asian females reaches its logical extension in "mail-order" bride services that bring White American men and Yellow women together in unholy matrimony. A case study in the confluence of sexual desire, neoimperialism, and racism—albeit an extreme example—is found in the creepy story of Jack Wayne Reeves, a fifty-four-year-old widower and retired U.S. Army veteran who acquired an eighteen-year-old Filipina named Emelita Villa through *Cherry Blossoms* magazine.[12] Emelita's impoverished parents had placed an ad in the publication hoping that a rich American would marry their daughter, take her to live in the United States, and thereafter provide financial assistance to the family back in Cebu City. Reeves rescued Emelita from dire poverty by marrying her and bringing her to live with him in Texas. After enduring a loveless marriage marked by brutality and obsessive control exercised by her tyrannical husband, Emelita was reported missing on October 11, 1994.

Jack Reeves's morbid fascination with death and sex was given free rein through the bodies of Yellow people. He claimed to have been a machine gunner during the Vietnam War and spoke with perverse relish about the "Vietcong" enemy he enjoyed killing by firing into the "spider holes" where they concealed themselves. Years later, while on a one-year tour of duty in South Korea during 1978, Reeves set up housekeeping with a woman who later became his second wife. Inconveniently, Reeves already had a wife of seventeen years, a White woman named Sharon Delane. She died of a shotgun blast in July 20, 1978, while Reeves, not so coincidentally, was home in Texas for a short visit from Korea. The death was written off as a suicide, and the way was cleared for Myong Hui Chong to become the second Mrs. Reeves. Myong was next to die while married to Reeves; she "accidentally" drowned in a few feet of water on July 28, 1986.

Reeves clearly viewed Asian women as the vehicles by which he could combine his Asiaphilic sexual obsession with the violent, murderous impulses that were given legitimacy through his career in the military. Reeves was a "killing machine," his own father observed. "It started in Vietnam," he said. "He liked the killing" (quoted in Springer 1999, 102). Reeves also had bragged to an investigator that finding sex in

Korea was cheap and easy, that women often would give G.I.s on guard duty blow jobs through the fence that surrounded the military compound. A search of his home turned up dozens of porn tapes with a decidedly Asian slant, including *Deep inside the Orient* and *Oriental Explosion*. Along with his extensive porn magazine and tape collection, police confiscated ammunition and more than forty guns. Even as evidence mounted incriminating Reeves as Emelita's murderer, he was busy trying to arrange for yet another impoverished Filipina to replace his third and final wife.

Myong Hui Chong and Emelita Villa were known intimately by their murderer, but the criminal actions of Jack Reeves differ only in degree from those of other Americans (including Blacks, Latinos, and Asian Americans) who have participated in the debasement and killing of Asian civilians both during war and in peacetime.[13] The thrill of battle and slaughter, according to more than a few participants, "could be likened to an orgasmic, charismatic experience" (Bourke 1999, 3). At the same time, a remorseless participant in the 1968 My Lai massacre, Lieutenant William Calley, has written almost lovingly in his autobiography of a Vietnamese prostitute he fantasizes about rescuing from her supposedly squalid life (cited in Faludi 2000, 329). An authority on the psychology of killing in military settings articulates the racist love/racial hate dilemma as follows:

> Most of the Vietnam veterans I have interviewed developed a profound love for the Vietnamese culture and people. Many married Vietnamese women.... But many U.S. soldiers in Vietnam spent their year in-country isolated from the positive, friendly aspects of Vietnamese culture and people. The only Vietnamese they met were either trying to kill them or were suspected of being or supporting Vietcong. This environment had the capacity to develop profound suspicion and hatred. One Vietnam veteran told me that, to him, "they were less than animals." (Grossman 1996, 163)

This admixture of anti-Asian racism, racialized sexual desire, and state-sponsored violence against Yellow people has given rise to a social psychology that I call the "Calley-Reeves syndrome." Oriental porn sites owe a great deal of their massive popularity to this syndrome.

Against Censorship

Given the above survey and analysis, one might conclude that restrictions should be imposed on purveyors of Web content that might be construed as racist, homophobic, sexist, or otherwise offensive. I argue the contrary: we must fight vigorously for absolute freedom of speech on the Internet and against any censorship of the World Wide Web. If any possibility remains that Internet communications technology can fulfill its early promise of facilitating the free and open democratic exchange of ideas and information, we must resist all efforts by corporations, government, and interest groups to silence unpopular voices.

Corporations already have taken the first step down the slippery slope of censorship with the March 1996 debut of the Platform for Internet Content Selection (PICS). Developed by the World Wide Web Consortium, PICS is the first major attempt by a nongovernmental body to regulate the healthy chaos and anarchy found on the Web. World Wide Web founding father Tim Berners-Lee (2000) disengenuously absolves himself from blame should corporations and governments abuse PICS. "Technologists have to act as responsible members of society," he argues, "but they also have to cut themselves out of the loop of the ruling world" (137).

As private industry experiments with different mechanisms of self-censorship such as NetNanny and CyberPatrol, U.S. government attempts at direct control of the Internet are proceeding on both manifest and clandestine levels. The Communications Decency Act of 1996, which was intended in part to prevent children from gaining access to sexually oriented material on-line, was struck down by the U.S. Supreme Court, which cited the First Amendment in doing so (Akdeniz 1999, 27–32). But the true indecency was its being tied in with the Telecommunications Act of 1996, which gave corporate oligopolies the green light to intensify and expand their freebooting activities to the Internet and allied digital media technologies.

Apart from passing legislation that favors corporate entities, the U.S. government has an interest in imposing order on the Internet as a matter of national security. The placement of "cookies" (messages sent by Web servers that enable information gathering and identification of users) on the Web browsers of Web site visitors was only a prelude to more nefarious developments. For example, the *New York Times* reported in 1999 that Intel had embedded serial numbers on its new Pentium III chip that "enable online marketers, even governments, to track computer users' movements on the Internet" (cited in McGowan 2000, 148). In 1996, an investigative journalist detailed the existence of a "globally integrated communications intellegence system codenamed ECHELON" (cited in Whitaker 1999, 93). The U.S. government has taken the lead among its Western allies in monitoring electronic communications (including telephone traffic and e-mail) and sharing information gathered in this way for intelligence purposes. Future surveillance technologies will give new meaning to the quaintly understated concept of "totalitarianism."

Electronic surveillance technology is also being put to direct use by corporate America, as seen in the case of fallen energy giant Enron. Over the past several years, the Houston company reportedly employed as many as twenty CIA agents whose function was to use their intelligence-gathering expertise to spy on foreign competitors. The CIA operatives relied upon the Echelon system to intercept e-mail, phone calls, and fax transmissions that carried sensitive economic intelligence, thus enabling Enron both to outflank other businesses and to exert "pressure on foreign governments through powerful figures in U.S. government" (Lynch, Hanrahan, and Wright 2002, 16). According to Redden (2000), a critic of the surveillance society, "Using 120 satellites and a chain of secret interception facilities around the world, Echelon

automatically searches through millions of messages looking for ones containing key words or phrases" (40).

Calls for censorship of Internet content by interest groups such as the National Asian Pacific American Legal Corsortium, which led the campaign against *Mr. Wong,* doubtless will continue no matter how ill-advised. Although such ad hoc actions perform an important service by reminding the public of ongoing media racism, they distract us from the larger but less publicized struggle against corporate monopolization of the Internet and related digital communications systems. Megaplayers such as MCI, GTE, and AT&T, with assistance from public policy makers, the U.S. Congress, and governmental regulatory agencies, already have assumed almost complete control over what once promised to be a radically democratic communications system that would allow for the free flow of news, information, and entertainment to diverse communities of users (McChesney 2000).

Threats to First Amendment guarantees come not only from ideologically diverse interest groups, government, and corporations but from presumably progressive quarters as well. For example, "critical race" theorists Richard Delgado, Charles R. Lawrence III, and Mari Matsuda have stood as field marshals in a symbolic battle against "words that wound" and so-called hate speech. A primarily academic audience nodded in affirmation to the arguments of these scholars while the Reagan-Bush administration waged a very real war against the working poor, non-White immigrants, and middle-class families. Paradoxically, feminist antipornography personalities, "hate speech" academic theorists, and their right-wing moralist counterparts have found common ground in agitating for repressive policies regarding speech and behavior. To their shame, many colleges and universities have capitulated to their demands despite a professed commitment to academic freedom.[14]

We must exercise caution where challenges to the right of free speech are concerned. Architects of repressive codes of behavior, guidelines, and legislation intended to "protect" aggrieved groups from supposed harm done by racist speech, erotica, and sexist expression often have found themselves hoist with their own petard. The very legal-juridical system that minority group members call upon to shield them from hurtful and insulting speech has more than a few times turned its punishing hand against those seeking protection from perceived harm. Lisa Duggan and Nan D. Hunter (1995) have chronicled, for example, the unintended disastrous consequences of antipornography legislation inspired by theorists Catharine MacKinnon and Andrea Dworkin.

Asiaphilic porn sites, *Mr. Wong,* White-power propaganda, and other sources of racist drivel—let them all multiply and flourish on the World Wide Web. With the advent of the Internet, we can be thankful that more people than ever can see with their own eyes the mind-boggling extent of the racist love and hatred that many Americans reserve for Yellow people. Political grandstanding against anti-Asian speech might be an effective method of advancing the individual careers of academic

professionals and boosting member support of interest groups that lead newsworthy attacks against adult erotica or *Mr. Wong,* but such activity does precious little to challenge the substantive power of government institutions, corporations, institutions of higher learning, and the military in enforcing White supremacist rule at home and overseas. So-called hate speech, "words that wound," and "pornography" are protected by the First Amendment to the U.S. Constitution. Intellectual inquiry, artistic expression, and political dissent are likewise protected. *Mr. Wong,* "The Nets Hottest Asians!!!" (asianporn.com), and free speech all come bundled with the system.

Notes

1. For an incisive critique of the false distinction between "old" and "new" media, see Chester and Larson (2002).

2. Kinsley is stepping down as editor of *Slate* due to health reasons, but will continue to contribute a weekly column to the Webzine in addition to doing work for *Time* magazine.

3. For example, see de Armond (2001) for a review and evaluation of the often sucessful use of the Internet by various groups involved in the November 1999 protest at the World Trade Organization meeting in Seattle, Washington.

4. His work keenly informed by contemporary social theory, Rheingold (1994) traces the historical development of the Internet.

5. McPherson (2000) examines the implied racial supremacist ideology found on neo-Confederate Web sites.

6. Figures gathered by the Southern Poverty Law Center placed the number of racist Web sites at more than 250 as of 1998 (Lee 2000, xli).

7. The Immigration Act of 1990 created the visa category H-1B, which allows an employer to import yearly a maximum of sixty-five thousand foreign temporary specialized workers. But there is research evidence that foreign-born computer scientists are being substantially underpaid compared to their U.S.-born counterparts (McDonnell and Pitta 1996, A12). Hence the reference to "coolie" labor.

8. More than thirty years ago, literary giant Frank Chin and Jeffrey Paul Chan (1972) introduced the notion of "racist love" in anticipation of the current wave of Asiaphilia.

9. Los Angeles "immigration consultant" Maria Hsia managed to escape a prison sentence in the case and instead received probation and a fine of five thousand dollars following her conviction on five felony counts under the Federal Election Campaign Act (Lichtblau 2001). Jeffrey Toobin (2000) has written an in-depth profile of Hsia.

10. Although he neglects to address the moral and ethical implications of Lee's role in maintaining the nuclear terror state, Robert Scheer (2000) provides the best account of the entirety of the Lee case.

11. Following Kirk Douglas's footsteps as fearless gook fighter, Michael Douglas has continued the family tradition with such gems of American cinema as *Black Rain* (Ridley Scott, 1989) and *Falling Down* (Joel Schumacher, 1993).

12. A "Cherry Blossoms, Inc." Web site can be found at cherry-blossoms.com. It is not certain whether this is the same company that facilitated the meeting of Reeves and Emelita Villa, but its listed date of founding (1974) makes it likely.

13. In Okinawa, unwilling host to thirty-two thousand U.S. servicemen stationed there, residents are terrorized by regular military maneuvers and periodic sex crimes such as the one recently commited by twenty-one-year-old Marine corporal Raven W. Gogol against a sixteen-

year-old girl. In 1995, three American military men raped a twelve-year-old, which brought angry local demonstrations against both the central government in Japan and the United States (Struck 2001).

14. For a critical account of contemporary censorship and political correctness in academia, see Kors and Silverglate (1999).

References

Akdeniz, Yaman. 1999. *Sex on the Net: The dilemma of policing cyberspace.* Reading, Eng.: South Street.

Bartlett, Michael. 2000. Digital Coast 2000: Debate heated over "Mr. Wong." *BizReport,* September 15. On-line at http://www.bizreport.com.

Berners-Lee, Tim, with Mark Fischetti. 2000. *Weaving the Web: The original design and ultimate destiny of the World Wide Web by its inventor.* New York: HarperBusiness.

Black, Kathi. 2000. Mr. Wong just not right, critics say. *Standard,* November 26. On-line at http://www.thestandard.com.

Blankstein, Andrew. 2000. Porn company IPO may raise eyebrows along with cash. *Los Angeles Times,* July 1, C1, C3, national edition.

Blum, William. 2000. *Rogue state: A guide to the world's only superpower.* Monroe, Maine: Common Courage.

Bourke, Joanna. 1999. *An intimate history of killing: Face-to-face killing in twentieth-century warfare.* New York: Basic Books.

Chan, Sucheng. 1991. "The exclusion of Chinese women, 1870–1943. Pp. 94–146 in *Entry denied: Exclusion and the Chinese community in America, 1882–1943,* edited by Sucheng Chan. Philadelphia: Temple University Press.

Cheng, Lucie. 1984. Free, indentured, enslaved: Chinese prostitutes in nineteenth-century America. Pp. 402–34 in *Labor immigration under capitalism: Asian workers in the United States before World War II,* edited by Lucie Cheng and Edna Bonacich. Berkeley: University of California Press.

Chester, Jeffrey, and Gary O. Larson. 2002. Something old, something new: Media policy in the digital age. *The Nation,* January 7–14, 12.

Chin, Frank, and Jeffrey Paul Chan. 1972. Racist love. Pp. 65–79 in *Seeing through shuck,* edited by Richard Kostelanetz. New York: Ballantine.

Clemetson, Lynette. 2000. Trying to right Mr. Wong. *Junipers: Asian American Matrix,* July 31. On-line at http://www.junipers.org. Reprinted from *Newsweek,* July 23, 2000.

Cohen, Jeff, ed. 2000. *Playboy's Asian Beauties* (special issue), July.

Colker, David. 2002. Banking on Slate. *Los Angeles Times,* February 18, C8, national edition.

de Armond, Paul. 2001. Netwar in the Emerald City: WTO protest strategy and tactics. Pp. 201–35 in *Networks and netwars: The future of terror, crime, and militancy,* edited by John Arquilla and David Ronfeldt. Santa Monica, Calif.: RAND.

Duggan, Lisa, and Nan D. Hunter. 1995. *Sex wars: Sexual dissent and political culture.* New York: Routledge.

Faludi, Susan. 2000. *Stiffed: The betrayal of the American man.* New York: Perennial.

Frutkin, Alan James. 2000. The faces in the glass are rarely theirs. *New York Times,* December 24, 31, 40.

Goodell, Jeff. 1996. *The cyberthief and the samurai.* New York: Dell.

Grossman, Dave. 1996. *On killing: The psychological cost of learning to kill in war and society.* Boston: Back Bay.

Hamamoto, Darrell Y. 2000. The Joy Fuck Club: Prolegomenon to an Asian American porno practice. Pp. 59–89 in *Countervisions: Asian American film criticism,* edited by Darrell Y. Hamamoto and Sandra Liu. Philadelphia: Temple University Press.

Hamamoto, Darrell Y., and Sandra Liu, eds. 2000. *Countervisions: Asian American film criticism.* Philadelphia: Temple University Press.

Iritani, Evelyn. 2000. Lee case is an awakening for some Chinese Americans. *Los Angeles Times,* September 25, A6, national edition.

Jackson, Robert L. 2001. Donor scandal figure faces sentencing. *Los Angeles Times,* January 19, A12, national edition.

Johnson, Chalmers. 2001. *Blowback: The costs and consequences of American empire.* New York: Owl.

Kiss, Jett. 2001. Dynamite flixxx. *Oriental Women,* January, 29.

Kors, Alan Charles, and Harvey A. Silverglate. 1999. *The shadow university: The betrayal of liberty on America's campuses.* New York: HarperPerennial.

Lee, Martin A. 2000. *The beast reawakens: Fascism's resurgence from Hitler's spymasters to today's neo-Nazi groups and right-wing extremists.* New York: Routledge.

Lewis, Michael. 2001. *The new new thing: A Silicon Valley story.* New York: Penguin.

Lichtblau, Eric. 2001. Fund-raiser avoids prison. *Los Angeles Times,* February 7, A8, national edition.

Lifton, Robert Jay. 1992. *Home from the war: Learning from Vietnam veterans.* Boston: Beacon.

Lowry, Rich. 1997. China syndrome. *National Review,* March 24, 38–40.

Lynch, Kevin, Michael Hanrahan, and David Wright. 2002. Enron: The shocking inside story of adultery, greed and how they ripped off America. *National Enquirer,* February 26, 4–5, 16.

MacDonald, J. Fred. 1985. *Television and the red menace: The video road to Vietnam.* New York: Praeger.

Matsui, Yayori. 1989. *Women's Asia.* London: Zed.

McChesney, Robert W. 2000. *Rich media, poor democracy: Communication politics in dubious times.* New York: New Press.

McDonnell, Patrick J., and Julie Pitta. 1996. "Brain gain" a threat to U.S. jobs?" *Los Angeles Times,* July 15, A1, A12–A13.

McGowan, David. 2000. *Derailing democracy: The America the media don't want you to see.* Monroe, Maine: Common Courage.

McPherson, Tara. 2000. I'll take my stand in Dixie-Net: White guys, the South, and cyberspace. Pp. 117–31 in *Race in cyberspace,* edited by Beth E. Kolko, Lisa Nakamura, and Gilbert B. Rodman. New York: Routledge.

Miller, Greg. 2000. Computer hacker Mitnick scheduled to be released today. *Los Angeles Times,* January 21, C2, national edition.

Ong, Paul, Edna Bonacich, and Lucie Cheng, eds. 1991. *The new Asian immigration in Los Angeles and global restructuring.* Philadelphia: Temple University Press.

Redden, Jim. 2000. *Snitch culture: How citizens are turned into the eyes and ears of the state.* Los Angeles: Feral House.

Reems, Moss. 1996. Cold stiffs, hot pussy. *Oriental Dolls* 7, no. 2:64–67.

Retire in the Orient! 2001. *Jade* 18, January, 36–41.

Rheingold, Howard. 1994. *The virtual community: Homesteading on the electronic frontier.* New York: HarperPerennial.

Scheer, Robert. 2000. No defense: How the *New York Times* convicted Wen Ho Lee. *The Nation,* October 23, 11–20.

Schlosser, Eric. 1997. The business of pornography. *U.S. News & World Report,* February 10, 42–52.

Shimomura, Tsutomu (with John Markoff). 1996. *Take-down.* New York: Hyperion.

Springer, Patricia. 1999. *Mail order murder.* New York: Pinnacle.

Struck, Doug. 2001. Another serviceman arrested in Okinawa. *Washington Post Foreign Service,* January 11, A22.

Toobin, Jeffrey. 2000. Adventures in Buddhism. *New Yorker,* September 18, 76–88.

West, Philip, Steven I. Levine, and Jackie Hiltz. 1998. Introduction: Sounding the human dimensions of war. In *America's wars in Asia: A cultural approach to history and memory,* edited by Philip West, Steven I. Levine, and Jackie Hiltz. Armonk, N.Y.: M. E. Sharpe.

Whitaker, Reg. 1999. *The end of privacy: How total surveillance is becoming a reality.* New York: New Press.

The Advertising Photography of Richard Avedon and Sebastião Salgado

Matthew Soar

In the introduction to their edited collection of essays about ethical issues surrounding the production and use of images, Gross, Katz, and Ruby (1988) discuss the importance of labeling, context, and audience assumptions for the "meaning and significance attached to a visual image" (18). To elaborate this point, they discuss some of the images typically produced by documentary photographer Lewis Hine in the early part of the nineteenth century. Hine, working in the interests of social reform, photographed and published somewhat posed images of desperately poor children laboring in factories. As Gross et al. point out, however, the responses that Hine desired of his audience (awareness, action) would be all but lost were these same images to appear on gallery walls: "The audience in this context are people whose primary interest lies in art and photography and not in reforming labor laws. The photographs are now regarded primarily for their syntactic elements, their formal and aesthetic qualities" (19).

In this chapter I am similarly concerned with the transformative implications of context. The examples discussed here relate to photographic images or genres familiar

in one arena (galleries, museums, books) and then transferred to another (advertising). Richard Avedon is best known as a commercial photographer of fashion and celebrities who, periodically, also produces "art" images. Sebastião Salgado, by contrast, generally presents himself as a concerned photographer in the manner of Hine—although his work is at its most public in the very venues Gross, Katz, and Ruby regard as primarily concerned with aesthetics. Both photographers, as it turns out, have replicated their gallery work for advertising clients: Avedon for Levi Strauss and Salgado for Le Creuset cookware and Silk Cut cigarettes.

Most obviously, then, the examples explored here underscore the degree to which advertising can successfully co-opt a relatively high-minded mode of expression for its own ends (and at the expense of the subjects so portrayed). Specifically, a distinctive style and/or subject matter is articulated to a product or service; the original photographer's claims to authenticity are preserved through his or her sudden anonymity, and any undesirable political valence can also be summarily stripped from the image. As a consequence, it appears that we are willing to regard photographers who produce both "art" and commercial work as credible artists as long as the latter activity remains secondary, anonymous, or both.

Is it not remarkable, then, that images produced in order to record and relate the pervasiveness of human labor and suffering become the very means by which the hedonistic pleasures of the few are encouraged and perpetuated? Ultimately, just how effective can socially concerned photography remain, given a contemporary media environment in which otherwise shocking photojournalistic images can be branded effectively in order to market sweaters? These are not exceptional circumstances; rather, they are the logical outcome of a commercial media system that has a vested interest in repeatedly challenging the boundaries of ethical propriety and taste. Surely part of our responsibility to the marginal, dispossessed, and truly downtrodden is to ensure *at the very least* that images of their plight do not become yet more ephemeral fuel to feed our own all-consuming desires.

A Theoretical Starting Point

Gross, Katz, and Ruby's (1988) discussion vividly demonstrates the inevitable polysemy at the heart of the receptive interpretation of images, a familiar-enough proposition that challenges the authority of the producer over meaning and the sanctity of the text as a vessel of singular authorial intent. Stuart Hall (1980) has epitomized this pervasive concern to elaborate a more sophisticated understanding of communication—a significant advance on the old mantra of sender/message/receiver—in an important essay titled "Encoding/Decoding." With hindsight, however, it is clear that although much effort has been applied to the exploration of "decoding" in both theoretical and empirical terms, very little work has been done that explicitly tackles the always-implied moment of "encoding." This is my underlying emphasis in this chapter, not least because I believe that an understanding of image ethics depends, to

a significant degree, on an exploration of the conditions of image production; indeed, I would venture that it is here that ultimate moral and ethical accountability must surely lie. In considering problematic advertising images, then, we should also address the proprietary world of commercial cultural production and the whole constellation of cultural workers who inhabit it. These are the "cultural intermediaries" (Bourdieu 1984; Featherstone 1991; Soar 2000), the hidden cast of individuals responsible for designing the advertisements, commercials, books, posters, and gallery exhibitions discussed here.

Of Mudmen and Cigarettes

I would like to share an anecdote that I hope will shed some light on these particular issues. At the beginning of a brief career as an advertising art director, I spent a year at a specialized art college in London. The school prided itself on its industry contacts, and extra evening classes were often held, each one hosted by a different advertising luminary. One night, we were visited by Paul Arden, a likable and somewhat reserved gentleman who was then the creative director of Saatchi & Saatchi—probably the most famous agency in the world at that time. I remember his considerable excitement as he gave us a sneak preview of some new ads that were currently being developed under his direction. They had been conceived as a continuation of a campaign for Silk Cut cigarettes, a brand familiar to most people in Britain. Because of increasingly stringent legislation relating to the promotion of tobacco products over the previous twenty years, cigarette advertising in the United Kingdom had begun to explore surrealist themes, a tactic most closely identified with the Benson & Hedges brand. For Silk Cut, this involved artful and often witty images in which a signature piece of purple silk had been cut, torn, or otherwise shredded by a menagerie of fanciful beasts and menacing objects. Overall, the campaign came to resemble a cross between Hitchcock and Dr. Seuss (for some examples, see Saunders 1996).

Each of the ads Arden showed us consisted of a black-and-white photograph with—in place of the usual headline, text, and logo—a single purple element. The ads' subject matter in this case was the "mudmen of Papua New Guinea" (Saunders 1996, 81). One ad in particular featured a formal group photo of more than a dozen men sitting or standing, wearing huge masks and loin clothes and clutching bows and arrows (see Figure 12.1). At the center of the photo was a rectangular wooden frame with what appeared to be an animal skin stretched across it. The "skin," of course, was purple silk, its surface mottled by many cuts.

I remember being entirely unimpressed with the ads, sharing none of Arden's enthusiasm—but not because of their dubious ethical footing. I did not know who Salgado was, and I couldn't have cared less that this constituted a "cynical echo" (Saunders 1996, 81) of his justly famous photographs of Brazilian gold miners, or the blatant exploitation of an indigenous people, or yet another lavishly funded tobacco promotion. At that time, all my training brought forth was a narrow dislike of the advertising

Figure 12.1. A British advertisement created by Saatchi & Saatchi as part of a long-running campaign for Silk Cut cigarettes in the early 1990s. The photograph, purportedly of a group of Papua New Guinea mudmen, was shot by Sebastião Salgado for Saatchi.

concept—an exceptionally myopic judgment that centered on the relative cleverness of the idea itself.

I do not claim that my experience in advertising, or indeed my response to these ads, was by any means typical. However, I do think that this particular incident speaks volumes about the relative isolation of various discourses (professional, critical) and the particular concerns that attend each one. The ad campaign is also the single most vivid reminder I have yet encountered of the potential ethical contradictions attending "serious" photographers when they accept advertising commissions. I believe it is incumbent on us to work hard to reconcile such activities, to open up for debate, rather than routinely elide, a situation that allows socially invested "artists" to contribute their talents quietly to commercial discourses without any moral accountability—not least because moral accountability is the very response they righteously attempt to elicit from us in their role as concerned photographers. When Lutz and Collins (1993) suggest that, "at their most effective," photographs of human suffering "lead us to ask how such a thing can happen—and how it can be kept from happening again" (271), one is tempted to ask the same question of ads that deploy precisely this kind of image, but to radically different ends.

The Commercial Trade in Documentary Photography

The Magnum agency, a legendary—if disorganized—collective of eminent photojournalists, is described in the title of a recent book as having spent "fifty years at the front line of history" (Miller 1998). This is a nod toward Magnum's preeminent status

as the source of a vast number of memorable images from around the world documenting war, famine, and other sources of human suffering that have served to characterize much of the history of the twentieth century. It includes stories about Robert Capa and his famous photograph of a dying soldier in the Spanish Civil War, the highly regarded work of Henri Cartier-Bresson, and even fortuitous news scoops. (For example, during his tenure at Magnum, Salgado was the only photographer to capture the immediate aftermath of John Hinckley's assassination attempt on Ronald Reagan.) Colin Jacobson (2000) describes the agency as being "renowned for its humanitarian objectives." He goes on: "It was founded . . . on the basis that a photographer's individual responsibility was paramount, as was respect for the subjects photographed."

Magnum, however, has also been at the front line of corporate history—albeit discreetly so. For example, the agency and its photographers have been credited with the creation of images in corporate annual reports: by Burk Uzzle for the American Can Co. in 1966 and by Bruce Davidson for H. J. Heinz Co. in 1975 and 1977 (see Potlatch Corporation 1999).[1] One graphic designer who has worked on annual reports says: "The photography is very important in an annual. It's the most effective, real, believable way of telling a story. . . . There are probably twenty or so really reliable, terrific annual report photographers. People like Bruce Davidson, Burk Uzzle, or Burt Glinn are so terrific that you're lucky if you can get one of them" (quoted in Squiers 1989, 208). Uzzle is a past president of Magnum (Rosler 1989, 312), as is Salgado (Miller 1998).

Squiers (1989) discusses the degree to which corporations rely on their annual reports to manage their public images and gives examples of instances in which companies have addressed (or elided) serious problems through these legally required documents: Union Carbide after the Bhopal disaster, Johnson & Johnson after the Tylenol poisonings, and Bethlehem Steel Corporation during an ongoing industrial crisis. The designers of annual reports attempt to achieve a certain degree of credibility through the use of documentary images—or, more properly, promotional images shot in a documentary style. In this context, then, "real" images are deployed to perform specific functions, such as reassuring shareholders and board members that all is well with their interests and investments. For example, Squiers notes that, in spite of textual references to the contrary, the Bethlehem Steel Corporation's annual report "leaves the impression that *workers,* not imports, are the industry's biggest headache" (214).

The most visible example of the marriage of photojournalism and advertising, at least in Europe and North America, has been Benetton's publicity in the mid-1990s, followed more recently by the Gap's magazine ads for khakis featuring Hunter S. Thompson, Jack Kerouac, and others, and Apple's "Think Different" campaign, which has deployed archival images of Gandhi, John Lennon and Yoko Ono, and Albert Einstein. The Benetton campaign, decried in popular and critical contexts as manipulative and crass—not to mention its being a puzzling strategy for selling sweaters—

can also be understood as commodified photojournalism: take a news photo of suffering, tragedy, or mayhem (or, more recently, several death-row inmates), simply add that telling green-stripe logo, and voilà—a Benetton ad. But how different is this from the work of Don McCullin for London's Metropolitan Police and Dyson vacuum cleaners, or the work of Margaret Bourke-White for Chrysler (Rodriguez 1998)? It would seem that all of these photographers have basically been able to offer their advertising clients a documentarian's eye: to bring all the credibility that photojournalism can offer to subject matter that may be politically sensitive, or to ensure that otherwise trite or patronizing marketing concepts are rendered with a degree of purpose and gravity normally reserved for the genuinely newsworthy.

It's in the Jeans: From the American West to British Levi's

Campaign, the trade journal of record for the business of advertising in the United Kingdom, holds a yearly competition to honor the best "press" ads (i.e., those appearing in newspapers and magazines). In 1991, an ad for Levi's jeans won gold in the category of best individual black-and-white advertisement (see Figure 12.2), with an ad for VW cars receiving the gold award for best individual color advertisement. The Levi's ad (also selected as the best fashion and clothing advertisement) was part of a series that also picked up a silver award for best campaign of black-and-white advertisements (see Figures 12.2–12.5).[2] The campaign had also just been awarded the Grand Prix at a competition called the Eurobest Awards (Garrett 1991, 6). The British ad agency that held the Levi Strauss account at the time was Bartle Bogle Hegarty (BBH), a small, independently owned company with a long-standing reputation for high-profile, "creative" advertising (see also Nixon 1997).

The *"Campaign" Press Awards* is a free supplement that appears once a year with the weekly edition of *Campaign.* This report carries reproductions of the award-winning ads and thereby ensures that the advertising community at large knows which ad creatives were responsible, the agencies where they work, the client companies that patronize "creative" advertising, and the photographers and/or illustrators commissioned to produce the chief visual element(s). As in most awards annuals, the panel of judges is also featured prominently in a group photo at the beginning of the report. Over the years, the *Campaign* judges have included copywriters, art directors, creative directors, chairmen, executives, and partners from various agencies. Occasionally, representatives from prominent advertisers are also invited to act as judges. (In 1992, for example, the panel included a marketing manager from BMW—a company known, at least in the United Kingdom, for being supportive of adventurous ideas. The BMW account is therefore a desirable account to work on.)

The Levi's campaign is of particular interest here. Specifically, each of the four ads features a huge photograph by Richard Avedon that is unquestionably intended to reproduce the look and feel of the subjects in his well-known touring exhibition and book *In the American West* (1985). That project consists of a series of portraits,

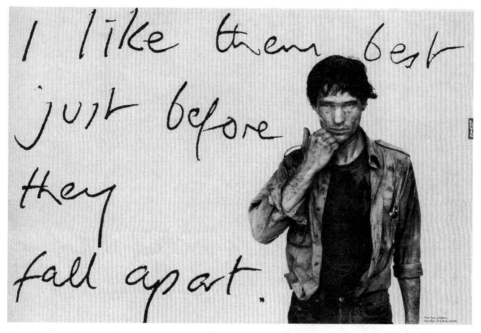

Figure 12.2. The first, and most successful, in a multiple-award-winning ad campaign for Levi's jeans from 1991. The photograph, shot by Richard Avedon specifically for this purpose, draws heavily on his previous work *In the American West*. The subject is identified as "Peter Ivan, plumber. Brooklyn, New York, 30/3/90."

taken over five years, of many individuals, who have been described as "the marginal and dispossessed citizens of the West" (Bolton 1989, 263) and the products of "a myth based on geographical desolation" (Kozloff 1994, 74). In fact, each subject was photographed against a stark white background, and is thereby dispossessed of any context or history whatsoever. All that remains is a caption containing the individual's name, a job description (if any), and the place and date of the subject's meeting with Avedon. Appearances are all we have left. As Kozloff (1994) observes, "All that would be required for 'polite' society to imagine these subjects as felons would be the presence of number plates within the frames" (72).

Although Avedon remains conspicuously ambivalent about the purposes of this project or how to categorize the work, Bolton (1989) notes that based on "press releases and news articles, many other people think of this work as a documentary record of the western United States" (264). Ultimately, Avedon "seems to exploit members of a lower class for the edification of his own" (264). According to Kozloff (1994), "The subjects are understood to be engaged with (or are caught in) nothing more than an unschooled or archaic attempt to comport themselves, which they more or less fumble, thus revealing their actual character" (68).

In the Levi's ad campaign, all four men are wearing jeans—although, as in *In the American West,* they are generally seen only from about mid-thigh or higher. Each

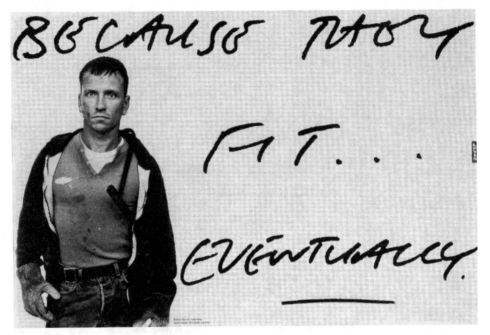

Figure 12.3. The Levi's campaign: "Robert Horton, fisherman. Staten Island, New York, 29/3/90."

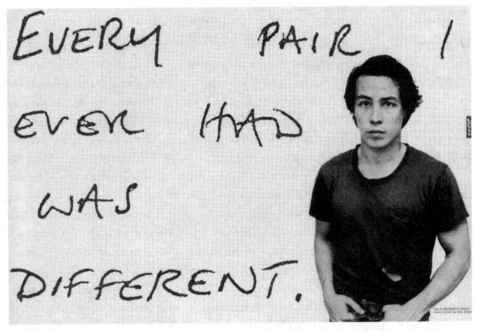

Figure 12.4. The Levi's campaign: "Ling Li, photographer's assistant. Gramercy Park, New York, 29/3/90."

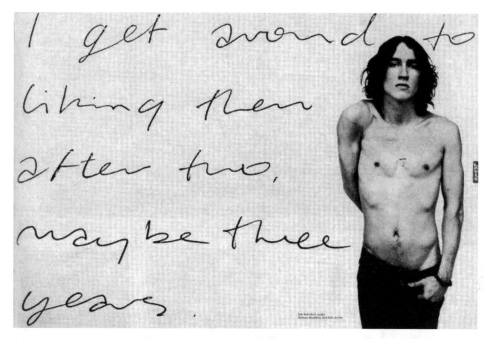

Figure 12.5. The Levi's campaign: "Erik Rodenbeck, welder. Midtown Manhattan, New York, 29/3/90."

image is juxtaposed with an oversized handwritten message that fills the white space around it—part autobiography, part fashion statement.[3] The gold-award-winning ad features an individual identified as "Peter Ivan, plumber. Brooklyn, New York, 30/3/90" (see Figure 12.2), a manual worker who scowls at the camera while rubbing his chin with the knuckles of one hand.[4] His face, hands, and clothes are smeared with oil and grease; a Yankees logo and the local number of a plumbers' union are barely visible through the grime on his partly obscured T-shirt. Another subject is "Robert Horton, fisherman. Staten Island, New York, 29/3/90" (see Figure 12.3). His disheveled clothes, stocky physique, and unflinching stare combine with protective gloves and a billhook, which hangs freely from one shoulder. In both ads, there is a palpable degree of anger and hostility in the subjects' gazes and stances (compare the "grumpiness" that Kozloff [1994, 68] detects in the westerners). This is forcibly articulated to the only other information available: the red Levi's tag/logo on the right-hand margin. These are "real" workers, then, frustrated with the burden of their labor, but happy in their jeans. (As we shall see, however, when the four ads in the campaign are viewed together, a cohesive reading such as this becomes untenable.)

In his withering critique of Avedon's book and exhibition, Bolton (1989) explores the ways in which Avedon "rewrites alienation into a form acceptable to the status quo, and how institutions [art galleries, sponsors, PR agents] have rewritten the work still further, turning the subjects of the work into entertainment and consumerist

frisson" (281). It is hard to disagree with Bolton. The apparent earnestness of Avedon's project, however veneerlike, is most damningly undermined when Bolton discusses the "Wild Cactus Ball" benefit, a fund-raiser for the Institute of Contemporary Art in Boston that was sponsored by Filene's, a local department store. With Avedon as guest of honor, the event provided Filene's with an opportunity to adopt the most clichéd of western stereotypes as the theme for the evening; hence the uncomfortable sight (275) of well-heeled Bostonians sporting pearls or bootlace ties, laughing and drinking in front of huge photographic reproductions of sullen-faced (read humorless), poorly dressed (read unfashionable) men, women, and children. As Bolton suggests, "Avedon's western subjects appear to have problems that fashion can solve: bad taste, unattractive faces, lack of grace" (268). Further, their mute expressions suggest that—at least in the images—they have little comprehension of their fate as a looming, permanent testament to the guilelessness of the Other.

It is unsurprising, therefore, to find that when Filene's adapted Avedon's work for its own advertising, the image chosen over all the others was that of a freckled teenage girl with long, clean hair and a pair of denim coveralls (see Figure 12.6; see also Bolton 1989) rather than, say, a young male drifter or two middle-aged male prisoners (both heavily tattooed, both portly, one of them an amputee). As the most innocuous image in Avedon's published collection of portraits, the teenage girl served as a conveniently chaste reference for a spread featuring two conventional fashion models wearing jeans and a dress available at Filene's.

It is also worth comparing the image of the girl from the American West with a recent Avedon image of model Kate Moss for Calvin Klein's fragrance cKbe (see Figure 12.7). The women have similar bodies, and both stare blankly at the camera. Both prints have white backgrounds and black edges. The black frame is an Avedon signature, created by simply not cropping the image once it has been developed. It seems to say, "Look, the image is real: I have included everything the camera saw; I have even left technical evidence of my working process that would normally be hidden from view." (Of course, such a visual gesture is also akin to a magician pulling up his cuffs and turning both his hands over to show his audience that he has nothing hidden "up his sleeve." It is a mere ritual, a performative gesture.)

Avedon is also a fashion and style photographer of considerable repute. His work has appeared in countless magazines, and he has written and directed ad campaigns and TV commercials. He has also recorded the faces of the literati and "glitterati" during long-term residencies at *Vogue* and the *New Yorker*. I do not want to suggest here that there is something *inherently* contradictory in an individual's having varied commitments as an artist and a professional; rather, I would argue that Avedon's "art" work is flawed because (as Bolton highlights) it is his training as a commercial photographer that informs and ultimately undermines these other activities. Indeed, as Kozloff (1994) has it, "for all their harshness, Avedon's portraits belong to the commercial order of seeing, not the artistic" (73–74). Bolton (1989) is more specific:

Figure 12.6. Perhaps the most innocuous of Avedon's images from *In the American West,* this photograph was reproduced in promotional materials by Filene's, a sponsor of Avedon's exhibition, and is seen here on the front cover of Avedon's book.

the "great consistency of Avedon's work is derived from his unwillingness to see human experience as manifested in anything but style" (266). To pursue this point, let us now look at the other two ads that deploy his "art" for the sake of Levi's.

The third ad in the series features a young Asian American (see Figure 12.4). On first inspection, "Ling Li" carries the same air of confrontation as the other two men; he is stockily built and his T-shirt appears to be secondhand and ill fitting, and it has a large hole in it. He also seems to be in the process of unbuttoning his Levi's. Is this

be hot. be cool. just be.

Figure 12.7. A recent Avedon image of model Kate Moss for Calvin Klein's fragrance cKbe.

the kind of sexually provocative gesture we might expect from one of Avedon's western subjects—a drifter perhaps, or a mental patient? The lewd equivalent of a middle finger raised in defiance and scorn? Perhaps not: Li, sporting an ear stud and described only as a "photographer's assistant," has in fact opened his jeans to reveal clean plaid boxer shorts. Suddenly, the gesture seems more like a coy come-on, a fashion model's affected ploy to show off the design of his underwear, rather than to mimic the unflinching act of a sexual aggressor. Further, his hands are resting, as if he cannot decide whether to take his jeans off or fasten them back up. (Perhaps he is waiting for instructions?)

The final ad in the Levi's campaign (see Figure 12.5) bears an uncanny resemblance not to anyone in *In the American West,* but to the mid-1990s ads and commercials for Calvin Klein's perfume/aftershave cKone. The fashion model—can he really be a

"welder," as the ad copy claims?—is washed and shirtless; he has shoulder-length hair parted in the center and a crucifix hanging from a chain around his neck. One hand is pushed far into his jeans pocket, pushing the pants down to partly expose the V of his groin area (he apparently has no underwear); he holds his other arm behind his back. However briefly "Ling Li" manages to sustain a vague hint of menace, in "Erik Rodenbeck" menace is entirely absent. Indeed, it might even be said that his is the kind of hippyish, androgynous pose that might just incur the hostility of an Ivan the plumber.

In this light, Bolton's (1989) claim—written in 1987, three years before the Levi's campaign and seven years before the cKone ads first appeared—is all the more prescient: "In a very real way, Avedon's project in the American West was a trial run for a new advertising approach" (270). The Levi's campaign is chiefly remarkable for illustrating, in radically condensed form, the betrayal of Avedon's pretension: his Art carries all the artifice of fashion photography. Remarkably, however, Avedon has claimed that, in Bolton's words,

> advertising would be more effective if it reflected the real conditions of workers' lives rather than romanticizing their experiences. He thought that his work in the American West would make him a more effective advertising photographer in this regard. "I'd like to merge my portraits of Americans with my knowledge of television advertising to bring a reminder of humanity to computers, oil companies, Detroit. It could be explosive." (269–70)

Commenting on Avedon's typically contradictory pronouncements regarding *In the American West*, Kozloff (1994) observes: "Such stridently mixed signals and elemental confusion about self-process have something to say to us about the derisive qualities of the work itself. . . . It is one thing to portray high-status and resourceful celebrities as picture fodder; it is quite another to mete out the same punishment to waitresses, ex-prizefighters, and day laborers" (72).

Inside an Advertising Awards Show

The *"Campaign" Press Awards* 1991 begins with an introductory note from the chairman of the judges. The twelve members of the judging panel are introduced on the next page with a group photo and individual notes on their current job positions and career highlights. Although the judges are described as "an eclectic mix of creative and non-creative names," they are in fact all white, and the group includes only three women. The last feature before the gallery of winning entries, runners-up, and commendations (which runs to more than seventy pages) is about the gold-award winners themselves. This article, titled "How the Best Was Won," includes excerpts from interviews with the "outright winners," telling "how they struck gold." Here, unsubtle allusions to the Wild West and gold rushes are reminiscent of the stereotyped references that accompanied Avedon's gallery party in Boston. The article is all

the more remarkable because the Levi's ads actually feature East Coast urbanites—"real people doing real jobs" (Garrett 1991, 6). The author notes that both of the winning ads (for Levi's and VW) "depend on a strong photographic idea for their impact," the Levi's ads in particular being "gritty, realistic and direct" (Garrett 1991, 6). Elsewhere, he calls the Avedon portraits "direct and unposed" (6); he quotes one of the judges, who points out that "it's fashion advertising, but it reinforces 'Levi-ness.' The real people and gutsy look seems to fit in with the way the target group feels about Levi's" (7).

And what of the target group? The ads appeared in style magazines such as *The Face* and *i-D* in an attempt to reach "the opinion-setting fashion cognoscenti." Because of this, the campaign apparently "had to be more subtle than the highly populist television advertising" (Garrett 1991, 6).[5] Will Awdry, the copywriter responsible, notes that "this is a group of people that increasingly displays total cynicism towards advertising" (quoted in Garrett 1991, 6). The struggle to create authenticity is epitomized in the caption accompanying the gold-award-winning advertisement featuring "Peter Ivan": "The Levi's ad, with its gritty black and white images, follows the current fashion for *verité* in advertising." The unintended irony of this claim ("the current fashion for *verité*") underscores the degree to which these intermediaries are invested in their capacity, should they so desire, to create "authenticity" when "fashion" so demands. This conceit is further elaborated when, in connection with the autobiographical headlines, the article states that the subjects were asked if they had a pair of Levi's in their wardrobe, and what they thought about them. There was an element of artifice: the responses, often illegible, were repenned word for word under [Martin] Galton's art direction" (Garrett, 1991, 7). So, apart from the fact that the headlines were handwritten by someone else, the admen ask their audience (of other intermediaries) to believe that the ads are entirely "authentic"—to a degree far in excess of anything Avedon would offer up with respect to the images in his original exhibition. Ironic indeed, then, that the third magazine carrying the ads is called the *Manipulator.*

What, then, is the function of the images in the Levi's ads? At their most obvious, they provide the British audience with yet another fabricated presentation of "real" American culture—a peculiar conflation of western and eastern stereotypes—accessible through clothing: jeans can be understood here as the great leveler, attire that ignores class boundaries and unites everyone in their common pursuit of the Dream. Here are "real" people wearing a brand of pants whose singular marketing proposition is "The Original Jeans" (Garrett 1991, 6). The images also invite fascination: the voyeuristic thrill of inspecting the faces, poses, and clothes of individuals who are clearly below "us" in class terms—but all the more "real" for it. So who are they, really? We are reminded that "having agreed to the project, [Avedon] put his 'people finder' onto the case in New York. The brief was to find 'real people doing real jobs.' Avedon whittled 30 faces down to 11, from which the BBH team chose the final four" (Garrett 1991, 6). Where does one go to find such people?

Ned Ambler is a "people finder" who has "created a thriving business by combing the bars, the bowling alleys and the streets of the city looking for the quirky, the tattooed and the pierced to feed the fashion industry's current appetite for raw realism" (Helmore 1996). His "discoveries" have appeared in *Vogue, Details,* and *The Face* and in ads for Calvin Klein and the Gap, and his clients include Richard Avedon. In summing up contemporary fashion, Ambler says that "this whole thing is called 'New Realism.' It's no longer that fake Eighties sugar-coated thing. People want someone they can relate to, not someone they wish with plastic surgery they could look like" (quoted in Helmore 1996). But, as the writer of this article helpfully adds, Ambler "also knows where to draw the line between simply weird and someone who could have mass-market appeal" (Helmore 1996).

It seems reasonable to surmise that this is indeed the role of Avedon's "people finder" (assuming that this person is not actually Ambler himself). As with product advertising, so with fashion: having mastered the creation of a "fake" aesthetic, these particular intermediaries effortlessly move on to "authentic"—without a hint of self-consciousness. The realism that Ambler seeks out for his clients is to be found in lives unsullied by the business: "I look for the models who look like they have a soul and a story, who look more cinematic. They have attitude and a life outside modelling" (quoted in Helmore 1996). This also provides for moments of private amusement. Of one "discovery," "a taxi driver who looks a little like actor Willem Dafoe," Ambler says: "I bought *[sic]* him to these really chic parties and everybody loved him. I love bringing people who are totally not into the fashion scene into it to watch what they do" (quoted in Helmore 1996).

It might be said that the men in the Levi's ads are more "like us" than "weird," to use Helmore's distinction. This also neatly describes the difference between Avedon's subjects in the American West and his Levi's "people": in selecting four individuals from the thirty who had been found for Avedon, he and Awdry and Galton spare us the excesses of the West *and* the East. Here we have four men who are lean (surely a prerequisite for jeans models) and employed; "real" but not "weird"; dangerous, perhaps, but not psychotic.

The article in *"Campaign" Press Awards* 1991 is accompanied by a series of portraits of the award winners. This allows us to raise a pertinent question: What strategies of representation are used by the intermediaries responsible for the Levi's ads when representing themselves? Even though Galton and Awdry did not take these portraits, it is likely that, as advertising intermediaries, they had far more in common with their photographer (in terms of class and occupation) than they had with Avedon's subjects.

The ad creatives are also decontextualized, to the extent that they have been photographed using dramatic lighting in very dark surroundings. The two men are well-groomed, each wearing a plain, open-collared shirt. Whereas the white backgrounds in Avedon's portraits allowed the photographer to "render the subject mute" (Bolton 1989, 264), the styling of these photographs has the opposite effect: the background

and lighting clearly add to, rather than subtract from, the presentation of the subjects. Indeed, they evoke an aura of mystery and urbane sophistication: they flatter their subjects by reminding us that we are in the presence of "real" creative talent (with all its attendant connotations of depth, mystery, and vision).

Workers of the World Be Still: Documentary Photography and Advertising

Sebastião Salgado is a native of Brazil who abandoned a career as an economist in order to pursue an emergent interest in photography. He was a member of the prestigious Magnum agency and, despite a controversial departure, is still a close friend of Magnum stalwart Henri Cartier-Bresson. Like Avedon, Salgado clearly has a remarkable sense of composition, an enviable technique, and, as a consequence, a finely attuned sense of what makes a great picture. Indeed, like all great images, his compositions can be profoundly affecting.

In his discussion of Salgado's work, Miles Orvell (1995) notes that "documentary photography has traditionally taken as its function the depiction and analysis of social distress, so that there is usually no shortage of subjects" (97). Martha Rosler (1989) crystallizes the class dynamic at play here when she notes that "documentary...carries (old) information about a group of powerless people to another group addressed as socially powerful" (306).[6] Further, she argues that in a postliberal world, "mainstream" documentary photography "has achieved legitimacy and has a decidedly ritualistic character. It begins in glossy magazines and books, occasionally in newspapers, and becomes more expansive as it moves into art galleries and museums" (306).

This is precisely the trajectory that Orvell (1995) discusses in relation to *Workers: An Archeology of the Industrial Age* (Salgado 1993), a "global report on the changing nature of work and a visionary statement about the future of human life," which he also describes as Salgado's "true magnum opus" (98). Indeed, as Rosler had anticipated, Salgado's work has appeared in the British *Sunday Times Magazine* and regularly in the *New York Times Magazine* (Orvell 1995, 98; see, for example, Salgado 1997).[7] Further, as Orvell notes, *Workers* was published as a huge book in addition to its life as an international traveling show ("as widely seen as any photographic exhibition in history"; 101) that ran simultaneously on three continents. Of course, this is not a pattern of display and publication that is peculiar to Salgado, or to documentary photography per se. Many have followed the same route—including Avedon in his project *In the American West.* The critical euphoria surrounding Salgado's achievement, however, was especially pronounced, with many writers and audiences insisting—sometimes to his face—that Salgado produces true art (see, in particular, Orvell 1995, 97–100).

Orvell (1995) acknowledges that "not since Walker Evans has the conjunction of a documentary and an artistic vocation been so aligned, and so proclaimed" (97). However, Orvell himself is not quite so beguiled: "*Workers* is . . . the ambiguous prod-

uct of a competition between an ideology of progress and an ideology of romanticism. Entering the marketplace as a critique of global consumerism, *Workers* can be read, against its own intentions, as itself a product of a visual global consumerism" (98). Echoing Gross, Katz, and Ruby (1988), Orvell suggests that there is a danger "that the political power of the image might be dissipated by our aesthetic response" (100). As Rosler (1989) expresses it, "One can handle imagery by leaving it behind. (*It is them, not us.*)" (306). I would argue that this is exactly the context of Avedon's book and exhibition. Whereas Salgado's project is *at risk* of being depoliticized in the showing, Avedon's *In the American West* is, in its very conception, a triumph of aesthetics (mere style) over content.

Given the problematic nature of Salgado's *Workers,* what are we to make of his advertising images? If it is true that we are most likely to respond to images in general—and ads especially—in aesthetic terms, what of an ad campaign that draws its "look" directly from *Workers*? Of course, we can *only* respond aesthetically; *not* to do so would be to recognize Salgado's intended political gesture (however inchoate)—which is entirely inconsistent with the work an ad must do. Hence we must conclude that his imagery is used in ads because it *looks good.*

From Workers to the Culinary Bourgeoisie

The Le Creuset campaign (see Figures 12.8–12.10) is a modest affair in terms of media exposure, the merest flicker on the radar screens of the British media. Like the photographs in *Workers,* those in these ads find their most direct precedent in some of Lewis Hine's images of industrial labor (Orvell 1995, 101). Hine's work had an urgency to it: he wanted to bring terrible working and living conditions to the attention of people who might then be persuaded to help improve those conditions. Salgado, however, was driven by a kind of curatorial impulse—"Salgado . . . presents himself as a kind of preserver of a vanishing past" (Orvell 1995, 103)—spending six years making and assembling the images from various ongoing projects. So, as well as being "an homage to workers, a farewell to a world of manual labor that is slowly disappearing," *Workers* is also "a tribute to those men and women who still work as they have for centuries" (Orvell 1995, 106). These can be no more than speculative readings after the fact, because nothing in the images conclusively indicates disappearance *or* permanence. Of course the latter, rather than the former, is the subtext of the Le Creuset ads; the company is surely not about to advertise the demise of its manufactory, not least because it appears to be so intrinsic to the brand's romanticized connotations of "old-fashioned" craftsmanship and "handcrafted" cookware. As the text in one of the ads reads, "Discover how we've made pots for 400 years."

In each of the three ads, the image is framed by a sea of orange ink (Le Creuset's signature color), which becomes gradually lighter from the left side to the right side of the ad (on the cookware itself the color gets lighter from bottom to top). The ad from 1992 (see Figure 12.8) won a silver in the *Campaign* Press Awards category of

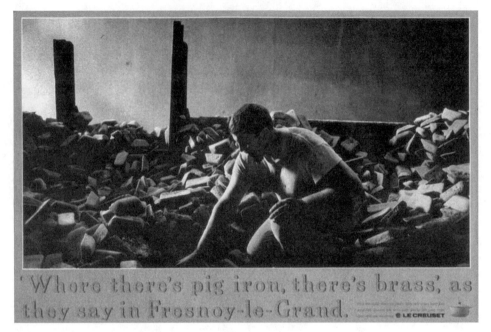

Figure 12.8. Le Creuset advertisement featuring a photograph specially commissioned by Saatchi & Saatchi. Apparently, Sebastião Salgado took these pictures during a five-day location shoot at the Le Creuset factory in France.

best household and garden products advertisement. It is a double-page spread (or DPS) and, from the scant evidence available, seems to have appeared in the catalog for a housewares exhibition. It features a monochromatic image of a gloomy, dirty room; in the foreground a man crouches down, his face mostly hidden by shadows. He reaches out for something on the floor, which is littered with ingots of pig iron. The headline reads, "'Where there's pig iron there's brass,' as they say in Fresnoy-le-Grand." The text reads, in full, "EVER WONDERED where the phrase 'filthy rich' comes from? Visit stand G44. Discover how we've made pots for 400 years. Order some. And stop wondering. LE CREUSET."

Apart from the dubious reference to an inclusive "we" (for the man in the photograph is surely not waiting to meet and greet at stand G44), the ad makes a joke at the expense of the image and its subject. The original aphorism is "Where there's muck there's brass." *Brass* is slang for *money* in Yorkshire, so, for a British audience, the play is on the juxtaposition of a singularly unpretentious working-class sensibility (mirrored in the figure of the worker in Salgado's photograph) with a very "foreign," or exotic-sounding, place-name. The ad is a play on the costliness of the cookware: in the filth of the factory can be found a source of immense wealth (as *filthy* means *exceedingly* in the context of money).

The second ad, from 1991, also won a silver for best house and garden advertisement in the *Campaign* Press Awards for that year (see Figure 12.9). In Salgado's pho-

Figure 12.9. The Le Creuset campaign.

tograph, four huge torches point downward into buckets on the factory floor; flames and/or smoke burst upward from three of them. Against a brick wall hung with various rudimentary tools, a man wearing heavy work clothes, boots, and a cap reaches out for another bucket that is also hanging from the wall. Sparks shoot forth from one pail, leaving trails of light (suggesting a fairly long photographic exposure—hence the slight blurring of the man's head and outstretched arm).

This ad appeared as a DPS in a publication called *The List*. Its headline reads "Our speciality. Pot au Feu." The text continues: "FOR FRENCH cooking at its best, why not try our little place at Fresnoy-le-Grand? Dress optional. Protective clothing recommended. LE CREUSET." A factory/restaurant analogy operates through a conflation of the term for a traditional French cooking pot (and/or the soup it yields) and the buckets of molten metal in the scene. Similarly, the dress code for the restaurant ("our little place") references the clothing worn by the worker.

The third ad, from 1989, has a slightly different composition: the image—a close-up of a man using special tools to handle stacks of cooking pots—takes up the entire left-hand side; the headline on the opposite side reads "CASSEROLE PROVEN-CALE: 8 lbs Pig Iron, 2 lbs Sand, 2 lbs Coke, 1 lb Enamel" (see Figure 12.10). The metaphorical recipe continues in smaller print: "Cook in factory for 30 mins at 800° C (or Gas Mark 24). Glaze, then enamel. Re-heat. Leave for three days. Serve."

Together, these ads can be understood as helping to create an unquestioning bourgeois window for "25 to 35 year-old housewives and serious male cooks" (Saunders

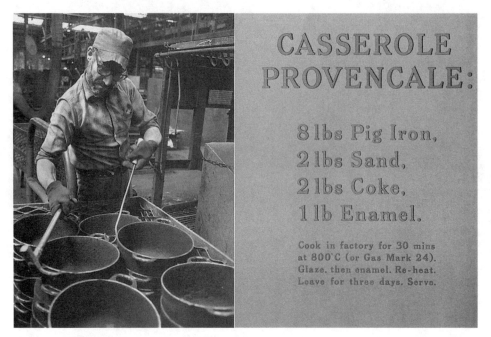

Figure 12.10. The Le Creuset campaign.

1999) onto a perpetual world of hard labor. We observe; the subjects seem oblivious. As this is apparently a "timeless" process—one that will presumably go on into the future for as long as it has already existed—there seems to be very little reason to question its premises. Any residual political gravity we might discern in the images is neutralized by the punning headlines and text.

Subjective Presence in Advertising Images

We cannot be sure whether Avedon's Levi's subjects were fully aware participants in the production of these ads. We do know that Avedon worked at a furious pace, spending a maximum of fifteen minutes with each subject (Rawsthorn 1990). The agency's art director, Martin Galton, told the writer of the article in *"Campaign" Press Awards* 1991 that Avedon "interviews people as he photographs them. He finds out the thing that really upsets them, and the moment they drop their mask, he takes the picture" (quoted in Garrett 1991, 7). The article goes on: "In the execution favoured by the jury, a Hungarian plumber from Brooklyn with the face of a prize-fighter growls: 'I like them best just before they fall apart.' Galton says: 'He was angry about everything'" (7). About what, exactly? His job? His jeans? Avedon? Perhaps about the fact that he was going to see very little of the quarter of a million pounds the campaign reportedly cost (Rawsthorn 1990)? Helmore (1996) notes in passing that only a very few of Ned Ambler's discoveries go on to earn sizable incomes through modeling; in fact, most earn just fifteen hundred dollars.

Orvell (1995) says of Salgado, "Observers of his work remark on the familiarity and mutual respect [he] engenders in his subjects" (109). Unlike Avedon, who seems to do something akin to mugging his subjects, Salgado apparently "spend[s] from three weeks to four months with each of his stories" (109). Further, he claims, ultimately, to

> create a relationship that doesn't disturb the people that you are photographing. And this relationship sometimes is so strong that it's not anymore that you are taking the pictures, it's the people in front of you that are giving the picture to you, like a gift, you know. It's the truth, it's the whole relationship. (Quoted in Orvell 1995, 109)

Of course, as Orvell points out, there are significant limits in making such a claim: "If the workers have given their pictures to Salgado, they have not given him their voices. . . . we have no idea of the subjectivities of those represented" (109–11). We also know that Salgado spent a *total* of just five days with his Le Creuset subjects (Saunders 1999, 112).

In his discussion of the section of *Workers* actually devoted to the steel industry in France, Orvell (1995) notes Salgado's affinity for this industry in particular, born from childhood memories in Brazil. Orvell quotes Salgado: "To this day, steel making is for me an almost religious exercise. And the high priest of this institution called production is the steelworker" (109). This is clearly a gravely mistaken—if poetic—reading of the relative power of manual workers, and a view he could surely not have maintained if he did indeed spend days or even weeks with them (let us not forget that Salgado also has a Ph.D. in economics).

I located the "Casserole Provencale" ad in a glossy historical retrospective titled *C20th Advertising* (Saunders 1999); the accompanying text, although brief, includes the following explanation of the genesis of the pictures in the Le Creuset ads:

> During the five days he spent at the factory in north-eastern France, Salgado established a rapport with the men, who were normally suspicious of outsiders. He shot some 3,000 frames of the grimy-faced Algerian and Italian immigrant workers in natural light, using three Leicas. The results were grainy, true-to-life and unpretentious. (Saunders 1999, 112)

The art director on the job, Antony Easton of Saatchi & Saatchi, added: "We asked Salgado because he has so much humanity in his pictures, as well as the machinery of industry—whether in a steel plant in Belgium or a Brazilian gold mine" (quoted in Saunders 1999, 112).

If the images were simply leftovers, photos rejected from the *Workers* collection, this might thereby have allowed Salgado to excuse himself from the need to reconcile his love of the industry with his function as an advertising photographer. All the more significant, then, that for Orvell (1995), "it's an open question whether Salgado's pervasive concern with the exploitation of the worker under post-industrial global

capitalism buys him immunity from a similar 'appropriation' of their lives" (112). What could Orvell possibly have said in Salgado's defense had he seen this ad campaign? For one thing, he recognizes our own complicity, our own appetite for images *regardless* of the context: "We of the first world who enjoy the fruits of Salgado's mighty labors are as much consumers of these visual goods [i.e., photographs] as we are of the raw materials and manufactured products [e.g., pots and pans] that are otherwise created in the countries Salgado has traveled to" (111–12). It remains my contention that it is Salgado, as an image producer, who must reconcile his bifurcated professional activities more so than we, the putative consumers of his images and of the pots and pans he has helped to promote.

We are asked to believe that the figures appearing in the Levi's and Le Creuset campaigns are not models, in the conventional sense. After all, the images quote liberally from highly publicized "documentary" work that has appeared in books and museum galleries worldwide. In the end, however, it is only by investigating the production process responsible for assembling the ads that we can be sure either way. What is clear is that *authenticity* is a relative term, and when used in the context of the subjects of "documentary" advertisements, it seems to be a far less reliable index of "truth" than we might ordinarily expect.[8] Indeed, one need not look far to discover that "authenticity" and "fakery" are, in advertising, equally fabricated strategies that, as we have seen, are apparently indistinguishable to advertising's practitioners.

I have argued elsewhere that ad creatives in particular are concerned with the invention and production of ads as markers of their own ingenuity—not for an audience of consumers, but for their peers (Soar 2000). Recognition comes in the form of creative awards (and there are many to be had), which help to ensure career advancement within the industry. A given ad must be effective, therefore, with an audience of peers, not with consumers; it must make an impression on a jury of professional ad people, not on a given month's sales figures. Indeed, the authorship of the ad creatives is unquestioned: theirs are the names that accompany the reproductions of their ad campaigns in any given awards annual. Given this evidence, it seems entirely feasible that when photographers of the caliber of Salgado or Avedon are hired by ad agencies, those who stand to gain the most in terms of professional and social kudos are the art directors and copywriters who thought up the ads in the first place.

Conclusions: Authorship, Authority, Accountability

Is advertising photography to be understood as photojournalism's "dirty little secret"? Should we turn a principled blind eye because it is "not just a way of subsidising less commercially viable documentary projects but a means of actual survival" (Rodriguez 1998, 14)? When I tried to reach Salgado at his Paris agency, Amazonas Images, to ask him some questions about his advertising work, his assistant replied via e-mail on his behalf. In part the message read: "He has done it in some rare occasions because it allowed him to support financially at the time journalistic photo essays, but it is so seldom that he does not believe he is a good example, his experience in

this line of work being far too limited" (Piffard 1999). It is clear, if only from this terse response, that Salgado himself minimizes his association with, and capacity to produce, advertising photography. Compare this with the comments of Paul Arden, creative director at Saatchi & Saatchi at the time the Le Creuset campaign was produced: "Most photographers go for the heart of a story and don't worry so much about the shape of the pictures. But Salgado instinctively produces pictures with form, as well as a story" (quoted in Saunders 1999, 112).

In thinking through the images discussed here, it occurred to me more than once that it was simply outré—a matter of bad taste—for me to insist on forging a link between the "legitimate" travails of documentary photographers and their discrete efforts in the realm of advertising. That it is a matter of taste suggests, above all, the degree to which middle-class audiences (myself included) for documentary photography and art photography (in Sunday magazines, galleries, museums, and expensive coffee-table books) have an investment in maintaining a privileged—*separate*—cultural position for the practitioners of such photography and their images. Ad creatives who use similar images then trade on this legitimacy, perhaps rewarding the onlooker for his or her own cultural capital. They also showcase the images they have procured: in the ads for Le Creuset, for example, the art director has provided a sacred space for the images by refraining from placing typographic elements over the photographs, and by pushing the flippant text and its accoutrements to the edges of the page (so, too, the identifying logo in the Levi's ads). Of course, the company logo and the image (the "pack shot") of the cookware are nonnegotiable elements in the composition, for they anchor the marketing function of the ad and, in doing so, confirm that this is indeed a piece of commercial communication. The analogy here is the museum or art gallery, which provides an unadulterated space for the images of a Salgado or an Avedon, but then must inevitably "frame" them with the confetti of patrons' and corporate sponsors' logos (e.g., Filene's for Avedon, Kodak for Salgado).

For their part, the creatives responsible for the Levi's campaign attempted to establish their own authorship by declaring not that they had seen Avedon's book and wanted to emulate it, but that he "seemed to be the natural candidate" (Garrett 1991, 6). Of course, looking at the striking resemblance between *In the American West* and the Levi's ads, it is hard to think who else they could possibly have had in mind. Further, it would simply have been too gauche and tacky to hire someone simply to mimic Avedon's style; how then could the brand claim to be "original"?

Perhaps the most important distinction that can consistently be made between these avenues of work is that advertising is largely anonymous: rarely, if ever, are the photographers responsible for the images used identified by name within ads or commercials. The credibility of a Lewis Hine or a Salgado, for instance, would surely be harmed if his ad work were as widely known as his concerned photography. And this is the crux of the matter: the recruitment of "name" photographers by ad agencies serves to legitimate the practices and internal cultures of advertising *to ad makers themselves*. The arrangement is thus a marriage of convenience that benefits all parties

involved in ad production at everyone else's expense: the "serious" photographer with a similarly "serious" reputation gets very well paid for his or her services, without being publicly associated with the ads to which he or she contributes, and the ad makers themselves have the opportunity to work with some of the best photographic talent available. Because the images in the ads then emulate the look of the "serious" work of an Avedon or a Salgado, the implicit cultural association is freely available to anyone who also sees the ads. Cultural capital is thereby distributed to, and accumulated by, the agency, the ad workers, the advertising client, and the brand being so advertised. The perennial losers in this transaction can consistently be identified as the subjects within the ads themselves, whose likenesses are paraded first before a hidden audience of unaccountable intermediaries and then in front of a doubly alienated audience of consumers.

Notes

1. The cover of the report for the American Can Co. features a black-and-white close-up of a manual worker's oily hands. Below them, the company's name is immediately followed by what appears to be an afterthought: the red, tilted words "and its people." The 1975 cover for Heinz features a color picture of a laborer standing in a field; behind her, other workers bend or kneel in the soil (see Potlatch Corporation 1999).

2. This, it must be said, is slightly puzzling, given that the ads include the famous Levi's tag logo, printed in *red* ink; further, the photographic reproduction appears to be in full four-color process (i.e., cyan/magenta/yellow/black).

3. Specifically, the messages read: "I like them best just before they fall apart," "Because they fit . . . *eventually*," "Every pair I ever had was different," and "I get around to liking them after two, maybe three years."

4. The dates on all four ads are in the British format—that is, day/month/year.

5. Hebdige (1988, 167–68) describes and discusses one of the British Levi's TV ads, "Russia." The lead actor in the ad also worked as an advertising copywriter in London. Indeed, as an illustration of how close-knit the culture of the intermediaries really is, when I was an art director, he and I worked together as a creative team for a couple of years.

6. By contrast, Rosler (1989) rejects the term *concerned photography* as a "nonsensical designation" that "signif[ies] the weakest possible idea of (substitute for) social engagement, namely, *compassion*" (334 n).

7. Salgado won a silver award from the Designers and Art Directors Association of London (D&AD) in 1988 for "most outstanding editorial photography" for his images of miners in the gold mines of Serra Pelada, Brazil. See Booth-Clibborn (1988, 338). It is worth noting not only that this award was sponsored by Kodak, but that *Workers*—which featured images from the Serra Pelada—was also "handsomely underwrit[ten]" by Kodak (Orvell 1995, 180 n).

8. See Goldman and Papson (1996, esp. chap. 5) for a discussion about advertising and authenticity (including campaigns for Levi's jeans in the United States).

References

Avedon, R. 1985. *In the American West*. New York: Harry Abrams.

Bolton, R. 1989. "In the American East: Richard Avedon Incorporated." In *The contest of meaning: Critical histories of photography*, edited by R. Bolton. Cambridge: MIT Press.

Booth-Clibborn, E., ed. 1988. 1988 *British design and art direction.* London: Internos.

Bourdieu, P. 1984. *Distinction: A social critique of the judgement of taste,* translated by R. Nice. London: Routledge & Kegan Paul.

Featherstone, M. 1991. *Consumer culture and postmodernism.* London: Sage.

Garrett, A. 1991. How the best was won. In *"Campaign" Press Awards* 1991*: The "Campaign" report* (suppl.), *Campaign,* March 22, 6–8.

Goldman, R., and S. Papson. 1996. *Sign wars: The cluttered landscape of advertising.* New York: Guilford.

Gross, L., J. S. Katz, and J. Ruby. 1988. Introduction: A moral pause. In *Image ethics: The moral rights of subjects in photographs, film, and television,* edited by L. Gross, J. S. Katz, and J. Ruby. New York: Oxford University Press.

Hall, S. 1980. Encoding/decoding. Pp. 128–38 in *Culture, media, language: Working papers in cultural studies,* 1972–79, edited by S. Hall, D. Hobson, A. Lowe, and P. Willis. London: Hutchinson.

Hebdige, D. 1988. *Hiding in the light.* New York: Routledge.

Helmore, E. 1996. Well spotted: Their faces can shift T-shirts and perfume like nothing else. *Independent* (London), December 6, 4.

Jacobson, C. 2000. Magnum farce. March 13. On-line at http://zonezero.com/magazine/articles/jacobson/magnum1.html.

Kozloff, M. 1994. *Lone visions, crowded frames: Essays on photography.* Albuquerque: University of New Mexico Press.

Lutz, C., and J. Collins. 1993. *Reading National Geographic.* Chicago: University of Chicago Press.

Miller, R. 1998. *Magnum: Fifty years at the front line of history.* New York: Grove.

Nixon, S. 1997. Circulating culture. In *Production of culture/cultures of production,* edited by P. du Gay. London: Sage/Open University Press.

Orvell, M. 1995. *After the machine: Visual art and the erasing of cultural boundaries.* Jackson: University Press of Mississippi.

Piffard, F. 1999. Personal communication, December 21.

Potlatch Corporation. 1999. *American design century,* vol. 3 (paper sampler). Cloquet, Minn.: Potlatch Corporation.

Rawsthorn, A. 1990. [Untitled article]. *Financial Times* (London), May 17, 20.

Rodriguez, J. 1998. Commercial break. *British Journal of Photography,* April 15.

Rosler, M. 1989. In, around, and afterthoughts (on documentary photography). In *The contest of meaning: Critical histories of photography,* edited by R. Bolton. Cambridge: MIT Press.

Salgado, S. 1993. *Workers: An archeology of the industrial age.* New York: Aperture.

———. 1997. Brazil's dispossessed. *New York Times Magazine,* April 20.

Saunders, D. 1996. *Best ads: Shock in advertising.* London: B. T. Batsford.

———. 1999. *C20th advertising.* London: Carlton.

Soar, M. 2000. Encoding advertisements: Ideology and meaning in advertising production. *Mass Communication and Society* 3, no. 5.

Squiers, C. 1989. The corporate year in pictures. In *The contest of meaning: critical histories of photography,* edited by R. Bolton. Cambridge: MIT Press.

Indigenous Media:
Negotiating Control over Images

Faye Ginsburg

Too often, in theoretical discussion of media images and their circulation, we forget what the stakes are for those who are out of power and are struggling to become producers of media representations of their lives. This chapter is an effort to explore this fundamental dimension of image ethics, an issue that is particularly salient for minoritized people who mostly have been the object of other people's image-making practices in ways that have been damaging to their lives. I base my discussion on my long-term research and advocacy for the development of new media practices—video, film, photography, Internet—among indigenous peoples in the United States, Australia, and Canada who over the past decade have moved from video experiments in remote communities to successful feature films (Ginsburg 1999).

I start with a story as a way of dramatizing the gravity of some of the concerns that surround the development of indigenous media and its relationship to representational practices in the dominant media. This story belongs to the Tuscarora artist, photographer, and professor of Native American art Jolene Rickard (1997); in it, she

clarifies how crucial it is to understand the political situations and historical processes within which indigenous cultural work is produced. She describes how she experiences the power of the state over the Iroquois nation's self-governance in an immediate, phenomenological sense, as she loses power for the computer she is writing on when her electricity is cut off by New York State authorities following the beating and arrest by the police of two Seneca women who had been peacefully protesting a decision to tax their territory.

> May 8, 1997. The phone rang only twice before I welcomed the distraction from writing a position paper for the Otsego Institute for Native American Art History. A Seneca colleague reported that two Seneca women had just been beaten by the New York State police at the border of the Cattaragugus Reservation. A special New York State swat "team" was sent in to subdue (club) and arrest Iroquois resisters (women and children) again on May 11 at the border of the Onondaga Nation. Within minutes of the Seneca incursion my phone was dead and the electricity powering my computer was off. These conditions are common if you live within the territories of the Tuscarora nation in western New York state in the late 20th century.
>
> The beatings were not reported in the local newspaper and the "incident" was played down on the Buffalo and Syracuse evening TV news. . . .
>
> What is significant in this modest telling of a moment in contemporary Iroquoia within the global discourse of visual culture? . . .
>
> Artists living with these experiences are deeply affected by these events. . . .
>
> Therefore I am suggesting that the cultural arena is a viable site to enact and witness art that probes indigenous experience in the ongoing struggle to have a presence in the global cultural space. The complication with the arts discourse as it relates to Native issues is that there is a long standing relationship of framing the "space" accorded to this work based on the reflection or needs of the dominant west. (1, 2)

The moment that Rickard describes crystallizes for her (and her audience) the distinctive circumstances—and ongoing experience of political and epistemological struggle—that both motivate and surround her own work as well as that of other indigenous media makers who have turned to a variety of expressive forms as a means of worldly intervention (Abu-Lughod 1997, 128; Ang 1996, 45–46, 79) that can simultaneously strengthen their own communities and assist in, and insist on, the broader presence of indigenous perspectives in a variety of arenas.[1]

Jolene Rickard is exemplary of people I have come across many times in the process of doing research on indigenous media.[2] In an effort to underscore what their work is about, I use the term *cultural activist* to describe the self-conscious way in which they are—like many other people—using the production of media and other expressive forms not only as a way to sustain and build their communities, but as a means to help transform those communities through what one might call a "strategic conservatism." This position is crucial to their work but is effaced from

much contemporary cultural theory, which emphasizes dislocation and globalization (as Rickard argues). The cultural activists creating these new kinds of cultural forms have turned to them as a means of revivifying local languages, traditions, and histories and articulating community concerns. They also see media as a means through which they can further social and political transformation by inserting their own narratives into national "mediascapes" (Appadurai 1990, 7) as part of ongoing struggles for Aboriginal recognition and self-determination.[3] Increasingly, the circulation of these media globally—through conferences, festivals, coproductions, use of the Internet, and the like—has become an important basis for a nascent but growing transnational network of indigenous media makers and activists. These activists are attempting to reverse processes through which aspects of their societies have been objectified, commodified, and appropriated by the dominant society; their media productions and writings are efforts to recuperate their histories, land rights, and knowledge bases as their own cultural property. These kinds of cultural productions are consistent with the ways in which the meaning and praxis of culture in late modernity have become increasingly self-conscious of their own project; these productions represent an effort on the part of cultural activists to use imagery of their lives to create what one might call an activist imaginary, a kind of shield against the often unethical use or absolute erasure of their presence in the ever-increasing circulation of images of other cultures in general and indigenous lives in particular.

At every level, indigenous media practices have helped to create and contest social, visual, narrative, and political spaces, for local communities and in the creation of national and other kinds of dominant cultural imaginaries that, until recently, have excluded vital representations by First Nations peoples within their borders. For example, through televisual media production, Aboriginal media makers working in the Australian Broadcasting Corporation's Indigenous Program Unit have been able to assert the visible evidence of Aboriginal histories and lives in a national public culture where Aboriginal activism and political claims had been effaced, until quite recently, from the official histories (Ginsburg 1993b). The capacity of such representations to circulate to other communities—from indigenous neighbors to nongovernmental organizations—is an extension of this process and is rapidly moving into other forms of mediation, such as cyberspace (Danaja and Garde 1997).

Such examples make it clear that indigenous media have raised important questions about the politics and circulation of knowledge at a number of levels. Within communities, this may be about who has had access to and understanding of media technologies and who has the rights to know, tell, and circulate certain stories and images (Michaels 1985, 1986; Turner 1990). Within nation-states, media are linked to larger battles over racism, sovereignty, and land rights, as well as struggles over funding, airspace, control over satellites, and networks of broadcasting and distribution that may or may not be open to indigenous work. This is readily apparent in Australia, where threatened budget cuts to ATSIC (the Aboriginal and Torres Strait Islander

Commission) and indigenous media operations are a reminder of the fragility of the victories of the 1980s that enabled the establishment of a few of the early and significant centers of indigenous media production, such as Warlpiri Media, EVTV, CAAMA, and the Indigenous Programs Unit of the ABC. In North America, Native Canadians are facing radical reductions in funding from previously sympathetic sponsors such as the National Film Board of Canada, and in the United States, Native American media makers are finding fewer sources of nonprofit funding in the current climate of privatization. Ironically, as support for production is decreasing, there is increased vitality in events organized around the exhibition of indigenous media, such as the burgeoning biennial Film and Video Festival of the National Museum of the American Indian (which in 1997 showed more than fifty films and videos), as well as radio programs and Web sites run by or devoted to information about more than thirty groups throughout the Americas. In the 1990s, Robert Redford's Sundance Film Festival, a relatively mainstream venue, developed a sidebar devoted to Native American work (a decision that Native American producers have both praised for its support and criticized for its implicit ghettoization of their work; see Vail 1997). We need to track and analyze these kinds of contradictory and fluctuating relationships among arenas of (indigenous) cultural production and government support and cutbacks, both historically and in the present, as they form the context that enables or constrains the production and circulation of different forms of cultural mediation.

Learning from the Local

The impacts of these fluctuations can be tracked in a variety of places—in fieldwork, in policy documents, and in the dramas of everyday life in cultural institutions. In this section, I briefly discuss two instances of image ethics that illustrate how different frameworks for understanding globalization, media, and culture are naturalized, operating as "common sense" on a daily basis in institutions in ways that marginalize indigenous media (and other parallel activities) either as irrelevant or as dangerous interventions in the status quo. Do we simply want to mirror the widespread concern over increasing corporate control over media production and distribution, and the often parallel panic over multiculturalism (Appiah 1997), or, following Rickard, can we help illuminate other possibilities emerging out of locally based concerns and speak for their significance in contemporary cultural and policy arenas?

The first story illustrates how easily activities of people in "out-of-the-way places" (Tsing 1993) can be dismissed, even by the sympathetic. It took place at an event of a sort that probably occurs frequently in the halls of academies, foundations, and government agencies; in this case, the setting was a dinner held at the university where I work. The guest of honor was a scholar who is probably one of the key intellectuals today trying to ground our understanding of processes of globalization and look at the complex ways in which these forces become localized. The dinner was sponsored by a dean who in general regards himself as someone who wants to diversify the cul-

tural perspectives represented at the university but who is still in the grip of hegemonic understandings of "what matters." He started the conversation by asking, "How are we to understand the increasing internationalization of the world here in the university?" After hearing various people deliver laments about the homogenization of culture, exemplified by the presence of McDonald's fast-food restaurants in remote Middle Eastern villages, some of us mentioned other kinds of examples, such as the effective use of cyberspace and video by Tibetan Buddhist activists to keep alive an international support movement for their human rights and independence from China, or the video work of the Kayapo Indians in Brazil, who orchestrated a remarkable and successful pan-Indian demonstration at Altamira to protest a World Bank–sponsored project to create a dam that would have flooded their lands and villages. Their savvy use of media—in which they employed their spectacular appearance and performance style to their advantage, as well as their association with the rock star Sting—succeeded in attracting world press and, in the end, helped to bring about the cancellation of the loan for the dam (Turner 1992). The dean listened patiently and then said, "Yes, but tell me, is this important?" Clearly, it was difficult for him to see these kinds of actions—and the people themselves—as anything but marginal and certainly irrelevant to the concerns of the academy.

By contrast, the second instance I want to relate is one that attributes disproportionate power to such activities. The encounter I describe took place at a conference on Native American art history that was convened to address the importance of bringing Native art into the canon. At least a third of the participants were Native scholars. In the question period following comments made by a non-Native tenured professor of history specializing in pre-Colombian art, one of the indigenous scholars (a community leader working on a doctorate) asked the historian why he had chosen to study this topic. The historian's response was to accuse the questioner of being the kind of person who had created the conditions for backlash against multicultural support systems and affirmative action in California. Everyone in the room was stunned by the virulence of the response. Jolene Rickard stabilized the explosive moment with the following remarks:

> At a time when the fashions of contemporary discourse, and the world itself seems to point towards the globalization of space and human experience, Native American and other indigenous activists are advocating the importance of specific cultural enclaves, of choosing to remain together despite all the pressures—historical and contemporary—to give that up.
>
> We provide the opposite of the way the human condition is moving, floating and migrating around the globe. Instead, we are strategizing to reconfirm a continuous relationship with a very particular part of the world. That's what we need to get to—but we need to clarify that it is about decolonizing, and sustaining our relationship to a particular space.[4]

Her comments helped to recenter the exchange around the issues and dilemmas faced by indigenous cultural activists who find their positions misunderstood and even out of fashion in contemporary discourse. At the same time, Rickard called attention to a key point that is both obvious and one we constantly need to remember: that institutional structures are built on discursive frameworks that shape the ways in which phenomena are understood, naturalizing shifts in state support for a range of cultural activities, as exemplified in the past decade of controversy over multiculturalism in the United States. In government, foundation, and academic institutions, these frameworks have enormous impacts on policy and funding decisions that, for better or worse, can have decisive effects on media work. This is true of many cultural forms, but it is particularly true of media such as film and video, whose production and distribution are expensive—for everything from cameras and editing to the festivals that underwrite the circulation through which this work can begin to have a global presence that nonetheless sustains its connection to its community of origin. In trying to understand the present moment, then, it is crucial that we examine current ideas regarding media as a social phenomenon—in particular the current preoccupation with media globalization for writers from right to left (Appadurai 1996; Bagdikian 1992; Barber 1996; During 1997; Featherstone 1990; Postman 1992; Schiller 1976; Tomlinson 1990; Wilson and Dissanayake 1996a).

The Fate of Culture in the Global Village

The two anecdotes presented above are grounded instances of some of the models circulating that diminish the ethical claims made to the control of images of local worlds, in this case indigenous ones. One of the most influential frameworks that erases the significance of local difference comes from work in communications. It is only a few decades since the idea of the global village, introduced by McLuhan's writings, became common parlance (see McLuhan 1964; McLuhan and Powers 1989). The metaphor evokes a vision of a world transformed by the widespread availability of media technologies that would, in McLuhan's (1964) words, "abolish both space and time as far as our planet is concerned ... when the technological simulation of consciousness, the creative process of knowing, will be collectively and corporately extended to the whole of human society, much as we have already extended our senses and our nerves by the various media" (24). McLuhan is not much in fashion these days, but his books and ideas were landmarks in their time, and they gave fundamental shape to North American attitudes toward rapid transformations in communications.

More contemporary North American media visionaries, such as Bill Gates (1995) and Nicholas Negroponte (1996), have not really altered McLuhan's paradigm substantially. In their arguments for the potential of new technologies to create more fluid social arrangements and electronic democracies, they, like McLuhan, fail to appreciate fully the significance and persistence of cultural difference as well as social

and economic inequalities. In the current romance with cyberspace, there is little concern about the fact that for the majority of people on the planet, access to a telephone is difficult if not impossible, let alone locating the on-ramp to the information superhighway. In these models (as in the first anecdote above), the local—especially in its non-Western and/or Third or Fourth World variant—is inevitably cast as marginal, or at best merely a stylistic problem for successful marketing, in relation to corporately driven processes engaged in what the business community euphemistically calls "global localization."

On the other hand, books such as Ben Barber's influential *Jihad vs. McWorld: How Globalism and Tribalism Are Reshaping the World* (1996) point with understandable alarm to the increasing presence of corporate popular culture—from Disney to McDonald's—everywhere on the globe in the wake of transnational capitalism.[5] At the same time, what Barber calls "tribal" conflicts (subsumed under the notion of Jihad regardless of their cultural bases) are viewed as threatening, likely to destabilize the supposedly culturally neutral space of civil society. (What are we lamenting in the domination of Hollywood film in the world market if not the loss of the very local culture that Barber finds so pernicious a force elsewhere?) Although we may share Barber's concern about the effects and ubiquity of American media and fast-food franchises, how are we to understand his blanket judgment against the assertion of culture as indicative of a dangerous "tribalism" fragmenting social life beyond the destruction wrought by the macroeconomic transformations summed up in the neologism *McWorld*? Such jeremiads do not allow for variations in the assertion of cultural identity; in their totalizing sweep, they fail to recognize local efforts to create new cultural possibilities and cultural and political spaces that offer countervailing tendencies to globalizing trends controlled by multinational corporations.

Where, then, can one find scholarly accounts of the impacts of indigenous media? Such accounts are beginning to be present in media scholarship and the work of globalization theorists, primarily through the posthumous publication of Eric Michaels's writing in the 1980s on the Warlpiri Media Association (WMA) at the Aboriginal settlement of Yuendumu in Australia's Central Desert. Michaels's (1986) descriptions of the early days of that group gave it unexpected visibility; for a variety of scholars alarmed at the "wasteland" of TV, WMA acquired an iconic status as a plucky outback David whose tiny satellite dishes and funky video productions served as a kind of well-targeted epistemological slingshot against the globalizing satellites and accompanying programming of media giants. Through Michaels's writing, scholars such as Dick Hebdige (1994) and Sean Cubitt (1993) took the example of Warlpiri television (and the exotic sense of high-tech primitivism associated with it) as a model for alternative possibilities of TV production, distribution, and reception. In his book *Cultural Imperialism* (1990), John Tomlinson gives the social fact of Aboriginal media a slightly different spin, with a visual image of Aboriginal people sitting outside a house watching TV in the desert. Tomlinson's central argument focuses on the threats posed

by cultural imports to indigenous cultures. Interestingly, none of these writers seems to be concerned with what has actually happened either to WMA or to Aboriginal media more generally since then. The result is that the image of WMA at Yuendumu remains fetishistically frozen in the past, even as that community has been developing new forms such as the compressed video linkups created with the Tanami network (Ginsburg 1993a) and more recent work with CD-ROM technologies and, in 1997, a feature documentary production, *Night Patrol,* made as part of a national documentary series shown on the ABC.

Australian media scholar Toby Miller (1995) offers an interesting perspective on this fetishistic tendency in his review of the ways in which Aboriginal life has been taken up as an object of Western fascination, from Durkheim and Freud to the current romance with Aboriginal media in cultural and media studies. Miller notes that First World scholars have too frequently written about Aboriginal people as a means to elevate their own academic status, rather than as part of an effort to support the broader project of Aboriginal cultural creativity. He notes:

> Clearly a fine line has to be walked . . . between a sloppy appropriation that wilfully loosens the sign from its referent in the form of a continuing process of logocentric white projection, and the desire to give some extraordinary political, theoretical, and aesthetic developments in First People's media their due significance. (15)

Part of walking that fine line is to demonstrate the importance of this work in its own right, as Miller argues, not only as a counter to certain theoretical claims but also as part of broader and historically grounded social processes through which new social arrangements emerge that counter the dominant cultural formations.

Other scholars concerned with critiques of globalization that recognize, more generally, the significance of indigenous and other locally situated cultural practices in relation to dominant models of globalization such as Barber's point instead to the importance of the productions/producers who are helping (among other things) to generate their own links to other indigenous communities through which local practices are strengthened and linked. In the introduction to their edited volume *Global/ Local: Cultural Production and the Transnational Imaginary,* Rob Wilson and Wimal Dissanayake (1996b) point to such processes as part of "an aesthetic of rearguard resistance, rearticulated borders as sources, genres, and enclaves of cultural preservation and community identity to be set against global technologies of modernization or image-cultures of the postmodern" (14).

Indeed, simultaneous with the growing corporate control of media, indigenous producers and cultural activists are creating innovative work, not only in the substance and form of their productions, but in the social relations they are creating through this practice. Although many indigenous media efforts are resolutely local and intentionally political, as in the creation of numerous media cooperatives in Oaxaca, Mexico, with the rise of the Zapatista movement (Berger 1997; Wortham 1996), others

are forming broader nation-based alliances to support their own media production, from the Native American Producer's Alliance in the United States and the Aboriginal Film and Video Arts Alliance in Canada to Te Manu Aute in New Zealand, to name only a few. These groups have created a social field that changes the ways we understand media and their relationship to the circulation of culture more generally in the early twenty-first century. They challenge, for example, those who focus on media as being simply the products of individual auteurs on the one hand or capitalist or state-driven desires on the other. Groups often organize to represent themselves collectively, sometimes in ways that actively resist the imposition (or seduction) of government interests, as in the development of "pirate television" at Yuendumu and Ernabella in Australia, which, although technically illegal, later became, ironically, the model for the development of a government-sponsored low-power TV project for remote Aboriginal communities (Ginsburg 1997; Molnar 1990). Another prominent example of this process is the Inuit Broadcast Corporation (IBC) in northern Canada (now in Nunavut), one of the most successful and earliest indigenous media efforts. The IBC's formation was the result of a long battle by Inuit people to gain some control over the use of communication satellites that initially had been launched over Canada's far north as part of military and corporate experiments with new media technologies (Roth 1994).

Such efforts are evidence of how indigenous media formed over the past few decades at the conjuncture of a number of historical developments; these include the circuits opened by new media technologies (ranging from satellites to compressed video and cyberspace) as well as the ongoing legacies of indigenous activism worldwide, most recently by a generation comfortable with media technologies and concerned with making their own media representations as a mode of cultural creativity and social action. They also represent the complex and differing ways that states have responded to these developments—the opportunities of media and the pressures of activism—and entered into new relationships with the indigenous nations that they encompass. In some cases, as in the stories that follow, protests related to events such as centenary celebrations triggered shifts toward multiculturalist politics—especially in Australia, Canada, New Zealand, and the United States—that initially helped to create new public understandings of the relationship between cultural and political rights.

Indigenous Counterpublics

The historical conjuncture that occurred in North America in the 1960s transformed the sense of opportunity for an emerging generation of indigenous activists. In this section, I draw on the works and lives of three pioneering Native North American media makers and activists—Sandy Osawa (Makah), Loretta Todd (Metis/Cree), and Jolene Rickard (Tuscarora)—to examine how such activists, shaped by a particular historical moment, are part of and creators of new social formations, what Nancy Fraser (1993), in her important critique of Habermas's public sphere, calls "counter-

public spheres." Through a variety of activities and formations—organizations, expressive media of all kinds, protests, school curricula—they and others of their generation have been engaged with making visible their own communities' histories and struggles as well as the politics of knowledge that shape representations of indigenous cultures. These concerns are at the heart of the narrative that prizewinning filmmaker, writer, and activist Loretta Todd tells about her initial introduction and attraction to media as a young Native woman coming of age in western Canada in the 1960s and 1970s.[6] During an interview, Todd (1997) recollected the early emergence of indigenous media in western Canada. Her account details the ways in which a counterpublic sphere was catalyzed by a number of specific developments: the migration of Canadian Native people to cities and the subsequent emergence of indigenous activism, the beginning of an Indian presence on popular television shows, and Vancouver's Centennial Celebration of the Canadian Confederacy in 1967, at which the actor Chief Dan George articulated a collective sense of anger at the erasure of an aboriginal point of view at that event.

> When I was very young, some Aboriginal people were gathering around the idea of media. One of the first media societies that occurred in Canada was in Alberta, Edmonton. It was a group of people who were really political people who came out of the political process and who wanted to do radio and film and video, who wanted to tell stories, who still had that connection and realized the power of the story. They realized that their political activity didn't just have to be to run political organizations and realized that wasn't what their politicization was meant to lead them to. They wanted to be storytellers.
>
> . . . There really was a galvanizing of people around the idea of stories of the life of Indians in these new places. I remember what happened with Chief Dan George playing the Indian in this TV series that the CBC was producing about life in western Canada called *The Caribou*. He became a means for us to realize that we could tell our stories too.
>
> In 1967 at the Vancouver Centennial, Chief Dan George was invited to the celebrations. When he got there, he stood up and said to the crowd, "I have nothing to celebrate." He then unleashed a powerful stream of oratory and poetry, of *story*, and there was this kind of realization, with the Native people living there who weren't necessarily from the territory—Cree, Dene, a lot of people down from the coast and from the prairies, maybe fifty, sixty different tribes in this one place. And that's probably something you hadn't seen for many centuries; when tribes had gathered in that number they would never live together for an extended period of time. And they started forming things like the Vancouver Indian Center. And Chief Dan George reminded us that we were storytellers. So he brought this really interesting confluence of people in one place and time in Vancouver, and a lot of people wanting to tell stories.

This sense of an emerging counterpublic sphere was furthered by the unprecedented introduction in the late 1960s of small-format video to First Nations communities in North America by progressive white activists (Boyle 1997). Todd calls these activists "media missionaries" because of the zeal with which they hoped to convert politically and culturally disenfranchised communities to this new form of communication. They were remarkably successful, and their efforts spurred the formation of the Native communications societies that are the formative base for most of those engaged in indigenous media making today, including Loretta Todd. She continues:

> And then video came along. And you get all these hippies, these earnest politicals, creating all these media collectives. And they thought, well, they'll go into the Indian community, you know, teach us to be political. Yeah right. I call them media missionaries. But nonetheless, they had the technology, and we were becoming increasingly interested in who we were as storytellers, so people started to pick up this medium....
>
> Then you started to see a lot of Native communications societies, people trying to form collectives, to take the values by which we lived into this medium, so we'd be collectives, you know, serving the community. I was too young to be directly involved, but I knew the people who did that, and heard their stories....
>
> So I was able to build on it and help form an organization called the Aboriginal Film and Video Arts Alliance in Canada. It's not like we have a president and a board.... What we are is a circle of people who really believe in the principles of collective action, who really have a relationship to their community, who want to preserve the power of the storyteller. We could go to different cultural institutions in Canada, to help put them on the red road, not as places of career enhancement but as places that speak to who we are as those people living on that land called Canada, and how we protect that land or don't. So you know, we've always felt really strong about trying to create partnerships and alliances with other Aboriginal people and other non-Aboriginal people who want to protect the land.

Similarly, Northwest Coast Makah filmmaker Sandy Osawa, a founding member of the Native American Producers Alliance and director of a number of award-winning documentaries on struggles over Native rights concerning land, sacred sites, fishing rights, and cultural property, situates herself in the activism of the 1960s and the particular spaces it opened up for young U.S.-based Native American activists at the time. She had been active in Makah life, and she had also been deeply influenced as a college student in the 1960s by her participation in the National Indian Youth Council, an organization sponsored by the Association on American Indian Affairs that brought young Native Americans together from around the country to learn about Indian history and foster leadership. Her experiences there, which were typical

of those of many of her generation and not unlike those Todd describes as part of a more informal process in Vancouver, fostered a sense of translocal identification. As Osawa (1997) describes it:

> People that went there went on to work for their tribes. . . . I had a very clear under-standing of all the dynamics involved with our own political situation and how we fit in with the whole American scene. . . . This also helped shape my feeling that I could really grasp, work with other tribes, because I felt like I had such a good over-all background. It was not unusual for me to want to do something with the Navajo people when I made the film *In the Heart of Big Mountain* or the Chippewa when I did *Lighting the Seventh Fire* because I already had this background in terms of what really affects us politically in common. I felt it was important to respond to issues in any part of the country. In fact, I would say, with indigenous people everywhere, I think it is important for us to pay attention to how indigenous people are treated. So that's really my own personal bent, to be interested in indigenous issues no mat-ter what tribe or what area. Because that says something about, you know, the whole world.

Resources of Hope

I would like to conclude on a note of cautious optimism. The evidence of the growth and remarkable florescence of indigenous media over the past few decades, whatever problems may have accompanied that growth, is nothing short of remarkable. In re-cent years we have seen some backlash in the United States, Canada, and Australia in response to the influential efforts of Native peoples in earlier decades to reframe na-tional imaginaries in a more inclusive manner, as evidenced by the decline in affirma-tive action and national arts agencies in the United States, the defunding of the cul-tural units at the National Film Board of Canada, and the popularity of politicians (such as Pauline Hanson) running on racist platforms in Australia. What these devel-opments will mean for the continued production and circulation of indigenous media remains to be seen. Certainly, the generation of people that includes Loretta Todd, Sandy Osawa, and Jolene Rickard, schooled in the political transformations of the 1960s and 1970s that affected First Nations peoples worldwide, have a legacy of strug-gle, a finely honed knowledge of media to fall back on in lean times, as well as an expanding base of media production with a growing infrastructure that ranges from indigenous initiatives at national film commissions to regional production and broad-cast centers and on to the mushrooming of local small-scale production centers.[7] In Australia alone, the first fragile experiments in video production at Yuendumu and Ernabella and in regional television and radio at CAAMA are now only three out of more than a hundred community-based initiatives. Added to this is the Aboriginal work by independent media makers coming out of urban centers, such as the films developed at the Australian Film Commission that were first broadcast nationally in

1997 in a series called *Sand to Celluloid,* as well as the work of others engaged with the Indigenous Program Units at the SBS and the ABC. Formations such as these, working out of grounded communities or broader regional or national bases (such as Canada's Aboriginal Film and Video Arts Alliance), offer important alternatives to those who are blind to this vitality, dazzled by the media spectacles that stand for the master narrative of globalized production. As a counter to that, Wilson and Dissanayake (1996b) argue, "local spaces of contested identification and belonging, if scrappy and minor in this micro-political sense, can still generate what Raymond Williams called 'resources of hope' within contexts of transnationalization" (12).

Indigenous media offer an alternative model of grounded and increasingly global interconnectedness created by indigenous people about their own lives and cultures. Although scholars such as Barber may choose to ignore such phenomena in their own right or as examples of alternative modernities, resources of hope, a new dynamic in social movements, or part of the trajectory of indigenous life in the early twenty-first century, those creating indigenous media, as well as those in power, do not regard these media as irrelevant. Whether for commercial or political purposes, controlling the representation of conflict, culture, and historical processes by nondominant groups with claims on the majority culture is always significant. This is made violently clear in the narrative by Jolene Rickard with which I opened this chapter; her writing was stopped literally midsentence by actions of the New York State government in its concern to control knowledge of contemporary Seneca resistance to the enforcement of new taxation. As we all struggle to comprehend the remapping of social space that is occurring as new media forms are being embraced for their globalizing qualities, indigenous media offer some other coordinates from which we can understand what an interconnected world might be like outside a hegemonic order.

It is this sort of remapping that Jolene Rickard addresses in her insistence on cultural productions that refuse to break their relationship to a particular part of the world. Given the significance she attributes to recognizing sources of knowledge and who has the rights to articulate that knowledge, often in storied form, it seems only fitting that I close this chapter with her words. Drawing on the activity of beadwork—a practice for which the Tuscarora are justifiably famous—as a metaphor for cultural practice, Rickard (1992) writes of her own efforts:

> My work is another bead on the cloth, visually linking our worldview to our experience. It is on our experience that I focus my eye, looking at the bits and pieces of our daily life while sorting through what belongs to us and what we picked up along the way. These images are not radically chic. I am just one Tuscarora woman who has identified the "center" as anywhere indigenous people continue to live, knowing that we have the oldest, continuously surviving cultures in the world. That has to mean something. Every day I explore that meaning from the inside looking out. (111)

Notes

My thanks to Jay Ruby for instigating the writing of this chapter, which is based on intermittent fieldwork in Australia (1988, 1989, 1992, 1994, 1997), at various conferences and film festivals devoted to indigenous media (Montreal 1992), at the National Museum of the American Indian (1989, 1991, 1993, 1995, 1997), and at Dreamspeakers in Edmonton (1992), as well as ongoing conversations with a number of indigenous filmmakers who were in residence at the Center for Media, Culture, and History at New York University, including Harriet Skye (Standing Rock Sioux), Dean Bear Claw (Crow), Frances Peters (Kamiloroi), Vincent Carelli (Centro de Trabalho Indigenista), Loretta Todd (Metis/Cree), and Sandy Osawa (Makah). Their fellowships were supported by the Rockefeller Foundation and the United Nations Environmental Programme. I could not have conducted my work in remote communities without the help of Fred Myers in 1988 and Francoise Dussart in 1992 in terms of both logistics and language. In addition, the following people in Australia have shared their time and insights with me (in 1988, 1989, 1992, 1994, and 1997): Martha Ansara, Brian Arley, Philip Batty, Jeremy Beckett, Priscilla Collins, Brenda Croft, Stuart Cunningham, Graham Dash, Jennifer Deger, Freda Glynn, Rex Guthrie, Annette Hamilton, Melinda Hinkson, David Jowsey, Tom Kantor, Francis Jupurrurla Kelly, Dick Kimber, Ned Lander, Marcia Langton, Mary Laughren, Brett Leavy, Michael Leigh, Judith and David MacDougall, Catriona McKenzie, Michael Meadows, Helen Molnar, Christine Morris, Trish Morton, Michael Niblett, Lorna O'Shane, Rachel Perkins, Frances Peters, Nick Peterson, Michael Riley, Rosie Riley, Tim Rowse, David Sandy, Walter Saunders, Claire Smith, Peter Toyne, Neil Turner, Ant and Jen Wallis, Evan Wyatt, and Tom Zabryczki. For research support, I am grateful to the Research Challenge Fund of New York University (1988), the John Simon Guggenheim Foundation (1991–92), and the MacArthur Foundation (1994–99), and to Claire Smith and Graeme Ward for inviting me to attend the 1997 conference "Indigenous Cultures in an Interconnected World."

1. In 1994, the international circulation and critical acclaim of the very successful Maori feature film *Once Were Warriors* (Lee Tamahori, 1994) marked a real watershed for the possibilities of indigenous media productions to receive widespread acclaim and recognition on a world stage. Specifically, *Once Were Warriors* enabled a story of contemporary Maori life to take on a powerful presence in the transnational world shaped by the circulation of independent film, although there has been considerable debate in the Maori community regarding the film's images of violence (Pihama 1996). On the other end of the media spectrum, many of the indigenous media projects being produced are oriented initially to local concerns and connections, part of self-conscious efforts to sustain and transform culture in contemporary Aboriginal communities, what Tony Bennett and Valda Blundell (1995), in a journal issue devoted to cultural politics and First Peoples, have called "innovative traditionalism." For example, the Inuit group Igloolik Isuma Productions, directed by Zacharias Kunuck, has creatively engaged in community-based video production in which elders create dramas about their lives in the early part of the century as a means for recuperating languages, ceremonies, and histories across several generations. The series the group has made based on that process, "Nunavut," has been seen by other Native communities all across northern Canada on TVNC, the station linking these communities (Berger 1995a, 1995b; Fleming 1995; Roth 1994).

2. These people have been using media to enhance struggles for Native rights, to ensure that their views (often erased in dominant media coverage) are heard and seen beyond their own communities, as in the extraordinary epic film *Kanehsatake: 270 Years of Resistance* (1994), by Abenaki filmmaker Alanis Obamsawin. Using her position as a veteran director for the National Film Board of Canada, Obamsawin was able to document the prolonged struggle at

Oka in 1990 by Canadian-based Mohawks who fought to maintain rights to sacred burial grounds that were being claimed for a golf course. At the same time the film makes a powerful claim for Mohawk interests in the current debate, it is intended to provide a historical document for future generations. Obamsawin, who is acutely aware of the absence of knowledge of these kinds of events from the native point of view from the colonial past, always regards her films as part of a political and cultural legacy to the next generation. With similar intentions, but mixing genres, Hopi filmmaker and artist Victor Masayesva Jr. both draws on and satirizes documentary to deconstruct the ways that Native Americans have been portrayed in dominant media. For example, in his feature-length film *Imagining Indians* (1993), a humorous yet stinging indictment of Kevin Costner's 1990 film *Dances with Wolves,* he offers a direct critique not only of contemporary Hollywood representations of Indians, but also of the treatment of Native actors who acted in these films.

3. Arjun Appadurai (1990) coined the term *mediascape;* it is one of five "scapes" of interaction that account for the current global cultural economy. The mediascape is created by new media technologies and the images created with them.

4. This quotation comes from my notes on Rickard's comments, recorded at the conference in June 1997.

5. Barber's book went into a second printing within a year of its publication, and it has been quoted favorably by President Bill Clinton. During a visit I made to the offices of the Ford Foundation to discuss media policy with some officers of the foundation, it was clear to me that *Jihad vs. McWorld* was being read as a kind of handbook for policy makers.

6. I quote below from an extensive interview carried out with Loretta Todd (1997) by Carol Kalafatic, Barbara Abrash, and myself as part of a series of dialogues with indigenous filmmakers conducted at the Center for Media, Culture, and History, an interdisciplinary center that I direct at New York University. The center, which sponsors fellowships, conferences, seminars, and screenings, was established in 1992 with the support of a Rockefeller Humanities Center grant. The center also receives money from the United Nations Environmental Programme to establish fellowships for people working on diaspora, Third World, and indigenous media. In the spring of 1995, Loretta Todd was a Rockefeller humanities fellow and Sandy Osawa was a U.N. media fellow.

7. A number of filmmakers have established themselves in more mainstream venues, such as Maori independent filmmaker Lee Tamahori, who has been working for Hollywood, and Aboriginal photographer and filmmaker Tracey Moffat, who opened a major exhibition at the Dia Arts Center in New York City in the fall of 1997.

References

Abu-Lughod, Lila. 1997. The interpretation of culture(s) after television. *Representations* 59 (summer): 109–34.

Ang, Ien. 1996. *Living room wars: Rethinking media audiences for a postmodern world.* New York: Routledge.

Appadurai, Arjun. 1990. Disjuncture and difference in the global cultural economy. *Public Culture* 2, no. 2:1–24.

———. 1996. *Modernity at large: Cultural dimensions of globalization.* Minneapolis: University of Minnesota Press.

Appiah, Anthony. 1997. Rethinking multiculturalism. *New York Review of Books,* October.

Bagdikian, Ben. 1992. *The media monopoloy,* 4th ed. Boston: Beacon.

Barber, Benjamin. 1996. *Jihad vs. McWorld: How globalism and tribalism are reshaping the world,* 2d ed. New York: Ballantine.

Bennett, Tony, and Valda Blundell. 1995. First Peoples. *Cultural Studies* 9, no. 1:1–24.

Berger, Sally. 1995a. Move over Nanook. *Wide Angle* 17, nos. 1–4:177–91.

———. 1995b. Time travelers. *Felix: A Journal of Media Arts and Communication* 2, no. 1.

———, curator. 1997. *Mexican video: Thorn of the mountain* (program notes for a video exhibition at the Museum of Modern Art), October 2–December 7, 1997.

Boyle, Deirdre. 1997. *Subject to change: Guerrilla television revisited.* New York: Oxford University Press.

Cubitt, Sean. 1993. *Videography: Video media as art and culture.* New York: St. Martin's.

Danaja, Peter, and Murray Garde. 1997. From a distance: Indigenous cultures in an interconnected world. Paper prepared for a Fulbright symposium.

During, Simon. 1997. Popular culture on a global scale: A challenge for cultural studies? *Critical Inquiry* 23 (summer): 808–33.

Featherstone, Michael. 1990. *Global culture: Nationalism, globalization, and identity.* Newbury Park, Calif.: Sage.

Fleming, Kathleen. 1995. Igloolik video: An organic response from a culturally sound community. *Inuit Art Quarterly* 11, no. 1:26–34.

Fraser, Nancy. 1993. Rethinking the public sphere: A contribution to the critique of actually existing democracy. Pp. 1–32 in *The phantom public sphere,* edited by Bruce Robbins. Minneapolis: University of Minnesota Press.

Gates, Bill, with Nathan Myhrvold and Peter Riearson. 1995. *The road ahead.* New York: Viking.

Ginsburg, Faye. 1993a. Aboriginal media and the Australian imaginary. In Screening politics in a world of nations [special issue], edited by Lila Abu-Lughod. *Public Culture* 5, no. 3:557–78.

———. 1993b. Station identification: The Aboriginal Programs Unit of the Australian Broadcasting Corporation. *Visual Anthropology Review* 9, no. 2:92–96.

———. 1997. In little things, big things grow: Indigenous media and cultural activism. In *Between resistance and revolution,* edited by Richard Fox and Orin Starn. New Brunswick, N.J.: Rutgers University Press.

———. 1999. Shooting back: From ethnographic film to indigenous media. Pp. 295–322 in *A companion to film theory,* edited by Toby Miller and Robert Stam. Malden, Mass.: Blackwell.

Hebdige, Dick. 1994. Foreword. Pp. ix–xxvi in Eric Michaels, *Bad Aboriginal art: Tradition, media, and technological horizons.* Minneapolis: University of Minnesota Press.

McLuhan, Marshall. 1964. *Understanding media: The extensions of man.* New York: McGraw-Hill.

McLuhan, Marshall, and Bruce R. Powers. 1989. *The global village: Transformations in world life and media in the 21st century.* Oxford: Oxford University Press.

Michaels, Eric. 1985. Constraints on knowledge in an economy of oral information. *Current Anthropology* 26:505–10.

———. 1986. *The Aboriginal invention of television in central Australia:* 1982–1986. Canberra: Australian Institute of Aboriginal Studies.

Miller, Toby. 1995. Exporting truth from Aboriginal Australia: "Portions of our past become present again, where only the melancholy light of origin shines." *Media Information Australia* 76 (May):7–17.

Molnar, Helen. 1990. The Broadcasting for Remote Areas Community Scheme: Small vs. big media. *Media Information Australia* 58 (November):47–154.

Negroponte, Nicholas. 1996. *Being digital.* New York: Viking.

Osawa, Sandy. 1997. Interview by author, Barbara Abrash, and Pegi Vail. New York University, Center for Media, Culture, and History, June 15.

Pihama, Leonie. 1996. Repositioning Maori representation: Contextualising "Once were warriors." Pp. 191–94 in *Film in Aotearoa/New Zealand,* edited by Jonathan Dennis and Jan Bieringa. Wellington: Victoria University Press.

Postman, Neil. 1992. *Technopoly: The surrender of culture to technology.* New York: Alfred A. Knopf.

Rickard, Jolene. 1992. Cew ete haw i tih: The bird that carries language back to another. In *Partial recall,* edited by Lucy Lippard. New York: New Press.

———. 1997. Native scholars/native voices. Unpublished position paper for the first meeting of the Otsego Institute for Native American Art History, June.

Roth, Lorna. 1994. Northern voices and mediating structures: The emergence and development of First Peoples' television broadcasting in the Canadian north. Ph.D. diss., Concordia University, Department of Communication Studies.

Schiller, Herbert. 1976. *Communication and cultural domination.* White Plains, N.Y.: International Arts & Sciences.

Todd, Loretta. 1997. Interview by author, Carol Kalafatic, and Barbara Abrash. New York University, Center for Media, Culture, and History, May 15.

Tomlinson, John. 1990. *Cultural imperialism: A critical introduction.* Baltimore: Johns Hopkins University Press.

Tsing, Anna. 1993. *In the realm of the diamond queen.* Princeton, N.J.: Princeton University Press.

Turner, Terence. 1990. Visual media, cultural politics, and anthropological practice: Some implications of recent uses of film and video among the Kayapo of Brazil. *Commission on Visual Anthropology Newsletter,* spring, 8–13.

———. 1992. Defiant images: The Kayapo appropriation of video. *Anthropology Today* 8, no. 6:5–16.

Vail, Pegi. 1997. Producing America. Master's thesis, New York University, Department of Anthropology.

Wilson, Robert, and Wimal Dissanayake, eds. 1996a. *Global/local: Cultural production and the transnational imaginary.* Durham, N.C.: Duke University Press.

———. 1996b. Introduction: Tracking the global/local. In *Global/local: Cultural production and the transnational imaginary,* edited by Rob Wilson and Wimal Dissanayake. Durham, N.C.: Duke University Press.

Wortham, Erica. 1996. Indigenous media in Mexico: Reconfiguring the Mexican national imaginary. Paper delivered at the meeting of the American Anthropological Association, invited session titled "Beyond representation: Visual anthropology and the Fourth World."

"Moral Copyright":
Indigenous People and Contemporary Film

Hart Cohen

The idea of "moral copyright" has recently been introduced into the discussions of a subcommittee of Screensound, the national film and sound archive of Australia, in relation to images of indigenous people used in contemporary films. Australia has a significant record in the protection of Aboriginal art and culture involving the cooperation of Aboriginal people, curators, anthropologists, lawyers, and academics.[1] The subcommittee has been discussing a proposal that authorization be required for the use of all images of Aboriginal and Torres Strait Islander people, archival or current, in ethnographic or documentary films. *Authorization* is here defined as the obtainment of consent to use these images from Aboriginal persons affiliated with the persons depicted in them.

One of the first tests of this protocol took place during the production of a film that I wrote and directed in 2001 titled *Mr. Strehlow's Films*. As the film used substantial archival photographs and film of Aboriginal people dating from the 1930s, authorizations, with respect to moral copyright, were difficult to clear. Nevertheless, the film production persisted with this protocol and removed images not authorized by the appropriate Aboriginal people.

The idea of "moral pause," from Gross, Katz, and Ruby's introduction to their 1988 edited volume *Image Ethics,* entails the notion that the power enjoyed by the media to make and circulate images and sounds should be accompanied by the responsible deployment of that power. With the media in many countries protected by free-speech provisions in their national constitutions, we are forced to rely on the "moral" consciences of those able to exert power and influence via the mass media. Gross et al. ground these concerns by reference to Walter Lippman (1922), which suggests that they are addressing the period beginning in the 1890s in which there was exponential expansion of the mass media. The current concerns relating to indigenous image ethics in Australia and elsewhere have recalibrated the debates following a period (the 1990s) that was not unlike the 1890s in the introduction of new media technologies. The "moral pause" that Gross, Katz, and Ruby called for in 1988 invokes an initial reflection about the need for the protection and responsible use of images. The development of digital technology has brought with it high-profile intellectual property cases such as those concerning Microsoft and Napster. The debates have now moved to occupy a highly visible presence in public and scholarly discourses, and the example of indigenous images is an important part of this development. The use of images of indigenous peoples has resulted in modifications of current copyright legislation. The enactment of moral copyright is an articulation of political and economic power, and the models of implementation of moral copyright are varied. In this essay, I discuss one such model in Australia.

Moral Copyright in Australia

The idea of moral copyright was proposed in Australia long before its recent implementation in an independent film documenting the life, work, and legacy of T. G. H. Strehlow, preeminent translator and recorder of Arrernte traditions in central Australia.

In the early 1990s, Wal Saunders, then head of the Aboriginal Film Unit of the Australian Film Commission, expressed the view that any image of an Aboriginal person used in films for public consumption should be authorized through a form of copyright release. In his view, the exploitation of images of Aboriginal people is based on the fact that they have frequently been filmed without their permission and without their awareness as to how the images would be used. Obtaining authorization would consist of requesting and obtaining consent from the appropriate indigenous people for the use of particular images within a contemporary film.[2] The potential for applying Saunders's proposal for a moral copyright when he enunciated it in the early 1990s was not great, but it gave pause—a moral pause, if you will—for reflection on the use and abuse of images of Aboriginal people in films at a time in which the production of films about Aboriginal people and their cultural history was on the rise in Australia. The approach to moral copyright of the Screensound (formally the Australian Film and Sound Archive) subcommittee is to seek the cooperation of documentary filmmakers and others through moral suasion, not through a legally binding arrangement.

In the case study related in this chapter, the film in question, *Mr. Strehlow's Films,* used extensive photographic and film materials from the Strehlow collection, which comprises hundreds of sacred objects, twenty-five hours of ceremonial films, eight thousand photographs, and several volumes of field and office diaries. In the making of the film, a documentary about Strehlow's life and work, I adhered to a policy of moral copyright in the use of archival film and still photos of Aboriginal people; that is, only those images of Aboriginal people that were authorized by Aboriginal persons appropriately affiliated with the persons depicted in the images were used in the film.

Restricted Images

The issues of image ethics are not new to Australia. Interestingly, they go back to some of the earliest ethnographic films in existence—the film work of Baldwin Spencer, dating from 1901 and 1912. In the 1980s, there occurred a debate in Australia about the withdrawal of a compilation of Spencer's films from public circulation because these films transgressed the restricted nature of Aboriginal ceremonial practices (see Cantrill and Cantrill 1982, 42–43). Those wanting the images to circulate freely argued on behalf of free speech and for the right of film researchers to view film materials as part of the general interest in knowledge production in this field. Cantrill and Cantrill (1982) asserted:

> A film or a photograph of a secret ceremony is not the ceremony itself, and we should stress that we are not suggesting that in asking for access to film and photographs, we are also asking for access to tribal secret objects. These should not be held in our society at all. Secret objects belong to the society which made them. Film and photography are our "objects," and they transcend the "pro-filmic" subjects. (56)

Those supporting the withdrawal of the Spencer films argued their case on the basis of cultural sensitivity, noting the potential for distress (and even death) that can arise in Aboriginal communities and within individuals when transgressions of these kinds occur. The debate and the consequences—the withdrawal from public circulation of these and other similar ethnographic films—constituted a watershed in the public restrictions surrounding the viewing of "sensitive" cultural materials in Australia. The withdrawals were frequent and immediate, particularly with films produced by Film Australia. Filmmakers who had not viewed their work as initially having to be restricted became constrained by the protocol and withdrew their films from public access. Other films had potentially offending material edited out. Most of the withdrawn films are stored in Canberra at the Institute for Aboriginal and Torres Strait Islander Studies.

Can Culture Be Copyrighted?

The issue at the heart of this debate concerns the institutionalization of secrecy in a society based on liberal democratic values. In an article titled "Can Culture be Copy-

righted?" Michael Brown (1998) argues against a "special-rights regime in pluralist democracies" (193), arguing that these regimes might be used by corporations or corporate groups inviting abuses of power. In this collision of the property rights of indigenous peoples and free speech, Brown prefers a model of joint stewardship and creative licensing rather than legally binding arrangements (restriction or protection of materials) granted in perpetuity.

Brown addresses a number of issues relating to ethical dilemmas, but he directs his most strident cautions toward property discourses that insist on indigenous peoples' control over cultural patrimony. The moral copyright interests expressed recently in Australia contradict Brown's view and imply that, in this instance, Brown's claims are overstated. The ethnographic context of Australia suggests the need for Australians to recognize the prior inequities laid down by historical circumstance that legitimate moral copyright protocols. There is also a slippage in Brown's work toward a rigid view of property itself. In a comment on Brown's article, Rosemary Coombes (1998) writes, "Property, though, is more dynamic than its ideological deployment might suggest; it is constituted of flexible nexi of multiple and negotiable relationships between persons and things that continually shift to accommodate historical recognition of prior inequities and social needs" (226). This suggests that property rights and moral copyright are not reducible to one another and that both are situated and contingent discourses demanding a flexible approach to the assignment of rights.

Background to the Strehlow Film Work

The recent application of a moral copyright protocol to a documentary film production in Australia may be best presented through an introduction to the main focus of the film, the life and work of T. G. H. Strehlow. Theodore George Henry Strehlow (1908–78), the son of Lutheran missionaries, grew up immersed in Aboriginal culture. He spoke the Arrernte language fluently and became the foremost ethnographer of Arrernte ceremonial culture—in his case, not only in writing but also through film, still photography, and tape recordings. Strehlow's film and sound recordings of Aboriginal cultural practices are among the most extensive made by any ethnographic filmmaker in the twentieth century. Strehlow recorded more than twenty-five hours of film and tape as part of his fieldwork in central Australia from 1935 to 1970. The majority of these recordings involve sacred practices, and a substantial portion is secret and of limited access to researchers. The subject matter of the filmed sacred material is men's ceremonial performance. Sound is nonexistent on most of the film material itself, but a collection of audiotapes of songs was previously archived by the Strehlow Research Centre.

Strehlow's collection of *tjurunga* formed much of the focus for negotiations held over ten years that brought the Strehlow collection to Alice Springs in the Northern Territory, where it is now housed in the Strehlow Research Centre.[3] The acquisition of the Strehlow collection by an act of the Northern Territory Parliament was controversial (see Hugo 1997). Counterclaims were lodged by both the Strehlow Research

Foundation in Adelaide through Kathleen Strehlow (Strehlow's widow) and the Central Land Council, an Aboriginal representative body based in Alice Springs on behalf of Arrernte people.

The *Stern* Incident

The application of moral copyright with regard to a film about T. G. H. Strehlow and the Strehlow collection is in step with community expectations in Australia. But the Strehlow collection was notorious not only for its special content but for an incident in which Strehlow sold culturally sensitive photographs to the German magazine *Stern* in 1978. At the time, Strehlow was in desperate need of financial resources to maintain his vast collection, and he sold photographs to *Stern* to raise funds. *Stern* then sold the photographs, without Strehlow's knowledge or consent, to popular magazines in the United States and, devastatingly, Australia, where they were published in *People* magazine. The appearance of these restricted photographs in central Australia angered many Aborigines there, and Strehlow was criticized by many of his academic colleagues for his carelessness. The extent of Strehlow's guilt in this incident is still debated. *Stern* absolved Strehlow of any responsibility, and *People* in Australia apologized and withdrew the issues in question from circulation in central Australia.

Strehlow had strict rules for the display of items from his collection, but he was naive about the modern business practices of syndicated publications that allowed the offending photographs to be sold on to others without his knowledge. The *Stern* incident remains a reference point for the problems and concerns related to the continued existence of secret/sacred knowledge in Aboriginal societies in Australia. The *Stern* incident alerted both Aboriginal and white communities to the harm that can ensue when modern communication media institutions encounter traditional cultural practices. The potential for cultural transgression and its consequences was realized. This suggests that a particular cultural context exists in Australia that may differ from cultures in other parts of the world and that these differences demand a special approach to the ethical practice of image use in Australia. With the development of digital forms of reproduction, the need is now even more acute.

Secrecy and Privacy

In their book *Media Ethics* (1998), Patterson and Wilkins, citing the work of Bok (1983), offer a distinction between privacy and secrecy. These definitions are useful for an understanding of the secret/sacred in Aboriginal society within the project of image ethics. As Patterson and Wilkins put it, "Secrecy can be defined as blocking information intentionally to prevent others from learning, possessing, using or revealing it" (123); privacy, in contrast, is concerned with limiting access to the information. Crucially, this means that under certain conditions, information about a group or person may reach the public view, but the group or person controls what is revealed and to whom. Secrecy, therefore, maintains a stronger prohibition than privacy on information. In relation to the sacred elements of Aboriginal culture, it is their secrecy

that Aboriginal people wish to sustain. Patterson and Wilkins are not concerned with indigenous values, rather with journalistic practices—but the transformational use of their distinctions offers insights into the practices of Aboriginal societies. The secret and the private would appear to overlap in the indigenous world. The "secret"—a means of communally managing sacred knowledge—is linked to forms of social familiarity or intimacy and the articulation of power.

Image ethics in this context, then, is governed by a cultural definition of access. The general public is not considered to be part of the communications sphere insofar as sacred knowledge is destined only for certain social members who are bound by rules of access such as initiation.

When Aboriginal societies encountered white settlement, the impact was devastating to their cultural practices and their ruled-governed networks. Sacred objects were traded, collected, and stolen, and the traditional authority of the elders was undermined. At that time, scholars such as Strehlow thought that no Aboriginal culture would survive white contact. Their response was to try to "salvage" as much of Aboriginal culture as possible. However, despite the pressures of modernity and the destructive aspects of white settlement, elements of Aboriginal culture have survived, and many Aboriginal people continue to regard their totemic affiliations and secret knowledge as significant. For this reason, Aboriginal social and cultural practices require protection. Moral copyright is a form of protection that extends the sanctity of the secret/sacred to include the moral rights related to the right to *privacy.* These are due to all indigenous persons, whether they are affiliated with those already deceased or alive and able to exert control over the use of their own images.

Mr. Strehlow's Films and the Process of Moral Copyright

My film *Mr. Strehlow's Films* documents the controversies that have dogged Strehlow's collection. These include a public auction of items from the collection held in 1999. The original inspiration for the documentary was Strehlow's twenty-five hours of 16 mm film footage documenting secret more than nine hundred secret sacred ceremonies. This footage, which has remained almost wholly unedited, is currently stored in the Australian National Film and Sound Archive in Canberra and at the Strehlow Research Centre in Alice Springs. Under the protocols established for the production of the documentary, no secret/sacred footage from the collection could be used. The producers also agreed to apply the terms of moral copyright in regard to supporting materials drawn from the collection. From the outset, it was unclear if we could manage to obtain the necessary authorizations without delaying or constraining the film's production process—or whether we could get the authorizations at all. Some of the images of Aboriginal people I wanted to use in the film dated back to the 1930s. The majority of the people in Strehlow's stills and films are deceased.

Research officers from the Strehlow Research Centre undertook a series of visits to find Aboriginal persons who would be able to authorize the use of these images legitimately, based on affiliation, and who then would consent to do so. Fortunately,

Strehlow's field diaries are detailed and comprehensive, identifying both the persons and the places in his films and photographs. Strehlow also maintained a comprehensive genealogical "map" of the Arrernte people as part of his research. These family trees document both extensive kin relationships and the conception sites of individuals. They establish totemic relationships, kin relationships ("skin"), and affiliations to place. These links to totem, kin, and place are the most important characteristics connecting Aboriginal persons to one another. Using this information, and armed with photocopies of photos, research officers traveled to find the appropriate people—sometimes hundreds of kilometers into the outback. In some instances, the results were refusals to allow certain names of Aboriginal elders to be mentioned in the film or to allow the use of images of elders now deceased. In one instance, an Aboriginal man in a relatively recent photograph was known to still be alive, but he and his relations could not be contacted, and the photograph in question was withdrawn from use in the film. In some instances, community council heads who, with their councils, took responsibility for particular jurisdictions in which the people in some photographs lived gave authorizations for a number of photos. Through this process, most of the images were authorized and the authorizations documented. Those images that could not be authorized to the satisfaction of the Strehlow Research Centre's interpretation of the moral copyright protocol were withdrawn from use in the film. This process reveals an approach based on a flexible interpretation of who could provide consent based on consultation with both Aboriginal people in the situation and research officers from the Strehlow Research Centre. The individuals granting consent ranged from elders who were responsible for specific sites and ceremonies to community representatives under whose jurisdictions certain institutions now fall.[4] In this sense the approach to establishing the process of moral copyright was a joint collaborative effort without pre-defined ideas as to how consent would be obtained.

Modernity, Repatriation, and Heritage

Modern forms of recording and preserving the secret and sacred elements of Aboriginal ceremonial practices have added increasing complexity to the status and choices available for their current use. The image ethics here includes not only the moral rights related to their use but the political and economic articulation of power in contemporary Australia. This power has its expression in various contestations of the repossession of land, objects, and information mediated by processes of repatriation, Native title legislation, and heritage law.

Repatriation

The word *repatriation* refers to a return, usually the return to or restoration of one's own country. *Repatriation* is commonly used in reference to persons who have been exiled or otherwise kept outside the borders of their country or native land and are returned or restored to it. Most recently, the term has been applied to archaeological materials, such as skeletal remains, that are handed back to their places of origin after

periods of dispossession by groups or individuals. In *Hunters and Collectors* (1996), Tom Griffiths reviews the significant conflicts in Australia surrounding archaeological finds and the strategies devised for the return of skeletal remains found by archaeologists. He acknowledges the repatriation of bones and other artifacts of indigenous peoples, and goes on to review the key episodes of repatriation in Australia—the return of the Crowther collection of Tasmania, the Murray Black collection, and the Kow Swamp skeletons in 1990. Griffiths notes that as early as 1973, Aboriginal people raised protests against the Kow Swamp archaeological dig, and he documents the successful resistance mounted by Jim Berg against the export of a Kow Swamp skull to an exhibition in the United States.

The 1990s proved to be a time when many skeletal and other grave-related materials were repatriated to Aboriginal people for reburial. Sometimes these occasions were marked by rituals to formalize the spiritual elements of the activity. Archaeology and tradition were not mutually exclusive pursuits in the context of these repatriations; rather, the two were able to coexist and serve common interests.

Michael Brown (1998) pays substantial attention to the "moral copyright" legislation in the United States governing repatriation of human remains: the Native American Graves Protection and Repatriation Act of 1990. Brown pays tribute to the legislation, describing it as "a first step in a historic reconciliation between native peoples and museums," but he goes on to raise questions about the "outer boundaries of the law," suggesting that it may be used to legitimate "comprehensive control over cultural records currently excluded from consideration" (195). Brown's position is not without parallel in Australia, drawing inspiration from critiques of a romanticized view of Aboriginal life.[5]

Heritage

Using a definition drawn from Daes (1993), Brown (1998) defines heritage as "all of those things which international law regards as the creative production of human thought and craftsmanship, such as songs, stories, scientific knowledge and artworks" (201). However, Brown notes that this definition troubles him because it includes concepts and thoughts as well as their concrete enactment. Another definition of heritage, given by Aboriginal people, is simply "the things we want to keep"; this makes heritage the benchmark for the contemporary return of many Aboriginal materials to Aboriginal custodianship or ownership. There is no universal agreement on the criteria for the value of the heritage interest, as evidenced in a most emphatic manner by reactions to the Strehlow collection auction in 1999. Nor has the potential conflict between the goals of scientific research and the misuse of sacred and significant materials been eliminated.

Some of the questions that emerge in relation to this conflict are useful to any consideration of the status of the image: Who owns the past (if anyone)? Does custody encompass the right to the repatriation of materials of any age or provenance,

irrespective of their significance? What meanings are contained in secret/sacred images, and who has a right to own them? What happens when the "sacred" is made into "heritage"? How are Aboriginal views and claims on the past to be viewed against those of white, "professional history"?

These questions cannot escape the paradox that images of traditional culture exist only as a result of the appropriative practices of nonindigenous persons, and any preservation of these practices through images is due to the interest of members of the new settler culture in "salvaging a dying race." This paradox is apparent when such images are marshaled in the defense of Native title claims. The idea of non-exclusivity of the two worlds (Aboriginal and white) may be not only possible but necessary. John Mulvaney, a distinguished Australian archaeologist, provides a further example of the mutual interpenetration of Aboriginal and white cultures and histories. He has stated that although he has been considered a "conservative" on the issue of repatriation, he has also participated in the substantiation process for land claims in the Northern Territory. Further, he has suggested that dreaming stories often confirm archaeological theories (or perhaps this should be stated in the reverse).[6]

The act of Parliament that claims the Strehlow collection for public maintenance currently prevents any repatriation of items in the collection from taking place. There is now strong pressure to have this law overturned, but most researchers believe that few Aboriginal people will be interested in claiming back any sacred artifacts from the Strehlow collection. As this situation illustrates, a number of questions remain surrounding repatriation, including regarding what should be repatriated and how repatriation should take place.

Time, Space, and the Sacred

The current conflicts, according to Griffiths (1996), hinge on time: How far into the past do Aborigines have a claim on skeletal remains? Gelder and Jacobs (1998) argue that this is also a spatial dilemma and that "the sacred permeates everywhere." By this they mean that the sacred is a conceptual tool that can be mobilized and that, in addition to religious purposes, it has political and historical purposes as well.

In the Western European tradition, museum culture tends to focus on separateness and preservation as a means of identifying the values of the past. Aboriginal beliefs, on the other hand, tend toward continuity and the reinventing of tradition—a logic of survival and the desire to keep cultural traditions alive and relevant. Image preservation practices provide a means for the adaptive and creative uses of a European cultural technology. The Strehlow film work is not only a means of preserving elements of Aboriginal sacredness; it is itself part of the sacred. This can be seen in Strehlow's (1947) definition of *tjurunga*, which are not only sacred objects but ceremonial performances and any representations pertaining to the sacred (see note 3). As Dick Kimber has noted about the status of Strehlow's films of ceremonial performances, "These images... were taken of what were considered sacred ancestors and in this

way go beyond our conventional concepts of film."[7] This raises the question: How does one repatriate images? What form of activity is best suited to the return of images, and how are sacred images to be treated in this context of repatriation? Before I can address these questions, I must first introduce the concept of Native title.

In Australia, Native title exists when a legal right to Native possession of property is recognized by Australian common law. Following the precedent-setting Native title case of Eddy Mabo, which resulted in the removal of the notion of *terra nullius* as a founding view of Australia at the time of colonization, the Native Title Act and its amendments suggest a contested view of Native title in Australia.[8] Although Native title should justify and substantiate a claim to property, there is continual evaluation of the grounds for such claims in moving from alleged to recognized rights. The return of sacred objects and images to Aboriginal custody is also an expression of Native title. As with the expropriation of land, the removal of objects from collective ownership (including the recording of images and sounds of ceremonial life, in the case of films, audiotapes, and photographs) was either unauthorized or a feature of the general degradation of Aboriginal social life.

Expropriation/Appropriation

The twin activities of expropriation and appropriation feature centrally in how land claims and images are connected. I define *expropriation* as the unauthorized removal of objects or artifacts from their usual context of use and collective ownership, or as Loretta Todd (1990) states, "when someone else speaks for, tells, defines, describes, represents, uses or recruits the images, stories, experiences, dreams of others for their own" (24).

Expropriation (of land, of sacred objects) was a mostly colonial-bound practice, whereas appropriation is strongly identified with the postcolonial era. One of the characteristics of appropriation is the valuing of indigenous cultural objects and artifacts while simultaneously rejecting the return of these materials to the rightful owners. Todd (1990) suggests that these tendencies are actually related: "What is most revealing is that in the appropriation and naming of Native as healer, as storyteller, as humorist, the appropriators name themselves. We become the object against which the Threat of difference is disavowed. Our difference is covered over by becoming a symbol, a fetish" (30). Todd suggests that the fetish of the *tjurunga* is as much a European fetish as an Aboriginal one, in that these objects and their representations have a European as well as an Aboriginal history.[9] The European "fetish" is the intense interest in collecting and displaying these objects in European institutions, but it is a fetish also in the sense of "sacred," with the sacred as a sign of difference, the exotic, and the Other. In Todd's view, this leads to a commodification of indigenous values and practices. In this regard, Barry Hill's (1996–97) naming of *tjurunga* (some of which were collected by Strehlow) as the "commodities of the sacred" (6) is convergent with this position.

The dual position of sacred images as European fetish and commodity occurs in their use as "evidence" in Native title hearings. One of the crucial criteria in Native title claims is the capacity for Aboriginal people to demonstrate an ongoing "cultural" relationship to the land. (In a very recent proposed amendment to the criteria, the term "spiritual relationship" appears.) The artifacts and images in the Strehlow collection demonstrate this relationship through their presentation of a totemic geography and recorded genealogies that have been confirmed by the oral histories already known through generations of stories and songs. Mavis Malbunke, an Aboriginal women married to an elder, reiterates this view in discussing the genealogical records that Strehlow collected:

> We found it was the truth that we were talking about. Before these old people, even Hezekiel died and my aunties and my father died—all this was given to us; and we had written in our minds and we still feel strong to pass it on to our children.
>
> If we hadn't had that genealogy we would have been lost, yeh we would have been just nobody and just live under government's law, but now we have very strong law that we can fight and tell the government we belong here.[10]

Repatriation of the films and photographs of Aboriginal sacred ceremonies and genealogies is therefore a critical intervention in historical terms but also in the contemporary politics of land rights. The secret/sacred element of the Aboriginal oral tradition cannot be overlooked in the manner in which this material must now find its "voice." For some, this will be a personal, almost private experience of reconnection to a spiritual chain that was temporarily broken but, through these images, may now be repaired. For others, this will be a framework for ongoing repossession of a past—temporarily erased—that through the filmographic possibility is resuscitated and returned.

Conclusion

The law pertaining to copyright in Australia has recently been revised to include "moral rights" (Copyright Amendment [Moral Rights] Act 2000). Authors or creators of various media can claim moral ownership over their works notwithstanding the contracts they sign with employers. These new rights include (1) the right to be acknowledged as the creator of the work (right of attribution) and (2) the right to object to derogatory treatment of the work (right of integrity). For Aboriginal people, the significance of the amendment is related to the appropriation of designs for purposes that are deemed inappropriate to the cultural purposes of those designs. Although not included in the law as yet, the idea of moral copyright is very close to the logic of moral rights and to the right of integrity of the work. In most of the twentieth century, Aborigines had no control over the destinations of photographs or other recordings of them or their cultural practices. These images potentially became the objects of "derogatory treatment" and suffered from a similar "lack of integrity." The

many diverse uses to which photographs of Aboriginal people may be put is a concern that the moral copyright protocol attempts to address. Moral copyright is not included in this recent legislation, however; recognition of moral copyright remains an informal practice based on moral suasion and undertaken on a case-by-case basis through a nonbinding protocol flexibly and collaboratively applied.

Notes

1. The Aboriginal and Torres Strait Islander Commission (ATSIC), which is the highest-level representative body for Aboriginal people in Australia, has recently appointed a full-time intellectual property and copyright expert.

2. According to Anderson and Benson (1988), the common criteria for informed consent are (1) conditions free of coercion and deception, (2) full knowledge of procedures and anticipated effects, and (3) individual competence to consent.

3. In Strehlow's introduction to his book *Aranda Traditions* (1947), he defines *tjurunga* in the following manner: "In this book I have used the Aranda term tjurunga in two ways, always differentiated by their spelling. When spelt tjurunga it refers to the sacred stone or wooden objects which figure in their religious life.... The other spelling, tjuruna shows that the word is being used in its wider native significance, which embraces not only the stone or wooden objects already referred to, but also the ceremonies and chants and practically everything intimately associated with the sacred ceremonies" (xiii).

4. For example, footage of Aboriginal children playing that Strehlow shot in the 1930s was used with the consent of an Arrernte community group. The images were filmed at an institution called the Bungalow—an orphanage for children of mixed race.

5. Brown (1998) cites the work of Alan Wolfe (1996); Roger Sandall (2001) expresses a similar view.

6. Mulvaney made these comments as part of his introductory remarks for a presentation at a conference titled "A Century at the Centre: Spencer, Gillen and the Native Tribes of Central Australia," University of Melbourne, Parkville, October 2–3, 1999.

7. Kimber made this statement in an interview that appears in *Mr. Strehlow's Films*.

8. *Terra nullius,* literally translated as "empty land," was the doctrine invoked by the British in their colonization and settlement of Australia; that is, they declared it to be a land without any people who had a system of land tenure.

9. See Durkheim (1915/1976). Hill (1996–97) suggests that Durkheim, using the work of Spencer and Gillen, put the *tjuringa* at the heart of totemistic society and in effect created the "European fetish" for them.

10. Malbunke made these remarks after viewing the genealogical records, in an interview that appears in *Mr. Strehlow's Films*.

References

Anderson, Carolyn, and Thomas W. Benson. 1988. Direct Cinema and the myth of informed consent: The case of *Titicut Follies*. Pp. 58–90 in *Image ethics: The moral rights of subjects in photographs, film, and television,* edited by Larry Gross, John Stuart Katz, and Jay Ruby. New York: Oxford University Press.

Bok, Sissela. 1983. *Secrets: On the ethics of concealment and revelation.* New York: Vintage.

Brown, Michael F. 1998. Can culture be copyrighted? *Current Anthropology* 39, no. 2:193–223.

Cantrill, Arthur, and Corinne Cantrill. 1982. The Baldwin Spencer film material: Conflict of interests. *Cantrill's Filmnotes,* April 42–43, 56.

Cohen, Hart. 2001. *Mr. Strehlow's films* (film). Sydney: Journocam Productions.

Coombes, Rosemary. 1998. [Contribution to comments on "Can culture be copyrighted?"] *Current Anthropology* 39, no. 2.

Daes, Erica-Irene. 1993. *Study on the protection of the cultural and intellectual property of indigenous peoples.* New York: United Nations Economic and Social Council, Commission on Human Rights.

Durkheim, Émile. 1976. *Elementary forms of religious life,* translated by Joseph Ward Swain. London: George Allen & Unwin. (Original work published 1915)

Gelder, Ken, and Jane M. Jacobs 1998. *Uncanny Australia: Sacredness and identity in a postcolonial nation.* Melbourne: Melbourne University Press.

Griffiths, Tom. 1996. *Hunters and collectors: The antiquarian imagination in Australia.* Cambridge: Cambridge University Press.

Gross, Larry, John Stuart Katz, and Jay Ruby. 1988. Introduction: A moral pause. In *Image ethics: The moral rights of subjects in photographs, film, and television,* edited by Larry Gross, John Stuart Katz, and Jay Ruby. New York: Oxford University Press.

Hill, Barry. 1996–97. Object lessons. *Australian Review of Books* 1, no. 4:5–6.

Hugo, David. 1997. Acquisition of the Strehlow Collection by the Northern Territory government: A chronology. Pp. 127–37 in *Strehlow Research Centre occasional paper* 1. Alice Springs, N.T.: Strehlow Research Centre.

Lippman, Walter. 1922. *Public opinion.* New York: Harcourt Brace.

Patterson, Philip, and Lee Wilkins. 1997. *Media ethics: Issues and cases,* 3d ed. New York: McGraw Hill.

Sandall, Roger. 2001. *The culture cult: Designer tribalism and other essays.* Boulder, Colo.: Westview.

Strehlow, T. G. H. 1947. *Aranda traditions.* Melbourne: Melbourne University Press.

Todd, Loretta. 1990. Notes on appropriation. *Parallelogramme* 16, no. 1:24–33.

Wolfe, Alan. 1996. *Marginalized in the middle.* Chicago: University of Chicago Press.

Family Film: Ethical Implications for Consent

John Stuart Katz

B y the end of the twentieth century, relatively early in the digital age, an aspiring videomaker or filmmaker had access to all of the tools of his or her trade for less than a few thousand dollars. As the digital age progresses, it is likely that such equipment will become more sophisticated and its cost will decrease. With this increased access to videography and filmmaking equipment, more and more people will turn their cameras on those closest to them, their families and friends. The family films and videos they make can be disseminated to huge audiences over the Internet with the click of a mouse. Although some computer users do not yet have the ability to send or receive moving images, the tools to do so will soon be readily available to many. This increasingly cheap and easy access to the means of making films and video and the ability to disseminate these images rapidly worldwide makes a study of the image ethics of family films timely and compelling.

In the making of many family films, the filmmakers decide what significant and life-changing actions their subjects should take, convince their subjects to act, and then film the resulting actions. Often these filmmakers see their motives in manipulat-

ing their subjects' lives as solely altruistic, but often the results of the filmmakers' actions are beneficial to the filmmakers as well and result in more interesting and entertaining films. In this chapter, I use two films by Ira Wohl, *Best Boy* (1979) and *Best Man: "Best Boy" and All of Us Twenty Years Later* (1997) as case studies. In *Best Boy,* Wohl decides that his mentally retarded adult cousin Philly should become independent of his parents and makes a plan that Philly follows to move from his parents' home to a group home. In *Best Man,* Wohl successfully convinces Philly to pursue the Jewish rite of passage to adulthood, bar mitzvah. I use the Wohl films here to illustrate and to explore the image ethics raised by documentary family films.

Family Film: The Private Made Public

The characteristics of family film that are salient to this discussion are as follows: (1) an emotional involvement of the filmmaker with the subject of the film; (2) the subject's willingness to talk openly, intimately, and unself-consciously with the filmmaker; (3) the unlikelihood that the subject would have consented to the making of the film had the filmmaker not been a family member; and, of course, (4) family membership on the part of the filmmaker.

Although family films have always existed (one of the Lumière brothers created one of the earliest motion pictures ever made when he filmed his baby in *Baby's Meal,* 1895), the golden era of family films began in the 1960s and 1970s. During those decades, political events and technical advances provided fertile ground for this genre of documentary films (Chalfen 1986, 106–8; Nichols 1991, 160–61). The growth of the human potential movement coupled with disillusionment on the part of many young people with the political process and the growth of various protest movements involving the Vietnam War, civil rights, and women's rights led many to believe that political, social, and economic change must begin with the individual and the family. This belief in individual responsibility fostered increased introspection and the mushrooming of self-help books, workshops, and courses, as well as growth in individuals' critical analysis of their own heritage (Gitlin 1987, 81–106). It is no coincidence that *Roots,* which aired in 1977, was one of the most widely watched television series in history (Rabinowitz 1994, 143). In the 1960s and 1970s, film schools began training a burgeoning number of students who wanted to make small, inexpensive, intimate films. This was a generation known for questioning values and events in their own, their parents', and their other relatives' lives. What better way to examine social mores and make affordable movies than by making family films? Lightweight portable equipment using synchronous sound and 16 mm film was readily available. Film stocks were becoming faster, so it was no longer necessary for filmmakers to set up extensive lights. A family film could be shot with only two or three crew members, who were most often friends or colleagues of the director. Intimacy, involvement, and the personal became accepted as part of the documentary movement (Ruby 1978, 9; Lane 1991, 3). In the 1980s, video equipment became readily

available, but the equipment for editing video remained prohibitively expensive. Only recently has video editing equipment become as accessible as one's own home computer. In the 1990s came the beginning of the capability to disseminate film and video images to wide audiences over the Internet, without any cost to the filmmaker or videomaker. Since that time, millions of novice documentarians have had unprecedented power to make and distribute family films.

The concept of what constitutes a family has changed radically in the United States in the past fifty years. *Family* is no longer understood solely to mean the traditional nuclear family consisting of mother, father, and children; today it also includes single-parent families and families in which the partners and parents are gay or lesbian. With the change in the definition of family comes a broadening of the definition of what constitutes a family film. For example, *Silverlake Life: The View from Here* (Peter Friedman and Tom Joslin, 1993) is a poignant family film that portrays a gay couple's struggle with AIDS.

The Practice of Changing Subjects' Behavior

The earliest and most notable example of a case in which a documentarian urged his subjects to change their behavior took place when Robert Flaherty was filming *Nanook of the North* (1922). Flaherty, often referred to as the father of documentary film, convinced his nomadic Eskimo subjects, including Nanook himself, not only to re-create a way of life they had not lived for at least two decades but also to hunt, for the purpose of his film, in a place both unfamiliar to them and farther to the north than they had hunted before, thereby endangering their lives (Rotha 1983, 36–39). Two years after Flaherty left, Nanook went back on his own to that distant hunting ground, where he died of starvation (Barsam 1988, 19). Flaherty's actions made *Nanook* a more compelling and dramatic film, but at the same time the filmmaker played with actuality and put his subjects in jeopardy.

Flaherty again influenced his subjects' behavior when he has shooting *Moana* (1926). In *Moana,* the director arranged for one of his subjects to have his entire back tattooed, a painful procedure and a custom the youth's South Pacific tribe had abandoned twenty-five years before filming began. The tattooing provides a dramatic climax to an otherwise uneventful film. Flaherty's subject bore the mark of the director's suggestion of a change in behavior for the remainder of his life.

The directors of the family films of the 1960s and 1970s professed to be recording only what was actually happening in their families. They said that they did not want to interfere or intervene in their subjects' lives. Although documentarians have been interfering with and intervening in their subjects' lives since *Nanook* and *Moana,* such an approach to filmmaking is certainly more problematic for those who claim they only want to show how their families behave, ostensibly an approach that eschews intervention. Family filmmakers of the 1960s and 1970s actually did influence the lives of their family members by urging them to act in certain ways; performing actions

that, at the least, forever altered their families' dynamics. Notable among the family films in which such manipulation took place are Maxi Cohen and Joel Gold's *Joe and Maxi* (1978), in which Maxi urges her father to reveal intimate details about his personal life, details he would not have revealed except for the filming and that likely changed relationships within the family. Similarly, in Jeff Kreines's *The Plaint of Steve Kreines as Recorded by His Younger Brother Jeff* (1974), the director intervenes and prods his brother into revelations he otherwise would not have shared with his family, probably forever altering the family dynamic.

Best Boy and *Best Man* provide good contemporary examples of family films in which the filmmaker, the cousin of the subject of both films, also acted in the role of a family member who suggested and then implemented actions that changed his subjects' lives (in these cases, fortunately, most of the changes the director suggested and then effected for Philly and other family members did not harm the retarded man or his immediate family). With the anticipated proliferation of widely disseminated family films in the digital age, we need to explore the ethics of family filmmakers' suggesting actions to their subjects and then filming those actions.

The Stories of *Best Boy* and *Best Man*, and Their Filmmaker

In order to understand how Ira Wohl intervened in his subjects' lives to create *Best Boy* and *Best Man,* it is helpful to know the stories of the films, how the films were made, some background on the filmmaker, and something about his relationships with his subjects. Ira Wohl's career began in 1966, when he worked with Orson Welles on *Don Quixote* (1966, unfinished). In 1975, he was a film editor and director working in children's television. At a family seder (Passover dinner), he heard one of his relatives comment that the family expected Wohl's middle-aged handicapped cousin to spill things on the table and make noise "because he is retarded." As Wohl relates in *Best Boy,* it was then that he decided to help Philly learn to live independently before Philly's elderly parents, Max and Pearl, died. Simultaneously, Wohl planned to film the process of Philly's becoming independent, which he did on a shoestring budget, using borrowed equipment and friends for crew. The film shows the history of Philly's becoming less reliant on other people; we see him progress from staying at home all day and helping his mother with the housework to attending a day-long training program, to making an extended trip to an overnight summer camp for the mentally handicapped, to finally moving away from the family home permanently to live in a group home. The film's opening scene shows Philly's dependence on his parents, with a shot of Max and Philly as they go through their daily ritual of the father shaving his son with a razor and shaving cream. At the end of the film, in the last sequence, we see in extreme close-up an electric razor shaving a face while we hear the razor's buzz. As the camera pulls back, we realize that it is Philly, alone in his new room at the group home and now more independent, shaving himself. *Best Boy* portrays the reactions of Philly's parents, his sister, Frances, and his cousin, the filmmaker,

to the mentally handicapped man's changing life. Max died while the film was being shot; Pearl died six months after Philly left home, while the film was being edited. After a few years traveling the film festival circuit with *Best Boy*, Wohl moved to Los Angeles, where he worked in theater and was on the short list to direct the fiction film *Dominick and Eugene* (1988), a story about a mentally handicapped man.[1] Robert M. Young, a veteran filmmaker, was eventually chosen to direct the film, and Wohl went on to train to become a psychotherapist. He practices in California and specializes in the treatment of individuals in the film industry.

Years after *Best Boy*'s release, people continued to ask Wohl how Philly was doing. When Wohl went to a family gathering many years later and saw Philly, who was then in his late sixties, he realized how much Philly's life had changed and decided to make *Best Man: "Best Boy" and All of Us Twenty Years Later*. Philly had been living in a group home for about sixteen years at the time Wohl began filming *Best Man*. He had settled into life at the home, had made friends, and spent a great deal of time with his sister, who continued to nurture him. During filming, Wohl suggested at Rosh Hashanah (Jewish New Year) that he and Frances take Philly to visit his parents' graves, as is customary on that holiday. Frances was reluctant and said she had never taken Philly there because she was afraid he would become upset. Wohl prevailed, however, and the film shows Philly and Frances at their parents' graves. Later in the film, after watching Philly participate in a Jewish heritage group, the filmmaker decides that Philly should have a bar mitzvah, the ritual that marks the passage to adulthood for a young man in the Jewish religion, usually performed at age thirteen. Wohl then finds a rabbi to train Philly, hires a band and a caterer, contacts long-lost relatives, and flies Philly to California for a seder and to buy him a suit for his bar mitzvah. Toward the end of the film we see Philly at the bar mitzvah service and then we see him thoroughly enjoying himself dancing at the celebration that follows.

The Role of the Filmmaker–Family Member in *Best Boy* and *Best Man*

In voice-over at the beginning of *Best Boy*, as we see Max shaving Philly and Philly meticulously getting dressed on his own, Wohl clearly states that he is documenting the execution of his personal plan to make Philly more independent:

> My name is Ira Wohl and this is my cousin Philly. Philly is fifty-two years old and he's been mentally retarded since birth. . . . I guess I'm as guilty as anyone else in the family of always having taken Philly for granted; I remember them saying that his mind stopped growing when he was five and I guess I always accepted that. But three years ago at a family gathering I began to wonder what would happen to Philly when his parents were gone, so I spoke with them and with his sister Frances about it. I told them that I thought he needed to become more independent, and although this idea was very difficult for them to deal with, they realized that for Philly's sake, as well as their own peace of mind, something needed to be done. The film is a record of what they did and how it changed Philly's life.

The filmmaker makes all of the arrangements for Philly's progress and tracks the results of the plans he makes for Philly on film. Wohl is very involved in Philly's going to doctors for psychological and physical evaluation as well as Philly's moving on to training school, then to a sleep-away camp, and, finally, to residence in a group home. Wohl speaks all of the voice-overs from his own point of view, emphasizing that these plans for Philly are Wohl's plans. At times, the voice-over seems to have a self-congratulatory tone. For example, Wohl says, "After many months of looking, we found a training center where Philly could learn to do things he'd never done before and learn to take care of himself." Later, he adds, "It was now one year since we started filming and Philly was going to start his new life at the training center."

The filmmaker is so instrumental in planning for Philly's independence that only he knows what Philly's next step will be; as Philly progresses, Wohl suggests to Philly's mother and father what their son should do next. Interspersed throughout the film are scenes in which Wohl informs Pearl at the dining room table of his plans for Philly's future and reassures her about what the family is doing and about the benefits and facilities of the institutions he is suggesting for Philly. Pearl and Philly clearly rely on Wohl to determine how to proceed at each stage of Philly's halting steps toward independence. When they talk about Philly's going to training school for the first time, Wohl, who is off-camera and almost a deus ex machina, says to Pearl, who is in frame, "He has to bring his lunch on Wednesday and Friday. Tomorrow is lunch at McDonald's." Pearl then says, "Ira, can I ask you a personal question? Can I give the bus driver a tip? I don't know?" Wohl replies that he doesn't know either. Later, Wohl tells Pearl, more as a family member than as a filmmaker, while they are both seated at the dining room table and in frame, about the new home he has found for Philly.

Commenting on Philly's going to sleep-away camp, Wohl says in voice-over, "For the first time in his life my cousin Philly voluntarily left home to be on his own. And he was doing fine. I felt very proud of him." Later, in voice-over, the filmmaker says, "Three years and two weeks after we began filming, Philly moved into his new home. I guess I had hoped from the start that this is where he'd eventually come to. Now he can make a home for himself." The acknowledgments in the film's closing credits are further proof of the filmmaker's influence over the events portrayed. In the first, Wohl thanks his "Aunt Pearl, Uncle Max, cousins Frances and Norman for allowing me to enter their lives and trusting me to handle them with care." And finally, he says, "and most of all to my cousin Philly for giving me the chance to do the most important thing I've ever done in my life and reminding me how very delicate and beautiful a human life can be."

It appears likely that without Ira Wohl's intervention in his cousin's life, Philly would never have made the transition to a group home, a transition that came just before his mother's death and that, as shown in *Best Man,* led Philly to a life full of rich social interactions. It is equally likely that without the filmmaker's intervention

during the making of the second film, Philly would not have visited his parents' graves and would not have had a bar mitzvah. In voice-over in *Best Man,* Ira Wohl says, "As is traditional just before the start of the Jewish New Year in late September I suggest to Frances that we visit the graves of Philly's and her parents as well as that of her husband Norman. She surprises me by saying she has never taken him out of concern that he might get upset." And they go to the cemetery. They approach the family graves. Frances says, "Come here Philly. I want to show you. Come here. This is Mama and Daddy. And that's Norman." Philly does become upset, as Frances feared, rubs his face, walks away, and leans on another gravestone. When they leave the cemetery and go to a diner, Wohl says to his cousin, perhaps to convince Philly that he is no longer upset, "You're in the diner. You're happy. Everything's okay, right?" Although many people may be upset at seeing their parents' graves for the first time, most are able to decide for themselves whether they want to subject themselves to that distress. Philly did not choose to go to the cemetery; Wohl took him there in spite of Frances's fears.

We then see Philly participating in a special Jewish heritage group for mentally disabled people at the 92nd Street Y in Manhattan. When the group leader asks Philly what a bar mitzvah is, he says, "Dress up, the music and pray. I go to *schul* [synagogue]. I go to daven [pray] for Passover. Seder in *schul.* Got to light candles. Got to get a *yahrtzeit* candle [a candle that is lit on the anniversary of a death]." Wohl then says in voice-over, "As I watched Philly participate in the service, it starts me thinking. Why shouldn't Philly be bar mitzvahed?" When Wohl asks Philly if he knows what happens right after a bar mitzvah, Philly says "eat there," "play" and "dancing."

The filmmaker then goes on a quest for a rabbi who will perform the bar mitzvah service for Philly, is rejected several times, and finally finds a willing rabbi who shows Philly how to repeat, apparently without any comprehension, the necessary prayers. Wohl then relates in voice-over his attempts to contact long-lost family members to invite them to the bar mitzvah.

The director flies Philly to California for a Passover seder and to buy a suit for his bar mitzvah. It is Philly's first flight and his first trip to California. When Wohl reminds Philly that the next week is his bar mitzvah, Philly says, "We're gonna have good food there. Dance. Music." Wohl says in voice-over, "It's traditional to get a new suit for your bar mitzvah. I'm proud to do the honors for Philly and I happen to know just the right salesman."

In a scene that poignantly sums up the lack of control Philly seems to have over decisions in his life, the salesman in the men's store where Wohl has bought Philly's bar mitzvah suit shows Philly three ties, asking, "Which one do you like better? Do you like one better than the other one?" Philly replies, "The other one." The salesman does not try again to find out which tie Philly really likes; instead, he dismisses Philly with, "All right, we'll make the choice."

At his bar mitzvah service Philly repeats the words the rabbi says. In voice-over, Wohl says, "I'm truly impressed at how well Philly has risen to the occasion. I couldn't be more proud of him if he were my own son. In fact, it almost feels as if I've been given a chance to create a bar mitzvah for the son I never had."

Without the filmmaker's intervention, Philly would likely not have made the successful transition from his parents' home to the group home and more independence, would never have visited his parents' graves, and would not have had a bar mitzvah. The ethics of filmmakers' coaxing family members to make major life changes or to take actions they would not otherwise take so that the filmmakers can capture the events surrounding those changes or actions is the subject of the balance of this chapter.

The Ethical Considerations in Family Films

In our introduction to *Image Ethics,* Larry Gross, Jay Ruby, and I enumerate four ethical areas that should be taken into account by persons dealing with the production and use of images:

1. the image maker's commitment to him/herself to produce images which reflect his/her intention to the best of his/her ability;
2. the image maker's responsibility to adhere to the standards of his/her profession and to fulfill his/her commitments to the institutions or individuals who have made the production economically possible;
3. the image maker's obligation to his/her subjects; and
4. the image maker's obligation to the audience. (Gross, Katz, and Ruby 1988, 6)

I will discuss these moral responsibilities and how they play out in *Best Boy* and *Best Man* under these subheadings and in the following order: (1) responsibility to self, (2) responsibility to the profession, (3) responsibility to audience, and (4) responsibility to subjects. I deal with these ethical considerations in a sequence different from that in *Image Ethics* in order to save the most difficult and potentially the most controversial ethical area, responsibility to subjects, for the last and the most exhaustive discussion.

Responsibility to Self

There can be little doubt that Ira Wohl has produced two films that reflect his intentions—to document Philly's move from his parents' home to more independence in a group home and to document Philly's progress years later because of that increased independence, including even his becoming a bar mitzvah.

Although Wohl does not specifically tell us in his films that he has made them to encourage others to help their mentally handicapped relatives become more independent, arguably he had that intention as well. He has successfully made films that

argue eloquently, but perhaps too generally, that a mentally handicapped adult should move to an independent living situation before his parents die so that the separation can be smoother, and that a mentally retarded adult can attain the same kind of recognition in his community as a person with an average I.Q.

Responsibility to the Profession

One aspect of a filmmaker's moral obligation to the profession of filmmaking is competence. Wohl has satisfied this responsibility in *Best Boy* by creating a critically acclaimed and award-winning film (Allen 1980; Angel 1980; Hatch 1980; Insdorf 1980; Kauffmann 1980; Robinson 1980; Stone 1979). Among many other awards, *Best Boy* won the Oscar of the Academy of Motion Picture Arts and Sciences for best documentary feature film in 1979. *Best Boy* and *Best Man* are also excellent examples of the subgenre of documentary family film.

Responsibility to Audience

Wohl fulfills his responsibility to the audience by exposing his prejudices and interests and by educating and entertaining. At the beginning of *Best Boy* and *Best Man,* the filmmaker clearly sets out his relationships with the subjects of the films and his interests: to see that Philly becomes independent before his parents die, to see that he moves into a residential home before his parents' death rather than afterward, and to see that he becomes a recognized member of the Jewish community by becoming a bar mitzvah.

Wohl fulfills another responsibility by educating audience members about mental retardation, family dynamics, the life of a Jewish family in Queens in the 1970s and the 1990s, and life in a group home for the mentally retarded. The films use Jewish music, Yiddish, Jewish syntax, and stereotypical Jewish family dynamics, including the pervasive use of guilt, to show the life of the Wohl family. In this sense, *Best Boy* and *Best Man* are excellent examples of ethnic films (Friedman 1991, 15; Desser and Friedman 1993, 27, 28).

Both films have profound emotional impacts on their audiences; by the end of each film, viewers have taken Philly, his parents, and his sister into their hearts. Wohl himself has summarized the audience reaction to *Best Boy:* "At the end of every showing, people applaud and seem to love the film" (quoted in Insdorf 1980, H19). Wohl has included scenes in both films that ensure that by the time the final credits roll, there is not a dry eye in the house.

Responsibility to Subjects

A filmmaker's responsibility to his or her subjects is the most complex area of ethical concern raised by *Best Boy* and *Best Man.* The family filmmaker's ethical responsibility to subjects is a particularly difficult issue. The subjects, in order to comply with the family member filmmaker's wishes, will likely grant him or her more leeway than

they would a stranger, as both family filmmakers and their subjects have reported (Katz and Katz 1988, 124). In both *Best Boy* and *Best Man,* the filmmaker secured consent from unsophisticated family members to film and intervened in his subjects' lives—to secure Philly's move from his parents' home to a group home and to see to it that Philly was bar mitzvahed. Wohl intervened not only to change his subjects' lives, but also to secure the most dramatic scenes and make the most interesting films he could, and in doing so, he changed the experiences of those he was filming. Although the reasons for Wohl's actions are laudable (that is, to produce artistic, successful, professional films and to move his cousin Philly to independence and to the accomplishment of a bar mitzvah), his attitude and his actions toward his subjects demand scrutiny, not only because of what Wohl did in making his films, but because of the potential for abuse and overreaching that exists for all family filmmakers and their subjects.

The question of subjects' informed consent has been of prime concern in documentary filmmaking, particularly when subjects are mentally challenged (Anderson and Benson 1988, 59), minors, members of disenfranchised groups (Winston 1988, 43), or prisoners deemed to be wards of the state (Pryluck 1988, 262).

Three criteria are commonly considered to be necessary for consent to be informed: (1) the conditions under which consent is granted are free of coercion and deception, (2) the subjects have full knowledge of procedures and anticipated effects, and (3) the subjects have individual competence to consent (Anderson and Benson 1988, 59). Pryluck (1988) insists that "utter helplessness demands utter protection" (266). Philly, a retarded man, was certainly not competent to enter into contracts, to consent to medical treatment, or to consent to the use of his image on film.

The consent issues involved in the making of *Titicut Follies* (1967) are relevant here. Frederick Wiseman filmed that documentary at the Massachusetts State Correctional Facility at Bridgewater, a hospital for the criminally insane. Many of the subjects in *Titicut Follies* were, like Philly, not competent to consent to filming and did not understand that they were allowing Wiseman to film them (Anderson and Benson 1988, 72, 83). The Massachusetts attorney general allowed the superintendent of Bridgewater to give his permission for filming, presumably because the inmates were wards of the state. He did so, but he also required that Wiseman obtain a release from each of the inmates he filmed (Anderson and Benson 1988, 67). No procedure was set up to determine which inmates were competent and which were not (Anderson and Benson 1988, 83), and the release that Wiseman asked each filmed inmate to sign was worded in obtuse, inaccessible legalese (Anderson and Benson 1988, 72). Later, state officials who disapproved of the finished film and thought it showed the institution in a bad light moved to enjoin Wiseman from showing *Titicut Follies* in Massachusetts. When Wiseman defended the consent procedure he had used in response to the injunction motion, he took the position that he assumed all subjects were competent unless he was specifically informed otherwise (Anderson and Benson

1988, 83). Wiseman was enjoined from showing the film in Massachusetts for decades, although it was shown elsewhere (Grant 1992, 49, 76).

The story of informed consent relating to the mentally disabled in *Titicut Follies* is a cautionary tale. It shows how people with mental disabilities cannot adequately protect themselves against those who want to use their images in film or video, either by withholding consent or through recourse after their images have been expropriated. In Philly's case, his parents and later his sister, as his legal guardians, were legally authorized to consent to the use of Philly's image in the films. For reasons related to the family nature of the films, it is unlikely that they gave intelligent, informed, or uncoerced consent for Philly or for themselves. Subjects who might refuse strangers the right to film certain intimate details of their lives often allow access to filmmaker relatives (Katz and Katz 1988, 128). Not only do they give such access more freely, they rarely evaluate the question of informed consent or issues about how the film will be used as rigorously as they would with an outsider filmmaker (Katz and Katz 1988, 122).

Because of the intimate relationships Ira Wohl had with his subjects, the likelihood of his obtaining their consent where a stranger could not was great (Katz and Katz 1988, 131). The U.S. legal system looks suspiciously on confidential relationships, which include close family relationships, because of the likelihood that one family member may overcome the will of another in contract, real estate, or estate matters. Perhaps the legal system should look just as suspiciously at the consent to use images secured by relatives. Obviously, legal regulation or scrutiny of interfamilial consent would in some cases likely compromise the filmmaker's responsibility to him- or herself, his or her profession, and his or her audience. Many family films would not be made if such regulation were in place. Ironically, although one might expect that filmmakers whose subjects are their family members would take the greatest care, such may not always be the case. Arguably, Ira Wohl's taking Philly to the cemetery in spite of Frances's concern is an example of this lack of care.

Other issues that affect an individual's ability to give consent freely are his or her economic status, level of sophistication, and access to legal assistance. Only a person with a significant amount of power, money, or both can truly negotiate with a filmmaker to establish how his or her image can be used. Consider what would have happened had Philly, his parents, and his sister been wealthy rather than middle-class (Ruby 1988, 316). The Boston Kennedy clan offers a good example. The likelihood that a film like *Best Boy* or *Best Man* would ever have been made about Rosemary Kennedy, the mentally disabled daughter of liquor magnate Joseph Kennedy and his wife, and the sister of the president of the United States, is minuscule. The Kennedy family almost certainly would not have consented. Had they consented, their lawyers likely would have placed so many conditions on the film (such as controlling who and what could be filmed and what questions could be asked) that it probably would not have been made. If it had been made in spite of their demands, the Kennedys could have determined whether or not and where the finished product could be

shown. People who are less wealthy, less media conscious, and less likely to hire a lawyer to advise them of their rights (like Philly, Pearl, Max, and Frances) often do not know what they can and cannot demand from a documentarian, even one who is a family member. The subjects of *Best Boy* and *Best Man,* although not poor and disenfranchised but solidly middle-class, did not have the knowledge or resources, either financial or legal, to protect their rights or the bargaining power to put conditions on the filming of their story. Few documentary stories like *Best Boy* and *Best Man* would be told if all potential subjects had the knowledge and resources of the Kennedys.

A further ethical consideration attached to the family film is the effect on the family of making the family's private life public. Will the film's exposing private matters embarrass the family or lower its status in the community? Both *Best Boy* and *Best Man* portray Philly and his family in a flattering way, but less benevolent filmmakers sometimes portray their families less kindly.

The relationship between filmmaker and subjects and the ethics that govern that relationship are even more complex in *Best Boy* and *Best Man* than in the usual family film, because the filmmaker not only engineered the films but also strongly influenced the events he filmed. The first question the films present in this regard is one of personal ethics: Is it ever appropriate for a family member to control or to attempt to control the lives of his or her relatives? The question becomes more complex because it appears the filmmaker's motives were benevolent, and, indeed, it probably turned out to be a good thing that Philly was living on his own before both of his parents died. Most critics have lauded Wohl's work to change Philly's life in *Best Boy* (see, e.g., Insdorf 1980; Kauffmann 1980; Angel 1980; Stone 1979), yet the fact remains that the lives of Pearl, Max, Philly, and Frances would have been quite different if Wohl had not influenced his relatives' decisions and had not made films about them. In *Best Boy,* both Max's and Pearl's lives were disrupted when Philly went to training school—Max had to get up and eat breakfast earlier than he was used to, and Pearl lost a companion who had kept her company all day and helped her with the household chores and shopping. In *Best Man,* Frances took Philly to see their parents' graves, although she had never done so before, and Philly had a bar mitzvah—an event he enjoyed but likely never would have taken part in without the filmmaker's suggestion. Wohl arguably went too far in taking Philly to the cemetery; in doing so, he put Philly in a situation, one his sister had shielded him from for twenty years, that clearly distressed him.

Should a filmmaker influence a subject, particularly one who is mentally retarded, to do things he or she otherwise would not do, even when the manipulation will arguably result in a better film? This is a particularly nagging ethical question when a subject, like Philly, is easily influenced because of a disability. Again, the conflict between the filmmaker's responsibility to his or her subjects and the filmmaker's responsibility to self, audience, and profession surfaces. Which responsibility should take precedence? Is the answer different if the subjects are the filmmaker's own family members?

A family film documentarian has ethical responsibilities to four masters: him- or herself, his or her audience, his or her profession, and his or her subjects. In *Best Boy* and *Best Man*, the most problematic area is the filmmaker's responsibility to his subjects, who are members of his family. In making *Best Boy* and *Best Man*, Wohl fulfilled his responsibilities to self, audience, and profession, but he did not fully honor his responsibility to his unsophisticated subjects. Ironically, family film documentarians may compromise their responsibility to subjects more easily than other filmmakers because of their close relationships with their subjects. In addition to obtaining informed consent from family members to appear in a film, the filmmaker should be required to obtain informed consent concerning any changes in behavior the filmmaker intends to instigate. Attention should be paid to effects of making the family's private life public. Filmmakers should explore their own motives as well as the effects on their subjects of taking actions suggested by filmmakers, particularly when the digital age allows wide dissemination of the finished products.

Under ordinary circumstances, of course, a family member would not be expected to obtain informed consent before suggesting changes in that relative's behavior, but the situation is different when a film is being made. A family film director should be required to obtain consent when suggesting a behavior change because the act of filming itself puts more pressure on the subject to make the suggested change and because the director has another agenda aside from the subject's well-being—a better film. All of the questions raised by the impact of the filmmaker's being a close family member and the issues of subject competence that relate to an individual's consenting to be filmed must be brought to bear to ensure that the filmmaker obtains proper informed consent to the behavior change.

The filming of the behavior suggested by the director also has an effect on the behavior itself. Once the filmmaker encourages his or her family member to embark on a particular course of conduct and films that conduct, does the act of filming further affect the completion of the acts the filmmaker has urged? Arguably, it does. The subject and the filmmaker become increasingly invested in the conduct's being completed—the filmmaker so that he or she can get a better film, and the subject so that he or she can aid the filmmaker in realizing his or her goal of a completed film that shows particular behavior on the subject's part. This dynamic was present in the making of both *Best Boy* and *Best Man*. Once Philly started on the path to moving from his parents' home to a group home and Wohl began filming the transition, both Philly and his parents arguably had a greater stake in successfully making the transition than they would have had if the events not been filmed. Not only was the transition important, but Wohl's film documenting the transition was also important, and the family's interest in helping the film was influential in their successfully changing their behavior. Similarly, in the case of *Best Man*, once Wohl convinced Philly and Frances that Philly should become a bar mitzvah and began to film, both Philly and Frances had incentive not only to make the bar mitzvah a reality, but to help their cousin Ira's film to succeed.

When we look at a family film in which a director's intervention has effected a behavior change in a subject, we must determine whether the director's actions have helped or harmed the subject. In the case of *Best Boy,* Philly's move from his parents' home to a group home just before their deaths appears to be beneficial to him. He has progressed a great deal by the time we see him again in *Best Man.* Arguably, Philly enjoyed his bar mitzvah service and the party that followed, although he apparently did not understand the religious significance of this rite of passage. On the other hand, Philly's visit to his parents' graves may have harmed him. He certainly seems emotionally upset by the experience in the film, as he retreats a short distance when his parents' graves are pointed out to him.

We must also scrutinize the motivation of the director in urging that a subject change his or her behavior. Were the motives narcissistic, altruistic, or both? Certainly Ira Wohl's motives in moving Philly from his parents' home to a group home and organizing his bar mitzvah service and party were altruistic. These actions were meant to make Philly more independent while his parents were still living and to allow Philly to have a great celebration of his coming of age. In fact, in *Best Man* we learn that Wohl has made a lifelong commitment to Philly, he will become Philly's guardian when Frances dies. However, we cannot ignore the fact that without Philly's move to more independence in *Best Boy* and the planning and execution of the bar mitzvah and the trip to the cemetery in *Best Man,* there would have been little or no drama or tension in either film. To the extent that Wohl's intervention to change his subject's behavior in *Best Boy* and *Best Man* made these films more dramatic and more poignant, the filmmaker certainly had other than purely altruistic motives. It is crucial that we analyze the motives of the makers of family films.

Ira Wohl's motives in making *Best Buy* and *Best Man* were primarily altruistic, and he effected important, beneficial changes in his cousin's life, but the motives of all family members who may in future take advantage of the increasing access to cheap means of making moving pictures may not be so benevolent. The urge to heighten the drama in their work may overtake some of these new filmmakers or videomakers. A misguided director could encourage a suicide, precipitate a divorce, or adversely affect a child custody arrangement, all for dramatic effect, in an ostensibly intimate film that could potentially be disseminated worldwide.

Conclusion

Those who make and those who critique family films in the digital age must be particularly sensitive to the filmmakers' duties toward the subjects of their films and to the potential for wide dissemination of seemingly intimate family portraits. Family filmmakers and videomakers should obtain informed consent from their subjects, taking into account any family members' lack of sophistication and reluctance to say no. These directors should also obtain informed consent from their subjects regarding any actions they propose their subjects undertake. Filmmakers should be aware

of the potential impacts that their suggestions and their filming can have on their subjects, including the effect of making a family's private life public. Critics of family films should scrutinize the motives of filmmakers who urge changes in their subjects' behavior and then film the process of change.

Note

1. In order for the readers of this chapter to assess any bias I might have in favor of or against *Best Boy* or *Best Man* or its director, I believe it is important for me to reveal that I programmed the world premiere of *Best Boy* at the Toronto International Film Festival and later acted as the Canadian distributor for *Best Boy*. I also programmed *Best Man* for the Philadelphia Festival of World Cinema in 1998.

References

Allen, Tom. 1980. Man-child in the unpromised land. *Village Voice*, March 3, 38.

Anderson, Carolyn, and Thomas W. Benson. 1988. Direct Cinema and the myth of informed consent: The case of *Titicut Follies*. Pp. 58–90 in *Image ethics: The moral rights of subjects in photographs, film, and television*, edited by Larry Gross, John Stuart Katz, and Jay Ruby. New York: Oxford University Press.

Angel, Roger. 1980. The current cinema: Simon and Philly. *New Yorker*, March 10, 130–36.

Barsam, Richard. 1988. *The vision of Robert Flaherty: The artist as myth and filmmaker*. Bloomington: Indiana University Press.

Chalfen, Richard. 1986. The home movies in a world of reporters: An anthropological appreciation. *Journal of Film and Video* 38, nos. 3–4:102–10.

Desser, David, and Lester Friedman. 1993. *American Jewish filmmakers: Traditions and trends*. Urbana: University of Illinois Press.

Friedman, Lester. 1991. Celluloid palimpsests: An overview of ethnicity and the American film. Pp. 11–35 in *Unspeakable images: Ethnicity and the American cinema*, edited by Lester Friedman. Urbana: University of Illinois Press.

Gitlin, Todd. 1987. *The sixties: Years of hope, days of rage*. Toronto: Bantam.

Grant, Barry Keith. 1992. *Voyages of discovery: The cinema of Frederick Wiseman*. Urbana: University of Illinois Press.

Gross, Larry, John Stuart Katz, and Jay Ruby. 1988. Introduction: A moral pause. Pp. 3–33 in *Image ethics: The moral rights of subjects in photographs, film, and television*, edited by Larry Gross, John Stuart Katz, and Jay Ruby. New York: Oxford University Press.

Hatch, Robert. 1980. Films. *The Nation*, March 22, 348–49.

Insdorf, Annette. 1980. The compassionate man behind Best Boy. *New York Times*, March 16, H19, H21.

Katz, John Stuart, and Judith Milstein Katz. 1988. Ethics and the perception of ethics in autobiographical film. Pp. 119–34 in *Image ethics: The moral rights of subjects in photographs, film, and television*, edited by Larry Gross, John Stuart Katz, and Jay Ruby. New York: Oxford University Press.

Kauffmann, Stanley. 1980. True love and other matters. *New Republic*, March 22, 22–23.

Lane, James Martin. 1991. The autobiographical documentary film in America: A critical analysis of modes of self-inscription. Ph.D diss., University of California, Los Angeles.

Nichols, Bill. 1991. *Representing reality: Issues and concepts in documentary*. Bloomington: Indiana University Press.

Pryluck, Calvin. 1988. Ultimately we are all outsiders: The ethics of documentary filming. Pp. 255–268 in *New challenges for documentary,* edited by Alan Rosenthal. Berkeley: University of California Press.

Rabinowitz, Paula. 1994. *They must be represented: The politics of documentary.* London: Verso.

Robinson, David. 1980. Philly's family. *Sight and Sound,* November, 268.

Rotha, Paul. 1983. *Robert J. Flaherty: A biography,* edited by Jay Ruby. Philadelphia: University of Pennsylvania Press.

Ruby, Jay. 1978. The celluloid self. Pp. 7–9 in *Autobiography: Film/video/photography,* edited by John Stuart Katz. Toronto: Art Gallery of Ontario.

———. 1988. The ethics of imagemaking or "They're going to put me in the movies. They're going to make a big star out of me." Pp. 308–18 in *New challenges for documentary,* edited by Alan Rosenthal. Berkeley: University of California Press.

Stone, Laurie. 1979. Slow but sure. *Village Voice,* October 15, 45.

Winston, Brian. 1988. The tradition of the victim in Griersonian documentary. Pp. 34–57 in *Image ethics: The moral rights of subjects in photography, film, and television,* edited by Larry Gross, John Stuart Katz, and Jay Ruby. New York: Oxford University Press.

Afterword

Digital Image Ethics

Howard S. Becker and Dianne Hagaman

I n December 1999, a major windstorm hit Paris and its environs, destroying thousands of trees. Versailles was particularly hard hit, but the urban forests of Boulogne and Vincennes also suffered serious damage. We had just returned to the United States from a month in Paris and wanted to know what had happened, how the places we had come to know, during that month and during previous visits, had fared. Coverage of the storm damage in American newspapers was sparse, certainly not the kind of detailed information we wanted. So we went to the Internet to see what was to be seen, knowing that what appeared there was not constrained by considerations of cost or space. We not only hoped but fully expected to see hundreds of pictures of a variety of places in Paris.

We were disappointed. There were, in fact, dozens of pictures to look at on the Web sites of such major "providers" as Reuters, but they were all the same few pictures: a child picking his way through a mass of fallen trees, a view of the Eiffel Tower through a pile of broken-off tree limbs, and so on. Worse yet, the few images that were so repeated told us very little about the actual damage that had occurred.

The hundreds of individual frames exhibited contained very little "information" of the kind the Web is supposed to inundate us with. There was no systematic coverage of different areas of Paris and the city's outlying neighborhoods. None of the photographs or their captions gave specific information about specific places ("Three large trees block Rue Such-and-Such in the Such-and-Such Arrondisement"). What we saw instead, over and over again, were the few icons that have come to represent Paris in photojournalistic shorthand; a shot of the Seine with the Eiffel Tower in the background was a typical favorite.

Sad to say, this was no surprise. Routine photojournalism, the daily coverage of spot news (which includes such untoward events as major storms) relies on just such shorthand to get the job done. Photographers made these pictures, after all, to give a little color to pieces of news copy. They did not make them to satisfy the unusual informational appetites of people like us, who wanted to know in detail what had happened to specific places. They made the photos to satisfy editors who wanted pictures that would, to use the standard newsroom jargon, "say 'Paris'" and "say 'storm'"—pictures that would, that is, be immediately recognizable by any ordinary reader as showing them what they already knew from the headline accompanying the story: a big storm had knocked down some trees in Paris. Such ordinary readers are not interested in the level of detail and specificity we were looking for and that we had hoped the new digital journalism would give us.

What the new age of digital photojournalism gave us, instead, was the same old stuff, nothing different from what would have appeared in a daily newspaper in the old predigital days. That summarizes one of the truths that several of the contributors to this volume have given us: the digital revolution has in many ways simply made it easier, quicker, and more efficient for organizations that use imagery to do what they have always done.

This is not a new idea. When photographers began to hear excited complaints about the digital manipulation of photographic imagery, many of them said, "So what? Nothing new. We always did that." That is, at the crudest level, photographers have long used the tools of retouching—bleach and inks—to change the look of photographs, often to alter details significantly (removing wrinkles from movie stars' faces, or dirt from factory floors, as Michael Lesy [1976] documented in his study of the Louisville photographic studio of Caulfield and Shook). And it has not always been that crude. Everyone who makes photographs for a living or in a serious way knows that by choosing the appropriate framing for an image—leaving this out and putting that in—or by choosing the appropriate moment to make an exposure (the fleeting and perhaps only moment when the person being photographed looked "that way")—you can make the resulting image say whatever you want it to say, even though you have used no artificial means to get that result. A photographer can make a politican look jolly, grim, defeated, victorious, lecherous, decorous—any of those—without employing the least "manipulation."

Bousé's chapter on wildlife films makes this point neatly. These films have, from the beginning, been phony, staged so as to create visions of the jungle and the animals in it that matched people's ideas of what those places and beasts are like. In the old, predigital days, the lemmings had to be herded over the cliff (left to themselves, they would not have jumped) by Disney employees. Now one lemming can be filmed, the resulting image sent (by the magic of digital superimposition) over a cliff it is nowhere near, and that image multiplied by a thousand to create the herd of suicidal lemmings the story line demands. Better yet, the image makers can produce animals none of us have ever seen, because they became extinct millennia ago, and have them engage in whatever might be thought to be their characteristic forms of behavior. We now see "real" dinosaurs, in the flesh, whereas in the old days we could see only obvious cartoon animations or assemblies of bones dolled up by taxidermists or illustrators. But we see the same stories told in much the same way, with the same narrative devices, the same characterizations of good and bad animals, ferocious killers and caring moms.

If nothing has changed, if photographers and filmmakers are only doing what they have always done, just a little more easily, then what is all the fuss about? Why, in particular, are people in these businesses raising questions about "ethics"? Editors who never blinked when their photographic staff altered photographs extensively with bleach, or waited for the opportune moment that told the story that was supposed to be told, have now begun to have fits of conscience over the digital removal of a Coke can or, in what has become the archetypal horror story, the moving of an Egyptian pyramid a few feet so that it would fit on the cover of the *National Geographic.* Why?

Visual imagery has always depended on visual and narrative conventions shared among those who make and consume it to get its work done and out. We have all learned to pretend that black-and-white or multicolored marks on a piece of white paper represent how things "really" are. Better put, we have all learned to read those marks in such a way as to allow us to feel comfortable making inferences about reality from them. A bargain has been struck. The image makers agree to do things in a certain way (for instance, not to alter the picture "substantially"), and viewers agree to accept the images as "real enough" for the purposes they want to put them to. In the case of photojournalism, the standards of most viewers, readers of daily newspapers, are not terribly high, because nothing much is at stake for them if, say, a movie star's blemishes are removed. They might be more worried if the picture of a youth being gunned down in Tiananmen Square turns out to be a picture of something that never happened, because they might base their own political beliefs and actions on the understanding that "it really happened that way."

Photojournalism thus depends (or at least its practitioners think it depends) on the public's belief that these agreements have been kept (see the discussion by John Hersey 1980). (Mind you, this is like other "social contract" stories; we don't mean that any such agreement was actually signed between competent parties, only that

everyone acts as though it had been.) When "the public" becomes aware that that might not be true, that some alterations that matter to our understanding of events have been made in the image, they may stop doing their part, start treating news photographs with the skepticism routinely applied to advertising imagery. And that might, in a sort of domino effect, cast doubt on the whole journalistic claim of "objective reporting" that, despite all the postmodern critiques, people in the news business still try to sell us.

This accounts for the strange stories Schwartz reports in her chapter, in which anxious editors begin to treat as criminal the use of what have always been standard photographic resources. She finds, on a Listserv in which news photographers discuss their troubles, the story of an editor who suddenly complains that the use of blur to indicate motion, a device photographers have used routinely since the beginning of the art, now constitutes an unacceptable "manipulation." Because it can be avoided, the editor decrees, it should be—as though the alternative, the freeze frame, is realistic in a way that the blurred photograph is not.

Because the dreaded reader skepticism might result from manipulations, were they known to occur, even the slightest, most harmless devices (like blur) must be avoided. The Coke cans the photographer forgot to remove from the scene before making the exposure, the horse droppings the parade workers didn't clean up in time, all have to be left in, because taking them out would create skepticism.

Why do these minor manipulations matter so much now? Because now, many people fear, the manipulations can be done undetectably, and that is qualitatively different. It isn't, of course; it is equally completely undetectable that I chose to make my exposure now instead of then, when the politician I want to malign is yawning rather than alert. But readers never understood the import of that kind of choice. Now they know that photographs can be redrawn undetectably, and that might produce the reader skepticism that scares editors.

There is no clear end in sight to this process of moral redefinition of photographers' resources. If using blur becomes questionable, then it is a short step to criticizing many other standard practices. Some photographers and editors are already wondering whether it is ethical to print a photograph originally made in color in black and white. And it is easy to see that the same problems could arise regarding the choice of lenses (is it ethical to "distort reality" by using a 28 mm lens instead of a more "normal" 50 mm or 35 mm lens?) or in the use of selective focus (stopping down so that only a "main subject" in the foreground is in sharp focus while all the other "confusing detail" is not; see Hagaman 1993). These are the routine ways that news photographers have met the editorial requirement that their images be easily read and that their meanings be clear to the reader on first glance. Will these routine devices now be banned by frightened, and therefore zealous, editors anxious to preserve an already shaky reputation for "objectivity"?

This is not simply to chastise silly editors; plenty of critics do that already. There is a deeper point. Scholars and critics have worried endlessly about the "impact" of

digital communications, as they earlier worried about the impact of "communications." The worries center on what these new kinds of communications will do to their consumers. Will exposure harm viewers' personalities? Their psychological development? Their social relations? The answer usually is yes, as it always was to similar questions about older forms of communication (radio, movies, comic books, television), although careful research has seldom revealed any actual harm (for a careful and critical review of this area of research, see Pasquier 1999, 215–23). We should not be looking for the impact of digital image making there, on innocent consumers of the product. Instead, what many of the chapters in this volume tell us is that we should be looking for that impact on the social relations that make up the world of image making and distribution.

The impact on news photographs, we have just seen, results from a shifting set of relations among photographers, editors, and readers occasioned by the possibilities of digital manipulation. And the impact is on the photographers and editors, primarily, and only in a secondary way on the final viewers of the imagery.

These changed relations show up in other ways. Perlmutter tells us in his chapter that photojournalists now work differently. They "shoot less, erase more, and keep few." They shoot more because the cost of film and the time spent in processing it are no longer relevant considerations, but they save fewer pictures, erasing the disks as soon as the choice of images for the immediate story has been made. As a result, newspaper photographic archives, once primary sources of data for historians and other researchers (not least for researchers on the practices of newspapers and their photographers), will soon cease to exist.

Similarly, the digital revolution has had a major effect on the marketing of what are called stock photographs, the familiar pictures of families and neighborhoods and gardens and oceans and lovers and so on—all the standard "stock topics" that editors and advertisers want to illustrate with pictures that deliver recognizable, generic images. This has led to a corresponding change in the financial and career prospects of the photographers who make those images. According to Frosh, the technology of digital reproduction has increased the number of available images astronomically. Stock houses, enterprises that offer enormous numbers of such images from which editors and art directors can choose, no longer have to produce and distribute expensive catalogs displaying their collections. Users no longer need to choose and pay for particular individual images. Instead, stock houses can sell CD-ROMs with thousands of images on them at very low prices or, even cheaper, make similar collections available on the Web. The increased number of images available makes individual images, which are mostly sold exactly for their generic rather than their distinctive qualities, less valuable. Stock houses drive increasingly hard bargains with the photographers who produce the images they sell, and that makes a career providing those images a much chancier affair than it used to be.

There is an exception to this arrangment. The very cheapness of most stock images, and the possibility that an ad agency will find the one it chose for a particular

ad in its competitor's ad as well, makes it possible and profitable for "artists" to create a "higher class" of images, images whose price alone makes them more exclusive and that can be bought for exclusive use. The digital "revolution" in stock photography has not, however, changed the experience of people who read advertising at all—they see the same pictures they have always seen. But it has completely changed the lives and professional opportunities of the people in the trade. Here, too, the change is in relations of work, relations of power, and economic practice.

What do all these shifts in institutional arrangements created by the introduction of digital imaging techniques have to do with ethics? A few generalizations seem reasonable. People define problems as "ethical" within the framework of the established social relations in their worlds of work and consumption and the associated conventional ways of getting the work done and using its products. Newspaper photographers operate in a world of editors, readers, and peers; stock photographers work in a world of agencies, advertising professionals, and print media; wildlife filmmakers play to their specific audiences of TV viewers, peers, and so on. Each of these worlds is so organized that some people provide services of a particular kind to some other people, often through a number of intermediaries. The relations among all these folks are governed by established understandings of how things are to be done, ways that everyone involved has come to rely on. An editor knows that the photographer will deliver an image the editor believes a reader will accept; photographers know that editors will accept images made in that way; readers know what to make of images made that way (see the discussion in Becker 1986).

Questions arise when some party to all this starts, for whatever reason, doing things differently, and someone else finds that change objectionable or inconvenient. Although the questions may be phrased as practical matters, involving mutual convenience or expediency or simple conflict of interest, they are just as often put as ethical ones, invoking higher-order moral concepts. If I am accustomed, as Joel Snyder and all the other historians of art are, to displaying slides of artworks so that I can discuss them with my students, I will find it not just inconvenient but unconscionable to be told that I am behaving unethically in making and displaying those slides as art historians always have, that I am in fact stealing someone else's property. I will feel, rather, that the people who are now monopolizing the use of such images are interfering with a long-established right and in doing so are acting unethically.

We are impressed by the legal arguments made by Weil and Halpern in this volume. They tell us that there is no simple right or wrong in the use by some people of artworks made by other people. These are simply matters of convention, of practices agreed upon long ago and hallowed by years, even centuries, of continued use. As conventional arrangements change, people find their interests affected. They no longer have the rights they once had as a matter of course, rights they had come to rely on. What they once expected in the behavior of others with whom they routinely do business they can no longer expect. Rather than treating these as ethical violations,

lawyers Weil and Halpern suggest, we should see these as similar to most legal matters, as involving conflicts of interest that are best resolved through compromise rather than through ethical upbraiding and name-calling.

The uneasiness over who has a right to do what to what kinds of images with digital technology—whether in the making of those images or in their use and distribution—reflects the unsettled and emerging social relations that constitute the worlds of image making today. New techniques and new possibilities undermine the bases of established cooperative arrangements among makers, distributors, and consumers of imagery. We (whatever combination of those roles we play) use the language of ethics to navigate these unmapped waters. The language of organizational analysis is probably more appropriate.

References

Becker, Howard S. 1986. Telling about society. Pp. 121–35 in *Doing things together,* edited by Howard S. Becker. Evanston, Ill.: Northwestern University Press.

Hagaman, Dianne. 1993. The joy of victory, the agony of defeat: Stereotypes in newspaper sports feature photographs. *Visual Sociology* 8:48–66.

Hersey, John. 1980. The legend on the license. *Yale Review* 70:1–25.

Lesy, Michael. 1976. *Real life: Louisville in the twenties.* New York: Pantheon.

Pasquier, Dominqiue. 1999. *La culture des sentiments: L'expérience télévisuelle des adolescents.* Paris: Éditions de la Maison des sciences de l'homme.

Contributors

Howard S. Becker has taught at Northwestern University and the University of Washington. He is the author of *Outsiders, Art Worlds, Writing for Social Scientists,* and *Tricks of the Trade.* He lives and works in San Francisco.

Derek Bousé is associate professor in the Faculty of Communication and Media Studies at Eastern Mediterranean University in Cyprus. His articles on environmental and nature imagery in the media have been published in *Film Quarterly, Critical Studies in Mass Communication, Journal of Visual Literacy, The Public Historian,* and *EBU Diffusion* (the journal of the European Broadcasting Union). He is the author of *Wildlife Films.*

Hart Cohen is senior lecturer in the School of Communication, Design, and Media at the University of Western Sydney, Australia. He lectures in media and cultural theory with a special interest in ethnographic film and indigenous media. He wrote and directed a documentary on T. G. H. Strehlow for SBS Television, Sydney, titled *Mr. Strehlow's Films,* and is now working with a collection of ethnographic films in the Strehlow Research Centre in Alice Springs in central Australia; the project is developing a plan for the documentation, organization, and repatriation of the films for use by affiliated Arrernte people.

Jessica M. Fishman received a Ph.D. from the Annenberg School for Communication, University of Pennsylvania. In her work she examines the relationship between social class and mass media, and she has also published on the visual codes used by U.S. news media to represent the moral order/disorder of other national groups.

Paul Frosh is a lecturer in the Department of Communication and Journalism at the Hebrew University of Jerusalem. His research interests include visual communication, consumer culture, communication theory, semiotics, cultural production, and new media technologies. He is the author of *The Image Factory: Consumer Culture, Photography, and the Visual Content Industry.*

Faye Ginsburg is the founding director of the Center for Media, Culture, and History and David B. Kriser Professor of Anthropology at New York University. Her work addresses social movements and cultural activism in a variety of locations. Her books include *Contested Lives: The Abortion Debate in an American Community; Uncertain Terms: Negotiating Gender in American Culture; Conceiving the New World Order: The Global Politics of Reproduction* (coedited with Rayna Rapp); and *Media Worlds: Anthropology on New Terrain* (coedited with Lila Abu-Lughod and Brian Larkin).

Laura Grindstaff is assistant professor of sociology at the University of California, Davis. She teaches and conducts research in the areas of popular culture, mass media, cultural studies, feminist theory, and ethnographic field methods. She is the author of *The Money Shot: Trash, Class, and the Making of TV Talk Shows.*

Larry Gross is professor and director of the Annenberg School of Communication, University of Southern California. His publications include *Contested Closets: The Politics and Ethics of Outing* (Minnesota, 1993) and *Up from Invisibility: Lesbians, Gay Men, and the Media in America.* He has edited or coedited *Image Ethics: The Moral Rights of Subjects in Photography, Film, and Television; Communications Technology and Social Policy; Studying Visual Communication; On the Margins of Art Worlds;* and *The Columbia Reader on Lesbians and Gay Men in Media, Society, and Politics.* He is associate editor of *The International Encyclopedia of Communications.*

Dianne Hagaman has worked as a photojournalist for the *Seattle Times* and other papers, and has taught at the universities of Missouri and Washington. She is the author of *How I Learned Not to Be a Photojournalist* and the creator of the CD-ROM *Howie Feeds Me.* She lives and works in San Francisco.

Sheldon W. Halpern is C. William O'Neil Professor of Law and Judicial Administration at the Moritz College of Law at the Ohio State University. He teaches courses in copyright, trademark, and defamation and privacy. His books include *Copyright Law: Protection of Original Expression; The Law of Defamation, Privacy, Publicity, and Moral Rights: Cases and Materials on the Protection of Personality Interests;* and *Fundamentals of United States Intellectual Property Law.*

Darrell Y. Hamamoto is professor of Asian American studies at the University of California, Davis. He has written extensively on popular culture and electronic media with special reference to race and ethnicity in the United States. His books include *Nervous Laughter: Television Situation Comedy and Liberal Democratic Ideology; Monitored Peril: Asian Americans and the Politics of TV Representation* (Minnesota, 1994); and *Countervisions: Asian American Film Criticism.*

John Stuart Katz is professor of English and film studies at the University of Pennsylvania. His work focuses on the influence of film on political and social change, independent fiction and documentary films, and the role of self-reflexive media in the history of the moving image. His publications include *A Curriculum in Film; Perspectives on the Study of Film; Autobiography: Film/Video/Photography;* and *Image Ethics: The Moral Rights of Subjects in Photographs, Film, and Television* (with Larry Gross and Jay Ruby).

Marguerite J. Moritz is producer of the documentary *Covering Columbine* and codirector of the program in journalism and trauma at the School of Journalism and Mass Communication, University of Colorado, Boulder, where she is professor and associate dean. Previously, she was a producer at the NBC-owned and -operated station in Chicago.

David D. Perlmutter is associate professor at the Manship School of Mass Communication at Louisiana State University. He is a senior fellow at the Reilly Center for Media and Public Affairs and editor of the politics@media book series of Louisiana State University Press. He is the author of a number of books, including *Photojournalism and Foreign Policy: Framing Icons of Outrage in International Crises; Visions of War: Picturing Warfare from the Stone Age to the Cyberage;* and *Policing the Media: Street Cops and Public Perceptions of Law Enforcement.* He is editor of *The Manship School Guide to Political Communication.* He has also written more than one hundred opinion essays for U.S. and international newspapers.

Jay Ruby is professor of anthropology and director of the graduate program in anthropology of visual communication at Temple University. His work explores the relationship between cultures and images, and his research interests revolve around the application of anthropological insights to the production and comprehension of photographs, film, and television. He has edited a number of books, including *A Crack in the Mirror: Reflexive Perspectives in Anthropology; Robert Flaherty, a Biography;* and *Image Ethics: The Moral Rights of Subjects in Photographs, Film, and Television* (coedited with Larry Gross and John Stuart Katz). Among his authored books are *Secure the Shadow: Death and Photography in America; The World of Francis Cooper: Nineteenth-Century Pennsylvania Photographer;* and *Picturing Culture: Essays on Anthropology and Film.*

Dona Schwartz is associate professor at the School of Journalism and Mass Communication, University of Minnesota. Her recent research in visual communication focuses primarily on the history and contemporary practice of photojournalism and documentary photography. Her work examining the emerging forms of multimedia documentary can be found at http://www.picturestories.umn.edu.

Matthew Soar is assistant professor of communication studies at Concordia University. His research on critical issues of media representation and cultural production has been published in *Jump Cut, Body and Society,* and *Cultural Studies.* He previously was the resident graphic designer at Media Education Foundation.

Stephen E. Weil is scholar emeritus in the Center for Education and Museum Studies at the Smithsonian Institution. From 1974 until his retirement in 1995, he served as deputy director of the Smithsonian's Hirshhorn Museum and Sculpture Garden.

Index